YALE UNIVERSITY PRESS
PELICAN HISTORY OF ART

FOUNDING EDITOR: NIKOLAUS PEVSNER

MICHAEL LEVEY

PAINTING AND SCULPTURE IN FRANCE
1700–1789

Michael Levey

Painting and Sculpture in France
1700–1789

Yale University Press
New Haven and London

Some sections of this book were previously published as Part One of
Art and Architecture of the Eighteenth Century in France by Penguin
Books Ltd, 1972
Copyright © Michael Levey, 1972, 1993
10 9 8 7 6 5 4 3 2

Set in Monophoto Ehrhardt, and printed in Singapore
by C.S. Graphics

Designed by Sally Salvesen

Library of Congress Cataloging-in-Publication Data

Levey, Michael.
 Painting and sculpture in France 1700–1789 / by Michael Levey.
 p. cm. — (Yale University Press Pelican history of art)
 Includes bibliographical references and index.
 ISBN 0-300-05344-4 (cloth)
 0-300-06494-2 (paper)
 1. Art, French. 2. Art, Modern—17th-18th centuries—France.
I. Title. II. Series.
N8846.L46 1992
759.4'09'033—dc20 92-32503
 CIP

Title page: Jean Siméon Chardin, *The Attributes of the Arts* (detail),
Minneapolis, Institute of Arts

To
Terence Hodgkinson
with affection and in homage

Contents

Preface

This book is a revised and considerably expanded version of the chapters on painting and sculpture I contributed to the Pelican History of Art volume entitled *Art and Architecture of the Eighteenth Century in France*, first published in 1972.

I am proud, and also somewhat relieved, that the book should now appear under the imprint of the new publishers of the series, the Yale University Press. My first debt therefore is to John Nicoll, with whom it has been a pleasure to collaborate again, and who has been in every way sympathetic and helpful in taking over a book in proof and ready for publication when disposed of by the Penguin Group. He and his staff have not only saved the author much tedious labour but produced an enhanced book, and I am deeply grateful to all those involved, especially to its designer, Sally Salvesen.

It is right that I should also record my real gratitude to several people who worked devotedly on the book while it was with Penguin, beginning with the late Judy Nairn, the gifted editor of the Pelican series there. By her steady, scrupulous care, she greatly improved the text, and it is a sadness to me that she never lived to see its publication. To Susan Rose-Smith, who patiently and tenaciously – and with cheerfulness – pursued good quality black and white photographs (as well as colour ones for this edition), I am also warmly grateful, as I am to the book's original designer, Gerald Cinamon, whose *rapport* over it I valued. In the tangled aftermath of Judy Nairn's death, Stephany Ungless at Penguin provided some continuity, as well as friendly interest. It was fortunate for me that Judith Wardman was willing to undertake detailed editing of the text, and I am especially grateful to her for seeing that task through to eventual publication.

To several scholarly friends and ex-colleagues I am also extremely indebted. The Preface to my part of the previous edition is reprinted here not least because it pays some tribute to the generous help I then received, for which I remain grateful. For fresh help and advice I am now grateful to John Ingamells and Neil MacGregor, and also to this book's dedicatee, thanks to whom some errors have been corrected. I must also mention with gratitude the help and interest of Denys Sutton, who sadly died while the book was in the course of going through the press.

Abroad, I am particularly grateful to Professor François Souchal, who generously gave me valuable indications concerning recent literature and research on sculpture of the period, and in general I am indebted to his own publications on the subject. To Dr Sergey Androssov, curator of sculpture at the State Hermitage Museum, St Petersburg, I am grateful for specific, timely help over a photographic matter.

Since the earlier edition of this text was published, study of both the painting and sculpture has greatly advanced, and is doing so even as I write. Exhibitions and monographs have clarified figures who were then truly obscure, and good general books have been published in English on the painting, as well as other studies on aspects of art at the period. I hope I have benefitted from this wealth of material, to which some reference will be found in the Notes. But I admit that my references are partial, and, given the time this book has been awaiting publication, inevitably not always up-to-date. Full references to each work discussed would have greatly added to the book's length. That is a measure of how active scholarship has been in an area of art history which for long suffered neglect and even a degree of scorn, particularly perhaps in Britain.

Obviously, I welcome the renewed and wide-ranging interest, which in purely personal terms has made me re-think my attitude to several figures, as also to the period as such. Anyone sufficiently intrigued will be able to compare the present text with that of the earlier volume and see where I have modified or even changed my views. And I may add that I have still not managed to accommodate all the talented artists, in sculpture equally as in painting, who deserve to be included. A completely new book would be needed to approach that goal, and one of a rather different kind.

In this book artists I rate highly tend to take precedence over others whose interest, as I see it, is chiefly historical. I cannot rank Carle van Loo as greater than Watteau – any more than I can Sir Walter Scott above Jane Austen. In both cases, I am aware, the judgment of their contemporaries would, broadly speaking, be against me. But the history of an *art* is bound to contain within it subjective elements. To pretend otherwise is one of the major modern academic treasons. The marvellous quicksilver that is art will never be contained in any single 'history', but I suspect we are attracted to study art because of its mercurial and ultimately unfathomable nature.

Very great artists, I believe, were at work in eighteenth-century France, some of them among the greatest in Western art. And that belief has sustained this book and its writer.

M.L.
April 1992

Preface to Part One of Art and Architecture of the Eighteenth Century in France

Given the daunting level of competence and the mass of practitioners – both of painting and of sculpture – in eighteenth-century France, it is obvious that a volume such as the present one must be highly selective. Although obvious, the fact could be forgotten by the devoted student of some comparatively little-known figure who may wonder why Watteau or Bouchardon, say, is discussed at length while his own candidate goes unmentioned. I am sorry for the casualties, yet I believe they were inevitable: not because my choice is historically always the correct one, but because I could write the book no other way. The pages could have been filled with lists of names; something at once more and less than a Bottin du dix-huitième siècle is attempted here.

Inevitably perhaps, it did not prove possible to treat the engravers, the water-colourists, and the miniaturists within the book; some attractive, if not tremendously important, decorative painters have also failed to be included. Nor was there space to offer any sustained discussion of artistic theory in the century – so literate, so lively, and so complicated that it will provide plenty of scope for more books by other authors. I could extend the list of *lacunae*. Yet it may also be worth saying that space has been given particularly to sculptors, some of whom have probably been discussed very rarely in English – and not much in French. With the great artist, whether sculptor or painter, I have often allowed greatness to prevail. In the kingdom of art there are doubtless many mansions, but some will always tower above others. I should add that, with the editor's warm agreement, certain sculptors have been included whose life and work carry one far beyond 1789; they have usually been history's victims – neither eighteenth-century fish nor nineteenth-century fowl. Something is said, then, of Chaudet and Chinard; but there could be no more than a brief reminder that Prud'hon also lived in the same period. I apologize for the inconsistency, as for the faults of omission and commission which are unavoidable in attempting such a survey.

In tackling it, I have been lucky enough to incur several notable debts. My first major one must be to my editor, Sir Nikolaus Pevsner, by turns patient and impatient, encouraging and goading, kindly and severe. Once or twice it seemed that the terseness of our exchanges preluded a breakdown of all communication; yet it was the very terseness of a telegram from Lübeck which gave me in a word generous praise and great encouragement. That telegram became a talisman while I went on with the work; and I am grateful besides for much shrewd editorial comment and help, especially from Mrs Judy Nairn.

There is not room to name all those who have helped me, answered my queries, and sent me photographs. I am especially grateful to museum colleagues in France, in Russia, in America, and elsewhere, who spared time to deal with letters and requests; I know how valuable museum officials' time is and how much of it such demands eat up. Great help was given me also by those who kindly typed my long manuscript, deciphered the notes, and brought order to the often-emended bibliography. In these ways I am indebted once again to Mrs Grace Ginnis and to Robert Cook, supplemented by timely aid from Miss Annette Forward.

Among colleagues and friends I should like to single out gratefully Terence Hodgkinson, Hugh Honour, Pierre Rosenberg, and Robert Rosenblum. Allan Braham and Peter Marlow kindly read portions of the typescript and made comments, for which I am most grateful; the former also read a proof. In Paris, at the Archives Nationales, where my interests were shamefully more in the décor than in documents, I had the agreeable advantage of being guided round, during a time of interesting restoration work, by Monsieur Jean-Pierre Babelon. At the Institut de France, Monsieur Philippe Brissaud was most kind and co-operative over my quest for the statues of the 'grands hommes'. At the Louvre I am especially indebted to Monsieur Jacques Thirion, Conservateur in the Department of Sculpture. His most kind reception and ever-friendly help have been not only sustaining but essential, since most of the sculpture at the Louvre which I was concerned with was not on public exhibition during much of the time this book was being written. I shall always be deeply grateful for the opportunities he gave me, including those to exchange views in the presence of some of the pieces themselves.

Finally, in no facetious spirit, I am conscious of a debt never repayable to another series of 'grands hommes de France', those nineteenth-century scholars like Montaiglon and Guiffrey and Courajod, as well as their successors such as Furcy-Raynaud, whose labours produced an unrivalled banquet of documentation, still being digested by us today. Their energy equalled their erudition, and with my sense of indebtedness goes a pang of envy.

M.L.

The Early Years

Painting: From La Fosse to the Death of Lemoyne and the Establishment of the Regular Salon (1737)

INTRODUCTION

'L'année 1700', Saint-Simon noted in his *Memoirs*, 'commença par une réforme.' Admittedly, this reform was simply that the king had decided to stop contributing to the courtiers' expenses at Versailles. Yet the sentence which introduced the new century in this way turned out to be widely applicable and prophetic, artistically as well as politically.

Reform is not a word usually associated with painting in at least the early years of the century in France; but it is useful to lay emphasis straightaway on that reforming element, in the sense of a return to older standards, which underlay *Rubénisme*, the so-called Rococo, and the development of the *fête galante* – all rather too easily associated with libertarianism and even general licence. When Roger de Piles was received into the Académie he announced that painting could no longer be permitted to be 'errante'.[1] The death of Louis XIV and the relaxed, gaily dissolute court of the regent, the Duc d'Orléans, are not the precipitating factors in creating a new style of painting. Perceptive critics may have noticed that Watteau no more depended on the regent's patronage than he did on the king's.[2] And though the *singerie* was a popular pictorial motif, this did not mean that painters were behaving like monkeys.

The old standard which was re-invoked, with increasing fervour and several changes of definition as the century advanced, was that of nature. Nature returned in just as traditional a manner as ever did classicism; it was found by invoking the great masters of the past like Veronese and Correggio, probably even more than Rubens. Nor did it imply that Antiquity must be rejected, but rather – in the words of Antoine Coypel early in the century – 'il faut joindre aux solides et sublimes beautez de l'Antique, les recherches, la variété, la naïveté et l'ame de la nature' (*Discours prononcez dans les Conférences de l'Académie Royale...*).[3] This in itself offers a substantial programme for any period. It might be said that with Watteau, Oudry, Chardin, Boucher, La Tour, Greuze, and David – to name no others – French painting throughout the eighteenth century examined these various aspects of nature with unparalleled thoroughness. It is obvious from Coypel's statement that he already places more emphasis on nature than on Antiquity; he quite rightly supposes that 'nature' is the more complex concept. It was not to be followed as a mere release but as a positive, profound discipline which would result in better works of art. Coypel also said of the painter: 'il doit fouiller jusques dans son âme par le secours de la philosophie'.[4] Watteau's drawings alone reveal the disciplined aspect of studying nature – as well as

being among the very greatest works of draughtsmanship ever produced. Falconet expresses much of his century when he writes (*Réflexions sur la sculpture*): '... le Beau, celui même qu'on appelle l'idéal, en sculpture comme en peinture, doit être un résumé du Beau réel de la nature'.

Although they were to gain a new importance, such ideas were not new in the eighteenth century. Before there could be a movement of *Rubénisme* there had to be Rubens, and indeed his century is that in which the 'Beau réel de la nature' had triumphed in painting. It was then that new categories of 'natural' picture had been established – genre, landscape, still life – which were to find such distinguished practitioners in the eighteenth century. These categories already challenged, at least tacitly, the respectable history picture, while flourishing European portraiture – with great portraitists in virtually every country – meant that this category of picture could not be kept down by academic disapproval.

What had actually happened was that France, owing to Colbert's policy of subordinating the arts to the state, had become out of step and out of date compared with the rest of Europe. Venice, Naples, the Netherlands, and Holland were artistically to be rediscovered by late-seventeenth-century France. The quarrel there over colour versus drawing was itself a storm in a very miniature teacup. The battle lines were hopelessly muddled – not surprisingly, since one of the leading artists invoked by the party of draughtsmanship and classicism was Poussin, who had in fact greatly admired the colour and 'nature' of Titian. What was at the core of the argument was really connected with the possible pleasure to be gained from a work of art. If more pleasure came from ignoring the ancients and the rules, then surely they should be ignored? That this had to be argued was not only typically French but had already been the subject of argument when Molière wrote *L'École des femmes*. Molière's answer to his critics is the sort of statement which might have shocked Lebrun and which could well seem typical of the 'freedom' of the early eighteenth century: 'If plays which are according to the rules give no pleasure, and those which do are not according to the rules, then it must of necessity be that the rules have been badly formulated.'[5]

In painting, the 'nature' which was to be so much discussed was not merely a matter of past painters. While the Académie at Paris was showing itself better qualified at debating than painting, the court painter in Flanders was the prolific, highly successful David Teniers, who did not die until 1690. The roots of French eighteenth-century painting, like so many of its practitioners', lie deep in the preceding century. Charles de La Fosse was born in Rubens's lifetime; and he lived to see Watteau *agréé* at the Académie. It remains a poignant if somewhat over-dramatized moment in Gersaint's long note

about Watteau (*Catalogue de feu M. Quentin de Lorangère*) when he describes the reactions of the aged La Fosse, 'célèbre peintre de ce tems-là', on first seeing Watteau's paintings: 'étonné de voir deux morceaux si bien peints...'. And, when Watteau himself appeared, Gersaint records La Fosse's words: 'nous vous trouvons capable d'honorer notre Académie'. Such painters as Largillierre, Rigaud, François de Troy, Audran, Santerre, and Antoine Coypel were all born well within the lifetimes of Rembrandt and Frans Hals. Nor are these just flukes of chronology; they serve as reminders that the very painters who seem to preside beneficently over the expanding eighteenth century had been formed by the previous one. When Watteau presented himself before the Académie that body might well recognize in him a genius within an established tradition of the 'natural'; the young David – if one can make the comparison – would probably then have appeared a very disconcerting phenomenon (and to some extent did so appear to the Académie in his own day).

There was one highly important fact, a fact of history almost more than of aesthetics, which gave both painting and sculpture in eighteenth-century France a significant place on the social scene: the existence of the Académie royale. In 1700 it was an institution already over fifty years old. Its structure – of teaching, of categories of picture and status of practitioners – was firmly established. The Académie might on occasion be rigid, even harsh, but it was highly professional.

Academies of art existed of course elsewhere in Europe, and others (like the Royal Academy in England) were to be founded during the eighteenth century. None, however, combined the various factors which gave special prestige to the Académie in Paris: at once royal, national, and central, and possessed of an 'out-station' for its students in Rome. The course of French art would probably have been very different had there not been the well-trodden route that took generations of gifted young artists, at state expense, across the Alps to come into direct, sustained contact with the presumed greatest monuments of antiquity and the presumed greatest achievements of the 'moderns', and brought them also into contact with nature, Italian-style. All that Colbert had envisaged would culminate in the career of Ingres, the *beau idéal* of the gifted, receptive student, returning to Rome years later to serve as head of the French Academy there.

What the Académie royale in Paris represented was the prestige of the arts of painting and sculpture, a prestige which existed regardless of individual merit. There lay the danger inherent in academic status. Indeed, like many such organizations, the Académie – and its aristocratic overseers and protectors – tended to be made uneasy by genius if it was accompanied by variations of nonconformity. And that the Académie was a *royal* institution was asserted with perhaps increasing emphasis as the eighteenth century advanced. Its royal character was part of its distinction. The rays of royal favour reached out to illumine the visual arts, but this shining benevolence could be obscured or positively withdrawn. The Académie answered to the Directeur général des bâtiments du Roi, who in turn depended on the king. The Directeur général wrote always in the king's name, and the longest-serving of these ministers during the eighteenth

century learnt how to play the royal card with great adroitness. Real power lay in recommending to the king purchase or commission of a work, provision of a pension, and so on (as well as conferment of public honours), especially as both Louis XV and Louis XVI normally approved what was proposed. Conversely, when the Directeur général expressed his regret at feeling unable to put a matter before the king, that effectively finished the affair.

In these ways, royal patronage – often barely or lightly treated in accounts of eighteenth-century French art – remained a reality. The shade of Louis XIV might hover satisfied that though his successors on the throne lacked his obsessive concern with the propaganda effect of the arts, the artistic system devised under him remained intact. If anything, it grew more strict in the last years of the *ancien régime*, largely owing to the efforts of the last Directeur général, the Comte d'Angiviller, who was attempting to revitalize and reform his miniature kingdom while comparable efforts were being made, too late, for the kingdom of France.

It may broadly be true, as is often stated, that there was a shift of artistic gravity during the eighteenth century from Versailles to Paris, but a more precise assessment of the position suggests that in art – as in politics – what was taking place was a tug of war between the palace and the city (which eventually the city would, in both cases, win).

The new phenomenon in the century of regular Salon exhibitions in Paris, organized by the Académie but under the 'protection' of the Directeur général, illustrates the complex position very well. And in some ways those exhibitions represent the chief advance of the visual arts in France during the *ancien régime*. They helped to create general public interest among a class of people no longer necessarily patrons or connoisseurs but simply spectators – going to look at the assembled pictures and sculpture as they might go to look at a firework display or a festive procession.[6] For such a growing public there inevitably arose forms of written comment, beginning with simple guidance, as provided by the *Mercure de France* in 1725 for example, and becoming fully-developed art criticism as literature with Diderot's unprinted but disseminated Salon reviews.[7] The *Mercure* explicitly declined to be critical, but by the mid-century, approximately, polemical pamphlets and highly critical comments were being published. Diderot seems to speak to and for the intelligent, cultivated person, interested in the visual arts without being either a professional practitioner or a patron: a person who may be thought of as *bourgeois* in tastes and appreciation regardless of his or her actual rank.

Yet what this public saw at the Salon exhibitions was, of course, art as interpreted by the Académie. Many of the works would, while the *ancien régime* lasted, be commissions from the Crown; and the ultimate decision about the exhibition of those lay with the king in the person of the Directeur général. In a word, the Salon was entirely official, which, as long as the monarchy endured, meant royal. It was held in the royal palace of the Louvre, and by tradition it opened on the King's name-day, 25 August, the feast of St Louis.

That the Crown was a direct force in terms of patronage is evident throughout the period, even if such patronage

was only sporadic. The public competition organized among history painters in 1727 by the Duc d'Antin, then Directeur général, was neither at the time nor subsequently judged to be a success, yet which other European country at that date could show comparable official instigation of art?[8] And in the end three of the pictures produced were purchased by Louis XV. Over the decades many of the major commissions to sculptors were royal ones, inclusive of Pigalle's magnificent tomb of the Maréchal de Saxe [143]. In painting, Vernet's 'Ports de France' represent a uniquely wide and literally ranging commission, which probably only the Crown could give. To Louis XVI, in the person of his Directeur général, the Comte d'Angiviller, is owed the sculpted series of the 'Grands hommes de France' and a number of equally high-minded, large-scale history pictures, which include David's *Oath of the Horatii* [294].

Like royal patronage, to which it was so closely allied, the Académie remained very much a fact of life for at least the artist based in Paris. To step outside the academic structure, as did Fragonard, and to some extent Greuze, might be liberating though also hazardous, certainly for anyone aspiring to an official career. It is interesting that Watteau, although an intensely 'private' artist, working almost entirely for private patrons, did not disdain the procedures of the Académie. Whatever may be legendary about his actual acceptance by that body, there is no doubt that he presented himself before it – and presented to it, as required, a *morceau de réception* (one which happened to be a masterpiece). It is not too fanciful to envisage him, had he lived an average lifetime, being approached in 1735 over the commission which went to Lancret and others, to decorate Louis XV's dining-room at Versailles. Indeed, he might even have come under consideration two years previously as a possible successor to Louis de Boullongne as *premier peintre du roi*, the post which was filled by Lemoyne.

In addition to the fixed points of the Crown and the Académie there was a further established source of patronage in the Church. Less centralized than the monarchy, and far less bureaucratic, it manifested its artistic requirements not just in Paris but throughout France. One of the finest sculptural monuments of the period was Michel-Ange Slodtz's Archbishop Montmorin tomb at Vienne [116], and one of the most effective and affecting of large-scale religious pictures was Restout's *Death of St Scholastica* [50], painted for a convent near Tours. In Paris, the church of Saint-Roch alone is a miniature museum of eighteenth-century French religious art, both painted and sculpted. Religious works continued to be commissioned, and frequently to be exhibited and admired at the Salon, up till the final years of the *ancien régime* – cf. Regnault's *Descent from the Cross* [288].

These facts are not in doubt. Officially, France was as Catholic a country as Spain, though intellectually it was much more lively, secular and 'enlightened'. But there is no contradiction, as some art historians seem to suppose, between stimulating rational argument, tinged with a good deal of scepticism, all of a kind that partly justifies calling the century the 'age of reason', and the continued production of religious works of art. One might as well suppose that no more churches would be built because Voltaire had attacked the Church.

To try to deduce, however, much about the actual depth of faith of those involved, especially of the artists, is a more delicate matter. The truth probably is that the chief belief of the latter lay in the potency of their own art, whether it was destined for a chapel or a boudoir (and again, no contradiction or conflict arises, since French society of the period broadly accepted the need for both locations). As for the quality of the art produced, religious or otherwise, that was and is a matter not of faith or morals but of the nature of an individual talent. An artistically successful altarpiece is not in itself evidence of profound religious sentiment, any more than a fine mythology by Boucher is evidence that he believed in Venus and Mars.

What the co-existence of these categories of picture points to, and what is confirmed by the additional categories of picture contemporaneously in demand, is the high degree of sophistication in French culture, epitomized by Paris. Perhaps nowhere else in Europe were the visual arts so well integrated into society, so widely utilized and patronized – and taken so seriously. Whatever individual complaints by artists there might be on occasion, and whatever resentment was felt at the way things tended to be arranged between the Bâtiments and the Académie, the system presupposed the importance of the visual arts on the social scene. The growth of art criticism during the century affirmed that importance, contributing a new and what may be termed a democratic voice (one thus not always welcome).

Although it is customary, in modern accounts of painting at the period, to lay stress on the academic hierarchy of the genres, with history painting accorded the highest place, the evidence of the Salons – and, of course, of the surviving work – indicates how remarkably all-embracing in practice were the categories of picture produced. Regardless of theoretical prestige, the portrait continued to be a major genre, from Rigaud and Largillierre to Vigée-Le Brun and Labille-Guiard. Landscapes were painted far more frequently than is generally recognized, and that genre merges into the inventive ruin-pictures of Hubert Robert, a great artist protected and patronized by the Comte d'Angiviller himself (less exclusively concerned, it would seem, with the strict hierarchy of the genres than some recent art historians). Chardin is the supreme exponent of still life in the period, but other painters, like Roland de la Porte, practised it successfully. A painter such as Oudry initially escapes from classification by genre, being much more than a mere painter of royal hunts, but he too enjoyed a highly successful career. These are the kinds of painter and picture which must be borne in mind in addition to the creators of elevated history pieces and not so elevated mythologies, and in addition to popular pictures of daily life, urban or rustic, of which some painters made a speciality.

All this is well exemplified by the Salon of 1761, to which thirty-three painters, nine sculptors, and eleven engravers contributed. 'Jamais nous n'avons eu un plus beau Salon', was Diderot's eventual verdict in his *Récapitulation*. Among the pictures he rapidly singled out as truly excellent were: a full-length portrait of Louis XV; *The Magdalen in the Desert*; *The Martyrdom of St Andrew*; *Socrates condemned to Death*; a Sunset; two views of Bayonne; several pictures by Greuze; Chardin's *Bénédicité*; a simulated bronze Crucifix; and a battle

piece.[9] Better proof could not be given of the range of subjects in demand.

The nub of the matter was accidentally grasped towards the end of the century, when in 1781 the elder Lagrenée boldly told the Comte d'Angiviller, 'On ne commande point aux talents . . .'.[10] The variety and brilliance of the really great talents in both painting and sculpture in eighteenth-century France refused to be codified and restricted by academic theory, or by directives ('fussent-ils émanés du Père Eternel', added Lagrenée, with delightful recklessness). That is the glory and character of the period – in painting so much more consistently lively than during the previous century.

It is true that France produced no Canaletto, Tiepolo, or Piazzetta (though Subleyras can come close to the latter), no Goya, no Hogarth or Gainsborough. But in the European context it remained unrivalled, less perhaps in terms of individual genius than in sheer professional competence, for which the system and the social climate deserve some credit. Differently manifested as the competence might be at different points up to 1789, it scarcely faltered. It would certainly be hard to sustain a thesis that the darkening political atmosphere of the late years of the old régime affected the visual arts in any deleterious way. The Salon of 1789, opening after the fall of the Bastille, was a positive declaration of the flourishing state of, in particular, painting in France. Thus, artistically, the period ended more promisingly than it had begun.

The century opened with no significant burst of artistic excitement or assertion of fresh talent. These years, the last years of Louis XIV's reign, seem rather directionless and stylistically uncertain. With the death of Lebrun in 1690 there disappeared a commanding figure who had been virtually dictator of the arts in France. There was no appointment to the post of *premier peintre* after the death of Mignard (1695) until Antoine Coypel's in 1716. Mansart died in 1708. Coyzevox, whose portrait busts include both Lebrun and Mansart, lived until 1720 and was to sculpt the very young Louis XV.

Several of the major painters of the older generation also lived on and continued to be active well into the eighteenth century. They have been dealt with in the previous volume in this series (Anthony Blunt's *Art and Architecture in France 1500 to 1700*) but they deserve some place additionally in this one.[11] That their presence on the scene remained a significant reality is testified to by the *Mercure de France* in 1725, when it drew attention to the Salon held that year (after a gap of over twenty years). 'If anything was lacking to satisfy the public at this exhibition, it was not seeing the work of Messieurs de Boullongne, de Troye, de Largillierre, and Rigault [*sic*], who, having nothing more to add to their reputations, have acquired fresh glory by believing they should not exhibit on this occasion, so as to do justice to the work of the young academicians, the majority of whom are their pupils.'

Continuity, not novelty, seemed the key-note. And in many cases the continuity was a fact in strictly family terms: Restout was trained under his uncle Jouvenet (1644–1717); Charles Coypel by his father, Antoine (1661–1722); and Jean-François de Troy by his father, François (1645–1734). Similarly close links existed among sculptors, with dynasties like that of the Coyzevox–Coustou, the Slodtz, and the Lemoyne, often active over a whole century across the merely chronological dividing line of the year 1700.

PORTRAITURE: RIGAUD AND LARGILLIERRE AND THEIR FOLLOWING

Altogether, it is apt to give priority of illustration to the Baroque assertiveness and formal splendour of Rigaud's full-length portrait of Louis XIV (Louvre) [1], painted in 1701 and exhibited at the Salon of 1704. A commonplace of criticism is to find in that portrait the influence of Van Dyck, especially that of his *Charles I* in the Louvre. But whatever the supposed similarity of pose, the change of ethos far transcends it. Van Dyck's king relaxes in the open air, half-dissembling his royalty and appearing an elegant gentleman out hunting (one not even mounted on horseback). The image Rigaud has evolved is essentially that of a monarch, shown at his most monarchical, in sumptuous robes and in a palatial setting, amid a proliferation of ermine and fleur-de-lis that reinforce the message that this is the royal ruler of France. He is every inch a king; and his inches are increased by high, scarlet-heeled shoes and the revelation of royal legs under the looped-up robes – giving the ageing, vain, faintly simpering figure something of the air of a music-hall star like Mistinguett. As a young man the king had danced in court ballets. Later comparable images of Louis XV and Louis XVI would be no less splendid in their accessories but, perhaps wisely, would make less of the leg-show.

Yet the picture is doubly a masterpiece. The swag of gold-embroidered, tasselled curtain, the massive pillar, and the very sweep of carpet, not to mention the throne, the sceptre, and the crown, all create a superb setting for consecration of a legend: of an unchanging, benevolent but majestic sovereign who incarnates France. Few monarchs anywhere, least of all in the eighteenth century, could so effectively be depicted as rulers. Neither of Louis XIV's two immediate successors inspired their portraitists with such tremendous conviction.

So much for Rigaud's achievement in meeting his sitter's aims. That is reinforced, however, by the artistic bravura of the portrait. As well as an image, it is a painting. Other portraits by the painter may better reveal his ability to catch a penetrating likeness, but few even of the most swagger of those match the sheer display of – and delight in – rich materials which characterizes the *Louis XIV*. A certain stiffness of pose, no doubt required by the elevated, autocratic subject, is counteracted by the cascading flow of ermine fur falling in folds from the king's shoulder, white and soft and unexpected (since it is actually the lining of his robe), and intensely memorable.

Hyacinthe Rigaud had been born in Perpignan in 1659 and reached Paris in 1681. After painting Monsieur, the king's brother, in 1688, he entered court circles and became the portraitist of royalty, the aristocracy, and distinguished foreign visitors at court. He lived until 1743, in which year (he did not die until late December) he finished his small *Presentation in the Temple* (Louvre), which he bequeathed to

1. Hyacinthe Rigaud: *Louis XIV*, 1701. Paris, Louvre

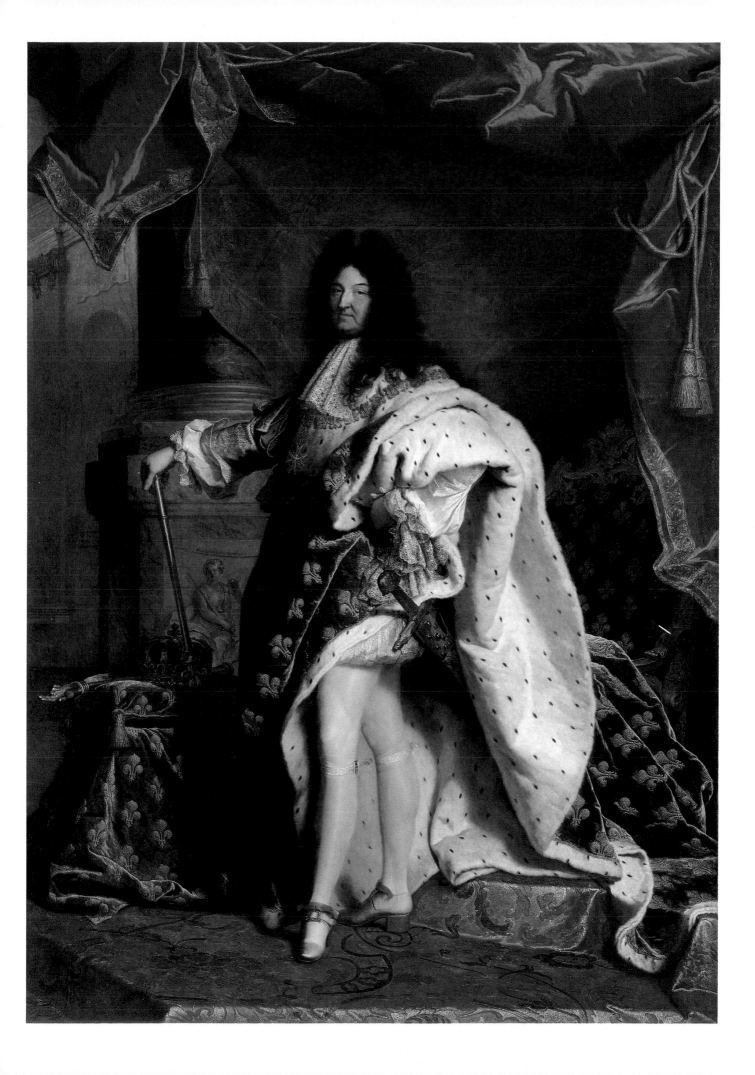

Louis XV. More than just a homage to Rembrandt, though clearly influenced by Rembrandt's early work, it shows the continuing vitality of Rigaud's talent, which could have challenged some well-known history painters of the day had he not restricted it to portraiture.

And as a portraitist he was capable of being direct and intimate as well as grand and official. His own varied collection of old master pictures included several Rembrandts, in addition to pictures by Rubens, Jordaens, Veronese, and Titian.[12] The rank of his sitters naturally affected his approach to them. Painting his mother's head in two positions (Louvre), to serve as guide for a bust by Coyzevox, he recalls less Rembrandt than Philippe de Champaigne (viz. the *Triple Portrait of Cardinal Richelieu* in the National Gallery, London). Given a cardinal as a sitter, he can be at his most grandiose and ostentatious, as in the wonderful, seated full-length of Cardinal de Bouillon (Musée Rigaud, Perpignan) of 1709. There a great prelate vindicates himself, having been banished by Louis XIV, combining almost royal state and status with religious, visionary overtones as he smilingly glances away towards a huge cross symbolizing the Holy Door of St Peter's he had been privileged to open. Indeed, he thought of himself as a prince secular as well as of the Church; and when finally he left France, he sent Louis XIV a stinging letter of defiance.

More intimate, yet with no mitigation of the imposing, is Rigaud's later portrait of another cardinal, of rather different character, *Cardinal Dubois* [2]. Smiling but shrewd, Dubois is seen as statesman at least as much as churchman, holding up a *billet* prominently inscribed *'Au Roy'*. Despite the partly Baroque air of the composition, with its swag of curtain and mysteriously animated cardinalatial draperies, it has a directness lacking in the portrait of Bouillon. Sitter and spectator confront each other almost as though they had pulled up chairs knee to knee in the same room. Such closeness of contact was to become a mark of much French portraiture of the century, and typical of much of it too is the suggestion of the sitter's actual environment, here conveyed by the still life of books, large seal and the tall handsome clock (all hinting at an active, busy life). Dubois had risen far, and rapidly, when the Duc d'Orléans became regent of France, from obscure abbé to cardinal and first minister. He seems to have savoured his career and enjoyed work and women, and is still shrewdly smiling as he kneels in Guillaume Coustou's fine funeral monument to him [67].

Among Rigaud's pupils was Jean Ranc, born at Montpellier in 1674, the son of Antoine Ranc, who had been Rigaud's first master. Ranc was basically a portrait painter and as such went, on Rigaud's recommendation, to the Spanish court at Madrid, where he died in 1735. Although too much can be made of the diffusion of French art throughout Europe, it is true that French painters of the period found receptive patrons, and sometimes second homes, in Germany and the North, as well as in Spain and Italy, on occasion becoming absorbed into the artistic story of their adopted country. Whatever the differing tastes in decorative terms (and most countries responded to some form of French *rocaille*), a 'good', that is competent, portrait painter was likely to be welcome everywhere.

Ranc's was a very slim talent beside that of his master, but

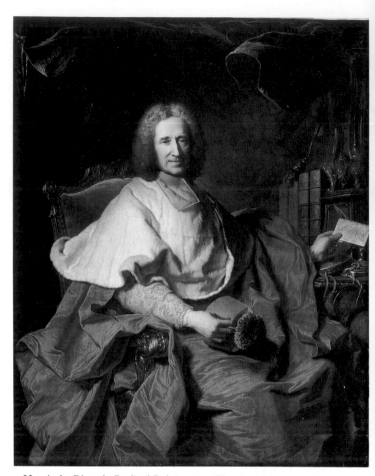

2. Hyacinthe Rigaud: *Cardinal Dubois*, 1723. Cleveland Museum of Art

Rigaud's primacy in France was effectively challenged by the other great contemporary painter also specializing in portraiture: Largillierre. Slightly older than Rigaud, and outliving him by a few years, Nicolas de Largillierre (1656–1746) was a friendly rival – and in certain senses no rival at all, for his portraits tended to be of less aristocratic sitters and he ranged much more widely in subject matter, to include religious pictures, still life, and landscape. It is notable that in his self-portrait of 1711 (Versailles) Largillierre points to an easel on which is sketched in outline no portrait but an *Annunciation*.

Like Rigaud, Largillierre was trained away from Paris – in his case away from France altogether, first in Antwerp and then in London. Lely is usually mentioned in this latter connection, but it seems that he also worked under the Italian Antonio Verrio. If anti-Catholic feeling had not arisen in England Largillierre could have had a career at the Stuart court. Charles II and James II both patronized him, though he might not have survived professionally when James fled the country. Lebrun, whom Largillierre painted, was instrumental in convincing him he should not return permanently to England from Paris; and Paris, in the shape of members of the city council, became his first important patron, during the late years of the seventeenth century.

It is always tempting to contrast Largillierre and Rigaud in style as well as in their sources of patronage. They were

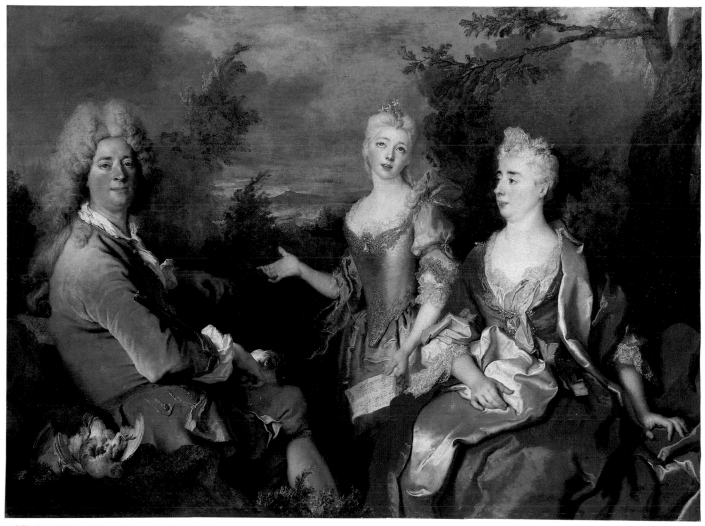

3. Nicolas de Largillierre: *Portrait of a Family.* Paris, Louvre

indeed different artists, but the contrast between them should not be exaggerated or allowed to mask their similarities. Both are basically of the party of Colour. In terms of patronage, Largillierre had some very grand clients, as well as wealthy Parisians. Both painters were indebted to Van Dyck and Titian; if Rigaud was influenced additionally by Rembrandt, Largillierre was influenced by Rubens. And there seems to be some stylistic interaction between the two great, friendly painters in their portraits. Certainly when Rigaud painted his portrait of *Gaspard de Gueidan* as the shepherd Céladon (Musée Granet, Aix), from Honoré d'Urfé's novel *L'Astrée*, he painted with a richness of pigment and brilliance of tonality that bring the picture close to Largillierre. Admittedly, the reason must lie in the fact that Madame de Gueidan had already been painted, as the shepherdess Flora, by Largillierre, and the two pictures were to be pendants. But then it was Rigaud who had first been approached by her husband to paint her portrait; in declining, he proposed Largillierre, who perhaps adapted his characteristic robustness to more Rigaud-like smoothness.

Largillierre's normal handling of paint is matched by a freedom and naturalness in the settings of many of his portraits, with often gracefully rustic, open-air scenery

anticipatory more of Gainsborough's portraits than of any vein of later French portraiture. The *Portrait of a Family* [3] has about it an informality and relaxation which the rich costume of the mother and daughter cannot disguise, unsuitable though it appears for such a deeply countrified location. The father, with his gun, dead game, and lively-eyed hound, is more suitably set. But all this is a tribute to the sensitivity of Largillierre's response – to the setting as much as to his human sitters. He 'portrays' the rugged bark of the oak tree at the right of the composition and the curling shapes of its russet-tinted leaves with a directness unprepared for in French painting. It can hardly be any surprise that he could also paint pure landscapes – or landscapes peopled only by such minute, unimportant figures as can be deciphered, just, in the autumnal woodland *Landscape* [4], which looks backward to Rubens and forward to Fragonard. There is real poetry in its vigour, and a delight in the wildness of nature, in towering trees and rich foliage, which makes one regret that this aspect of his art is so rare. Combined with his still lifes and with the fascinating *trompe l'œil* decorations of his own house, it helps to explain contemporary appreciation of him as a 'universal' painter.

Yet it must ultimately be by his portraits that Largillierre

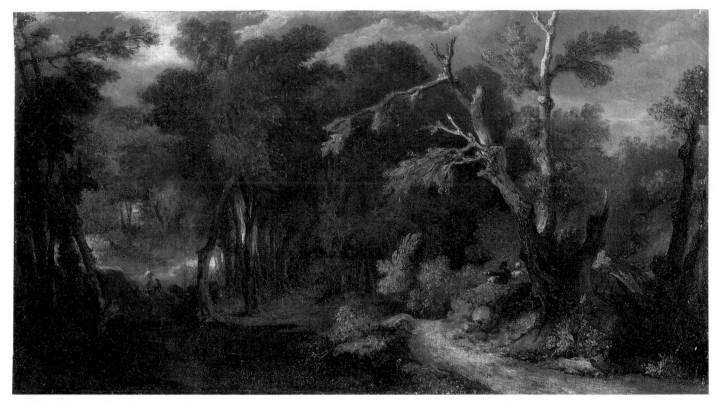

4. Nicolas de Largillierre: *Landscape*. Paris, Louvre

is esteemed. Effective as a portraitist of groups and able to achieve in single portraits grandeur or intimacy, depending on the circumstances, he remained impressively consistent in artistic quality. He was in his seventies when he portrayed so delicately and perceptively Elizabeth Throckmorton [5] in her habit as a Blue Nun. Pale-complexioned, pensive, and felt as distanced from the world, she is also very much a living presence, with liquid eyes and scarlet mouth, the colour of which is almost startlingly vivid amid the austere white fabrics that enfold her. Largillierre responds to their textures as well as to their tones, and gently lets fall over them the half-transparent blackish-blue veil, painted with an extraordinary modulation from his usual boldness into something akin to tenderness. The picture's artistic ancestry lies in Philippe de Champaigne, and perhaps also in Rubens's engraved portrait of the Archduchess Isabella wearing the habit of a Poor Clare, but Largillierre is indebted to no one for his perception and refinement of touch. He seems to savour, with the sitter, withdrawal from worldly standards and worldly costume; and the portrait might almost take its place in the period as a personification of the cloistered, religious life.

The influence exerted by Largillierre extended far beyond portraiture. Among his pupils was Jean-Baptiste Oudry, whose own nice management of tones of white and cream [cf. 44] vied with his master's. Largillierre's vigorous yet subtle handling of paint is likely to have appealed to Watteau, while in general he brandished a banner of 'Colour' (with no weakness in drawing) that must have been inspiring for painters up to the mid-century – during most of which he himself was alive and active.

Among Largillierre's pupils was one portrait painter able

to absorb his lesson and produce work at least as lively and vigorous, without falling into mere pastiche: Jacques-François Delyen (1684–1761). Trained first in Ghent, Delyen went to Paris and exhibited in 1722 at the *Exposition de la Jeunesse,* the annual one-day open-air show held in the city on the feast of Corpus Christi. Although this event in the Place Dauphine had no official status, it was supported by artists as well as public, and the artists were often established ones, no longer to be classed in any way as among the 'Jeunesse'. Thus Rigaud exhibited there a portrait of Cardinal Dubois which is likely to be illustration 2, or a version of it. On the other hand, Chardin was comparatively young when he exhibited first in the Place Dauphine in 1728, with several pictures including *La Raie* [214].

Delyen seems to have been primarily a portrait painter, though there exist a few genre scenes in his so far very restricted *œuvre.* He was received by the Académie in 1725, on presentation of two portraits, one of the painter Nicolas Bertin (1667(?)–1736), the other of the sculptor Guillaume Coustou I [6]. At that date his master, Largillierre, was rector of the Académie, a fact that can only have facilitated Delyen's admission to the body. The portrait of Coustou pays frank homage to Largillierre but has its own near-florid robustness and animation. It is very much a 'speaking likeness' with the sculptor gesticulating in what is virtually an *exposé* over a bronze reduction of his statue of the Rhône, the large-scale original of which occupied one side of the base of Desjardin's equestrian statue of Louis XIV at Lyon. Delyen's bravura portrait, in which the bronze sculpture looks as animated as the sitter, speaks also of a new style of portraiture, vivid, spontaneous-seeming, and 'engaged', for the depiction

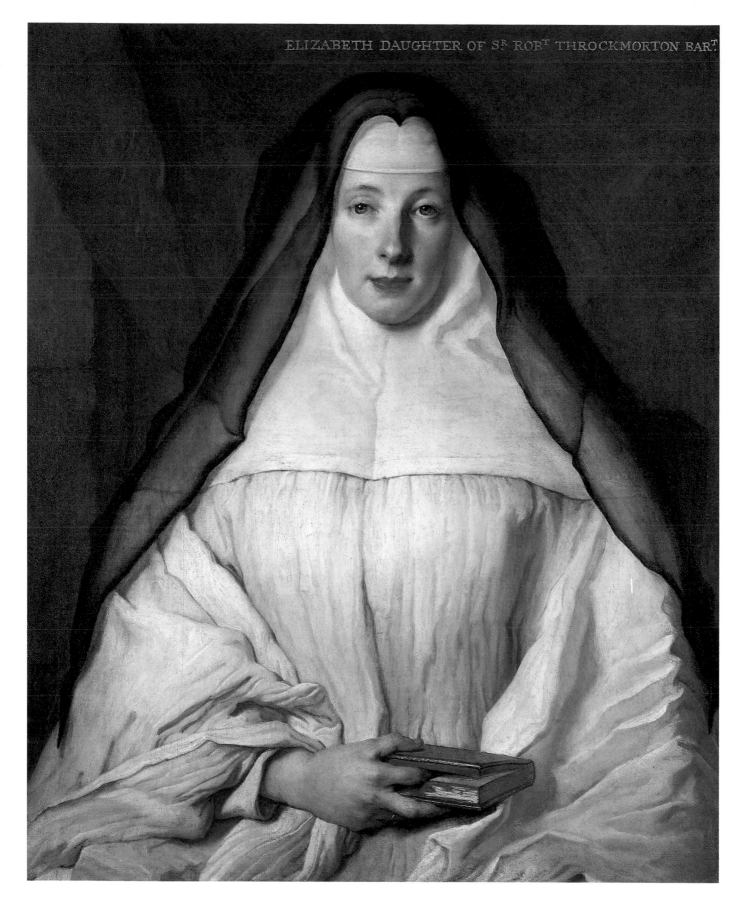

ELIZABETH DAUGHTER OF S.ᴿ ROBᵀ THROCKMORTON BARᵀ.

5. Nicolas de Largillierre: *Elizabeth Throckmorton*, *c.* 1729. Washington,
National Gallery of Art

6. Jacques-François Delyen: *Guillaume Coustou I*, 1725. Versailles, Musée National du Château

especially of fellow-artists. Mignard's *Lebrun* (Louvre), for example, appears dignified and distant when compared with Delyen's *Guillaume Coustou*. Even the portrait of Guillaume's brother, Nicolas (Versailles), by Jean Legros (1671–1745), is stiff by comparison with Delyen's vigorously lively characterization, not the least skilful aspect of which is the tilting up of the sitter's head, so that Coustou gazes expressively sideways, as though momentarily engaged in conversation with an interlocutor who is not the spectator. In that effective device lie seeds of Fragonard's so-called 'portraits de fantaisie'.

HISTORY AND DECORATIVE PAINTING: LA FOSSE – JOUVENET – LOUIS DE BOULLONGNE THE YOUNGER – COURTIN – SANTERRE – ANTOINE COYPEL

The quality and calibre of portrait painting in the early years of the century are unfortunately not paralleled by the history and decorative pictures of the same period, though painters of the former were much in demand and often highly esteemed. Esteemed as they might be, and also highly competent, they simply failed to possess that spark which lifts the best work of Rigaud and Largillierre from talent to genius, and it is hard not to feel that there was a fatal lack of energy and of originality in the hybrid sub-Italianate style which they generally practised. It was in fact easier for portrait painters to evolve fresh stylistic solutions to their ordinary human subject-matter, aware of tradition yet not inhibited by it, than it was for history painters, who could not approach their elevated subject-matter without an almost crushing consciousness of the prestige of the achievements of the past. Besides, it may reasonably be said, the typical history painter was eager to share in that prestige and become part of the tradition going back to the Carracci and Raphael. It must remain a moot point whether the climate of tradition was too strong for any history painter to combat or whether the painters themselves were too weak to formulate a truly new style. In any event, the result for posterity is that Rigaud and Largillierre have an inherent greatness that no amount of special pleading will ever win for their contemporaries in the field of history painting.

The two most interesting of these painters, La Fosse and Jouvenet, are scarcely of the eighteenth century, though both lived into it and were to prove influential. Charles de La Fosse (1636–1716) is indeed something of a founder-figure for decorative painting,[13] though one may wish that he had inspired more artists with his confident, instinctive flair for handling paint. Yet he touched the life and art of Watteau significantly, and passed on a torch – one richly glowing with colour – to be seized by François Lemoyne, himself the master of Boucher.

La Fosse's appetite for assimilation was voracious. He absorbed lessons from Raphael, Correggio, Veronese, Rembrandt, Rubens, and Pietro da Cortona. He had arrived in Rome during the lifetime of Poussin and he lived to be patronized by Pierre Crozat, for whose new Parisian house he painted one of the last and largest of his decorative works, now destroyed, a ceiling showing *The Birth of Minerva*. Venice and painting in Venice (inclusive of the work of such foreign painters as Jan Liss) probably represented the most profound and creative of the many influences on him. With his strong Venetian links and his friendship with Crozat, La Fosse ought ideally to have survived until Rosalba Carriera reached Paris in 1720. As it is, she became friendly there with his niece, whose portrait she painted, and it was to Rosalba that Crozat communicated the news of La Fosse's death, asking her to pass it on to Sebastiano Ricci.[14] Referring to La Fosse in another letter to her, a few years later, Crozat described him as 'l'un des meilleurs peintres qu'il y eut en France et peut estre en Europe'. That praise is by no means excessive.

La Fosse returned from six years in Italy in 1663. He was soon employed on official decorative commissions, thanks to Lebrun, who had been his master. His style at this period is well represented by *The Rape of Proserpina* [7], his *morceau de réception* for the Académie in 1673, though possibly painted earlier. Although a close friend of Roger de Piles, and thus associated with the party of *Rubénistes*, La Fosse was never doctrinaire in his art (and is recorded, interestingly, as not much concerned about theories of art). The *Rape of Proserpina* shows recollections of Poussin in some of the figures, while the landscape possesses a Venetian 'romantic' quality, and the flying Cupid shooting at Proserpina has a proto-Rococo air. Already detectable in the picture is a mitigation of severe seriousness combined with a fresh response to paint as a medium.

7. Charles de la Fosse: *The Rape of Proserpina*, *c.* 1673. Paris, École des Beaux-Arts

La Fosse was soon greatly in demand, and his style developed a much bolder vein, where Rubens and Veronese meet and are fused into an original manner which becomes La Fosse's own. Such evolution was clearly a matter of artistic temperament, suggesting a painter confident he could impose his own style on official taste and lead the way. After a sojourn of a few years in London, he returned in 1692 to Paris, where he remained until his death. He worked for Versailles, for Marly, and for several churches, both in Paris and elsewhere. The commission for the decoration of Mansart's new church of the Invalides, originally intended for Mignard (who died in 1695), was destined for La Fosse in its entirety, though eventually it was shared out among other artists, including Noël Coypel (1628–1707), father of Antoine, and the brothers Bon and Louis de Boullongne.

At the royal château of Marly La Fosse shared a commission around the turn of the century for a set of *Four Seasons* with Louis de Boullongne, Antoine Coypel, and Jouvenet. While Jouvenet was suitably assigned the male subject of *Winter*, La Fosse no less suitably dealt with *Autumn*,

in the persons of Bacchus and Ariadne [8]. This is no dramatic encounter of god and mortal girl but, consciously or not echoing a treatment of the theme by Guido Reni (County Museum, Los Angeles), La Fosse shows them in happy, graceful dialogue, and amused rather than disturbed by the loyal barking of Ariadne's pet dog. It is the picture's glowing, half-autumnal tonality, not its somewhat inert composition, that makes it attractive, combined with its sensuous paint surface. It has none of the eroticism associated with the mythological pictures of Boucher – indeed, the subject is handled with patent decorum – but a natural charm and vitality that were to elude many a mid-eighteenth-century history painter.

La Fosse showed himself to be equally effective as creator of religious pictures, on both a small and large scale. Perhaps only in large-scale decorative work could he fully display the vigour of his temperament, summed up in the late *Resurrection* in the apse of the chapel at Versailles. Inspired by his subject-matter, La Fosse conveys a tremendous sense of excitement sweeping across the composition, culminating at its spacious

8. Charles de la Fosse: *Bacchus and Ariadne*, *c.* 1699. Dijon, Musée des Beaux-Arts

9. Charles de la Fosse: *The Assumption of the Virgin*. Dijon, Musée Magnin

centre in the solid-looking yet soaring figure of Christ, risen from the tomb at the lower left and silhouetted, pausing, as it were briefly, in his trajectory heavenwards. From early on in his career La Fosse was instinctively at ease in illusionist effects of this kind. Away from the court, he had managed soon after his return from Italy to France to decorate the coffered dome of Charles Errard's rather clumsy circular church of Sainte-Marie-de l'Assomption, in the Rue Saint-Honoré, Paris, with a highly effective *Assumption of the Virgin*, now heavily restored but praised by contemporaries. A preliminary sketch [9] reveals the *élan* which came so naturally to La Fosse in such work, and the effect here is

already Rococo; at a casual glance, this sketch might pass as by some eighteenth-century Venetian painter under the influence of Ricci and Tiepolo. It is there that La Fosse's affinities lie.

Markedly different was the artistic character of Jean Jouvenet (1644–1717), who, significantly, never visited Italy. Yet he too began his career under the patronage of Lebrun and took part in decorative schemes for Versailles and the Tuileries. His true talent, however, was in the depiction of great moments of Christian religious drama – often on a huge scale – painted with sober, impressive power and conviction. If La Fosse seems one of nature's cavaliers, graceful, relaxed,

10. Jean Jouvenet: *The Raising of Lazarus*, 1706. Paris, Louvre

and half negligent, Jouvenet is nature's puritan, stern, austere, and almost Protestant, in a French tradition, though of course working for the Catholic church. Part of his power comes from an unusual fusion of the elevated and rhetorical with the earthy and the realistic. His roots lie in Poussin and Le Sueur, but there are passages in his pictures that presage David and even Géricault.

It is not surprising that Jouvenet could prove a forceful portraitist, concerned – as in the pungent characterization of Dr Raymond Finot (Louvre), exhibited at the Salon of 1704 – to grasp personality rather than the trappings of fine clothes. But he is at his best in orchestrating those scenes of Christ's miracles which allow him to exploit their dramatic impact to the fullest extent. His Christ tends to be an ideal figure, gesticulating commandingly and setting in motion the expressive gesticulation of the onlookers. Within that dignified and 'classical' idiom, the equivalent of the tragic stage, it is a shock to encounter areas of naturalistic detail, painted with almost macabre intensity. *The Miraculous Draught of Fishes* (Louvre), one of four vast canvases painted by Jouvenet early in the eighteenth century for the church of Saint-Martin-des-Champs in Paris, offers probably the most famous example, where the prominent, gasping, glassy-eyed fish, just landed, enhance Christ's miracle. Jouvenet is said to have travelled to Dieppe to study such detail, but he might also have been aware of the marvellous fish Rubens included in his treatment of the subject, in the triptych in Notre-Dame au delà de la Dyle at Malines. Less frequently commented on in Jouvenet's picture is the nautical, coastal atmosphere of the whole composition, with bellying sails and taut lines of rigging, and a glimpse at the left of the open sea.

When Jouvenet painted the miracle of Christ raising from the dead the widow of Nain's son (a picture now in the cathedral of Versailles), he gave eerie force to the dramatic gesticulation, amid so much surrounding gesticulation, of the arms of the corpse being galvanized back to life, so that the effect is almost more frightening than edifying. And it seems typical of Jouvenet's attraction towards sombre 'realism' that the foreground of the picture should be occupied by grave-diggers, with their picks and shovels, at work preparing the grave. In such stubborn pursuit of grimly prosaic fact, Jouvenet anticipates not so much David as Courbet.

The huge *Raising of Lazarus* [10], another of the Saint-Martin-des-Champs series, is a tour-de-force of Jouvenet's realistic vein combined with the elevated and idealized. Here the figure of Christ is somewhat over-bland and insufficiently assertive amid the agitated crowd gathered around the looming rocks of the tomb, but Mary, the sister of Lazarus, takes on the role of heroine, distressed yet decorous, and very consciously posed, in garments of gleaming white, gold, and green, to hold the centre of the stage. She is the embodiment of French academic classicism and could serve equally as Esther before Ahasuerus or as the wife of Darius at the feet of Alexander – would, effectively, serve in comparable guise in many other pictures of the period. What she gestures towards, however, is dramatic in a different idiom: the stark moment of Lazarus's return from the dead, with him awakening in the deep cavernous gloom of his burial-chamber, lit only by a single torch, and experiencing hardly less violent and painful astonishment than do the figures gaping around him.

Authentic *frissons* of terror and grief can be felt in

Jouvenet's pictures as in few pictures, religious or otherwise, by his contemporaries and by subsequent eighteenth-century painters. When he depicts the Deposition, for example, the body of Christ appears tragically broken, and the muffled mourners are almost sinister in their dark, haunting shapes. Jouvenet was to suffer his own artistic tragedy in his later years, with the paralysis of his right hand. Stoically, he refused to stop painting and made use of his left hand. More substantial consolation existed for him in the talent of his nephew and pupil, Restout, who was to create some exceptionally powerful, emotionally-charged religious pictures[15] [50]. They are by no means merely echoes of Jouvenet, but yet it is permissible to think that without the example of his uncle's art – and of his distinguished, successful career – Restout would not have achieved what he did.

Although Jouvenet rose through the grades of the Académie to become Directeur, neither he nor La Fosse was appointed *premier peintre*. After the death of Mignard in 1695, the post was left unfilled for many years before being given first to Antoine Coypel and subsequently to Louis de Boullongne. Louis de Boullongne (1654–1733) was the older man of the two, himself part of a dynasty, though not a very extensive one. He was the pupil of his father, the elder Louis, and brother of Bon Boullongne (1649–1717), but most significantly affected by five years in Italy, whence he returned to Paris in 1680.

Like La Fosse, he was much employed as painter of both mythological and religious pictures, for the royal palaces and for churches. But though as imbued as La Fosse with Italian influence, he represented the more traditional orientation towards Bologna and Rome in contrast to Venice. Not surprisingly, he was an accomplished draughtsman and is perhaps more attractive to modern eyes in that capacity than as a painter. His efficient, would-be graceful, if somewhat insipid style, with its echoes of Domenichino and Albani, served well enough for large-scale and decorative purposes. It seems apt that he should have been involved in a replacement when Louis XIV, probably under the influence of Madame de Maintenon, had removed from the Galerie at Fontainebleau some mythological pictures not considered proper. Rosso's totally nude *Bacchus, Venus, and Cupid* (Musée du Grand Duché de Luxembourg) gave way to Boullongne's *Zephyrus crowning Flora*, one of the 'sujets sages' the king had requested, which the painter treated in a safe manner, with abundance of drapery and hardly a hint of eroticism, while providing a pleasing piece of none-too-serious decoration.[16]

Numerous painters trained in Boullongne's studio, and he is known to have taken a positive interest in their abilities and prospects. Among the more original of these pupils was Jacques Courtin (1672(?)–1752), a painter of extremely varied subject-matter,[17] from altarpieces and mythologies to portraits and 'fancy-pieces' of a *galant* kind, featuring chiefly girls: girls who would certainly not have won Madame de Maintenon's approval and who, anticipatory now of Boucher and now of Greuze, represent a new vein of French taste, consciously unlearned and mildly erotic.

The popularity of Courtin's work in this vein is attested by the quantity of engravings of it. Girls with kittens and

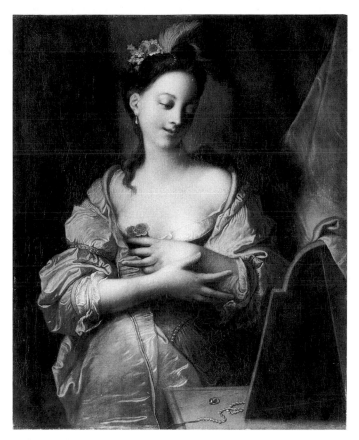

11. Jacques Courtin: *Young Girl at a Mirror*. St Petersburg, Hermitage

squirrels and *billets-doux* – in half- or three-quarter-length format – were piquantly posed wearing fancy dress that usually managed to leave exposed some portion of bosom, and occasionally makes that the frank focus of the composition, as in the *Young Girl at a Mirror* [11], engraved as 'The Comparison'. The eventual source for this type of semi-toilette theme lies in Titian's variations of Venus with a mirror. But what was expressed openly by Titian has become somewhat covert, and hence coy, in the art of Courtin, as is that of other French painters of the day producing comparable pictures. They have about them a proto-Edwardian or *belle époque* sauciness, a rather irritating quality of the *risqué*, which must yet be understood as expressing hedonistic high spirits at the coming of a new, less buttoned-up century (and, soon, a new, less buttoned-up monarch). Not for nothing might one draw an analogy between the end of Louis XIV's reign and that of Queen Victoria's. And under all the suffocating scholarly drapery of the ideal, the earnest, and the academically respectable, which modern revisionism has wrapped around the facts of painting in eighteenth-century France, there will continue to appear naughty incongruous wisps of lace-edged petticoat, indicative of a tendency which is not only part of the century's taste but a perennial aspect altogether of Gallic taste.

Even into ostensibly religious subject-matter the erotic could intrude, and a lost *St Theresa* by Jean-Baptiste Santerre (1658–1717), painted for the chapel at Versailles in 1709, is recorded as having caused some scandal for this reason. Indeed, Diderot was later led to observe of a *Joseph and*

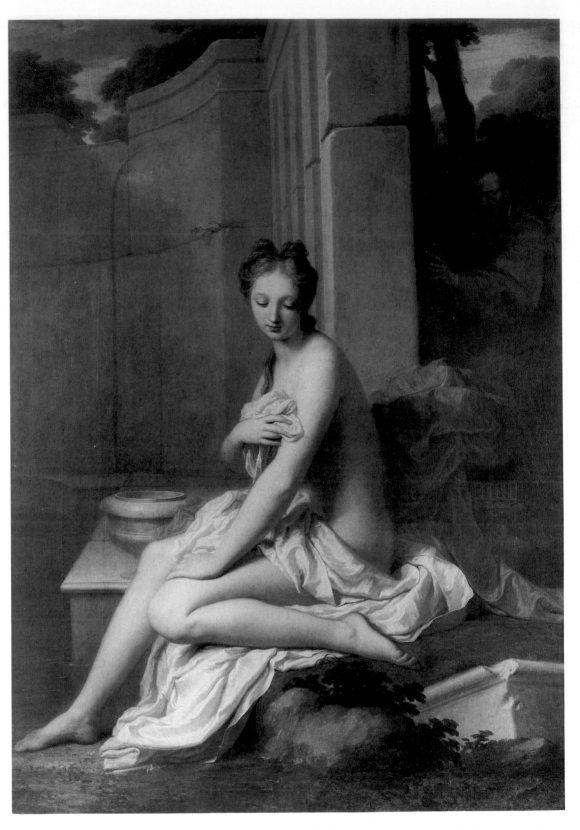

12. Jean-Baptiste Santerre:
Susannah at the Bath, 1704.
Paris, Louvre

Potiphar's Wife by Deshays that so voluptuous was it that if intended for a church, it would 'damner le prêtre au milieu de sa messe et donner au diable tous les assistants' (*Salon* of 1763). Santerre was a pupil of Bon Boullongne. A competent portrait painter, particularly of women, he is chiefly remembered on account of the *St Theresa* and of his *Susannah at the Bath* [12], which was his *morceau de réception* for the Académie in 1704. This accomplished and graceful piece of painting is sometimes treated as a forerunner of the 'Rococo' art of Boucher, and cited as a picture of deliberately provocative femininity under cover of a religious theme. Even the fact that Santerre set up a sort of academy for young lady artists was once, perhaps not too seriously, introduced into comment on the picture.[18]

Yet although some suggestions may faintly linger there of a Leda without the swan, it is only fair to the painter to recognize that the subject of Susannah is anyway barely scriptural (as part of the Apocrypha) and certainly not doctrinal, while the excuse it offered for painting the female nude had been very frequently taken from the Renaissance

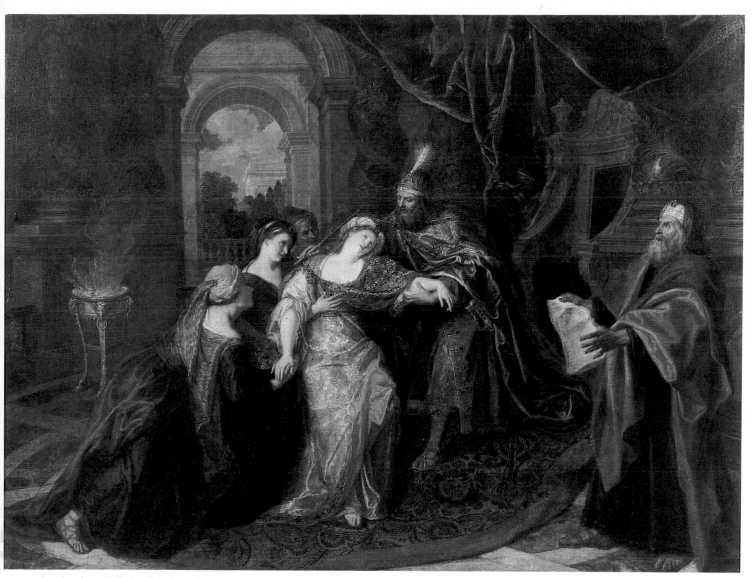

13. Antoine Coypel: *Esther Fainting before Ahasuerus*, 1704. Paris, Louvre

onwards. Besides, Santerre is far from anticipating Boucher or Fragonard in giving his heroine a quite chilly air of the chaste – and that is detectable in contrast to Courtin's self-ogling girl. There is a cool, semi-sculptural chastity of design about Santerre's whole concept. As a *baigneuse* this Susannah anticipates not Boucher but Vien [cf. 193] and, perhaps even more, some of Falconet's statuettes, such as the *Flora* [132]. In this connection, it is interesting to find Orlandi recording as early as 1719 that Santerre himself had modelled a terracotta statuette of the figure and had actually planned to execute a marble version of it (*Abécédario*). How well the picture accorded with taste in the latter half of the century is indicated by the extreme popularity it enjoyed through being engraved by Carlo Porporati, who submitted his engraving of it as his own *morceau de réception* at the Académie as late as 1773.[19]

Of all painters active in the early years of the century, none probably was more greatly esteemed or officially more successful than Antoine Coypel, born in 1661. He did not die until 1722, but illness overtook him in his last years, so that his career ends virtually at the same time as La Fosse's and Jouvenet's.

Antoine's father was Noël Coypel (1628–1707), a painter of standing in Paris who founded a distinguished dynasty

of painters extending to Charles-Antoine Coypel, Antoine's son.[20] In 1672 Noël Coypel was appointed director of the French Academy in Rome and took the young Antoine there with him. Tradition records that the boy received advice from Bernini and Maratti. In Italy he visited Parma and learnt to admire Correggio. Back in Paris by 1681, he became aware of Rubens, paying Flemish painting almost too frank homage in the half-length *Democritus* (Louvre) of 1692.

These varied influences were never entirely fused by him into a single personal style, but that was far from being a hindrance to his success. The sheer range of subjects he tackled – from a stark *Crucifixion* to a charming *Love visiting Anacreon*, and inclusive of allegory, history, and Old Testament scenes – is some indication of how well he met the requirements of the period.[21] Sometimes he seems rather markedly 'classical' in his compositions; at others, he has anticipations of Boucher. In 1708 he received the important commission for the ceiling of the chapel at Versailles, and proved himself a highly effective decorator in a Roman Baroque idiom, the powerful *trompe l'œil* illusionism of which at first disconcerted and displeased Louis XIV. Coypel was favoured particularly by the Orléans family, and following Louis XIV's death he was appointed *premier peintre* to the

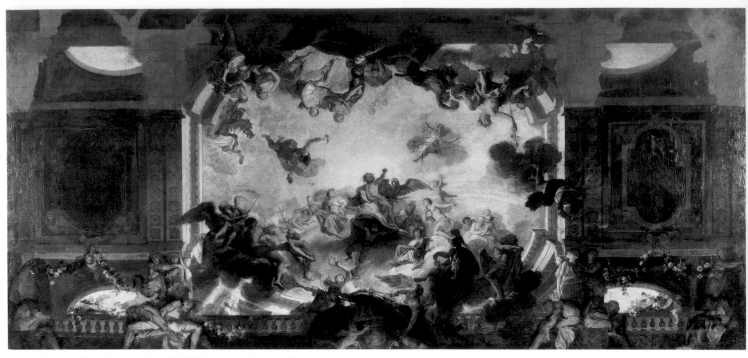

14. Antoine Coypel: *Assembly of the Gods*, c. 1702. Angers, Musée des Beaux-Arts

youthful Louis XV, already holding the equivalent post to Philippe, Duc d'Orléans, who had become regent of France. At the Académie, he was both director and rector. He was a friend of Roger de Piles, though perhaps in de Piles' eyes too influenced by Roman and Bolognese *seicento* art and insufficiently 'Venetian' in his orientation. His literary interests and friendship with leading literary figures had its effect on his pictures – or, at least, on their subject-matter – and some germ of that concern passed to his son Charles-Antoine, active as dramatist as well as painter.

Before working at Versailles Coypel had painted the vault of the now destroyed gallery in the Duc d'Orléans' Palais Royal in Paris, with an *Olympus* as apparently visionary and effectively illusionistic as the religious heavens of the chapel ceiling. In place of God the Father, Jupiter occupied a commanding central position, and the future of Aeneas, instead of Christ, was adumbrated. To hang along the walls, Coypel painted a few years later large canvases with scenes from the *Aeneid*.[22] About these there is an uneasy, inhibited air, for all the grandiloquent gestures of the personages involved – and occasionally, as in the *Aeneas appearing to Dido* (Musée des Beaux Arts, Arras), a plethora of stylized posing that borders on the ludicrous. Italian and French influences have failed to synthesize. One of Coypel's problems in such pictures seems to have been a difficulty in actual construction of the composition, and another was his strange inability to relate figures properly to setting. Both weaknesses are equally apparent in what is meant to be a highly affecting theatrical scene, recalling Racine's tragedy *Esther*, the *Esther fainting before Ahasuerus* [13], which Coypel exhibited at the Salon of 1704.

Seen as the creator of such work, Coypel is of little more than historical interest. But the boldness and airiness of the Palais Royal ceiling, as far as can be judged from the surviving sketch [14], suggest a much more stirring artist, a worthy contemporary of La Fosse and a skilled master of those illusionistic effects popular at the period in Paris and to be

aimed at subsequently in Lemoyne's ceiling of the Salon d'Hercule at Versailles. An assertive sentence attributed to Largillierre aptly sums up this decorative emphasis which was to drop out of fashion in France while continuing for much of the century to be popular in northern Italy, as in Germany and Austria: 'Je ferai, quand je voudrai, passer votre vue à travers le mur.'[23]

BOUYS – RAOUX – GRIMOU

Although there is a chain of elevated history painting, inclusive of large-scale decorative schemes, loosely linking La Fosse and Antoine Coypel to François Lemoyne, that was only one element – a major one, admittedly – amid the variety of both styles and subject-matter practised during the century, from the early years onwards.

It would be wrong to impose too firm a pattern for reasons of historical neatness on the development of painting in a period when the unexpected individual artist could appear and be welcomed, as was, supremely, Watteau. Nor should one be too quick to adopt the academic standards of the period in the face of the evidence, which is the art produced. The so-called 'minor genres' become major when practised by great figures. The age was rich in talent as well as genius, and plenty of gifted painters existed who 'represent' in effect nothing but themselves. Sometimes it is a matter less of the individual artist than of an individual work of art, as in the case of *La Récureuse* [15] by the fairly obscure André Bouys (1656–1740), born at the furthest possible extreme from Paris, at Hyères. Bouys went to Paris and studied under François de Troy (1645–1730), a competent portrait painter and father of the more famous Jean-François de Troy.[24]

Bouys became chiefly a painter of portraits (among those painted by him was one of La Fosse), but a late genre picture by him like *La Récureuse* comes as a delightful novelty, even allowing for the influence of Chardin, so much younger an artist. The subject is humble enough, domestic and also

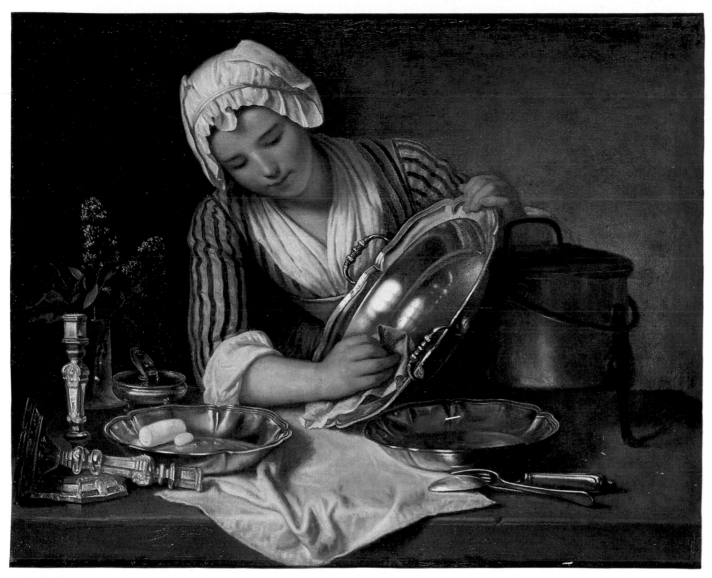

15. André Bouys: *La Récureuse*, 1737. Paris, Musée des Arts Décoratifs

notably demure in treatment. In her prettily-striped dress, the young servant girl does not pose coyly but is seriously absorbed by her task of polishing the scattered silverware, itself painted with serious, absorbing attention to shape as well as to surface. The result is very much more than a pastiche of Chardin. Probably it owes something to seventeenth-century genre pictures, especially Dutch ones (for the theme, one might cite and compare Schalcken's *Old Woman scouring a Pot* in the National Gallery, London), though its flavour makes it unmistakably French, and of its own century. Bouys here is indeed ahead of his generation and half-anticipatory of early Greuze and late Lépicié (e.g. the style represented by the so-called *'Lever de Fanchon'* [224]). Yet *La Récureuse* has validity as an individual work of art; its mode may be a minor one, but within that the picture is a masterpiece.

Much has been written about the phenomenon of *Rubénisme* in the early years of the period, but the concurrent if lesser one of *Rembrandtisme*, a suitably more shadowy phenomenon, also needs to be recalled. It represented a new or renewed interest in genre and in semi-fancy pictures of characterful 'heads', and was probably stimulated at least as much by Rembrandt's etchings as by his paintings (though

pictures by or attributed to him were owned by French painters other than Rigaud, and at least one belonged to the champion of the *Rubénistes*, Roger de Piles).

Rembrandt's influence was by no means restricted to France. In Venice, Piazzetta and Tiepolo are only two of the more outstanding painters who paid direct homage to him, and slightly later in the century English painters showed some sporadic interest in his work. It has to be borne in mind that Rembrandt had not at that time undergone canonization and been elevated to a place virtually superior to that of any other painter. His humble Northern birth and his 'unlearned' style made him a rather doubtfully respectable figure, and certainly one not exempt from criticism. Nevertheless, as he stood pre-eminently for 'nature', and as the 'natural' exercised increasing allure throughout Europe, his status rose. By the early nineteenth century Hazlitt encapsulated the new, awestruck attitude when he hailed Rembrandt almost as an artistic Moses: one of the great founders and legislators of art.[25]

That claim would have astonished or amused Voltaire, who airily thought Rembrandt was equalled by Raoux at his best.[26] And in rather similar terms, a graceful compliment was paid to Grimou by calling him 'le Rembrandt français'.

Jean Raoux (1677–1734) has not much benefited with posterity from Voltaire's praise. His pictures tend to be hard and shiny in surface, nearer to Netscher in technique and to Schalcken in subject-matter than to anything actually by Rembrandt. It is worth emphasizing, in passing, that Schalcken (who did not die until 1706) had enjoyed great international success and was to be much imitated for his popular night-pieces.

Raoux was born at Montpellier and studied under Ranc before moving to Paris to become a pupil of Bon Boullongne. In 1704 he won first prize at the Académie and was sent to Rome for the usual three-year period. At the end of that time he went to Venice, where he met the Grand Prieur de Vendôme, who became his patron. In the train of the Prieur Raoux returned to Paris, was *agréé* as a history painter at the Académie in 1716, and presented his *morceau de réception* (*Pygmalion Falling in Love with his Statue of Galatea*; Montpellier) on the day that Watteau presented his.[27] In 1720 he was in London, perhaps contemporaneously with Watteau.

Raoux's work presents a certain amount of variety in subject-matter, within well-defined limits. He is rightly associated with lightly-allegorized or mythologized female portraiture, of a kind developed with greater accomplishment and grace by Nattier, but he also painted male portraits (including one of his patron, the Grand Prieur). In addition, he made something of a speciality of the subject of Vestal Virgins, girls, and women generously draped in gleaming folds of white or silvery grey satin, studied with a response to material that recalls, presumably by chance, the drapery treatment by Savoldo in his versions of *St Mary Magdalene*. Raoux's Vestals handle torches with a flicker of *Rembrandtisme* (a handsome example, of a mature Vestal with youthful virgin attendant, is at Brunswick). And in other types of picture, like the *Woman reading* (Bayeux), Raoux develops the mood with an effective play of light and shade embracing the three-quarter-length figure.

Lightly allegorized portraits had occasionally been produced, but Raoux took the concept further, and in a more light-hearted spirit. Given an actress as his subject, he was free to portray her character, at once of the theatre and yet in the open air, as in *Mademoiselle Prévost as a Bacchante* [16]. A celebrated dancer, Françoise Prévost, is shown in the role she took in the opera *Philomèle*, revived in 1723, the year the picture is dated. The setting is much more naturalistic, one may guess, than an actual stage of the period. Although there remains a hint of artifice about the disposition of the trees and temple, the sitter seems to dance with a certain pagan exhilaration; and the stylistic climate she inhabits seems not far removed from that of the *Companions of Diana* which were being contemporaneously sculpted.[28]

Less varied in his subject-matter, but arguably a more sensitive painter, is Raoux's close contemporary, Alexis Grimou (1678–1733). His lack of invention was to be commented on in an obituary notice, and he seldom attempted compositions of more than a single half-length figure. Nothing is known of his early training, but possibly François de Troy was his master. He had a modest, unofficial career. Though *agréé* at the Académie in 1705 as a painter of portraits, he never presented his diploma pieces (two portraits, one of Antoine Coypel) and became instead a master painter in the much humbler Académie de Saint-Luc. Legend has made Grimou a debauched and 'difficult' character, but this is not necessarily accurate.[29]

He had a truer *rapport* with Rembrandt than had Raoux, responding to the mystery of smoky light and shade, and fond of faces staring out of the penumbra at the spectator, with sometimes touching effect. And what the period appreciated in Rembrandt is well expressed by Antoine Coypel, who spoke of works by the Dutch master which had 'autant de suavité et de rondeur' as those of Correggio. It is in that sense that Grimou followed Rembrandt; it is significant that he is recorded as copying also Murillo, because that attractively coloured, sweetened art represented a fusion of genre and decoration. Murillo had already seen 'nature to advantage dress'd'; Grimou probably preferred nature to come to him through the art of other painters.

He was indeed one of the first painters of the century to utilize Spanish-style accessories for his portraits. These are usually semi-fancy pieces, charming and faintly mysterious rather than penetrating character studies, but more beguiling than the hard-faced *opéra comique* nymphs of Raoux. His popular and extremely youthful 'Pilgrims' (examples in the Uffizi) appeal directly to the spectator with almost wistful gaze: children setting out on life's pilgrimage perhaps, as they clasp their tall staves bravely but a little uncertainly. Recollections of Rembrandt combined with a certain pensive charm make individual such a piece as Grimou's *Girl reading*

16. Jean Raoux: *Mademoiselle Prévost as a Bacchante*, 1723. Tours, Musée des Beaux-Arts

17. Alexis Grimou: *A Girl reading*, 1731. Karlsruhe, Staatliche Kunsthalle

(Karlsruhe, signed and dated 1731) [17]. In fact, she is not reading but pausing for reflection, one hand supporting her chin and the other marking the page of her book. The mood of the reverie suits Grimou's art, and the picture passes out of the category of 'fancy piece' to take on sober conviction as a portrait which records more than just the sitter's features and attempts to show a state of mind. Grimou partly succeeds by not attempting too much; he prefers a brand of 'reality' in which dressing up is not pompous but picturesque. It is even possible to see a relaxed, romantic, and private simplicity about his people when compared with the more florid public personages of Largillierre and Rigaud. In the *Girl Reading* the concept, the handling of paint, and the air of spontaneity, all look forward to Fragonard; between Rembrandt and Fragonard, Grimou is a slight yet viable bridge.

JEAN-FRANÇOIS DE TROY

A much more ambitious, important, and indeed more varied painter than Bouys, Raoux, or Grimou was Jean-François de Troy (1679–1752), son and pupil of François de Troy. He was to show himself a master of several categories of picture – painting large religious and mythological compositions and designing two series of Gobelin tapestries – but it was in 'l'imitation juste de la nature' (as one of his early biographers said)[30] that de Troy excelled. He could create the actual prosperous world of upper-class Parisian life, without sentiment or satire; the verisimilitude of the so-called *Reading from Molière* [18] seems complete, and completely absorbing in its detail of furniture and dress. This civilized 'nature'

remains typical not only of France but of the whole eighteenth century; the manners and modes of polite life become a suitable subject for art in themselves, without any of the moral application to be given to them by Hogarth. De Troy establishes a phenomenon to be duplicated later by Pietro Longhi at Venice, and Troost in Holland. Hints probably came to him from Watteau and from Lancret. He was incapable of Watteau's subtle erotic poetry and lacked Lancret's charm; even when he attempts to suggest gallantry, he achieves no vital spark. The appeal of his genre pictures was what it has remained: they are minute records of what the tone of social life was like, convincing just because it is so obviously unenhanced. Perhaps the final touch of convincingness comes from De Troy's own personal fondness for being in the milieu he depicts.

His father was a native of Toulouse, but De Troy was born a Parisian. At first he was not encouraged to be a painter, and he seems early to have revealed his talent for enjoying himself and causing scandal. Through the influence of Mansart he became a pensioner at the French Academy in Rome, though it was his father who had paid for his journey to Italy. De Troy remained pleasantly engaged in Italy from 1699 to 1706, moving from Rome first to Florence, where he found a rich Italian patron, and then to Pisa, where he made love to the young wife of an aged judge. Back in Paris, he was *agréé* at the Académie in 1708 during the period of his father's directorship; presumably because of this, he was exceptionally allowed to present a picture on the spot as his *morceau de réception* (a *Niobe and her Children* now at Montpellier). And long before his father's death in 1730, he had become professor at the Académie. At the Salon of 1725, he exhibited seven pictures of varying sizes and subject-matter, from a large *Rinaldo and Armida* to a small, brilliant genre scene of a woman repulsing a man attempting to retie her garter.[31] De Troy was not interested in following his father as a portrait painter, though he was more than equal in ability (as is shown by the array of portraits in his *ex voto* of St Geneviève in Saint-Étienne-du-Mont, Paris). He seemed perfectly placed to be the great all-round artist, gifted if not inspired, with a

18. Jean-François de Troy: *A 'Reading from Molière'* (?). Private Collection

good grasp of 'nature' and yet capable of decorative effects. In 1725 he stood as one of the leading painters in France, apparently destined for a great career. Yet this did not in fact follow.

He came into artistic conflict with a younger painter, François Lemoyne, who had also showed his paces at the Salon of 1725. Two years later a royal *concours*, organized by the Duc d'Antin, revealed them as open rivals. There was already a sense that serious history painting was declining in France, and it was to instigate fresh efforts that D'Antin instituted his competition. In the way of such things, the results pleased nobody, including De Troy. One of the most attractive items produced was Noël-Nicolas Coypel's *Rape of Europa* [48], which won no official prize. To his chagrin, De Troy had to share first place with Lemoyne, and it is something of an irony that today the two pictures singled out hang near each other in the museum at Nancy. Lemoyne went for seriousness and an affecting historical incident. De Troy typically preferred cheerful mythology, painting the subject of *Diana Reposing* in a somewhat incoherent composition of rather lumpish female nudes.

Lemoyne was on the road to becoming *premier peintre*. De Troy had to be content with the post of director of the French Academy in Rome (which he accepted in 1738, on the second occasion of its being offered to him). At Rome he remained until his death in January 1752. He continued to send to the Salon exhibitions in Paris and received one important royal commission, for seven tapestry cartoons dealing with the story of Jason and Medea (exhibited at the Salon of 1748). He had earlier shown his ability to execute work of this type with a series of cartoons illustrating a biblical subject, one exotic and colourful and also exemplary: incidents from the life of Esther.

De Troy's sketches for the Jason and Medea series [e.g. 19] reveal his gifts and his limitations. On this smallish scale he handled paint with considerable verve, making the picture surface alive with vivid, rapid strokes. The story is treated in decorative terms, reasonably enough since the end product was to be tapestry, and there is little sense of the gruesome aspects of a not particularly attractive 'love' story.

A set of the Gobelins woven from De Troy's designs was chosen to decorate the reception pavilion for Marie-Antoinette at Strasbourg in 1770, when she arrived in France to become dauphine. Among those present was the young and impressionable Goethe. He was horrified at this choice of subject-matter to welcome a bride, exclaiming, 'Is there no-one among the architects and decorators who understands that pictures *represent something...?*'[32] The choice does not, it must be admitted, seem very happy. Yet perhaps the organizers instinctively understood that in De Troy's hands the story was robbed of unpleasantness, as also of much significance. His pair of Jason and Medea, with warriors and flying dragons and snorting bulls, exist in a convention close to that of masquerade or opera. And by 1770 De Troy's designs must have seemed old-fashioned and almost flippant in their 'Rococo' lack of learning and seriousness.

In his large-scale pictures, De Troy tends to lose vivacity of touch, replacing it by a rather heavy handling which can yet be effective, though it probably accounted partly for the unenthusiastic reception his actual cartoons, for example, had in Paris. His imagination was rather heavy, too. The result could be a curious blend of the prosaic and the painterly, as instanced in the *Allegory of Time unveiling Truth* (National Gallery, London) [20], dated 1733. There is something ludicrous about Time's would-be flying figure, suspended so awkwardly and with his legs oddly detached. Altogether, as allegory, the composition remains prosaically earthbound. Yet in painting the women's heads and their garments De Troy shows his ability. The apparent heaviness of touch helps to give semi-sculptural weight to the folds of drapery, painted with response to pale creamy tones as well, so that comparisons come to mind with Subleyras (and even Solimena).

When De Troy retired from Paris to Rome a new generation of French painters, headed by Boucher, had emerged at the Salon.[33] The style they stood for was more

19. Jean-François de Troy: *Jason taming the Bulls*, 1748. Birmingham, Barber Institute of Fine Arts

20. Jean-François de Troy: *An Allegory of Time unveiling Truth*, 1733.
London, National Gallery

animated, more ebullient, and more graceful than his. It represented an enchanted world of make-believe, whereas his strength lay in a solid world of facts, to which he could give its own enchantment. His finest contribution was indeed in those 'tableaux de modes', as Mariette called them. Perhaps not unfairly, they were preferred by connoisseurs to his history pieces because they appeared 'plus soignés'.[34] The whole century was fascinated by its own manners and behaviour, and the civilized environment it had constructed for life (of those who were better-off). In France Moreau le Jeune may continue where De Troy stopped. But the *Reading from Molière* (perhaps actually of a contemporary playwright reading his work?) confirms De Troy's empathetic response

to all the things that made up 'modern' life, from the shape of a tapering shoe to the sit of a skirt when a woman threw herself back comfortably in a deep armchair, inclusive of the physical environment of a fashionable interior, where Meissonnier-like twisting candelabra ornament the mirror, and a handsome, Boulle-style mantel clock of gilded bronze occupies the top of a bookcase, decorated, incidentally, with a figure of Time far more adroitly conceived than Time as painted in the London *Allegory*.

At Rome as director of the Academy De Troy proved popular and also perceptive in his attitude to the young pensioners.[35] The Président de Brosses might somewhat sourly observe that he conducted himself as 'presque un

seigneur', but eventually De Troy's existence was saddened by the death of his wife, accompanied by loss of all his seven children, and by being replaced at the Academy by Natoire. Yet he had perception enough to detect the early ability of Saly as a sculptor, praising him warmly[36] and prophesying future greatness for him.

AUDRAN, HUET, GILLOT

Just like other aspects of painting early in the century, the arabesque interior decorations – to be associated particularly with Audran, but executed also by Gillot – claimed a traditional origin even while seeking for more lighthearted and gracefully 'natural' effects. Everyone declared that the taste for painted arabesques and grotesques went back to Antiquity and had been resurrected by Raphael. Nor was it in any way an innovation of the Régence; the elder Bérain practised the style for tapestries and painted rooms throughout the reign of Louis XIV. It was adopted not only for private houses but, where suitable, for rooms also in the royal palaces. Audran was to work successfully at Meudon, Anet, Fontainebleau, and at La Ménagerie at Versailles, as well as – it should be noted – in chapels of the Invalides. He was very fully employed on such work when the century opened, and taste came to prefer his designs to those of Bérain.

The evolution of interior decoration is a subject beyond the scope of this book, but De Troy's interiors in themselves show the new emphasis on grace and elegance. Designers like Juste-Aurèle Meissonnier (1693–1750) were so richly inventive that they are poorly served by being described as 'Rococo'. Indeed, Meissonnier, Italian by birth, was possibly too exuberant for French taste and was certainly to be vehemently criticized later in the century for 'formes bizarres & contournées', recalling the 'mauvais gout' of Borromini and his period.[37]

Yet in their day, the designers of interior décor and decorative painters like Audran and Huet, in particular, were very much part of 'advanced' taste. Their definite lack of high seriousness was part of their appeal, along with the artistic freedom their work seemed to proclaim in its caprice and patent fancifulness. To stigmatize it as 'incorrect' may have been gratifying to theoretical writers some decades later but would probably have been interpreted by the artists themselves as a compliment.

Claude III Audran (1658–1734) was the eldest son of Germain Audran, one of a numerous family of engravers and painters who, although of Parisian origin, had established themselves at Lyon.[38] Nowadays Claude III is most usually thought of in connection with Watteau, but he is a significant phenomenon in his own right. Born at Lyon, he reached Paris at an unknown date but certainly by 1684, when he attended the funeral of his uncle the painter Claude II Audran, with whom he was probably then living. He became a master in

1692 as 'painter, sculptor, engraver and decorator'. Payments document the variety of his talents: designing tapestries, painting on glass, executing a 'feu d'artifice', and gilding gondolas for the canal at Fontainebleau. In 1704 he was appointed keeper of the Luxembourg, but continued to be much occupied as a general decorator and designer. Among his very last work was that in 1733 for the Duchesse de Maine at Anet, where he had first been employed some time before 1698.

Inevitably, the greater portion of Audran's decorations has been destroyed or obscured by later alterations or repainting. Much of this actual work was probably executed by his pupils and collaborators; it is established that he had a team which followed the designs he prepared. It is his drawings therefore which best represent his style, and fortunately a very large group of these was acquired from his estate in 1734 by a young Swedish architect, Cronstedt (and survives today in the National museum at Stockholm). In them Audran is revealed as more lyrical and bolder than his obvious counterpart and elder, Bérain, achieving almost dizzy effects of space annihilated in fluttering movement where everything dances and swings. Nature takes over in the shape of monkeys and tumblers, comedians and birds, all rocking or swaying amid exiguous branches like ribbons, and thin trellises festooned with leaves and slender plants that curve up to support fringed platforms like that where a *Naturmensch*, a proto-Papageno, kneels surrounded by singing birds [21]. This drawing shows Audran at his least abstract. Indeed, in

21. Claude Audran III: *An arabesque drawing*, c. 1704. Stockholm, Nationalmuseum

22. Christophe Huet: *Salon des Singes* (detail), *c.* 1735. Chantilly, Musée Condé

some ways it is more typical of Gillot than Audran, and there is even a hint of Watteau in it. Not only is it 'natural' in its motifs (the birds at the corners recall that Desportes had collaborated with Audran) but it has the relaxed, undidactic atmosphere of art that is free simply to be art: more bizarre than anything previously seen, deliberately not truthful, stirring neither patriotic nor moral strings, but beating drums for the sheer love of gaiety and noise.

It is significant that some of the most effective surviving décor in the 'goût pittoresque' should make its central theme the activity of monkeys in place of human beings. The Salon des Singes at Chantilly [22] by Christophe Huet (d. 1759) is at once accomplished and amusing. Not much is known about the artist and his career, but he seems to have been attached to the monkey theme in terms of the animal aping man's behaviour – and woman's too, as the illustration here shows.

23. Claude Gillot: *Quarrel of the Cabmen*. Paris, Louvre

Amid the graceful twists and curls of the painted ornament, made up of many natural motifs like fronds and tree-trunks, fashionably-dressed female monkeys show us ourselves, in effect, in a 'natural' state, perhaps with a none too solemn hint that our activities have their ridiculous aspect when put in a monkey perspective. As the egregious little artist declares in Henry James's *The Madonna of the Future*, 'Cats and monkeys – monkeys and cats – all human life is there!' The implied message of the Salon des Singes is that those entering the room should be amused at the antics so charmingly depicted on its walls, and in amusement find relaxation.

Different but no less liberated is the art associated with Claude Gillot (1673–1722), with its own 'natural' bias, even if the nature involved is that of the stage. It is too easy to think of that in terms of artifice, but Gillot's characters are nearer the music hall than the elevated theatre. Gillot is now an artist inextricably bound up with Watteau's early years in Paris, and although there are a few paintings clearly Gillot's work, confusion existed already in 1737 when two pictures in the sale of the Comtesse de Verrue were listed as by either Gillot or Watteau.[39] A considerable group of drawings reveals the close stylistic affinities of the two artists and presents problems of attribution. With stylistic affinity there also went, it would seem, temperamental affinity.

One of Watteau's self-portraits is close in mood, and strangely even in physical appearance, to Gillot's portrait of himself.[40] Gersaint records that the two men closely resembled each other in temperament – too closely to get on well together. Gillot was born at Langres, the son of a painter-decorator, Jean Gillot. At an unknown date he arrived in Paris, where he worked in the studio of Jean-Baptiste Corneille (d. 1695). In 1710 he was *agréé* at the Académie – by which time Watteau had probably quarrelled with him. When Watteau came to be received himself in 1717, Gillot voted for him. Meanwhile Lancret had become a pupil of Gillot's, and he too was to be much influenced by his master. Slow to produce his *morceau de réception* – Gillot, like Watteau, took five years – he was officially received into the Académie only in 1715, on presenting the for him somewhat unexpected subject *Christ about to be nailed to the Cross* (Noailles, Corrèze). A chronology is difficult to establish for the few surviving pictures by or attributed to Gillot, but it seems clear that after beginning as a sort of general decorator (executing 'plusieurs idées fantastiques', in the words of Caylus[41]) he turned to the novel subject of the Italian comedy.

It was as a result and while in Gillot's studio that Watteau was to discover this subject-matter – or, more accurately perhaps, to realize the full pictorial possibilities of it. Caylus indeed goes on to say that after Watteau left him Gillot never painted again; although not correct, that expresses anyway some aesthetic truth, because Gillot's amusing but basically prosaic scenes of theatrical comedy [23] are almost totally eclipsed by Watteau's enchanted use and interpretation of such material. And though there is good evidence that Gillot

24. Claude Gillot: *Italian Comedians*. Drawing. Paris, Louvre, Cabinet des Dessins

in fact went on painting, he was in the final years of his life more occupied as etcher, and book designer. His last project was to design some plates for an edition of the statutes of the Order of Saint-Michel, but he died before he had executed more than a sketch for the frontispiece. When Gillot's death was reported at the Académie on 30 May 1722, it was taken as an occasion for reinstating the custom of requiem services for deceased members; a general one was to be held for members recently dead, but a special one was planned for Antoine Coypel, Premier Peintre, who had died earlier the same year. Such an honour was unlikely to be accorded to an artist of Gillot's status. His inventory confirms a humble existence. He lodged in one room; his finest possession seems to have been a satin dressing-gown, and there is a certain pathos in the mention of 'five pictures representing various subjects, not finished, from the Italian comedy'.[42]

It may be said that in comparison at least with Watteau, Gillot remained very much a straightforward illustrator of the *Commedia dell'arte*, his work dependent on its subject-matter for humour, wit, or any amorous overtone. In the *Quarrel of the Cabmen*, the incident depicted is far livelier than the paint by which it is depicted; the scene is enacted virtually as it must have been on the stage – to the point where one may wonder whether the picture's original function could have been that of a signboard or comparable advertisement.

Gillot was obviously much attracted to the whole milieu represented by the Italian comedy and similar fairground theatre. He became involved in a variety of ways, and may have written for it as well as delineating it. His self-portrait would suggest he even saw himself as a *Commedia dell'arte* character. He certainly could not have more distinctly marked his distance from the average bewigged image of artists in the period. By natural talent, he was more draughtsman than painter. Often preferring to use the pen, where Watteau would use chalk, Gillot recreated and expanded scenes from the *Commedia*, with a rapid, lively grasp [24]. He assembled the characters for whom Watteau would create a far more ranging and more subtle theatre, of a kind that eludes description. Yet Gillot has the priority in seeing the potentiality, and the fascination, of this largely novel subject-matter. Under fancy costumes and exaggerated types, the 'comedy' is a thoroughly human one. Like monkeys, clowns may not merely amuse the spectator but nudge him into awareness of real truths about human behaviour.

Audran, Huet, and Gillot might have united in shrinking from any high claim to be more than decorative artists-cum-designers. Their aim was to amuse and please. What no one could foresee was that via the studios of two of them would come an artist who fused nature and artifice in a unique way that passed beyond the decorative: who would turn familiar, light-hearted, even trivial subject-matter into overwhelmingly serious, truly profound art.

WATTEAU

It is against the background of the early years sketched here that one must see the career of Watteau, an artist so personal, independent, and great that he keeps transcending the context of his period. Yet one of the remarkable aspects of his career is how rapidly the period responded to his art. The rigid structure of the Académie grew pliant at the sight of his early work; and the sculptor Van Clève,[43] president when Watteau was *agréé* in 1712 (and owner later of two of his paintings), gave him no specific subject for his *morceau de réception* but left it 'à sa volonté'.[44]

Those words accidentally offer the key to Watteau's career, shaped by his own impulses rather than outward circumstance or dominant patronage. Some of his finest work was self-commissioned. It was his own expressed wish, against the feelings of his friend Gersaint, which led to the creation of his largest painting, the *Enseigne de Gersaint* (1721?, Charlottenburg) [32], an unexpected picture which was to be in more than one sense his last testament, hung in the open street, attracting passers-by, and, in Gersaint's words, 'L'on sait la réussite qu'eut ce morceau.'[45] About this picture even the intensely self-critical creator felt some cause for pride. What Gersaint goes on to say of it hints at the secret of accord between Watteau and the standards of his period: 'le tout étoit fait d'après nature.' Nature may seem obvious enough in the *Enseigne de Gersaint*. It is perhaps not the first thing which would now be thought of in connection with Watteau's other work. Yet it was on Watteau the student of nature that his close friends and contemporaries always laid emphasis; Watteau's drawings confirm the study; and he himself might perhaps have said that all his endeavour was to follow nature as Pope defined it: 'At once the source, and end, and test of art.'

Jean-Antoine Wattcau was born in October 1684 at Valenciennes. Since several of his friends felt a particular urge to write down details of his life and character in a way unparalleled for any other French painter of the century,[46] we know that from his earliest years he showed a passion for drawing – after nature, too, because his very first subjects were the charlatans and quacks selling remedies in the streets of his native town. Watteau's father was (as was his grandfather) a tiler whose brawling is a documented fact about which the painter probably, and certainly his early biographers, remained silent, though Gersaint described him as 'naturellement dur'. Jean-Philippe Watteau died in 1720, some eighteen months before his painter son.

Watteau's father is documented as receiving plenty of work in and around Valenciennes, though the town itself began to decline after it became a French possession in 1677. Whether at an early age Watteau entered the studio of some painter there, or indeed elsewhere in the neighbourhood, is unclear. It seems most likely, in any event, that he early revealed a talent for painting ('comme il avait donné dès son enfance des marques de la disposition naturelle, qu'il avait pour la Peinture...', wrote one of his first biographers, Jean de Jullienne), and it is not inconceivable that a local painter, Jacques-Albert Gérin (who died in 1702), was his teacher. In or around 1702, Watteau left Valenciennes, without money or decent possessions, and sought refuge (Gersaint's phrase, perhaps echoing Watteau's) in Paris, hoping to enter the studio of some painter who could aid his artistic progress.

Such a progress from the provinces to the capital is a cliché of artists' biographies. It has already appeared here in the careers of Audran and Gillot. With Watteau, where nothing is quite ordinary, there remained a strong attachment to his place of birth – to the place as such, we may suspect, rather than to the family home. Twice, when everything seemed to fail him, he thought of Valenciennes; when he did not win first prize at the Académie in 1709, he retreated there and by chance met the future director of the *Mercure de France*, Antoine de la Roque, who became a close friend. And when he was in fact dying, Watteau became convinced that he would be cured if only he could return to his own countryside; he sold his few effects and lingered through the early months of 1721, hoping to regain sufficient strength for the journey. He was reconciled with Pater, whom as a pupil he had treated harshly and unfairly; and perhaps he sought the reconciliation partly because they were compatriots. But he never saw Valenciennes again, dying at Nogent on 18 July 1721, in the arms of Gersaint, who had been going to accompany him on that return home.

It is more than just fanciful to think that Valenciennes played a great part in forming Watteau. He remained provincial, even rustic, the native of a small country town which was close to the Flemish border and which had become French territory only seven years before he was born. When he painted peasant scenes he was not merely following a taste for Brouwer or Teniers; the actuality had been experienced, however much he might care to enhance it, and the same is true of his military pictures – inspired by what he saw in the region when he returned there at the time of Marlborough's campaigns. That was a bitter period for France generally and must have been particularly felt in a frontier town so close to some of the actual fighting. The very subjects of Watteau's earliest drawings at Valenciennes – those 'différentes scènes comiques que donnent ordinairement au public les marchands d'orviétan' – are rightly indicated by Gersaint as probably the origin of his later attraction towards similar sorts of scene, 'malgré le caractère triste qui dominoit en lui'. Clowns, mountebanks, and charlatans, shifting gipsy-like people who live on their wit and their wits, were perhaps already recognized by the artist as his sort of people; just as for Domenico Tiepolo later in the century, they might represent 'nature', indeed truth, almost as a relief from the claims of traditional high art. Watteau had already tacitly rejected the traditional category of history painting and was perhaps sketching what appealed to him in the streets of Valenciennes.

Nevertheless, he was not a realist nor a painter of nature in any nineteenth-century sense of those words. The centre of his art is a concern with mankind, and mankind within the social framework, stirred by passions. His work is activated by a feeling for drama on the Shakespearean principle that 'all the world's a stage'. His characters are always engaged in acting a scene, seldom in total repose (in this, as in so much, opposed to Chardin), and rarely out of fancy dress. Watteau usually contrives that circumstance should have freed them from the ordinary conventional pressures of society: they seem to owe allegiance to no one but themselves, pay taxes for nothing except being in love, and calmly declare their

occupation to be pleasure. The roots of these people are not in peasants or petit-bourgeois citizens of Valenciennes; increasingly they perform no scenes of rustic toil or useful employment. But there remains a clear affinity with the rudimentary theatre devised by travelling quacks, at once colourful, transitory, and deluding even while entertaining. Ambiguity is one characteristic of Watteau's art. And all that Gersaint tries to explain – from the actual comic performances seen at an early age to the dominating 'caractère triste' of Watteau – is summed up by the artist himself in the large-scale, late masterpiece of *Pierrot* (Louvre) [31]. That painting alone would justify one in saying that Watteau ended as he had begun.

The hopeful young painter who arrived in Paris about 1702 was to find employment at first only in the lowest form of hackwork, executing copies in a sort of picture factory which paid very badly; however, he told Gersaint, as a charity a daily ration of soup was also provided. All the early biographers mention this period of Watteau's life, which was indeed the worst he ever experienced. It shows the difficulty for an unknown painter arriving in Paris without an introduction and emphasizes the grave step Watteau had taken in leaving Valenciennes. His biographers agree that even during this black period he continued in what spare time he had (by night, as well as day) to draw 'd'après nature'. Probably he had already begun to assemble the nucleus of those figure studies which remain the foundation of his art and which fully justify the contemporary praise of him as 'exact observer of nature'.[47] At this date he was probably still unacquainted with much in the way of old master art, apart from such pictures by painters like Dou which he then so frequently copied. Nor can it have been at all clear what sort of painter he would prove to be. Uncertainty, timidity, and lack of guidance combined to delay him. Although there may be some vaguely Flemish-style peasant pictures by him which can be placed about this period, it was in encountering Gillot that Watteau at last found an artist worthy to help him, one who introduced him also to that significant subject-matter of the Italian comedy.

The chronology of both Watteau's work and life is very vexed. Even the dates for his stay with Gillot and move to Audran are vague, but probably by 1708 he was working for Audran. In 1709 he entered the student competition at the Académie and was placed second. As it happened, no students were sent to Rome that year. Watteau next appears documented in 1712. Although there was no competition, the Académie met on 11 July to decide which student should proceed to Italy. This was the occasion on which Watteau showed paintings which so impressed La Fosse and other senior members that they invited him to join the Académie. All the early biographies make this a significant moment; they may have enhanced the story, but it is hard to believe they entirely invented it. By this act Watteau, the somewhat old pupil of twenty-eight, became established as a young, highly respected master. Thenceforward he was to be ceaselessly active in the lifetime of nine years – to the very same month of July – which was left to him.

Probably in the period Watteau was working with him, Gillot painted the comic *Quarrel of the Cabmen* [23]. Something very Gillot-like is apparent in Watteau's '*Belles,*

25. Antoine Watteau, engraved by C.-N. Cochin: '*Pour garder l'honneur d'une belle*'. London, British Museum

n'écoutez rien' and '*Pour garder l'honneur d'une belle*' [25], which now exist only in Cochin's engraving. The *Commedia dell'arte* characters appear in traditional guise. The setting is quite clearly a stage, and there is a stiffness in the grouping of the actor-figures – slenderly proportioned in typically Gillot style. Yet here are all the elements out of which would be fused shortly afterwards the complete creation of Watteau's *fêtes galantes*. Gillot – whose temperamental affinities with his pupil are stressed by Gersaint and Caylus – interpreted nature in quite a different sense, one that may now look artificial but which represented freedom for the artist's imagination. The theatre, tragic as well as comic, interested him as a designer and presumably as a spectator. He sought modernity in fantastic costumes, seeing himself halfway to being a clown when he executed a self-portrait in floppy, falling collar. In effect, Gillot introduced Watteau to the potentialities of art: the make-believe yet real world of theatre, in which passions are always spinning double plots, those of the actors in private behind-scenes existence as well as those on the stage. The crude charlatans of Valenciennes merge with the sophisticated actors of Parisian opera and theatre.

It is significant how rapidly Watteau was to dispense with stage scenery, both compositionally and emotionally. In the pictures engraved by Cochin, the clear-cut scenic architecture of wing and floor gives way behind to foliage and melting countryside, yet with a hint of classical Antiquity in the vast carved urn. He quickly dispensed too with the actual characters of the Italian comedy, retaining their clothes for the much more refined people of his acquaintance or fancy. The dialogue of music and love which is here only part of the scene becomes virtually his main subject-matter; and the *fête galante* is born.

Of course, it needed Watteau's genius to make of this subject-matter something poignantly beautiful and profound. His concentration on it culminates in the *Fêtes vénitiennes* (Edinburgh) [30], which is the final summing up of all that lies in embryo in the earlier compositions, transfigured into something so highly personal that it cannot be properly

characterized. Jullienne's (*Abrégé de la vie d'Antoine Watteau*) is the most perceptive of the early biographies on this point, emphasizing the dependence on themes which had been Gillot's, yet going on to say: 'il n'est pas moins vrai de dire que, dans la suite, il [Watteau] les a traités d'une manière qui luy étoit propre, et telle que la nature, dont il a toujours été adorateur, les luy faisoit apercevoir'.[48] The lesson that Gillot had to teach Watteau was almost too quickly understood. Something sharper than the usual difficulties between talented master and genius pupil seems to have severed the relationship between them; their very affinities as artists and as personalities perhaps meant the greater antagonism when they separated. This was probably the first manifestation of that impatience and restlessness which was part of Watteau's illness. He left Gillot, and continued for the rest of his life wandering from lodging to lodging, being somewhat troublesome to his friends and yet capable of retaining their strong devotion. Gillot, as has been mentioned, certainly voted in his favour at the Académie in 1717. Although Watteau seems to have always recognized the merit of Gillot's work, he disliked being questioned about the period of their intimacy and their break.

It is impossible to feel that his study under Audran was so close or so fraught. The two artists had quite different, rightly different, ideas about their gifts. Audran was not a painter of pictures. Watteau, though he executed a few arabesque designs, was not basically a decorator. Audran's chief value to Watteau was his post as keeper of the Luxembourg, thanks to which the Rubens *Marie de Médicis* cycle became available for him to study. Audran owned two early pictures by Watteau in 1732, but it is not necessary to believe that these Teniers-style paintings – *La Marmotte* (Hermitage) and *La Fileuse* (lost) – had been painted while Watteau worked under him. One would naturally expect to see the impact of Rubens dramatically apparent in Watteau's paintings, but this is not so; and it is patently lacking in these two pictures. Watteau may well have been acquainted with the *Marie de Médicis* cycle before he moved to Audran, though only while staying with him could he have come to daily familiarity with it. Compositionally, its public pageant would have had little influence on him, and his chalk studies of it concentrate on the female nude and cupids; by virtually a symbolic act, his most consistent borrowing from all its rich welter of motifs is the 'natural' one of the curled-up dog in the *Marriage* picture, a motif he became fond of using. Other motifs from other Rubens pictures begin to occur in Watteau's work, but some at least may derive from engravings. The importance of the Luxembourg paintings for him lay in their technique. That was at the heart of *Rubénisme*: a triumph in the handling of paint which in this case did not by any means imply a triumph of colour at the expense of draughtsmanship. Both gifts had been Rubens's own, and both were to be Watteau's. Gillot had shown Watteau the way to personal subject-matter for pictures; Rubens showed him how to execute it. The final demonstration that the lesson had been learnt was on a large scale – at least by Watteau's standards – in the bravura, confident handling of the *Enseigne de Gersaint* (where suitably occurs, for the last time, the dog from Rubens's *Marriage of Marie de Médicis*). Watteau's technique is too large a subject for treatment here, but his exquisite colour and rich, even

fatty, oil paint are important aspects of his achievement.

The discovery of Rubens as painter and colourist probably first turned Watteau's eyes to Italy, paradoxical as it may sound. It was in the hope of being selected as a pensioner for the French Academy in Rome that he presented himself at the Académie in 1709 and 1712; and the geographical confusion in Gersaint's mention perhaps reveals what Watteau thought of even while he spoke of Rome: 'Il eut quelque envie d'aller à Rome pour y étudier d'après les grands maîtres, surtout d'après les Vénitiens...'. Although he never visited Italy, it was later to come to him in the personal shape of Rosalba and Sebastiano Ricci, and in the work of Veronese and Titian – all representatives of the Venetian school whose acquaintance he would owe to Crozat.

Despite his failure in 1709, Watteau emerges that year as no longer a pupil or employee but as an independent painter with his own style and the first of his own themes. At that date it was not the *fête galante* which interested him but the no less 'modern' subject of military life. Because Watteau is so closely associated with the creation of the *fête galante* category of picture, it is easy to forget the variety of subject-matter he treated. In the earliest known note on him, the Swedish collector Carl Gustaf Tessin recorded in his diary in 1715 that 'Watho' succeeded as a painter of grotesque (decorations), landscapes, and 'modes'. Within the *fête galante* itself there are great varieties of treatment. In addition to military subjects, arabesque decorations, and Flemish-style genre, he painted one or two portraits and some religious and straightforward mythological pictures, as well as a few genre scenes: now in some erotic *Toilette* anticipating Boucher, and now Chardin in the sober *L'Occupation selon l'âge*.[49] The selection of military themes around 1709 seems at first unexpected. It can probably be explained not merely as in a Flemish-Dutch artistic tradition but as directly related to Watteau's own origin in the very countryside which was then the area of Marlborough's victories. In September 1709, by which time Watteau had probably withdrawn to Valenciennes, came the battle of nearby Malplaquet. Such actuality is typical of the natural basis of all Watteau's art; and his soldiers are seen naturally, not engaged in battle but simply marching or resting – no more glorious than might be strolling players – countrified recruits who scarcely understand the seriousness of war, but try to preserve some touch of domesticity even while encamped.

In a strange way, the apparently incongruous military subject-matter is transmuted by Watteau until it seems as personal and typical of him as any *fête galante*.[50] Unfortunately, several of these painted compositions survive only in engravings or in pictures of dubious status, but there is a new graceful mastery apparent – confirmed by some of the existing vivid chalk drawings which were utilized for single figures. Callot had long before shown the miseries of war; artists like Van der Meulen and Joseph Parrocel had made war a more glorious and stirring spectacle.[51] Watteau banishes battle to the past or future; it lies beyond the horizon, and yet its reality is what gives point and poignancy to the temporary bivouacs and the garrisons bravely setting out.

The engraving of Laurent Cars, so responsive to Watteau's subtle effects, catches a great deal of the lost *Escorte d'équipages* [26], the original of which belonged to Jullienne

26. Antoine Watteau, engraved by L. Cars: *Escorte d'équipages*. London,
British Museum

and was praised by Mariette as 'un merveilleux tableau'. It
is indeed the most sophisticated of these military scenes,
organized into a microcosm which contains the experience
not just of army life but of all life: at the centre of the camp,
between flirting soldier and girl, and the cookpot suspended
over a makeshift fire, at peace in contrast to the distant
soldiers forming up around their commander, lies a sleeping
baby. It seems not too fanciful to detect some echo of the
theme of the Rest on the Flight, and a more mysterious
composition of probably the same early date, *La Ruine*, shows
a huddled woman on a donkey escorted by a soldier with a
staff – which seems a quite conscious echo of the Flight into
Egypt. The microcosmic view of life mirrored in society –
with children, old people, animals – and society not passive
but actively engaged in being social, is carried over by Watteau
from scenes of military life into those of people released
from all duty except the profoundly human one of seeking
happiness. Those people too, however, will find a threat on
the horizon: not of war but of time.

Watteau's military pictures enjoyed an immediate vogue.
The first picture he sold was one of these, bought by the
dealer Sirois, Gersaint's father-in-law. In itself the fact might
not seem remarkable, but it reveals one more of Watteau's
quietly revolutionary intentions (the firm intentions of
someone who was 'entier dans ses volontés', as Gersaint later
wrote). This concerned patronage. Left 'à sa volonté' even by
the Académie, Watteau was obviously much happier without
commissions to paint specific subjects for specific patrons;
but he needed to earn a living. It may fairly be guessed that
in general he was more at ease with dealers and *antiquaires*
than with upper-class patrons, however well-intentioned. He
never sought commissions as such, any more than he sought
fame or praise. Caylus (*Vie de Watteau*), by no means an
uncritical admirer, vividly records Watteau's indifference,
mingled with satire ('il était né caustique'), to flattery and to
money, in addition to his tendency to undervalue his own
pictures. For all these reasons, a friendly dealer offered him
more in the way of freedom than could any patron. Watteau's
relations with Sirois remained strong and sympathetic; they
continued after Sirois' death in the person of Gersaint, who
needs no greater tribute than that it was for his shop that the
Enseigne was painted. The military picture for Sirois was

27. Antoine Watteau: *La Mariée de village*. Berlin, Schloss Charlottenburg

soon followed by another. And the demand rapidly exceeded Watteau's own interest in the theme; it was to be taken up by the young Pater at a period when Watteau was evolving his concept of the *fête galante*, the category of picture which he may be said to have invented.

Hints for it came from the contemporary French theatre and from engravings by artists like Claude Simpol and Bernard Picart. Scholarly search for previous treatments of comparable subject-matter leads back eventually to the Giorgionesque *Concert champêtre* (Louvre), which then hung in the royal collection at Versailles. Here is already stated the theme of a group of fashionable people out in the countryside, themselves idle and relaxed, enjoying conversation and music, indulging a mood of lazy amorousness which seems to defeat time, so slowly does anything move or change in the lulling, afternoon air. This quintessential picture may stand for a whole Venetian *cinquecento* atmosphere, which was to become actual to Watteau when he was introduced, through La Fosse, to Pierre Crozat and his collection of drawings and paintings. Probably this occurred in 1712, after Watteau's failure and yet success at the Académie; and such artists as Titian and Veronese, who had influenced Rubens, were directly absorbed into Watteau's own stream of *Rubénisme*. In some ways this natural Venetian world, natural in its relaxation and

sensuousness as well as in landscape, was almost more valuable to Watteau than had been Rubens; it was more remote, chronologically and geographically. After 1712 he perhaps realized that he himself would never see Italy; it remained a *pays lointain*, familiar only through the medium of art – and doubtless for that reason the more hauntingly vivid.

Between the military scenes and the fully evolved *fêtes galantes* comes such a key picture as *La Mariée de village* (Charlottenburg) [27], which at first glance might seem a faintly idealized rustic Flemish scene, but which is much more. A bridal procession is making its way in beautiful weather to a Palladian church of almost dreamlike proportions. This village with its cloudy, feathery trees, sharply prominent pine, and mossy overgrown masonry is the perfect setting for silk-clad country people native to no land except Illyria – and a crystallization of all associations of Italy and the south. It is quite within the mood of *Twelfth Night* that a carriage is passing through the village, its occupants staring out with mock curiosity at villagers no less refined than themselves. Behind the picture lies a sense of theatre – open-air theatre – with, once again, a panoramic view of human life. There are the suggestions, graceful and unemphasized, of the range of society: from carriage class to

28. Antoine Watteau: *'L'Amour paisible'*. Berlin, Schloss Charlottenburg

the mummer-like village musicians. There are the variations of age which Watteau often introduces, and still makes play with in the *Enseigne de Gersaint*; that is one aspect of time's passage. There is his typical, inevitable sense of movement: here literally expressed in the progress of the bridal pair towards the church porch where the priest waits. Above all, hovering like the tutelary genius of the century, is the most sheerly natural of the emotions: Love – animating the whole scene and binding the couple – at once social, forceful, and unsentimental. Watteau's picture is not *like* any particular village wedding in any particular locality; it is a painted metaphor for a psychological truth. In every way except subject, it is the opposite of Greuze's *L'Accordée de village* [228], which is almost sensibility's revenge for Watteau's sense.

Contained within *La Mariée de village* is the essence of the *fête galante* which Watteau was to develop with increasing freedom: moving out of the village context as he moved closer to concern with groups of people. The setting remains countrified but more like park scenery – as enchanted as the always pleasant weather. There is an increasing freedom too about the content of his pictures, which seldom again show such a specific incident as a wedding or betrothal. The society he depicts is 'free', outside the convention of marriage but actively seeking happiness with the right partners – who by an easily understood metaphor are shown as partners in

dance or song. Even while presenting his elegant, beautifully dressed people in surroundings as attractive as themselves, exposed to all the favourable influences of nature, Watteau remains psychologically truthful.

He also manages to be remarkably varied and inventive in composition, and equally in mood. Nothing could be less true than one of the criticisms made by his erstwhile, academic, and ambivalent friend, the Comte de Caylus (who might have supplied the subject for a satiric epistle by Pope), that his pictures suffer from 'uniformité'. And to some extent, the words *'fête galante'* are misleading if applied too generally. The open-air settings of most of Watteau's paintings prove on examination to be remarkably varied in themselves. Sometimes they are parks and gardens shaped by mankind, where nature is enhanced by a graceful statue or a dignified bust. In such settings the people inhabiting them may also be enhanced by semi-fancy dress or given social freedom by temporary borrowing of the costume of clowns and peasants; and then the resulting picture perhaps reflects (as some modern scholars are so anxious to stress) actual diversions of contemporary society. At other times, less often, Watteau puts his figures into much more patently rustic and grander, even wilder scenery.

Seldom did he depict a countryside as grand, uncultivated and yet unhostile as that in *'L'Amour paisible'* (Berlin) [28]: a countryside whose sole indigenous occupant is an easily

29. Antoine Watteau: *'Le Pèlerinage à Cythère'*, 1717. Paris, Louvre

overlooked shepherd seated among his flock in the middle distance. Yet this landscape blended so exquisitely from Flemish and Venetian sources, and not to be looked for on French soil, happily accommodates three interlinked pairs of lovers (or would-be lovers), their attendant guitarist and a faithful, sleeping hound, who are as it were tourists here, refugees from the city, seekers of all the agreeable sensations a day in the open countryside can give – inclusive of aphrodisiac ones. For once, the title of the picture, derived from the engraving after it, is beautifully apt, and one might wish a pun existed on 'pays' and 'paix'.

The scene is too simple to be described as a *'fête'*, and the women's clothes at least are as everyday as those worn in the *Enseigne*. No dancing goes on, and the single, boyish musician is shown pointedly detached, without a partner, nor appealing to one, but seeming to strum for himself alone. Yet love is in the air. And love is felt as a real, earthy, erotic force, illustrated perhaps in three stages or aspects of behaviour, from the contentedly united standing couple at the far left, already arm in arm, to the pleading, gesticulating man at the right whose love-making is more couth, though possibly less successful, than that of the central reclining man who physically grapples with his chosen partner.

Described in words, the picture sounds like a crude illustration, whereas its spell lies in its inherent but unspoken theme. Landscape and figures are fused in a perfect, artistic

harmony, one of tone and touch as well as mood. To its other felicities is added its fine state of preservation. As a piece of sheer painting it is moving and memorable. Against the olive greens and darker greens of the trees and grass the subtle tints of the costumes flower with orchidaceous delicacy, flaring into boldness in the unbroken expanse of the standing woman's sacque-dress of brilliant scarlet.

Caylus believed, or claimed to believe, that such pictures as this one meant nothing: 'ses compositions n'ont aucun objet'.[52] However, it is clear that artists do not paint as Watteau painted without a purpose or a theme. Questions seem to lurk at the heart of his scenes of society at play which certainly do not exist in, for instance, De Troy's pictures of modern modes, and still less in the pictures, delightful though they may be, of Pater and Lancret. It makes better sense to suppose that Watteau had thoughts about the nature of sensations, the oscillations of the human heart, the goal of happiness, and, above all, about the power of love, because all the evidence is that he was as a person thoughtful, literate, and complex.

That he also suffered from tuberculosis is probably as relevant to his art as it would be to Beardsley's. It is no later romantic legend that created Watteau as changeable and melancholic. The testimony of his friends is precise, though they were baffled to explain it. 'Inquiet et changeant . . . même critique malin et mordant, toujours mécontent de lui-même

30. Antoine Watteau: *'Les Fêtes vénitiennes'*. Edinburgh, National Gallery
of Scotland

31. Antoine Watteau: *Pierrot*. Paris, Louvre

32. Antoine Watteau: *Enseigne de Gersaint*. Berlin, Schloss Charlottenburg; *facing page*: detail

et des autres,' in the words of Gersaint. Jullienne called him 'un peu mélancholique'. 'Il était né caustique,' declared Caylus, who thought him possessed of an 'instabilité naturelle', being presumably ignorant of the effects of mortal disease. The gulf which existed between Watteau's imagination and reality was acutely perceived by Gersaint, who memorably formulated it in the words, 'libertin d'esprit mais sage de mœurs'.[53]

Watteau did not always leave his subject-matter and its significance inexplicit. When he eventually composed and completed his reception-piece for the Académie, he painted an unusually elaborate and specific subject [29]. When addressing the Académie, and recalling it was painted by Watteau 'pour sa réception', Caylus called the picture 'l'Embarquement *de* Cythère' (present author's italics). And he positively excluded it from the usual run of Watteau's pictures without subjects. He may have been aware that when the picture was presented in 1717, the minutes of the Académie had entered the title as 'le pelerinage a lisle de Citere' (sic).[54] For some reason, that was deleted and the words 'une feste galante' were substituted. From that deletion, and the substitution of what was not a true title but a descriptive category, began a long train of misunderstanding, by no means finished. But the revised words at least document the Académie as accepting, literally, a picture of this then novel kind. Watteau had created something that was not genre in a De Troy vein but nor was it a proper 'history' piece. The title he chose for it gave it a resonance and actuality which, on reflection, may have been felt to be misleading, whereas in fact they were fully justified. The picture had the most official genesis of all Watteau's paintings. It was destined not for the cabinet of some *amateur* but to be scrutinized by his fellow artists. Its personal

relevance for him is shown by his willingness to execute a second version – a unique incident in his career – which is even more explicit in its imagery. Yet, allowing for the uncertainty of Watteau's chronology, it is possible that this subject represented the artist's intended last word about the *fête galante*.

The misleadingly called *Fêtes vénitiennes* (Edinburgh) [30] must be later and is rather more intimately direct – even to inclusion of the artist's self-portrait.[55] The late *Pierrot* (Louvre) [31] is again unexpectedly a different sort of picture, in mood and scale, and something of its effect is compositionally heralded in *La Danse* (Charlottenburg composition usually accepted). The contrasting day and night scenes of the *French Comedians* and the *Italian Comedians* (both at Berlin-Dahlem) are not *fêtes galantes* but a mature return to the world introduced originally by Gillot. Finally, confirmation of Watteau's deliberate departure into fresh themes, with consequent changes of technique, is shown by the *Enseigne de Gersaint* [32] – the least foreseeable of all Watteau's pictures but the ultimate testimony to him as 'sempre instancabile' in the study of nature (Orlandi, *Abecedario*, already in the 1719 edition, thus within the painter's life-time).

In the *Pilgrimage on the Island of Cythera* (Louvre) Watteau united allegory and reality in the same way, and for the same purpose, as Rubens had done in his *Garden of Love* pictures. Somewhere, at the end of the world, must be supposed a lovers' paradise. Rubens had devised a garden which could almost be based on his own handsome one at Antwerp; Watteau prefers an enchanted island, set in a misty sea, less accessible, altogether less physical than Rubens's May-Day-like festivity – symbolism Rubens had frankly used when he congratulated a young bridegroom on planting the may in his

beloved's garden. The *Garden of Love* depicts a cheerful fertility rite, in which the only doubtful note comes from bashfulness. In the *Pèlerinage à Cythère* the mood is poignant. A festive day is over. The statue of Venus has been hung with its tribute of roses and as evening approaches the reluctant pilgrim-lovers must leave the island. The idea of time's passage, the inevitable movement of life, is conveyed by compositional movement: unwinding from the stone impassivity of the statue – fixed pole amid fluidity – through the three pairs of lovers who represent a gradual awakening to reality, down to the cheerful group boarding the boat amid a flutter of guiding cupids. At the exact middle of the composition, movement is checked by the male pilgrim's pose, held between homeward journey and past felicity, poised on the crest of the hill through the action of his partner who has turned back momentarily with a smile which mingles pleasant recollection and regret [33].

33. Antoine Watteau: *'Le Pèlerinage à Cythère'* (detail), 1717. Paris, Louvre

A bitter-sweet reality lies there under all the light-hearted trappings of allegory and fancy dress; yet the picture escapes from the genre category, just as it does from being mythological. Its central concern is with humanity – in which it remains typical of its century. It is typical too in the importance it gives to women – not as slaves, coquettes, or queens, but as man's equal partners; and it is personally typical of Watteau in the emotional weight placed on a woman, whose impulse of turning round is perhaps the subtlest thing in the picture.

Thus, in this first, official *fête galante* Watteau already transcends the apparent subject-matter. Far from suggesting timeless bliss in an Arcadian world, as may still sometimes be carelessly assumed, he conveys the frailty of human happiness. Even the most beautiful day must end; the happiest lovers, deep under Venus' spell, must leave her shrine and return to a more prosaic world. He is as serious as Poussin (as, indeed, Vivant Denon perceptively and bravely stated[56]), and as individual, in requiring the spectator to 'read' his picture; but even at the time its significance was blurred. Later critics like Diderot were to see only surface grace and artifice in such work, and by redefinition of the word 'natural' to stigmatize Watteau's nature. It was the easier to do this amid the flotsam of the *fête galante* as practised by Watteau's followers and imitators, an accumulation of trivia – for the most part – which began as tribute to Watteau's innovatory genius and ended by damaging his reputation. Had Watteau lived, we may guess that his rejection of the theme would have become absolute. Yet it is what he was able to make of it which matters; it attracted him not because it was pleasing and frivolous, but because it allowed him to discuss the implications of love and serious human search for happiness. It is far from Gillot's scenes of Italian comedians to Watteau's metaphorical climate in which we are all comedians, wear masks or cap and bells, and play parts; and there human transience is pointed up by the eternity of monuments, those stone figures who alone seem to survive time, still standing when the music has faded and the singers are gone.

*

Watteau's legacy was not in fact connected with any single category of picture. It was perhaps in his drawings rather that the essence of his genius lay, and these were after his death to become widely known and disseminated in a remarkable way, thanks to the enterprise of Jullienne in having them engraved and published. Ruined by the failure of Law's financial system, Watteau had visited London in 1720 perhaps hoping to consult the famous physician who was also a collector, Dr Mead. It was when he returned to France, more ill than when he set out, that he sold the major portion of his effects and added the resulting sum to such capital as Jullienne had managed to save for him from the Law débâcle.

Far greater, in every sense, was his artistic capital. It lay in the mass of his drawings, themselves varied beyond his paintings in their range of subject-matter, the fruit of incessant study and the product of marvellously matched eye and hand. Rarely did Watteau, it seems, make preparatory studies with particular paintings in mind; but he had assembled a whole visual vocabulary from which he could select what he required for any painting. The drawings show him keenly aware of life in the streets but even more of life in a more intimate way – the life particularly of women. A sheet of sketches may contain a series of women's heads [34] at different angles. Or he studies with sensuous attention a woman's body [35], very much 'from the life', a few delicate touches of sanguine crayon conveying the flesh and blood of ear, hands, and foot, while strokes of white chalk suggest the sheen of the skin. In this superb drawing the body is fondly delineated as at once wrapped and yet revealed by the creased, almost rustling draperies, caught up to expose a calf and slipping down to give glimpses of a breast. And even among

34. Antoine Watteau: *Studies of Women's Heads*. Drawing. Paris, Louvre, Cabinet des Dessins

the mature drawings are decorative ones which recall the idiom of Audran [36], though in a more inspired, enchanted vein. The surface of the paper seems to shimmer in its framework of ribbons and wreaths of foliage amid which are vividly summoned up in rapid chalk two classical vignettes of exuberant but definite rape.

Watteau bequeathed his drawings to four devoted friends who between them represent a few fixed points in a tragically unsettled, consciously withdrawn existence: Gersaint, then a young dealer, with whom Watteau had lived for a while after his return from London; Hénin, an amateur, an acquaintance of Caylus and himself an engraver and draughtsman; the Abbé Haranger, possibly a Fleming and certainly a canon of the Flemish community's church in Paris, Saint-Germain-l'Auxerrois; and the sensitive, supportive collector, Jean de Jullienne, who only in the year of Watteau's death inherited his great wealth. The major portion of the drawings, however, went to Haranger.

It has very reasonably been suggested that Watteau's bequest to this quartet was the stimulus for the project of the *Œuvre gravé*, consisting eventually of four volumes, produced by a number of engravers under Jullienne's direction and at his expense. Some stimulus for the project may also have come from the publication a few months after Watteau's death of the first volume of the *Recueil Crozat*[57] (which included engravings of good quality after drawings).

Crozat's project was on a grand, European scale, and sadly failed to come to fruition. Jullienne's was more modest and more concentrated, and on 31 December 1739 he was able to present a set of the four volumes to the Académie royale. In them are collected not only a range of Watteau's drawings (sometimes mere sketches, often in brilliant near-facsimile), as well as arabesque designs, but the majority of his finest paintings, sometimes reproduced on double pages. The previous comparative inaccessibility of Watteau's work was thereby changed. No single artist ever before had been the object of such sustained reproduction, or of such sustained posthumous patronage. It revealed not only Watteau's versatility but the extraordinary amount of work achieved by a sick man, slow to find fame and always full of self-doubt. From posterity's point of view it is also an invaluable guide to pictures now lost or destroyed. The artistic influence of the *Recueil Jullienne*, a deserved title which the instigator modestly did not choose, is hard to calculate. In France alone its influence must have been considerable, not least on one young and talented, then unknown, artist who participated in it as an engraver: Boucher. Outside France its influence was perhaps more subtle still: Gainsborough owned a copy of it and is sometimes patently indebted to it; Domenico Tiepolo certainly owned some engravings after Watteau; and, consciously or not, Goya is an inheritor of Watteau's achievement. Such great names are really more interesting

35. Antoine Watteau: *A Seated Woman*. Drawing. New York, Pierpont
Morgan Library

than the immediate following of Watteau's French imitators, satellites who, for the most part, were revolving round a vogue rather than round a genius.

The frontispiece to the third volume of the *Œuvre gravé* prints a well-meaning poem by the Abbé de la Marre which in its very commonplaceness is perhaps revelatory of its century. An allegorical fable entitled 'L'Art et La Nature', it was chosen by Jullienne to introduce, in effect, the two volumes of Watteau's paintings. Art and Nature quarrel but are reconciled by the appearance of Watteau; he unites them peacefully, saying:

> Vous estes faits pour estre ensemble.
> Je veux vous unir à jamais.

Feeble as the verses are, they express a truth that is profound.

LANCRET, PATER, LAJOUE, AND LESSER PAINTERS OF FÊTES GALANTES

Lancret is the one painter who stands out among the Watteauesque artists, and he is also the one who has suffered most perhaps from juxtaposition to Watteau. The dreadful fate of being 'émule de feu M. Vateau' was already his in 1723; yet considered in his own right he is an attractive, competent figure, with a lively eye for topical manners – no poet but a charming essayist. To savour his vivacity, and his talent, it is sufficient to compare his pictures with De Troy's similar gallant scenes; that comparison does some justice to Lancret, if not as pioneer at least as the better painter.

Nicolas Lancret was born in Paris in 1690 and there he died in 1743, no more than middle-aged and yet having outlived the majority of the *fêtes galantes* painters like Pater, Bonaventure de Bar, Octavien, and Quillard. The death of Watteau, followed by Gillot's death the subsequent year, left Lancret the outstanding exponent of this type of picture. He had been an unruly student at the Académie in 1708 and then moved to become a pupil of Gillot during 1712–13; Gillot's influence on him is apparent not only in subject-matter but in the slender proportions of his figures, at least in his early pictures: lively marionettes who are often assembled in considerable numbers, dancing or flirting in the open air. *Agréé* in 1718, he was formally received the following year when he presented as his *morceau de réception* a *fête galante*. In 1722 and 1723 he exhibited in the Exposition de la Jeunesse at the Place Dauphine; he appeared at the isolated Salon of 1725 and was a regular exhibitor at the re-established Salon in the last years of his life. Made councillor at the Académie in 1735, he became an established, popular artist whose work was greatly in demand, especially in court circles. He executed pictures to decorate rooms at Versailles, but some were also owned by Jullienne, and many were later to be collected by Frederick the Great. The very collectors so responsive to Watteau seem to have been unaware of obtaining an inferior article with a Lancret; it was left to Mariette to sum up with cold accuracy the trouble about Lancret, that he was basically no more than a 'practicien'.

The range of his art varied little. The mood is more cheerful than even particularly *galante* – and it ends by being rather monotonous *en masse*. He perhaps deliberately

36. Antoine Watteau: *Le Berceau*. Drawing. Washington, National Gallery of Art, Ailsa Mellon Bruce Fund 1982

modelled himself on Watteau, yet he could not conceal his much more *mondain* interests, skilfully blended with a persistent prettiness. Although the figures in his pictures are sometimes meant for portraits, they lack any real tang of individuality; certain types of wide-eyed, ever-smiling, faintly infantile faces keep recurring and become a hallmark of Lancret's style. In some ways he is nearer Boucher than Watteau.

Lancret's light-hearted charm almost conceals his extreme competence – a competence which is, however, confirmed by his drawings. His ravishing colour sense, with pale pastel-yellows and poppy-reds, never deserted him. Although the graces of the *fête galante* soften all his depictions of would-be real life, it was in such latter scenes that Lancret produced his best work. If in those he was emulating Watteau, it was Watteau the creator of the *Enseigne* who inspired him. Lancret's figures assume a larger, firmer place within the composition, and several of his last pictures – like the *Montreur de lanterne magique* (Charlottenburg) – achieve a limpid balance between extremes of art and nature. The *Family in a Garden* (National Gallery) [37] was exhibited at the Salon of 1742, the last in Lancret's lifetime, and is a masterpiece, emancipated from all influences. The family anecdote is charming, just tinged with humour; the figures

37. Nicolas Lancret: *A Family in a Garden*, 1742. London, National Gallery

themselves have a flower-like charm and freshness, anticipating early portraits by Gainsborough. According to the Salon *livret* the family are taking coffee, and the younger girl is obviously experiencing her first taste of it. It might almost be her first taste of the grown-up world, exchanged for the doll discarded in the foreground, but Lancret is too delicate and delightful for such moralizing. The secluded garden with its graceful sweep of fountain and tall, flower-entwined urn is décor which almost succeeds in convincing the spectator it could exist, and much the same is true of the cluster of hollyhocks amid which a dog chews his bone – fashionable hollyhocks dyed to suit Lancret's palette.

A heavier fate was reserved for Watteau's sole pupil, Jean-Baptiste Pater, in artistry devoted and timid, and the more irritating the more closely he pastiches his master. Born at Valenciennes in 1695, Pater studied there under the painter Jean-Baptiste Guidé before coming to Paris and working for a short time as Watteau's pupil, probably in 1713. Although Watteau treated him badly, no doubt out of moodiness rather than from any jealousy, his influence on Pater was decisive. When he was dying at Nogent he was reconciled with Pater, who had meanwhile spent a two-year period back in Valenciennes; Pater very briefly became again his pupil, and Gersaint tells of Pater's declared indebtedness to this tragic month's teaching. In 1728 he was accepted as a member of the Académie, presenting a military piece in the style popularized by Watteau, *La Réjouissance des Soldats* (Louvre). Overwork and a miserly temperament – according to Mariette – brought Pater to a premature death; he died in Paris in 1736.

38. Jean-Baptiste Pater: *Landscape with a Cart*. Berlin, Schloss Charlottenburg

39. Jacques Lajoue: *A Park by Moonlight*. Potsdam, Palace of Sanssouci

The majority of his pictures are insipid *fêtes galantes* where not merely the theme but most of the figures are directly borrowed from Watteau: an anthology of imitation much closer than anything contrived by Lancret, and executed in rather greyish, powdery colours with a flickering use of line that is the most personal characteristic of Pater's style. His subject-matter moves away from Watteau and towards Hogarth in the series of fourteen pictures produced in the last years of his life, illustrating Scarron's *Roman comique*; yet here the basic theme, of a troupe of travelling players in northern France, strangely brings us back almost to the actual world of Valenciennes seen and sketched by the very young Watteau.

Pater's illustrations are humble, hasty, and pedestrian in their attempts to be funny: it is somehow sad, yet not surprising, that they should have ended up in the cabinet of Frederick the Great who owned, as well as pictures by Watteau, an extraordinary amount of Pater's work.[58] Among these, however, are one or two pictures in which Pater successfully, if temporarily, seems to foreshadow Boucher: not only in groups of *baigneuses* but in the pretty, stage-like *Landscape with a Cart* (Charlottenburg) [38]. There the figures are totally subordinated to the fragile buildings and picturesquely twisted trees, and the whole composition has a feathery, calligraphic delicacy which suggests the extreme of evanescent Rococo to be found in Fragonard or even Francesco Guardi. The picture has been dated to the last years of Pater's life; it suggests a distinct shift away from Watteau, perhaps from the *fête galante* world altogether, but Pater was deprived of the opportunity to consolidate such a move.

A much more substantial and original figure was Jacques Lajoue, whose life and art have only recently come into full scholarly focus. He was almost certainly born in Paris, probably in 1686. In April 1721 he came before the Académie with two pictures, 'représentant chacun une perspective dans un paysage', with the intention of being *agréé*. However, he was accepted outright as an academician. After that he rarely appears in connection with the business of the Académie

(though he exhibited at the Salon) until April 1761, when news of his death earlier in the month was recorded.

Although traditionally associated with, and even made out to be a collaborator of, Watteau and Lancret, Lajoue was basically much more allied to the purely decorative and ornamental artists of the period. His own art was fused, in fact, from the two sources, with the decorative elements prevailing. His figures, from wherever they derive, are nearly always subordinated to the openly fantastic but highly inventive architecture. Less typical is his charming portrait of himself and his wife, with their young son, in a garden setting (Louvre), exhibited at the Salon in 1737, which is patently under the influence of Lancret. Conversely, one might claim that the décor of Lancret's *Family in a Garden* has been borrowed from some of Lajoue's designs of garden urns and fountains. The fantasy quality of Lajoue's imagination gives something dream-like to his scenes where every object is exaggeratedly in animation. Watteau might occasionally have touched a statue in one of his pictures into graceful semi-life, but Lajoue puts in motion an array of architectural motifs. Curving balustrades accompany dizzying flights of steps beside streaming cascades, while clusters of pillars seem to sway like the tall tree-trunks which twist close by. And in such an excited universe there are intimations of Fragonard.

Lajoue was probably at his most spontaneously inventive when not having to compose pictures as such. In verve he could rival Meissonnier, as books like his *Divers Morceaux d'Architecture, Paysages et Perspectives*, of which the first volume was published in 1740, indicate. Even more riotously Rococo are the designs in the two undated volumes of *Tableaux d'ornements et rocailles*, which must have appeared shocking and outmoded well before Lajoue died. If his paintings are rather variable in quality, he could manage at his best to produce effects which have their own magic, of atmosphere as well as of design. Several of his sunset or sunrise and moonlight scenes are lost, but there survives the *Park by Moonlight* (Potsdam) [39] which, for all its look of a stage set, casts an eerie spell. The rays of the moon, half-

obscured by branches, ripple coldly on the water and fitfully illumine this deserted park where strange female statues seem to stir under those rays and display themselves erotically, as in some voyeur's paradise.

The painters who reflect Watteau more closely, often as exponents of the *fête galante*, are more shadowy figures, artistically slight in terms of surviving work and sometimes themselves doomed to early death.[59] Some signed pictures establish a basis for the *œuvre* of François Octavien (1682–1740), who emerges from obscurity in 1724 when he was *agréé* at the Académie; the following year he became a full member on presentation of the Van-der-Meulen-style *Foire de Bezons* (Louvre) as his *morceau de réception*. Little is known about him, but he seems to have been influenced by Watteau only comparatively late in such career as he had. More interesting and promising were the two close contemporaries, Quillard and Bonaventure de Bar. Pierre-Antoine Quillard (born between 1701 and 1704; died 1733) twice competed at the Académie *concours*, having the bad luck to lose first place in 1723 to Boucher and in the following year to Carle van Loo. In 1726 he travelled to Lisbon with a Swiss doctor who required an artist to execute drawings for a work on natural history; and there he remained for the rest of his brief life.[60] He was well patronized by the Portuguese court and produced lively pictures, usually crowded with small figures in a style close to Watteau in such works as *La Mariée de village* [27]. Whether he ever was a pupil of Watteau is unclear, and the character of his own art is well conveyed in the *Fête de mariage* (Dublin). Quillard may stand as an aspect of the expansion of French art outside France but he cannot be claimed as carrying the ethos of Watteau to Portugal because in his pictures the echo of anyway Watteau's mature work is very faint.

Closer to Watteau, but with a marked Flemish flavour, are the few pictures by or attributed to the even more briefly-lived Bonaventure de Bar, who died at Paris in 1729 no older than the century. He attended as a pupil at the Académie, failing to win a prize in 1721 and failing in 1723 to be among those selected by the Duc d'Antin, Surintendant des Bâtiments, for the journey to Rome, although designated by the Académie. He was *agréé* on the same day as Chardin in 1728, when the Netherlandish orientation of his art was underlined by his being approved as an artist 'dans le talent particulier de la figure comme Téniers et Wauwermanns . . .'.[61] What exists of his art does indeed suggest a response to rustic manners; and he seems the most artistically robust of all the artists who followed Watteau. Far from making even more artificial the *fête galante*, he would probably have brought it back, quite literally, to earth. His career had hardly begun before it was interrupted first by illness and then soon after by death. At that time he was lodging with the Marquis de La Faye, the original owner of Watteau's *Mariée de village*, which passed to La Faye's mistress, the Comtesse de Verrue, herself possessor of a very choice collection; almost too neat a circle seems traced by the fact that it also included one version of Rubens's *Garden of Love* and no less than four pictures by de Bar.[62]

The painters mentioned here do not exhaust the subject of Watteau's influence, felt in such artists as Antoine Pesne (1683–1757) and his pupil Philippe Mercier (1689–1760).

Both artists lie outside the scope of a book on French art. Pesne was in any event very variously influenced, rarely to the benefit of his art, which, despite the extravagant praise of his patron, Frederick the Great, has not won much esteem from posterity. Occasionally Pesne achieved something of merit, and his portrait of Watteau's friend, the painter Vleughels (Louvre) [40], done in Paris in 1723, has unusual

40. Antoine Pesne: *Portrait of Vleughels*, 1723. Paris, Louvre

conviction and effectiveness; in style it seems a tribute to the contemporary current of *Rembrandtisme*. Mercier was much more truly receptive to Watteau's influence but the major portion of his working life was spent in England.[63]

Other artists have sometimes been loosely linked to Watteau. One or two are basically draughtsmen, like the highly gifted Jacques-André Portail (1695–1759), whose 'borrowing' from Watteau chiefly consists of his use of the *trois crayons* technique.[64] Portail produced some firm yet delicate figure studies and equally delicate landscape drawings which can be associated with the emphasis on sketching from nature fostered in the circle around Oudry.[65] 'Nature' as interpreted by Watteau was perhaps to prove of more interest than the 'art' in his unique synthesis. To some extent what he had united was divided and continued by Chardin and by Boucher – thus becoming the greatest of his posthumous pupils. The final triumph of the *Œuvre gravé* was probably to affect taste almost without its being consciously noticed;

few artists can have escaped from some touch, however remote, of Watteau's genius, and his compositions proved good to steal from, as also for the decoration of porcelain, books, and indeed rooms. Yet in this dilution lay partly the reason for reaction. Lancret might seem to have diluted the style sufficiently in painting, and by the time of his death in 1743 the whole idiom of the *fête galante* was out of date. In 1752 the Marquis d'Argens was positively to attack a taste for artists like – he instanced – Teniers and Watteau: good enough to be represented by a few pictures in a small cabinet, but not to be ranked with the glory of French art in the living persons of Carle van Loo, Restout, Boucher, and Natoire.[66] Those were the great names of the mid century, some of them not long after to come under critical fire; while such a painter as Restout represented a tradition which had continued unaffected by the Régence or the *fête galante*.

OUDRY AND PARROCEL – THE COYPEL, RESTOUT, AND LEMOYNE

Traditional tendencies which continue across the chronological barrier of 1700, taking little notice of a new century, are apparent in the work of Jean-Baptiste Oudry (1686–1755), the pupil of Largillierre and the continuator of a style of still-life painting practised first in France by François Desportes (1661–1743). Desportes' patrons had been headed by Louis XIV and Louis XV; the latter was to be Oudry's greatest patron, and to some extent the two painters' careers overlap. They both sought their sources in the rather specialized aspect of *Rubénisme* represented by Snyders and Fyt, and also – perhaps stylistically closer still – in the hard, decorative hunting pieces and still lifes by two painters of the Dutch school, the Weenix father and son.

Although it is with pictures of similar subject-matter that Oudry is most often associated, he was also a portrait painter and a decorative painter, producing arabesque designs and at least one sub-Watteauesque *Italian Comedians* (Paris, A. G. Leventis Collection),[67] and it was as 'peintre d'histoire' that he was received at the Académie in 1719. Oudry was the son of a painter–picture-dealer established on the Pont Notre-Dame. Trained first under his father and Michel Serre, he had an unusual opening to his career, becoming a member of the Académie de Saint-Luc, as well as being a pupil of Largillierre. His portraits clearly derive from Largillierre,

41. Jean-Baptiste Oudry: *The Dead Wolf*, 1721. London, Wallace Collection

42. François Desportes: *Étude de paysage: coin d'étang*. Sèvres, Manufacture Nationale

who is said to have advised him to take up still-life painting – advice which was probably shrewd rather than rude, and given by a painter who had himself practised it. Although Oudry was to be concerned with Buffon's *Histoire naturelle*, to depict the royal animals alive and slain, and to paint the royal hunts, he rarely ventures very far into a totally natural world. However exotic their origin, his animals are contained within the environment of civilized park or garden, often with suggestions of balustrade or wall, usually accompanied by glossy dead game or baskets of unblemished fruits [41]. Even his thistles betray a decorative intention.

Contemporaries might praise him for following the hunts in the forest of Compiègne so as to 'faire des études d'après nature' before designing cartoons for the Gobelins *Chasses royales*, but Oudry's 'nature' proved well suited to the conventions of the medium. In 1726 he was appointed official designer at the Beauvais tapestry factory, becoming its director eight years later. In 1736 he was appointed to a similar post at the Gobelins factory. Oudry can certainly not be accused of idleness. His output was vast, and his virtuosity is not in doubt. To the large collection of his work assembled at Schwerin by the Duke of Mecklenburg-Schwerin, frequently mentioned in accounts of Oudry, should be added mentally the smaller but choice group of his pictures at Stockholm (Nationalmuseum), which includes one of his most direct and sympathetic animal 'portraits' in Tessin's dachshund, 'Pehr' (signed and dated 1740).

From an artist who studied nature on the spot, the backgrounds to some of Oudry's paintings can be surprisingly conventional. What could be achieved had been shown in the extraordinary, though private, oil sketches made by François Desportes (1661–1743), sketches made, as his son stressed, in front of the natural phenomena to which they instinctively respond. Quite timeless is Desportes' sketch of, for instance, a few clouds lit by the setting sun; and an uncanny beauty haunts a comparable study of a tree-fringed lake, with the sky reflected in it (both Manufacture Nationale, Sèvres) [42]. The latter has an almost pantheistic feel for nature serene and undisturbed by any hint of mankind's presence.

Oudry might not equal that intensity of vision, but in his drawings of the Duc de Guise's park at Arcueil [43] he revealed his response to a thoroughly eighteenth-century aspect of nature and art united in a garden setting. At Arcueil there is evidence of man's artful and elegant re-ordering of nature, though nature appears on the point of taking over once more. The trellises look frail under heavy, burgeoning foliage, and trees are encroaching on the limits of the lawns. Out of this enchanted blend Oudry created poetic effects that are the more truly 'natural' for lacking, usually, the presence of people.

It is strange that the creator of this pleasantly peaceful vision should so often in his paintings have depicted the natural animal kingdom as actively savage and aggressive. Leaving aside the slaughter celebrated in the hunts of Louis XV, and the compositions of predatory birds and beasts, Oudry can hardly paint a leopard or a gazelle without the accompaniment of dogs angrily yelping at the handsome, exotic animal. What is more, for all the glossy skill of their outward depiction, his animals ultimately lack the natural empathy possessed by the animals painted by Stubbs.

Perhaps the truth is that Oudry – regardless of subject-matter – was essentially a decorative painter. The *tour-de-*

43. Jean-Baptiste Oudry: *The Park at Arcueil*. Drawing. Paris, Louvre, Cabinet des Dessins

44. Jean-Baptiste Oudry: *The White Duck*, 1753. Private Collection

force of *The White Duck* (Private Collection) [44] remains exactly that. The objects lack the weight and gravity with which they would have been invested by Chardin. They are arranged to serve as a demonstration – a highly effective one – of the differing qualities of white in a variety of materials, from paper to silver, as Oudry had outlined in a lecture at the Académie in 1749, four years before he demonstrated the point in this picture.[68] Something of its academic origin can perhaps be detected, for all its virtuosity of handling. Pleasing enough as his pictures can be, particularly when he is freed from the royal obsession with slaughter and dead game, they do not represent a profoundly new grasp of nature, nor a particularly revolutionary aspect of art. Indeed, rather the opposite. The aura of the *grand siècle* conditioned Oudry, more perhaps than he realized; he is much closer to it than to the nature and natural reactions of a Diderot or Rousseau. There is something faintly mechanical in the vivacity of even his best work; like Burke as described by Paine, he could almost be one of those *ancien régime* figures who 'pities the plumage but forgets the dying bird'.

The *grand siècle* hung quite incontrovertibly around Charles Parrocel (1688–1752), a close contemporary of Oudry. His father Joseph (1648–1704) was himself the third generation of a Provençal family to be active painters; Joseph had worked in Italy with Jacques Courtois and became a famous battle painter after settling in Paris in 1675. Charles

45. Charles Parrocel: *Halte de grenadiers*, *c.* 1737. Paris, Louvre

was the elder son, formed as a painter not only by his father and also by La Fosse but by a year's service in the cavalry. While Oudry recorded Louis XV's private fights with wild animals, Parrocel recorded the royal victories on the battlefield in the years 1744–5, following the king as Van der Meulen had followed Louis XIV.

Pictures like the *Halte de grenadiers* (*c.* 1737, Louvre) [45] are more genre than military in their atmosphere: convincing in detail and with lively colour, they are powered also by the painter's interest less in battle as such than in horses. With perhaps more profound observation than Oudry, he brought an almost scientific eye to the study of horses he specifically conducted to illustrate the *École de Cavalerie*, published at Paris in 1733. Whereas Oudry is constantly concerned with the chase, postulating man the hunter behind all his pictures of wild life, Parrocel emphasizes man more usefully employed, his commands enhancing the beauty and movement of the horse. Cochin's *Essai de la vie de M. Charles Parrocel* (1760) mentioned this very point. Parrocel becomes virtually an ideal figure beyond the confines of books on

equitation, preparing the way for the combination of superb animal and intelligently commanding rider that is David's *Count Potocki* [292].

Even more impressively linked to the seventeenth century was the dynasty of the Coypel, represented after Antoine's death in 1722 by his son Charles-Antoine (1694–1752) and his always much less famous half-brother, Noël-Nicolas Coypel (1690–1734). Antoine Coypel had himself enjoyed the advantages of a famous father, director of the French Academy at Rome; he had been encouraged by Bernini and patronized by the Grande Mademoiselle long before his success during the Régence. The fame and prestige of the Coypel form really a happier subject of discussion than their art – with the ironic exception of Noël-Nicolas, the least successful at the period but easily the most attractive artist of the family. Antoine Coypel might have seemed to represent a peak of grandeur and power not to be equalled; but it was very much thanks to his position that Charles-Antoine professionally advanced, becoming heir to his father's honours, directeur of the Académie, and finally Premier

46. Charles-Antoine Coypel: *Rinaldo abandoning Armida*, 1725. Paris, Baron Élie de Rothschild

Peintre in 1747 – a post renewed after a ten-year gap, which in terms of artistic merit should have gone to Boucher.

Trained inevitably under his father, Charles-Antoine was received at the Académie in 1715. He had no opportunity of showing his ability in public until the Salon of 1725; it was then noted in the *Mercure de France* that this was the first time that the painter had exhibited his work 'aux yeux de public'. This isolated Salon was the occasion for the public display of De Troy's talents, and also those of François Lemoyne. The three painters were already perhaps jostling for position as the outstanding artists of a new generation; and even if none of them was in fact startlingly young, they were all youthful by comparison with the over-seventy-year-old Louis de Boullongne, who in 1725 was appointed Premier Peintre. And they were all painters in the tradition of decorative historical painting exemplified by Antoine Coypel and La Fosse – thus more flexible in talent than Oudry or Parrocel – yet each was to show some interest and ability in either genre, portraiture, or even landscape. In 1727 the Duc d'Antin was to organize the *concours* which brought De Troy and Lemoyne into direct rivalry. Then the prize might well have been awarded to Charles Coypel, whose *Perseus delivering Andromeda* (Louvre) was executed for the competition and had its own partisans; it was indeed acquired for the Crown. Something of a *concours* element already enters into the 1725 Salon, when all three painters, possibly by chance, exhibited pictures drawn from the *Orlando Furioso*,

specifically from the love-story portion of Rinaldo and Armida. Coypel, the youngest of the trio, showed a *Rinaldo abandoning Armida* which is probably to be identified with illustration 46 (Baron Élie de Rothschild Collection).

But this was a mere sample of his abilities, displayed – surely consciously – on a wide range. There was a group of portraits, executed in pastel as well as oil, including a double portrait of two boys, sounding proto-Chardinesque in its motif, 'dont un fait un château de cartes', though rather different in its slightly simpering effect. Royal tapestry commissions were represented both by a biblical subject (*Joseph recognized by his Brothers*) and a cartoon for the big series of *Don Quixote* tapestries, a task given to Coypel in 1714 and not completed until 1751.[69] To confirm his ability as decorative painter on an even more ambitious scale, there was his sketch showing the proposed allegorical scheme for a room at Saint-Cloud, where ceiling and wall were interestingly planned to be merged in a single illusionistic effect: 'le plafond et le bas ne devant faire qu'un seul morceau' (*Mercure de France*). To touch the new taste for charming *galant* subjects, tinged with overtones of genre, there was *Cupid as a Chimneysweep*.

Thus Coypel tacitly declared himself armoured by all-round talent – and he was talented in other directions too, being literate and witty, writer of not only Académie discourses but poems and several Molière-style comedies. Under his directorship the Académie became the scene of discussions and lectures; 'lives', like those of Watteau and Lemoyne, composed by Caylus, were read; aesthetic theory was discussed. Coypel took his duties very seriously, acting in support of sculpture as well as painting. In the last year of his life, he is found proposing that a grove at Choisy should be nominated 'le Bosquet de la paix'[70] and adorned with sculpture by five leading sculptors, of whom Michel-Ange Slodtz would receive the major commission. All this was accepted by the future Marigny and approved by the king. The scheme got under way, despite Coypel's death, but other deaths, some reluctance, and the usual lengthy delays prevented it from ever being completed. In the reign of Louis XVI, and with d'Angiviller as Directeur des Bâtiments, Charles-Antoine Bridan exhibited a *Vulcan* statue which – though probably no one could then remember the fact – was directly related to Coypel's project.[71]

Histories of French eighteenth-century art have found it easy, however, to pass over Charles Coypel the painter, and there are good reasons for this. Some of them are hinted at in the *Rinaldo abandoning Armida*, which is a favourable specimen of his work. If the organized, literary basis of the Académie under him suggests a return to the standards of Lebrun, Coypel's paintings equally suggest a return – to the decorative standards of his father and La Fosse. Rubens and Veronese certainly haunt his art, but in a pastiche mixture that is already familiar particularly from La Fosse's pictures. In Coypel's composition the conventional gestures – faintly silly in Armida's grab at Rinaldo's clothing – and insipid faces reveal a talent which is either not robust enough in itself or else cannot be bothered to take imaginative trouble. Like some other academically respectable French painters of the period, Coypel seems to begin enervated, overshadowed by the example of the past and unable to formulate a fresh style. His own mediocrity was recognized at the time; Mariette

insufficiently pretty and inadequately serious. Its wavering quality can fairly be detected amid other contemporary altarpieces in the church. These are by no means masterpieces, but they show that Coypel could not compete with the competent if perfunctory work of Carle van Loo; and an early Vien altarpiece (signed and dated 1754) is rather better. Some of Coypel's designs for the *Don Quixote* tapestries are lively in a simple-minded way; his portraits are competent but seldom specially interesting.[72] In his life he had honours enough, and he collected a fine assembly of old masters. For posterity his uncle, the obscure Noël-Nicolas Coypel, is much more attractive as an artist.

Noël-Nicolas seems to have been a timid, unbrilliant personality, rising only slowly in the academic hierarchy. Trained under his father, he was *agréé* in 1716 and received the following year but not made *professeur* until 1733, the year before his death. He took part in the *concours* of 1727, executing *The Rape of Europa* [48] which, though not awarded a prize or bought by the Crown, was highly thought of by some connoisseurs. Although he never went to Italy, his art owes a great deal to the example of Correggio and also, it is reasonable to guess, to Rosalba. It is probably his more forward nephew, Charles-Antoine, whom she often mentions as the 'figlio Coipel' in her Paris journal for 1720–1; but both Coypel practised as pastellists, almost certainly under her influence. Noël-Nicolas was praised by discerning contemporaries for religious work as well as for mythologies – but most of the former has been destroyed. The always decorative, effectively decorative, nature of his talent was seen in the dome of Blondel's Chapel of the Virgin in Saint-Sauveur at Paris: there around 1730 he was working with the most painterly of sculptors, Jean-Baptiste Lemoyne (who has left a brilliantly vivid portrait bust of Coypel), in an illusionistic scheme where painted angels merged into sculpted ones – also coloured – streaming around the Virgin.

Such a mingling would be commonplace in a German or Austrian church, but it clearly disconcerted some sectors of taste in Paris – though praised by others. The scheme indicated Lemoyne's essentially theatrical flair, increasingly greeted with reserve by classicizing theorists like Caylus. The scheme brought trouble to Coypel, involved in disputes with the church authorities over expense; upset and emotionally distracted, he accidentally injured his head when passing through a doorway, and died from this injury.

Coypel best survives today in a fairly homogeneous group of mythological pictures, not on too vast a scale, which breathe a lively hedonism and relaxation without insipidity. They form a distinct link between the Régence and Boucher.

The Rape of Europa is probably Coypel's masterpiece and it stands in its own right as well as being a remarkable anticipation of Boucher's *Triumph of Venus* [167]. It deserved to win the *concours* of 1727, but the injustice then done to Coypel was remedied by the Comte de Morville, a *secrétaire d'état*, who shrewdly bought the picture and paid for it the amount the king had promised for the winning work; the ultimate loser was to be the French state.

47. Charles-Antoine Coypel: *The Supper at Emmaus*, 1746. Paris, Saint-Merry

used this actual word of him and shrewdly analysed his faults with phrases that cannot be bettered. His failure lay in not recognizing the necessity 'd'étudier d'après nature. Il s'étoit fait une espèce de routine...'.

The subject of Rinaldo and Armida is one which was to inspire great eighteenth-century painters, Tiepolo among them, and not only painters – as Handel's *Rinaldo* and Gluck's *Armide* may serve to recall. To Coypel it perhaps seemed merely operatic in a pejorative sense. Unfortunately, he was not to prove a better painter of more elevated subjects; his *Supper at Emmaus* [47], painted in 1746 for a chapel designed by Boffrand in Saint-Merry at Paris, is inept. This is one of his last pictures, a strange mixture of Correggio-style angels and dim anticipations of the neo-classical – at once

Detail of plate 48

48. Noël-Nicolas Coypel: *The Rape of Europa*, 1727. Philadelphia, Museum of Art, Gift of John Cadwalader

Coypel's *Rape* is an aquatic carnival in which the only creature not enjoying things very much seems, oddly enough, to be the bull. Air and water are alive with floating, flying beings, realized with an unforced brio welcome in French painting at the period and perfectly attuned to the subject as a mythology. The picture is decorative yet far from trivial. Although it declines to be learned or solemn, it includes careful – and pleasurable – study of the nude. Above all, it has an infectious, painterly vitality which could with advantage have infected some of the other competitors, not least Coypel's nephew and De Troy.

Although a lesser work, *The Alliance between Bacchus and Venus* (Geneva, signed and dated 1726) [49] has something of the same charm and spontaneity. The alliance may be of two great powers but the emphasis is on the female one; Venus is the hostess entertaining in her own realm, where cupids and nymphs kiss or gather grapes. With his artistic high spirits and his confidence in handling paint – and his ability to kindle sparks of eroticism – Coypel should have enjoyed a successful career, and even now it is unclear why he passed into obscurity. The painter who came nearest to Coypel was François Lemoyne; but before turning to him there remains in Restout one *grand siècle* relic rather different in style, mood, and taste from anything conventionally associated with the Régence, still less with Louis XV and his usual pursuits.

Restout's *Death of St Scholastica* (Tours) [50] comes as a considerable shock after the work of virtually all the painters

49. Noël-Nicolas Coypel: *The Alliance between Bacchus and Venus*, 1726. Geneva, Musée d'Art et d'Histoire

50. Jean Restout: *The Death of St Scholastica*, 1730. Tours, Musée des Beaux-Arts

'It is necessary', Restout stated, 'for the painter to have noble feelings, an elevated mind, an excellent character, to treat his subjects worthily.' This maxim, enshrined in his discourse to the Académie in 1755, he said he had imbibed from his father: an impressive testimony to the seriousness of the young Restout, who was scarcely ten years old when his father died. The Restout family is one more dynasty of painters, though none challenges him in importance. Marguerin Restout was a painter active at Caen in the early seventeenth century. Several of his sons became painters; the elder Jean Restout (1663–1702) married at Rouen Marie-Madeleine Jouvenet (*c.* 1655–1698), herself a painter and sister of Jouvenet. There the younger Jean Restout was born in 1692. Although early orphaned, he had already received some artistic training from his father, who seems to have combined this with very rigorous, even harsh educational standards; nor were these lessened when Restout came to Paris about 1707 to work under his uncle.

Jouvenet completed the formation of a character universally remarked on for its reserve, integrity, and industry – much the same terms as apply to Restout's pictures, equally indebted to Jouvenet's training. Restout was *agréé* in 1717, the year of Jouvenet's death, and was received at the Académie in 1720. In turn professor, rector, director, he became chan-cellor in 1761 and died in 1768, after a career of impressive activity. His son Jean-Bernard Restout (1732–97) was also a painter; he executed a portrait of his famous father (Versailles) which shows an austere face, rather grim compared with the usual convention of smiling ease for this sort of portrait. Restout's pupils included Deshays, Barbault (possibly), and Cochin;[74] but the most significant tribute to his teaching came from La Tour, who told Diderot that Restout was the only painter who had given him useful advice.[75]

Restout laid particular emphasis on truth and expression. His few portraits reveal his sober pursuit of natural appearances, catching facial character in a way that has indeed affinities with La Tour. A rare portrait by him of a young boy (Stockholm, signed and dated 1736) [51] suggests affinities also with Chardin in its soberness and artistic integrity. The very concentration of the unsmiling child, not inveigling the spectator but gazing gravely, almost judicially, into the distance, has its weightiness, which the painter complements by solid delineation of the shape of the cap, the folds of tucked-up bib, and the metal porringer at the child's propped elbow.

Restout's serious concern with observing a given subject and conveying its signficance made him a painter of religious historical pictures which are more remarkable than the dutiful mythologies closer to the climate of Noël-Nicolas Coypel and Lemoyne. Some of his classical history pictures too, at once emotional in content but severe in style, carry him markedly towards David. Not too much perhaps should be made of his choice of subject-matter, but it may be significant that at the *concours* of 1727 – when De Troy produced his mildly erotic *Diana Reposing* (Nancy), and the Coypel uncle and nephew respectively the *Rape of Europa* [48] and *Perseus and Andromeda* (Louvre) – Restout offered the more dignified and emotionally charged subject of *Hector bidding Farewell to Andromache* (Vésier Collection, France).

so far discussed. *Fêtes galantes* and light-hearted mythologies, topical amorous scenes, hunting or battle pieces – all seem abruptly rebuked by a serious Baroque altarpiece strayed, it might be thought, from a Roman seventeenth-century church, not from Paris in 1730. The truth about Restout is, however, a little more complicated.[73] Although always associated with austere religious works, he was a painter also of some portraits and several mythological and classical subjects; his *morceau de réception*, for example, was *Alpheus and Arethusa* (now at Compiègne), and at the Salon of 1725 he showed – along with a vast picture of the *Healing of the Paralytic* (now at Arras) – a small easel painting of *Jupiter and Callisto*. Nevertheless, it is right to sense in him an artist much more serious, both artistically and in personal character, than the two Coypel. His career was tremendously successful and he exercised an influence, through a long life, which links him to the revival of history painting as a school for morals and virtue in the later years of the century.

51. Jean Restout: *Portrait of a Boy*, 1736. Stockholm, Nationalmuseum

representative, so Lemoyne painted some church decorations and even religious pictures which are scarcely more than charming and graceful exercises. Lemoyne was born in Paris in 1688 and, unlike so many painters of the period, came from no artistic dynasty. His father was a postilion, an occupation so humble that Caylus could not bring himself to mention it when he eventually read his 'life' of Lemoyne to the Académie. The postilion died early in Lemoyne's childhood and his mother married again, this time the portrait painter Robert Tournières (1667–1752). Tournières gave Lemoyne his earliest training, which was more interestingly supplemented by study under Louis Galloche (1670–1761), a 'chef d'école' partly lost sight of today. A friend of de Piles, Galloche cultivated in his pupils respect for Raphael and enthusiasm for Rubens, Correggio, and Veronese; but he laid special emphasis on the new century's key word of 'nature'. By this Galloche meant not only the living nature of humanity but the countryside as well[76] (thus providing one further piece of evidence that this was not a Romantic discovery). His advice was taken seriously by Lemoyne, whose pictures reveal a considerable response towards the nature of fields and woods – sometimes more directly observed than the Veronese-cum-Correggio-derived beings he sets among them. At the Salon of 1725 Lemoyne exhibited, amid his typical mythologies, one pure landscape which he had painted 'd'après nature' when travelling on the road from Loreto to Rome.

Lemoyne does not usually figure in histories of landscape

Through Jouvenet he had a link back to the vein of French seventeenth-century religious painting represented by Le Sueur, and also by La Hyre in such pictures as *Pope Nicholas V before the Body of St Francis* (Louvre). The factual realism of Restout's contributions to the series of pictures of the life of Vincent de Paul, beatified in 1729, is indeed close to La Hyre's picture, despite the fact that there is a gap of time between them of a hundred years. But on other occasions Restout, while preserving an austere, concentrated composition, gives literally swooning intensity to his figures. The *Death of St Scholastica*, signed and dated 1730 (Tours) [50], was commissioned for a monastery at Bourgueil, not far from Tours, and is the companion picture to an *Ecstasy of St Benedict*. These two pictures represent an expressive extreme not often attempted by French art and best paralleled perhaps in some of Michel-Ange Slodtz' sculpture, for example the *St Bruno* [115]. Combined with the prominent, hypnotically detailed floorboards and observation of the wood grain of the desk, the collapsed figure of St Scholastica dissolves like a dying flame – suggesting the final extinction of consciousness with a psychological perception that is only tautened by the 'hard-edge' detail of the setting with its truly 'nature-morte' of hour-glass and skull. To render a subject 'dans toute sa vérité et son expression' was Restout's advice to other painters; and he here follows his own precept to create a highly personal masterpiece. The demand for religious pictures had not slackened. Most of Restout's contemporaries had to execute at least some but, apart from Subleyras, none equalled his intense, artistic conviction.

Certainly François Lemoyne did not. Just as Restout produced some mythological pictures which are not truly

52. François Lemoyne: *Baigneuse*, 1724. St Petersburg, Hermitage

53. François Lemoyne: *Salon d'Hercule* (detail), 1736. Versailles

painting; nor can it be pretended that it was in this branch of art that he made his major contribution. Some versions of his *Narcissus* (e.g. Private Collection, Strasbourg) nevertheless confirm his interest and his ability in the subject. His interest in it helps to show that a single definition of 'nature' and the natural could, in the early part of the century, activate the same painter to produce without discrepancy such pictures and also subject pictures which later taste was to stigmatize as artificial. Lemoyne's *Baigneuse* (St Petersburg) [52] might well look false and posed after the subject had been painted by Courbet; in 1724 it was itself something of a revolution for its natural effect of the female nude, placed in a natural outdoor setting, without any literary context, and for its excitingly natural motif of a girl – neither Venus nor Susannah nor Bathsheba – testing the water with her toe – in a pose anticipatory of Falconet's famous statuette [134]. Even Watteau's picture of a very similar subject is seen on examination to show Diana at the bath.

Lemoyne was *agréé* at the Académie in 1715 and received in 1718. Ambitious to carry out large-scale decorative schemes, he hoped to receive the commission to decorate the vast ceiling of the then Banque Royale.[77] He executed sketches for this, but the commission was given in 1719 to Pellegrini,

Rosalba's brother-in-law, much to Lemoyne's disgust. His own first major commission was to paint the *Transfiguration* in the choir vault at the church of Saint-Thomas d'Aquin, and the culmination of such work came with the commission for the *Apotheosis of Hercules* ceiling of the Salon de la Paix at Versailles, completed in 1736. In some ways, the church ceiling is the more daring in its use of sheer space, allowing a complete luminous vacancy to shimmer around the ascending Christ at the centre of the composition. However, there is no doubt that to Lemoyne's contemporaries it was his work in the Salon de la Paix (renamed the Salon d'Hercule) [53] which consecrated his fame and reputation. Approved by Cardinal Fleury and the court, praised by connoisseurs, one of the few modern works favourably mentioned by Voltaire, it gained for Lemoyne the coveted post of Premier Peintre du Roi. He did not long enjoy it. A series of events, perhaps beginning with the strain of work and including the death of his wife and the death in 1736 of the Duc d'Antin, Surintendant des Bâtiments and his great protector, led to insanity. In a fit of madness he hacked himself horribly to death in 1737.

And in many ways the *Apotheosis of Hercules* ceiling marks an artistic end also. Much more brilliant in colour, and more

54. François Lemoyne: *Hercules and Omphale*, 1724. Paris, Louvre

poetry or mythology, emphasizing in different ways 'les charmes voluptueux' of femininity and the female nude. This quotation comes from the description given by the *Mercure de France* of Lemoyne's picture showing Armida's enchanted island with the warriors searching for Rinaldo beguiled by her spells: the ideal, eternal theme of Lemoyne's art, where prettiness, however, rather than voluptuousness reigns. Femininity strangely extends to the men too in Lemoyne's pictures, so softened by association that there is not much travesty element in his *Hercules and Omphale* (1724, Louvre) [54]. Omphale or Andromeda became much the same pretty blonde, slimmer than Veronese's women but, like his, with some recollections of Parmigianino, adding elegance to their other attractions. Shortly before the 1725 Salon Lemoyne had been travelling in Italy with his patron François Berger, ex-Receveur-général des Finances of the Dauphiné.[78] The *Baigneuse* was actually begun in Italy, but shows no particularly fresh impact of Italian art – probably because Lemoyne's Italian orientation was already established. At Paris in the collections of the regent and Crozat – to name no others – he had seen the work of those *cinquecento* painters, Veronese above all, who continued to influence him, compositionally as well as in handling of paint.

Consciously or not, the influence behind Lemoyne's winning submission in 1727 of the *Continence of Scipio* [55] was probably that of Pietro da Cortona. The picture should be seen as a very earnest attempt, in terms of both art and personal ambition, for its creator to be publicly recognized as the leading history painter of France. The avoidance of mythology and choice of an elevated historical subject (one by implication flattering to rulers) marked Lemoyne's care, and it is intriguing to see in the resulting picture how his aspiration was nullified by his natural artistic tendencies. For a great Roman commander, Scipio is oddly epicene, and the Carthaginian fiancé looks hardly more male. Women and children, in fact, form the freshest and best passages of the picture, the right-hand portion of which takes on a proto-Greuzian air of maternal anecdote, all more effective than the scattered, vacuous Roman soldiers who, along with Scipio, fail to dominate the scene.

If the work privately pleased nobody very much, that is understandable. Nearer to Pellegrini than to Tiepolo, Lemoyne had misjudged his own gifts; he would have been better advised to take a subject like 'Achilles among the Daughters of Lycomedes'. But in any event, his graceful yet somehow rather flaccid paintings and his large-scale decorations signal the close of an epoch: one where *Rubénisme* had flourished (little though Lemoyne caught of Rubens's robustness) under La Fosse and Antoine Coypel, not to mention Watteau. Even the death of the *ancien régime* figure of the Duc d'Antin, never perhaps profoundly concerned with artistic quality, has symbolic significance.

The Salon of 1737, which opened after Lemoyne's suicide, gave an opportunity for the public exhibition of work by very different painters, the new men who would increasingly occupy attention and patronage throughout the middle years of the century. Some, like Boucher and Natoire, were Lemoyne's own pupils. Others, like Chardin and La Tour, stood for completely new styles of art – their own. A certain type of high Italianate art was dropping out of fashion, but

gracefully organized than anything by Lebrun, the concept nevertheless goes back to the decorative schemes planned under him at Versailles; its luminosity and ease of manner relate it particularly to La Fosse's work, though Lemoyne's Olympus consists of much more subtly planned groups, spiralling up on two sides to where Jupiter and Juno are seated under an asymmetrical curling drapery more banner than canopy. This drapery in itself might seem to signal Rococo liberation. In Italy, where Lemoyne's ceiling would already have appeared rather out of date – at least in Venice – a fresh generation would achieve more audacious effects. In France there was to be no sequel. This style of large-scale decoration, basically a Baroque inheritance, was replaced by a preference for more intimate canvases often inserted in the cornice area – such as Natoire's *Cupid and Psyche* series at the Hôtel de Soubise. Small rooms were preferred to large rooms, even by the king. Elaborate perspective illusionism is never attempted by Boucher. Olympus is no longer situated on ceilings, and Mariette lived long enough to lament that Lemoyne's once famous ceiling had grown neglected.

From the first, Lemoyne seems to have seen himself as a painter of preferably decorative, mythological pictures. He was not tempted to challenge De Troy's excursion into topical genre or ape the would-be all-round talents of Charles Coypel. At the Salon of 1725 he was represented by a typical group of his usual decorative pictures; apart from the solitary *Landscape*, all were vaguely *galant* in theme, drawn from

55. François Lemoyne: *The Continence of Scipio*, 1727. Nancy, Musée des
Beaux-Arts

no hasty explanation about the middle classes or 'realism'
should be offered. These same years were to see Nattier's
portraits at their best and most popular, and also the
triumphant, official career of Carle van Loo, Premier Peintre
before Boucher. All these artists were assiduous exhibitors at
the Salon. Its re-establishment first as an annual and then as
a biennial event from 1737 onwards is one definite factor,
affecting both painters and sculptors. Another is the
developing personality of the king, no longer the faithful
husband but soon to be settled into a relationship with

Madame de Pompadour, whose uncle and brother between
them would serve the Bâtiments for nearly thirty years.

Such are a few of the tendencies that are to characterize
the middle years of the century. Meanwhile, one must turn
back to the beginning of the century to see the development
of sculpture in those early years, still haunted by overtones
of the Baroque, still partly ruled by concepts formulated
under Louis XIV, and remaining to some extent a less
adaptable medium – artistically as well as physically. Yet in
that art too, 'nature', was to prove the significant keyword.

Sculpture: From the Coustou to Slodtz

INTRODUCTION

The place taken by sculpture in the artistic hierarchy was in general below that of painting. It is reflected in the outward circumstances, and even perhaps in the personalities, of the sculptors themselves. They remained consciously craftsmen, occupied with problems of their art and little given to theoretical pronouncements on the arts. This is largely true throughout the century. Apart from Falconet, no great sculptor in France showed any inclination to write about himself, his art, or his attitude to other sculptors.

As a result their personalities remain dim, obscured amid the dust of marble chips and made fainter by a taciturn character shared by such disparate sculptors as Lemoyne and Bouchardon. The craftsman tradition shows itself more strongly in that dynastic tendency which stretches across the whole century, and can be illustrated at its widest extent by the relationship which runs from Coyzevox, born in 1640, to his great-nephew, Guillaume Coustou II, who died in 1777. Not only are painter families like the Coypel and Van Loo less numerous than the sculptor families who include the Slodtz, the Adam, the Lemoyne, but they are basically less distinguished in their members. The emphasis on craftsmanship could be inherited and though, for example, it is usual to think of Bouchardon as a solitary figure, his father was a distinguished provincial sculptor and one of his brothers was also a talented sculptor.

Other, more important factors separated the sculptors from the painters throughout the century. The first of these was the problem connected with their medium. It must be remembered that before Clodion no sculptor worked so exclusively in terracotta and on small-scale objects. Until Houdon no sculptor specialized so totally in portraiture alone. Most sought or received large-scale commissions which required large blocks of marble which might or might not be already in the commissioner's possession. If bronze was the medium, problems of casting arose. Such problems soon became as much financial as artistic, especially when one considers the length of time that could elapse between first model and final large-scale work – often a space of many years. Pigalle received the command for what became the greatest achievement of the century, the Marshal Saxe tomb, in 1752/3; the final monument was unveiled under Louis XVI in 1777. Nor is this an isolated example.

Expense of material, and necessary length of time working on it, meant that few sculptors worked other than to commission. There could be little room, especially in the early years of the century when the Crown commissions were very important, for private fantasy and expression. No sculptor therefore is comparable to Watteau. None could afford to go against the whole accumulated tradition of official patronage and large-scale work. The nearest equivalent is Robert Le Lorrain, himself an individual and 'difficult' character, who significantly received little official encouragement and was not much employed in Paris. Thus royal patronage, exercised through the Directeur des Bâtiments, was of vital concern to the sculptors. If withheld, it could harm a career – as Houdon learnt.

Since they were very much at the mercy of patrons, not so much forming a public as being subservient to it, sculptors had a status necessarily thought of as lower than that of painters. No sculptor was ever appointed director of the French Academy at Rome. No sculptor was honoured by the order of Saint-Michel before 1769; nor was there any post comparable to that of Premier Peintre. The prejudice, as old as Leonardo, against the mechanical aspect of sculpture continued to be felt and manifested itself openly in the history of the failure to obtain the Saint-Michel for Michel-Ange Slodtz.[1] One of the chief officials under Marigny at the Bâtiments told Cochin on this occasion 'qu'il y avoit bien des mécanismes dans la sculpture'; and though Cochin made a spirited reply, it remained ineffective as regards Slodtz. The subservience to painters was made quite explicit when they provided the designs from which sculptors must work – and Charles-Antoine Coypel, Boucher, even Cochin, produced drawings to be followed in this way.

Although several collectors specialized in acquiring small-scale models, small bronzes and terracottas, few in the first half of the century directly commissioned such work from the beginning. They were more likely to ask for the model, or the reduction, of a larger work executed originally for the Crown, a city, or possibly a church. Success of the original might lead to a demand for versions of it, but success was an essential ingredient. Hence the importance of exhibiting, either at the Salon or in the sculptor's studio. Clodion could afford to dispense with exhibiting at the Salon, but that marks a shift in sculptural aims and patronage. Naturally, portrait busts and portrait-style heads were in a different category; they were commissioned by anyone who could pay. Yet there too one could lose sight of the original commissioned amid the duplicates which followed – just as it often remains hard to tell which is the truly original piece. Saly's *Head of a Girl* was one of the most popular of such objects, early ceasing to be thought of as a portrait, and was executed in a variety of media [cf. 128].

The popularity of the statuette, preferably naked and preferably feminine, was given tremendous impetus at the mid century by the coincidence of Falconet, Madame de Pompadour, and the material *biscuit de Sèvres*. The result was more than a vogue and resulted in the creation of virtually a new genre. It marked a significant break with the sculptural preoccupations of the seventeenth and early eighteenth centuries. The ideal location was no longer a garden but a

56 and 57. Antoine Coyzevox: *Fame and Mercury*, 1702. Paris, Place de la Concorde

boudoir. The way was prepared for a career such as Clodion's; he never bothered to become a full academician, and though he received a Crown commission (for the very fine statue of Montesquieu) it is not by that that he is usually remembered. Once the small-scale group or single statuette became popular it was obvious that the range of patrons was increased. The sculptor could recover a sort of freedom, if only from the lengthy struggles connected with work on and payment for large-scale, semi-public monuments.

This shift to the private and unofficial is possibly of more importance and significance than the three major projects of the century which have sometimes been thought to mark changing taste: the early Crown commission for the series of statues of the 'Companions of Diana';[2] the mid-century project of replacing the plaster statues in the Invalides;[3] and the series of 'Great Men', initiated by d'Angiviller under Louis XVI. All were attempts to employ the leading sculptors at the relevant periods, and it is certainly true that the first and third may conveniently mark a change in official policy. Under Louis XIV sculpture was serving a decorative function, chiefly in the royal parks and gardens. It was for Marly that the 'Companions' were originally destined, where Coyzevox had already executed his equestrian *Fame* and *Mercury* [56, 57] which were to be replaced there by his nephew Guillaume I Coustou's famous *Horses*. D'Angiviller's concept was more public, overtly patriotic and even defensive, at a period when acute artistic and political crisis could be sensed in France. What was now needed was history, not

mythology or allegory. The statues erected in the gardens at Marly may fairly stand with the contemporary work of Watteau. The 'Great Men' – always destined for a museum – belong naturally in the public world of David.

NICOLAS COUSTOU
AND GUILLAUME COUSTOU I

Of all the distinguished sculptors at work in the eighteenth century, none was more profoundly of the *grand siècle* than the team made up by the two Coustou brothers. Sons of Coyzevox's sister Claudine and a minor sculptor in wood, François Coustou, of Lyonnais origin, the brothers together and separately carried art over that transitional period which took no account of the year 1700. Although it is a temptation to make them thus appear counterparts of their near contemporaries Largillierre and Rigaud, the Coustou were really quite different in their aims, much bolder, more ambitious and less restricted in their subject matter. The younger, Nicolas, was born in 1658 and was to be commended by Louis XIV. 'Coustou est né grand sculpteur,' the king is recorded to have said.[4] Guillaume, born in 1677, was to achieve his greatest success in 1745, the penultimate year of

58. Antoine Coyzevox: *Bust of Marie Serre*, 1706. Paris, Louvre

59. Antoine Coyzevox: *Bust of Antoine Coypel*. Paris, Louvre

60. Guillaume Coustou I: *Louis XIII kneeling*, 1715. Paris, Notre-Dame

his life, when his *Horses* were placed beside the abreuvoir at Marly – the last significant addition to the elaborate, ever-shifting scheme of the grounds there. The year that they were installed at Marly saw Madame de Pompadour installed at Versailles.

The Coustou began with the fortune of being trained by a great sculptor, one perhaps greater as portraitist than in decorative work, Coyzevox. But ultimately the distinction is invidious, for Coyzevox was truly great. His bust of Rigaud's mother, Marie Serre (Louvre, signed or inscribed and dated 1706 [58], has both directness and dignity, while that of Antoine Coypel (Louvre) [59] is perhaps more subtle still and presumably based on study from the life. There is inherent authority in the features – in the eyebrows alone, one might say – but also sensitive, unflattering record of the creased and thickening throat exposed by the unbuttoned shirt.

Both portraiture and decorative work in Coyzevox's vein were to be developed brilliantly by the Coustou, though they never produced any single, indubitable masterpiece quite so impressive as the collaborative achievement of the tomb of Cardinal Mazarin (Chapelle de l'Institut, Paris).

Like their uncle, the Coustou were centred on the court, serving Louis XIV, then the regent and his circle, and finally the young Louis XV. This closeness to the court did not, however, lead to a narrow court style. They retained much of Coyzevox's bravura combined with instinctive, commonsense grasp on personality – an almost Flemish frankness and self-confidence. Amid Baroque concepts they kept a sober tang of

actuality, and were capable of producing under the sweeping periwigs portrait faces of pungent realism. At his death in 1720 Coyzevox was said to have been 'le van Dyck de la sculpture' (*Eloge funèbre*). The Coustou might, in these terms, approximate more to Rubens. Although they lack the effortless range and sweep of his genius, they possess something of his bold imagination and vitality. Like him, they instinctively think on a grand scale, and, at their best, with an unforced sense of drama. Both are manifested in one of their few works to survive largely unmutilated and *in situ*, the *Pietà* group with Louis XIII [60] and Louis XIV on the high altar of Notre-Dame, where they collaborated with Coyzevox. Something of it can still be felt too in the Place Bellecour at Lyon where replicas of their bronze Rivers, Nicolas' *Saône* and Guillaume's *Rhône* (which were completed by 1720), are placed at the foot of François-Frédéric Lemot's *Louis XIV* in the positions occupied by the originals when the equestrian statue of the king was by Desjardins.

In such work there is often no distinction of style between the two brothers, but there is increasingly a distinction in quality which has become quite apparent by the time they received the commission for *Louis XV and Marie Leczinska as Jupiter and Juno*. By then Nicolas was old, and he was to die in 1733. From the first he had been the less versatile of the brothers – or, at least, the one less capable of evolution – though this judgement is only apparent after the event. His fame and wealth were considerable; and to Mariette he was far

the better sculptor. His portrait (Louvre) [61] by Guillaume shows him in workman's déshabillé – as the craftsman he was and always remained. The personality expressed here seems shrewd, proud, and fully confident of itself, needing no conventional trappings.[5]

Nicolas' career was of the pattern to be established in the eighteenth century. He won first prize at the Academy School in 1682 (receiving his gold medal from Colbert) and went the following year to Rome. There he studied the antique and dutifully executed the requisite student's copy of an antique original (and also a reduced copy of the Borghese *Gladiator*), but it was really the 'modern' idiom of Baroque Rome which, along with Coyzevox, formed his style. Orlandi names him as 'scolaro' of Bernini; and though Bernini was no longer alive, his work was there to be studied. Nicolas did not neglect to do so. Back in France in 1687, he was to present his *morceau de réception* a few years later – one of the last pieces of bas-relief and not a fully modelled statue – and to rise through the varying grades to become chancellor of the Academy in the year of his death. Guillaume's career was to be very similar. He had returned from Italy by 1703 and began to share in the commissions given to his elder brother. Some trouble – 'Quelques tracasseries de famille' – had

61. Guillaume Coustou I; *Bust of Nicolas Coustou*. Paris, Louvre

62. Nicolas Coustou: *Apollo*, 1711–14. Paris, Louvre

63. Guillaume Coustou I: *Daphne*, 1713–14. Paris, Louvre

64. Nicolas Coustou: *The Seine and Marne*, 1712. Paris, Tuileries Gardens

interfered with Guillaume's term at the Academy in Rome, and he seems to have despaired at one point of returning to France. He considered in desperation going to Constantinople, but was prevented by the friendly counsel of Frémin. His ability is revealed in the first established work, his *morceau de réception* of 1704: the *Hercules on the Pyre* (Louvre). This is intensely dramatic and forceful. Years later Cochin was rightly to single it out as one of Coustou's finest works.[6] It shows a talent already formed and very definite in its character.

Between them the brothers produced such statues as the decorative and dynamic pair of *Apollo* (1711–14) [62] by Nicolas and *Daphne* (1713–14) [63] by Guillaume, originally on an island in the Bassin des Carpes at Marly, now in the Louvre. The *Apollo* especially is a conscious echo of Bernini. This is sculpture vigorous and robust, fully modelled, with the emphasis on action and space – the space of the open air. The pose has to be immediately effective when approached from several angles, glimpsed against a background of trees, or, as in the case of *Apollo*, made the centrepiece of a fountain. Just as Marly itself represented rural freedom in comparison

with Versailles, so this garden sculpture escapes from any requirements of state or religion. There was nothing ludicrous in feeling amid alleys of shrubbery, or at a fountain's side, that this was the ideal setting for classical gods and goddesses. Beyond the palace and the church, for those hours when the king lost himself in hunting, there existed a rural environment where it was only fitting to encounter other hunters like Atalanta, Meleager, or Diana. For such sculpture, so quickly to grow weathered, a finished surface, in the sense it was conceived by Bouchardon, was not required. A coarser texture is responsible for the animation of surface, with bold, wind-blown draperies and muscular bodies, and with an energetic drama of expression. A momentary action, in which gestures almost speak, is seized upon, with a preference for the natural over the dignified. Guillaume's *Daphne*, with her desperate, gesticulating hands, looks forward to the 'natural' drama of his horses and their tamers, executed many years later.

Nicolas' group (of 1712) of the *Seine and Marne* [64], also originally for Marly and now in the Tuileries Gardens, so much admired by Mariette, shows his ability to produce straightforward allegory. It is much less wrought and refined

65. Nicolas Coustou: *Pediment of the Custom House* (cast), *c.* 1726. Originally Rouen, Hôtel des Douanes

than Van Clève's comparable nearby group of the *Loire and Loiret*. But it is much more satisfactorily and subtly composed, with its complementary personifications who are linked into a single whole yet gaze out in opposite directions, encouraging the spectator to walk all round. The putti at two corners serve a similar purpose, as well as being charming and lively in themselves. The work continues to compose at each angle but reveals fresh facets. Above all, it enshrines the grand-scale, yet not florid, world of the Coustou. Public without being pompous, decorative without over-refinement, effortlessly allegorical but never pedantic or cold, their sculpture has a tremendous confidence about it. It touches no particular emotions beyond vaguely stirring the spectator. It is as masculine and as commonsense as Dryden's verse. He indeed might have written a sonorous but not too serious poem to Commerce in a style akin to Nicolas Coustou's illustration of the theme for the pediment of the Custom House at Rouen [65], executed around 1726. Mercury presides over a lively bas-relief where shipping and trade take on memorable images: the nervously handled figure of the naked seaman with a corded bale, the alert scribbling putto at the far left, and the vivid dog crouched at the right – one of Nicolas' liveliest animals. At the same time all is carefully planned to fill the difficult triangular space, and the final impression is one of the seated central god, dominating as symbol and as sculpture.

The work executed by Guillaume alone shows him moving, probably unconsciously, out of *grand siècle* concepts, with increasing emphasis on nature and 'reality'. His ability as a portrait sculptor is proved by other busts as well as that of his brother, with their pungent response to personality and what seems like a delight in ironic expressions amid the official wigs and the thick folds of impressive robes. A fine example is his bust of the wealthy banker and important artistic patron Samuel Bernard (Metropolitan Museum, New York) [66], shown with wind-blown cravat and proudly wearing the order of the Saint-Michel, still vigorous and tough, even calculating, in his old age.

Altogether, Coustou was the ideal sculptor for the tomb of Cardinal Dubois – that shrewd, shabby Régence figure who managed to grasp a red hat just a year or two before his death in 1723. His weasel's face was inevitably criticized by Saint-Simon, but it is the culminating irony in Guillaume

Coustou's image of him [67]. The rest of the tomb, once in Saint-Honoré, is destroyed. It was executed about 1725 and seems from the first to have been wrongly placed. In Saint-Roch the cardinal now kneels against a wall and faces out at the spectator; what Coustou intended was to break the straightforward axis by having the head inclined towards the high altar of Saint-Honoré, as the cardinal turned to share in worship at the Mass. It is this twist of the head, even while the hands remain stiffly in prayer, which imparts so much

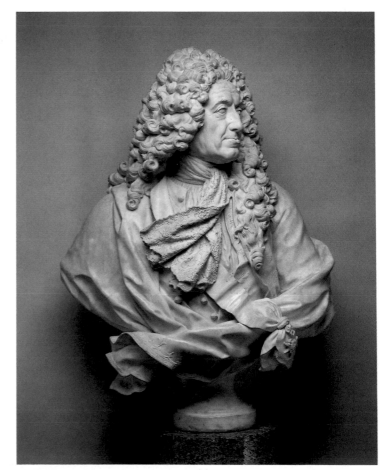

66. Guillaume Coustou I: *Bust of Samuel Bernard*, *c.* 1727. New York, Metropolitan Museum of Art

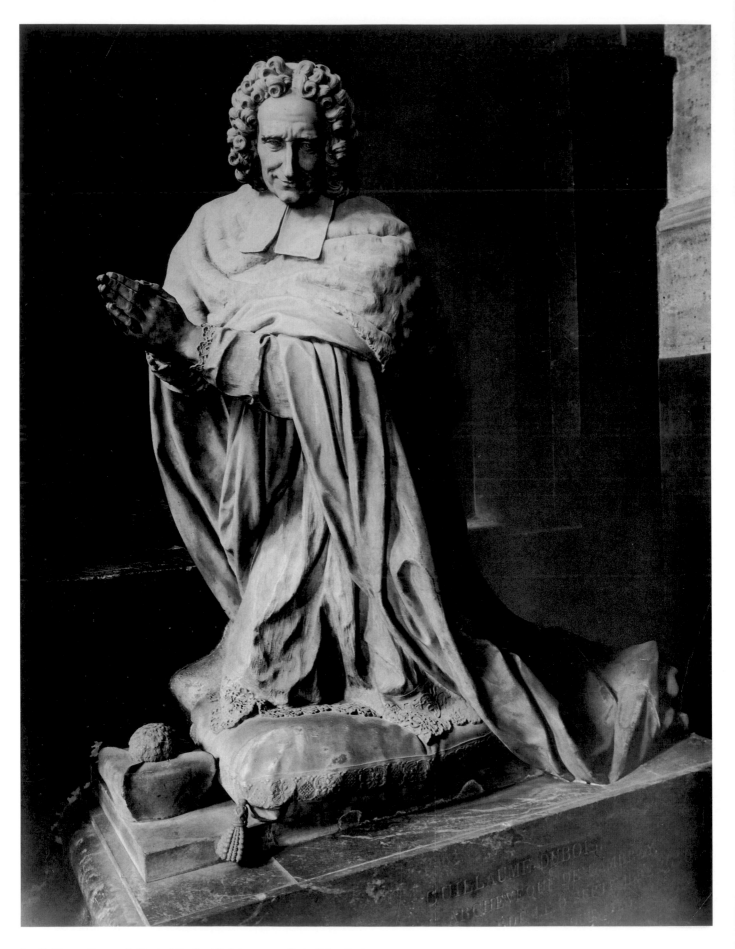

67. Guillaume Coustou I: *Tomb of Cardinal Dubois*, *c.* 1725. Paris, Saint-Roch

68. Guillaume Coustou I: *Marie Leczinska as Juno*, 1731. Paris, Louvre

69 and 70. Guillaume Coustou I: *The 'Marly Horses'*, 1745. Paris, Place de
la Concorde

vivacity to the statue. Something of the effect had already
been obtained in the remarkable kneeling *Joly de Blaisy*
(Musée de Dijon) by the distinguished Dijonnais sculptor
Jean Dubois (1625–94). But with Coustou there is an
unexpected contrast between the heavy folds of cardinalatial
robes, the brilliant fringes of rich lace, the pious pose,
and that mask of the face, so *rusé*, smiling, Voltairian,
unexpectedly sharp and even malicious. All seems to promise
a solemnity and piety which the face dispels. It is almost as
if the low-born abbé, witty, dissolute, powerful as he was, is
amused by his final achievement – forever kneeling as a Prince

of the Church, when so much of his life had been passed in
other postures.

After the great tombs of the great cardinals, Girardon's for
Richelieu and Coyzevox's for Mazarin, Coustou's is suitably
of lesser range for the lesser man. It dispenses with allegory,
and hardly attempts to impress, any more than it is meant to
be moving. The effect is of directness and intimacy. Despite
the bold broad shape of the cape and the deeply cut folds of
drapery, bulk is suggested rather than executed in the marble,
aided by the vibrant texture it is given; below the waist, the
statue and its robes tend to diminish speedily. It would be an

exaggeration to say that it is basically a bust that has been extended – for the biretta and cushion are there for horizontal emphasis – but it is the upper half of the statue that has really absorbed the sculptor. In Coustou's later comparable tomb, for Forbin Janson (at Beauvais, 1738), begun by Nicolas, this is no longer true; but lost there is that concentration on the features which, along with the turn of the head, makes the statue of Cardinal Dubois so spirited and so impressive.[7]

Something of the same directness and honesty is given by Coustou to the full-length of the young *Marie Leczinska as Juno* (Louvre) [68], begun in 1726 and finally paid for in 1733

(signed and dated on its pedestal 1731). Inevitably this invites comparison with Coyzevox's *Duchesse de Bourgogne as Diana* (Louvre, 1710), and it is obviously inspired by the earlier statue. But it is in many ways a less Rococo piece of work, more solidly handled, more compact in its design, and more static in pose. Despite the squeezed-out clouds – like thick paint pressed from a tube and overflowing the pedestal – the figure is less airborne than Coyzevox's breathless, hastening, graceful woman.

This unexpected difference between the work of uncle and nephew does not make for neat generalization about

increasing Rococo tendencies in eighteenth-century France, yet it is a difference that becomes quite explicit when one examines the two sets of *Horses*. What is, however, equally true is that Guillaume's *Marie Leczinska* does appear 'rococo' when compared with Nicolas' companion piece of Louis XV as Jupiter (executed in the same years). This is simply a heroically posed, somewhat dull, Baroque statue. Guillaume's is animated by a feeling once again for character: not yet the placid bourgeoise of Nattier's familiar image, the queen is shown youthful, unflattered, with an individual likeness which has its own piquant, unexpected, charm. The flying putto at her thigh gives an otherwise static composition welcome vivacity and softens the mood into playfulness. The putto presses forward with the sceptre; Marie Leczinska half-idly grasps the crown of France, while the shield with the lilies is barely noticeable. All that in Coyzevox seems taut grace is here relaxed. The personification as Juno is only partly serious, though it has certainly its apt application for a woman whose husband was so constantly to deceive her.

But Guillaume Coustou remains, above all, the sculptor of the Marly Horses [69, 70]. To nearly everyone – except Caylus, the champion of Bouchardon, Coustou's pupil – the *Horses* were one of the finest achievements of the century. They originated in a significant discovery, made only after the death of Louis XIV, that the pair designed by Coyzevox for the abreuvoir at Marly was not sufficiently large to fill this somewhat difficult position. And with this new aspect of taste went a change in the concept of what might, superficially, seem similar. Coyzevox's pair are specific allegories: divine, winged animals, effortlessly bounding skywards, and as effortlessly bearing Mercury and Fame, who do not even sit astride but perch, enchanted, against the horses' flanks [56, 57]. They enshrine the idea of military victory, with a tumble of armour over which they rear. It is they who have a sort of Rococo abandon, symbolized by the essentially decorative twist to the tail of Mercury's horse, which curls round completely to touch its rump. Throughout, they are animated by decorative poetry; they are steeds sprung into existence beside some classical stream and themselves, like Pegasus, capable of making a fountain gush over their hooves. And all this must have seemed more obvious when they stood beside the water of a horse pond.

That is the starting-point for Coustou's conception. His *Horses* are not so much decorative, still less elegant, but romantic and natural. Rough-hewn rocks replace those trophies of arms, and emphasize the natural and untamed spirit of the rearing animals whom their naked attendants can barely control. Man and beast are in conflict now. These horses, for all the savagery of their jagged manes and staring eyeballs, remain earthbound, just as they remain riderless. They break out of the monumental Baroque into a wilder manner and express a desperate urge towards the freedom of being natural. All the formal beauty of the gardens at Marly virtually ended with the horse pond: closed at one end by a terrace where originally Coustou's *Horses* stood, and at the other shallow and open to allow ordinary, real, horses to enter the water.[8] Nor were Coustou's statues placed, as far as one can judge, at anything like the extreme height they now are at the entry to the Champs-Élysées. Their plinths were quite low, keeping some contact between the onlooker and these

forces of nature held in stone. Part of their power is in their directness. They are not meant to glorify *La France*, nor were they ever intended for an urban setting. Surrounded by the woods and ponds of Marly, they were, rather, an early expression of the romantic wildness of nature. The men who struggle with them are identified by Dezallier d'Argenville as a Frenchman and an American[9] – and they adumbrate in more ways than one a new world. Only Napoleon will be able to mount such fiery horses; and only Géricault will do full justice in paint to the battling sense of man versus beast.

The models for Coustou's *Horses* were ready by the Salon of 1740 but could not be exhibited there owing to their size. They are mentioned in the *livret* as available to be seen in the sculptor's studio. And in 1745 the groups themselves, the marble for which had been selected at Carrara by Michel-Ange Slodtz, were set up at Marly, where they remained for fifty years. Their popularity probably dates from 1740 and is attested by numerous small-scale replicas as well as by written testimony. Yet it is doubtful if they exercised any significant influence on any French sculptor of the century – except Falconet. Coustou himself was briefly to train Bouchardon, but this would hardly be guessed from their two styles; and they appear to have retained a natural antipathy to each other. Coustou's son Guillaume II was established as a successful sculptor before his father's death in 1746, but he was another sort of artist who was to achieve his own minor masterpiece in a very different key.

VAN CLÈVE – CAYOT – LEPAUTRE AND OTHER CONTEMPORARIES

Much older than Nicolas Coustou was that long-lived sculptor Corneille van Clève,[10] President of the Académie when Watteau was admitted in 1712. Like Watteau, Van Clève was Flemish in origin. The son of a goldsmith, he was born in 1646 and did not die until 1732, only a year before Nicolas Coustou. He was to be employed at Versailles and Marly on very similar decorative work to that of the Coustou. Like them he studied at the French Academy at Rome and, rather unusually, spent a further three years at Venice. He returned to France in 1678, impregnated not only with Bernini but with – one may guess – the work of another Fleming like himself, Duquesnoy. Nor had he failed to study Annibale Carracci's frescoes in the Farnese Gallery; his *morceau de réception* (presented in 1681), the *Polyphemus* [71], is directly derived in pose from Annibale's composition there, and his inventory at death recorded, among much else, 'la gallerie de Carach, complete gravé'. Nevertheless, despite its derivative nature, the *Polyphemus* is important as the first reception piece to be a completely modelled statue and not a bas-relief. Its forceful musculature and robustly confident air initiate a whole series of such pieces; and its influence can be traced as late as Guillaume Coustou II's reception piece, the *Vulcan* of 1742.

Van Clève was only one of a talented generation of sculptors born in the middle years of the seventeenth century and living on into the reign of Louis XV. He was not necessarily the most accomplished of them but he enjoyed a distinguished career, with considerable royal patronage, lodgings in the Louvre, and a succession of high offices at the Académie,

71. Corneille van Clève: *Polyphemus*, *c.* 1681. Paris, Louvre

72. Corneille van Clève (after): *Bacchus and Ariadne*. San Francisco, California, Palace of the Legion of Honor

whose Chancellor he became on the death of Coyzevox in 1720.

The inventory made at his own death reveals a fascinating variety of work in bronze, plaster, and terracotta, much of the latter now inevitably lost. There were figures which raise associations of Watteau – a Mezzetin, a Pierrot, a Scaramouche – and twelve terracotta figures representing subjects from the Metamor-phoses. Van Clève was perhaps something of an innovator in creating small-scale decorative statuettes for private collectors, and the inventory records that he kept a number of small bronze statues in his rooms, 'to show ... to the public and sell ...'.[11]

Although involved in several large-scale commissions, he was probably at his happiest in more intimate work. When compared directly with, say, Nicolas Coustou, as in his pendant group of the *Loire and Loiret* (Tuileries Gardens), originally at Marly, he tends to seem rather timid and over-

refined in decorative details. A more relaxed aspect of his art (not typical of the character of the man, who was found 'prickly')[12] is seen in his sculptures of children, notably the trio of water imps he contributed to the Parterre d'Eau at Versailles. The original of his bronze group of *Bacchus and Ariadne*, shown at the Salon of 1704, appears untraced, though at least one copy survives [72]. Grace and urgency combine in this skilfully composed group, where the god gesticulates in a swirl of drapery as he assures the girl of immortality, and as the group is surveyed from the back Cupid is unexpectedly disclosed, lying concealed behind the lovers.

One might be tempted to echo the famous, if variably quoted, words of Louis XIV's letter of 1699 about the decoration of the Ménagerie for the Duchesse de Bourgogne, 'il faut de l'enfance repandue partout',[13] though the motif of children is not in itself a definition of a new 'rococo' style. Children – often playful, animated little cupids – go back in sculpture to Hellenistic and Roman examples, and their decorative possibilities were explored notably by Sarrazin, who was to be a major figure in the sculptural idiom developed particularly for Versailles. It seems significant that in Van Clève's bronze group of Psyche discovering Cupid asleep, Cupid should be no adolescent but a virtual baby. And it was in this baby genre that Van Clève's assistant, Claude-Augustin Cayot (1667–1722), created a memorable group.

Cayot[14] was the son of a sculptor but was apparently first trained under Jouvenet as a painter. His sculptural training was with Étienne Le Hongre (1628–90), who, it is worth noting, had ties by marriage with the Jouvenet family. Cayot did not, as is often said, go to Rome as a pensioner at the French Academy there; for well over a decade he served in the studio of Van Clève. Little work by him survives, but the *Cupid and Psyche* (London, Wallace Collection) [73], signed and dated 1706, is remarkable for its accomplishment and its fully *dix-huitième* sentiment and treatment at so early a date. The group already contains in essence the children of Pigalle and the *Cupid* of Falconet, and is more flagrantly pretty than either of those sculptors' work. Its pervasive infantile grace is such that Psyche too has become a child – a very unusual motif – but the play between the two children is hardly innocent.

The piece has an almost Alexandrian sophistication and provocation (and one might compare the Hellenistic bronze group of a naked Cupid and a child-like, clad Psyche in the Louvre). Marble is handled until it takes on a butter-like meltingness (with all that 'souplesse ... qui fait le véritable caractère de la chair' which was the exact quality Caylus indicated as lacking in Van Clève's handling); where Psyche's hand clutches at Cupid's arm, the flesh yields slightly under her pressure, giving the faintest tremor to the contour. The children who had decorated fountains or played with animals were rustic but ignorant compared with this interlaced pair so fitted for a boudoir, both stimulating and stimulated. Although the group might well be directly inspired by the embracing winged children in the centre of Titian's *Venus*

73. Claude-Augustin Cayot: *Cupid and Psyche*, 1706. London, Wallace Collection

74. Claude-Augustin Cayot: *The Death of Dido*, 1711. Paris, Louvre

gallery of the Palais Royal, where the *Death of Dido* was naturally included; that scheme seems to have prompted renewed artistic interest in the whole love story, testified by both paintings and sculpture.[15] Cayot's Dido is a martyr to love, and the whole statue is imbued with a double *frisson* of *l'amour* and *la mort*. The figure's pose is, especially when seen from the side, an almost violent, ecstatic arabesque, emphasized by the very fluent draperies which manage both to cling and to expose. This woman is dying of love, with a sword thrust deeply into her flesh, eyes upturned, and mouth slackly opened. The carefully executed pyre, with Aeneas's armour about it, not only follows Virgil's text closely but adds its own excitement, tilting the figure and also solving the problem of the base of such a statue – every inch of marble being made to play its dramatic part.

All this becomes tame in the bronze version, presumably of *c.* 1711 (in the Hermitage), where the pyre is no longer built up to a crescendo and Dido herself is no longer so perilously posed on it. A conventional helmet is placed on the cushion beside her there, whereas in the original marble the helmet is brilliantly displayed, gaping open towards the spectator – a fishy monster's mouth – and given its own staring life by the trick of a huge eye in the headpiece. Cayot's virtuosity in this, one of the outstanding reception pieces of the whole century, embraces mood and execution: he displays a gamut of dramatic movement, erotic sentiment, and brilliant execution. Presented to the Académie while Louis XIV still reigned, the *Dido* seems to speak a new language, as markedly new as its feminine subject seems new. But in both these things Cayot was not the innovator; and for both of them he was probably consciously indebted to a greater sculptor, Robert Le Lorrain (1666–1743).

Before considering Le Lorrain's rather private career, the paradoxical complement of his outstanding talent, it is useful to consider the activities of a few of the numerous other sculptors of the period. In terms of artistic individuality some of them may be ranked as lesser figures, though they often enjoyed successful careers and esteem. The closing years of the seventeenth century saw Crown patronage of the arts flow sluggishly in France. Some sculptors took opportunities to go abroad, or at least to work outside Paris. But with the coming of the eighteenth century there came at least the royal commission for the series of statues, the *Companions of Diana*, destined for Marly, and distributed among several sculptors, including Cayot.

It seems fitting that the artistic glories of the old century should have been commemorated by the oldest of the sculptors under discussion, Louis Garnier (*c.* 1638–1728), whose age at death is recorded as 89. The bronze *Parnasse français* (Museum, Versailles) [75] was commissioned from him by Evrard Titon du Tillet, and is more remarkable icono-graphically than aesthetically.[16] Its antique classical idiom extends from Apollo at its peak, symbolizing the king, to the half-naked or heroically clad writers and musicians (there are no visual artists on this Parnassus) like Racine, Molière, and Lully. Care was taken that these figures should, however, be portraits that were recognizable. Titon du Tillet published a

Worship, it speaks a less frankly sensual language and one more titillating. A very conscious concept of modesty placed that piece of drapery between the thighs of a girl who has hardly ceased to be a baby – concealing the sex of one barely possessing sex. These highly experienced children do not quite kiss but savour the moment of their lips' proximity without actually being in contact. An age-old erotic thrill is given new excitement by being expressed in the youngest possible protagonists.

A definite drama, also inspired by love, is apparent in the even more sophisticated *Death of Dido* (Louvre) [74], Cayot's *morceau de réception* of 1711. This combines detail of the sort approved by Van Clève with an appropriately writhing 'rococo' dramatic pose: Dido emerges here as one of the first operatic heroines of the new century, suitably enough when a few years later Metastasio was to produce *Didone abbandonata*. More directly relevant for Cayot were probably the almost contemporary Aeneid decorations by Antoine Coypel for the

75. Louis Garnier: *Le Parnasse français*, 1721. Versailles, Musée National du Château

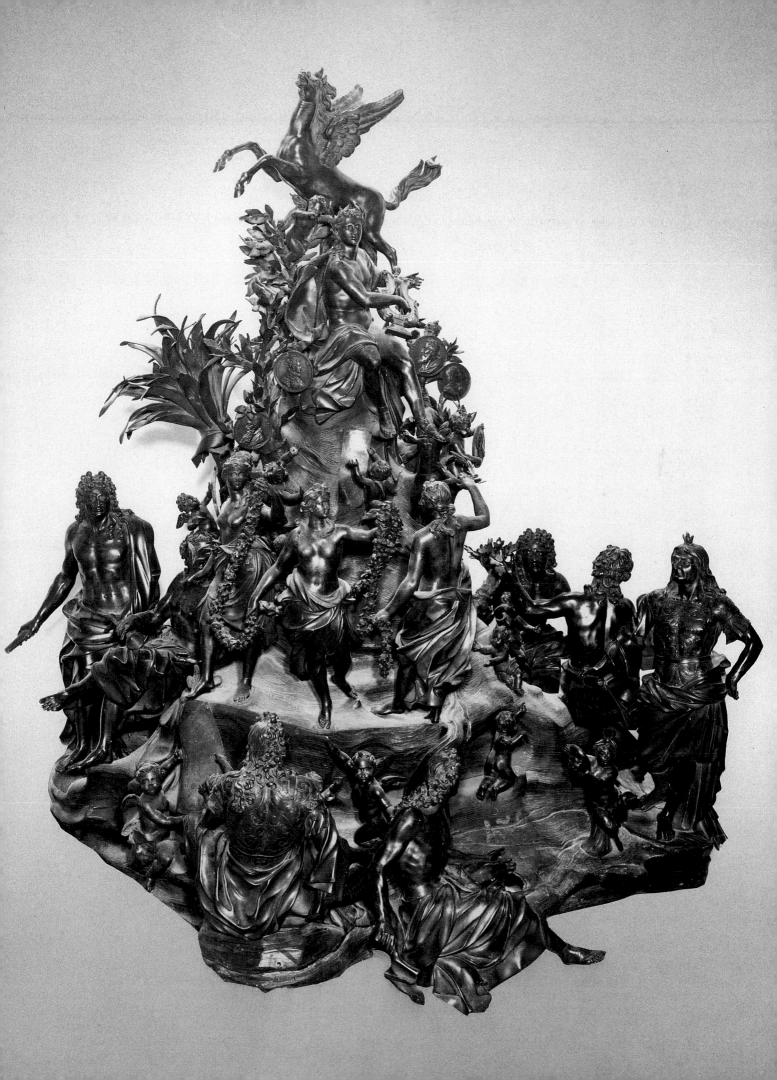

76. Anselme Flamen: *Angel with the Lance*, 1712–13. Paris, Notre-Dame

77. Claude Poirier: *Angel with the Nails*, 1712–13. Paris, Notre-Dame

learned, illustrated brochure on the subject of his *Parnasse* and was himself to be sculpted by Pajou[17] for inclusion on the monument when, following his death in 1762, it was accepted by Louis XV. At Titon's request, Pajou had previously added statuettes of Crébillon, Rousseau, and Voltaire.

Garnier is a fairly obscure figure, with a meagre *œuvre*. He was never a member of the Académie royale, belonging instead to the Académie de Saint-Luc. More important and active were the sculptors involved in creating the six large bronze angels, holding in-struments of the Passion, which form part of the *Vow of Louis XIII* scheme on the high altar

of Notre-Dame.[18] In addition to Van Clève the sculptors included Anselme Flamen (1647–1717), a member of the Académie from 1681. He worked for the gardens at Marly and Versailles, sometimes finishing statues begun by other men (e.g. the marble group of *Boreas abducting Orithyia* (Louvre) started by Marsy). To the series of angels at Notre-Dame he contributed the rather heavy if expressive *Angel with the Lance* [76], typical of his style, where a certain stockiness invests the pro-portions of his figures.

Marginally more graceful is the *Angel with the Nails* [77], the work of Claude Poirier (1656–1729), who is first recorded as working in Girardon's studio. He too was commissioned

78. Simon Mazière: *The Raising of the Cross*, 1714. Chartres Cathedral

for statues in the gardens at Marly and Versailles (and also for the chapel there). Poirier became a member of the Académie royale in 1703 but, with the Académie's permission, retired from Paris in 1717, settling at Auxerre. In his own parish church of Saint-Eusèbe there he executed two angels embracing the tabernacle, probably destroyed at the time of the Revolution. He may well have carried out other local work yet to be certainly identified.

Flamen and Poirier were both commissioned to produce statues for the *Companions of Diana*, as was also Simon Mazière (1648– after 1721), a sculptor of whom little is known before his emergence around 1679 working at Versailles. His sculpture includes two dignified, effective and symmetrical tombs, of André Blanchard de Saint-Martin and Noël Le Blond at Pontoise (Museum), his native place. In 1712 he was given the commission to complete the high-relief Gospel scenes along the exterior of the choir enclosure at Chartres, which had been begun in the early sixteenth century. In such an impressive setting, amid so many competing claims for contemplation, Mazière's scenes are perhaps little noticed by visitors today. Yet, as the largest of these, *The Raising of the Cross*, reveals [78], Mazière achieved a near-Renaissance idiom, forceful and dramatic, by no means incongruous and quite free from any overly 'decorative' flourishes. Indeed, were his scenes not documented – to the years 1712–16 – they might pass as work of a much earlier period.

Mazière must be ranked as something of a minor figure. More prominent was Pierre Lepautre (1659/66–1744), one of a prolific family of master-joiners, engravers, and architects. He became a student at the French Academy in Rome at the same time as his close contemporaries Le Lorrain and Pierre Legros II (whose father married as his second wife Lepautre's sister). On his return from Italy he was to be much employed in royal service, though interestingly he preferred to join not the Académie royale but the Académie de Saint-Luc. Lepautre also contributed a (now lost) statue to the *Companions of Diana* and created a pair of large-scale marble groups destined for Marly but soon moved to the Tuileries gardens: *Paetus and Arria* and the more famous *Aeneas carrying Anchises from Troy* [79].

The two groups do not make very obvious pendants, either in composition or theme, or even in number of figures (from four to three in the latter group). The *Aeneas* group is signed and dated 1716, and it largely follows a model supplied by Girardon. Its popularity is attested by versions and reductions in bronze and terracotta (Lepautre himself kept one of these in his studio).[19] The highly picturesque composition is not much varied from Girardon's design except in giving Anchises a Phrygian cap and having him gaze skywards, not down at his grandson, Ascanius, the small, subsidiary figure of the group. The motif of one muscular male lifting another bodily from the ground goes back to the theme of Hercules

79. Pierre Lepautre: *Aeneas carrying Anchises from Troy*, 1716. Paris, Tuileries Gardens

to Heaven (Salon of 1704) is virtually a reworking of the Rape of Helen design, with buoyant additional grace and sense of lightness – suitably enough for its theme of celestial ascent. Bertrand could not always translate these qualities into large-scale marble sculpture. Although he seems in principle the ideal artist to sculpt the undoubtedly difficult subject of *Air*, the result as it survives today (Paris, Garden of the Ministry for Foreign Affairs) looks sadly solid and unaerial.

A major figure in the field of decorative sculpture, with an extensive *œuvre*, was René Frémin (1672–1744), the pupil of two great sculptors, Girardon and Coyzevox. His finest achievements lie in Spain, chiefly in the gardens of La Granja, near Segovia.[20] Frémin came from a family of goldsmiths. He studied at the French Academy in Rome and became a member of the Académie royale on his return to Paris in 1701, the same year as Bertrand. He was invited to work at La Granja by the Spanish king, Philip V, Louis XIV's grandson, and left France in 1721, finally returning only in 1738, having accumulated a large fortune.

Frémin's work at La Granja was considerable. His task was to adorn a transplanted Versailles, in a much more rewarding natural setting, with a constant supply of vases, avenues of statues, and elaborate groups for fountains, often in the medium of lead. Before leaving France he had gained experience working in lead and in a comparable decorative idiom for Marly and for Versailles itself, sometimes in a team that included Bertrand. His is one of the most vivacious of the *Companions of Diana* (Paris, Louvre) [81], signed and

80. Philippe Bertrand: *The Rape of Helen*, 1701. Fontainebleau, Musée National du Château

and Antaeus as treated by Ammanati and Giambologna in Florence, though what is there an aggressive action becomes in Lepautre one of filial piety.

Giambologna certainly had a marked influence on some of the comparably composed though more svelte bronze groups of Philippe Bertrand (1663–1724). Like so many of the sculptors mentioned here, Bertrand received commissions for Versailles and Marly. He was *agréé* at the Académie in 1700, and in November of the following year became a member on presentation of his small bronze *Rape of Helen* (Fontainebleau) [80], which he subsequently showed at the Salon of 1704. From Giambologna's treatments of the theme of the *Rape of a Sabine Woman*, Bertrand took the device of making the apex of his groups an outstretched arm with gesticulating hand. But with him Helen hardly seems to resist the action of Paris, who moves with balletic ease. Such forcefulness as exists is restricted to the bent, toiling boatman, over whose bare back Helen seems coquettishly to dangle a slim foot.

The medium of bronze suited Bertrand's fondness for fluid, graceful, and often flying bodies. Even in the grim subject of *Prometheus Exposed* he arranged the tortured man's limbs to elegant effect. His group of *Mercury conducting Psyche*

81. René Frémin: *A Companion of Diana*, 1717. Paris, Louvre

82. Pierre Legros II: *St Dominic*, 1706. Rome, St Peter's

briefly to France in 1715, when he was befriended by Crozat. He was disappointed not to be received favourably by the Académie, given his status in Rome. He returned there for what remained of his life, and there he died.

Legros's work really belongs in the story of Italian art, not least because of the powerful Italian influences on him and the Italian location of much of it.[21] The ardent drama which characterizes it might have been viewed in Paris with considerable reserve, if not disapproval. He was chiefly employed in Roman churches, executing large-scale bas-reliefs of religious subject-matter, as well as statues, including the virtuoso complete *tableau*, in variegated marble, of the young Blessed Stanislas Kotska on his deathbed (Rome, Convent of Sant'Andrea al Quirinale) – a performance difficult to imagine being required or created in Paris at the period. Legros' *St Dominic* (Rome, St Peter's) [82], put in position in 1706, gives a good flavour of his stirring, dynamic style; the saint's ardour and authority are well conveyed, emphasized by the ample, skilfully handled sweep of his draperies. The sculpture is conceived to make a bold impact on the spectator. And perhaps in Legros' art lies a foretaste of the aims and achievement of Michel-Ange Slodtz.

Much younger than any of the sculptors whose activity has been sketched above, though also one working in part away from Paris, was François Dumont (1687 or 88–1726), brother of the painter Dumont 'le Romain'.[22] Dumont is an intriguing artist whose career was cut short in a macabre manner. Felled by the lead curtain he was arranging on his large-scale tomb of Louis de Melun at Lille, he died of his injuries. Dumont trained in Paris. His father had served as sculptor to the Duke of Lorraine, and Dumont was appointed the duke's first sculptor in 1721, going to Lunéville to supervise team-work there. Dumont's attraction towards a form of Baroque is shown in his forceful, almost shocking *Titan Struck Down* (Paris, Louvre), his *morceau de réception* at the Académie in 1712. The nearly naked body of the overthrown giant lies sprawled at a steep angle in violent agony, his mouth open in a howl. The composition anticipates the elder J.-B. Lemoyne's *Death of Hippolytus* [89] and, to a lesser extent, the more gracefully stricken *Icarus* [114] of P.-A. Slodtz.

A tender rather than robust vein is revealed in Dumont by the sole remaining and mutilated fragment from the Demoiselles Bonnier tomb (Montpellier) [83], commissioned in 1719 for the Bonnier chapel in the church of the Récollets at Montpellier. The sad and unusual circumstances of a monument commemorating the deaths of two very young (non-princely) children resulted in a novel, if not unique, design, the full effect of which can only be guessed at. The half-kneeling pose of the five-year-old girl, who stretched out her hand to her sister, dead at birth, is at once a little awkward and convincingly child-like; her costume is handled with delicate detail, as was probably the now somewhat damaged face, and the statue has an unaffected poignancy, enhanced perhaps by its fragmentary state.

Dumont's premature death removed a highly talented sculptor, in a decade when several older figures were also to die. And around the middle years of that decade the most talented figure of all, Robert Le Lorrain, appears to have been languishing in Paris unemployed.

dated 1717. It seems a natural development from his earlier full-length *Flora* (Louvre), with a greater sense of animation. The nymph turns her head away and down, even as she steps briskly forward, expostulating half-playfully with the extremely lively greyhound which rears up at her side, its forepaws on her bow. As she gazes down, a smile hovers over her face (a typical Frémin touch), while the hound arches itself back in frisky anticipation. Vitality imbues the whole concept, and the statue must have offered first-rate evidence that its sculptor had the energy, if nothing else, to cope with the demands to be made at La Granja.

Even less active in France was Pierre Legros II (1666–1719), son of the distinguished sculptor Pierre Legros I, whose first wife was a daughter of Gaspard Marsy. Although born and trained in Paris, the younger Legros made his career largely in Rome, working first as a student at the French Academy. He rose to be a famous artist in the city and a rival of such native figures as Rusconi. Illness brought him back

83. François Dumont: *Tomb of the Demoiselles Bonnier*, c. 1719. Montpellier, Musée Fabre

ROBERT LE LORRAIN

It might have been Le Lorrain who went to Spain instead of Frémin, but he refused, on the grounds of the climate there. That was doubtless a genuine reason, yet the refusal seems to mark something about his character. He had previously refused the directorship of the French Academy in Rome, and proudly declined to solicit commissions for work. There is in his art a distinction and poetry that separate him from the general run of sculptors of his day. Because of the comparative paucity of his surviving work, he is also an elusive figure artistically. And although his isolation should not be exaggerated – he was, for example, employed for both Marly and Versailles – he appears to have been happiest, as man and as sculptor, when he could experience 'freedom'.

Among his finest achievements were, significantly, small-scale single figures or groups, executed for private patrons who might often be his friends. Freedom and a degree of privacy characterize one of his great surviving works, the bas-relief of the *Horses of the Sun* [84], still somewhat secluded *in situ* at the Hôtel de Rohan in Paris. Its delicacy and sinewy refinement make one regret the more the loss of Le Lorrain's series of bas-reliefs with the poetic-sounding theme of *The Winds shrouded in Clouds*, executed by him for Antoine Crozat's mill at Clichy-la-Garenne and, according to one of the sculptor's sons, reckoned among his best works.[23]

Le Lorrain was born at Paris on 15 November 1666 and from his earliest years 'eut un goût décidé pour les arts'. Unlike so many contemporary sculptors, he had no family tradition in which to be trained, and his apprenticeship was in fact with a minor painter. He is later mentioned as executing pictures, though nothing by him seems to survive. When at Rome he was in the habit of drawing in the streets, and his best work preserved an almost earthy directness and observation. As a sculptor his training was under Girardon, with whom he is recorded to have worked on the tomb for Richelieu, and he attracted the notice of Lebrun. Thanks to Lebrun, he received a grant from the Académie, where he had previously won several prizes. He was at the French Academy in Rome, with Lepautre and Pierre Legros II, from 1692 to 1694. Back in Paris, he gained some private commissions and joined the Académie of Saint-Luc, because the Académie itself was taking no new members and official commissions were few. Only in 1701 was he received there, on presentation of the marble *Galatea* (Washington) [85], signed and dated that year, and intended as a pendant to Van Clève's *Polyphemus*. Like that, it takes its inspiration from Annibale Carracci's fresco in the Farnese Gallery, though Le Lorrain has not attempted to duplicate Galatea's flying twist of drapery. But the pose – one of momentary stillness, interpreted gracefully and undramatically – is recognizably Annibale's and only makes full sense when accompanied by the complementary Polyphemus, leaning amorously forward from his rock. Galatea turns her head and pauses in her passage over the sea, a figure of lyrical elegance, delicately and yet keenly modelled in piquant contrast to Van Clève's statue. She is one of the first of those feminine nudes which discriminating collectors sought from Le Lorrain, and which seem often to include similar marine classic associations, like the *Andromeda* for Pierre Crozat (a version is in the Louvre), and the now lost *Thetis*. The *Galatea* was presented to the Académie when La Fosse was director and de Piles its honorary councillor. De Piles is mentioned as one of Le Lorrain's friends, and there must have been a quick sympathy between the champion of Rubens and the sculptor who preferred his students not to be correct but 'échauffés par la nature'.

Though praised for uniting nature and the antique in the *Galatea*, Le Lorrain was really a partisan of nature. Interpreted by his gifts, nature came to mean sculpture that was more relaxed and personal, and on a much smaller scale, than the typical work of the Coustou brothers. Le Lorrain's ideal setting was less a palace interior or its gardens than the cabinet of an amateur. Though lost, the two groups that he showed at the Salon of 1737 are described in the *livret* in terms which reveal the original concept and unofficial mood of most of Le Lorrain's art – and even the material, terracotta, points to a warmer, more rapid style of execution: 'Deux petits Groupes de fantaisie en terre cuite, l'un representant une fille qui frise son Amant; l'autre une fille tenant un Lapin qu'un jeune homme veut lui arracher, et l'Amour témoin de leur scène.' These sound like a foretaste of Boucher groups in miniature, anticipating one aspect of Falconet. Nor were their mood, size, and material new to Le Lorrain, for already in the Salon of 1725 he had exhibited two small terracotta genre groups, 'des Jeux'.

84. Robert Le Lorrain: *The Horses of the Sun*. Paris, Hôtel de Rohan

It was for such work, which had no connection with the antique, that he was specially prized. The younger d'Argenville was right in finding him 'incorrect' though graceful. Mariette did not allow him so much, criticizing him for insufficient study of nature and for being mannered in his style.[24] The ultimate character of Le Lorrain's work accords with his own personality, which seems to have been socially difficult outside his own circle of discriminating and highly literate friends. He probably disliked the rigour of royal commissions, and it was suggested by his biographer that his career had been passed in obscurity because of his misanthropy and also 'un amour peutêtre mal entendu de la liberté'. Whatever incidents are concealed under this general remark, the inference is clear. It was less easy for a sculptor than for a painter to preserve individuality of thought and action, and that *fantaisie* which is Le Lorrain's strength.

He seems to have enjoyed working for the Rohan-Soubise family, and when employed by the Cardinal de Rohan at the château of Saverne, for some six years from 1717, is stated to have experienced a sense of mental freedom. Unfortunately, the complete *salon* he decorated there, under the direction of Robert de Cotte, was destroyed by fire well before the end of the century. The cardinal employed him

again in the years 1735–8, this time in exterior decoration of his huge palace at Strasbourg, and something of Le Lorrain's verve is apparent in the now weathered group of three children, a small part of a large scheme, one of whom is playfully trying on a cardinal's hat [86].

Apoplexy cut short Le Lorrain's work at Strasbourg, though he seems to have continued to model in Paris. The exact date at which he created the *Horses of the Sun* relief is not established, but traditionally it was in his old age and in winter, probably around 1736.[25] The commission cannot have ranked as major. Its subject was obvious as decoration of the stables of the hôtel; and about the same approximate date the grandiose stables at Chantilly, which had been designed by Jean Aubert, were being enriched with a profusion of fully modelled horses' heads and hunting trophies, in comparison with which Le Lorrain's task looks modest. Yet his relief is the greater achievement.

Its exciting surface is achieved by the delicate transitions from very low relief, where clouds and horses' necks and flailing hooves are lightly incised in the plaster, as if drawn, to the projection of the central portion, where a horse's head protrudes, drinking greedily from the beautiful fluted shell, itself gripped by the fully-modelled arm of a kneeling

85. Robert Le Lorrain: *Galatea*, 1701. Washington, National Gallery of Art, Samuel H. Kress Collection

86. Robert Le Lorrain: *Group of Children with a Cardinal's Hat*, 1735–8. Strasbourg, Château des Rohan

attendant. All might seem casual, mannered, and incorrect to a pedantic eye, but in fact the relief is carefully planned, and then warmed by poetry. The Horses of the Sun are real horses, nervous, sinewy, as restless as the clouds which curl around them, as fiery as the last rays of sun which shoot at the upper left corner. The whole concept remains intensely linear. It emphasized Le Lorrain's long training in drawing and design – he was, said Lemoyne, 'bon dessinateur et ses ouvrages de sculpture s'en ressentent'.

Yet it is line with the springing vitality of the *quattrocento*, with the wild air of Botticelli or Agostino di Duccio, even if a closer stylistic parallel is with the reliefs of Goujon. Le Lorrain ignores the architectural setting, indeed banishes it by treating the wall merely as the support to a thoroughly pictorial effect whereby the rusticated façade is blotted out by drifting cloud. The subject itself is a perfect allegory of freedom, as here at the imagined rim of the world the sun's horses snort and pant and quench their thirst, now unbridled and released from their hot day's task. The relief breathes sympathy and above all a poetic conviction by which classical mythology regains the intensity it had for the Renaissance. That feeling alone would suffice to make it rare in eighteenth-century France.

The relief of the *Horses of the Sun* was not to exercise any influence on the course of sculpture. It is an isolated masterpiece. But though Le Lorrain himself still remains an elusive artistic figure, something of his quality is apparent in the testimonies – and the work – of his two greatest pupils.

Both Lemoyne and Pigalle remained grateful to their master. To one of Le Lorrain's sons Lemoyne wrote a letter in 1748, already quoted above, which has rightly been shown to indicate something of his own art while defining that of the older man, as well as expressing affection.[26] In Pigalle the imaginative fire of Le Lorrain, an earthy but inspired vigour, is at work from the *Mercury* onwards. As for Lemoyne, who had praised his old master's observation of physiognomies, he was to become the most brilliant portrait sculptor of his period – perhaps the most brilliant France has ever produced.

THE LEMOYNE

Among the many dynasties of sculptors the Lemoyne cannot claim to be the most distinguished or multifarious. Their claim lies in the very wide and varied activity of Jean-Baptiste Lemoyne (1704–78), whose name – but hardly his output – can be confused with that of his similarly-named uncle. Always esteemed as a portraitist, but usually denigrated for his religious and monumental sculpture, Jean-Baptiste Lemoyne has been treated by posterity much as he was by connoisseurs of the period. A re-examination of what survives of his non-portrait work (much inevitably destroyed) shows how erroneous is the received idea; his art is really one brilliant, theatrically brilliant, whole.

The career of his father is a shadowy anticipation of his own. Jean-Louis Lemoyne (1665–1755) was the son of a

87. Jean-Louis Lemoyne: *A Companion of Diana*, finished 1724. Washington, National Gallery of Art, Widener Collection

1710. That had been commissioned by the Duc d'Antin for his own château, but there is a sense in which all the 'Companions of Diana' are companions to Coyzevox's famous figure. Lemoyne's statue speaks a softer, less brilliant language, but its style helps to explain how in his seventies the sculptor was able to create the pretty, 'rococo' group, first in terracotta and then in full scale in marble, of *La Crainte des traits de l'Amour* (full-scale statue, Washington). This was a commission from Louis XV, who eventually gave it, not unsuitably, to his Directeur des Bâtiments, Marigny.

Coyzevox was naturally the dominant influence on the portrait busts by Jean-Louis Lemoyne. When received into the Academy at Bordeaux in 1692 he presented a bust in wood of the king (Louis XIV). At Paris equally the Académie made his *morceau de réception* a bust of its protector, Hardouin Mansart, and this imposing marble [88], of 1703, now in the Louvre, is probably the most successful of Lemoyne's few official busts. It is the Coyzevox formula for the king utilized for the king's representative. This is not Mansart the architect or planner so much as the seignorial fount of patronage. Though his behaviour as surintendant was capricious, and often harsh, Mansart set in train various artistic enterprises. In Lemoyne's bust he shines out, heavy, confident, assertive, amid a profusion of lace and curls, one of the last *grand siècle* personalities. Everything seems pushing; the marble rolls grandiloquently, but the characterization is otherwise rather slight, smoothed away in an aura of pomp and dubious benevolence.

There is a more spontaneous feeling, and a greater sense of observation, in Lemoyne's bust of a fellow artist, Louis de Boullongne (as far as one can judge from photographs, in the absence of the original). The sympathetic directness anticipates the expressive powers of Jean-Baptiste Lemoyne, who seems to have been able to create a link of comparable sympathy and *rapport* attaching him to almost all his sitters. The surviving busts by the elder Lemoyne are all of men except for that of Madame Moreau (née Le Detz) (Private Collection, New York), which is signed and dated 1712.

Despite his extremely long life Jean-Louis did not enjoy an equally long career, for he had been prevented by blindness from working for some fifteen or so years before his death at the age of ninety. Already in 1728 he had asked for his son to remain in Paris rather than take up the pensioner's post that was his in Rome. From that date onwards it is likely that Jean-Louis' work benefited from his son's assistance. Beside this pair Jean-Louis' brother, Jean-Baptiste Lemoyne the Elder (1681–1731), is a very minor, even short-lived figure. It was he who began the *Baptism of Christ* (Paris, Saint-Roch) [91], which must however be largely his nephew's work, for at his death in 1731 he had done no more than sketch out the St John. The only other surviving identifiable work by him is his *morceau de réception*, presented tardily in 1715, of the *Death of Hippolytus* (Louvre) [89]. This dramatic, Baroque piece is rather awkwardly handled, but shows something of his nephew's talent for bravura effect. It pays tribute to the significant and pervasive influence of Rubens in the early years of the century. Even if it is not positively

peintre-ornemaniste, himself the son of a sculptor who had worked on the façade of the Louvre. A contemporary and presumably friend of Robert Le Lorrain, he was to receive many more official commissions in Paris and for the royal residences. And he was also to show a marked gift for portraiture, suitably enough for someone trained under Coyzevox. Like his son, Jean-Louis did not visit Italy. In both cases this failure – not connected with ability, for both were academically successful and eligible – may have prejudiced contemporary opinion. Of Jean-Louis it was unkindly said by Mariette that his chief merit was in begetting his son, but that is more spirited than just.

His *Companion of Diana* (Washington) [87], finished 1724, is one of the outstanding statues in the series, full of a sense of movement and life, colourfully and gracefully interpreted. There may well be in it some influence of Le Lorrain, while in the nymph's dialogue with her hound the influence of Frémin's earlier statue in the same series [81] seems overt. Even the effective gesture of the nymph's arm crossing her body echoes the similar gesture in Frémin's treatment, while a basic influence on the whole concept – perhaps for both sculptors – must have been Coyzevox's *Duchesse de Bourgogne as Diana* (Louvre), which dates from

88. Jean-Louis Lemoyne: *Jules Hardouin Mansart*, 1703. Paris, Louvre

89. Jean-Baptiste Lemoyne the Elder: *The Death of Hippolytus*, 1715. Paris, Louvre

derived from a particular Rubens composition, it must be generally indebted to him in its pose, though surely not without some awareness of Dumont's *Titan*, of just a few years earlier.[27]

Painting played an important part in the formation also of Lemoyne's famous nephew. Jean-Baptiste the Younger was born at Paris on 19 February 1704 and seemed to have every advantage of circumstance, with a father talented and prosperous. The collapse of Law's 'System' abruptly ruined Jean-Louis Lemoyne and precipitated his son into a completely professional role at the age of sixteen. He worked by night as well as day; and he was not to cease working for another sixty years. By the standards of Bouchardon he must have seemed unlearned to the point of illiteracy. He never visited Italy – indeed, he did not need Italy. There was in his art something pictorial that makes it unsurprising that he should polychrome some of his religious sculpture. That feeling for painting must have received encouragement during his training under Robert Le Lorrain, and Lemoyne from his early years sought the advice of François de Troy and Largillierre, while painters like François Lemoyne also helped him. Such men were instinctive *Rubénistes*, belonging to the party of Colour, more 'natural' than intellectual in their art, and uncurbed by concepts of the antique.

The standards these artists adumbrated are those by which Lemoyne must be assessed. His fire and brilliance could not be denied, but they could be disapproved of. He represented, without being part of any conscious programme, the Rococo element that was a sort of 'infâme' to be crushed by connoisseurs and classicists in France. Even had Bouchardon been less contemptuous in general of other sculptors, still he would have had an antipathy to the work of Lemoyne. The two men were doomed to be artistic enemies. Bouchardon's comment on Lemoyne's elaborate altar at Saint-Louis du Louvre is inevitable in its sweepingness and as brutal as Cézanne's dismissal of Van Gogh: 'ce n'est pas là de la sculpture'.[28] But, fortunately for art, it cannot be defined by a single style or a single artist, however great. The consistent

refusal in eighteenth-century France to do justice to Lemoyne, or to the Slodtz brothers, is merely part of that country's temperament. In Germany at the same period all these sculptors would have been artistically at home, though their Rococo is tame beside the superb achievements of, say, Günther and other Bavarian sculptors.

It is not surprising that Lemoyne should show equal vivacity and fire in portraiture – and there the century's obscession with the natural made it impossible to deny his greatness. However, the category of portraiture was itself not the highest; once back in France, Bouchardon, the supreme example of the correct and classical, executed only a single portrait bust. Yet Lemoyne's range through all the grades of society made his success irresistible. He was Louis XV's favourite sculptor,[29] and the king's taste is as much to his credit as George III's preference for Gainsborough was to him. Lemoyne executed busts of courtiers, magistrates, scholars, great writers, and – most significant of all – actors. His sitters were almost exclusively from French society; unlike Houdon he did not portray a series of distinguished foreigners, but it is fitting that one of the rare exceptions should have been the greatest European actor of the day, Garrick (the bust is lost).

Perhaps there was something of the actor in Lemoyne himself – not in the conventional sense of being a showy personality, for he was the reverse of that, but in what can only be called empathy, whereby he seems to become the personality he is sculpting, so intense is the vitality that plays around the features. He aims more perhaps at expression than at character, and indeed emphasizes expression almost as if

90. Jean-Baptiste Lemoyne the Younger: *Louis XV*, 1757. New York, Metropolitan Museum of Art, Gift of George Blumenthal, 1941

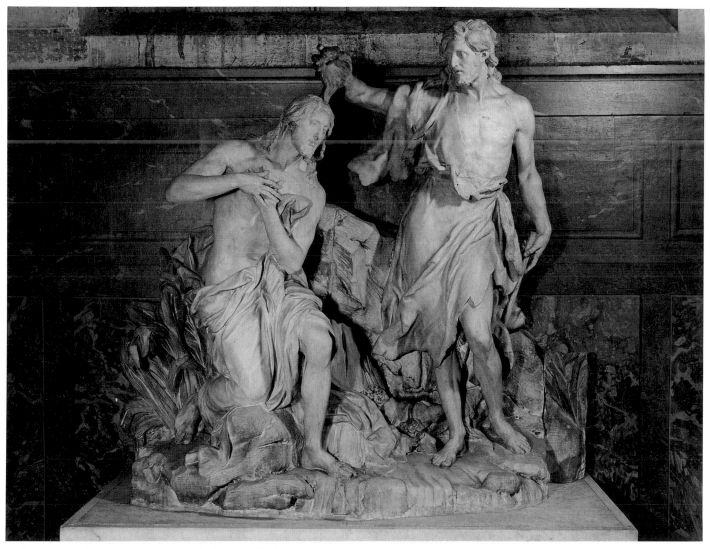

91. Jean-Baptiste Lemoyne the Younger: *The Baptism of Christ*, 1731. Paris,
Saint-Roch

making faces in the mirror. Though never verging on
caricature, this element explains why his male busts tend to
be more memorably brilliant than those of his female sitters.
He remained more modeller than carver; his terracotta busts
are better than his work in marble, as Diderot pointed out.
And at times he treated marble as if it were terracotta or
plaster, those more rapid media where he was naturally more
at ease. He always understood that he was translating into
sculpture the mobility of flesh and the sparkle of eyes. Long
before Houdon he recognized the importance especially of
the eyes to convey life and expression; and in the busts of
Louis XV [90] done over a period of forty years he has caught
the declining sparkle, the increasing pouchiness, of the king's
one-time *beaux yeux*.

Lemoyne's public career begins in 1731. *Agréé* at the
Académie three years before, he was in 1731 to receive by
chance two important works. The death of his uncle brought
him the then largely unfinished group of the *Baptism of Christ*
[91], destined for Saint-Jean en Grève; Lemoyne must have
worked on this with tremendous speed, for it is signed and
dated 1731. In contemporary eyes a much more distinguished
commission was the bronze equestrian statue of Louis XV

for Bordeaux which had been given originally to Guillaume
Coustou. But so high was the sum Coustou demanded that
Jacques Gabriel, creator of the splendid Place Royale for
which the statue was destined, turned elsewhere in disgust.
The Lemoyne, father and son, received the commission,
though one was very old and the other very young.

Thus Lemoyne was launched as sculptor of the king; he
began with a bust that pleased and went on to the troublesome
task of the whole huge statue which was to cost so much
time, labour, and money, only to be pulled down at the
Revolution. It was set up in 1743, and its appearance is
recorded by an engraving [92] as well as by several reductions
which were executed in Lemoyne's studio. France's obsession
with equestrian statues of Louis XV resulted in a series of
works which seldom seem to have been of great artistic
interest, or even variety, as far as can be judged in the virtually
complete absence of the original statues *in situ*. In Lemoyne's
may be detected a conflict between the requirements of
decorum and the artist's natural verve. It had been stipulated
that the horse 'sera marchant' but Lemoyne's horse gives the
impression that this action has been recalled only just in
time – such is the fiery quality of the head and the *élan*

92. Jean-Baptiste Lemoyne the Younger, engraved by N. Dupuis: *Equestrian Statue of Louis XV at Bordeaux*, set up in 1743. Paris, Bibliothèque Nationale

which carries the animal forward. The sense of movement is increased by the king's flying draperies, which make an almost romantic silhouette. Inevitably, the statue invites comparison with Bouchardon's, on which the example of *Marcus Aurelius* has laid its restraining hand and where dignity and nobility are expressed in calmness. Lemoyne's is a bravura concept which looks forward to his pupil Falconet's *Peter the Great* [136]. Nor is this quite accidental, for Falconet was in Lemoyne's studio when the statue was being executed, as he later recorded. What was more immediately important to Lemoyne was the king's publicized delight in the model. Despite the rain, the *Mercure* recorded with awe, the king had actually turned aside on his way to La Muette on 29 March 1735 to visit Lemoyne's studio; he had snubbed a courtier who tried to criticize the work and himself had drawn attention to the beauties of 'this superb monument'.

The *Baptism of Christ* is something much more original and striking. Quite apart from being one of Lemoyne's few large-scale works to survive intact, it has the added importance of being one of the few successful pieces of religious sculpture in the whole period. Part of its success, and doubtless part of the reserve it may have inspired among classicizing connoisseurs, is in its deliberate choice of a moment of action. It is in effect a group of frozen theatre, with the figures consciously placed in attitudes that could be held only for a few seconds. This vivid, instantaneous mood culminates in the water pouring on to Christ's head, but it is

apparent equally in the expressive faces – St John's almost palpitating, wide-eyed and open-mouthed. The group makes a single frontal impact. Intended for the high altar of Saint-Jean en Grève, it naturally had to make a bold and arresting effect and to hold its own under a cupola supported by columns, but it is not planned to be seen from a variety of angles. Today it is placed against a wall in Saint-Roch. One would not anyway be encouraged to walk around these figures – that again is part of their *coup-de-théâtre* effect – and, though they are fully modelled, they have a fluid ectoplasmic grace which minimizes any sense of solidity. The result is a thoroughly pictorial concept. Emotion runs excitedly through it, agitating the draperies into flying, creased folds and giving a lyric swing to the figure especially of the Baptist. He virtually dances forward, with that balletic *élan* Lemoyne was daringly to give the king, somewhat similarly posed, in a projected standing statue for the Place Royale at Rouen.[30]

The year after the *Baptism* Lemoyne was involved in a more elaborate scheme of Parisian church decoration, this time at Saint-Sauveur, already mentioned in connection with Noël-Nicolas Coypel. Some of the accompanying angels around the Virgin were painted, others carved in low relief and coloured. Although no visual record of the scheme apparently survives, and the church was demolished before the Revolution, it is a further reminder of Lemoyne's essentially pictorial decorative gifts. In 1732 they were

93. Jean-Baptiste Lemoyne the Younger: *Monument to Mignard*, 1743. Paris, Saint-Roch

appreciated as they deserved; the *Mercure de France* was warm in praise of the whole ensemble at Saint-Sauveur, and in particular of the young sculptor who was already 'homme consommé dans son art'. But 1732 was also the year of Bouchardon's return from Italy. In the subsequent twelve years or so, which saw the disappearance of the generation of the Coustou, Le Lorrain, and the rest, Lemoyne's leadership was challenged most patently by Bouchardon. And taste was in general to side with Bouchardon. The two sculptors met in the competition in 1743 for the tomb of Cardinal Fleury; Bouchardon won the commission, but, ironically, it was Lemoyne who eventually executed the tomb.

The fate of Lemoyne's tombs has been almost as unfortunate as that of the rest of his monumental work. Of the four that he executed, two are completely destroyed. The Crébillon tomb, probably always the least successful, is now in the museum at Dijon. The earliest commissioned – and almost certainly the finest – survives in a mutilated state in Saint-Roch: the monument to Mignard [93], which was originally set up in the nearby Jacobins' church. This was commissioned in 1735 by the painter's daughter, Madame de Feuquières. Her first project, of long before, had been for a mourning figure of Painting with various trophies, surrounding the bust of Mignard executed by Girardon. By the time she came to commission Lemoyne, she had decided to substitute herself as the mourning figure; the tomb thus became her monument as well, though its central point remained Girardon's bust of her father. That portion of the ensemble survives. How very different, and how very much more elaborate, was the complete tomb Lemoyne executed is shown by Lépicié's engraving of 1743 [94], the year in which the tomb was finished. The monument was executed in a variety of media. The shield and garlands are likely to have been in bronze; the high pyramid was probably of coloured marble, while the figure of Time and the drapery he wields are recorded to have been of lead.

In this original concept, inspired perhaps by *pompes funèbres* ceremonies, the tomb became the site of a drama, a clash between the imploring woman at its base and inexorable Time with his prominent scythe. The two were connected compositionally by the tremendous twist of fringed drapery which curled around the obelisk and cascaded right down behind the tomb to touch the floor. With brilliantly dramatic effect Lemoyne seems to anticipate the drama of Slodtz' Languet de Gergy tomb. The fullest theatrical treatment is given to the figure of Time – so cleverly attached to the side of the obelisk – whose outstretched wings increase the sense of urgency and menace. As is so often apparent in other tombs of the century in France, the imagery employed is starkly pagan. Death itself is a threatening, leaden curtain which falls alike over genius and filial piety. Beyond the grave is annihilation. It is that to which the Maréchal de Saxe will come in Pigalle's superb concept.

Time or Death – a figure probably compounded of both – was to play its part in Lemoyne's first ideas for the tomb of Cardinal Fleury. That would have been an innovation in the monument for such a highly-placed religious personage. Lemoyne did not include it in his final and much later sculpture which was put in Saint-Louis du Louvre and inaugurated only in 1768. The monument is destroyed,

94. Jean-Baptiste Lemoyne the Younger, engraved by N.-B. Lépicié: *Monument to Mignard*, 1743. Paris, Bibliothèque Nationale

though two mutilated fragments,[31] a description of it, and also a feeble engraving exist. From these it is clear that the eventual design was strongly indebted to Girardon's Richelieu tomb, probably because that had been the patent inspiration behind Bouchardon's own eventual design. Death has been banished, and the aged cardinal quietly expires surrounded by heavily draped allegories of Religion, Hope, and *La France*. Though the mood here was pathetic rather than dramatic, Lemoyne preserved his virtuosity of working in a variety of media and even, it would seem, of tinting the allegorical figures in monochrome so as to achieve an effective pallor in the marble features of the dying cardinal. Although taste had turned sharply away from the Baroque ideas expressed in the Mignard tomb, Lemoyne, while obedient to the new tearful simplicity in his design, continued to execute his sculpture in literally picturesque terms and with consciously theatrical effects.

By a quite easily understood paradox, Lemoyne was using these effects in the interests of verisimilitude. The drama of Christ's baptism, the cutting off of a life by death, or the paleness of a dying head, all were to make impact on the

95. Jean-Baptiste Lemoyne the Younger: *Bust of Arnaud de la Briffe*, 1754. Paris, Musée des Arts Décoratifs

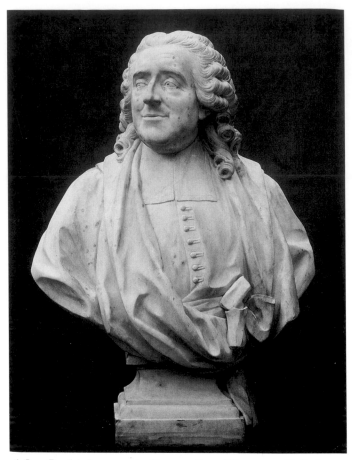

96. Jean-Baptiste Lemoyne the Younger: *Bust of Maupeou*, 1768. Paris, Musée Jacquemart-André

spectator by an actuality more vivid than in real life but closely connected with it. He sought a psychological truth rather than any abstract idea of 'correctness' or dignity in sculpture, still less any imitation of the ancients. It is significant that when commissioned to execute a statue of St Theresa, Lemoyne wished to borrow a Carmelite habit – managing to do so, incidentally, only with difficulty.[32] He needed that actual garment to begin with, before he could fill it with the fiery sentiment of the saint. His attention to the clothes of his sitters was to be criticized at the time as lowering their dignity, but in fact this is part of the individual envelope of personality which his finest portrait busts possess; out of the wardrobe of cloaks, buttons, shirts, Lemoyne created clothes as animated – almost – as the people he put inside them. It is in this sense that his portraiture too belongs in the world of theatre.

Lemoyne's first exhibited portrait busts were in his favourite medium of terracotta and were shown at the Salon of 1738, one of them being a head of *Madame de Feuquières*. Well before this date, however, he was launched on a successful social career as portraitist. News of the first Louis XV bust had reached Vleughels at Rome by January 1733, and he begged for a plaster of it. Lemoyne exhibited for the last time at the Salon of 1771; after it had opened he sent a bust of *Marie-Antoinette as Dauphine* (now Vienna) which by its subject alone reveals the span covered by his activity. At the same Salon Houdon made his first appearance with non-Roman work.

Over the years Lemoyne's technique hardly altered. What altered with each sitter was the concept of the bust, altering apparently effortlessly as the sculptor placed himself before an unparalleled range of society. It is as if it was he who, almost like a tailor or hairdresser, adapted himself to his subject, allowing each to impress an image upon his receptivity – but always an intimate physical image. In plaster and terracotta his bravura effects seem endlessly varied: symbolized by the *tour de force* at the Salon of 1742, when he showed three heads (perhaps with the same features?) at three different stages of life. At times he reduced the shoulder to being hardly more than a single fold of drapery, as with the Arnaud de la Briffe bust (1754, Paris, Musée des Arts Décoratifs) [95], where the heavily jowled face seems as a result to take on added ponderousness and weight. It may be compared with the very different effect achieved in the long-fronted, official marble of Maupeou (1768, Paris, Musée Jacquemart-André) [96], an almost deliberately old-fashioned bust which exudes a heavy, legal air. Maupeou is invested with that falsely smiling benevolence that so often accompanies the law's undue assumption of its own majesty. The superficial resemblances between the two men's appearances, and their careers, only help to underline the profoundly different concepts which animate them.

Above all, Lemoyne is the sculptor of expression. It was not suprising that he should succeed with such individual and revealing faces as Voltaire's or Crébillon's, but his skill gives individuality to a whole series of faces – some

97. Jean-Baptiste Lemoyne the Younger: *Bust of Mademoiselle Clairon*, 1761. Paris, Comédie Française

98. Jean-Baptiste Lemoyne the Younger: *Bust of Réaumur*, 1751. Paris, Louvre

still anonymous – which express a gamut of emotions. *Mademoiselle Clairon* (Comédie Française) [97], a bust shown at the Salon of 1761 (the year it is dated), expresses inspiration; she is in the guise of the Tragic Muse, though arguably appears not tragic enough. At the other extreme of cool, aloof confidence is the mask of the famous surgeon Le Cat (Rouen), not inspired but calmly competent. It is the play of features which makes the terracotta bust of Réaumur (1751, Louvre) [98] outstanding even among Lemoyne's varied, mimetic achievements. The expression is seized in a positive rictus, the lower half of the face bitten deep into by a trench of wrinkle running down either side of the nose, while the eyes are wide-open and staring. All has been caught as if by flashlight photography, but the vitality persists from whatever angle the bust is studied. So intense indeed is its sense of life that it is a slightly uncanny object, especially if unexpectedly encountered, throwing back at the spectator a beam of *trompe l'œil* realism. It lives, as if a personality were enshrined inside the material. No longer a mask, the face here seems like a lantern lit from within.

Lemoyne could not always carry over such effects into his marble busts. He was basically a modeller rather than a carver. It was true, as Diderot complained, that marble was refractory to Lemoyne's efforts; it was simply the wrong material for him, and even its surface contradicts his striving for a warm, palpitating surface which should resemble skin. It suggested the permanent, whereas he aimed at the fleeting. The fragility of terracotta as handled by him comes to stand for the fragility

of human existence; and his people are the more moving for being vulnerable. As an artist his final justification could be that he was 'natural'.

Though the century certainly advocated nature, it was seldom content with art that had no greater ambitions. Already in 1785 the anonymous author of a *Discours sur l'origine ... de la peinture en France* accused Lemoyne of being 'un des premiers corrupteurs de l'art';[33] he was disgracefully ignorant of the ancients; he had not attempted the nude; the 'true' sculptor's material of marble did not really suit his work. To all these strictures there existed an almost too perfect answer in Bouchardon.

BOUCHARDON

In contemporary eyes there could be no doubt who was the greatest French sculptor of the century. Cochin (*Mémoires*) represents enlightened opinion, fair without being over-partial: 'M. Bouchardon a été certainement le plus grand sculpteur et le meilleur dessinateur de son siècle.'[34] From the close friend of Slodtz, from someone who was not blind to the faults of Bouchardon either as man or as artist, this statement is impressive. Yet to posterity Bouchardon's place must be lower; his actual surviving masterpieces are fewer than Falconet's or Pigalle's. When every tribute has been paid to his outstanding technical mastery, and also to his

ability as draughtsman, it still remains possible to doubt if there is any sculpture by him that really deserves to be called a masterpiece. The truth is that his period over-estimated Bouchardon.

Not only did he represent the sculpture of reason and intelligence, and of intellect in place of passion, but he was the leader of the return, in Cochin's words, to 'le goust simple et noble de l'antique'. That was his title to esteem naturally in the eyes of Caylus and thus in those also of Mariette. However, Bouchardon cannot be treated as some form of neo-classical artist and explained simply in that way. Because of the period, and his character, the situation is more complex. He was the close contemporary of Chardin and Boucher; he rose to fame in France about the same date as did they, and it is impossible to impose a single epithet on the society which welcomed three such diverse talents. Bouchardon, so conscious of his own genius and so disdainful of the gifts of others, recognized the opposition of his style to the alternatives offered by the Adam, Michel-Ange Slodtz, and of course Lemoyne. All those grow in differing ways out of the sculpture practised at the beginning of the century, the tail-end of the Baroque which curves on from Coyzevox to the Coustou brothers. There was no reason why, as Guillaume Coustou's pupil, Bouchardon should not continue the manner; indeed, he was to study the true Baroque very carefully in Rome and was capable, when required, of producing Baroque work.

That he did not usually do so was due to his own nature, not to antiquarian fashion or the advice of Caylus. His stern, rather disagreeable yet timid character, and his proud isolation, must have increased his intention of excelling in a new way, of stamping his work with completely personal authority. Drama, rhetoric, colour, did not appeal to him. He re-asserted the standards of design with all the confidence of being an accomplished draughtsman. The ancients and the great masters of the past encouraged his concept of what was 'correct' and monumental. It is true he copied Pietro da Cortona, but he really studied Raphael and Domenichino's St Cecilia frescoes;[35] and they proved the more potent in his development.

Thus Bouchardon is a sharp break across the general pattern of French sculpture in the early years of the century. He must have felt it his duty to bring the picturesque to heel – and hence the harshness of his criticisms and his hostile attitude to fellow sculptors. Hence also the exaggerated care and extreme finish which he gave to most of his work. It was meant as a rebuke but often resulted in flawing the final sculpture; it became too finished, too chaste, and, at times, icily dull. Intelligence and application have polished the surface until all fire is lost.[36] An almost rancorous rejection of the adventitious, or the merely charming, can make his work artistically displeasing. It is perhaps the tragedy of Bouchardon that such a complex personality never received the commission which would have allowed him to express satisfactorily his greatest gifts. Or perhaps the tragedy was that Bouchardon feared to express himself fully.

Edme Bouchardon was born in 1698, son of a provincial but not negligible sculptor, Jean-Baptiste Bouchardon (1667–1742). Two of his other children also showed some talent for sculpture: a daughter who helped her father, and Jacques-Philippe (1711–53), who worked in Sweden and produced some attractive portraits.[37] The father was active at Chaumont, where he settled, and where his distinguished son was to be born, as well as in other parts of Champagne and Burgundy, including Dijon. He was both sculptor and architect. In a provincial milieu he held an important place and ranked as famous. Under him Bouchardon was to receive not only an apprenticeship but his earliest commission – the bas-relief of the *Martyrdom of St Stephen* (1719–20), for the church of the saint at Dijon – which is mentioned by the elder Bouchardon in May 1720 as executed 'sous ma conduite'.[38] Thus, before he ever reached Paris, Bouchardon was technically proficient and experienced. Though he studied for a while with Guillaume Coustou, he probably thought he had little to learn from such a source. In later years he openly expressed disdain for his old master, who had warmly recommended him for the journey to Rome.

By the autumn of 1723 he was a pensioner there at the French Academy. His talent had been publicly revealed when in 1722 he won the first prize for sculpture at the Academy in Paris; the following year the winner was Lambert-Sigisbert Adam, and together the two new pensioners travelled to Italy. It was a significant moment in France: the year of the death first of Cardinal Dubois and then of the Regent Orléans. Long before either Bouchardon or Adam returned home, Louis XV would have begun to reign in earnest and France would have regained some stability under Fleury.

There was some irony in the proximity of the two young sculptors, both trained in the provinces, both about to experience at first hand 'le goust simple et noble de l'antique' – with very different results. In Rome they were often to be placed in direct artistic rivalry, and though the French seem from the first to have preferred Bouchardon, it was, for instance, Adam who won the Fontana di Trevi competition. In Rome they shared several patrons, and a few years later in Paris they were to share at least one commission; Adam's contribution then was the worst object, according to Bouchardon, that he had ever seen. Adam undoubtedly was the inferior sculptor – posterity, said Cochin, will never understand how he could have been paragoned with Bouchardon – and yet it is possible to see hints of Adam even in Bouchardon's Rue de Grenelle fountain.

Like all pensioners, Bouchardon was set the task of copying an antique statue for the king. His was the Barberini *Faun* (1726–30, Louvre), and the resulting free interpretation, rather than copy, took several years to complete. It did not reach Paris until 1731 and was not seen by d'Antin until the spring of the following year; a few months later Bouchardon himself was back in Paris. His delay on the royal commission was only the first of his delays, but it is easily explicable. What had seemed promise in Paris now blossomed into accomplished fact in the sympathetic artistic climate of Rome. Bouchardon executed and projected a whole range of works which carried him far beyond the status of a student. In Rome he became famous. Well might d'Antin, pressing for the return of him and Adam to France, coldly point out: 'ce

99. Edme Bouchardon: *Bust of Philipp Stosch*, 1727. Berlin-Dahlem, Staatliche Museen

n'est pas pour enrichir les paiis étrangers que le Roi fait tant de dépenses à son Académie'.[39] Although Bouchardon did not, as he had hoped, enrich Rome with a fountain, nor execute the tomb of Clement XI, nor even the figures for the Corsini Chapel at St John Lateran (for which he was definitely commissioned), he did carve several remarkable portrait busts.

That of Philipp Stosch (Berlin-Dahlem) [99] was the earliest and in some ways the most remarkable. It was completed in 1727 and is consciously revolutionary in its cold, pure classicism.[40] Not only the portrait of an antiquarian, albeit a shady one and a spy, it is deliberately antique in concept and execution: indeed, so completely neo-classical is it that one is surprised to realize that Winckelmann was only ten years old when it was executed. Though Bouchardon certainly studied busts like Bernini's of Cardinal Borghese, what he has produced here is a rejection of the Baroque. It is such a perfect pastiche of the late classical style that it might be of some short-lived, decadent emperor – and Stosch would probably have appreciated that analogy. Nor is the concept to be explained entirely by Stosch's own classical interests, for Bouchardon was soon after to conceive a life-size virtually naked statue of the *Prince de Waldeck* (1730), while the sole portrait bust he executed in France was that of the *Marquis de Gouvernet* (1736, Comte Aynar de Chabrillan), where he dispenses with even the formal strip of drapery appearing on the Stosch bust. That represents one extreme of Bouchardon's Roman style. It was followed by other busts, of women and men, two of which were of English sitters and were despatched from Rome to London.

Bouchardon's Roman patrons were naturally extended to include the French cardinals Rohan and Polignac; he executed busts of both of them.[41] His entry into the circle around Cardinal Albani, facilitated doubtless by the Stosch commission and by his friendship with Ghezzi, was to be useful. And when in 1730 a Corsini pope was elected as Clement XII, the friendship of Vleughels and the art-loving papal nephew Cardinal Neri Corsini brought Bouchardon the important commission for a bust of the new pope. This impressive marble (Florence, Prince Tommaso Corsini) [100] shows that, while Bernini had not been looked at in vain, Algardi was the more distinct influence. Bouchardon aims here at the natural and actual, with virtuoso treatment of the cape, the cap, and the fur trimmings, all enhancing the dignified portrait likeness itself. The concept had already been fixed, even to the direction of the head, in the Polignac bust; but the papal one is still more highly finished in its details – as in the patterned stole with its knotted cord and tassel – and the whole bust is finished off by the soft line of the fur-edged cape. Attention has been paid particularly to the sitter's eyes, the pupils being only lightly incised: perhaps to suggest the pale colour of them (they were blue) and also the milky gaze of incipient blindness.

The bust of Clement XII thus represents the other extreme of Bouchardon's art from the bust of Stosch. While the latter lifts the sitter out of everyday appearances, and out of time too, the Clement records in exact detail an old man in papal vestments; though it is dignified, it makes no gesture in the direction of rhetoric or flamboyance, and its dignity is the pope's own.

The same extremes are everywhere in Bouchardon: from the elevated nobility of the Rue de Grenelle fountain to the common street genre of his 'bas-peuple' in the 'Cries of Paris'. Perhaps it could be said that, rather like Batoni and Mengs, he is better at his more natural, when not attempting too public a statement. Yet in Bouchardon the extremes were really part of the same character, and not discrepant. His art is based in realism, in ruthless study of the natural appearance, and he never generalizes. It is on a basis of the natural, the truthful, that he imposes classical calmness. In the *Marquis de Gouvernet* bust Caylus praised 'le sentiment de la chair, joint à la plus grande simplicité'.[42] For him, as for the sculptor, that is a perfect alliance of the natural and the antique; from that alliance springs the finest art.

However, it was not always easy for Bouchardon to find opportunities to achieve this alliance, itself one that came only after great pains had been taken. When he returned to France, to a career of just thirty more years, he instinctively expected some important royal commission to compensate him for what he had potentially left at Rome.[43] What he first received was the command for a statue to replace Coyzevox' *Louis XIV* in the Coustou *Pietà* in Notre-Dame. Bouchardon disliked the task, probably hardly worked on it, and abandoned it a few years later. His imperious ideas were bound to conflict with the civil service attitude of royal servants and with the implications that he too was only a servant. By 1736 d'Antin was warning him, 'si vous voulés que le roi se serve de vous', to be less difficult and to stop his daily demands for money. More aggressive than Le Lorrain, Bouchardon was equally expressing the artist's wish for independence. Meanwhile, he executed in boldly Baroque style a *Hunter with a Bear* which, with a pendant by Adam, was presented by Louis XV to his Garde de Sceaux, Chauvelin,[44] and entered into arrangements with Languet de Gergy, the curé of Saint-Sulpice, for a series of twenty-four stone statues of which only ten were completed, and then probably with studio assistance.

While the court was always to remain somewhat unenthusiastic about Bouchardon, the party of connoisseurs represented in Paris by Caylus and his familiar Mariette expressed enthusiasm of a type no previous sculptor had enjoyed. Not content with praising Bouchardon, they must denigrate other sculptors; and in the end they had actually contrived to damage his reputation by their ruthless treatment of potential rivals. Mariette was, however, especially useful as the anonymous writer of pamphlets in praise and defence of Bouchardon's two famous achievements,[45] one for the city, the other for the court – and neither left uncriticized: the fountain of the Rue de Grenelle and the *Cupid*. Bouchardon needed some mediator with the public, to explain why neither of these works was like the ordinary presupposed concept of a fountain or the god of love.

In 1737, when the re-established Salon opened after twelve years, he exhibited more pieces than any other sculptor, and displayed the full range of his talents and media, perhaps at the instigation of Caylus. There was his marble bust of Cardinal de Polignac; sanguine drawings which ranged from the learned (*Les Fêtes de Palès, célébrées chez les Romains ...*) to portrayal of Mariette's children; and the brilliantly dynamic terracotta models connected with the Chauvelin

100. Edme Bouchardon: *Bust of Pope Clement XII*, 1730. Florence, Prince
Tommaso Corsini

commission which were to enter the cabinet of the discriminating Jullienne. In 1737 these exhibits represented Bouchardon's declaration of his stature as an artist. They seemed also to underline the fact that no single important commission had come his way since he returned five years previously from Italy.

This was quite soon remedied. The first contract for the Rue de Grenelle fountain was signed between the city of Paris and the sculptor on 6 March 1739. And in that year Bouchardon exhibited at the Salon his terracotta first model for the *Cupid*. In Rome not only had he competed for the Fontana di Trevi but, as his drawings record, he had familiarized himself with Bernini's fountains. The combinations of water and sculpture must indeed have fascinated him, and he effortlessly fantasized on the theme in many drawings [101]. At Versailles he had contributed to

101. Edme Bouchardon: *Drawing for a fountain*. Paris, Louvre, Cabinet des Dessins

the Bassin de Neptune scheme, though the major part of that decoration had gone to Adam. In the Salon of 1738 Bouchardon showed 'an idea of a public fountain for a city', and perhaps the Rue de Grenelle commission was already under discussion. The civic theme was to be a significant aspect of the final monument, as was Bouchardon's awareness that he was not working for a piazza in a southern country.

But it is reasonable to think that some aspects of the Fontana di Trevi project remained in his mind. The linking of the fountain to an architectural screen may have been partly forced on him by the restricted, awkward terrain of the Rue de Grenelle site. Yet it was, for different reasons, inherent in the Roman plan all along; Salvi's eventual design is more classical than Rococo, and the concept of wedding façade and fountain can be traced back to Pietro da Cortona. Bouchardon's fountain is the final repercussion of that. He may even have recalled Adam's winning design, which is known to have included in the upper portion a seated statue of Rome flanked by Doric pillars. Or Bouchardon himself may have included such a motif in his submitted Trevi project, and reworked it for Paris. What he undoubtedly did was to curb any elements of fantasy, suggestions of Baroque

jets, rocaille sculpture, or anything that might evoke the garden world of Versailles and Marly. It is sometimes hard to remember that Guillaume Coustou's *Horses* are closely contemporary with the fountain of the Rue de Grenelle.

Since cleaning of the fountain, there has emerged a startling contrast between the white marble figures of Paris, with the reclining Seine and Marne, and the honey-coloured stone against which they are set [102]. Most photographs make the whole scheme look dull and rather pompous, and oddly Second Empire in effect. The urban setting, the narrowness of the sloping street, the public utility of the proposed fountain – all these contributed indeed to the creation less of a fountain than an architectural façade. As a result, the theme of flowing water has been repressed to an almost ludicrous degree – two taps at the base of the central feature. Voltaire and Diderot, and Laugier, shared an astonishment at the absence of this *raison d'être* of the whole monument. It is doubtful too whether the sculpture is bold enough in scale or execution to hold attention, placed so sparingly along the façade, and raised so high above the ground. Only the central group is in marble, so that the statues of the Seasons tend to merge into their niches, and even the famous bas-reliefs below [103] play only a minor part in the scheme as a decorative whole.

It seems likely that Bouchardon miscalculated, for Cochin saw the sculptures in the artist's studio and *in situ*, and found that in the latter they had lost half their original effect. To impose on a very powerful and high façade they needed to be conceived on a much grander scale; and even their actual scale appears diminished by the meticulous finish, which seems to have robbed them of vitality. The seated Paris is a chilly figure of draped rectitude, a Roman matron dwarfed by the huge portico behind her and herself as much a façade, hiding inner emptiness. To Mariette, the richness of the complete scheme was achieved by its extreme simplicity. But looked at without his *parti-pris*, its simplicity hovers dangerously on the borderline of banality.

The figures of the Seasons are individually more *mouvementé* and graceful, and the bas-reliefs below are positively playful. Among the Seasons, the pose of Spring seems to show notable anticipations of the statue of Cupid, the *Amour se faisant un arc de la massue d'Hercule* (*c.* 1750, Louvre), which Caylus said was a subject chosen by Bouchardon himself: 'il préféra celui de l'Amour adolescent …'.[46] Even more than at the Rue de Grenelle does the resulting work [104] illustrate Bouchardon's dilemma. In his anxiety to follow nature by studying naked adolescents he was led first into an awkward incident on the banks of the Seine and then, more artistically serious, into the awkward problem of how far to reproduce exact nature in a mythological work for the Crown. The result did not seem in court circles to be a successful fusion of the natural and the antique; it looked more like Cupid turned into a street-porter, it was said, while the intended action of the figure was merely puzzling. This cannot be criticized as too literary to be translated into art, since it is the exact action in a Parmigianino composition, a copy of which probably influenced Bouchardon. But Bouchardon stopped well short of charm and grace; he checked his figure's movement so that it remains either not sufficiently pronounced or disturbing

102. Edme Bouchardon: Fountain, commissioned 1737. Paris, Rue de Grenelle

103. Edme Bouchardon: Bas-relief detail from the fountain of the Rue de Grenelle

in what might otherwise be complete repose. The head is deliberately stylized and the elaborate hair is flattened with broad bands and then twisted into strange corkscrew curls.

The whole concept is akin – as concept – to Falconet's *Seated Cupid* [133] completed a few years later. But the results are different in every way. Falconet does not try to resist, instead surrenders to, all the implications of slyness, erotic charm, and decorative effect; the result is a perfect boudoir child. Bouchardon's *Cupid* is at an awkward age, and his awkwardness is emphasized by the action. It is apparent in the dichotomy between winged god and Parisian adolescent

which was rightly detected at Versailles. The statue was destined for the Salon d'Hercule, but it was rapidly banished to Choisy. Bouchardon protested that his work was not intended for a garden but a room. He may even have thought that he had made some concessions to court taste, and it might be judged appropriate that the Hercules motif had been introduced into a statue to stand in the Salon d'Hercule. However, in 1752 Marigny was stating the categorical fact that it must go, 'puisque le Roy ne la veut absolument pas dans le salon d'Hercule'.[47] At Choisy it was placed in a miniature temple of its own. Perhaps France was lucky to retain it at all, for despite the fact that it had been a royal commission, Bouchardon stated that he had had a better offer from an Englishman; and as a result the Crown had to pay an unusually high price for the statue.

It was possibly Bouchardon's insistence on being paid at his own valuation that led to the collapse of the royal project

104. Edme Bouchardon: *Amour se faisant un arc de la massue d'Hercule, c.* 1750. Paris, Louvre

considerably evolved (both Louvre); the first is a clear recollection of Coyzevox's Mazarin tomb and the second equally clearly recalls Girardon's Richelieu tomb. Fleury had achieved great but unspectacular things for France; he had preferred peace to glory, and was by no means unworthy of that analogy with the cardinal ministers of the *grand siècle* at which both Bouchardon's designs hinted. The earlier maquette expresses the public sense of loss at the death of a distinguished statesman; France holds three crowns of laurel, oak, and olive, symbolizing respectively the cardinal's care for his king, his country, and peace; afflicted Virtues mourn over the globe, where Europe figures prominently. This grandiose concept gives way to something more direct and pathetic in the second maquette [105], whose design was approved by the king. No longer kneeling, Fleury is shown expiring in the arms of Religion. Though France was still to be weeping, the crowns have gone, as have the globe and other allegorical trappings. The cardinal's achievements are hardly referred to, and the whole concept has become not only simpler but more private. This design suited Bouchardon as much as Louis XV; he was artistically much closer to Girardon than to Coyzevox, and the refinement of his handling of, for example, Fleury's draperies is apparent even in the small wax maquette. Perhaps in the eventual marble their flowing lines, which seem to symbolize the dissolving consciousness of a dying man, would have been wrought too carefully to retain this delicate harmony.

Bouchardon's final important commission was to be worked on so long, and with such intense application of detail, that he did not live to complete it. This was the huge equestrian statue of Louis XV, commissioned by Paris formally in 1749 for the Place Louis-Quinze [106]. More than four hundred surviving drawings testify to Bouchardon's pains over this project, which cost him so much labour in the very years that he was growing ill.[49] For some time before his death in 1762 he had suffered from 'une main tremblante' – a particularly cruel affliction for one who had been such an accomplished draughtsman. The *Louis XV* must have seemed to him to offer the ideal opportunity to crush the reputation of Lemoyne; and it is reasonable to see it as a 'reply' to the famous statue at Bordeaux. The horse and rider are almost too patently inspired by the *Marcus Aurelius*, but corrected by greater truth to nature. While dressing Louis XV in Roman military style – thus differently from the pacific togaed figure of the emperor – Bouchardon produced a much more profoundly studied and more pensive horse.[50] For the pedestal he conceived something quite novel – both neo-classical and classical, and perhaps faintly awkward as well: four Virtues who effortlessly supported the platform in place of the conventional slaves. Hints towards this concept are provided in the Louis de Brézé tomb at Rouen, with its caryatid figures, and also in the balcony of the ground-floor Salle at the Louvre by Goujon. The idea of praising men by showing around them the statues of men they had enslaved was to be criticized by Voltaire, and in turn very consciously rejected by Pigalle. Bouchardon rejected it too, perhaps more on artistic than enlightenment grounds, but his solution seemed absurd to Grimm. Yet more 'enlightened', Grimm would have liked to see great contemporaries like Saxe, Montesquieu, and Voltaire himself, at the feet of the monarch.

for a monument to Cardinal Fleury.[48] Judging from the surviving maquettes, it seems likely that he would there have achieved an indisputable masterpiece. The death of the aged minister in 1743 was quickly followed by the king's expressed desire to build a worthy tomb for him. Among the competitors Bouchardon, Lemoyne, and Adam stood out; it was Bouchardon who received the commission, but for reasons never made explicit he did not execute the tomb. When it was finally carved by Lemoyne, the cardinal's family – not the king – paid.

Bouchardon designed no less than four models, two

105. Edme Bouchardon: *Cardinal Fleury dying in the Arms of Religion*, 1745. Paris, Louvre

106. Edme Bouchardon: *Equestrian Statue of Louis XV* (engraving after), commissioned 1749. Paris, Bibliothèque Nationale

The *Virtues* were Bouchardon's final expression of a preference for the ideal over the actual; they take up that classical interest made patent as early as the bust of Stosch, but the shift is now from Rome to Greece. More slender and more graceful than the Rue de Grenelle *Paris*, they belong in a much more profoundly classical world. Their effect has to be judged largely from engravings and reductions, since the monument was inevitably destroyed at the Revolution. But in addition there remains the mutilated wax maquette (at Besançon) where two headless, armless bodies beautifully animate the corners of the pedestal, seeming to flow into it, so organically do they belong there. Their draperies, hinting at the forms beneath, have an effortless, rhythmic rightness that is classic as well as classical. Though they have come a long way from the caryatid porch of the Erechtheum, these figures are recognizably akin.[51]

The actual full-scale statues were the part of the monument on which Bouchardon had done least. Humbled by illness and by awareness of approaching death, he – who had scorned so many great fellow-artists – had finally to seek one worthy to complete his work. The Caylus party naturally assumed that their creature Vassé would receive the dying sculptor's voice, but Bouchardon's intelligence triumphed over intrigue. In his solemn letter of 24 June 1762 to the city of Paris he declared his chosen 'cher et illustre confrère', naming the greatest: Pigalle.[52] Little more than a month later, Bouchardon was dead.

THE BROTHERS ADAM

Along with Lemoyne, the name and the presence of Lambert-Sigisbert Adam (1700–59) had long haunted Bouchardon. Adam stood not only for a style but for a team practising it, of which he was the business head. In sheer talent he was inferior to his younger brother Nicolas-Sébastien (1705–78), but he asserted himself by a pushing character and an almost desperate determination to receive commissions. Cochin was right to think posterity would be puzzled by contemporary opinion that Adam shared artistic honours with Bouchardon, but in fact opinion was gradually turning all the time against Adam. Nicolas-Sébastien lived to receive Diderot's abuse, and soon after the two sculptors were forgotten. If they were mentioned at all it was because their nephew was Clodion.

Yet no more than the admittedly much greater Lemoyne did the Adam deserve abuse or neglect. Nicolas-Sébastien produced one of the few poignant monuments of the century – but not for Paris. Lambert-Sigisbert reached a decorative peak in the Bassin de Neptune statues which justified the choice of him for the task, though admittedly he never again came near equalling that achievement. The Adam were consciously court artists, unassailed by doubts about nature, antiquity, correctness, or morality. They conceived their function to be decoration. To this they were restricted by a lack of ability in portraiture; one of their rare essays – Lambert-Sigisbert's bust of Louis XV – led to a tangled tragi-comedy in which Adam's persistence was defeated only by the king's absolute determination to refuse the object.

The Adam family had a long-established connection with Nancy and with sculpture. Perhaps Claude Adam, active in Rome in the seventeenth century and sometimes wrongly supposed to have carved the *Ganges* for Bernini's Four Rivers fountain, was a relation of that Lambert Adam of Nancy, a *maître fondeur*, whose son was Jacob-Sigisbert (1670–1747). He was a sculptor and the father of three sculptor sons, of whom Lambert-Sigisbert was the eldest. Though he is said to have visited Paris late in life, when his sons were well-known and active there, he was basically a provincial figure, occasionally employed by the court of Lorraine and executing statues in wood, as well as small-scale terracotta pieces. He trained his sons carefully and perhaps exercised some hereditary influence over his daughter Anne, the mother of Clodion.

Lambert-Sigisbert was to break out of this provincial milieu and to start on a career which each of his brothers followed. He left Nancy for Metz at the age of eighteen and then made the long, significant journey to Paris. In 1723, when Boucher won first prize at the Académie for painting, Lambert-Sigisbert won that for sculpture – though he was the only sculptor competing. That year he accompanied Bouchardon to Rome, where Cardinal de Polignac quickly became his patron. Adam added to and altered the cardinal's antique sculpture and in 1724 produced busts of *Neptune* and *Amphitrite* (Charlottenburg) which the cardinal immediately acquired. Despite their classical subject, these are patently Baroque in feeling, but rather slack in treatment. The orientation to Bernini may already be apparent here and soon becomes the dominant note in Adam's strangely limited style. The starting point for his *Neptune* bust is indeed likely to have been Bernini's *Neptune* group (now Victoria and Albert Museum) at Villa Montalto, and a few years later Adam was producing some quite conscious full-length derivations from that.

Though he presumably satisfied Cardinal de Polignac as a restorer and interpreter of antique statuary, though he dutifully copied the Ludovisi *Mars* and built up his own collection of Greek and Roman sculpture, he was scarcely touched by any classicizing tendencies. He might mention his classical studies when pressed, like Bouchardon, to return to Paris; but he was speaking nearer the truth when he mentioned, as an additional reason for remaining in Rome, his wish to give deeper study to Bernini's style.[53]

Soon the Adam family was re-united in Rome. In 1726 came Nicolas-Sébastien, who was already a speedy and experienced worker, though untrained at the Academy. Finally, the youngest brother and the most mediocre as an artist, François-Gérard (1710–61), arrived. His signature was not put on the joint work of the Adam; and, though he was to become first sculptor to Frederick the Great, he seems to have been summoned to Berlin originally in mistake for Nicolas-Sébastien. Left to himself he produced a series of garden statues for Potsdam, adequate but uninspired.

The basic attraction of Rome for Lambert-Sigisbert was the series of important, attractive commissions he received. It was he who won the competition for the Fontana di Trevi,[54] though machinations saw to it that such a prize did not eventually go to any foreigner but to the native Salvi. This sort of decorative sculpture was perfectly suited to Adam, as he made clear at Saint-Cloud and, most triumphantly, in the Bassin de Neptune at Versailles. Meanwhile, at Rome he completed a bas-relief for Clement XII's Corsini Chapel in St John Lateran, and on the strength of it was received into the Accademia di San Luca. Given the situation in Rome, and granting that prejudice against foreign artists could be overcome, Adam might well have had a more fortunate career in Italy than in France. Before him Pierre Legros stood as an example of such a transplanted career,[55] while a few years after Adam left Rome Michel-Ange Slodtz was to begin there

108. Lambert-Sigisbert Adam: *Head of 'Water'*, 1737. St Petersburg, Hermitage

a whole series of masterpieces, culminating in the Montmorin monument.

Speedy in execution, imaginative rather than intellectual, Adam had not a wide range of ideas but he was capable of effective, if unoriginal, sculpture. His *morceau de réception* of *Neptune calming the Waves* (Louvre) [107] reveals his ability and his limitations. Back in Paris in 1733, he completed the model the following year and the piece itself in 1737. Its debt to Bernini needs no emphasizing; nor does the piece, for all its bravura, survive too close a scrutiny of its movement and anatomy. But it has a compensating largeness of effect, despite its small scale, and a welcome vigour. It is a piece of illusionism, with its dramatic movement – Neptune now advancing forward to quell the waves, instead of being balanced in the equilibrium Bernini had devised – and its bold flying swag of drapery which emphasizes the action. It may be only pastiche Bernini, but compared with Bouchardon's reception piece, itself pastiched from Michelangelo's *Christ* in Santa Maria sopra Minerva, it has refreshing authentic vitality. There is even a sense of poetry in the sturdy impressive head. At the Salon of 1737 Adam exhibited a group of busts of the elements. The terracotta model for the head of *Water* is in the Hermitage [108] and shows that the vein of poetry in Adam's 'fancy pieces' was very real. The limpid treatment of the hair, the ardent yet

107. Lambert-Sigisbert Adam: *Neptune calming the Waves*, 1737. Paris, Louvre

109. Lambert-Sigisbert Adam: *Neptune and Amphitrite*, completed 1740.
Versailles, Bassin de Neptune

wistful gaze, reveal an unusual delicacy and response, perhaps more those of a modeller than a carver.

It was probably an aid to the success of the grand group of *Neptune and Amphitrite* [109], for the Bassin de Neptune, that it should be executed in lead. Thanks to d'Antin the commission had been given to the Adam, and his death in 1735 meant the loss of a powerful patron. While Lemoyne and Bouchardon were given only the subsidiary groups of *Ocean* and *Proteus* respectively, the Adam had the ambitious central theme where amid a riot of marine motifs, curving shells, and fishy heads and tails, the god and goddess of the sea sit enthroned. Such a picturesque pagan world was one the elder Adam instinctively understood. His earliest commission on returning to France had been for the vast reclining figures of the *Seine* and *Marne* to decorate the cascade at Saint-Cloud. In his design for the Trevi fountain there had been a place for Ocean and the Mediterranean, along with sea-horses and tritons; but what was there only one portion of a very elaborate whole has at Versailles become the complete subject. Frustrated in Rome, Bouchardon and he were each to get the opportunity in France to compensate themselves with not irrelevant tasks: the fountain in the Rue de Grenelle, with its conscious, static calm, its deliberate simplicity, and the exuberant, rolling, almost rollicking *Neptune and Amphitrite*, rich, noisy in comparison with

Bouchardon's marble silence. The huge lead group is all movement and action – Neptune poised as if about to rise and strike with his trident, and the whole rocky platform with its people and animals about to swing forward over the water. It is the *Seine* and *Marne* group for Saint-Cloud, and his *Neptune* presented to the Académie, which flank Adam in the unusual self-portrait drawing from these years (Oxford) [110], itself one testimony to his ambitious, pushing nature.

Though Lambert-Sigisbert was to live on for many years after the Bassin de Neptune was completed in 1740, and to be employed on other work for the Crown, he never quite rose again to that level of inspiration; nor did he receive another opportunity to work on that scale. Almost like a detail he had not managed to fit in there was the popular *Boy bitten by a Lobster* – of which the plaster was shown at the Salon of 1740 – intended for a fountain and commissioned by the Comte d'Argenson (bronze, Victoria and Albert Museum). But his terracotta allegories of France and the king seem to have been less successful. That which was intended to celebrate Fontenoy was never executed on a large scale because the project was declined. The allegory he exhibited at the Salon in 1750 was so complicated in its adulation that it required several paragraphs of explanation, accompanied by a somewhat acid note that these appeared at the author's express wish.

Adam's restricted diet of a few motifs went on sustaining him, even if it had begun to pall on his patrons. The *Lyric Poetry* (Louvre) was commissioned by Madame de Pompadour for Bellevue and is signed and dated 1752. Here absurdity is only too apparent, and the statue's faults of windy affectation must have been more cruelly revealed when it was seen with its pendant at Bellevue, Falconet's *Music*. A new generation of sculptors had arisen and Adam, though not old, was out of date. He was bitterly to witness Pigalle supersede him in the project for the Louis XV monument at Reims. Caylus and Mariette and Cochin were soon to be joined in their strictures by Diderot, though Lambert-Sigisbert did not survive to receive them. At the Salon of 1765 Diderot was to exclaim: 'Abominable, exécrable Adam!' before the work of Nicolas-Sébastien.[56] Almost as if he had heard, the younger Adam never exhibited there again.

Yet it is doubtful if he was at all inferior to his brother in talent. They can be fairly judged by the bronze bas-reliefs each contributed to the chapel at Versailles, where the elder's *St Adelaide taking leave of St Odilo* is accomplished but fussy when compared to the clearly organized, highly pictorial *Martyrdom of Sainte Victoire* [111] by Nicolas-Sébastien. He indeed practised sometimes as a painter, and d'Argenville was not exaggerating in suggesting that his orientation towards painting was apparent from his sculptural work. His bas-relief is almost a homage to Pietro da Cortona in composition, but executed in a fluent pastiche manner that is closer to Sebastiano Ricci. The dying heroine, the pagan altar, the

110. Lambert-Sigisbert Adam: *Self-portrait*. Drawing, *c.* 1740. Oxford, Ashmolean Museum, Department of Western Art

111. Nicolas-Sébastien Adam: *The Martyrdom of Sainte Victoire*, 1747. Versailles, Chapel of the Château

dramatic action of the aged priest, and the whole classical atmosphere, are ready to be transmuted into another of the younger Adam's reliefs, that of the *Sacrifice of Iphigenia*. If his brother was best employed in masculine subjects, Nicolas-Sébastien interpreted in equally decorative terms more graceful, feminine themes. His subjects are Clytie, Juno, Iris, or the Virgin; and it seems doubly suitable that he should be one of the few sculptors to have tackled the *Banquet of Cleopatra*, that famous tribute to a woman's power so popular with his century's painters.[57]

He was the ideal choice for the tomb of Queen Catharina Opalinska, set up in 1749 in the church of Notre-Dame de Bon Secours in his native Nancy [112]. Nevertheless, his brother struggled hard to be preferred for the task. But panache was not needed so much as lyricism and a gentle piety, in commemorating the quite unglamorous, humble, religious wife of Stanislas of Lorraine and mother of Marie Leczinska. Bon Secours had been built by Stanislas a few years before with the intention of its containing tombs of himself and his wife, and the church's title might have suggested to Adam the theme he was to illustrate in his touching masterpiece of a soul helped by a vision. The useless royal crown and sceptre, which had proved so barren in life, are deliberately laid aside at the moment of passing from death into immortality.[58] The queen, made youthful again, kneels in prayer, while an angel points her way to heaven. The eagle of Poland, the incense burners that smoke with the queen's praises, are unimportant in the central depiction of a simple allegory which has the rare merit of also expressing a truth. All the testimony is that Nicolas-Sébastien was himself a simple, pleasant man. A chord seems to have been struck in him by the unhappy story of the woman who had been queen of Poland and duchess of Lorraine. And it must have vibrated the more keenly when the sorrowing widower took his hand and exhorted him: 'Travaillez avec cœur pour votre souveraine.'[59] Adam's emotional response can be detected even in the lines that described the model for the tomb in the Salon *livret* for 1747, with their Bossuet-like threnody: 'Détachée depuis longtemps de tout ce que le Monde a de flatteur, elle a déjà déposé les marques de ses Grandeurs et de son Rang . . .'.

The juxtaposition of the person com-memorated and the angel of immortality is not dramatic – as it had been in the Marquis de la Vrillière tomb at Châteauneuf[60] and was to be in Slodtz' Languet de Gergy monument. In that lack of drama lies its whole point. The hand of the Lord, the revelation of eternal happiness, cannot startle someone who has waited so long for them. The queen's face expresses no surprise, only ecstasy. The angel and she are integrated into a single form, in effect a white bas-relief set against the coloured marble of the pyramid; its steep lines are broken by the long undulating diagonal that runs up from the lowest fold in the queen's mantle and culminates in the extended forefinger of the angel's upraised hand. In composition the tomb is not original. Rather similar devices can be traced in the *pompes*

funèbres for Anne of Austria and Mademoiselle d'Orléans in the previous century: perhaps it is no accident that both examples come from funeral ceremonies for women.[61]

The pyramid and the smoking incense-burners were to be taken over nearly twenty-five years later when Vassé designed the tomb of Stanislas opposite. Superficially it appears to be a pendant to Adam's for the queen, but it is markedly different in mood. The king reclines in an oddly old-fashioned pose, doing nothing; and the Virtues beneath him collapse and gesticulate in unconvincing sentimentality. The failure of Vassé's monument is the sculptor's own artistic failure, but in concept it shows a shift of taste away from the gentle rhetoric of Adam, with its billowing draperies and picturesque cloud, and its affirmation of immortality. While Stanislas calmly reposes, Catharina Opalinska is about to ascend, guided by the angel; everything breathes aspiration upwards and the pair seem softly taking flight for heaven. Just as much as Lambert-Sigisbert's Bassin de Neptune, but more subtly, Nicolas-Sébastien's concept expresses the principle of movement.

MICHEL-ANGE SLODTZ

René-Michel Slodtz (1705–64) was his proper name, but it is inevitable to think of him under the nickname he was first given by fellow students in Rome and which he used when signing his work. The close contemporary of Lemoyne and the Adam – born the same year as Nicolas-Sébastien – Michel-Ange Slodtz was easily the most distinguished exponent of the Italian-inspired Baroque style, with a French accent, which they practised in common. No other great French sculptor of the century remained so long at Rome, but this had disadvantages for his career. He was not always to be fully employed when finally he returned to France, and his last years were clouded by ill-health and various troubles. He exhibited only once – in 1755 – at the Salon. His greatest achievement, the Montmorin tomb, was executed in Rome and was destined to be placed in France far from the capital, at Vienne.

Nor has his reputation ever been consolidated by posterity. Until fairly recently no monograph existed on him or the family from which he sprang. More like the Adam than Lemoyne in that he rarely executed portrait busts, he displays a brilliance and nervous sensitivity much closer to Lemoyne's – while his invention and execution are far finer. Contemporary opinion was interestingly divided over him, for while Caylus despised him and Bouchardon thought the Languet de Gergy tomb absurd, Cochin was much attached to him and his work. Dezallier d'Argenville praised the Languet de Gergy tomb as 'cette composition poëtique', and Diderot – in reviewing the Salon of 1765 – showed himself fully conscious of the loss to French art through Slodtz' recent death. Marigny thought highly of the Montmorin tomb,[62] yet it was he who withheld the much-striven-for order of Saint-Michel from the sculptor. And by the end of the century Slodtz was a byword among neo-classicists for his disgraceful style. The strictures of Milizia are almost more moral than aesthetic in their vehemence: 'this artist sinned against the purity of forms'.[63]

René-Michel was one of five sons of the sculptor Sébastien

112. Nicolas-Sébastien Adam: *Monument to Queen Catharina Opalinska*, set up in 1749. Nancy, Notre-Dame de Bon Secours

Slodtz (1655–1726), a Fleming by birth, who had moved from Antwerp to Paris; there he became a pupil of Girardon. Employed later in the Menus-Plaisirs du Roi, he remained in a subordinate posi-tion and executed ephemeral decorations of the kind afterwards associated with his sons – notably some *pompes funèbres*. As a sculptor Sébastien Slodtz produced competent but un-original work. His *Hannibal* (Louvre; signed and dated 1722 but begun many years before) was, somewhat unexpectedly, praised by Mariette, yet says nothing not said better by the Coustou. A sort of dull application seems typical of his style, for portraiture as well, to judge from the *Titon du Tillet* bust (Private Collection; signed and dated 1725) with its slightly too careful transcript of appearances. His chief claim to attention really is that he produced five sons, all of whom were in one way or another to be connected with the arts. Only two however, apart from René-Michel, require even brief mention: Sébastien-Antoine and the more interesting and more ambitious Paul-Ambroise.

Both were to follow their father in the service of the Menus-Plaisirs and much of their work too – sculpture *en carton* and *feux d'artifice* – was by its nature ephemeral. The elder, Sébastien-Antoine, was born in 1695. At Meissonier's death in 1750 he succeeded to the latter's post as Dessinateur de la Chambre du Roi, and at his death in 1754 Paul-Ambroise followed him there. It can hardly be claimed that Sébastien-Antoine is properly a sculptor, and in the joint activity of the two brothers it is probable that in general he designed and Paul-Ambroise executed. Between them they produced some impressive *pompes funèbres*, as even Cochin – not very sympathetic to them – had to admit. That for the dauphine, Marie-Thérèse of Spain, in 1746, shows the splendour they extracted from catafalques and weeping putti, yards of ermine and thousands of candles [113]. It was all very well for Cochin to stigmatize this sort of thing as bad taste, but in fact as a young man he engraved the scene reproduced here and only later learnt to condemn such displays. They need to be judged by the standards of masques, and this one is a grand allegory of Time's triumph, seated on the globe of the world, under a baldacchino decorated with sable plumes and skulls.

Paul-Ambroise (1702–58) could be called an under-estimated figure, but his *morceau de réception* of 1743, the *Dead Icarus* (Louvre) [114], is sufficient to reveal his very real gifts.[64] The plaster model for this was included in the Salon of 1741, the first at which Slodtz exhibited, and he was to appear on and off there for ten years. His charming bas-relief *Angels* in Boffrand's graceful chapel at Saint-Merry are effective decoration and completely uniform in style – though separated in execution by more than a decade.[65] In the porch at Saint-Sulpice the bas-reliefs are more serious and less purely charming. The decorative emphasis of Paul-Ambroise's work ultimately robs it of much individuality or robustness; he might indeed feel some jealousy, as Cochin more than hints, of his younger brother, René-Michel.

Yet the *Icarus* is a brilliant piece of drama, in one way an academically respectable study of the nude, in another highly picturesque. The almost pretty handling of the long feathers of the wings and the loops of ribbon is counteracted by the starkly dramatic pose of the broken body, whose flotsam-like character is conveyed by its being supported on the crest of a wave. It is raised only to be about to fall again; and already

113. Les Slodtz, engraved by C.-N. Cochin: *Pompe funèbre for the Dauphine, Marie-Thérèse of Spain*, 1746. Paris, Bibliothèque Nationale

the water draws away in foam at the lower right. While remaining elegant, the piece yet manages to convey a sense of shock; in its effect it is not so much Rococo as romantic. One hardly exaggerates in saying that it would serve as a suitable monument to Shelley.

In the joint work of the Slodtz Cochin professed to see a marked difference after the return of Michel-Ange from Italy. And in Michel-Ange's own design for a catafalque at Notre-Dame there was remarkable nobility and simplicity after the 'colifichets' of his brothers. But Cochin's sympathy for the man made him partisan, and the imagery and varied media of the Languet de Gergy tomb suggest very different qualities. It is true, however, that the sculptor was brilliantly various and had the potentiality to follow two quite different styles.

Michel-Ange Slodtz won first prize for sculpture at the Académie in 1726 and two years later went to Rome. Not until 1736 did he cease to be a pensioner. During the next decade he remained at Rome, producing an astonishing range and variety of monuments of increasing importance and authority. He began with the simple monument to Vleughels in San Luigi dei Francesi and culminated with the huge

114. Paul-Ambroise Slodtz: *The Dead Icarus*, 1743. Paris, Louvre

Baroque Montmorin tomb and the *St Bruno* for St Peter's (both finished in 1744), throwing off soon afterwards the delicate, neo-classical, Marchese Capponi tomb (1746). Slodtz' style was like an instrument responding to the player's touch, and his shifts within it are made in accordance with dramatic demands. It is drama – high, emotional drama of an intensity rare in French sculpture of the century – which dictates his effects: his silences as much as his bravura tympani. If he does nothing more, he demonstrates the futility of trying to label eighteenth-century artists with single stylistic adjectives. Whereas with Bouchardon there is sometimes an assumption of the Baroque for outdoor decorative purposes, with Slodtz there is occasionally, for all the core of Baroque energy, a whitewash coating of the neo-classical. It is because he perfectly understood that the object should dictate the style that one longs to know what was his concept of Cupid – that central presiding personage of the century, a statue of whom was to be commissioned from him by Madame de Pompadour, but never executed. As for the strange polarity which exists between Slodtz and Bouchardon, this almost seems recognized at Rome by the pair of busts they executed of, respectively, Vleughels and his newly-married wife in 1731. And it is symbolically right that, like Bouchardon, Slodtz should copy Michelangelo's *Christ* in Santa Maria sopra Minerva.

From the moment Slodtz arrived in Rome Vleughels seems to have recognized his quality, even though he was timidly conscious of having no positive proof of it. D'Antin sensibly pushed Vleughels on in a letter of 20 December 1728, encouraging him and the young sculptor. His advice was to have Slodtz do some fine figure: 'cela le perfectionnera bien davantage, et lui faire surtout travailler quelque chose d'imagination et de son propre dessein, ce qui avance bien plus que de copier.'[66] This intelligent, pointedly unacademic recipe was fully borne out by the results, but must naturally have startled someone as lacking in imagination – of every kind – as Vleughels. The superiority of Slodtz was to lie in the power of his imagination; and it is pleasing that an early proof of this should be the monument for Vleughels.

Two 'fancy' busts executed at Rome reveal Slodtz' two manners: the *Iphigenia* and *Chryses* (Lyon, Académie).[67] Even if these identifications are not quite sure, the busts are certainly classical in subject matter and are conceived as pendants, in effect of a priestess and priest. The *Chryses* is a fully Baroque head – anticipatory of Tiepolo's Calchas in the Valmarana *Sacrifice of Iphigenia*. That of *Iphigenia*, however, is oblique, retiring, a veiled profile which is a remarkable essay in the recreation of a classical mood; to find its parallel in Italian painting of the time one would have to turn to Batoni. Already here, as again in the Capponi tomb, it is a woman whom Slodtz classicizes. There is an antique Roman distinction in his attitude to the sexes: a woman is a 'gracious

silence', concealed by draperies, while men take their place firmly on the public stage of life. Even the idea of bright sun and pale moon is subtly present in the Lyon pair of heads: the priest is robustly of the daylight, with eyes raised to invoke Apollo (whose name is inscribed on his forehead), whereas the ivory-pale priestess shrinks away, obscured under robes that are decorated with the crescent moon. Superficially recalling the elder Adam's busts of Neptune and Amphitrite, Slodtz' are distinct not merely in their superior handling but also in their innate sense of drama.

It is this which distinguishes his Roman masterpiece, the *St Bruno* [115] in St Peter's, signed and dated 1744, but commissioned a few years before. Rome was to Slodtz not so much the city of the ancients as the home of Bernini – and also, it is worth suggesting, that of Borromini too. Borromini's elegant, emotionally motivated architecture would make the ideal setting for Slodtz' statue, itself so nervously refined, with its ectoplasmic, fluid white draperies. The saint's hands are long and flickering like tongues of flame as he gesticulates his repugnance for the bishopric symbolized by the mitre and crozier held up to him by the child angel; and his whole body is animated by the swing of this refusal.[68] An expressive serpentine rhythm runs from the polished crown of his head down to the extreme lower right, where the folds of fringed cope bulge out of the niche. And across this there cuts the tautly linear, dead straight, diagonal of the crozier. Within the limited space Slodtz makes use of every dramatic device, recessing the saint on a plane behind the angel, on a rocky eminence that suggests the Chartreux, with beside him a skull and length of chain that form the ascetic answer to episcopal honours.

Yet for all its tension, and its huge scale, the statue's final effect is of delicacy and grace. It beautifully suggests the momentary and fleeting, despite the solidity of its medium: in some ways the statue is a Pontormo figure, executed in marble.

The obvious comparison is with Houdon's *St Bruno* [255], also for a Roman church and done just over twenty years later. It has been customary to see the differences between the two statues as due to a shift in taste, yet in fact after Slodtz' *mouvementé* concept, Houdon had little choice but to conceive an entirely static figure. Slodtz had taken to an extreme the drama to be extracted from a single standing figure destined for a niche. His *St Bruno* is swept and tormented by emotion into an arabesque that is only just contained within the space. It is an instant's vision – for the putto must disappear and the saint regain his placidity. And Houdon's figure might have been conceived to express exactly that recovery of tranquillity. His *St Bruno* is a figure of stone, perfectly still, completely contained within its niche, a statue that is deliberately statuesque: as much an extreme as Slodtz'. But it is a classical and traditional extremity – that tradition so often agreeably thought of as French, by the French. By any standards it is a *reasonable* work of art, in concept and execution; the saint is shown as philosopher and stoic rather than a vessel of divine fire. Slodtz goes to the edge of reason to excite and exalt, to disturb the spectator by the spectacle of the disturbed saint.

Yet Slodtz' *St Bruno* is unique in his work. It is in four sculptured tombs that his art, which thus remains in the

115. Michel-Ange Slodtz: *St Bruno*, 1744. Rome, St Peter's

family tradition of the *pompes funèbres*, is seen at its most varied, producing some of the finest French funerary monuments of the century. The earliest of these is also the simplest: that for Vleughels (who died in 1737) in San Luigi dei Francesi. It is really no more than an extended bas-relief, with the deceased shown in a medallion, and a single child genius with draped head, holding a palette. The inspiration

116. Michel-Ange Slodtz: *Monument to Archbishop Montmorin*, 1740–4. Vienne Cathedral

117. Michel-Ange Slodtz: *Monument to Archbishop Montmorin*, 1740–4.
Detail. Vienne Cathedral

is clearly from Duquesnoy, and the putto suggests direct reference to the Van den Eynde tomb. It hardly prepares the way for the grand-scale monument which followed, for which indeed there is really no prototype. This was the combined tomb and monument which was commissioned from Slodtz in 1740 by the Cardinal de la Tour d'Auvergne, completed by 1744 and set up in 1747 in the cathedral at Vienne [116]. The cardinal slowly mounts the steps, his hand held by his old mentor, Montmorin, the earlier archbishop, who seems to have returned to life to indicate that the cardinal shall succeed him. Thus the monument unites those twin eighteenth-century obsessions of the portrait and the tomb. Living and dead are brought into close contact, and the succession to the proud See of Vienne is expressed in terms more actual than allegorical. The whole concept was the cardinal's own, and letters between him and the sculptor document the various stages in the evolution of the monument; already when the contract was signed in Rome on 1 October 1740, the cardinal had seen Slodtz' preliminary wooden model.[69]

Unlike the majority of French funerary monuments of the century, the Montmorin tomb remains intact and in its original position, in the apse to the right of the high altar. The long harmonious line of the nave remains unbroken by this addition of centuries later which, far from dominating the church, makes sense best from the steps of the altar – itself also by Slodtz. Almost as if to suit the grave, severe beauty of the surrounding architecture, the tempo of the sculpture is more stately and much slower than in the *St Bruno*. And the effect is, of course, much richer, though obscured under cobwebs and dust. Against the pyramid of mottled mauvish-grey marble, Montmorin reclines on a cushion of brownish-red, and the same warm marble is used for the thick surrounding draperies with yellow fringes. His vivid, penetrating face – the pupils of the eyes drilled very deep – is the focal point of the whole monument. Though conventionally reclining to convey that he is dead, Montmorin is throughout invested with keen vitality, with his expressive pointing hand, the sharp folds of his robes, and his foot projecting over the edge of the black marble tomb, suggestive of stepping back into life again [117]. That it is *his* monument is emphasized by the profile figure of the cardinal who might be stepping up, hesitantly, to pay homage, and who seems to come reluctant to accept another's honours.

It is with this figure that Slodtz radically altered what would otherwise be merely a funerary monument. The cardinal is in fact a fully modelled statue of a living person placed on a tomb not as mourner but, as it were, in anticipation of his own death. The uniqueness of the concept must have been emphasized when the cardinal himself officiated at the altar, close to the monument he had had erected. While Montmorin is all sharpness – of personality, it would seem, as much as in sculptural treatment – Cardinal de la Tour d'Auvergne is conceived in more *adagio* rhythm, bulky in his tremendous, swollen robes, and in actual physiognomy a contrast to his patron, fatter-faced, heavily-

118. Michel-Ange Slodtz: *The Capponi monument*, early 1740s. Rome, San Giovanni dei Fiorentini

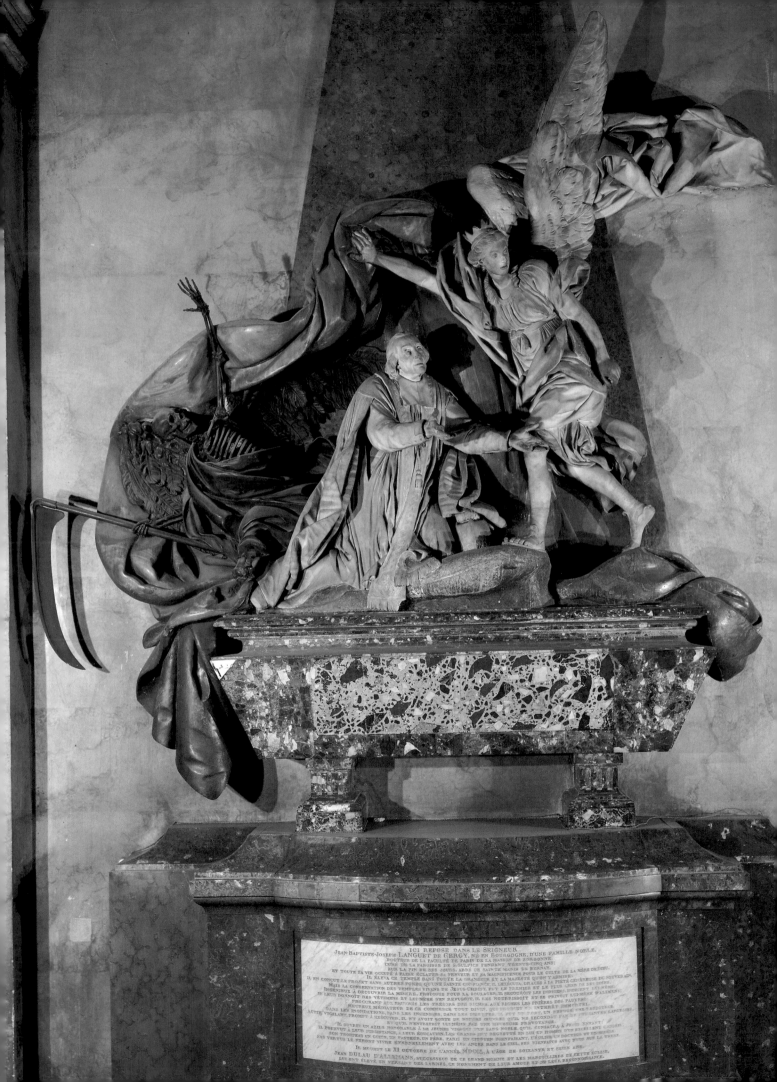

ICI REPOSE DANS LE SEIGNEUR

JEAN-BAPTISTE-JOSEPH LANGUET DE GERGY, NÉ EN BOURGOGNE, D'UNE FAMILLE NOBLE,
DOCTEUR DE LA FACULTÉ DE PARIS DE LA MAISON DE SORBONNE
CURÉ DE LA PAROISSE DE S.-SULPICE PENDANT TRENTE-CINQ ANS,
SUR LA FIN DE SES JOURS, ABBÉ DE SAINTE MARIE DE BERNAY.
ET TOUTE SA VIE OCCUPÉ À FAIRE ÉCLATER SA FERVEUR ET SA MAGNIFICENCE POUR LE CULTE DE LA MÈRE DE DIEU.
IL ÉLEVA CE TEMPLE DANS TOUTE LA GRANDEUR ET LA MAJESTÉ QU'ON Y ADMIRE:
IL EN CONÇUT LE PROJET SANS AUTRES FONDS QU'UNE SAINTE CONFIANCE; IL L'EXÉCUTA, GRACES À LA PIÉTÉ GÉNÉREUSE DU SOUVERAIN.
MAIS LA CONSERVATION DES TEMPLES VIVANS DE JÉSUS-CHRIST, FUT LE PREMIER ET LE PLUS CHER DE SES SOINS
INGÉNIEUX À DÉCOUVRIR LA MISÈRE, PRODIGUE POUR LA SOULAGER; IL SECOUROIT LES INDIGENS, DONNOIT AUX PAUVRES
ET LEUR DONNOIT DES VÊTEMENS ET LUI-MÊME S'EN PRIVOIT; IL LES NOURRISSOIT ET SE PRIVOIT LUI-MÊME D'ALIMENS;
PROCURANT AUX PAUVRES LES TRÉSORS DES RICHES, AUX RICHES LES FRÈRES DU PAUVRE;
HEUREUX MÉDIATEUR DE CE COMMERCE, TOUT DÉVOÛ, QUI PROFITOIT D'UN INTÉRÊT IMMORTEL:
DANS LES INONDATIONS, DANS LES INCENDIES, DANS LES DISETTES, IL FUT TOUJOURS, UN REFUGE UNE RESSOURCE,
ACTIF VIGILANT, PROMPT À EXÉCUTER, IL N'Y AVOIT SORTE DE BONNES ŒUVRES QU'IL NE SECONDAT PAR SA BIENFAISANTE LARGESSE
ET QU'IL MONTREROIT LUI-MÊME PAR SON HEUREUSE PRÉVOYANCE.
IL OUVRIT UN ASILE IMPORTANT À LA JEUNESSE VIERGE ET NOBLE, QU'IL CONSACRA À DIEU ENFANT;
IL POURVUT À LEUR SUBSISTANCE, À LEUR ÉDUCATION, LES GRANDS ONT REGRETTÉ EN LUI UN HOMME D'UN EXCELLENT CONSEIL,
SON TROUPEAU UN GUIDE, UN PASTEUR, UN PÈRE, PARIS UN CITOYEN BIENFAISANT, L'ÉGLISE UN DOCTEUR ET SA MÉMOIRE
SES VERTUS LE FERONT VIVRE ÉTERNELLEMENT AVEC LES ANGES DANS LE CIEL, SES BIENFAITS AVEC AVEC SUR LA TERRE.
IL MOURUT LE XI OCTOBRE DE L'ANNÉE MDCCL, À L'ÂGE DE SOIXANTE ET ONZE ANS.

JEAN DULAU D'ALLEMANS, SUCCESSEUR DE CE GRAND HOMME ET LES MARGUILLIERS DE CETTE ÉGLISE,
LUI ONT ÉLEVÉ, EN VERSANT DES LARMES, CE MONUMENT DE LEUR AMOUR ET DE LEUR RECONNAISSANCE.

wigged, a sculptural *tour de force* of brilliantly executed lace and draperies which retain in marble the light creases of silk as they gently balloon out over the steps of the monument. Though the textures are cleverly simulated, it is the expressive lines of the folds themselves that give to the falling train something of that beautiful singing rhythm found in Pilon's treatment of drapery (e.g. *Cardinal Birague*, Louvre).

In this double monument of two churchmen, set up in their own cathedral, there is a marked absence of religious imagery, and a complete neglect of death. It is conceived in a spirit not of piety but of *pietas*: a monument to fidelity first, and then to power. The sole allegorizing touch is that of the putto who hastens to inscribe the event in the annals of the cardinal's house. And in some ways, for all its Baroque manner and for all its mingling of materials, the monument is animated by an extraordinary Renaissance concept, an affirmation of the splendour of being human, and the immortalizing in art of human glory.

After it the Capponi monument in San Giovanni dei Fiorentini, Rome, is tenderness and grief personified, literally, in the graceful, mourning Virtue who contemplates a skull beneath a medallion portrait supported by two putti [118]. With her much pleated draperies and willowy pose, she is somewhat similar in style to Filippo della Valle's work, but markedly more neo-classical. It is not surprising that the two sculptors worked together in Santa Maria della Scala, but the result was to give a frenchified air to the extremely attractive work of della Valle rather than to affect Slodtz. Yet the Capponi tomb is typical of tendencies in Rome during the 1740s, and it is notably modest in effect when compared with the grandiose Montmorin tomb or the dramatic pageant of that for Languet de Gergy. Slodtz made no attempt to involve Capponi as an actor in his monument, but expressed instead the conventional idea of a female mourning figure, raised out of banality by the delicate treatment of robes that seem positively to rustle, yet posed with un-Rococo tranquillity. Perhaps not too much should be made of Slodtz' nascent neo-classicism, which may here be explicable through haste or some lack of interest in the commission. Certainly the Languet de Gergy tomb is a violent contrast to it.

Slodtz returned to Paris in 1746, and that tomb [119], completed in 1753, is the most important work he executed during the remainder of his life. It is also the most rhetorical of his tombs and possibly shows some signs of strain – despite, or because of, its virtuoso technical display. He was to receive several commissions for work at Saint-Sulpice, itself a monument to Languet de Gergy, as Slodtz was to indicate in the tomb. The monument is a narrative in allegorical terms, expressing almost the sentiment of Donne's words: 'Death, thou shalt die.' Languet de Gergy represents, as it were, the Christian soul over whom Death has no power, vanquished by the appearance of an angel who thrusts back the curtain of mortality and brings a vision of eternal happiness. The dramatic effect is somewhat overpowering in the small chapel where the monument is placed, and there is a distinct mannerism in, for example, the angel, which was not apparent in Slodtz' earlier work.

119. Michel-Ange Slodtz: *Languet de Gergy tomb*, 1753. Paris, Saint-Sulpice

The profusion of materials is today less obvious, and the tomb is shorn of several details. On the plinth below the sarcophagus were originally two child genii symbolizing Religion and Charity, along with a festoon, a cornucopia, and the Languet de Gergy arms. The angel held a huge ring, probably of bronze, and also a long fluttering paper bearing the plan of the church. The skeleton of Death is in bronze, the curtain apparently of lead, while a range of coloured marbles – comparable to those at Vienne – serves for sarcophagus, cushion, the angel and the curé, and the pyramid against which the action takes place. Amid all this Slodtz manages, however, to keep attention focused on Languet de Gergy himself, whose expressive outstretched hands and ecstatic face wonderfully suggest the unseen vision. The vividness of the head was praised by La Font de Saint-Yenne and by Diderot, and some credit is due to the young Caffiéri who had carved Languet de Gergy in 1748, and whose bust appears to have been utilized by Slodtz. Nevertheless, it is the conviction of the emotion in the face which makes it remarkable – the more remarkable as Languet de Gergy was by no means above the suspicion of being a charlatan. Slodtz makes him a worthy subject to be fought over by Death and Eternal Life, the centrepiece of an easily-read, effective allegory. The monument is the three-dimensional expression of words inscribed on the plinth below it: 'ses vertus le feront vivre éternellement avec les anges dans le ciel'.

Yet the monument also marks an extreme. It may not look one by the standards of German and Austrian Rococo sculpture, but it represents the further limit of French art and is basically in opposition to French taste. This type of allegory, especially with the skeleton of Death, increasingly seemed puerile and absurd. The mocking comment Bouchardon is reported to have made on it is typically rational: 'vous rirés bien'.[70] And though Cochin defended the tomb, he notably avoided such imagery when involved a few years later in designs for the tomb of the Dauphin [122,123]. Pigalle draped Death on the two occasions he carved the figure, and even then did not escape criticism.

Slodtz' Languet de Gergy monument would, however, have fitted remarkably well into a Flemish church milieu. Indeed, in St Bavo at Ghent there are late-seventeenth-century tombs, such as that of Bishop Eugène-Albert d'Allamont, with its bronze skeleton of Death confronting the prelate, executed in 1673 by Jean del Cour, which could be claimed as virtual prototypes.[71] By chance or not, Slodtz seems to have dramatically reverted to his Flemish ancestry.

Indications of new, critical taste had been felt by both Adam and Bouchardon, and also the presence of new sculptors. Perhaps because of Slodtz' delays on executing the *Cupid* for Madame de Pompadour, the commission for such a statue went to Falconet – and resulted in a masterpiece.[72] Over a period of five years Adam, Bouchardon and Slodtz all died, and all prematurely, it could be said, by the standard of longevity set by Girardon and Coyzevox; of the great sculptors of their generation only Jean-Baptiste Lemoyne was to survive into his and the century's seventies.

It was a new generation of sculptors that was rising to fame in the middle of the century, often to enjoy the patronage of Madame de Pompadour, often to be praised or blamed (possibly without knowing it) by Diderot.

The Middle Years

Sculpture: From the Generation of Falconet and Pigalle to Pajou

INTRODUCTION

The middle years of the century saw the emergence of a cluster of talented new sculptors in France and the striking arrival of two closely contemporary geniuses, Pigalle and Falconet. After the burst of talent at the Salon of 1737, there was no comparable revelation in painting for this period until the début of Greuze in 1755, and he was much younger than the group of sculptors born in the second decade of the century; the only remarkable names of new painters from the same period are first Vernet and then Vien.

These sculptors were becoming established in the years when French literature was producing a diversity of revolutionary, and rich, work: from the *Esprit des Lois* (1748) to *Candide* (1759). In 1750 there appeared the prospectus to *L'Encyclopédie*, and in Diderot perhaps of all eighteenth-century literary figures there are most typically assembled the contradictions, frank impulses, emotions, and rationality that make up the complexity of the age. This would remain true no doubt even if he had not shown an interest in the arts which largely separates him from Rousseau. With his reviews of the Salon, and his close friendship with Falconet – and not forgetting his ability to write – Diderot becomes relevant in a new way, quite different from that of a Caylus or Mariette.[1] It is not only his ideas – sometimes, not always, finding expression in the art of his contemporaries – which are important but his central belief in the power of art. At the Salon of 1765 he made a claim specifically for sculpture, conscious of the monuments that have survived from Antiquity: 'Ce sont les ouvrages de sculpture qui transmettent à la posterité le progrès des beaux-arts chez une nation.'[2] In these years art is seen as able to possess a purpose, a moral purpose, which would have baffled the two Coustou and seemed irrelevant to Le Lorrain, as much as it must have done to the middle-aged Boucher. But the way is prepared for David.

Diderot legislated for a moral art, while Rousseau became celebrated by his crushing negative answer to the Dijon Academy's question: 'Si le rétablissement des Sciences et des Arts a contribué à épurer les mœurs?' The famous prosopopoeia of Fabritius, scribbled under a tree and read in a delirium to Diderot,[3] seemed to have its application to Paris rather than Rome: 'brisez ces marbres, brûlez ces tableaux ...'. Expanded, it was to appear in 1750 as the *Discours sur les sciences et les arts*, revealing Rousseau as opposed to the very civilization on which his century prided itself.

Luxury and refinement were no longer goals to seek but vices to be crushed; and in fact Rousseau was expressing – in a hectic manner – the century's growing preference for the 'natural' (redefined) and the un-artificial, a preference which was to affect the arts. It is already seen where it might not superficially be expected, in the patronage exercised by Madame de Pompadour. This was to touch, sometimes briefly, sometimes significantly, all the leading sculptors of the new generation: Allegrain, Pigalle, Coustou le fils, Vassé, Falconet, and Saly. Some lingering confusion caused by nineteenth-century ideas of rouge, a mistress, and 'douceur de vivre' seems to have given Madame de Pompadour a reputation for artificiality and high solemnity – to which even her name may have accidentally lent some colour. The truth is very different; but the naturalness she sought in art is itself of a thoroughly eighteenth-century type. It was represented by statues of girls engaged on tasks of butter-churning and cheese-making in her dairy at Crécy. Or in being portrayed in dignified surroundings, and yet with total frankness, by Drouais [207]. It is symbolized by her action at Bellevue in arranging a midwinter garden of spring and summer flowers – but all of porcelain.

Porcelain was indeed to play its part in the new dissemination of sculpture which naturally sought more decorative and playful subjects for small-scale execution.[4] There was a growing tendency to prefer other media to the formality and finish of marble; porcelain could be prettier, and terracotta seemed fresher. The interest in terracotta models was not quite new but it developed very much parallel to increased interest in painters' sketches. One was closer to the artist's original inspiration in such work – an idea that would have surprised, or left indifferent, the average *grand siècle* patron. When La Live de Jully published the catalogue of his cabinet in 1764 he explained his preference for the terracotta maquette: 'Ces modèles', he pointed out, 'ont souvent plus d'avantages que les marbres parce que l'on y trouve bien mieux le feu et le véritable talent de l'artiste.'[5] Three years later, in reviewing the 1767 Salon, Diderot was to inquire rhetorically why we prefer a fine sketch to a fine picture and to give the same answer as La Live de Jully, though at greater length.

Yet the middle years of the century, suitably enough for its complex nature, were also to see the construction of three major monuments, all royal commissions though one was from a foreign sovereign, but none set up in Paris: Falconet's *Peter the Great* at St Petersburg, Coustou's tomb of the dauphin at Sens, and Pigalle's tomb of Marshal Saxe at Strasbourg. Two of these sculptors received the order of Saint-Michel, the first of their métier to be so honoured, and valuable recognition of the importance of their status in official eyes. In their different ways the three monuments heroicize, or celebrate heroism. They continue the cult of the great man in an age growing somewhat short of great men – apart, of course, from men of genius in the arts. It was to be a minor revolution when a life-size statue of Voltaire

was subscribed for in 1770 by Madame Necker's weekly dinner guests.

Madame de Pompadour did not live to subscribe, though she might well have done so. The art she fostered was quite apart from any previously associated with the court; while she lived there was in effect a double stream of royal patronage, administered by her brother Marigny. Pigalle received, on the one hand, the public commission for the Saxe monument – enshrining masculine glory and national honour – and on the other, at the same period, commissions personal to the Pompadour: herself as Friendship, allegories of Love's education, and, most personal of all, a tender, graceful monument to her changed relationship with the king, *Love and Friendship*. The resulting statues remained her private property and were destined for her own gardens at Bellevue. The career of Falconet in France was, of all sculptors' careers, that most seriously affected, indeed diverted, by the patronage of Madame de Pompadour – just as Boucher's is the outstanding example among painters. But for some twenty years, up to her death in 1764, she offered new kinds of opportunity to all artists. Thus in sculpture the middle years of the century are, to some extent, hers artistically. She provides a bridge between the *retardataire* Baroque world of the Coustou and the softer, even sentimental climate of Houdon, Chinard, and Chaudet that brought with it a new century.

ALLEGRAIN

Of all the new generation of sculptors Christophe-Gabriel Allegrain was the oldest and probably the least exciting.[6] He owed his advancement, such as it was, to his brother-in-law, Pigalle, who also generously helped him in the execution of his work. Son of the painter Gabriel Allegrain (1679–1748), he was born in 1710 and lived on, artistically extinct, until 1795. He seems to have been slow to develop and was slow to be recognized. His first appearance at the Salon was in 1747 with a plaster *Narcissus* of which the marble became his reception piece at the Académie in 1751 (now at the Château de Sagan). Once attributed to Pigalle, the *Narcissus* has the rather sleepy charm which is typical of Allegrain at his best, while the very subject seems to anticipate the narcissistic *Venus at the Bath* (Louvre) [120], which was probably his most famous work, and certainly his sole court commission – apart from the lost *Batteuse de beurre* executed in stone, to Boucher's design, for Madame de Pompadour's dairy at Crécy.

Commissioned in 1756 and completed some ten years later, the *Venus* was mentioned in the Salon *livret* for 1767 as available for inspection in the sculptor's studio. Diderot was eloquent about it, and angry that the artist should have been assigned a defective block of marble. This unpleasant texture of the material is perhaps partly responsible for the statue's displeasing effect, yet it is – like the *Narcissus* – somehow deficient in rhythm. Cochin was to tell Marigny, in answer to an inquiry, that he knew nothing by Allegrain except

120. Christophe-Gabriel Allegrain: *Venus at the Bath*, *c.* 1767. Paris, Louvre

the *Narcissus* which he found 'figure aimable pour la composition'.[7] Doubtless because derived loosely from Giambologna, the concept of the *Venus* is much better than the execution, whereby the goddess remains lumpish and her draperies inert and mechanical. The treatment of the flesh is positively ugly, and the final artistic blow is given by comparison with Falconet's *Nymphe qui descend au bain*, admittedly of very different scale from Allegrain's life-size figure with its top-heavy head. It remains strange that Diderot, so sympathetic in his response to Falconet, could also fall into ecstasy before Allegrain's inferior work. This appealed to Madame Du Barry, who obtained the *Venus* and placed it at Louveciennes, and commissioned in 1772 from the sculptor a pendant of virtually the same subject in less languorous mood: a *Diana surprised by Actaeon* (Louvre), completed five years later and then exhibited in the artist's studio. The obvious contrasts in composition were made, while both statues aimed at the erotic. What in the earlier nude was a sort of contemplative self-love in the act of disrobing (like Handel's Semele: 'Myself I shall adore, if I persist in gazing') becomes excited consciousness of being nakedly exposed to a stranger's gaze – and drama replaces the mood of quiet contemplation.

Allegrain had no original contribution to make to the study of the nude. Apart from the disparate pair of Diderot and Madame Du Barry, few people showed any inclination, even at the period, to esteem him very highly. Even the proximity to Pigalle could hardly raise his work to the level of being interesting. But Allegrain outlived many of his younger and artistically much more attractive contem-poraries.

GUILLAUME COUSTOU II

The youngest Coustou, Guillaume II, was born in 1716, son of a famous father. He was the exact contemporary of Vassé and Falconet, but appeared at the Salon earlier than either of them, exhibiting first in 1741, on his return from a period at the Academy in Rome. He was to enjoy a prosperous career, much patronized by Madame de Pompadour and by Marigny, as well as by the king. When Marigny quitted the Bâtiments in 1773, Louis XV offered him a large-scale statue of his monarch, leaving him free to select the sculptor, and Marigny chose Coustou. That was one of the sculptor's last works; it reached Ménars in 1776, only a year before his death. Among his earliest important work had been the *Apollo* of 1751 for Bellevue, paid for by Madame de Pompadour, for whom he was also commissioned to execute *Une Marchande d'œufs* at Crécy (1753), which accompanied Allegrain's figure there.

The plaster model of *Vulcan* he exhibited in 1741 served for his *morceau de réception* [121] the following year, and he thus entered the Académie while his father was still alive. The *Vulcan* (Louvre) might indeed be mistaken for the elder Guillaume's work, so completely is its idiom his vigorous 'engaged' Baroque. Except in its rather more nervous treatment of the hair, it shows in fact no advance on Van Clève's *Polyphemus* [71], executed more than half a century earlier, and patently the inspiration for the statue. If this suggests some lack of originality in Guillaume Coustou II, that seems correct. His work is not impressed with strong

121. Guillaume Coustou II: *Vulcan*, 1741. Paris, Louvre

individuality, and is often oddly flavourless for all its steady competence. Although much of his decorative work has been destroyed, it is not unfair to suspect that this was in general trite, however charming and graceful. It is significant that his major achievement, the tomb of the dauphin in the cathedral at Sens, is almost certainly not his in design.

He proved to be the sculptor of the last *ad vivum* image of Louis XV, 'en habits de son sacre, ayant à ses pieds sa couronne', and that is one testimony of traditionalism and court attachment to him. This feeling was to increase when the dauphin's son succeeded to the throne as Louis XVI, anxious to honour the sculptor of what had become a memorial to both his parents. Ill, in fact dying, Coustou was given the Saint-Michel, granted with special permission to wear it before his actual reception into the order, but he never lived to see the monument set up at Sens. When the Salon opened in 1777 he was dead; the completed monument, finished except for gilding of its bronzes, was available for public inspection in his studio.[8] The result was Coustou's most important work.

This tomb is something quite fresh in sculpture at the date of its commissioning, and indeed in the tradition of funerary sculpture in France. It is a deliberate attempt to create a new type of monument, almost certainly conceived by Cochin but

122. Guillaume Coustou II: *Monument to the Dauphin*, designed before
1767. Sens Cathedral

probably influenced to some extent by Diderot. The basic concept of the monument was dictated by the prominent free-standing position it was to occupy in the choir of the cathedral, and by the wishes of the dauphine, Marie-Josephe de Saxe. She required it to serve a double purpose '... qui éternisât à la fois son attachement pour Mgr. le Dauphin et le souvenir des vertus de ce prince' (letter of Marigny to Louis XV). Louis de France died in 1765 and by his will asked to be buried at Sens.[9] Coustou was chosen as sculptor of the monument – 'le plus magnifique qui ait encore été élevé en France' – and during the summer of 1766 he and Cochin must have planned different interpretations of the theme. Coustou executed at least two models, and the final choice was made by Marigny. At Cochin's request, Diderot threw off several literary projects for the tomb, of which one mentioned two urns with a seated figure of Justice ('Et voilà ce que les anciens auraient appelé un monument', he wrote significantly),[10] and also the mourning wife with one of her children. In the light of that project it is strange to read Diderot's condemnation of Cochin's *Allegory on the Life of the late Dauphin* (a drawing exhibited at the 1767 Salon) for its mingling of real and imaginary people. But two urns remained the central point of the eventual monument, and must have seemed prophetic when the allegory of married fidelity took on reality with the death of the dauphine in 1767.

The monument's novelty is in the absence of any image of the deceased. It is conceived as a catafalque and, in the end, consists entirely of mourning allegorical figures grouped about the two urns [122]. There is no skeleton of Death, no mingling of the real and personified which Diderot said he objected to. It is quite without drama and aims at poignancy, and it may interestingly be compared with the semi-actual deathbed of the Dauphin as painted by Lagrenée [234]. It is conceived within the complete convention of the allegorical, and that largely pagan. Indeed, it is the first large-scale neo-classical tomb to be built in France.[11] It rejects the ideas of Lemoyne and Slodtz, substituting a dignity and pathos which aim to imitate the ancients. The mood is resignation, not Christian hope – despite the presence of Religion and Immortality.

The design breaks away from the wall tomb or niche and returns to the all-round concept of, supremely, Pilon's monument for the heart of Henri II. Today, Coustou's monument is banished behind a locked grille in a side chapel at Sens, and a tissue of cobwebs adds to its neglected appearance and general inaccessibility. In fact, the monument hardly makes sense when it can no longer be walked round, and to understand it properly one must turn to a record of it in its original place in the centre of the choir, before Servandoni's high altar replaced it [123]. The single urn of Pilon's reliquary is doubled for husband and wife. While Religion and Immortality are placed closest to the altar, with Religion holding up a crown of stars, at the opposite end Conjugal Love mourns, and Time remorselessly veils the dauphine's urn, having already covered that of the dauphin. Though from no single point are all four figures properly visible, each group is planned to be complementary – even to the raised left arm of Time and the raised right one of Religion, and the mourning putto at each end. And the focal

point is, as it were, quite literally the heart. The imagery is pathetic, but it makes no *coup de théâtre* assault; the spectator is instead invited to meditate and is forced to take time to assimilate each facet of the monument: the urns, the inscriptions, the cypress-decked royal arms, the broken chain of flowers. At each point further imagery is disclosed – too much in fact, and the monument betrays its literary origin.

Yet it remains a daring concept in one of France's finest cathedrals. Entering under the central doorway, with its Christ enthroned in Paradise, the visitor originally approached the tomb, standing between the nave and high altar, to see nothing but the back of Time and the sorrowing figure of Conjugal Love [124], perhaps carved by Coustou's pupil, Julien, and in itself anticipatory of Canova. This aspect is the more bitter, the more effective, and the more realistic. There are no assuaging angels, any more than a grimacing Death. Nothing is allowed to prevent time's action in covering the urns. All the classical feeling at which Diderot had hinted finds full expression here, where grief is seen to be powerless and the promise of immortality faint and chilly. It is a monument of rationality and feeling whose sentiment must conflict with the very building in which it is placed; and its removal to the obscurity of a side chapel during the nineteenth century pays tribute to its disturbing, pagan power.

123. Nineteenth-century painting of the monument to the Dauphin in its original position. Location and artist unknown

124. Guillaume Coustou II: *Conjugal Love and Time*, detail from the monument to the Dauphin, designed before 1767. Sens Cathedral

Perhaps inevitably, Coustou's part in it all is rather mechanical. He has dutifully executed rather than fully responded. Yet he captures the new spirit in the carefully executed, grave folds of the draperies and in the slow, restrained, but noble gestures. The youthful winged Conjugal Love is gracefully classical, with his extinguished torch and his anguished gaze. He is the presiding genius of the tomb. If the result is all rhetoric, it is no longer a rhetoric to stir amazement or fear, but to appeal. It asks for the spectator's tears. In this it is one of the most typical, as well as one of the most neglected, monuments of its period.

VASSÉ AND SALY

Although Vassé and Saly both received the opportunity to execute large-scale monuments, neither could produce anything to equal the artistic level of Pigalle or Falconet; and neither was to equal the intellectual interest of Coustou's monument at Sens. In the Paris of that period they could hardly compete unless aided by intrigue, and as protégés of Caylus they were to be involved in intrigue. Saly was the more talented and in every way the better man. Vassé's ability was directed more to intriguing than to executing works of art. Diderot shrewdly hit his weakness, that of so much French art of the century, when he remarked of him '. . . que

m'importe que vous soyez supportable, si l'art exige que vous soyez sublime?'[12] Cochin's *Mémoires* tell in sober detail the extraordinary depths to which Caylus and 'son cher Vassé' sank in their efforts to wrest from Pigalle the task of finishing Bouchardon's *Louis XV*; and the pettiness of Vassé's actions seems to have permeated his sculpture too.

Louis-Claude Vassé was born in 1716, son of the sculptor and accomplished decorator François-Antoine Vassé (1681–1736).[13] Having already trained under Bouchardon, he went to Rome as a pensioner in 1740, the same year as Saly, but taking second place. He naturally thought of himself as Bouchardon's successor, and did succeed him as Dessinateur des Médailles du Roy at the Académie des Inscriptions. He was diligent in exhibiting at the Salon; between 1748 and 1771 – the year before his death – he appeared there regularly, and with a great diversity of work: projects for tombs in vaguely neo-classical style ('une Femme qui pleure sur une Urne' was his favourite motif), portrait busts which included one of *Benedict XIV*, and marble medallions, as well as bathing nymphs. Despite all Caylus could do, Vassé failed to be entrusted with either Bouchardon's *Louis XV* or the statue of the king that the city of Reims wished to erect: like the former, the latter went to Pigalle. But Vassé was the obvious choice for the monument to Caylus at his death in 1765, and he finally obtained the commission for the frigid,

125. Louis-Claude Vassé: *A sleeping Shepherd*, 1751. Paris, Louvre

126. Jacques Saly: *Faun holding a goat*, 1751. Paris, Musée Cognac-Jay

127. Jacques Saly: *Hebe*, 1753. St Petersburg, Hermitage

uninteresting tombs of Marie Leczinska and her father that were put up close to Adam's of Catharina Opalinska at Bon Secours.

Vassé's *morceau de réception* of a *Sleeping Shepherd* (Louvre) [125], presented in 1751, reveals a general indebtedness to Bouchardon accompanied by a sentimental slackness. The pose is too contrived to be convincing – indeed, it is slightly absurd as well as uncomfortable – while the execution lacks all the accomplished handling which helped to make such a success of Saly's *morceau de réception* in the same year, the *Faun holding a Goat* (Paris, Musée Cognac-Jay) [126]. Both statues derive from antique prototypes which they reduce and frankly prettify, but Saly achieves this completely, whereas Vassé remains awkward. He never lost this awkwardness, as the Virtues at the base of the Stanislas of Lorraine monument confirm on a large scale.

Jacques Saly was historically perhaps not much more important than Vassé but he was a genuine talent whose early work showed more promise than was ever to be fulfilled. He was born at Valenciennes in 1717 and outlived Vassé, dying in 1776. In 1753 he left France for Copenhagen, to work on

the equestrian statue of Frederick V of Denmark, and the remainder of his active career was passed there.[14] Although recommended by Bouchardon for the task, and though ambitious and academically respectable in Denmark, Saly was not *au fond* a monumental sculptor nor, possibly, even a portrait sculptor, but a graceful, playful artist who might have enjoyed the vogue of Falconet or Clodion. In his short Parisian career he was well patronized by Madame de Pompadour and, for the sake of glory abroad, and a monumental commission, he gave up the style which had led to such charming neo-Pompeian essays as the St Petersburg *Hebe* [127], shown at the Salon of 1753, the marble of which was destined for Bellevue.

Already, during his years in Rome, Saly had been singled out for high praise by De Troy, then Director of the French Academy. One of his earliest commissions came from De Troy – 'une jolie tête de fille' – which may well have represented one of De Troy's own children. The marble head in the Victoria and Albert Museum is perhaps the original which was duplicated in a variety of media [128]. If the result is charming, the sense is of truthful portraiture: an

128. Jacques Saly: *Head of a Girl*. Copenhagen, Statens Museum for Kunst (on permanent loan from the Ny Carlsberg Glyptothek)

unsentimentalized, even somewhat sad, rendering of childhood. Here are no roguish graces, no tantalizing hints of the erotic. It is the portrait of a child in which truth comes before prettiness – and in that it is classical. It combines a feeling for substance and weight with delicacy of handling: the still smooth child's flesh, the carefully plaited hair, and the individually crinkled ears. Houdon's children may be, indeed are, much more sparklingly alive – children as adults like to think of them. Saly sacrifices that effect deliberately, by the downcast eyes and the closed mouth which convey a touching sensation of the withdrawn. Though it has been common to think of the child portrayed as Madame de Pompadour's short-lived daughter, it is more subtle, if less glamorous, to recall that she is quite likely to be the recently widowed De Troy's sole surviving child, who herself never reached adulthood.[15]

Back in France in 1748 Saly was quickly famous. The *Faun holding a Goat* created such a stir that it had to be shown to Louis XV, and though the Duc de Luynes (*Mémoires*) was careless in his spelling, he at least noted the event on 27 June 1751: 'Le Sr. Salvy avait fait porter son chef d'œuvre pour l'Académie, qui est un faune que le Roy a trouvé fort beau . . .'. The king's taste was shared by Grimm and by Caylus, whose comment on its dignified treatment of a rustic theme is one of those perfect mid-eighteenth-century dicta; Saly had chosen 'un homme de campagne', he wrote in the *Mercure*, 'mais c'est un jeune homme que tous les rapports

rendent noble et agréable.' The reassuring 'mais' calms any fear that the rustic might lead to the rude. So little rude was Saly's svelte, and somehow *petite*, concept that some critics felt it was altogether 'trop galant'.[16] The statue is androgynously elegant and makes an effect of being smaller and daintier than it really is: it seems already a product of the Sèvres factory, and was in fact soon to be translated into porcelain. It is Falconet who comes to mind before the statue, for though it is less striking than his nymphs, it inhabits the same Anacreontic world of grace and charm.

Saly's ambitions led him in 1752, even before he left France, to a statue of Louis XV for his native Valenciennes. But basically more relevant to his talent was the final commission from Madame de Pompadour of a small marble *Amour* as a child testing his arrows. Saly's original is lost or destroyed. Slodtz never finished his *Cupid* for her. It was left to Falconet to conceive and execute the quintessential statue of the whole century, in the *Seated Cupid* [133], done after Saly had settled in Copenhagen. There Saly produced a bust of *Frederick V* (Statens Museum, Copenhagen) which seems fresher and more impressive than the eventual equestrian statue [129].

Yet that is perhaps an unfair comment since the equestrian statue cannot be scrutinized so directly and closely. Saly did manage to preserve a good deal of the king's lively, benevolent expression in the final monument, which is dignified enough as a re-working of the *Marcus Aurelius*, but which suffers from an insufficiently high pedestal and lack of the colossal scale needed to dominate an attractive but very wide and airy setting. Frederick himself was responsible for the Amalienborg, with its four handsome, formal, but distinctly domestic palace façades.[17] The result is a memorable piece of urban design, which however, paradoxically, calls for a central feature grander and more dynamic than Saly could quite produce.

Something of the pains taken by him over the statue can be learnt from the contents of the sale held in Paris on 14 June 1776, after his death. The catalogue lists the models, studies, and drawings which it had given rise to; but it evokes also the sculptor's early years in Italy when he was young and promising. Among the pictures he owned were pairs by Panini and Vernet – the latter noted as done in Rome. There were caricatures by Saly himself and also one by Ghezzi, probably of him; and a drawing of a *feu d'artifice* done in 1746 by Piranesi to celebrate Saly's recovery from an illness.

FALCONET

Saly provided a prototype for the export of a French sculptor to a northern capital to execute the statue of a foreign monarch. And altogether his career has some analogies with Falconet's. The creator of small-scale *Baigneuses*, the director of the Sèvres factory, was also to be the creator of the most original and romantic equestrian statue of the century. 'Vous allez', wrote Diderot, 'au milieu des glaces du Nord élever un monument au plus grand des monarques.'[18] Falconet had gone to Russia in 1766 and was not to return until 1778, chilled and disillusioned by more than Russian weather. He left behind him the Peter the Great monument, but it was to have no influence in France. That represents Falconet at his

129. Jacques Saly: *Equestrian Statue of Frederick V of Denmark*, 1768.
Copenhagen, Amalienborg Square

most masculine artistically, while in his own country it was his feminine work, feminine in subject and feeling, which brought him fame. His career falls into two distinct portions. There are in effect two sculptors in Falconet, at least two conflicting aspects of an artistic nature in a character recognized at the time as remarkably ferocious, temperamental, and literate. Falconet was individual in the highest degree; he looked it, as is shown by the able, loving bust, now at Nancy [130], from the hand of his devoted

130. Marie-Anne Collot: *Bust of Falconet*, *c*. 1768. Nancy, Musée des Beaux-Arts

pupil and daughter-in-law, Marie-Anne Collot;[19] and even his library revealed it, for no other French sculptor would have owned a copy of Pope's poems.[20]

Étienne-Maurice Falconet was born of very humble stock in Paris in 1716 and was among the fortunate many – including Pigalle, Pajou, and Caffiéri – who trained under Jean-Baptiste Lemoyne; and Lemoyne retained a special affection for him. The two had much in common as artists, not least the fact that neither made the visit to Italy. It was perhaps through Lemoyne that the young Falconet discovered the sculptor who was to serve instead of Italy in his artistic development and who remained for him 'the greatest sculptor of his century': Puget. They had similar temperaments, though Falconet had the advantage of living

in an age without a Colbert or a Louis XIV; Catherine the Great was to prove a more intelligent and sympathetic patron.

Not since Puget had a French sculptor allied such independence of thought with genius. Falconet's discovery of the *Milo of Crotona*, then slowly losing its surface in the open air at Versailles, led to a piece of homage so direct in subject-matter as to be stigmatized for supposed plagiarism, the plaster model of *Milo of Crotona* (Louvre) which marked his first Salon appearance in 1745. His devotion to the sculpture of Puget symbolizes his firm belief in the superiority of the moderns over the ancients, a superiority consisting above all in vital realism: life, movement, textures of flesh, and sense of blood beneath the skin. The concentrated drama of Puget's sculpture and its 'engaged' quality set it apart from the majority of work executed for the gardens at Versailles. Puget transmuted his experiences of Italian Baroque art into something highly personal; in turn Falconet was to be inspired by Puget to produce personal art which should enshrine a clear idea, which should have a very definite purpose. Puget showed him that one need not turn to the ancients, still less to one's contemporaries, to achieve great art; it is in oneself that it should lie. Falconet possessed exactly that self-confidence, and an ability to express his ideas in writing as well as in marble, which Bouchardon lacked.

But it took time for him to be formed. One of the least precocious sculptors of the period, Falconet was slow to be admitted to the ranks of the Académie, found little royal favour, and was never to become chevalier of the order of Saint-Michel. His stormy independence had official disadvantages. During his early years he was too poor, and too preoccupied with getting himself an education, to undertake any major work. To this late start must be added his premature end as an artist, perhaps first through increasing blindness, and then by an abrupt paralytic stroke in 1783. From leaving Russia in 1778 until the end of his life he executed no more sculpture. Although he lived on until 1791 he had nothing to do but put his writings in order and grow daily more cantankerous.

It is typical of Falconet's tendency to be involved in conflicts that his career should start with the Académie's doubts about the choice of *Milo* as possibly encouraging plagiarism. If that made him feel a grudge he was certainly right, to judge by the final, accepted, marble (Louvre) [131], not finished until 1754, and totally unlike Puget's composition in every possible way. It is typical too of Falconet's art that he should have succeeded ultimately with this vividly dramatic and forceful subject, whereas he failed with the subject the Académie assigned him in place of the *Milo*, an allegorical *Genius of Sculpture* (1745–6) which was in the end recognized as inferior to Falconet's own original proposal. By the time the marble *Milo* was finished Falconet had already received commissions from Madame de Pompadour, for the elegant marble *Music* (Louvre) destined for Bellevue, and the now lost or destroyed stone statue of a *Jardinière* which accompanied similar statues by Allegrain, Coustou, and Vassé in the dairy at Crécy. Since he never received a major crown commission and seldom executed portrait busts, he certainly needed such patronage. However gruff and sarcastic his actual character, he had to produce work of a very different tenor, giving marble the air of being already *pâte tendre*, replacing drama by a lyrical eroticism.

131. Étienne-Maurice Falconet: *Milo of Crotona*, 1754. Paris, Louvre

The *Milo* seems truer to the artist's natural inclinations. It has in miniature something of the unconventional and bravura force that was to set Peter the Great riding dynamically beside the Neva. Milo is seen pinned to the ground in a pose that goes back to Titian's *Prometheus* in the Prado but here is more untidily interpreted – with the desperately flailing leg and mouth expanded in a howl of horror. Less emphasis is placed on the hand caught in the cleft of the tree trunk than in Puget's concept. That is indeed the central point of Puget's drama and composition: the long agonized arc extending through the tree and arm up to the contorted face. It makes an almost expressionistic effect of pain even without the presence of the lion. Falconet is much more concerned with the encounter of beast and man; the two heads are juxtaposed on the same level, mirroring ferocity and suffering. The head of Milo is particularly personal, being a portrait of the sculptor himself. Milo's reversed pose emphasizes the drama of the moment, and this is further enhanced by the splendidly fierce lion, with its shaggy body seen from the back and conceived in Barye-like terms of realism – very different indeed from Puget's heraldic animal. The opposing forces are balanced, momentarily, on the uneven rocks; a tension is held between them which looks back to Rubens and forward to Delacroix.

It was followed by a series of popular successes in the very opposite vein, that least to be expected from a sculptor characterized as 'cet homme sévère'. Fascination with the problem of conveying flesh in marble was to lead Falconet to the feminine nude, to become a sort of severe Boucher of sculpture – though rarely on a large scale. The taste for small models and maquettes was easily extended to highly-finished pieces which preserved the proportions of what had once been preparatory work. Not surprisingly, La Live de Jully was one of Falconet's patrons – perhaps one of the very first – and was the owner of the plaster *Milo*. Other rich bourgeois patrons included the Thiroux, for whom the *Baigneuse* and the *Pygmalion* were to be executed. It was this milieu rather than the court which favoured Falconet, and which to some extent was the natural one also of Madame de Pompadour, herself bourgeoise. Falconet thus had virtually a new public which was neither from the court nor from the circle of antiquarians. It was really closer to the milieu from which he himself came. It did not require sculpture to be large and impressive, still less learned and severe, but to charm: by its smallness and by its frank eroticism. When sculpture did not positively depict Love in some guise or other, it postulated him by its treatment of the female body.

But there is a chill air to the eroticism in Falconet's case, coming strangely from the admirer of Rubens. Even about his concept of *Flora* (Hermitage) [132], of which he showed the model at the Salon of 1750, there is a touch of the wintry. One can hardly call this work neo-classical, and it seems to point rather to some gap in Falconet between his written preference for 'strong' effects in works of art and some, though only some, of his own productions. It is of course quite legitimate that he should vary his idiom with the nature

132. Étienne-Maurice Falconet: *Flora*. St Petersburg, Hermitage

of a commission, but some of the female statuettes inspired by him or copied from him have a strangely proto-Victorian air and suggest that the medium in which they have been executed is white lard. The erotic power supposed to reside in his work of that kind was recognized at the period, in a way eclipsing Victorian prudery, when the Thiroux d'Arconville actually draped the Galatea of Falconet's famous group with 'une chemise de satin', as Diderot records, ' qu'on lève de temps en temps en faveur des curieux'.[21]

Falconet's real success came with the Salon of 1757 when he exhibited the *Baigneuse* [134] and also the *Cupid* (both Louvre). The *Cupid* [133] was Madame de Pompadour's commission; it became, and has remained, one of the most famous pieces of eighteenth-century sculpture. Falconet tackled a subject which had already been treated notably by Bouchardon and Saly. Madame de Pompadour had asked for the same subject from Slodtz, but he had done no more than execute the drum-shaped pedestal. That *Cupid* had been intended for Bellevue but perhaps with the sale of the house in 1757 and in the light of Slodtz' continual delays, the project was abandoned and replaced by Falconet's comparable work for her Paris house.

This was conceived in very different terms from the standing figures of Bouchardon and Saly. As presiding god and *genius loci*, Cupid is seated, cloud-borne, in deceptive, apparent repose. He is a boy, a baby, made diminutive by

133. Étienne-Maurice Falconet: *Seated Cupid*, 1757. Paris, Louvre

affection. The statue incarnates the attraction, and yet the threat, of love. In one profile Cupid is seen with hand on lip, urging discretion and secrecy – only the extended tip of his quiver hints at more. From the other side, and from the front, it is apparent that his left hand is drawing an arrow from the quiver; an ambiguity is now apparent too in the gesture of finger to lip which becomes less conspiratorial and more threatening. And finally, all Love's ambiguity is summed up in the prominent spray of roses carved at the base of the cloud.

The statue is perfectly prepared for entry into Fragonard's pictures, to be the dynamo that sends waves of erotic energy through their every curve and twist of paint. Falconet makes Cupid not only a boy but a toy, consciously charming, mischievous, and yet paradoxically powerful. In one way, it is such an effective piece of sculpture because it is so serious. Other gods and goddesses might continue to be carved as a mere fashionable continuation of mythology, but this god is – as the century fully recognized – real. He really does preside over its art, from Watteau's *Pèlerinage à Cythère* to Mozart's *Nozze di Figaro*. Falconet did not attempt to say anything new about Cupid, or to present him in any novel guise. His concept is obvious, but with the obviousness of genius. It deserved its instant fame, its reductions, the copies, its transference into paintings. It immediately spoke to the whole century and crystallized – canonized – its strongest belief: 'Qui que tu sois, voici ton maître.' Although Voltaire's distich was not written for Falconet's statue it might well have been, and was quickly inscribed on its pedestal as homage to the god: 'Il n'est, le fut ou le doit être.' The power is seen also as a promise; love is seldom quiescent. Part of Falconet's success comes from that sense of the youthful god only momentarily poised on his cloud, momentarily still before withdrawing the arrow: with his prominent, finely-feathered wings, he is a 'farfallone amoroso' of marble, about to flutter once more into activity.

After the *Cupid*, the *Nymphe qui descend au bain* (Louvre) [134], exhibited at the same Salon, and equally popular, does not deserve her success. Svelte to the point of being meagre, she is a graceful bagatelle which has almost ceased to be sculpture; later French critics have been rather shocked by Gonse's pronouncement that the level of the object is that of an 'agréable dessus d'étagère', but he spoke the truth. A faint chilliness is apparent in the polished limbs of the *Cupid*, but in the *Baigneuse* the marble becomes icy, while the small scale adds to its doll-like insipidity. Apart from the interest of the pleated chemise, the handling is chastely dull, and it is hard to recapture the bather's supposed allure. There was a *frisson* to be shared in the concept of the figure's foot just advancing into contact with the water – but that is not a motif invented by Falconet and had appeared in painting as early as Lemoyne's *Baigneuse* of 1724, itself not perhaps without some influence on him. In Falconet's final result the gracefulness of the pose is too stylized and commonplace, with the head seen on the same axis as the advancing leg. The plaster (Hermitage) is less patently graceful but more striking in pose, the head tilted to one side, and the body animated by a greater sense of movement.

The *Baigneuse* of 1757 was only the first of Falconet's variations on the theme. It led to a whole range of figures,

134. Étienne-Maurice Falconet: *Baigneuse*, 1757. Paris, Louvre

now standing, now seated, sometimes accompanied by a Cupid, but of which the main purpose always remains a study of the naked female body – a body which does not vary very much in type, being always youthful and slightly immature. Above all, the purpose and the appeal of such work lay in the sense of marble turned to flesh. The myth of Pygmalion, so popular in eighteenth-century France,[22] was fittingly to be carved by Falconet [135]. The result appeared at the Salon of 1763, to be enthusiastically received by everyone, including Diderot. The *galant* connotations of the theme added to its popularity. Diderot wished for greater physical contact to be shown between sculptor and statue as a woman slowly emerged from the marble block. Pygmalion must be excited before the sight of his concept assuming living shape; and each spectator of Falconet's group became himself a Pygmalion:

135. Étienne-Maurice Falconet: *Pygmalion and Galatea*, 1763. Baltimore,
Walters Art Gallery

'appuyez-y votre doigt et la matière qui a perdu sa dureté cédera à votre impression', breathed Diderot in ecstasy.[23] This was probably the greatest moment of public success in Falconet's career, though it did not coincide with his finest work. The group's popularity was connected less with its merits than with its subject, which inspired several paintings and Rousseau's *scène lyrique*, among other theatrical pieces, as well as some philosophic interpretation. The myth expressed, above all, the idea of woman coming to life under a man's hands; it had seldom been utilized by sculptors, and Falconet's Pygmalion kneels in rapture before what amounts to a double act of creation.

The group is earnest in a way that Boucher seldom was. Indeed, for all the eroticism of the theme, it is notable how severe is Falconet's actual treatment of it, and how little *galant* when compared with the much earlier painted treatments by Raoux and Lemoyne. It has more than a touch of that sensibility which was quite apparent in Falconet's *Douce Mélancolie*, of which the completed marble also appeared in the Salon of 1763 (Hermitage). By 1765 this was pronounced to a positive degree of sentimentality, in the classically-shaped *Amitié* who offered her heart with both hands in a gesture which offended some critics, but not Diderot. It marked Falconet's last Salon appearance and also the extent to which his sculpture had been moulded by current tastes, moving away from the early vigorous *Milo*, Baroque in style, through the pretty if chilly phase of the *Baigneuses* to the Greuzian rhetoric of *L'Amitié*.

Yet this is only one aspect of Falconet's activity. Admittedly, it is the aspect which had gained him the effective directorship, with Boucher, of the Sèvres factory from 1757 onwards. His Salon exhibits were adaptable, and were immediately adapted, to duplication as figures in *biscuit de Sèvres*. Though this dissemination of his designs, often with minor variations, meant fame, it is significant that he himself never bothered to list what he had executed for the factory, clearly not thinking of it in terms of sculpture. The taste which he had satisfied was to be catered for next by Boizot, who succeeded him, after an interval, at Sèvres; and then, with much greater élan and light-hearted bravura, by Clodion.

While this represents to some extent a new taste, Falconet's other work in the years up to 1766 was more traditional in its scope. His chief opportunities for sculpture on a large scale were given by religious commissions, though the results seldom survive. The evidence at Saint-Roch is difficult to interpret today, but the *Fainting Christ* is a displeasingly rhetorical and sentimental figure, and the *Glory* he devised there is dusty and faintly tawdry, a sadly-distant echo of Bernini, and unexpectedly tame in execution. Through it was planned to be seen the artificially lit *Calvary*, which Diderot could not defend – indeed, his strictures on the whole scheme remain apt. Falconet had at Saint-Roch a splendid opportunity, one that occupied him for a considerable time, and yet the eventual decorative scheme was not judged a success by anyone, not even by the sculptor himself. Apparently more dramatic and exciting was the *St Ambrose*, intended to replace a statue of the same saint by Sébastien Slodtz in the Invalides. That statue, by Michel-Ange's father, showed the saint quietly blessing. Falconet's concept,

possibly inspired by Rubens, placed him as a protagonist in the dramatic moment of refusing the emperor admittance to the cathedral at Milan.[24] All that can be evoked of it (removed from the church and probably destroyed at the Revolution) suggests a return to the dynamism of Falconet's earliest work and a prophecy of his greatest achievement. He made his saint a hero, playing a hero's part, with windswept drapery and a face of noble defiance. The effect was grand and terrible, and was probably Falconet's most successful large-scale work in Paris; but it was not to be placed in position until after he had left for Russia in 1766.

His fame remained that of the sculptor of such work as the *Baigneuse*, and thus he was not among the obvious candidates to create the bronze statue of Peter the Great. The names that first occurred were those who had worked for Russian patrons, as had both Pajou and Vassé, or those who, like Guillaume Coustou II and Saly, were already associated with large-scale monuments. Ultimately, Falconet was chosen because he was the cheapest in his estimate, and was also prepared to reduce that still further.[25] Like so many other great sculptors of the period, he wished to raise a monument to himself as well as to an ostensible subject. In his case the wish is particularly interesting as marking a break – a final one – with the bourgeois patronage that had made him famous. No important royal commission had come his way in France. Madame de Pompadour had died in 1764. La Live de Jully was to become mentally disturbed in 1767. Falconet himself was well aware of his position when he wrote to Marigny in 1763: 'j'ai bientôt cinquante ans et je n'ai rien fait encore qui mérite un nom.'[26]

By the time he was in fact fifty he was engaged for Russia, to raise the monument to Peter the Great 'au milieu des glaces du Nord'. This phrase of Diderot's serves as a clue of sorts to Falconet's inspiration. The location of his statue was exotically far from Paris, in a city that was the creation of the person to be commemorated. Peter the Great was an inspiring subject – in contradistinction to Louis XV in the last decade of his reign. At once general and lawgiver, Peter was the greatest ruler of the greatest empire in the world; and the earliest Russian project for the monument emphasized that fact. Though he had died only in 1725, well within Falconet's lifetime, he was already a figure of mythology, the hero of a lengthy but unfinished *Pétréide* by the then famous rhetorical poet, Thomas, who also wrote an *éloge* on the Maréchal de Saxe. The grandeur of the project stirred Diderot as well as Falconet. The commissioner of the statue, Catherine, was herself glorified by it. Everything encouraged an original concept which should do justice to the originality of the project; and it is significant that the preliminary idea came to Falconet before he ever saw St Petersburg. One day in Diderot's study he sketched in a flash the essential elements of his composition: the emperor, 'gravissant ce rocher escarpé, qui lui sert de base, étendant sur sa capitale une main protectrice'.[27] That alone makes clear its break with the Marcus-Aurelian tradition of Girardon, Bouchardon, and Saly; and it is already apparent that it will be more excitingly 'engaged' than Lemoyne's statue for Bordeaux.

A quite different solution to the problem of the equestrian statue had been propounded by Bernini's *Louis XIV*, where the king rode high on the crest of ragged rocks – almost as

136. Étienne-Maurice Falconet: *Equestrian Statue of Peter the Great*,
unveiled 1782. St Petersburg

airborne as Bellerophon on Pegasus, in the drawing, but
muted in the final statue which had signally failed to please,
and was converted by Girardon into Marcus Curtius. This
offers the prototype of uneven ground under the horse's
hooves, but unfortunately Falconet thought the statue very
bad, perhaps because of Girardon's modifications. For the
horse's rearing pose it is usual to cite Tacca's *Philip IV* at
Madrid. Falconet's attention was indeed drawn to this by his
enemy, the Russian Director of Fine Arts, Betskoi, but once
again the sculptor condemned the statue as a poor thing,
though he may well have benefited from it. Finally, the
Marly *Horses* contain some seeds of Falconet's concept; their
installation, and fame, had coincided with the young
sculptor's début at the Académie, and they can hardly have
failed to impress him.

Their naturalness heralds the naturalness of Falconet's
Peter the Great [136]. The statue was to express the 'idea' of
a hero, and yet without allegorical trappings. Whatever the
final mutual disillusionment of the sculptor and the empress,
they agreed in this and they achieved it in the eventual
monument. The fused concept of ideal, heroic, and yet
natural at which Falconet aimed is shown by his modelling
the czar naked. Probably he realized he would never be
allowed to cast the actual statue with his hero nude, but he
avoided both conventional Roman dress and also specifically
Russian costume. The czar wears timeless robes, lifting him
into an ideal sphere and achieving the same result therefore
as nudity. There were to be no allegorical groups round the

statue's base; 'mon héros se suffit à lui-même', Falconet
pointedly declared.[28] There was to be no rhetoric in the
inscription. Catherine not only shared these views but, like
posterity, was rather worried by the single allegorical element,
the snake crushed by the horse's hooves. Falconet's defence
was largely technical: the pose of the whole statue presented
problems of casting; the bronze had to be heavier at the back
than the front, to preserve its equilibrium, and the snake
helped in fixing it to the rock. Perhaps it was Falconet's
concern with the ideal aspects of his statue which allowed
him to leave the head of Peter the Great to be executed by
Marie-Anne Collot. He had little interest in portrait
sculpture, while her narrow but genuine talent was for this
category alone. Diderot thought her bust of him better than
that by Falconet; so did Falconet, who consequently smashed
his. And from the first he widely proclaimed her valuable
part in the execution of the monument.

What was united in it was ideal and natural, reason and
passion, symbolized in the calm rider on his fiery horse.
Diderot perceptively apostrophized the result as 'le centaure
Czar', and the concept looks forward not only to David's
Count Potocki [292] but to the *Napoleon crossing the Alps* [297],
which enshrined a ruler's express wish to be depicted 'calme
sur un cheval fougueux'. But unlike that, it emphasizes
reason. The czar is more legislator than conqueror. Like
Catherine herself, he stands for liberal autocracy, ease in
place of pomp, intelligent achievement over mindless show.
Whereas the ruler of France must always be bolstered by

imaginary glory and high-pitched homage ('Victoriarum Auctor et Ipse Dux' flattery dared to inscribe in praise of Louis XV on the very monument to Marshal Saxe), the two Russian sovereigns could stand by themselves and display a truer pride. Falconet instinctively understood it when he conceived that four-word inscription which Catherine immediately approved: 'Petro Primo/Catharina Secunda'.

Falconet was back in France when the monument was finally unveiled in 1782. Though he never saw it *in situ*, plenty of French visitors to St Petersburg did, and their disapproval is the best testimony to its originality. The monument's romantic bravura, its naturalness, departed from all the conventions of a royal equestrian statue as conceived in Paris. It is fitting that it should have inspired Pushkin's 'Bronze Horseman', for in many ways it anticipates Romanticism.[29] Yet it remains very much of its own century in its humanism, in its expression of the philosopher-king, not threatening but protecting his city with outstretched hand. Falconet's enshrining of such concepts in sculpture, like his friendship with Diderot and acquaintance with Voltaire, make him a new sort of sculptor in France; he is part of the Enlightenment in a way unparalleled by any other great artist except Pigalle.

But in one aspect he surpasses Pigalle – and every other French sculptor of the century – for Falconet is unique among his profession in his command of the written word. His writings are lively and original, and pungently polemical. He was, in his way, a *philosophe*; he admired Socrates, and pointed out that he too had been a sculptor. What is remarkable for a visual artist of the period in France is not only his holding of strong, often unconventional opinions but his determination to proclaim them. The first edition of his writings appeared in 1781, ten years before his death, and it ran to six volumes.[30]

Pigalle could be no rival in literary terms. In the matter of sculpture it was otherwise, but the rivalry of the two artists was different from that of, say, Bouchardon with Adam. Intelligent taste rightly recognized that, wherever one's own preference might lie, Falconet and Pigalle were both great. Far from representing two extremes of style, their general idiom is remarkably similar, though pronounced in each case in a highly personal accent. They are commanding figures of the mid century. Surveying the Salon of 1765, it was of them that Diderot thought, to show posterity 'que nous n'étions pas des enfants, du moins en sculpture'. His own tendency was to prefer Falconet; and yet: 'Au demeurant, ce sont deux grands hommes.'

PIGALLE

Perhaps it was only when Pigalle died in 1785 that his greatness could be fully appreciated. Even if no one positively came forward then to claim him as the greatest French sculptor of the century, the testimonies to his ability and achievement were more sustained than for any other sculptor. On the invitation card to his funeral the titles and honours form a miniature biography, evoking a career that runs from the first tremendous success, that of his *morceau de réception*, the *Mercury*, the most successful ever in the Academy's history, to the final solemn inauguration of the Saxe monument. After the *Mercury* came the success of Louis XV's monument at Reims – and that prompted Bouchardon to nominate Pigalle as his successor for the Paris monument to the king; the greatest sculptor of the age, in most people's eyes, singled out the next greatest. But Pigalle's wealth and honours were unparalleled: with Saly, the first sculptor to receive the Saint-Michel, he was one of the very few to become chancellor of the Academy, being in addition a member of the Académie royale at Rouen and honorary citizen of Strasbourg. No more indifferent to honours than to money, Pigalle fought hard for the official equality of sculpture with painting. Though the post of Premier Sculpteur du Roi, which he had envisaged, was never created, his impressive career is the triumphant culmination of sculpture's struggle for individuality and respectability within the framework of the arts in France as first devised under Colbert.

Although no one could perhaps fully realize it, a whole tradition died with Pigalle; his death signals the end of the French Baroque style, and with it the end of the system of royal patronage. The great court painters were long since dead. Of comparable sculptors it is true that Falconet lived on, but completely inactive. Vassé, Saly, Coustou le fils, were all dead, as was Lemoyne. 1785 was an eventful year, politically and artistically; politics and art were soon to be dramatically entwined, and meanwhile in that year France experienced the scandal of the Diamond Necklace and the instant success of the *Oath of the Horatii* [294]. Soon David was to challenge the authority of the Académie whose chancellor Pigalle had been; and not only royal patronage but royalty itself was to be overthrown.

A great distance, of more than actual years, separated those events from the world of Pigalle's birth in 1714. Jean-Baptiste Pigalle, born while Louis XIV still reigned, had risen higher than any other sculptor but came from the very humblest rank of society, comparable in origin to that of Falconet. As with Falconet too, there is an unorthodox start to his career. Falconet never visited Italy; Pigalle was to go there under official auspices and yet, it seems, not as a royal pensioner. It was one of the last acts of d'Antin to sign the *brevet* on 7 October 1736 which allowed the young sculptor to work at the Academy in Rome, a considerable privilege, since he had failed to win first prize at the Academy Schools in Paris. Like Falconet, he was a pupil of Lemoyne; but before that he had worked under Le Lorrain, the first individualist among the century's sculptors. Neither of these masters could be claimed as 'correct'. Indeed, it was to be recorded by Pigalle's friend, the Abbé Gougenot, that Le Lorrain preferred pupils who were 'échauffés par la nature'; and that is the keyword for Pigalle's own style. From his earliest success onwards, he made nature his study; even the pictures which he collected in his prosperity proclaim an interest in the natural, and the names of Chardin and Greuze are prominent.

But the 'nature' that he sought needs definition and qualification. Closer to Falconet than to Lemoyne, he was never much attracted to portrait sculpture. His concept of nature had in it something of Rubens's Baroque vigour and warmth, and something also of his preference for the large-scale. It had a ruthless quality of honesty which could lead to the awkward result of the naked *Voltaire* but which gives tremendous symphonic force to the drama of the Saxe monument. Its force and almost rude power were best

displayed in masculine subjects, and it is noticeable how free is all Pigalle's work from slyly *galant* or erotic overtones. The *Mercury* is rightly famous, while the *Venus*, its pendant, was little esteemed from the first and deserves its obscurity.[31] Even his work for Madame de Pompadour is, not altogether by chance perhaps, concerned with friendship rather than love. Vigour banishes from his style any of the century's tendency towards the pretty, just as – as far as possible – it concentrates on the big scale and avoids the statuette. Every aspect of his art is summed up in the Saxe monument, beginning with the sheer fact that the man commemorated was worthy of a great monument, and ending with the fact that it is concerned with an inescapable law of nature: death. Naturalness leads to the grim skeleton who prepares Saxe's tomb for him; there is no place for the comforting Slodtz concept of Death Overthrown. Thus, for all the panache and the allegorical figures about Saxe, the central moment is intensely, poignantly, natural.

Hardly anything is established about Pigalle's early years in Rome, except that he seems to have benefited already from the friendship and generosity of Coustou le fils, who many years later was to be a witness at his marriage. His entry for a competition at the Accademia di San Luca resulted in his gaining a second prize, but he had entered against the French ambassador's wishes and had to withdraw. Neither Antiquity nor Bernini – those twin Roman lodestones – seems to have

137. Jean-Baptiste Pigalle: *Mercury* (terracotta), 1742. New York, Metropolitan Museum of Art, Bequest of Benjamin Altman, 1913

exercised much influence upon him, though he must have been fully aware of both. He was capable of copying the antique directly, as in the *Dice Player* (Private Collection),[32] which was executed in Rome about 1738, and equally capable of contributing years later to the *mise-en-scène* at Saint-Sulpice with the Virgin and Child in a stucco glory.[33] Yet it is significant that neither of these works is truly typical of the sculptor: he is not of the party either of Bouchardon or Slodtz; and the attempt to see him combating the Baroque by the classical makes him an 'engaged' artist of exactly the type he was not. As easily as Chardin, he sails between those two preoccupations of the century and emerges as attached to a third party – that of nature. He was distinguished by a 'surabondance de vérité' which was at times too pungent for some tastes but which pointed the way, rather like Goya's art, towards the new century.

Traditionally, the *Mercury* was executed or at least conceived in Rome during Pigalle's student years, which ended in 1739. There seems no real reason for this view, and the statue might equally well have originated during the period he spent at Lyon on his return from Italy and before settling in Paris. In 1741 he was back in Paris, and the following year the terracotta *Mercury* [137], now in New York, destined to be the preparatory model for Pigalle's *morceau de réception*, was exhibited at the Salon. Two years later he presented the marble version (Louvre) [138], to the Académie and became instantly famous. He received a royal command for large-scale marble versions of this and its pendant, a *Venus*, which the king was to despatch to Frederick the Great. But the *Mercury*'s fame was not connected with that, and indeed the large-scale marble is of diminished power, just as the marble reception piece is itself a less impulsive and dynamic object than the preliminary terracotta.

All Pigalle's art seems concentrated in this. There is a concentration of form, allied with the concentrated pose in which strength is held in potentiality; Mercury is the perfect allegory of speed and power, and though, when Pigalle added *Venus*, he attempted to tell a story, the statue is basically sufficient by itself. It is not a narrative of the kind displayed in the bravura of Falconet's nearly contemporary *Milo*, but the expression of all those qualities associated with Mercury. As has been suggested, the brilliant pose – worthy to have derived from Rubens – may well derive from Jordaens;[34] but it was a pose Jordaens had used for Mercury slaying Argus, whereas Pigalle retains the crouching pose and keen gaze as inherent in the concept 'Mercury', illustrating simply his character. The action of tying the sandal hardly matters; what is supremely summed up in the work is a sense of coiled power – the potential to take off which is locked inside the medium but communicates a vibrating sense of energy to the boldly-handled surfaces. The forms seem to relate to each other through a series of exciting, bumpy transitions – where the sculptor's ability as a modeller is felt – which flow together more gracefully in the marble but less forcefully. The rough, uneven contour of the hat brim in the terracotta version is not only closer to Jordaens' treatment but has a vigour which

138. Jean-Baptiste Pigalle: *Mercury* (marble), 1744. Paris, Louvre

is smoothed away in the neat outline of the marble hat, under which too the hair has become more prominent, softening the original pulled-down effect which was part of its unconventional power.

Less literate and less pugnaciously a 'character', Pigalle was as much as Falconet unconventional by nature and perhaps *au fond* more stubborn in pursuit of his aims – both in life and art. His own self-portrait bust of 1780 (Louvre) [139] has a

busts of *Louis XV* and *Madame de Pompadour*, allegorical statues, a white and black marble crucifix for the dauphin, and finally the Saxe monument. It was in the statues for Madame de Pompadour that Pigalle came closest to comparisons with Falconet, and it was there also that he came closest to surrendering his own stylistic preferences. Several of the statues included her portrait in allegorical guise and more attractively than in the straightforward bust of her

139. Jean-Baptiste Pigalle: *Self-portrait bust*, 1780. Paris, Louvre

140. Jean-Baptiste Pigalle: *L'Enfant à la cage*, 1750. Paris, Louvre

heavy authority along with its pungent self-awareness. It is a face the very opposite of the mercurial, mischievous mask of Falconet; what in him was a biting quality of mind was in Pigalle a growling, bear-like tenacity. It is sufficient to instance Pigalle's obstinate refusal to change his Cupid on the Saxe monument into a genius of war; he appeared to yield, but finally left it, as he had always intended, a Cupid. Inevitably, Pigalle and Falconet ask to be compared; like Turner and Constable, or like Dickens and Thackeray, they share similarities for all their individual differences. They remain of their period, and in Madame de Pompadour they shared a patron.

In the years immediately following on the success of the *Mercury* Pigalle was to be very fully employed by the Marquise and by the Crown. No other sculptor received such a rich share of important commissions; they included portrait

(1748–51, Metropolitan Museum) which is strangely waxen and impersonal. The much weathered but still tender *Love and Friendship embracing* (Louvre, signed and dated 1758) is probably the most ambitious of her commissions to Pigalle – apart from the *Education of Cupid* group, never executed on a large scale in marble. The *Love and Friendship*, for all its allegorical theme, has a naturalness that is maternal rather than anacreontic; it is conceived in terms of realism rather than prettiness. The pose of *Friendship* must always have seemed rather awkward, but the *Love* has still a childlike vivacious appeal, and originally its modelling must have added to the effect.[35]

Pigalle had already revealed in the marvellously studied, unsentimentalized *Enfant à la cage* (Louvre) [140] how brilliantly he could convey not only infant flesh but even infant character. An actual portrait of the one-year-old son

of Pâris de Montmartel, it appeared at the Salon of 1750, and its popularity was so great that it nearly eclipsed that of the *Mercury*. This was Pigalle's first essay in what was almost a new genre, or rather a return to the antique Roman type of statues of children. Pigalle's statue became in fact a pendant to an antique one presumably already owned by the financier, of a child holding a bird. The statue's success led to its being duplicated and much copied, and Pigalle himself returned once or twice to the theme of children, now sitting, now standing, usually with fruit or a bird. They may be charming, but they seem separated from the first and most famous example by its pronounced, idiosyncratic portrait air. It is resolutely ungraceful and unidealized; indeed, it is, just as much as the *Voltaire nu*, the result of obsessive truth to nature. Although it has been claimed to possess 'une grâce alexandrine', it is distinguished from so many children and cupids and putti of the century exactly by its lack of that sophisticated air. Pigalle seems to have recognized its worth by buying it back later for much more than he had been paid; it was in his studio at his death and was the most highly valued of all the sculpture he then possessed.

Its public success was due to its having been exhibited at the Salon, but Pigalle was never to exhibit there again after 1753. Although he did execute a few small-scale decorative works, he left to Falconet the vogue for statuettes like the *Baigneuse* and the *Pygmalion*, and turned to the sequence of large-scale monuments by which he is best known. Yet he also found time to execute some busts, chiefly of writers and doctors – significantly not courtiers but people who had thought and worked, and who often were his friends. Technically less dazzling than Lemoyne's busts, or Caffiéri's, they seem the result of profounder sympathies: personalities that had stirred Pigalle by some affinity with his own. There is never any virtuoso display, either in the costume or the sculptor's treatment of it; the neck and shoulders are treated with sobriety and the face too is sober, unsmiling, usually somewhat tense. The terracotta *Desfriches* (Orléans) [141] is probably the most outstanding achievement in its sim-plicity and worried lifelikeness. The physiognomy of this *amateur*, friend of Pigalle and Cochin, has a resemblance to Pigalle's own; it gives the same sense too of life's pressure upon the features, and all the working of the clay expresses the tensions which have gone to shape the exposed flesh, marked by lines about the mouth and heavy-lidded eyes. There is something naked and vulnerable about the effect which makes it moving.

But it is, finally, Pigalle's monumental art which raises him above his contemporaries and which illustrates also royal and official confidence in him. In 1750 Madame de Pompadour commissioned from him a full-length statue of the king and, though this was not completed until 1754, it may have combined with his other court work to gain him the Marshal Saxe commission which was confirmed early in 1753. Though Lépicié, secretary of the Académie, had proposed Coustou, it was Pigalle whom the young Vandières (not yet Marquis de Marigny) announced as chosen by the king. The resulting task was to occupy more than twenty years of Pigalle's career and is best considered outside the context of the rest of his work. But, once given, the commission singled out Pigalle as potentially the greatest sculptor in France.

It led to him receiving the commission from the city of

141. Jean-Baptiste Pigalle: *Thomas-Aignan Desfriches*. Orléans, Musée des Beaux-Arts

Reims for the monument to Louis XV, preferred to the ageing Lambert-Sigisbert Adam and to the Caylus protégé, Vassé. In turn, the success of the Reims monument prompted Bouchardon to select him to finish the monument to Louis XV for Paris. In addition, Pigalle executed the statue of *Voltaire* (Paris, Institut) that had been commissioned by Madame Necker's circle in 1770 and which never found a public site, and also the confusedly sentimental tomb of Claude-Henry d'Harcourt, set up by his widow at Notre-Dame. To these actual works can be added two other monuments projected but never executed, the *Joan of Arc* for Orléans, which was to consist of two figures in bronze, and the grandiose plan for the Place Royale at Montpellier, which was to have four groups of *grand siècle* personages surrounding the equestrian statue of Louis XIV.

In each of these cases Pigalle produced new solutions: shocking people by the novelty of the *Voltaire*, which became, and has remained, something of an embarrassment. In the Harcourt monument, where he was tied by the widow's elaborate programme of conjugal reunion, there is an unexpectedly neo-classical, *larmoyant* tendency. That is his

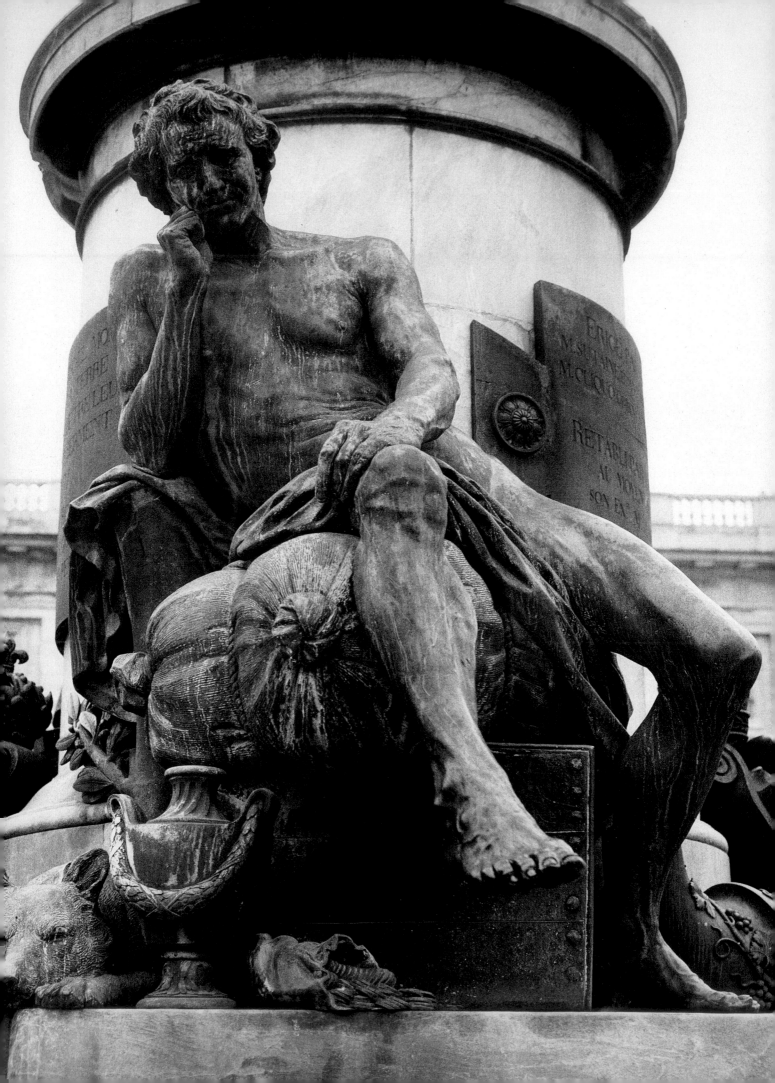

last large-scale monument and in its execution shows no diminution of the high competence which characterized his handling of marble. Even if the programme of the monument was devised by the sorrowing widow, the result remains strikingly novel. It is a completely dramatic illustration of the same sentiment that had been commemorated less effectively in Coustou's monument to the dauphin – that too originally intended to immortalize marital devotion.

The novelty of the monument to Louis XV set up in the Place Royale at Reims was entirely Pigalle's own, and he set his personal seal upon it by including himself on the monument. The concept put forward by Adam was completely rejected – as completely as was Adam's choice of medium; instead of lead statues of the king in coronation robes, with Minerva and Remus (an allusion to the city of Reims), Pigalle executed in bronze the king clad in Roman military costume but with arm benevolently extended – 'pour prendre le peuple sous sa protection', said the sculptor. This theme of benevolence guided him in the figures below, also of bronze: not the conventional slaves signifying a conqueror which, as he pointed out, had been stigmatized by Voltaire, but emblematic figures of mild government and of a contented nation.[36] The latter was symbolized by a citizen [142] who is a portrait of Pigalle. While the woman who leads a tame lion, symbolizing France, is a rather trite and unconvincing piece of allegory, the *Citizen* is a powerfully modelled figure, admittedly in mood more like Rodin's *Penseur* than a happy man, which suggests the influence not of the antique, nor Bernini, but Michelangelo. The figure has a brooding, timeless, sense which lifts it out of all associations with the allegorical luggage around it, and with the rest of the monument. It is an enlightened reply to the chained slaves at the base of Desjardins' *Louis XIV*; yet, as it gazes out, uneasily posed, it seems to embody not so much exhilaration in liberty but awareness of the responsibilities that liberty brings.

Although the *Citizen* is individually memorable, and perhaps magnificent, the Reims monument must always have failed to make a single, coherent effect. It is doubtful if even the original statue of the king was satisfactory – the position of the feet in Moitte's engraving suggests a penguin rather than a man – and it was singularly detached from the huge allegories at its base. The ideas Pigalle was trying to express were not totally suited to a royal monument, not even one raised to the 'best of kings'.

In both the Reims monument, completed in 1765, and the quite different Harcourt one, of some ten years later, there is a tendency for the parts to be more effective than the whole. One of the achievements of the Saxe monument is that – at last, one is tempted to say – execution is matched by successful invention; the parts cohere into a striking whole, unique in its tremendous power [143]. Yet the concept is in fact the earliest of Pigalle's large-scale monuments. The king had selected and approved the design by 19 March 1753 and the model was completed by 1756, though another twenty

years were to pass before the final monument was inaugurated under Louis XVI. Even here the ultimate coherence of the design and the effect from which it gains so much – came almost by chance. Pigalle had planned the marshal looking away to the left at the symbols of his defeated enemies; and it was a court suggestion, transmitted by Vandières, which proposed instead his gazing, 'avec la même fierté', at Death.[37]

Maurice de Saxe, bastard of the elector of Saxony, marshal of France, brilliant soldier and victor above all of Fontenoy, had died prematurely at his château of Chambord on 30 November 1750. If the death of the aged Cardinal Fleury, seven years previously, had caused little grief except to the king and perhaps some far-sighted pacific spirits, the death of Saxe stirred all those associations of military glory and bellicose France which still continue to haunt that nation. Between Louis XIV and Napoleon there was Saxe; he gave a heroic tone to an essentially unheroic, but intelligent, age; and the widespread grief at his death was sincere, deepened yet further by his repute as lover as well as soldier. It was indeed his boudoir victories which had hastened his death. Although he died comparatively young he was, as well as great in himself, a link with the great past. As a boy he had been present at Mons and Malplaquet; he had served under Peter the Great; for him the title of 'Marshal General' had been revived, not having been used for anyone since Turenne.

All these considerations are relevant to Pigalle's eventual concept; and several of them were to find expression in his monument. He had read Voltaire's *Siècle de Louis XIV* and studied the monument to Turenne (then at Saint-Denis) which he thought a poor tribute to a great soldier. Originally he planned two different designs for the Saxe tomb: one expressed the sense of his country's grief, and showed the hero dying in the arms of France – a clear echo of Girardon's Richelieu tomb – while the other emphasized the heroic rather than the pathetic. It was the latter the king chose. The marshal stands; even at the moment of death he seems invincible, and the proud isolation of the standing figure against the pyramid is the first and literally arresting effect of the monument.

Just as chance played its part in the marshal's pose, so chance governed the site of the tomb. Being Protestant, Saxe could not be buried in Notre-Dame or at Saint-Denis. Saint-Thomas at Strasbourg was chosen as a Protestant church on French soil, and reduced to being in effect a temple around the Saxe shrine, in a way that would not have been possible in either of the more important buildings. Alterations to the choir, re-arrangement of the windows, were made to achieve the concentrated central effect: the main door opens to reveal the well-lit monument filling the space of the apse. It can be approached only frontally – and its impact is increased by the movement of the figures towards the spectator, away from the wall. Pigalle has rejected the proscenium frame concept of Slodtz and Adam, in which the figures tended to be bas-relief-like, however fully modelled, and replaced it by a totally three-dimensional sense of the scene acted out in depth on different levels that descend towards us [145]. This sense is further increased by the powerful cutting of the marble, with its tremendous folds of thick drapery, manifested at its most powerful perhaps in the shrouded figure of Death [144]. Pigalle has conceived this with no gesticulating rhetoric,

142. Jean-Baptiste Pigalle: *Monument to Louis XV*. Detail. Reims, Place Royale

143. Jean-Baptiste Pigalle: *Monument to the Maréchal de Saxe*, designed 1753. Strasbourg, Saint-Thomas

144. Jean-Baptiste Pigalle: *Monument to the Maréchal de Saxe*. Detail, *Death*

145. Jean-Baptiste Pigalle: *Monument to the Maréchal de Saxe*. Detail

making it instead a compact and intensely sombre shape – inevitable mirror image of what even the heroic Saxe shall soon be. The weeping Hercules is conventional by comparison; and the animals symbolic of defeated countries are, like the huge standards, so many rhetorical flourishes which only decorate the main theme – the actual drama – of Death and the Marshal.

For the final stark but superb effect comes from Pigalle's concentration on that encounter, with scarcely any mitigating suggestions of Christian resurrection or immortality.[38] The opened tomb is there before us and cannot be avoided. But Saxe does not deign to glance at it; he steps forward at Death's summons, hardly restrained even momentarily by the imploring figure of France who vainly intercedes for him. He goes to death like Regulus back to Carthage, as calmly as if, in Horace's words, 'tendens Venafranos in agros', but with the panache of his own century. His bravery consists exactly in facing the reality of death, in gallantly setting forward for a battle that is already lost.

This is only one way in which he anticipates another fighting lover, Mozart's Don Giovanni. Dissoluteness and bravery excite a sort of envy. When carried to the extremes of a Saxe or a Don Giovanni they lead to premature death and the retribution which is almost the same thing: 'Ho fermo il cor in petto/non ho timor, verrò.' Sculptor and composer both turn back to the Baroque for their treatment of the one subject that even the Enlightenment could not wholly rationalize. The honesty which runs throughout Pigalle's work is seen here at its most impressive, in the very place where the subject might tempt an artist to hyperbole. But Pigalle emphasizes *la condition humaine* which controls the hero as much as the ordinary man; the greatest glory ends in death. Even while recognizing this, Pigalle's Marshal Saxe re-mains also a character, a definite portrait not in generalized robes but positive armour, and set within a truthful perspective. When d'Angiviller commissioned statues of great men from several sculptors, Pigalle did not apply for a commission. In the monument to Marshal Saxe he had already created his concept of a great man – on an unparalleled scale.

BOUDARD, CAFFIÉRI,
TASSAERT, LECOMTE, MIGNOT,
DEFERNEX, ATTIRET

The second half of the century was rich in competence as well as genius; indeed, Patte declared in 1765 'les progrès de la sculpture au jugement des connoisseurs, passent pour être supérieurs à ceux de la peinture'.[39] There is a positively embarrassing choice of lesser sculptors who remain basically unoriginal but usually proficient. Few of them, however, were to prove very successful in working on a monumental scale – even when they were anxious to do so. The best that was produced therefore was some graceful, charming, decorative sculpture, often rather insipid, and many highly competent portrait busts. Several of these sculptors were outside the established circle of the Académie royale at Paris; thus Defernex belonged to the Academy of St Luke and was patronized by the Orléans faction, and Attiret, also a member of that academy, was active largely in Burgundy.

There were also other French sculptors who found employment largely outside France, among them Jean-Baptiste Boudard (1710–68), who settled successfully at the highly Frenchified court of Parma.[40] He had been a contemporary of Bouchardon and Slodtz at the French Academy in Rome, and after a period in Lyon went to Parma where he held the post of professor of sculpture at the local academy. For the city and court he produced some decorative work and several busts. Among the less grand but vivid of these is the terracotta of the Abbé Frugoni [146] of 1764, a bust worthy of Lemoyne in its frank, fleshy, and unidealized characterization, suggestive of an abbé more spirited than spiritual.

In France these middle years were awkward ones, marked by a slackening of artistic energy, a dissatisfaction with the verve and *manière* of the first part of the century, and an uncertainty which preceded the more 'engaged' discipline which involved the neo-classical. Meanwhile, an artist was safest in being natural and true, taking little imaginative

risk. It is no accident that the most successful category was 'natural' portraiture, acceptable to all ranks of society, and always saved by being a good likeness even when not very interesting art. Lemoyne went on exhibiting at the Salon up to 1771 and his influence remained potent. But aimlessness and lack of any definite style are most clearly revealed in the best known, if not in fact the best, of these sculptors, Pajou: drifting on the currents now of the Baroque, now the neo-classical, with no more difficulty than he had in serving first the king and then the Revolution.

It was to give sculpture a purpose, to revitalize the country with a tonic both artistic and moral, that d'Angiviller conceived the series of statues of the great men of France, the first group executed in 1777. The scheme is as much conscious reform as were the efforts at fiscal reform under Louis XVI, and no more successful, despite some individual achievements. The best of Pajou's work cannot be said to be his contributions to the series, and the same is yet more strikingly true of Caffiéri. It was genius which counted, and the unexpected success of the series as executed is Clodion's *Montesquieu* – showing also that genius needs no rules. Its energy can triumph when lesser talents are infected with a general lassitude.

Jean-Jacques Caffiéri cannot, however, be accused of any lack of vitality, either in life or art. In neither did he fully

146. Jean-Baptiste Boudard: *Bust of the Abbé Frugoni*, 1764. Parma, Accademia di Belle Arti

147. Jean-Jacques Caffiéri: *Bust of Jean de Rotrou*, 1783.
Paris, Comédie Française

succeed in directing the vitality to achieve his ambitions; he never gained the Saint-Michel, never executed the statue of his ancestor Lebrun which he proposed, and in Houdon encountered a rival who has triumphed only too well over him posthumously. Caffiéri's portrait busts can be stunning, but almost too virtuoso in effect. He is virtually a Liszt of sculptors, never quite receiving his due through some inherent suspicion of his sheer brilliance. Perhaps it was because he felt the reserve – which over his *Molière* became open criticism – that he gave so much time to pushing his career, his work, his gifts, his wishes for place and ennoblement, and left posterity an entertaining and sad correspondence which is an undoubted tribute to his persistence. In Caffiéri there was a strong aggressive strain, neatly and eternally sidestepped by d'Angiviller as Directeur des Bâtiments and recipient of the sculptor's letters and memoranda. It is not too much to detect the same aggression in Caffiéri's work, especially the trick of tilting the heads in his portraiture to give a challenging air, investing them with a rather insolent pride very different from his master Lemoyne's busts.

Caffiéri was born in 1725, son of the outstanding *fondeur-ciseleur* Jacques Caffiéri, and thus a member of that famous family who descended from 'one of the most ancient and honourable families in the kingdom of Naples' (in Caffiéri's own words), brought to France by Mazarin.[41] As the sculptor counted it in 1787, it represented one hundred and twenty-seven years zealous service for the arts and the Crown. His grandfather, Philippe, had indeed been Sculpteur du Roi under Louis XIV; his father was much employed by the Bâtiments and also executed some portraits in bronze, and Jean-Jacques was trained first by him. Something of his Rococo audacity passed to the son, who was exclusively a sculptor, chiefly in marble. After training with his father he worked under Lemoyne, for whom he retained affectionate respect, a fact the more noteworthy as in general Caffiéri was openly scornful of fellow sculptors.

From Lemoyne he must have learned a technical dexterity which sharpened his natural gift for portraiture – and it was there that Caffiéri's talent lay – but it may be doubted if he had, or could acquire, Lemoyne's natural sympathy with his sitters. It is perhaps significant that one of Caffiéri's finest busts is the *Jean de Rotrou* (1783, Comédie Française) [147], a poet who had died before the sculptor's grandfather reached France; Caffiéri's particular brilliance lay in such animating of the faces of the past. In the case of the Rotrou bust he worked from a painted portrait. He himself had a special interest in collecting the likenesses of great artists, whether painted or carved or modelled, and was constantly offering the Académie engravings, marbles, and especially casts of, among others, Raphael, Rubens, Pietro da Cortona, Watteau, Bernini, and even Andrea del Sarto and Dürer.

Even before going to Rome he had revealed his ability in the bust of *Languet de Gergy* (Musée de Dijon) which was executed from life in 1748, the year that Caffiéri won first prize as a pupil at the Académie. From 1749 to 1753 he was in Rome, where he executed the stucco group of the Trinity above the high altar in San Luigi dei Francesi, stigmatized by Natoire as revealing the sculptor's lack of study of the antique but accorded papal approval. In fact, the antique was hardly relevant to what was virtually a modelled 'glory' in Italian Baroque style. Caffiéri was doubtless more interested in modern Rome, and part of his time there must have been spent in taking casts of the busts on various funerary monuments as well as executing some portrait busts of living sitters – including Benedict XIV. Already he was noted as 'entêté et difficile à gouverner'; and already his ambitious projects were collapsing, like the proposal for him to execute statues at Caserta.

Though later to be touched, somewhat unexpectedly, by fashionable sentimentalism, he remained basically a Baroque sculptor and his *morceau de réception*, the almost awkwardly vigorous *River* (Louvre) [148], shows his true character. The terracotta model appeared at the Salon in 1757, the first to which Caffiéri contributed, with a dazzling array of work in all categories. His facility was proclaimed, and in the following thirty years he was to be considerably employed, by the Crown for the Invalides, as well as for the 'grands hommes' series, by Madame du Barry, and – most memorably – by the Comédie Française on busts of

148. Jean-Jacques Caffiéri: *A River*, 1759. Paris, Louvre

dramatists. In the midst of letter-writing, pleas for pensions, complaints about lodgings, Caffiéri continued to press for further commissions from the Crown, itself none too firmly placed after the fall of the Bastille. He remained devoted to this source of patronage and as late as 1791 was writing directly to the king urging the commissioning of a statue of Lebrun. His persistence was strangely removed from political facts. Within six months of Caffiéri's death in 1792 Louis XVI was tried and condemned to the guillotine. It was almost a double event which ended the Caffiéri and the royal family they had long served.

Caffiéri's finest work was not produced for either Louis XVI or Louis XV. His bravura and panache were better suited to the world of the theatre; his busts are portraits conceived very much as 'characters', and this sense is enhanced by the virtuoso details of costume. Madame du Barry fits into this atmosphere well enough. Caffiéri's marble bust of her (Hermitage) [149] is much more showy than Pajou's, typically more assertive, and almost the rendering of an actress posing as a courtesan: her breasts pointing through the silky, lace-bordered, slipping drapery, and a garland of roses cascading over her shoulder. The handling of the lace is brilliant; that of the over-blown peony-like flowers more brilliant still, reminding one that Caffiéri executed a complete marble bouquet (exhibited at the Salon in 1781) which he later offered to Louis XVI. All Caffiéri's sitters seem fully conscious of who they are, and his portraits of great people from the past are especially marked by this – seldom more impressively than in the *Rotrou* bust, with its 'Three Musketeers' romantic aura, boldly-handled hair, bare throat, and masterly sweep of cloak seeming to echo the sweeping moustaches.

When he sculpted Molière full length [150] for the 'grands hommes' series, over the years 1784 to 1787, he made a drama out of the seated figure who seems to be actor and director as well as writer of plays: a figure seized as if momentarily, arresting the spectator's attention with that slanted pose and gesticulating left hand. At the same time Caffiéri took typical pains with the likeness. The Salon *livret* of 1787, when the full-length marble was exhibited, noted that the head was 'd'après un portrait peint par Pierre Mignard ...'. It is part of Caffiéri's wide range that he responded to personality and character equally when sculpting contemporaries, shrewdly capturing the physical appearance of men like Rameau or Favart, and the memorable *bon-homme* Pingré (Louvre) in his many-pleated surplice. It is with busts like these that he comes closest to Lemoyne; he is a master, one probably undervalued, of what might be termed enhanced realism. The milieu in which he is artistically at home is one of professional men – Mesmer, Rousseau, Benjamin Franklin, and Helvétius [151]. He executed several busts of Helvétius, all apparently posthumously of the sitter – which would scarcely be guessed from the impressive terracotta, at once acute and sensitive in its response to features which seem moulded by life and by the mind. The character suggested is complex, and that is true enough of the subject.

But some of these sitters, inclusive of Molière, were to be portrayed at least as successfully by Houdon, working with more thought perhaps and less instinct. Inevitably, Caffiéri and he were rivals, and Caffiéri must certainly have felt the

149. Jean-Jacques Caffiéri: *Madame du Barry*. St Petersburg, Hermitage

sting of challenge offered by the much younger man, himself capable of virtuoso effects, brilliant lifelikeness, and impressive characterization. Yet the comparison, if a comparison still has to be made, is not all to Caffiéri's disadvantage. His ability to astonish is a thoroughly eighteenth-century gift. If his effects tend to be meretricious, they are dazzlingly fluent at first sight. Indeed, at their best his portraits confront one with the startling sensation of

151. Jean-Jacques Caffiéri: *Bust of Helvétius*, 1772. New York, Metropolitan Museum of Art, Gift of Mr and Mrs Charles Wrightsman, 1973

The elder and less interesting of the two sculptors was Jean-Pierre-Antoine Tassaert (1727–88), son of the Flemish sculptor Felix Tassaert and nephew of the painter Jean-Pierre Tassaert.[44] He was born in Antwerp but went to Paris when young and became a pupil of Michel-Ange Slodtz. Only after Slodtz' death in 1764 did he emerge as a figure in his own right. His career in France was brief, for in 1774 he succeeded one of Clodion's brothers as court sculptor to Frederick the Great at Berlin. As well as decorative sculpture for Potsdam, he produced the *Catherine the Great as Minerva Protectress of the Arts* (Hermitage) [152], a work more Flemish than French in its somewhat confused and untidy Baroque idiom, and altogether somewhat old-fashioned. The child symbolizing Painting is perhaps the most accomplished aspect of it.

Félix Lecomte (1737–1817) was a much more prominent artist, surviving into the Napoleonic era and elected a member of the Institut in 1810. He was patronized by the court in the late years of the *ancien régime*, executed the tomb of Terray, and received commissions for the 'grands hommes' series. He was the pupil of Falconet and Vassé, with Vassé's influence predominating, not surprisingly for a sculptor who was to execute the tombs at Nancy which Vassé had designed. It was Vassé's influence presumably that led him towards a form of neo-classicism. Lecomte's reception piece, *Phorbas and Oedipus* (signed and dated 1771, Louvre), suggests by its subject alone something of the new climate and places the sculptor alongside such committed figures as Chaudet and Chinard.

having been abruptly unveiled: they throw back at the spectator a supercharged vital gaze, as impressive as that of the sculptor himself in Wertmüller's sumptuous portrait where Caffiéri stands, very much *en grande tenue*, waiting only to be adorned with the cordon of the Saint-Michel which never came.[42]

Among Caffiéri's decorative work is the group of children symbolizing – just – *Geometry and Architecture* (signed and dated 1776, Waddesdon Manor) [153], which was one of four groups of the arts executed for the Abbé Terray, and probably commissioned during the abbé's brief period as Directeur des Bâtiments.[43] Each group was by a different sculptor, though the resulting pieces are homogeneous in style and indeed represent the culmination of sculpture in a private setting, yet not on a miniature scale, playful, graceful, and decorative. Clodion contributed the *Music and Poetry* (Washington, Kress Collection). The two other groups, *Painting and Sculpture* (Kress Collection) and *Astronomy and Geography* (Waddesdon Manor), were respectively by Tassaert and Lecomte [cf. 154].

152. Jean-Pierre-Antoine Tassaert: *Catherine the Great as Minerva*. St Petersburg, Hermitage

150. Jean-Jacques Caffiéri: *Molière*, 1787. Paris, Comédie Française

153. Jean-Jacques Caffiéri: *Geometry and Architecture*, 1776. Waddesdon Manor (National Trust)

154. Félix Lecomte: *Astronomy and Geography*, 1778. Waddesdon Manor (National Trust)

His *Astronomy and Geography* (Waddesdon Manor) [154] are fully modelled but seem lacking in energy, even allowing for Astronomy conceived as reclining, gazing skywards; and the two figures fail to compose into a single, integrated group. For the 'grands hommes' Lecomte executed first *Fénelon* (1776–7, Institut); in choosing this subject for him d'Angiviller explained to Pierre that it appeared 'analogue à son caractère ...'[45] Whatever the implied compliment, Lecomte did not receive a second commission until he reminded d'Angiviller in 1785 that he alone of his colleagues was in that position. He was given the subject of the scholar-historian Rollin.

But it is as a sculptor of busts that Lecomte deserves best to be remembered by posterity. Like any artist working as a portraitist, he was partly dependent on the features of his sitters. His terracotta bust of *Holbach* (Hermitage) celebrates a nose to rival the Duke of Wellington's but does justice generally to Holbach's expression of keen intelligence. The impact of the face would actually be greater without the rather fussy, over-emphatic suggestions of costume, and that tends to apply also to the most famous and duplicated of Lecomte's busts, that of *Marie Antoinette* (1783, Versailles) [155]. Looking at once aloof, imperious, and benevolent, the queen is portrayed more truthfully perhaps than in any painted portrait – and not without a definite hint, if a hint discreet compared with Caffiéri's *Madame du Barry*, of feminine allure.

Yet franker femininity exhales from the rather unusual *Sleeping Bacchante* (Birmingham) [156] by the now comparatively obscure Pierre-Philippe Mignot (1715–70), who trained under Lemoyne and Vassé. He was a Parisian, *agréé* at the Académie in 1757 and from then on assiduous for several years as an exhibitor at the Salon. There he showed the *Bacchante* in 1761. To contemporaries there seemed,

155. Félix Lecomte: *Bust of Marie-Antoinette*, 1783. Versailles, Musée National du Château

156. Pierre-Philippe Mignot: *A Sleeping Bacchante*, 1763. Birmingham Museum and Art Gallery

157. Jean-Baptiste Defernex. *Madame Favart*, 1762. Paris, Louvre

according to Diderot, something antique in the effect, though the graceful folds of drapery on which the totally nude figure lies look more neo-classic in a Vassé vein, while the mattress has an obtrusive, 'modern' appearance which rather mars the timelessness.

It is in a humbler sphere that Jean-Baptiste Defernex (1729–83) takes his place. Though he began his career as a modeller at the Sèvres factory, he is best known for his portrait busts which, as they survive, seem more usually of women.[46] The treatment is very simple, almost uncouthly so in comparison with the flash and dazzle of Caffiéri, and there is little attention to costume. Indeed, the busts are seldom more than of head and neck, with rather heavy features and a somewhat lumpish air. They have not only homogeneity but conviction: honest, unidealized, quite free from gallant flattery, they make something of the straightforward effect of Greuze's portraits. Defernex was sculptor to the Duc d'Orléans, and worked at the Palais Royal on some gilded lead groups of children. He was not a member of the Académie royale but belonged to that of St Luke, and himself ran a school for sculpture and drawing where Durameau was to study. Naturally, he received no official commissions for sculpture, and he remains a slightly obscure figure whose early training is not clear. It is easy to see how unfashionable his art would be. It shows a dogged attachment to nature, and in a way this becomes Defernex's style, certainly the hallmark of his portrait busts. All the graces and tender amorous atmosphere that floated about Madame Favart seem dispelled by his convincingly truthful bust of her (1762, Louvre) [157].

158. Claude-François Attiret: 'La Chercheuse d'esprit', 1774. Dijon, Musée des Beaux-Arts

Also from the Academy of St Luke, and also to be connected, however tenuously, with the Favart, was Claude-François Attiret (1728–1804). He was born and died at Dôle. Some of his religious work is in Saint-Bénigne at Dijon, but he is remembered, if at all, by the bust of *La Chercheuse d'esprit* (Dijon) [158], of which the marble was exhibited under this title at the St Luke exhibition in 1774. The title comes from a comic opera by Favart, and it has even been suggested that the *Chercheuse* is Madame Favart, though that is most unlikely. There is something slightly idealized in the bust, which indeed seems hardly to have the air of a portrait.[47] If Defernex represents in sculpture one aspect of Greuze, Attiret suggests another – the more typical one. The bust has a refinement and delicacy of handling, enhanced by the freshness of the terracotta medium, which makes one pardon its slight air of coy consciousness. There is artfulness, as well as art, in its simplicity. This becomes obvious when it is compared with what must have inspired it, Saly's *Head of a Girl* [128], which was too famous and duplicated to have remained unknown to Attiret. Such a comparison emphasizes the idealizing spirit of *La Chercheuse*, which is a clear indication of its date of execution; and in its simplicity and

bland maiden purity there is as much of neo-classicism as of nature.

For all these sculptors, including Caffiéri, the portrait bust offered the most successful results for technical reasons, as well as because of its realistic standard. The problems of organizing a large-scale figure, whether from the Bible or from French history, were considerable; those of a monument even more so. It is significant that Caffiéri's brilliance in bringing to life again faces from the past – in which he was undoubtedly the most gifted of French sculptors – fluctuated somewhat in the full-length statues of Corneille and Molière. Invention of a pose, execution of it, avoidance of the pitfalls both of rhetoric and of dullness, such were qualities taxed to their utmost, especially by the requirements of the series of 'grands hommes'. Above all, the centralizing of sculptors' commissions on the Crown inevitably led to a weakening of effort when the Crown manifested as little personal interest as it did under Louis XVI, who, though eager to reform the court of his grandfather, chose for the sculptor of the first bust of himself as king the very favourite of Madame du Barry, Pajou.

PAJOU

The finest work of art inspired, accidentally, by Louis XVI was the decoration of the opera house at Versailles, executed on the occasion of his marriage as dauphin in 1770, under the direction of Marigny. The sculptural portion of the whole elegant blue and gold ensemble, today restored virtually to its original state, was allotted to Pajou and remains the most attractive monument to his basically thin talents.

Augustin Pajou was born in Paris in 1730, son of a craftsman sculptor who had married the daughter of a yet more obscure sculptor. Though the milieu might be humble, it offered an early useful grounding for the young artist, who then went on to work under Lemoyne. Five years younger than Caffiéri, he was to follow him closely: first with Lemoyne, then at Rome (where at one point it seemed that Pajou too would execute something for San Luigi dei Francesi), and finally back in Paris, working both for the Crown and for Madame du Barry. But Caffiéri seems never to have sensed a hated rival in Pajou – whom indeed it was probably difficult to dislike. All that is known of Pajou's character suggests a docile, industrious, untemperamental man, who remained on affectionate terms with his children even over involved money matters and who was represented by his son (in the year VIII of the Republic) looking remarkably youthful, amiable, and undisturbed by thoughts of any kind.[48] Even his unusual obstinacy in seeking to be paid what he considered the correct amount for his work at Versailles seems to have been stimulated by his wife, who herself wrote several of the begging letters – not only to d'Angiviller but to the Comtesse d'Angiviller – in an affair which dragged on for nineteen years. Content to work for Madame du Barry or for Louis XVI, Pajou was equally content to serve new masters when these persons had been dramatically removed from the scene.

He was the sole sculptor on the committee appointed to organize the National Museum during the Directoire and was particularly concerned with the project of creating a

museum at Versailles. And though his very late sculpture is rather pathetic, he remained active enough to exhibit a bust of *Caesar* (Paris, Palais du Sénat) at the Salon of 1802 – an official command from the Senate, for whom a year later he also produced a plaster full-length *Demosthenes* (Chambre des Députés), one of the series to which Houdon contributed his *Cicero*. Member of the Institut, chevalier of the Légion d'Honneur, he lived on, though he had ceased to work some years before, until 1809, dying in the same year as Vien. He was the most important surviving sculptor from the high years of the eighteenth century; he had won the first prize at the Academy school in 1748, the year of the treaty of Aix-la-Chapelle, and he died only two months before the Battle of Wagram.[49]

Any excitement engendered by great events is banished in Pajou's work, in which the mood is quiescent, tending to lapse into the sentimental and particularly into the inert. To that extent he was – rather like Vien – born orientated towards neo-classicism rather than the Baroque. His training under Lemoyne did little to affect this preference for stillness over movement, and a preference for the linear over the three-dimensional. After Bouchardon he was probably the sculptor who produced the finest drawings in the period.[50] Nor is it any accident that much of his best sculpture is bas-relief; even in fully modelled work his effects are often markedly linear – as, for example, on portrait busts where the pupils of the eye are usually incised very lightly. This aspect of his art was recognized by his appointment as designer to the Académie des Inscriptions on the death of Vassé; for twenty years he was responsible for composing its medals. He was certainly the most suitable sculptor to add figures to Goujon's famous Fontaine des Innocents, and he took particular pains to study Goujon's manner and achieve stylistic harmony.

Drawings are among Pajou's earliest recorded works. Some done at Rome in 1755, while he was still a pensioner at the French Academy, won the approval of Marigny: 'j'y trouve de l'exactitude et de la correction', he wrote with other laudatory phrases. The following year Pajou was back in Paris, with a recommendation from the Abbé Barthélemy to Caylus – a further indication of the direction in which his talent tended. Perhaps the sculptor himself hardly understood this. It is rather typical that his *morceau de réception* of 1760 – with the rare subject of *Pluto holding Cerberus chained* (Louvre) – should be a Baroque essay which suggests direct study of Caffiéri's *River* [148], though it has greater repose. Much closer to Pajou's nature, however, was the marble relief which he showed at the Salon of 1761 with the somewhat unpromising theme of the *Princess of Hesse-Homburg as Minerva consecrating on the Altar of Immortality the Cordon of the Order of St Catherine . . .* (Hermitage) [159].[51] Though the subject might be obscure, Pajou's treatment of it effectively avoids both the ridiculous and the fussy. The execution is of great delicacy, with graceful chiselling of the patterned helmet and the folds of Grecian-style drapery that gently fall about the shoulders. While the bas-relief below is a piece of historical narration, the main portion is composed with deliberate calm, aiming at harmony of line, a sense of interval, and a purity of form, which lift it out of direct association with events in Russia and make it a timeless meditation. The result is obvious pastiche of a classical stele, but the concept

159. Augustin Pajou: *The Princess of Hesse-Homburg as Minerva*, 1761. St Petersburg, Hermitage

and its limitations were exactly suited to Pajou. What he had achieved here in elevated vein was to be repeated, with less constraint and solemnity, at the Versailles opera house.

Like nearly all his fellow sculptors, Pajou was also to be employed as a portraitist; like them he showed his most sustained ability in this category of work. Though he had none of the instinctive empathy of Lemoyne, and even less any of Caffiéri's panache, he was capable of being inspired to fine effect by the right sitter. When his old master Lemoyne sat to him the result was a brilliantly direct, unexpectedly forceful bust (Louvre), made the more striking by the sitter's own memorable physiognomy, but remaining a testimony to the young sculptor's skill.[52] The terracotta is dated 1758 and is therefore one of Pajou's earliest busts; it may perhaps have been executed at Lemoyne's instigation for his ex-pupil to display his ability. It speaks of reciprocal sympathy.

Lemoyne remained interested enough in Pajou to sign the register at the latter's wedding, and it was probably through him that Pajou received the commission for a bust of Louis

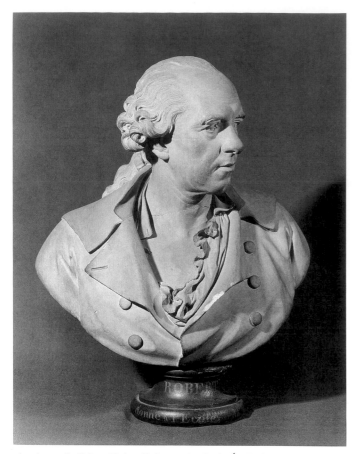

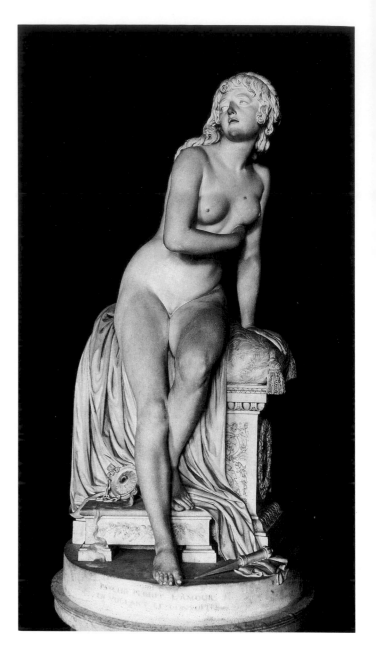

160. Augustin Pajou: *Hubert Robert*, 1789. Paris, École des Beaux-Arts
161. Augustin Pajou: *Psyche abandoned*, completed by 1791. Paris, Louvre

XV. He was to carve likenesses of both Marie Leczinska and the dauphin (a posthumous portrait), but he remained most successful in portraying those people he really knew. The *Hubert Robert* (Paris, École des Beaux-Arts) [160] is the result of friendship and knowledge, as well as talent. It was shown at the Salon of 1789 and represents Pajou's art much better than the busts of Madame du Barry so often associated with him and which brought him particular success. Not only does he idealize and refine in those, but his concept remains commonplace beside Caffiéri's voluptuous, recklessly insolent courtesan. The *Robert* is at once direct and delicate. The painter appears negligent, relaxed, and almost breathlessly alive – the mouth very slightly open, the expression a momentary one, rapidly seized. The delicacy of Pajou's handling is well shown in the treatment of the hair and the lines of hair-like slightness at the corners of the eyes which aid the expressiveness of the face. With the delicacy of observation and execution goes a feeling for the bulk of head and shoulders, an effect enhanced by the broad shape of the lapelled coat with its prominent, plain buttons.

But official commands and his own very variable gifts did not often allow Pajou to create something so effectively simple. The more imaginative the effort required, the more Pajou failed. This did not prevent him from attempting the unfortunate marriage of actual and symbolic which produced

the full-length *Buffon* (1776). He was chief among the sculptors chosen to contribute to the series of great men, and his *Bossuet* (1778–9, Institut), indebted patently to Rigaud's portrait, is highly accomplished, unforceful yet suave, the lace brilliantly treated like carved and pierced ivory. After this the *Turenne* (1782–3, Versailles), more ambitious in intention, is a near disaster, even allowing for its 'troubador' tendencies. Among all his official work there is no doubt that Pajou himself would have singled out the *Psyche* (Louvre) [161] as his major contribution, and in many ways this statue remains most typical of his art, as it is certainly typical of its particular period.

It was a Crown commission, given with the intention of providing a pendant to Bouchardon's *Cupid*. The pose, even the subject, had apparently been left to Pajou's own devising, and in February 1783 he reported to d'Angiviller that he had now conceived a Psyche in the sorrowing attitude of having lost her lover through indiscretion; at her feet would be a

dagger and lamp; and he added that the head 'sera susceptible d'expretion [sic]'.[53] What he finally produced was much praised; yet already at least one critic remarked how ill the *Psyche* matched Bouchardon's statue, in concept alone. Not only does it not form a pendant to his in any way, but it is a sentimental and much softer object, over-insistent in such details as the embroidered cushion and decorated plinth, and slack in its consciously graceful pose of distress; Psyche's timid gesture fails to convince, being evocative not so much of heartache as of heartburn. Pajou seems uncertain of the idiom in which he is working. An air of the neo-classical is superimposed on virtually a Greuzian anecdote; the complete nudity and absence of movement are combined with a tearful appeal to the emotions. Yet without its head the statue would not be expressive of anything. It is simply a dutiful but unexciting study of a tranquil, seated nude. The head is made the expressive centre of the statue and bears a weight of intensity which it cannot properly carry; grief is not allowed to disturb the features out of their decorous unity any more than it had stimulated a gesture beyond that of crossing one arm across the body.

The very theme of a grieving, deserted girl – whether genre or derived from classical mythology – was, not surprisingly, to grow less popular in art, because it had enjoyed a long vogue. In the stirring world of the young Napoleon, and in David's art, the place of women is less important. The *Psyche* marks the end, in enervation, of a typically eighteenth-century fiction; and ultimately its weakness is not the heroine's but Pajou's.

In the opera house at Versailles Pajou was working primarily as a decorator of surfaces – within his own powers, that is – but even here he is less successful when the scale is large. The groups of *Venus* and *Apollo* in the foyer are charming but lacking in some essential rhythm; Apollo's arms are awkwardly articulated and the accomplished gracefulness apparent in the preparatory drawings is replaced by wooden execution – the less pardonable as Pajou was positively working in wood and should have managed to preserve a light touch. It is the gilded bas-reliefs of 1768–70 [162, 163] on the lowest tier of the boxes in the auditorium – also of wood – that best represent his art. There is in these elongated, reclining figures (lapsing into languor, in typical Pajou mood) a hint already of the sculptor's study of sixteenth-century models, notably the achievements of the Fontainebleau School. Delicately incised rocks and trees provide a setting for mannered bodies with rippling draperies and lively companions in the shape of dogs and birds and cupids. Within the regular format Pajou cleverly devised variations, and managed to fill each area satisfactorily but not oppressively; Mars crouches, Diana sleeps, Venus exchanges kisses with a dove, in fluid, thinly modelled, essentially linear designs which perfectly fulfil their purpose. Each panel is separated from the next by blue and gold cameo-style medallions; and the two arcs gracefully curve round the auditorium, with a serpentine line undulating from relief to relief.

It is not great art, but then Pajou is not a great artist. Indeed, he is perhaps most interesting for the period he lived through, his friendship with the architect de Wailly, who built his house, and the artistic problems he embodied. The *élan* and vitality which he did not possess were to enter his life by proxy, as it were, when Clodion became his son-in-law.

162 and 163. Augustin Pajou: Bas-reliefs, 1768–70. Versailles, opera house

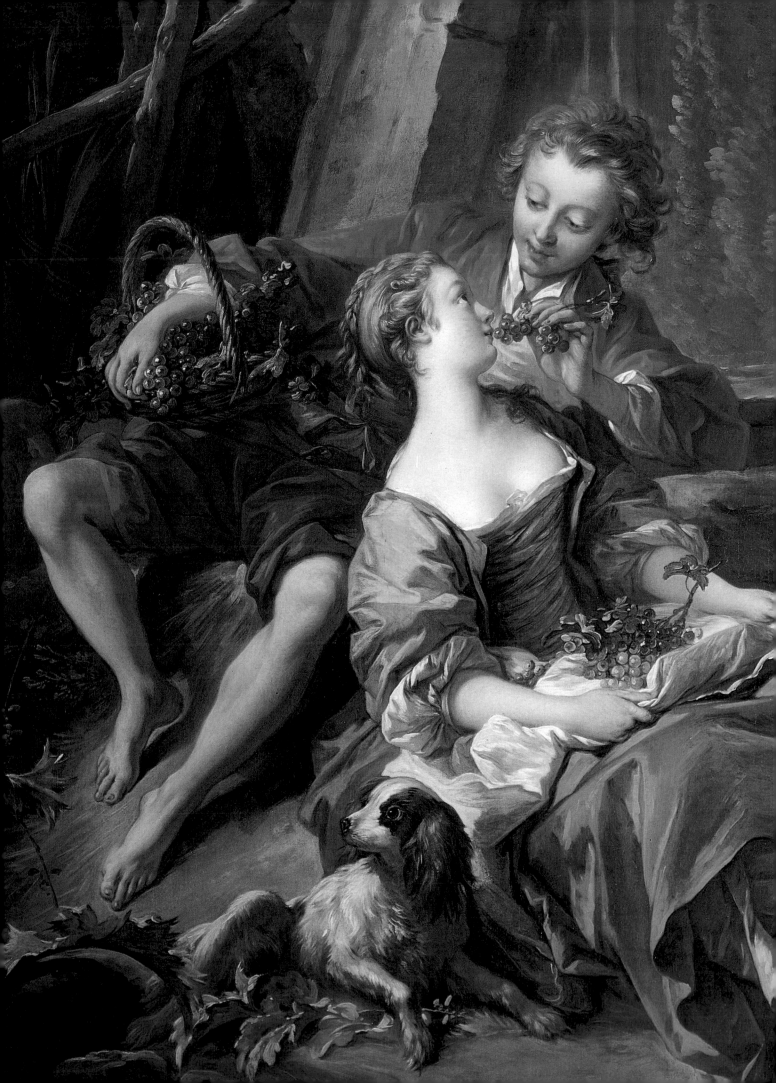

Painting: Up to the Death of Boucher (1770)

INTRODUCTION

The middle years of the century are even more complex to characterize for painting than for sculpture. The medium itself offered greater possibilities of variation, with sometimes a more directly personal response by the artist, and the opportunity too to respond easily – and inexpensively – to a particular patron's wishes. Sculpture has never been a medium which the public can appreciate without difficulty, at least since the Renaissance and outside Italy. The growth of public interest in painting in France in the middle years of the century – an interest which was really more literary than visually artistic – introduced a new social factor. Style became less important than subject-matter; the way was prepared unwittingly for the basic philistinism of Napoleon's patronage, while an obsession with pictures that tell a story virtually shaped the rise and fall of Greuze (who lived to paint the First Consul). At the same time, the stylistic complications are no less real. It must be for each person to decide whether the strictly contemporaneous and successful careers of Chardin and Boucher represent a paradox, or whether the two painters are basically united despite appearances to the contrary; certainly in handling of paint they could scarcely differ more. Yet both the Swedish court and Louis XV owned work by them. Patrons were not always partisans. The last royal purchaser, within the artist's lifetime, of a pungent study by Chardin was Madame Victoire, Louis XV's daughter, who had once been portrayed lightly allegorized into the element of Water by Nattier's brush.

It is also remarkable how certain distinguished and influential painters of a much earlier generation lived on well into the century, bringing with them an air from the *grand siècle*. Watteau's premature death is the more striking against the longevity of Rigaud and Largillierre, the former dying only in 1743, the latter not until 1746, the year in which died also Guillaume Coustou the Elder, equally an echo of the *grand siècle*. And it was Largillierre who had given praise to the young Chardin's work, supporting his candidature at the Académie as warmly as La Fosse had earlier supported Watteau's.

By 1746 the reign of Madame de Pompadour had begun at Versailles. This was to mean more than a new mistress for the king. Probably for the first time in France since Marie de Médicis, a woman was to take a leading part in patronizing the arts. That passion outlasted any passion for the king, and since Madame de Pompadour held her place at Versailles as royal friend long after she had ceased to be Louis XV's mistress, her reign as patron did not stop until her death in 1764. And in 1746 her brother, later the Marquis de Marigny,

was already designated Directeur des Bâtiments to succeed her uncle Lenormant de Tournehem. Marigny retained that post until 1773, the penultimate year of Louis XV's life. Officially and unofficially, brother and sister were – it could be said – the Crown; and they neatly reflect its public and private faces in the ordering of elevated, 'national' work on the one hand and on the other purely pleasurable, decorative pictures.[1] The latter are for ever associated with Boucher, but it must be remembered that he represents only certain aspects of the period.

A much inferior painter, Carle van Loo, was more highly esteemed and remains much more truly typical: the author of history pictures and often vast religious compositions (occasionally royal commands, like the insipid *Sainte Clotilde*, intended for Louis XV's chapel at Choisy) as well as small *galant* mythologies which were sometimes owned by Marigny. Nor did Van Loo become merely Premier Peintre to the king: he was, as Diderot wrote at his death, 'Premier peintre ... aussi de la nation'. Mediocre though Van Loo remained, he was yet active in producing pictures in every category – including portaiture. His timid, nerveless style steers a middle course between the gifted extremes of Boucher and Chardin, or those of Nattier and La Tour; it is indeed typical of a vein of French painting in the years between Watteau and David.

In many ways these were confident years for France, and for painting. Even if one discounts the Dr Pangloss-like euphoria of Patte, who in 1765 found everything – from painting to agriculture – in perfect state under a king who was 'un vrai héros de l'humanité', still there seemed good cause for contentment. The Peace of Aix-la-Chapelle in 1748 was to be celebrated pictorially by Dandré-Bardon in *Louis XV donne la paix à l'Europe ...*'.[2] In 1748 too there was established with royal approval the École royale des élèves protégés, of which Van Loo became governor the following year.[3] This institution started better than it finished; and it is not quite clear how definite its effect was on painting and young painters. Its charter, however, is one more symbol of reforming zeal; the pupils selected were to be given not only art instruction but 'une teinture suffisante de l'histoire, de la fable, de la géographie, et autres connoissances ...'. This is worth emphasizing as the mid century's official aim, another attempt to stop painting from becoming 'errante'.

A further factor was the re-establishment of the Salon, first as an annual and then as a biennial event. Van Loo himself was a considerable exhibitor there. The whole concept of public exhibition – and at first there were also student exhibitions at the École des élèves protégés – introduced a new aspect. Whether works of art were commissioned by the Crown, by the Church, or by rich amateurs, they now underwent also public scrutiny in public exhibitions where they might be praised or blamed. An artist's success thus lay

in more than pleasing a single patron. 'Le public', wrote Dezallier d'Argenville in 1745 (*Abrégé de la vie des peintres*), 'est l'arbitre souverain du mérite et des talents.' Without much pleasure Mariette, himself something of a *grand siècle* echo, connoisseur and collector rather than in any sense an art critic, was to say much the same, speaking of 'le gros public' which delighted in Chardin but had less appreciation of high-style Italianate art. With the establishment of the Salon exhibitions as an event where the public could pass its verbal vote on contemporary art (an ordeal which most painters positively sought, often begging a patron to consent to public exhibition of privately commissioned work), there arose the factor of written criticism of the exhibits, destined for a cultivated public who might however be not collectors or connoisseurs, but simply literate people.[4] The most famous example is, of course, Diderot; but since his criticism was not published at the time its effect was probably very slight compared with what was printed in, for example, the *Mercure de France*. Increasingly, each Salon gave rise to its own cluster of pamphlets, apart from the relevant *livret* itself, which often provided a lengthy explanation of what was depicted. What culminates with Diderot begins with La Font de Saint-Yenne, already criticizing and analysing the current artistic situation in 1747 (*Réflexions sur quelques causes de l'état présent de la peinture en France*). La Font, who published anonymously, created a certain sensation with this brochure; he annoyed several of the artists he criticized (his criticisms being indeed often niggling and unfair) and stimulated some quite sharp replies, e.g. *Lettre sur l'exposition* ... (1747) and *Lettre sur la peinture* ... (1748). His praise was seldom whole-hearted and his writings lack utterly Diderot's response to the phenomenon of art. Obsessed with choice of elevated subject-matter and with the primacy of the history painter ('Le Peintre Historien est seul le Peintre de l'âme, les autres ne peignent que pour le ïeux'), he urged these views yet more strongly in his anonymous *Sentimens sur quelques ouvrages de Peinture, Sculpture et Gravure* (1754), partly also a review of the 1753 Salon. It is, however, not quite true, as is sometimes supposed, that he just complained of degeneracy and languor. The stylistic situation was complex; he himself was perhaps among the last of his century to give extremely high praise to Watteau; and he was warmly appreciative of Vernet and La Tour. As some contemporary critics pointed out, he had scarcely complained of decadence in modern French painting than, in praising numerous individuals, he seemed to argue 'qu'elle y est plus florissante que jamais'.

At what may be reasonably claimed as the very latest manifestation of the artistic tendencies of the middle years of the century, the Salon of 1773 (the last to be held under Marigny and Louis XV), there is apparent a mingling and variety of styles which justify one in emphasizing the complex nature of those years. Van Loo and Boucher were of course dead, but Vien – though not yet Premier Peintre – showed a group of commissioned pictures which in themselves suggest diversity: beginning with a large history picture, *St Louis giving the Regency to his Mother, Blanche of Castille*, one of a series by different painters, destined for the chapel of the École Militaire[5] – a type of national patriotic subject which was to become increasingly common under d'Angiviller's subsequent directorship of the Bâtiments. There were also a couple of essays in Vien's insipidly pretty antique manner (*Two Young Greeks swearing Friendship not Love*; *Two Greek Girls finding Love asleep*), pseudo-chaste and chicly neo-classical for Madame du Barry, who had rejected Fragonard's work. For the king, Rococo in taste until the last, Vien had painted a *Diana and her Nymphs returning from the Chase* ..., intended for the Trianon, and in subject alone sounding like a last graceful evocation of that mythological kingdom where Boucher had once been sovereign. And at this same Salon of 1773, the aged Chardin exhibited *Une Femme qui tire de l'eau à une fontaine*, noted as a repetition of his picture in Sweden – a composition which dated from exactly forty years earlier.

BOUCHER

Whatever historical attention is required by Van Loo, and whatever the variety of other contemporary talents – rising to genius with Chardin – yet the middle years of the century rightly belong to Boucher. No other painter was attacked by Diderot with the vehemence he devoted to diatribes on someone about whom he had to admit 'Cet homme a tout, excepté la vérité' (*Salon* of 1761). There are times when one senses an undercurrent of attraction which Diderot feels he must struggle against – anticipating Baudelaire's equally partisan but more intellectual struggles against the spell of Ingres. If Diderot in 1761 could almost yield ('C'est un vice

164. François Boucher, engraved by L. Cars: *Le Malade imaginaire* (1734). Paris, Bibliothèque Nationale

165. François Boucher: *Madame Boucher* (?), 1743. New York, Frick Collection

si agréable ...' he significantly went on to confess), that is perhaps tribute enough to a painter who has remained misunderstood, though no longer perhaps ridiculed, and who has only recently begun to be appreciated for his true merits. His supposedly frivolous subject-matter has stood in his way ever since his own period. Had he depicted St Louis or Duguesclin he would have had a higher reputation. Although it is no longer obligatory to judge art by Diderot's standard of 'vérité', it happens that there exists a considerable vein of 'vérité' in Boucher's work which is by no means all frivolous, licentious, and meretricious – adjectives which may anyway prove more profoundly applicable to Greuze.

François Boucher was born at Paris in 1703, the son of an obscure painter who apparently recognized very quickly that his son's talents needed a more gifted master. His choice of Lemoyne was perceptive, though it seems to have been true that Lemoyne gave little attention to his pupils. Boucher was to declare that he had not gained much from the few months of his apprenticeship, though he later professed respect for Lemoyne's work. In this, there is probably no paradox. Many of Lemoyne's most sensuous proto-Boucher paintings, such

as the *Hercules and Omphale* (1724, Louvre), date from the period after Boucher had ceased to be his pupil. *Rubénisme* of a kind which included within it Correggio and Veronese was already widespread; Lemoyne was scarcely needed to introduce the style to Boucher.

There was, further, a more significant influence on the young artist – and a more formative activity even than painting. Boucher's speed and dexterity made him early an accomplished draughtsman for book illustrations. He was attracted into the studio-factory organized by the elder Cars, himself an engraver like his better known son. There Boucher learnt to practise engraving as well as drawing. Thus he became a suitable artist to take a major part in Jullienne's publication of the *Œuvre gravé* of Watteau; and perhaps by the early 1720s he was actively involved in this. 'Sa pointe légère et spirituelle', wrote Mariette, 'sembloit faite pour ce travail.'[6] And in many ways Boucher is Watteau's great posthumous pupil: graceful, lively, already enchanted in his view of life, he yet remains natural. How well his basic affinity with Watteau was recognized, even after he had become a famous, established painter, is shown by the description of

166. François Boucher: *La Pêche chinoise*, 1742. Besançon, Musée des Beaux-Arts

him in 1745 (in a 'list of the best painters' drawn up for the Bâtiments): '... Excellant aussy aux paysages, aux bambochades, aux grotesques et ornements dans le goût de Watteau ...'. Indeed, his compositions for, for instance, the beautiful six-volume edition of Molière's work [164] – which was published in 1734 – show a flickering Watteauesque sensitivity of touch, as well as a serious ability to respond fully to details of modern costume, furniture, and setting. Other Boucher drawings – whether figure or landscape studies – often unexpectedly confirm the sheer grasp on reality which under-lay even the most 'false' of his decorative paintings. One thing which is consistent in his work is an emphasis on design, and indeed on *dessin*; his inventive compositions retained coherence until the last years, and throughout his career he preserved an ability to, as it were, sketch in the medium of paint – a gift to be equalled only by Fragonard.

In estimating Boucher's true talents, it is important to realize how little his early work and interests linked him to the decorative tradition represented by the Coypel and Lemoyne.[7] He was more 'modern'. Even before taste had turned against the large-scale architectural decoration which culminated in the Salon d'Hercule at Versailles, Boucher had

tacitly withdrawn into more intimate scale and literally less elevated treatment. Dazzling Italianate decorative *trompe l'œil* was never his; he is much closer to the 'Flemish' School, as interpreted by the eighteenth century. His earliest appearance at the Salon (in 1737) was by 'divers sujets champêtres', and several of the earliest pictures reasonably acceptable as by him confirm this pastoral interest. Thus the influences which conditioned his early work are better represented by such painters as Bloemaert, Berchem,[8] and Castiglione – all influences which, it may be said, continued to condition him. His occasional, sober portraits are another indication of the real nature of his talent; the wonderful and varied series of full-length portraits of Madame de Pompadour – seldom shown without books or music beside her – convey settings as well as the sitter. His graceful transmuting of his childishly pretty wife into goddess or nymph is commonly mentioned; but it needs to be recalled that he also painted an almost satirically pointed portrait of a woman who is probably she, as she and her untidy ambient really were (1743, New York, Frick Collection) [165]. Guided by such evidence, it is possible to see that Boucher was closer to De Troy than to Lemoyne, and that his artistic world was not always totally alien to that of Chardin.

167. François Boucher: *The Triumph of Venus*, 1740. Stockholm, Nationalmuseum

What may well be true is that from the first Boucher had no inborn respect for facts as such. His vernal woods – like the nymphs and shepherdesses who tripped through them – were never intended to teach 'more of ill and good than all the sages can'. It was this sense of moral 'vérité' which was rightly to be detected as lacking in his work. The wish to find such a quality in art is one that did not, however, become urgent until the second half of the century – and then only gradually. It is unfortunate that it should have coincided with Boucher's own declining powers and ability. By the time of Diderot's attacks he was already ill, his eyesight was impaired, and even his remarkable energy had flagged. He struggled on, the 'aged gladiator' of Diderot's last sneers. Many of his late pictures are frankly, sadly, bad. Yet if by 1760 he was a spent furnace, the previous thirty years or so had witnessed him blazing with talent: creator of ravishing landscape paintings and genuinely enchanted pastorals, as well as tapestry and stage designs, portraits, and the finest of those mythological pictures – at once famous and yet little studied – where he did indeed respond to the female nude, in a way unequalled since Rubens and not to be rivalled again until Renoir.

Only a little of this was apparent in Boucher's early work, which strikes one as competent but somewhat lacking in positive direction or emphasis. There is something slightly ludicrous in the very title of the picture with which he won first prize as a student at the Académie in 1723 – so far was this assigned, obscure, biblical subject from Boucher's later tastes: *Evilmerodach, fils et succésseur de Nabuchodonosor, qui délivre des chaînes Joachim que son père avoit tenu captif dix-sept ans*. Yet it was his very competence which triumphed, even in a category of picture to which he probably rarely returned. Although technically a student, Boucher was in fact working as a professional artist, continuing among other activities his engravings for the *Œuvre gravé* of Watteau (his plate after Watteau's self-portrait was frontispiece for the first volume, published in 1726). There is a certain obscurity about Boucher's life in these years. Although he went to Italy in the spring of 1728, in the company of the young Carle van Loo, he seems not to have been a full pensioner at the Rome Academy despite being accommodated there by Vleughels in 'a little hole of a room'. The description is Vleughels' own, as is that which qualifies the young artist at the same time as 'de beaucoup de mérite'. No facts have come to light about

Boucher's stay in Italy, but it is likely that he spent no less than three years there – not necessarily all at Rome – and he was certainly back in Paris by 24 November 1731, when *agréé* at the Académie.

It remains difficult to decide what effect Italy had on Boucher's art, and when the Goncourt wrote, they could speedily glide over the whole problem. There can be little doubt that he must have responded to work by such painters as Pietro da Cortona, though Cortona's work need not have come as a revelation. Although it is sometimes said that Boucher admired Tiepolo, it remains uncertain what Tiepolo paintings he could then have seen, and even more uncertain whether he would have admired Tiepolo's style in the decade 1720–30. Boucher's links with Venetian art remains at best tenuous. It is much more likely that he was affected by the Franco-Italian Rococo style fostered at Rome and especially at Turin,[9] well represented by, for example, Beaumont; that Beaumont was living in Rome during the years 1723–31, and that Carle van Loo was in the same period working under Luti, are probably more significant pointers to the atmosphere in which he moved and worked. In a more allusive way too Italy affected Boucher, whose landscapes often have echoes of an Arcadian Italy, recollected at a distance in tranquillity, with ruined temples and blue mountains. These recollections are not derived from secondary pictorial sources but, sometimes at least, from actual observations on the spot: amid French eighteenth-century catalogue references to Roman views by Boucher is one of 1781 (Sireuil sale) where a view of the *Temple of Concord* is noted as painted at Rome.

With Boucher's return to France his public career began. He was never to be idle; and even his death occurred in his studio in front of a fresh, unfinished painting. An echo of Lemoyne is still apparent in the *Rinaldo and Armida* (Louvre) of 1734, his *morceau de réception*, though already the piquant Armida indicates what was to be his main theme. His decorative gifts were quickly made use of – by, among others, Marie Leczinska for her apartments at Versailles, long before Madame de Pompadour had arrived on the scene. Equally he had, before her arrival, worked for the king. He was employed on stage designs for the Opéra, and was associated with Oudry in tapestry design for the Beauvais factory. It was for Beauvais that he produced his enchanting 'sujets chinois' (sketches at Besançon), decorative, flippant, and deft: presenting a sort of Cloud-Cuckoo China, with palm trees, doll-like people, feathery hats, and a mass of properties such as fans, parasols, guitars – suggesting a generalized, amusing exoticism – all executed with a lively touch. It is hard to single out any of this delightful set (all exhibited as sketches at the Salon of 1742), but *La Pêche chinoise.* [166] has extraordinary artistic conviction, showing how powerful was Boucher's imagination. Yet he remained only one of the painters at the period specializing in decorative, lightly erotic subjects. Employed about 1736 on the decorative schemes for Boffrand's newly designed apartments at the Hôtel de Soubise, he shared the commission with such close contemporaries – virtually rivals – as Natoire, Carle van Loo, and Trémolières.[10] Nor can it be pretended that stylistically Boucher's paintings differ drastically from theirs, though the quality is usually notably higher.

In the years that followed there were to be few dramatic changes in either his style or his career. The favour of Madame de Pompadour gave him, it is true, particular opportunities for the exercise of his talent, yet what is certainly one of his very finest pictures, the *Triumph of Venus* (Stockholm) [167], dates from 1740 – five years before Madame de Pompadour met the king. That painting is arguably the quintessence of his abilities, perfect in size as well as execution, and seems to have been sent to the Salon as uncommissioned work. If anyone may claim to have been its inspirer, it is Madame Boucher, for she is probably the ravishingly pretty, slightly shy blonde goddess, so demure at the centre of this marine triumph.

This picture, which could be called Boucher's *Pèlerinage à Cythère*, is even more effective a key to the aspirations and tastes of a whole period. To begin with, its very size is adapted to the small-scale room, essentially for living rather than mere parade, represented by the graceful Boffrand apartments at the Hôtel Soubise and by the Petits Appartements which Louis XV had created amid the grandeur of Versailles. It is no coincidence that both schemes had involved Boucher.[11] The fact that his pictures were so often intended as part of the décor of living does not explain, but at least enhances, their *joie de vivre*. So much are they part of such décor, that it is somewhat unfair that they now have usually to be seen in standard museum conditions; where those happen to be sympathetic, the pictures again come to life. Boucher's basic gift lay perhaps in the ability to express *joie de vivre* in purely visual terms. His standards were not nature's but art's.

Yet there remains a sense in which his work could be called natural – an important uncommitted sense which starts with the noticeable fact that nearly all his most typical pictures choose an open-air setting, preferably the countryside. The very expanse of sea and sky in the *Triumph of Venus* is part of this nature, interpreted to mean freedom: a freedom culminating in that light, light-hearted twist of salmon-striped silver drapery which is so effortlessly sported with by tumbling amoretti, tossed into the air like a banner of liberty. Another aspect of Boucher's freedom comes in the actual subject-matter, treated as the excuse for a spontaneous aquatic frolic – a bathing party along the coast of Cythera – rather than anything seriously connected with the bloody genesis of the goddess. Glassy water and bodies as pale as the pearls which twine about flesh and hair virtually *are* the subject. Boucher is here – as wherever possible he always is – free of drama. He prefers a lulling incantation certainly closer to Correggio than to Rubens, and very different from Fragonard's ceaseless erotic energy. In the *Triumph of Venus* the sea nymphs recline indolently, borne up on velvety-textured waves as if on *canapés*, free to be idle like the clustering doves and the almost sleepy putti around them.

The mood is one of semi-languor, the mood of many of Boucher's pastorals, where nature teaches the agreeable lesson of relaxation. In Boucher's art the highest moments of pleasure seem to come in reposing and being depicted in repose. That is definitely part of the spell cast by the

Detail of plate 167

168. François Boucher: *Le Repos de Diane*, 1742. Paris, Louvre

effortlessly beautiful *Repos de Diane* (Louvre) [168], almost certainly among Boucher's exhibits at the Salon of 1742, though it passed uncommented upon. The heat of the day, which sends the goddess's hounds to the pool at the left, turns the two blonde bodies of herself and attendant nymph into golden glowing flesh, set off by the greens of the natural scenery but also by the deliberate artifice of the great bolt of blue velvet cascading down the grassy bank as if unrolled by a divine stage-manager. The goddess is simply a piquantly pretty girl, in a piquant pose, toying with some pearls rather as would Colette's Chéri. Men make little impression, even when they occur in Boucher's pictures. Most often, they are postulated as looking on, looking in, much as from outside a shop-window, at scenes mythological or pastoral [169], where girls are as elegantly arranged as is nature.

In Boucher's portraits of her, Madame de Pompadour is usually reposing. Mood and atmosphere are caught much better than any psychological or very personal probing of the sitter. It was left to Drouais to show her positively at work [cf. 207], but Boucher shows her by no means idle in her repose. In the small portrait of her seated, simply dressed, communing with nature, putting down her book to listen to

a bird (Victoria and Albert Museum), her priority is an unusual one in sophisticated France. And in the big, altogether much grander one of her in a splendid interior (Munich, Alte Pinakothek) [170], the earlier portrait of the two, virtually a 'state' portrait (though never exhibited), there is plenty of overt emphasis on intellectual pursuits, even if books, pens, and papers mingle with artfully-fallen pairs of roses. This queen of love, whose mirror reflects not her face but her mind (her bookcase, at least), is no brainless beauty.

No more was the painter brainless. Indeed, this picture alone shows him composing as cunningly as does Ingres. But the very success of his art, and his comparative inability to evolve, to shift artistic gear as it were, meant that there would come reaction against it. He met a taste of his age but it would be wrong to imply that he thereby became its pander. Fundamentally, the taste he catered for was his own. His imagination dwelt in that semi-pastoral world which had been created by him from mingled sources, not least Rococo decorative vignettes, but which ultimately became recognizable as his alone.

A quintessence of this extraordinary achievement, on a handsomely large scale, is the *Autumn Pastoral* (1749, Wallace

Collection) [171]. We are conditioned to dismiss such work as 'typical' and as 'artificial', and it hardly needs Diderot to explain that rural conditions in France were not like this. But Boucher is not depicting France but a *pays lointain*, mildly Italianate, where autumn is just touching the trees with agreeable russet tones, and a delightfully dilapidated fountain still gushes water, while boy and girl peasants, bare-footed but not ragged in dress, flirt gently with grapes which might be of glass, so little do they purport to come from a real vine. In the impossibility of such perfect countryside days lies part of the intended charm. The pastoral had always been a convention, which does not mean that it was sterile; it is a dream, and few painters have realized that dream more magically than did Boucher. When a typical anonymous publication of 1747 (*Lettre sur l'exposition . . .*) sighed that such an accomplished artist had not sought in history 'quelque fait digne de son pinceau' (thus heralding the turn of the tide of his repute), it missed the point. Under his enchanted brush subjects like the *Autumn Pastoral* become worthy.

Although it would be wrong to accept too literally the criticisms which Boucher increasingly encountered – because taste was changing, regardless of the quality of his work – it is true that most of his finest pictures had been painted by the mid century. Those years saw him achieve pensions and honours – notably the ever-desired privilege of a studio in the Louvre (granted to him at the death of Charles Coypel in 1752, when Carle van Loo became Premier Peintre). Nor must his successes at the Salons be forgotten. His own apogee and decline are heralded by the large pair of pictures the, *Rising* and the *Setting of the Sun* (London, Wallace Collection) [172, 173]. They excited general admiration at the exhibition of 1753, and even La Font de Saint-Yenne (in his *Sentimens sur quelques ouvrages de peinture . . .*) gave them rather grudging praise, mingled with typical, somewhat petty criticisms. Boucher himself is recorded to have been satisfied by them – and his modest estimate of his abilities was well-known. Both pictures were acquired by Madame de Pompadour for Bellevue.[12] And the whole mythological climate of them seems to belong to her – to the point where one might well identify her directly with the nymph Tethys who so openly welcomes, and is welcomed by, Apollo at evening in a *Coucher du soleil* at once personal and royal. Whereas in its pendant Apollo prepares for day amid a flock of female courtiers, Tethys is singled out, made prominently central, distinguished by the attention of a still radiant god in whom flattery could easily see symbolized Louis XV.

169. François Boucher: *Sylvie guérit Philis d'une piqûre d'abeille*, 1755. Paris, Banque de France

170. François Boucher: *Madame de Pompadour*, 1756. Munich, Alte
Pinakothek

171. François Boucher: *Autumn Pastoral*, 1749. London, Wallace Collection

172. François Boucher: *The Rising of the Sun*, 1753. London, Wallace
Collection

173. François Boucher: *The Setting of the Sun*, 1753. London, Wallace
Collection

These two masterpieces, for such they are, in themselves
justify Boucher as artist even during the years when he was
granted more honours than praise. His constant activity –
and indeed his fidelity to royal taste – received full recognition
at last when in 1765 he became Premier Peintre; but some
irony resides in Marigny's eulogistic letter to him announcing
the distinction, with its phrase, 'qu'il semble que Sa Majesté
ait consulté le vœu public'. The final five years of Boucher's
life began with illness and culminated in widespread public
criticism of his declining powers and monotony of artistic
expression. He died in 1770 in that long-coveted studio
in the Louvre, amid his own canvases and the even more
remarkable richness of what he had acquired in the way of
porcelain, minerals, shells, lacquer, armour, precious stones,
'et autres productions de l'art et la nature'. The words are
Wille's; they might aptly serve to describe not only Boucher's
possessions but the style of his own work.[13]

There was one category of picture where his powers best
and longest survived: in the marriages of art and nature which
are his landscapes. 'Nature to advantage dress'd' was his
standard for these, and his brilliance partly consists of the
variations he can play on the steady subject-matter of
watermills, dovecotes, rustic bridges, and distant ranges of
blue-green hills. Yet it is not sufficient to dismiss such
'arrangements' as mere stage scenery – though it is true they
are artfully designed and always intended to please. They
have a vein of real natural poetry in them, but it is the poetry
of Pope's *Pastorals* or *Windsor Forest*, with landscapes devised
so that '. . . order in variety we see'. It is probably correct to
feel that such landscape pictures represented a certain relief
for Boucher from the pressure of demands for his figure
painting. He could virtually banish humanity, reduced to
Guardi-like specks to activate a scene which seldom strayed
from a countryside with some homely human associations, but
which often frankly represented a dream landscape, neither
Italian nor French, simply Arcadian.

The large *Evening Landscape* (Barnard Castle, Bowes
Museum, signed and dated 1743) [174], though not known
to have been commissioned, is one of the most sustained
and poetic of such scenes. Evening has already darkened
to marvellous blue-green the heavy foliage of this summer
landscape, where the small figures of a girl and young child

174. François Boucher: *Evening Landscape*, 1743. Barnard Castle, Bowes
Museum

pause near a ruined temple, while outside a cottage a woman gathers in her washing and doves settle on the thatched roof with its smoking chimney. Like art and nature, Italian reminiscence and French actuality are subtly blended. A few streaks of red on the sultry horizon mark the close of day. Silence seems to be approaching like darkness – conveyed by the cold hue of the still water in the foreground – and a mood of faint melancholy is evoked by the ruined temple and slow atmospheric approach of night. Everything here is certainly contrived – but beautifully so. The influence of Ruisdael, perhaps of Pynacker, probably of Claude, may all be detected; comparison could be made with the contemporaneous early landscapes of Zuccarelli, though they were from the first much weaker. Boucher's picture absorbs influences into a totally coherent, personal creation – as valid as Gainsborough's view of landscape was to be, a decade or so later – at once artificial and yet natural.

Nevertheless, such landscapes, though they provided more than a hint for Fragonard, must have found increasingly few people to appreciate them. Like the rest of Boucher's work, they were to be judged part of that 'doratisme de la peinture', as Falconet brutally called it, so seductive but so false.[14] It was finished with. Boucher had been a friendly, popular artist, generous in helping his pupils. Yet in the very artists closest to him fatality intervened. His two sons-in-law Baudoin[15] and Deshays – the latter highly thought of by nearly all contemporaries, including Diderot – predeceased him; his own son was a total disappointment. When in 1785 Madame Boucher, still alive, had her pension doubled by d'Angiviller, she wrote effusively to thank him for this fresh testimony 'to the memory of her husband and his talents'. They were touching words to be recorded in the year when the Salon contained David's Oath of the Horatii [294] – and when almost certainly there were few people left to cherish the memory of François Boucher as the talented artist he had been.

THE VAN LOO, DANDRÉ-BARDON, NATOIRE, TRÉMOLIÈRES, SUBLEYRAS, PIERRE – VIEN

Although the Van Loo formed a numerous, somewhat confusing and certainly cosmopolitan family, only one of them is of real significance for the history of painting in eighteenth-century France. Amiable, deeply stupid and uncultivated, Carle van Loo appeared not merely the leading French painter during the middle years of the century but – in the words of Grimm, who frankly called him 'fort bête' as a person – 'le premier peintre de l'Europe'. This astounding judgement was widely shared among patrons and academic circles. La Font de Saint-Yenne, who also esteemed him, thought it however necessary to raise some caveat when a brochure reviewing the Salon declared of Van Loo 'qu'il fait quelquefois mieux que Rubens'. Madame de Pompadour and Marigny patronized him at least as much as they did Boucher; well might Van Loo paint for Marigny an allegorical picture of the arts deploring Madame de Pompadour's death (Salon of 1765). Diderot and Grimm warmly praised him. At the Académie he rose to be Directeur; in 1750 he received the coveted honour of the Saint-Michel, having already been created governor of the newly established École des élèves

protégés. In 1762 he was made Premier Peintre and was complimented graciously by the dauphin when he thanked the royal family for this honour.[16] His death in 1765 seemed something of a national disaster.

Yet even the most partisan modern historians have had difficulty in being enthusiastic about Van Loo's work. Adopt the mid century's standards though one may and grant the maximum to his highly efficient drawings, still it is impossible to see in him more than a dutiful but basically uninventive artist. Boucher annihilates him, and even De Troy produces livelier sketches. Trémolières is more graceful, and Subleyras is far superior in robustness and handling of the actual matière, where Van Loo grew increasingly dull and dry. Although the case of Van Loo must remain in part baffling, probably his very mediocrity, combined with undoubted industry, guaranteed his success. It must have been hard to dislike the style of a painter who so signally lacked anything in the nature of a style. He left little to the imagination, perhaps because he seems to have possessed so little of it himself.[17]

The Van Loo family was not French in origin but Flemish. Jacob van Loo, its artistic founder, was a Fleming who had lived in Amsterdam before settling in Paris, where he died in 1670. His son Louis-Abraham (d. 1712) had two sons of very disparate ages: Jean-Baptiste (1684–1745) and Charles-André, called Carle, born at Nice in 1705.[18] The death of his father so early in Carle van Loo's life led to his apprenticeship under his much elder brother, who was working in 1712 at the court of Turin. Jean-Baptiste remains most familiar in England as a portraitist. Yet he had in fact trained as history painter, working under Luti at Rome and later at Genoa, and at Turin he was employed on decorative schemes. His work there for the Prince di Carignano was successful enough for the prince to ensure a continuation of patronage at Paris by his father, the famous Prince de Carignan, when the two Van Loo brothers arrived there under the Régence in 1719. Jean-Baptiste was a typical member of the family in his competence and lack of imagination, but he seems to have been a good if severe teacher. In France he began by executing some pictures for Parisian churches and achieved some fame with an equestrian portrait of the boy King Louis XV (1723). His morceau de réception, the Diana and Endymion (signed and dated 1731, Louvre), shows the most favourable aspect of his basically unexciting talent, which indeed seems to have increasingly been left under-employed in Paris. In 1737 he decided to come to London and was an immediate, fashionable success as a portrait painter, though his portraits are unremarkable enough. He was quickly patronized by the Prince and Princess of Wales, who the following year visited his studio and, in Vertue's words, 'staid there to see him paint with great satisfaction'. Until 1742 he remained in London, leaving apparently through ill health, which rapidly increased on his return to France. He retired to his birthplace of Aix-en-Provence, where he died.

Van Loo's sons all benefited from their father's teaching. The eldest and most talented, Louis-Michel (1707–71), a far better portrait painter than his father, and perhaps the best artist of the family, is probably the only painter to have produced official full-length portraits of Louis XV and also a portrait of Diderot (1767, Louvre; amusingly reviewed by Diderot himself in his Salon critique of that year).

A successful student at the Académie, Louis-Michel accompanied his uncle Carle and Boucher to Rome in 1727. From the first he concentrated on portraiture, and in 1737 was appointed court painter to the Spanish Bourbon court under Philip V, remaining in Madrid until 1752. His portraits executed there seem to have had some influence on Goya, though they scarcely attempt profound characterization. It must also be admitted that the pungent realism of La Tour was equally beyond Van Loo's range.

He became a frequent exhibitor at the Salon on his return to Paris, deservedly popular for his vivacious, convincing likenesses, and the smoothly rendered materials worn by his sitters and revealed in their settings. 'Un luxe de vêtement à ruiner le pauvre littérateur,' was Diderot's comment on the portrait of himself. In painting the king in state robes, Van Loo responded to all the possibilities of sumptuous yards of ermine and vast bronze throne upholstered with patterned brocade, creating a grandiose setting of canopy and towering marble pillars that manages to outdo Rigaud's *Louis XIV* [1]. Even in this formal portrait Van Loo managed as well to retain some sense of humanity, almost a sparkle in the royal features (a version is in the Wallace Collection, London). On other occasions he took every opportunity to suggest the instantaneous, actual moment – in sudden alertness or relaxation – which the century increasingly required from portraiture. The group portrait of the family of his uncle Carle (Musée des Arts Décoratifs) is probably the most familiar and large-scale example. That Van Loo could carry this mood beyond such personal confines is shown in the much smaller and later double portrait of the *Marquis et Marquise de Marigny* (Scotland, private collection) [175]; this is almost as much a genre scene as a portrait. It gives a sense, rare enough in double portraits at any date, of positive dialogue between the two sitters, and evokes a domestic harmony between husband and wife – married only two years previously – which was in reality of short duration. The picture's intimacy is like that of some topical Moreau le Jeune engraving – and is only the more remarkable given the highly-placed personages and the fact that the portrait was publicly exhibited at the Salon in 1769.

Of Louis-Michel's two brothers, the elder, François, was killed in a carriage accident in Italy while still a student; the other, Charles-Amédée-Philippe (1715–95), was an industrious, unremarkable artist, but one who at least kept up the family tradition of international travel. In his case it was to Berlin, where he became court painter to Frederick the Great – an honour previously declined by Carle van Loo and by Boucher. Amédée rose to be rector of the Académie in Paris and a frequent Salon exhibitor. Diderot (Salon of 1761) did not care for such religious pictures of his as *The Baptism of Christ* (Cathedral, Versailles) but praised his two *Families of Satyrs* (one is in the Milwaukee Art Center) for a sort of colourful robustness, which he summed up as 'poetry, passion, flesh and character'. And in fact the full-length angels in Amédée's *Baptism* are also by no means lacking in vigour and character.

In Louis-Michel's group portrait of Carle's family, Carle van Loo is shown in the process of portraying his daughter. Although portraiture was not a main activity of Carle's, he was nevertheless to exhibit at the Salon full-length portraits

of the queen and the king, as well as his own self-portrait (respectively Salon of 1747; 1750, Versailles; 1753, Nîmes). Yet it is notable, and perhaps more than coincidence, that he did not show portraits again there after the return of Louis-Michel from Spain. He certainly accepted at least one commission from Frederick the Great; though he would not travel to Berlin, he sent his *Sacrifice of Iphigenia* (1757, Potsdam, Neues Palais), which was highly praised by Caylus.[19] And that too represents an additional triumph for Van Loo – to have united in praise of his work the antagonistic figures of Diderot and Caylus. Even Voltaire mentioned Van Loo favourably.

Carle van Loo certainly began his apprenticeship at an early age. He was only fourteen when he returned to France with his elder brother in 1719, yet already he had studied painting under Luti in Rome and sculpture under Legros (who was working for Juvarra's Carmelite church at Turin about 1717). His brother's training had played its part too: its strictness was such that Van Loo was not permitted to paint until he reached the age of eighteen. His drawings are indeed always highly competent and assured, though no more inspired than his paintings. Academically, his early professionalism and application were, however, well rewarded. He became a pupil at the Académie and proceeded to win first a medal for drawing and then in 1724 the *premier prix* for painting. When he reached the French Academy at Rome in 1727, history repeated itself. He won a special prize for drawing at the Accademia di San Luca and the first prize for painting. While we have to piece together a few hints about Boucher's sojourn in Italy, we know more than enough about Van Loo's activity there. Although, by an irony, his name was much later to be associated with supposed Rococo excesses and to inspire a pejorative verb, 'vanloter', the bias of his nature is revealed by the artists to whom he was attached and whose work he copied – Raphael, the Carracci, Domenichino, Reni, and Maratti. An unfortunate mixture of native stolidity and academic timidity held Van Loo back from creating any truly great works of art. Timidity might pass as 'correctness', industry as genius – it being easily granted that no one sent *bigger* pictures so constantly to the Salon than did Van Loo – and yet before his death a few criticisms had tentatively been expressed about the tendency of his pictures to heaviness.

This tendency is something which certainly was increasing towards the end of his life. Such vivacity and decorative powers as he had were really seen best in the years 1732 to 1734 when he returned to Turin – no longer a boy in the studio of his brother, but a fully fledged painter who had won honours at Paris and Rome. In buildings like Stupinigi, for example, he was working with other decorative painters, all of them benefiting from the architectural setttings. Much the same is true of his work at the Hôtel de Soubise [176] when he eventually came back to Paris and joined the group of friends and rival decorators active there, including Natoire and Trémolières, as well as Boucher. In 1734, on his return,

175. Louis-Michel van Loo: *The Marquis et Marquise de Marigny*, 1769. Paris, Louvre

176. Carle van Loo. *Venus at her Toilet*, 1737. Paris, Hôtel de Soubise

Van Loo was *agréé*. By an exceptional favour (perhaps unprecedented since Watteau) he was allowed to select his own subject for his *morceau de réception*, choosing the academic, notably unappealing one of *Apollo flaying Marsyas* (1735, École des Beaux-Arts). The rest of his career was exceptionally successful and unimpeded.

Under Italian seventeenth-century influence, and given a single figure to depict, as in the *St Stephen* at Valenciennes [177] of around 1740, Van Loo produced an agreeable colour harmony of olive, green, and gold. Although the saint is shown martyred, there is no blood, and indeed the stones at his feet are pasteboard, totally without any sense of weight or sharpness (a typical failure by the artist). But as a pious and contemplative image the picture is quite effective, and painted with some feeling for pigment and tonality.

Van Loo lacked nothing in experience. In Rome he had frescoed the ceiling of San Isidoro. At Turin he had painted

some altar-pieces. He appeared well equipped to deal with both elevated history subjects and more Boucher-style ones of nymphs and goddesses. With him, however, there is a proto-Victorian quality to the latter, and altogether in his art a vein of the banal which no amount of industry could conceal. Year after year he exhibited at the Salon paintings ten to sixteen feet high: *The Adoration of the Kings* (1739, Saint-Sulpice), *St Peter curing a Lame Man* (1742, Saint-Eustache), the *Vow of Louis XIII* (1746, Notre-Dame-des-Victoires), and the series of scenes for the same church (*in situ*) illustrating the life of St Augustine (1746–55). In such work Van Loo kept alive a perfectly honourable historical tradition, mingling influences in a way that is truly eclectic – and legitimate – but which yet fails to create anything very fresh, still less exciting. In recent years Van Loo has become something of a hero to art historians. One of his warmest modern admirers has defined his artistic character in a way that is more

177. Carle van Loo: *St Stephen*, *c*. 1740. Valenciennes, Musée des Beaux-Arts

178. Carle van Loo: *The Condemnation of St Denis*. Dijon, Musée des Beaux-Arts

devastating than any criticism could be: 'He does not stir emotions but forces respect.'[20]

It is of course useful to be reminded, if reminder is necessary, that the period's artistic concerns – in painting as in sculpture – consisted of much more than boudoir decoration and portraiture. The tradition of serious history painting remained very much alive, even if there was an element of life-support machine in the operation. In a large-scale painting like Van Loo's *Condemnation of St Denis* [178] a bridge exists between the obvious echoes of the past and the extremely earnest, 'engaged' history pictures to be encouraged towards the end of the *ancien régime*. Splendid architecture, would-be noble figures, an emotional clash (here touched with patriotic overtones, for the saint condemned by the Roman prefect is the patron saint of France): Van Loo composes and unites them all in a thoroughly conscientious piece of picture-making. It would be wrong not to recognize that such work was respected, even esteemed in the middle of the century. It seemed nobler than anything by, say, Boucher – but that was partly a matter of subject-matter as

well as style. We ought to be able to discriminate a little more subtly two hundred years later.

Perhaps one further cause for Van Loo's success lay in his variety of subject-matter – he even produced for public exhibition one fairly large landscape.[21] While he could offer history pictures of a kind scarcely attempted by Boucher, and ones more firmly designed and painted than anything comparable by Coypel, he was also the creator of a Falconet-sounding *Amour qui tient négligement son arc et paroît méditer sur l'usage qu'il va faire de ses traits* (1761)[22] and *galant* mythologies, in addition to the faintly exotic, semi-genre Turkish subjects, like the *Grand Turk giving a Concert* (1737, London, Wallace Collection) [179], the vein in which he started a fashion and in which he is to modern taste most attractive.

It may also be a factor in the consecration of Carle van Loo as the greatest talent in mid-eighteenth-century France that several possible rivals were gradually removed by fate from the world or from the Parisian scene. The suicide of Lemoyne in 1737 was followed the next year by the retirement

179. Carle van Loo: *The Grand Turk giving a Concert*, 1737. London, Wallace Collection

to Rome of De Troy, appointed Director of the French Academy. In the subsequent year Trémolières died prematurely. His brother-in-law Subleyras never came back to France. In 1751 Natoire left, to replace De Troy in Rome. Such facts help to explain why the death of Coypel in 1752 must have seemed the culminating disappearance, merely emphasizing the stature of the man who was left alive, active, and soon to be hailed as a national glory.

Carle van Loo was early commemorated in an *éloge* (of 1765) from the pen of a fellow-painter, Michel-François Dandré-Bardon (1700–83), who had trained under J.-B. van Loo and also J.-F. de Troy. He is an interesting, somewhat neglected phenomenon, pursuing an active career as a writer as well as painter; he was also a gifted draughtsman and continued drawing, if not painting, after an attack of apoplexy in his seventieth year.

Dandré-Bardon was born at Aix-en-Provence, and he retained roots in the south while being prominent in Paris. Most significant for his artistic style were his years in Italy, which included a stay of some months in Venice. On his

return to France he entered the Académie in 1735, with a *morceau de réception* dealing with a rare subject, *Tullia driving her Chariot over her Father's Body* (Montpellier) [180]. This strongly Italianate picture, where, it might be said, Raphael meets Giordano (and Solimena too), is suitably vigorous and almost deplorably exciting – though the horror aspects of the incident have been considerably mitigated by the painter. An untutored spectator might suppose Tullia was herself deploring what has occurred, whereas she is meant to be impiously urging her charioteer to drive on regardless. At the centre of the composition her horses decoratively prance without quite touching the prostrate corpse (the nearer horse borrowed directly from that on the right in the *Attila* fresco in the Stanza of Heliodorus). The result is not intended to be seriously grim or particularly 'realistic' but an effective, boldly painted piece of semi-Baroque theatre – which it is.

To some extent, the career of Natoire is that of a slightly less famous and less 'solid' Van Loo. Charles-Joseph Natoire was born at Nîmes in 1700, the son of an architect and sculptor.[23] He came to Paris and studied under Lemoyne,

180. Michel-François Dandré-Bardon: *Tullia driving her Chariot over her Father's Body*, 1735. Montpellier, Musée Fabre

181. Charles-Joseph Natoire: *Cupid and Psyche*, 1737–8. Paris, Hôtel de Soubise

182. Charles-Joseph Natoire: *The Siege of Bordeaux, c.* 1736. Troyes, Musée des Beaux-Arts

won first prize at the Académie in 1721, and went to Rome two years later. He was certainly one of the most gifted of Lemoyne's pupils, and seemed destined for a more glittering career than he was actually to have. His graceful, facile style was well suited to decorative commissions, but proved monotonous on a large scale and somewhat flimsy when unsupported by its setting. His most familiar work – the *Cupid and Psyche* series of 1737–8 at the Hôtel de Soubise – is also among his best [181]. When he returned to Paris from Italy in 1728 he was considerably patronized. He entered the Académie in 1734 with a very typical *morceau de réception* of *Venus begging Arms from Vulcan* (Louvre), and later as teacher at the Académie he was to have among his pupils both Pierre and Vien – in whose work can be detected the last echoes of his own softly coloured, rather weakly prettified style. Before Natoire began the Soubise series, he had been personally commissioned by Orry, newly appointed Directeur des Bâtiments, to execute a rather different series on the *History of Clovis* (Musée de Troyes). It is quite likely that Orry, who was to be involved in the national-patriotic scheme for a monument to Fleury, was the first Directeur to turn back to national history for pictorial subjects.

Natoire might seem an unlikely choice of painter for a commission which was something of a landmark at the date (1737) in its national, patriotic emphasis. But he took it seriously and indeed is later heard complaining that the public want only 'agreeable' subjects from painters. Natoire's *Siege of Bordeaux* [182] owes a good deal to Pietro da Cortona but suggests the press of battle in an exciting, consciously rhetorical way, skilfully treading a line between the over-decorative and anything grimly realistic (Clovis, king of the Franks, is, after all, being celebrated).

Natoire's decorative gifts were to be utilized in a number of important commissions, including designs for tapestry. One of the most fascinating and unusual schemes in which he was involved was the decoration of Boffrand's Chapelle des Enfants-Trouvés, sadly destroyed but recorded in an engraving [183]. Paris seems an unlikely location for the

183. Charles-Joseph Natoire and the Brunetti: *Decoration of the Chapelle des Enfants-Trouvés* (destroyed), engraving by E. Fessard, 1759. Paris, Bibliothèque Nationale

184. Charles-Joseph Natoire: *View of San Gregorio*, Rome. Drawing, 1765. Edinburgh, National Gallery of Scotland

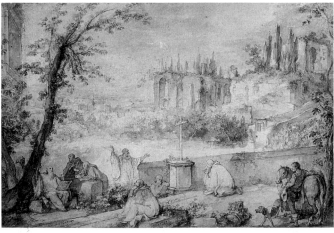

apparent bravura of such illusionism, with its extraordinary half-ruined architecture and dizzy mixture of actual and feigned, with real and fictive illumination. The chapel was consecrated in 1751, the year in which Natoire was appointed director of the French Academy in Rome. It was not banishment but an honour; yet it marked the effective end of his career. Nor was Natoire particularly talented as an administrator, to put it kindly. He never returned to France and, after retiring from his post, lived at Castel Gandolfo, where in 1777 he died. That romantic spot is suitable for an artist who during his last Italian years had manifested a new,

unexpected interest: in landscape painting. His own paintings and drawings of Rome [184] and the Campagna are quite unlike anything he had attempted before. Scarcely had he reached Italy and taken up his new post than he was writing that it might be good to encourage the student hopeless at history painting to study 'celuy de paysage, qui est si agréable et si nécessaire, car nous en mancons'. A year or two later Fragonard and Hubert Robert would arrive in Rome, to satisfy the need Natoire had indicated.

Two close contemporaries of Natoire, the brothers-in-law Pierre-Charles Trémolières (1703–39) and Pierre Subleyras (1699–1749), might have proved a sharp challenge not only to him but to the establishment of Van Loo. Like Natoire, both painters were provincials – though from different regions of France – but unlike him they worked largely away from Paris.[24] They married the daughters of the Italian musician Tibaldi, and for both of them Rome was a more significant location. Indeed, Subleyras became a complete expatriate and may reasonably be thought more relevant to Italian eighteenth-century art than to that of his native country. He was born in southern France and worked for a time in the studio of Antoine Rivalz (1667–1735) at Toulouse. This interesting and individual artist showed no more wish than Subleyras to live in Paris; his independence extended to his style, and both perhaps influenced his pupil. After early training in Paris, Rivalz went to Rome for over a decade at the end of the seventeenth century. On his return he settled at his native Toulouse, painting numerous pictures for local churches, in a highly individual, partly Caravaggesque style.

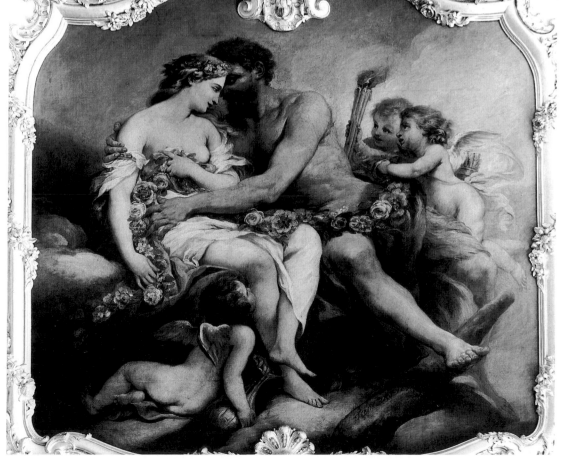

185. Antoine Rivalz: *Self-portrait*, c. 1726. Toulouse, Musée des Augustins

186. Pierre-Charles Trémolières: *Marriage of Hercules and Hebe*, 1737. Paris, Hôtel de Soubise

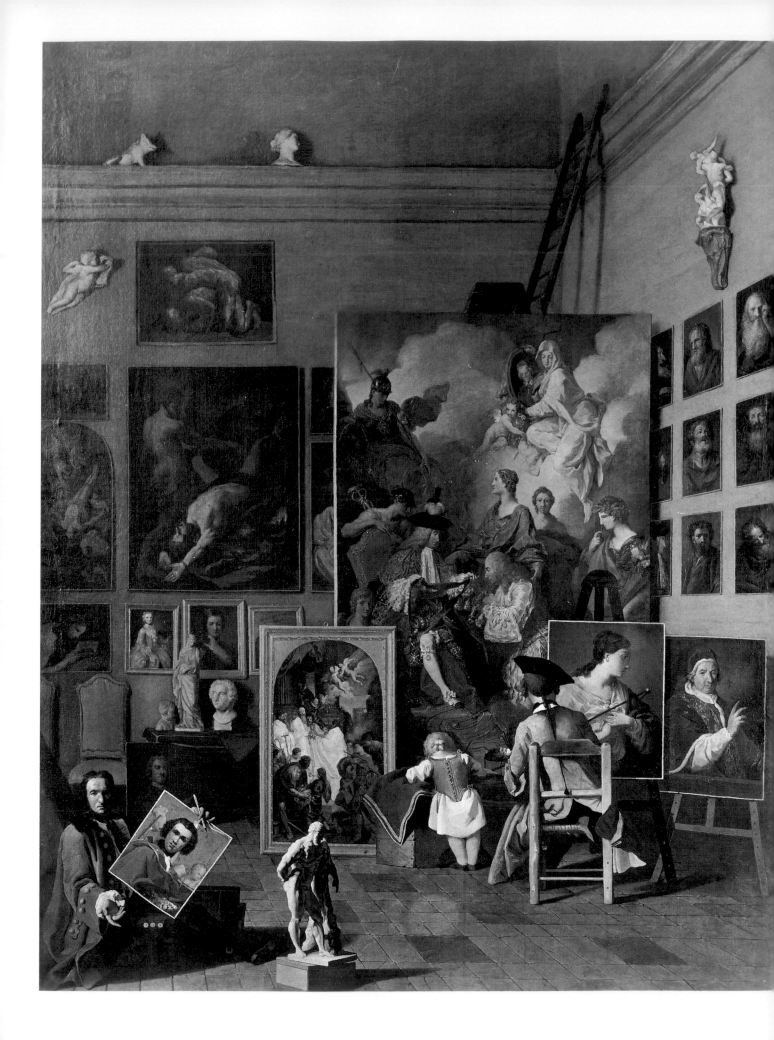

Among his large-scale works is the *St Michael overcoming the Rebel Angels* (Cathedral, Narbonne), a study for which is being drawn by the artist in his typically forceful and unconventional *Self-portrait* [185], one of the more powerful images left by a French painter of the period. It also appears to have deliberate echoes of a self-portrait by his father, Jean-Pierre Rivalz, himself a painter of distinction.

Subleyras followed something of the same pattern of career as his master, except that he never returned from Italy. In 1727 he received the *premier prix* at the Académie in Paris, after three years' study. The following year he left for Rome.

The shorter-lived Trémolières inevitably remains a more shadowy figure. The protégé of Caylus (who was to compose a 'life' of him, read at the Académie in 1748), he was the pupil of Jean-Baptiste van Loo, who taught him competence without damaging his delicate, almost fragile gracefulness and elegance. Unfortunately his health was poor, as already noted during his years in Rome, where among other work he painted now lost landscapes. He was back in Paris by 1736, in which year he received from Guillaume Coustou, as director of the Académie, the subject of *Ulysses saved from Drowning by Minerva* for his *morceau de réception* (Musée Fabre, Montpellier). The subject was not the most sympathetic for such a painter. Like Natoire, he is seen at his best in the Hôtel de Soubise [186], and at the Salon of 1737 he exhibited several decorative mythologies, destined for different rooms there. His work was well received. He was recognized as full of promise, and was given a royal commission for a series of tapestries, *The Four Ages*, he did not live to complete. By 1738 tuberculosis was affecting him. In the year of his death Subleyras married Madame Trémolières' sister at Rome.

The range of Subleyras' work, and a good deal of its quality, is conveniently conveyed in the artist's picture of his own studio (after 1740, Vienna, Akademie) [187], situated near SS. Trinita dei Monti. From this painting alone it is apparent that Subleyras was pursuing his own individual manner, in opposition – conscious or otherwise – to the style represented loosely by Lemoyne and his pupils. Of all French painters of the period, Subleyras is closest perhaps to Chardin: he has something of Chardin's gravity, response to density of objects and materials, and subtle use particularly of white as a colour. There is something too of Poussin in him, though in handling paint he is more directly influenced by Italian examples; Sacchi, Mola, and Solimena all seem utilized and assimilated – Solimena quite patently, since Subleyras spent some time in Naples. In contemporary France, only Restout might have claimed to possess Subleyras' deep seriousness of purpose and sense of sober conviction in treating religious subjects. That category of picture, with portraiture of an equally sober kind [188], represented Subleyras' preference: both are prominent in the view of his studio, including the portrait of *Pope Benedict XIV* and the sketch for his *Mass of St Basil* – probably his most famous work – commissioned by the pope for St Peter's.

The pope, the cardinals, and the religious orders (the latter particularly keen when the canonization of one of their members took place) were Subleyras' major patrons, to whom should be added the French ambassador in Rome, the Duc de Saint-Aignan. The latter is as close as Subleyras came to retaining connections with France. Although his artistic stature entitles him to much more sustained attention than he is here given, Subleyras must pay some penalty for leaving France. It is notable that few of his pictures returned there. He exercised little influence; among his few pupils was Duplessis,[25] and perhaps the gap between their styles is sufficient illustration.

A return to the main stream of historical and decorative painting is represented by the chameleon-like figure, artistically speaking, of the highly ambitious and highly successful Jean-Baptiste-Marie Pierre (1713–89).[26] His 'story' is to some extent that of Carle van Loo all over again, except that there seems to have been a good deal of contemporary suspicion that he was basically a mediocre artist – a term positively applied to him by Madame Vigée-Le Brun, who admittedly had no cause for liking him.

No single adjective can characterize the work of someone so skilfully various, who seems to have studied the work of earlier artists with art-historical intensity, whether it be Vouet, the Carracci, or Rembrandt. He has been praised by one scholar for the originality of the device of the tall cross illuminated against the sky in his *Lamentation over the dead*

187. Pierre Subleyras: *The Painter's Studio*, after 1740. Vienna, Akademie der bildenden Künste

188. Pierre Subleyras: *Don Cesare Benvenuti*, 1742. Paris, Louvre

189. Jean-Baptiste-Marie Pierre: *The Murder of St Thomas à Becket*, 1748. Paris, Notre-Dame-de-Bercy

190. Jean-Baptiste-Marie Pierre: *Mercury turning Aglauros into Stone*, 1763. Paris, Louvre

Christ (Cathedral, Versailles), though that effect seems directly derived from Rembrandt's treatment of the same subject (National Gallery, London), which had been engraved by Bernard Picart in 1730 and was to be borrowed openly by the Tiepolo father and son.

Pierre sought to be dramatic in his *Murder of St Thomas à Becket* (Notre-Dame-de-Bercy, Paris) [189],[27] to be quietly pietistic in the *Adoration of the Shepherds* (Detroit Institute of Arts), not unlike a French-speaking Pittoni, and decorative in a 1763 Salon picture, *Mercury turning Aglauros into Stone* [190], the vein where he is, arguably, at his most agreeable and effective. That was not Diderot's view. His biting comments culminated in the witty observation: 'Ce n'est pas Aglaure, c'est l'artiste et toute sa composition que Mercure en colère a pétrifiés'.

In fact, Pierre's ability as a painter was increasingly less displayed the more heavily he was involved in administration. From about 1763 until his death in 1789, he scarcely produced any pictures, but his earlier work had attracted a good deal of favourable attention. The pupil of De Troy and then of Natoire, Pierre began as a decorative painter in a sub-Boucher

style but even he – typical product of his century – early showed marked interest in genre, represented by his *Figures dessinées d'après nature du bas peuple à Rome*, which was published in 1736. He had studied at the French Academy in Rome, and this not totally expected work was the first fruit of his years there. A more obvious bid to be a serious, elevated artist came with his *Medea*, which created considerable interest at the Salon of 1746. Although Pierre does not deserve too much of posterity's attention, it is useful to realize how concurrently with Boucher and Carle van Loo he flourished artistically. He received a rare token of esteem in 1750, when Rousseau (in the famous *Discours sur les sciences et les arts*) linked his name favourably with Van Loo's. Two years later Pierre became Premier Peintre to the Duc d'Orléans. He rose high in the hierarchy of the Académie and within a week of Boucher's death had replaced him as Premier Peintre to the king. When d'Angiviller became Directeur des Bâtiments in 1774 under Louis XVI, Pierre served him loyally, somewhat too loyally, becoming the servant of the system rather than daring to stand up for the independence of painting or painters. D'Angiviller must have been amazed to read a letter

191. Joseph-Marie Vien: *A Sleeping Hermit*, 1750. Paris, Louvre

192. Joseph-Marie Vien: *St Denis preaching*, 1767. Paris, Saint-Roch

(already quoted[28]), written as early as 1781 by the elder Lagrenée, coolly informing him: 'On ne commande point aux talents ... les arts ont toujours été et seront toujours enfants de la Liberté.' Such language could never have been Pierre's. Luckier in some ways than d'Angiviller himself, Pierre died in the historic year 1789. As Premier Peintre he was succeeded immediately by Vien, who lived to see fierce dissension in the Académie and the collapse of the whole *ancien régime* system of state patronage, but who yet survived to be made a senator and finally a Count of the Empire by Napoleon.

Joseph-Marie Vien (1716–1809) thus enjoyed a career which makes it possible to treat him – the mentor of David – as a figure of the later part of the century; but his own claim for his significant activity stressed the year 1750, when he returned from Rome to Paris. Referring to that period, he wrote in the third person as 'citizen Vien' in 1794/5: 'His astonishment was equalled by his regret when he saw that instead of presenting young people with nature as a model and guide all they were being offered were bizarre examples and bad taste ...'[29] What Vien first offered them – high-falutin sentiments of forty years later apart – was the *Sleeping Hermit* (1750, Louvre) [191], which was exhibited and much praised at the Salon of 1753.[30] It is unexpected work by the standards of Vien the neo-classical regenerator, but to some extent that role was one Vien would later claim against the

evidence of his paintings. Perhaps that is too harsh a judgement; but certainly the forcefulness of Vien lay more in his claims to be a great and influential figure than in any of the work he produced. At the same time, the *Sleeping Hermit* suggests that he had been studying in Rome the work of Mola, at least as much as the monuments of Antiquity. Nor is Mola an altogether bad prototype for the somewhat unnatural and assumed classicism of Vien – himself an acute case of a painter without pronounced stylistic affiliations and without much individuality of style. Since Diderot has often had to be quoted here praising indifferent painters, it is only fair to quote him characterizing the art of Vien. In 1765 he found the painter's *Marcus Aurelius* (Amiens) 'sans chaleur et sans verve; nulle poésie, nulle imagination'. Two years later he gave measured praise – with some justice – to *St Denis preaching* (Saint-Roch) [192]. However, on *Briseis led from Achilles' Tent* (Salon of 1781, now at Angers) he remarked that the Homeric description provided ideas for two or three pictures 'infiniment mieux ordonnés, infiniment plus intéressans que celui de M. Vien'. And though it is true that in summing up the state of French art in 1767 (*Salon*) he had named Vien as taking first place, he had carefully limited that primacy to technique, adding sharply 'Pour l'idéal et la poésie, c'est autre chose.' Finally, while Diderot is commonly quoted à propos Vien with his testimony of 'sapit antiquum', it

should also be noted that à propos the same painter he exclaimed 'Oh! que nos peintres ont peu d'esprit! qu'ils connaissent peu la nature!'[31]

Vien is in fact an excellent further piece of evidence for the complex and critical position of French painting in the middle years of the century. He claimed, at least retrospectively, to be following nature. Diderot applied the same criterion: sometimes he found Vien passed the test (in his *Saint Germain* of 1761, 'c'est la vérité'), but probably more often he did not.

Vien was born at Montpellier and after some early training arrived in Paris, to become a pupil of Natoire. And, to some extent, he never threw off that influence. He never forgot how to be graceful and decorative, whatever style he practised. His style was increasingly, however, one which by its very lifelessness approximated to what passed for classicism. Less and less action, figures arranged like bas-reliefs, chic references to and depictions of Greek manners and furniture – such were the contributions of Vien to steering art back towards the recovery of noble simplicity. It was less forceful than Boucher, less energetic than Fragonard, less intense than David. The typical *Greek Girl at the Bath* (1767, Ponce) [193] belonged to Choiseul, who placed it in his bedroom where it hung near two semi-erotic pictures by Greuze and a *Sacrifice to Priapus* by Raoux.[32] The juxtapositions may tell enough about the nature of Vien's 'neo-classicism'. In many ways he

193. Joseph-Marie Vien: *A Greek Girl at the Bath*, 1767. Ponce, Art Museum

is comparable to Pajou, though a good deal older; in both 'neo-classicism' seems no burning doctrine but something of a stylistic accident, encouraged by lack of vigour in their own temperaments.

Vien's first years in Rome were as pensioner at the French Academy. Returning to Paris in 1750, he was *agréé* the following year and received at the Académie in 1754. His *morceau de réception* was a *Daedalus and Icarus* (École des Beaux-Arts) which already showed – in distinction to the *Sleeping Hermit* – a knowledge of how to appear 'antique', inspired by Caylus, whose protégé he had become. Boucher is said to have encouraged him. Madame de Pompadour certainly patronized him, as Madame du Barry was also to do. In 1776 he returned to Rome as director of the Academy there – remarkably enough, taking David with him. Five years later he was back in Paris, and proceeded in semi-old-age to amass honours and prove impressively adapted to survive into the Napoleonic Empire. He outlived Greuze and died in the same year as Pajou.

If Vien was no dynamic innovator but basically a trimmer, he was at least a trimmer who very early realized whence fresh winds were blowing – from Rome and from classical Antiquity, because there seemed the location of 'nature'. Even if no one was quite clear what they would mean in redefining that key-word, it was clear negatively that the quality was lacking in Boucher's landscapes, and also in Nattier's portraits. When in 1767 the Académie assembled to hear Nattier's daughter, Madame Tocqué, record her father's life and unhappy last years, they had clear hints of the changed world which had gradually grown up around them: 'la guerre, le fléau des arts, l'inconstance du public, le goût de la nouveauté, tout se réunit pour lui faire éprouver le plus triste abandon.' The adept Vien was not caught in any of those ways. That variety of work which he offered at the Salon of 1773 – the last, one may repeat, to be held under Louis XV – takes on an additional significance. The future 'citizen Vien' was the last *ancien régime* appointment as Premier Peintre. He was among the first painters in France to practise an admittedly diluted, somewhat perfumed neo-classicism. He was one of David's masters, but he had much closer affiliations, at least in subject-matter, to Boucher's erotic mythology. He is both epilogue and prologue; for that reason, perhaps, he plays little part as a protagonist.

PORTRAITURE: NATTIER AND TOCQUÉ – LIOTARD, ROSLIN, AVED, NONNOTTE, COLSON, DUPARC, LA TOUR, AND PERRONEAU – DROUAIS

Like Boucher, Nattier is popularly associated with a style of slightly unreal decorative painting – of portraits particularly, in his case – which might seem to stand as representative of Rococo taste as fostered by the court under Louis XV and Madame de Pompadour. Yet, as with Boucher and the whole central period of the century, the facts are more complicated. To begin with, it is not Nattier but the more pungent La Tour and the more prosaic Drouais who have left the most memorable portraits of Madame de Pompadour, apart from Boucher's. It was Nattier who in 1748 produced the relaxed, homely, though still charming image of Louis XV's neglected

194. Jean-Marc Nattier: *Marie Leczinska*, 1748. Versailles, Musée National du Château

queen, *Marie Leczinska* (Versailles) [194]. Perhaps this is the less unexpected since the queen herself was a good amateur painter. Other less famous portraits by Nattier confirm his ability to be direct and simple when he – or his sitter – wished it. He could not however help remaining a graceful painter. It is true that he had often lightly allegorized his female sitters into goddesses or nymphs – and taste turned against such mythological trappings. Just as much of a convention, but one paying tribute to a redefinition of 'nature', is apparent in the artifice of Drouais' popular device of depicting royal and princely children as beggar boys, chimneysweeps, or gardeners. Indeed, that prepares the way for the no less conscious simplicity of Madame Vigée-Le Brun's portraits, with drapery arrangements which are not natural but artistic, echoing Domenichino rather than reflecting actual costume as it was worn.

All these devices to enliven and present a sitter are understandable enough, given the basically prosaic task of the portrait painter. An element of the mechanical in his art was, perhaps unfairly, recognized by the Académie, which always ranked the portraitist in its inferior grades. It must also be recalled that the very popularity of the portrait among patrons of all kinds – a popularity that extended of course to sculpted portraiture – meant that any artist might turn momentarily to this category of work. As well as portraits produced by the portrait painter as such, there were also the isolated but often successful portraits by painters like Boucher and Carle van Loo – pictures very much better usually than the few attempts at subject pictures by the portraitists. Good as Greuze's portraits are, it was not until David that a painter appeared capable of truly sustained great work both as portraitist (e.g. the full-scale *Lavoisier* portrait [296], of 1788) and as history painter.

Perhaps something of that double aspect haunted Jean-Marc Nattier (1685–1766); he presented himself at the Académie as a history painter, but it was as a portrait painter that he was destined to become famous. The destiny is more than mere cliché, because his father, Marc Nattier (1642–1705), was a Parisian portrait painter of respectable standing, and even his mother had worked as a miniaturist. It is hardly surprising that such parents encouraged the talents of their two sons: Jean-Baptiste (1678–1726), who committed suicide the day after he was expelled by the Académie, and the always much more gifted Jean-Marc. As a boy Nattier already attended the Académie and was soon awarded a prize for drawing. His drawings after Lebrun's battle pictures indeed received the approbation of Mansart; his first drawings after Rubens' *Marie de Médicis* series in the Luxembourg Gallery were shown by Mansart to Louis XIV, and the artist himself appeared before the aged king in 1712 to present his drawing executed after Rigaud's portrait [1], intended for the engraving. The Nattier family preserved, even if they slightly embellished, the royal encouragement given on that day: 'Monsieur, continuez à travailler ainsi et vous deviendrez un grand homme.'[33] More direct encouragement was provided by Jouvenet, who seems often to have given him generous protection; he urged him towards a vacant place at the French Academy in Rome, but Nattier regretfully declined, finding himself over-occupied with work at Paris.

Although he did once, somewhat unexpectedly, travel to Holland and work there briefly for Peter the Great, Nattier remained a Parisian phenomenon. As for his artistic training, this was probably best summed up by the versifier in the *Mercure* who greeted him as 'l'élève des Grâces' at the time of the 1737 Salon. For the subsequent twenty years that was indeed Nattier's title to interest. Although he occasionally painted portraits of men, these were often strangely emasculated and insipid. His portraits of women were at their best remarkable for more than just graceful painting – though that in itself is welcome against the leaden handling of such a painter as Carle van Loo. Nattier could catch a likeness speedily; without losing it, he could yet make the unattractive look delightful. If he never aimed to present character seriously, he was yet responsive to vivacity and charm. For all their allegorical properties, his sitters appear relaxed and at ease; there is more 'nature' in such portraits than in Raoux', which are the most obvious prototype. Nattier's succession to Raoux is made quite explicit by the patronage extended to him at Raoux' death by the Grand Prieur de France, the Chevalier d'Orléans.

Over the years Nattier's style evolved scarcely at all. His sitters were drawn equally from Parisian society and from Versailles, but it was his increasing popularity at court which made him famous. His first portrait of one of the Mesdames de France, *Madame Henriette as Flora* (Versailles), was commanded in 1742 by the queen and was also fortunate enough to please the king. Although Louis XV sat to Nattier, and although the portrait of *Marie Leczinska* is among Nattier's finest work, it was probably through his whole series of portraits of their daughters that he was best known. And while he often portrayed them as goddesses, as the seasons, as the elements, he also portrayed them in a sort of stately intimacy, mingling such Baroque devices as pillars and looped-up curtains with modern truth to nature. Madame Henriette thus appeared in a sumptuous full-length portrait, playing the bass viol (Versailles); she had been a keen musician and the portrait ('un de mes meilleurs ouvrages', wrote the painter) was allowed to be exhibited at the Salon in 1755 after her death. It then belonged to her sister, Madame Adélaïde, who was portrayed the following year in a wonderful coral-red dress powdered with gold stars, engaged in the domestic diversion of knotting (Versailles). Two years later she was painted again by Nattier, in a pendant to the full-length of her dead sister, beating time while practising some music, accompanied by a pet dog which has already torn up a sheet of music on the floor (Louvre) [195].

Probably the tone for such comparative simplicity had been set by the portrait of Marie Leczinska, where we know that it was the queen's express wish to be shown in ordinary costume. Here there are no mythological trappings. The queen appears in her own setting – her apartments at Versailles – dressed in lace cap and furred red dress, a wintry costume (the sittings were actually in April) which in its resolute un-décolleté is almost a bourgeois reproach to court fashion. Her hand rests on the Bible – but in one version, for the queen's friend, the président Hénault, this was changed to a book of philosophic essays.[34] Without any diminution of his usual charming manner, and with steady attention to details of dress and setting, Nattier achieved a portrait which was widely praised – and rightly – for its 'noble simplicity'.

195. Jean-Marc Nattier: *Madame Adélaïde*, 1758. Versailles, Musée National du Château

196. Louis Tocqué: *Nicolas de Luker*, 1743. Orléans, Musée des Beaux-Arts

With dignity, it was also more direct, truthful, and intimate than any royal portrait which had previously been publicly exhibited. It appeared at the Salon of 1748, at the same time as La Tour's pastel of Marie Leczinska, which has equal directness but no nobility. Nattier's woman is more than a pious bourgeoise; the setting – and the chair with the fleur-de-lis – are reminders of royal status, and those things make her simple costume and devout occupation only the more remarkable.

Towards the end of Nattier's long life and active career, taste was changing. It is often said that his own work began to reveal signs of fatigue and skimped handling. Yet a portrait such as that of *Manon Balletti* (London, National Gallery), admittedly only a bust length, shows that even as late as 1757 Nattier could respond with enchanting effect to an enchanting sitter. Doubtless he grew tired, as he certainly grew ill and dispirited. The accidental death of his son, intended as a painter, and drowned at Rome in 1754, was a dreadful blow. He had never been careful about money and was in serious difficulties when Marigny reduced the payments for all royal commissions. Words like 'false' began to be used of his art. A witty article in the *Mercure* by Cochin, posing as a future critic in the year 2355, made fun of the extraordinary fashion there must have existed in eighteenth-century France for women to lie about holding pots of water or taming eagles to drink wine out of gold cups. It was Cochin, in fact, who was in 1767 to read to the Académie the sad account of Nattier's

last years which had been compiled by his eldest daughter, Madame Tocqué. And it was Cochin who had written interestingly to Marigny some years earlier about Tocqué's singular fatality in never enjoying Nattier's vogue, 'malgré ses rares talents'.[35]

Louis Tocqué (1696–1772), a Parisian, had married Nattier's daughter in 1747. Although he inevitably came under Nattier's influence, he was basically a quite different type of portraitist. If he never had a great vogue, he undoubtedly had considerable success. In some ways he was more sheerly competent than Nattier, but he was also more commonplace. In 1762 the two painters painted each other's portraits (both at Copenhagen), and these reveal their differing attitudes: Nattier is shown very much at work, with a strong sense of verisimilitude; Tocqué is also at work, but something ineradicably graceful haunts his very pose, and he is given what can only be described as an air. In his portraits Tocqué preferred harder, uncompromising effects [196]. Not for nothing was he an admirer of Largillierre and, more pertinently, Rigaud. His portrait of *Marie Leczinska* (dated 1740, Louvre) is intensely formal, for all its smiling good nature, and hard in its outlines, its solid paint surface, its sober recording of rich detail. Indeed, although Tocqué portrayed some other members of the royal family, and worked most successfully at the Russian and Danish courts, he was not at his best with either women or royalty. Nattier might be 'l'élève des Grâces', but Tocqué really responded

to a masculine world where sitter and setting proclaimed themselves as very much part of ordinary existence: the soldier with a cuirass or helmet, a gentleman relaxing with his snuff-box, or reading and writing in his study. He had first made a name at the Salon of 1739 when he had exhibited a large portrait of the youthful dauphin 'dans un Cabinet d'Étude' (Louvre). That style suited his art much better than excursions into pseudo-Nattier compositions, of which *M. Jéliotte, sous la figure d'Apollon* (ex-Wildenstein), shown at the 1755 Salon, was undoubtedly the most high-flown.

In those pictures which portray the setting of a person as well as his features, and in sometimes selecting 'engaged' poses where work or study are suggested, Tocqué touched a nerve of the period. Yet he often retained touches of conventional drapery and poses which recall Rigaud and Largillierre; an echo of the *grand siècle*, more than a hint of stiffness even, is apparent in him. He remains a not very interesting or original painter, despite his competence. Nevertheless, there can be little doubt that to intelligent, would-be advanced taste like Cochin's, his work was much more sympathetic than Nattier's. Again much closer to Tocqué is Drouais' portrait of Madame de Pompadour [207], no longer graceful but prematurely middle-aged, busy at her embroidery. Portrait painters who were adept at a good likeness and could do sufficient justice to lace and velvet, yet without too luxurious a display, would always find patronage and popularity. Among the embarrassingly rich choice it might seem perverse to single out two technically foreign painters, yet that serves as reminder of the influence exercised by Paris as a centre of culture and the arts. Both Liotard and Roslin worked in France, and Roslin especially became part of the established artistic scene at Paris. High claims should not be made for either as an artist, but they pleased by sheer truth to nature; indeed, Liotard, the better painter anyway, sometimes produced extraordinary *tours de force* of verisimilitude which are in their own small way unrivalled.

Jean-Étienne Liotard (1702–89) was born at Geneva and studied there for a time before arriving in Paris in 1723, to work under the painter and engraver Jean-Baptiste Massé, a close friend of Nattier's. Two years older than La Tour, Liotard also was probably influenced by the success in Paris in 1720–1 of the Venetian pastellist Rosalba Carriera. Though he executed some oil paintings, he specialized in pastel portraits, and in 1736 set out on a long period of travelling which took him successfully to Constantinople as well as to Rome, Vienna, London, and Holland. Finally he settled at Geneva in 1758, though still travelling elsewhere until late in life. His considerable stay in Constantinople resulted not only in portraits as such but in remarkable genre studies which seem already to have something of J. F. Lewis's romantic response to languorous moods as well as to exotic costume. At the same time Liotard achieved some shadowless, exquisitely uncluttered effects – placing, for instance, a richly dressed Turkish woman against a large area of completely blank, creamily cool wall – which almost anticipate certain Ingres drawings. The summit of his virtuosity as a pastellist is in the *Maid carrying Chocolate* (before 1745, Dresden) [197]. Here the medium challenges the power of oil paint. Smooth as velvet in surface, and with its own bloom, pastel is made to simulate a gamut of textures and dazzling effects –

of which the most brilliant is the glass of water on the tray the girl is holding. The tenacious power of observation in this picture is confirmed by Liotard's almost disconcertingly realistic portraits, sharp close-ups of the human face. Just as the *Maid carrying Chocolate* is no pert, ogling chit posing as a servant, so no flattering charm – still less any of Nattier's grace – is allowed to soften the impact of these candid portraits. They do not have the temperamental conviction of La Tour's portraits, nor much exploration of character, but as sheer likenesses they may well be more powerful.

Competence rather than power marks the portraits of Alexandre Roslin (1718–93). 'Roslin Suédois', as he sometimes signed and was often called, was born at Malmö and trained in Sweden. After visits to Germany and Italy, he settled in Paris, and from the 1750s onwards was an assiduous exhibitor at the Salon.[36] He was *agréé* at the Académie in 1753 and received later the same year. He seems to have become something of a pillar of the Académie, attending its sessions regularly up to his last years, and in himself he may stand for several Swedish artists who gravitated to France. His solid, even stolid portraiture was extremely popular, both at the French court and at the other northern European courts to which he was summoned. In 1774 he returned to Sweden and went thence to St Petersburg, coming back to Paris via Warsaw and Vienna; the Swedish royal family, Catherine the Great, Maria Theresa, were among his sitters, between whom Roslin catches a common likeness. Slightly heavy and not particularly animated, his people share a bourgeois strain – even when they are high-born. They are prosperous bourgeois, however, with gleaming coats and highly polished buttons. Sometimes the facture of Roslin's portraits, at their best, suggests the manner of Allan Ramsay, and this may be more than accidental. Both painters had spent significant periods of time in Italy, Ramsay studying directly under Solimena; Roslin too may have learnt something from the same source, less directly because he arrived in Italy only in 1747, the year of Solimena's death.

Roslin's *John Jennings, his Brother and Sister-in-Law* (Stockholm) [198], dated 1769, the year it was exhibited at the Salon, shows his very real ability and offers the comparative novelty of a trio of adults, with John Jennings's physical bulk making its impact on the composition. The sitters are not flattered but they live convincingly, even while they pose, and part of the conviction comes from Roslin's attention to every detail of their clothes.

Although it is now difficult to be excited by Roslin's portraiture, it is easy to see that his steady competence would remain in demand whatever currents of taste affected painters of more pronounced style. He survived quite literally too, outliving Tocqué, the pastellists La Tour and Perronneau, and the much younger court-favoured portraitist, Drouais. Apart from these, there was one other distinctive portrait painter, Aved, of whom it might be said that he represented Chardin to the Boucher of Nattier. Indeed, Nattier and Aved were to be contrasted in mid career; this does not mean that

197. Jean-Étienne Liotard: *Maid carrying Chocolate*, before 1745. Dresden, Gemäldegalerie

198. Alexandre Roslin: *John Jennings, his Brother and Sister-in-Law*, 1769.
Stockholm, Nationalmuseum

taste necessarily preferred one to the other, but that both seemed to express aspects of the period. In Nattier there could be found 'tout le faste et l'orgueil de la nation française'; Aved offered 'ses beautés solides et vraies'.[37]

At least one monograph has been written about Aved, and yet he remains a somewhat unfamiliar painter outside France, perhaps because his official career was not particularly brilliant, and more probably because his comparatively small output is scattered. Although Jacques-André-Joseph-Camelot Aved (1702–66) was not a foreigner, he was to some extent a painter brought up in a foreign style, from the first more concerned with Dutch realism than with French grace. Born in or near Douai, he was first trained at Amsterdam; later he was to own pictures by Rembrandt and, though there is scarcely any *Rembrandtisme* in his style, there may well have been some compositional influence on him. From Amsterdam, Aved went to Paris, to study under the portraitist Alexis-Simon Belle (1674–1734). *Agréé* at the Académie in 1731, he was received three years later on presenting portraits (now at Versailles) of Jean-François De Troy and Cazes, the

master of Chardin. It is customary to link Aved and Chardin, rightly, because the two men were friendly. Chardin painted Aved's portrait, and Aved owned some of his still lifes. Yet Aved seems to have been friendly also with Boucher and Carle van Loo, at least in these early years. His patrons proved quite often to be royal or at least noble; ambassadors like Count Tessin sat to him, and Louis XV commissioned a portrait which, however, caused Aved trouble and which took long to complete. It may well be that court portraiture as such did not suit him, but he travelled to The Hague in 1750 to paint the Stadhouder William (Amsterdam) – with rather conventional results.

Much more remarkable, and noted at the time as remarkable, was the portrait of *Madame Crozat* (Montpellier) [199], which he showed at the Salon in 1741. In the nineteenth

199. Jacques-André-Joseph-Camelot Aved: *Madame Crozat*, 1741.
Montpellier, Musée Fabre

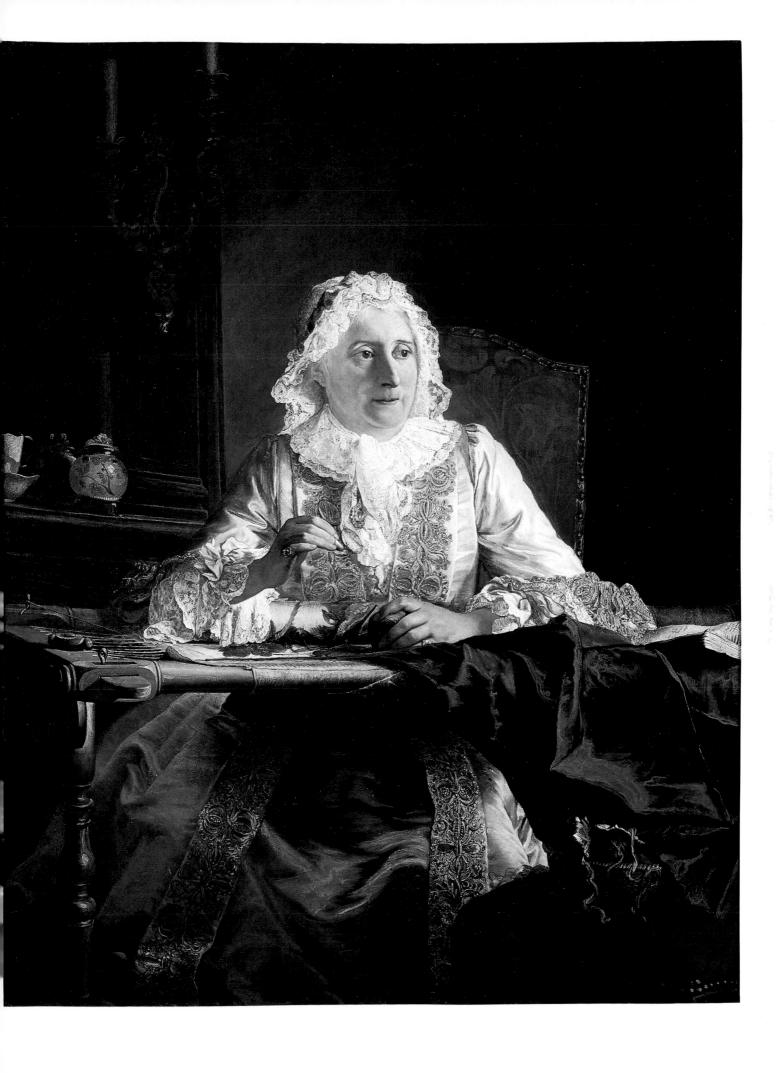

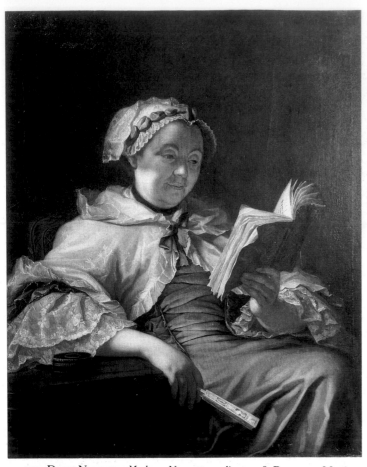

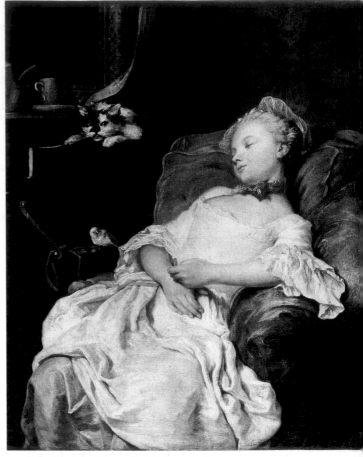

200. Donat Nonnotte: *Madame Nonnotte reading*, 1758. Besançon, Musée des Beaux-Arts

201. Jean-François Gilles called Colson: *Le Repos*, 1759. Dijon, Musée des Beaux-Arts

century this was supposed to be by Chardin. As it happens the picture contains a hint rather towards Nattier's *Marie Leczinska* of seven years later [194]. More than a mere likeness is aimed at. Aved conveys something of the sitter's character – including a lack of vanity – and her ordinary existence. With her tapestry work and a teapot handy in the background, she might stand as representative of the highest bourgeoisie: sensible, comfortable, industrious. It was thought worth commenting on in 1741 that another woman would have suppressed the fact of those spectacles which Madame Crozat has just taken off and still holds; Aved seizes on this very detail to give a sense of momentary pause in a pleasantly busy domestic life. As for the detailed suggestion of environment, this was rightly praised as 'd'un naturel ravissant'. Something similar had been attempted in the portrait of Tessin, certainly seen at ease in his study, but the *Madame Crozat* is more remarkable. Perhaps it owes something to Chardin's large-scale genre studies such as the *Woman sealing a Letter* (1733, Charlottenburg), shown at the Salon of 1738. It represents a tendency which increasingly developed: not only made fashionable by portraits like Drouais' of Madame de Pompadour but apparent in provincial centres. Indeed, in a simplified form, its artistic pendant is *Madame Nonnotte* (Besançon, signed and dated 1758) [200] shown reading, deeply absorbed – slumped in a chair – a closed fan clasped idly between two fingers, by the talented local portraitist, Donat Nonnotte (1708–85).[38]

The myth of the eighteenth century as totally calm, civilized, and content is enshrined in Nonnotte's

unpretentious picture, almost by chance. Leisure is shown as an active pursuit, whereas leisure of a more idle kind is suggested by the near-contemporary *Le Repos* (signed and dated 1759; Dijon) [201] by Jean-François Gilles called Colson (1733–1803). However, that idleness is deliberate, as Colson planned the picture as the pendant to one of *Action*. Chardin and Greuze are often invoked in connection with *Le Repos*, but to British eyes there is a hint of Hogarth also there, not least in the bright-eyed, predatory cat (recalling the similar one in *The Graham Children*).

Colson, born in Dijon, settled in Paris, and had a varied career, as part-engineer, architect, and sculptor, but was chiefly known for his portraits. It is hard not to feel that there were advantages for artists who came from provincial milieux and who may have been less inhibited by strictly academic, Parisian standards. Colson has charm; and more impressive, even severe, is the art of a provincial woman painter, Françoise Duparc (1726–78), born in Spain but trained first in Marseille.[39] Few works by her are yet known, but she travelled widely, to England and Germany, active as a portraitist.

Duparc's *Seated Woman* (Marseille) [202] is certainly a sharp reminder of existence outside the bourgeois world of Paris or the court one of Versailles. What, one might ask, have this plainly dressed, somewhat careworn woman and the Marquise de Pompadour, as depicted by Boucher [170], in common? They might scarcely be thought of as of the same sex, though perhaps each has – in her different way – human dignity. Duparc manages to invest her patient sitter

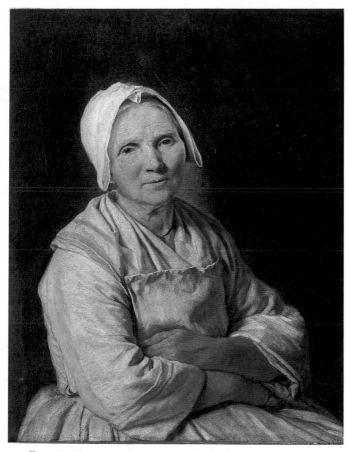

202. Françoise Duparc: *A Seated Woman*. Marseille, Musée des Beaux-Arts

203. Maurice-Quentin de La Tour: *Mademoiselle Fel*. Musée Antoine Lecuyer de Saint-Quentin

with as much of that (and with no trace of sentimentality) as any famous figure of the period. There is integrity in the actual handling of paint: a slightly tough texture which is far from insensitive and which increases the firm, uncompromising air of the portrait. When every recollection of the Le Nain and of Dutch seventeenth-century art has been culled, there remains a pungent sense of Duparc's own artistic personality in the presentation of the sitter.

The most famous of all portraitists in the middle years of the century was of course Maurice-Quentin de La Tour (1704–88). The man, as well as his masterly pastel portraits, made a mark on society – partly by the slightly manufactured 'character' he presented, a sort of homespun Voltaire of portraiture, lively, opinionated, satiric, and sometimes rude. Something of this emerges from his portraits. They retain an astonishing impact of vivacity and vitality, unequalled except by the busts of Lemoyne. They are virtuoso achievements which stole, and still steal, éclat from the portraits of Perronneau which, on a more sober assessment, may well be more sensitive and penetrating likenesses. La Tour is full of tricks; Perronneau seems to disdain them. Perronneau spent a good deal of time out of France. La Tour, once arrived in Paris from his native Saint-Quentin, passed the rest of his working life there apart from an early stay in London; he was to become a familiar part of the social scene.

La Tour arrived in Paris for the first time probably during Rosalba Carriera's triumphant success there in 1720–1. It may well have been her pastel portraits which encouraged him to take up that medium where he was easily to eclipse her, despite some loyal protests from Mariette. La Tour's early danger was too great facility. After a brief but successful period in London (about which little is known), he returned to Paris, was *agréé* in 1737, and appeared that year at the Salon with portraits of pretty *Madame Boucher* and 'l'autre, celui de l'auteur qui rit' (examples at Geneva, etc.). An anecdote is recorded of how, some years before this, Louis de Boullongne (d. 1733) had warned La Tour to concentrate on drawing; La Tour himself later more than once paid tribute to the useful advice he had received from Restout. At the Salon of 1737 his work at once attracted attention; thence onwards until 1773 he was a constant exhibitor, and his mastery of the pastel medium led not only to imitation but to fears that he would provoke a distaste for oil paint. His sitters ranged as widely through society as La Tour pleased. From the king downwards everyone wished to be portrayed; they paid for the privilege, when La Tour granted it. Highly successful and prosperous, he was by turns dramatically generous or stingy, a social delight but a sensational disaster at court, capricious, vain, full of wild schemes yet tenacious about his art, and, in the end, apparently feeble-minded. His fascinating character is still not totally clear; it almost stands in the way of the art, but both are convincingly evoked by the Goncourt in probably the best chapter of *L'Art au dix-huitième siècle*.

Despite some ambitious essays in what might be called Aved-style portraiture, cul-minating in the large-scale *tour de force* of *Madame de Pompadour* (Louvre, signed and dated 1755), La Tour was at his best in concentrating on the face alone: the face as an expressive, palpitating mask. Like the people of Lemoyne's busts, his sitters assume the character of actors, and there is an extra mobility of feature about their so often smiling faces, an almost theatrical vivacity greater

204. Maurice-Quentin de La Tour: *The Abbé Huber reading*, 1742. Geneva, Musée d'Art et d'Histoire

than any in life. This is what the artist meant when he spoke of the limit of 'un peu d'exagération' that art allows beyond nature. In that way La Tour may have flattered his sitters; he could not help, perhaps, letting his delight in their appearance emerge in the pastel – and even that observation is probably made somewhere by the Goncourt. For vivid directness – a sense of being surveyed and quizzed – nothing equals La Tour's *préparations* [203], sometimes much rougher and more patently hatched in their application than the final, smoothly blooming surface of his finished work. Inevitably, La Tour could at times be dull, try as he might to avoid commissions which did not inspire him; he was always uneven – in a very difficult and capricious medium – and towards the close of his career he was seized with a mania for re-doing pictures, experimenting with new fixatives, and so on.

Yet the body of his finest work, at once consistent in quality and varied in attitude to the person portrayed, must rank with the best of European portraiture in the century. He carried the pastel medium to a point of sheer technical brilliance not reached before or since. Technical brilliance, intimacy, and vividness combine in the *Abbé Huber reading* (Geneva) [204], which was shown at the Salon of 1742. Less

famous than the full-length *Madame de Pompadour*, it is stamped with a sense of the artist's personal knowledge of the sitter. We seem present beside Huber, who, planted on the arm of his chair (as the Salon *livret* noted), hunches absorbed over a book, unheeding of a just-guttered candle – a detail David was to seize on in *Napoleon in his Study* (Washington). There are other aspects of La Tour too which deserve mention. If he had affinities with Lemoyne as creator of likenesses, he was nearer to Falconet in his dogmatic individual theorizing. Not only did he have general ideas about art, but he – like Falconet – centred them on the concept of natural, unadorned, and unlearned nature. La Tour probably saw his own methods as coming between the academic extremes he criticized (as recorded by Diderot): the cold slaves of the antique, on one hand, and on the other the devotees of a false 'libertinage d'imagination'. In that he becomes very much a typical voice of his century, stressing the need to follow nature; and it is typical of the century too that he should interpret the concept entirely as of human nature.

La Tour's personality undoubtedly excites more interest than Perronneau's. Yet Jean-Baptiste Perronneau (1715(?)–

205. Jean-Baptiste Perronneau: *Madame Chevotet*. Orléans, Musée des Beaux-Arts

206. Jean-Baptiste Perronneau: *Portrait of a Man*, 1766. Dublin, National Gallery of Ireland

1783) has several times been esteemed by posterity as highly – if not more highly – as a portraitist. Born in Paris, he became the pupil of Natoire and of the engraver Laurent Cars. He himself worked for a time as an engraver, but abandoned it for painting – in oils as well as pastel. He first exhibited at the Salon in 1746, the year in which he was *agréé* at the Académie, and one of La Tour's quietest years as an exhibitor, but his reputation in France remained over-shadowed by the older, established man. He began travelling abroad around 1755, visiting Italy and Holland, and, late in life, Russia; he died in Amsterdam, where he had frequently worked.

Perronneau's pastels show less technical virtuosity than La Tour's, perhaps quite deliberately. Something of a *préparation* remains in the finished portrait, giving a gritty, unflattering, yet forceful character to his work. He is less concerned with simulating the texture of skin or hair, for example, than with lively drawing in pastel; the strokes remain, and add their vibrancy to Perronneau's sharp observation. His sitters are seldom smiling or exuding a charming vitality: if anything, they often seem rather heavy and disagreeable – but very convincing. Even about the alert, full-face *Madame Chevotet* (Orléans) [205], a brilliant example of what Perronneau could achieve in the pastel medium, there may be doubt in terms of her 'niceness', though none about the impact of a personality. And the virtuosity of handling is here no less remarkable, with lace foaming in black and in white, setting off the pale blue silk of the dress. Yet the costume remains very much subordinate to the face itself, and if the expression there can be read in more ways than one, that only points to the subtlety of the depiction.

Unlike La Tour, Perronneau was also an adept at using oil paint, achieving some of his best portraits in this medium. Outstanding is the *Portrait of a Man* [206] of 1766 at Dublin, as pungent and penetrating as a Goya portrait. The hand is painted almost roughly; the lace is suggested rather than painstakingly detailed; and the clever, challengingly shrewd face twists round with disconcerting abruptness, as if defying the spectator to slip by.

Among the five portraits Perronneau showed at the Salon of 1746 was one of the respectable painter Hubert Drouais (1699–1767). Drouais himself was a good portraitist, but he is chiefly of interest as the father of a highly fashionable court portraitist, François-Hubert Drouais.[40] Born in 1727, the younger Drouais was to inherit in effect the clientèle of Nattier – his senior by forty-two years. Yet he died nine years after Nattier, in 1775, having lived only just long enough to paint one portrait of Marie-Antoinette as queen of France. Had he survived, he might have adversely affected Madame Vigée-Le Brun's rise to court favour. As it is, he remains a phenomenon of Louis XV's reign. As befits such a figure, he is sometimes to be found echoing Nattier in a stilted style (e.g. *Marie-Antoinette as Hebe*, 1772–3, Chantilly), but more often preparing the way for the climate of rustic royalty and rather self-conscious simplicity associated with Louis XVI's court.

Drouais studied not only under his father but also under Nonnotte, Carle van Loo (most markedly), and Boucher. From this training he emerged with a hard, competent, but basically monotonous style, rather patently 'academic'. At twenty-eight he was *agréé* at the Académie, and speedily

proceeded to establish himself as a popular portraitist, particularly of royal and aristocratic children. If he did not positively invent the genre, he made supremely fashionable the device of showing such children temporarily dressed up as well-bred little gardeners and prosperous, healthy beggars. From clothes to foliage, everything in these portraits had its glossy surface and slightly wooden charm. There is a lack of personality which might seem due not to Drouais but to his often very youthful sitters – yet the same lack is apparent in his portraits of Marie-Antoinette and Madame du Barry.

More truly remarkable than the children's portraits, for which he became so famous and fashionable, is Drouais' large, full-length portrait of *Madame de Pompadour* (National Gallery) [207], begun in the last year of her life and still unfinished at her death in 1764. An interior suits him better as a setting; some of his hard, wooden manner is usefully employed in painting furniture, especially the shiny embroidery frame. Even the ever-present lack of characterization is less apparent amid so much detail of the sitter's environment and the triumphant recording of her boldly floral dress. This picture takes its place logically in the progress out of mythological portraiture into the everyday but highly personalized reality which culminates in David's *Lavoisier* portrait [296]. The aspect of daily life had been touched on by Nattier and developed by Aved. La Tour had scrutinized his sitters, as Drouais devastatingly does here. The portrait is very near to being a masterpiece, and perhaps it should not be denied that title; it is certainly the masterpiece amid his *œuvre*. And something, of course, attaches to it from the sitter – patroness and subject of some of Boucher's most enchanting pictures – about whom as shown here one can only murmur moralistically: 'L'occupation selon l'âge.'

LANDSCAPE: VERNET
AND SOME LESSER PAINTERS

The middle years of the century showed no rich crop of landscape painters to compare with the crowd of talented portraitists. The Abbé Du Bos had not rated landscape very highly in his *Réflexions ...* (1719), even when depicted by a Titian or a Carracci.[41] Apart from theoretical disdain, as a category of picture the landscape was not particularly in demand. It remained largely a personal, even private concern of any painter at a given moment; thus François Lemoyne, as has already been mentioned, had exhibited a rare landscape at the Salon of 1725. Watteau's landscapes were scarcely to be thought of in that category. Only Boucher evolved a highly decorative style of landscape – and that was the first aspect of his art to come under attack when new definitions of the 'natural' were formulated in the later part of the century. By then there was apparent a marked increase in the number of gifted landscape painters; Fragonard may be a special case, but Robert, the elder Moreau, and Valenciennes are three significant examples, all preluding nineteenth-century achievements.

One outstanding exception to the mid century's dearth exists, however, in Claude-Joseph Vernet, who enjoyed a European reputation and indeed became the most famous landscape painter – though 'marine painter' does better justice to the type of picture he commonly produced. Vernet is not a totally satisfactory phenomenon as an artist, but in his middling talent he is perhaps typical of the period at which he lived. He worked industriously – exhibiting regularly at the Salon from 1746 until 1789, the year of his death. He received much praise from Diderot, who coupled him with Chardin. Although there are some refreshing pure landscapes by him, it was for his seascapes, sometimes calm, sometimes tempestuous, at different times of the day and night, that he became so celebrated. The mixture of two elements in his art – prosaicism mingling with proto-romanticism – is accidentally but well defined in a letter of 1756 to him from Marigny, à propos the important royal commission to paint the ports of France: 'Vos tableaux doivent réunir deux mérites, celui de la beauté pittoresque et celuy [sic] de la ressemblance ...'. In fact, this extensive commission caused Vernet a certain amount of trouble, as well as travel. The 'pittoresque' played a large part in his art, and when he expressed a wish to avoid painting the port of Sète on the spot ('petite méchante ville', he called it) Marigny firmly reminded him of 'l'intention du Roy, qui est de voir les ports du royaume représentés au naturel'. For this reason, Vernet was obliged to finish, in Marigny's words, 'votre tableau du port de Cette à Cette même'.[42] Vernet was never less than competent (his standard being quite remarkably sustained over a long working life), but the results of this major royal and patriotic commission were bound to be somewhat variable, if only because of the nature of the various sites.

Nevertheless, Vernet achieved remarkable results, at times with some of the less rewarding, less obviously picturesque ports. The flat landscape at Rochefort promised little, and the air was not good (malaria often arose in the marshy surroundings). The low-lying terrain was skilfully utilized by the painter in *The Port of Rochefort* (Paris, Musée de la Marine) [208] not only to set off some imposing ships' masts and rigging but as a foil to one of his most crystalline and atmospherically sensitive skies, enhanced by a cloud of man-made smoke. And he did full justice to the port's human activities, with its employees at work or play, soldiers and visitors, all of whom animate the foreground, to the right of which is the port's rope-works. Well might the *Mercure de France* in 1763, when this picture and its companion of the port of La Rochelle appeared at the Salon, speak of the way the spectator could engage with 'nature' in contemplating such work.[43]

Vernet was born at Avignon in 1714, son of a humble journeyman painter, and his formation as an artist was remote not only from Paris but from France. With the patronage of local nobility around Aix, he was enabled to go to Rome at the age of twenty. There he settled, marrying an English wife in 1745 and being much patronized by English clients. He was recalled to France by Marigny in 1751 but did not settle permanently in Paris until the early 1760s, by which time he was established and famous. As much as Claude, he was formed by Italy – except that Claude too played some part

207. François-Hubert Drouais: *Madame de Pompadour*, 1763–4. London, National Gallery

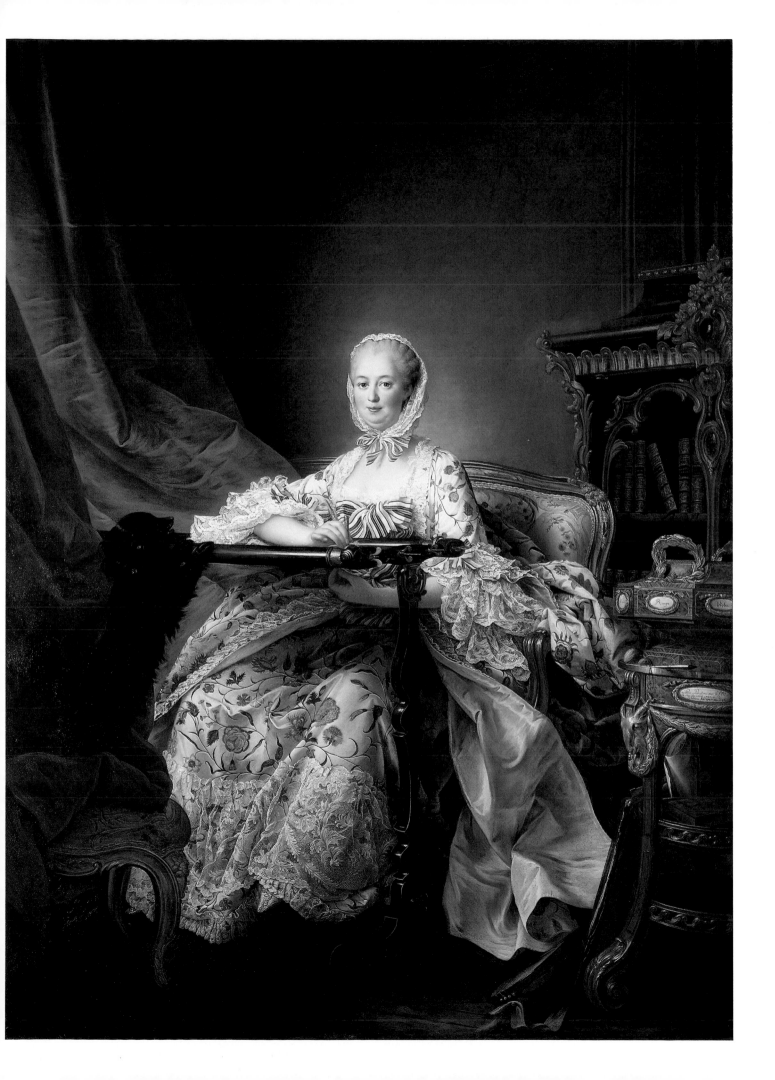

208. Claude-Joseph Vernet. *The Port of Rochefort*, 1763. Paris, Musée de
la Marine

209. Claude-Joseph Vernet: *A Seashore*, mid 1770s. London, National
Gallery

210. Antoine Le Bel: *Seaport at Sunset*, 1761. Caen, Musée des Beaux-Arts

211. Pierre-Jacques Volaire: *Eruption of Vesuvius*. Le Havre, Musée des Beaux-Arts

212. Jean-Baptiste Lallemand: *View of the Château de Montmusard, c.* 1770. Dijon, Musée des Beaux-Arts

in the evolution of his subject-matter, if not his style. Once found, his style scarcely evolved. He was sensitive to atmospheric effects, but probably responded best to steady, tranquil – Claudian – moods, tending to become somewhat rhetorical in extremes of storm and shipwreck; he lived long enough to paint the sublime and sentimental shipwreck of *Paul et Virginie* (St Petersburg), not quite convincingly.

Italian scenery, especially coastal scenery, had a decisive effect on him; it became his preferred subject-matter and continued to haunt his art well after his return to France. Indeed, some of his paintings of the mid 1770s show as vivid if slightly unlocalized a response to the Italian coast as any painted on the spot [209]. And his views are always enlivened by people, often elegant sightseers and tourists, who are completely of the period; they are not to be dismissed as mere *staffage*, because there is in them acute, vivid observation of cos-tume and manners – and a liveliness that approximates to wit. For such figures there can be little doubt that Panini proved a significant influence; the stylistic affinity is clear, and the fact of Panini's close personal relations with the French colony at Rome increases the likelihood of direct influence. One negative effect of Panini's presence in Rome may have been to keep Vernet away from the ruin picture; that aspect of the picturesque was left to Robert to develop, largely away from Italy and after Panini's death. An ultimate tribute to Italian artistic influence is apparent in one of the pictures Vernet exhibited at the Salon in the final year of his life, where in a last extraordinary burst he showed well over a dozen paintings, including 'Un Temps orageux dans un lieu sauvage ... dans le goût de Salvator-Rosa.'

Vernet's influence is a difficult subject, because in many ways he was a popularizer, not a great innovator. Based on

seventeenth-century models, he drew together several threads of his own century's growing interest in natural scenery and phenomena, combined with utterly unnostalgic tourist concern and a steady emphasis on the decorative. Commonly held beliefs in the 'age of reason' restricting imagination may seem to receive support from Vernet's coolly rational work: his prospects always please, and man is never vile. The potentially most rewarding aspect of his influence lies outside France, in Wilson and Joseph Wright. The closest of Vernet's followers, to the point of copying his compositions extremely carefully, is Charles de Lacroix, a painter from Marseille and presumably Vernet's pupil at Rome in the early 1750s. He conveniently signed many of his Vernet copies; his other pictures are usually seaports, more obviously capricious than Vernet's, in a tradition that goes back again to seventeenth-century Rome. Little else is known about him except that in or around 1782 he died in Berlin.

Among the frankly minor figures some stand out if only for a rare, unusual seascape, like that lit by the setting sun by the Parisian Antoine Le Bel (1705–93) which caught Diderot's eye at the Salon of 1761 (Caen) [210]. The Claudian influence is obvious enough but a new romanticism is apparent in the towering cliffs at the right.

It is perhaps significant that such other landscape painters as deserve mention before the decade of Fragonard and Robert were – like Vernet himself – provincial by birth. Unlike him, however, they seldom arrived, in any sense of the word, on the Parisian scene. Pierre-Jacques Volaire (1729–1802?) was a native of Toulon, taken as an assistant by Vernet while working on the 'Ports de France' and subsequently settled in Italy.[44] He specialized, to a rather monotonous extent, in views of Vesuvius erupting (e.g. Le Havre) [211],

213. Jean-Baptiste Pillement: *Shipping in the Tagus*, 1783. London, Private
Collection

though a single specimen also shows why his eerie
combination of calm moonlight and pyrotechnic display
by nature exercised such popular appeal. Nothing could
be further from Claudian tranquillity, and this stirring,
exploding natural phenomenon (to be painted notably by
Wright of Derby) is also a symptom of new taste and interest.

Other landscape painters, admittedly not great names, have
their own charm and individuality, and serve also as further
reminders that throughout the century there was considerable
artistic activity and patronage in the French provinces, often
far away from the capital.

Jean-Baptiste Lallemand (1716–1803) was born at Dijon;
though he did visit Paris and exhibit at the Académie de
Saint-Luc, he produced his best landscapes after a return to
Dijon.[45] He had spent some years in Italy, but recollections
of pictures by painters like Weenix mingle with observed fact
in his fanciful seaports. More indigenous and interesting are
views like those of the *Château de Montmusard* (*c.* 1770, Musée
de Dijon) [212] which combine observation of manners with
response to a notable piece of contemporary architecture,
even though one never finished.

Quite patently decorative, with retardataire Rococo
touches, is the work of Jean-Baptiste Pillement (1728–1808).
Pillement was born at Lyon and died there in poverty after
a highly peripatetic career which carried him from Lisbon to

London, and included visits to Italy as well as a period in
Vienna. Some of Pillement's designs for tapestries are closer
to Watteau than to Boucher, yet his final success was as
painter to Marie-Antoinette. Too much can be made of the
inevitable decorative element in his landscapes, which are by
no means all artifice in a pejorative sense. Some views around
Lisbon, for example, are notably sensitive in conveying
atmospheric effects [213]. Wynants and Berchem certainly
influenced him, and perhaps Cuyp too. In some ways
Pillement is more sheerly romantic than any earlier French
painter; tall trees and rushing cascades dominate his
compositions, reducing mankind's importance and seeming
to hint at that triumph of natural scenery in its own right
which will culminate in Corot.

One other extremely versatile figure deserves mention,
though he passed – both figuratively and literally – from
the French scene to that of England: Philippe-Jacques de
Loutherbourg, born in Strasbourg in 1740 and dying in
London in 1812.[46] By his mid teens he was in Paris as a
pupil of Carle van Loo. He worked also under, perhaps for,

Detail of plate 209

François-Joseph Casanova (1727–1802), familiar as a battle painter but a landscapist as well.

Louterbourg was influenced in part by Vernet but formed himself very much on earlier Dutch painters, especially Berchem, as Diderot was quick to notice when Louterbourg first appeared, at the Salon of 1763, with an array of pictures. A mild criticism by Diderot, among much praise for the young artist, led Grimm to interpolate a mild defence, adding, 'd'ailleurs il est Allemand'. And by the late 1760s Louterbourg was travelling in northern Europe. In 1771 he settled in London, where he enjoyed a highly successful and very varied career. He lived to depict the new industrial landscape of England (*Coalbrookdale by Night*, 1801; Science Museum, London), picturesquely but with some-thing of the smoky, polluted atmosphere which would become a grim environment for so many people in the nineteenth century.

CHARDIN

The prominence which Chardin now customarily receives in any history of his century's art would almost certainly have surprised his contemporaries. That is only one of several good reasons for not writing about art entirely through the eyes of period witnesses. It was not Chardin who was named as the leader or the hope of the apparently declining French school in the mid century. It was not his death but Carle van Loo's which seemed a national disaster; nor is this merely because Chardin had lived a long, active life. Certainly he was a well-known painter, widely esteemed, and within his small circle warmly liked. He was eloquently praised by Diderot, though not before he was middle-aged; by then he had virtually ceased to paint genre and was associated with still-life pictures. Other talents – often more patently appealing – had risen to attract attention. Above all, there had appeared Greuze. Chardin was probably most praised publicly in the earlier half of his career, when he seemed more of a novelty. By the time d'Angiviller had replaced Marigny at the Bâtiments, it was not only Chardin's age and tendency to exhibit repetitions of his earlier work that might cause reservations, but the fact that he had never practised, in words Pierre drafted in 1778 for d'Angiviller to use to him, 'les grands genres'.[47] This was something which mattered much more in Louis XVI's reign than at the close of Louis XIV's. But the age of the *grand monarque* may reasonably be evoked when we hear how Chardin's early paintings won the approval of Largillierre, even while deceiving him: '. . . very good pictures. They are surely by some good Flemish painter.' And in this connection it should be remembered that Largillierre himself, the master of Oudry, had painted some still-life pictures; he was also to own at least one genre picture by Chardin.

Jean-Siméon Chardin was born at Paris in 1699. His father was a respectable, respected carpenter, *maître-menuisier*, and it is tempting to seize on the circumstances of his birth and see reflected in his art – in the still lifes as much as in the genre scenes – the narrow, typically Parisian household where economy is practised almost with religious devotion. It is as well to be cautious on this point, because Chardin's early circumstances were probably little different from Boucher's.

The rigour and austerity of Chardin's work are more artistic than social. Indeed, it might be said to be the more extraordinary achievement for someone who came from comparatively humble surroundings to show them in a light as flattering, for all its sobriety, as Chardin undoubtedly does. There exists an ideal aspect of Chardin's art, attaching perhaps as much moral value to enjoying austerity as Boucher's does to the duty of enjoying luxury.

Boucher's early working years were hard, laborious at least, and Chardin's were considerably harder. He seems to have had little formal education. Nothing is known of his life before he was apprenticed in 1718 to Pierre-Jacques Cazes (1676–1754), but it is most unlikely that he had been allowed to spend his time up to then in idleness. Possibly he began by assisting his father at carpentry. There is an element of practicality about all we know of him that makes this quite conceivable. Something well made, well built, and even – one might add – inlaid, marks his work. His technique was to be compared by contemporary critics to mosaic or tapestry, because of its slotting-in effect of juxtaposed tones, but a closer analogy is with marquetry. In any event, Cazes proved a quite uninteresting, unimportant teacher for Chardin, who is next recorded about 1720 working as assistant to Noël-Nicolas Coypel,[48] collaborating on still-life accessories in his pictures. When finally in 1724 he emerged as a professional painter, it was at the Académie de Saint-Luc. This début, which Chardin was soon to repeat at the socially more prestigious Académie royale – turning his back totally on the Académie de Saint-Luc – has been ascribed to his father's craftsman-like ambitions and milieu. That may be so, but it should also be noted that Oudry had followed the same route,[49] and Oudry's precedence – and presence – certainly affected Chardin's activity. Unlike him, however, Chardin was received at the Académie in 1728 not as a history painter but a painter 'des animaux et fruits'.

Neither category very satisfactorily covers *La Raie* (Louvre) [214], which is not Chardin's first still life but is among the first which brought him to public attention. It was one of several pictures he showed on Corpus Christi day, June 1728, in the annual young painters' competition in the Place Dauphine. This was the occasion of his being encouraged by several academicians to present himself at the Académie royale. In September of that year he was *agréé* and, somewhat exceptionally, received on the same day. One of his two *morceaux de réception* was *La Raie*. In this, to a remarkable extent, are already present much of Chardin's attitude to still life and his compositional preferences. The stone ledge and austere interior setting – in marked contrast to the garden settings of such predecessors as Weenix – are typical. The sense of a few plain objects arranged not artistically but practically, not for show but for use, the hinted human activity of the knife projecting out towards the spectator, the frugality of what is displayed combined with sensuous response to textures of metal, earthenware, linen (never silk, and only occasionally porcelain or silver), all remain typical. The slightly anecdotic cat amid the oysters – not, incidentally, a very successful animal – is one of the few indications of the picture's early period; it is the sort of traditional northern still-life episode which seldom reappears in Chardin's work.

214. Jean-Siméon Chardin: *La Raie*, 1728. Paris, Louvre

His still lifes grow intensely still and are animated only by the sheer application of the paint, requiring no living presences. But the most disconcerting, almost shocking, aspect of *La Raie* lies in the fish itself, bloody and disembowelled and with some horrible sense of grinning, suspended on its hook. This is realism of a kind Chardin did not repeat, at least in such an aggressive manner. It is arresting certainly, and is doubtless intended to be so – perhaps something of a youthful riposte to the highly ornamental, tasteful, and polished still lifes of Desportes and Oudry. All the same, Chardin may well have also consciously emulated, at least for his fishy subject-matter, two elaborate still lifes with trout, lobsters, and other fish which had been executed by Oudry, 'à Dieppe d'après nature', and which were shown at the isolated but important Salon of 1725. To seek a precedent for Chardin's powerful effect is not necessary, but it is at least worth mentioning Rembrandt's *Flayed Ox* (Louvre), a picture which was almost certainly not known to Chardin.[50]

Yet although Chardin was active in the 1720s as a still-life painter, and was received at the Académie with this still life

and the ostensibly more agreeable, and more artificial, *Le Buffet* (Louvre), he had in fact earlier had experience of painting some genre. It was not therefore a total departure when he began to exhibit genre scenes, and it is difficult to accept as more than legend the story that it was a remark of Aved's which directed him to this new source of subject-matter. The earliest recorded work of Chardin is a sign (long lost) painted for the shop of a surgeon-apothecary who was a friend of his father. The composition showed both a shop doorway – with a wounded man being tended after a duel – and the street outside. The inspiration for this picture is most likely to have come from the *Enseigne de Gersaint*, and there are other indications that Chardin at this obscure period of his career was paying attention to Watteau's work. Chardin's sign, on wood, was even longer than that for Gersaint and appears to have been composed of no less than fifteen figures. It remained quite exceptional in his *œuvre*, not merely for its size but for its drama, its social panorama, and its somewhat raw actuality: the duellist stripped to the waist and being bled, the arrival of the police, onlookers peering from windows. It sounds more like Daumier than Chardin's usual, intensely

215. Jean-Siméon Chardin: *A Copper Cistern*, c. 1734(?). Paris, Louvre

intimate domestic scenes, rarely of more than two people. Perhaps it is not too fanciful to parallel this unexpected genre with the unexpected bloody still life of *La Raie*: both indicate currents which might not be apparent from Chardin's later and more – in all senses – familiar pictures.

A further reason for doubting the story of Aved piquing Chardin into painting genre rather than still life is in the homogeneity not only of Chardin's attitude but of the objects which appear in each kind of picture. It is an obvious extension from the marvellously dignified still life of a copper cistern (*c.* 1734?, Louvre) [215], with every indication of use, to the appearance of it in the several-times-repeated design of *La Fontaine*, where the implicit has become explicit: it is now located in a cobbled scullery and a maid bends at it, filling the very jug which stands beside it in the pure still life. From kitchen objects, brooms, pans, a few vegetables, Chardin was naturally led to depict their users: and use extends into a subtly moral domestic climate where work and industry are tacitly praised, and where order, duty, even education, focus on women. There are rarely fathers (seldom men at all) in Chardin's domestic interiors, and where boys occur they usually require – if only by implication – to be disciplined. It is mothers and quasi-maternal women who are prominent: preparing meals and children for school or church, and for household tasks. Part of the power of the subtly-painted *La Gouvernante* (1738, Ottawa) [216] comes

from the sense of everything in it being tightly organized, both aesthetically and morally. There is no Greuzian voluptuous delight in disorder. The *gouvernante* (not a 'governess' in English nineteenth-century terms) admonishes the boy in a strictly private way – but the lesson for future conduct of life is clear, though unstated. Modern commentators tend to miss the strongest moral aspect of the subject: a servant takes on the duty of reproving someone who might grow up to be her employer, and is already the 'young master' and her social superior. There could be no greater contrast, symbolically, between the boyish litter of playthings on the floor at the left and at the right the open work-basket that is the woman's.

How Chardin paints is, of course, far more important than what he paints. Yet his achievement lies in the extraordinary fusion of technique and subject-matter. In his art as much gravity invests two pots as two people. His people are indeed themselves still lifes: inexpressive in features, serious and as compact as some man-made object. Child and chair become one in *Le Bénédicité* (1740, Louvre) [217], again a moral subject, this time derived from Dutch seventeenth-century painting (as are often several of Chardin's devices, like window embrasures framing a scene). Conveyed through the medium of Chardin's paint, what might otherwise be a dangerously 'soft' theme takes on wonderful toughness, rigorousness, and sobriety.

Well before the regular establishment of Salon exhibitions in 1737, Chardin was producing both genre and still-life pictures concurrently. He continued to exhibit at the Place Dauphine, being favourably reviewed in the *Mercure de France* in 1732: '... une vérité à ne rien laisser désirer ...'. In 1734 he exhibited sixteen pictures. The following year he had an opportunity to exhibit briefly at the Académie; among his work was mentioned *Petites femmes occupées dans leur ménage*, and again the *Mercure* spoke perceptively well of him: 'On loua beaucoup sa touche sçavante et la grande vérité qui règne partout avec une intelligence peu commune.' Chardin was already assiduous in attending sessions at the Académie, and he became an assiduous exhibitor. With what Mariette deprecatingly called 'le gros public' he grew popular for his genre scenes, a speciality Chardin cultivated probably the more because of Oudry's continued presence as *the* painter of still life. It is surely significant that not until 1753 – only two years before Oudry's death – did Chardin exhibit any still-life paintings at the Salon. The popularity of his genre pictures was increased by engravings after them; popularity and engravings led to copies, and English sales already by 1738 record versions of pictures which – whether by Chardin himself or only after him – testify to the dissemination of his work.[51]

In engraving some of his pictures, but even more in directing towards him the benevolent attention of the Bâtiments under Marigny, Cochin proved a good friend to Chardin. He is only one of a group of artist-admirers of Chardin, several of whose pictures belonged to Aved – which is not surprising; but the sculptors Jean-Baptiste Lemoyne, Caffiéri, and Pigalle all had choice examples of his work. Although Mariette might condescendingly refer to the taste

Detail of plate 217

216. Jean-Siméon Chardin: *La Gouvernante*, 1738. Ottawa, National
Gallery of Canada

217. Jean-Siméon Chardin: *Le Bénédicité*, 1740. Paris, Louvre

of the 'gros public' for Chardin's genre scenes, these appealed far beyond such limits. To speak of Chardin's patrons is to mean something different from Watteau's; between them and Chardin there was less personal involvement, but their rank alone is sufficient refutation of any suggestion of Chardin's appealing specifically to a bourgeois or advanced taste. *Le Bénédicité* and *La Mère laborieuse* were in the French royal collection by 1744; other genre subjects were early owned by Frederick the Great and the king of Sweden. Although less interest was probably manifested by these and other highborn collectors in Chardin's humble still lifes, his late decorative pictures – almost a return to the manner of Desportes – were destined for the royal château of Choisy and Bellevue. A version of *Les Attributs des arts* was acquired by Catherine the Great, and Chardin's public existence ends with the exchange between him and Madame Victoire, Louis XVI's aunt, who had admired *Un Jacquet* (presumed lost) at the Salon of 1779, in the last year of his life. The painter presented it to her and she sent him in return a gold box 'comme témoignage du cas qu'elle faisait de ses talents'.

Chardin's career was thus honourable and successful. Although naturally he never rose to the highest posts at the Académie, he held the treasurership and also for long the more delicate post of *tapissier*, annually responsible for the hanging of the pictures at the Salon. Perhaps it is no accident that one of the very rare disputes he had, while generally applauded for his tact and fairness in the difficult task, should be with Oudry's son. The elder Oudry and Chardin were often openly compared, not merely as two painters in what seemed the same category of picture but, to Chardin's detriment, in terms of Oudry's rapid, prolific output against his slowness and, even, laziness. Comparable complaints were heard contemporaneously in Venice against Piazzetta; both painters suffered through living in a century of virtuosi and brilliantly speedy executants, where speed for its own sake was admired.

Although there were no dramatic fluctuations in either his career or his style, Chardin certainly evolved as a painter, and his career falls, in fact, into three fairly marked portions, with an epilogue. His early work basically comprises still life, of a humble sort and usually connected with food, whether a loaf of bread or a dead hare. Whatever kind of meal is adumbrated, it remains no banquet. This restriction is, of course, artistic; Chardin finds enough exercise in the placing of a jug and a game bird against a patch of bare wall. The colour too is usually restricted in these early still lifes, with their grainy texture, soberness, and – a word contemporaries used of the artist himself – probity. What has been sought is not the novel or beautiful object but artistic, geometric novelty and beauty: horizontals, verticals, the cone, the cylinder, which matter much more than eye-deceiving effects. Indeed, despite all that has been said – from Diderot onwards – in praise of Chardin's illusionism, he is not perhaps the greatest master of such effects: at least, that is not his primary aim. The convincing power of his pictures comes first from their scaffolding, not their surface. Already in the early still lifes – as in a much later picture such as the *Vase of Flowers* (Edinburgh) – there is one homogeneous surface texture, vibrant and yet saturated. That is true of the texture shared by the vase and the flower petals and the ledge. It would be easy to find flowers, by Van Huijsum, say, which

looked more like real flowers, and this extends to colour as well as texture (the Edinburgh bouquet contains an unrealistic amount of blue, marvellously harmonized with the bluish-white and blue-patterned porcelain).

It was a development, probably from not before 1733 or so, when Chardin began to concentrate on figure compositions; and, even if encouraged by Aved, he certainly turned for inspiration again to seventeenth-century Holland. His early figure pictures tend to present a large, almost close-up, virtually a portrait even when not positively a portrait, like *Le Souffleur* (Salon of 1737, now Louvre), which is presumed to be of Aved. The concept here, even to the three-quarter-length figure, is borrowed from Rembrandt's followers rather than from Rembrandt himself, and close analogies exist with, for example, Bol's *Astronomer* (London, National Gallery). It may not be an accident that Chardin seems to execute these echoes of *Rembrandtisme* just at the time Grimou and Raoux, those two much older supposed exponents of the same style, died. These large-scale pictures – perhaps the least successful of all Chardin's work, as he also may have felt – were soon replaced by the small genre scenes, fully-realized interiors, which proved so successful. In these Chardin established a speciality; he had moved beyond any relevant comparison with either Desportes or Oudry.

Technique separated his pictures totally from those seventeenth-century Dutch painters whose subject-matter had prompted some – not all – of his own. To such an extent was his conception blended with execution that he lifted daily genre studies into a world as timeless and grave as Poussin's. His servant maids are as calm and unmoving as statues. Everywhere there is repose, the repose of people and things

218. Jean-Siméon Chardin: *The Jar of Apricots*, 1758. Toronto, Art Gallery of Ontario

219. Jean-Siméon Chardin: *The Attributes of the Arts*, 1766. Minneapolis, Institute of Arts

in their appointed place, and fixed in the heavy medium of the paint which seems physically to weight as well as to shape each object. Chardin had learnt too – from no one unless from Watteau – how to enliven his compositions with passages of unexpected colour. Like the sudden glimpse of sage-green stockings in the woman stepping into the shop of the *Enseigne de Gersaint* are touches such as the bright blue ribbon round the neck of *L'Écureuse* or, more pertinent, the aquamarine stockings surprisingly worn by the strict *Mère laborieuse*.

There is not space here to develop the point, but it is likely that much of the original popularity of Chardin's genre scenes came from their subject-matter rather than appreciation of the painter's style. Then, as taste required something more 'literary', they may well have increasingly seemed ineloquent and without sufficient incident. 1755 was the year not only of Oudry's death but of Greuze's first appearance at the Salon. Two years before, Chardin had exhibited his small picture *L'Aveugle* (Fogg Art Museum), a simple, single figure, begging but dignified; if not positively the last it was one of his last genre inventions. In 1755 Greuze exhibited his arch *L'Aveugle trompé* (Moscow), painted the previous year, when shown at the Académie. Amid his other highly successful

Salon pictures, this particular Greuze was not of great significance; but even its title hints at new anecdotic tendencies in genre, a direction in which Chardin could not – or would not – go.

Over the next decade and beyond he returned to still life as his major subject-matter. It was in a new mood, however, that he did so. The objects themselves have often become more elaborate, and are usually collected together in more elaborate array. The life they reflect is less austere; instead of raw beef and copper saucepans, there is now fruit and china [218]. The handling of the paint is less saturated and at times tends to a rather disconcerting scratchiness. It may be wrong to say that something of Chardin's impressive power was gone, yet certain critics complained of diminution already in the 1750s. Along with the elaborate meal-tables and fruit and game pieces, Chardin began to paint still lifes of a more sheerly decorative kind, with musical instruments and attributes of the sciences and the arts in the shape of a microscope, books, portfolios, and plaster models (notably Pigalle's *Mercury* [219]); the natural and the physical are replaced by artifacts and the mental. The picture here belonged to Pigalle's widow. Several of these still lifes were

220. Jean–Siméon Chardin: *Self-portrait*, 1775. Paris, Louvre

221. Étienne Jeaurat: *Le Marché 'des Innocents'*, Paris, 1750s. The Trustees of the late Countess Beauchamp

first commissioned as overdoors for the royal châteaux, and then repeated; they represent Chardin coming as close as he could to the style of picture in vogue when he was young, when Desportes and Oudry were receiving steady royal patronage.

That might seem a suitable close to Chardin's career; but in addition to sobriety and probity he had tenacity. Failing eyesight and poor health in his last years led him to change his medium to pastel, but he continued to work and exhibit. He first exhibited pastel heads in 1771, and for the rest of his life he continued to produce similar heads, several of which are lost or unidentified. What he could achieve in the medium, however, remains memorably, movingly clear in the well-known portraits of himself [220] and his wife (Louvre). They owe little to La Tour or Perronneau. Instead, pastel is made to conform to Chardin's ever-recognizable technique: hatching, inlaying of colour, tonal sensitivity without illusionistic tricks, marvellous firmness of forms – utter unsentimentality of vision – such are the qualities of the pastel portraits. Chardin had indeed always possessed them, and was triumphantly in his late seventies to prove that he retained them. It is fitting that Chardin should have had no

true pupils or imitators; those who attempted to emulate him became, in Diderot's apt term, his victims.

We know very little for certain about Chardin the man. No private letters of his exist, no theoretical writings; nor can it be thought that he would have had much to say about his own art. From this it would be wrong to deduce that he was not highly conscious of the effects he obtained, or that he had less to express than Greuze simply because he told no overtly affecting stories in paint. One illuminating anecdote about him was recorded in the year following his death: to another painter who boasted of his own technique for colours Chardin had replied, 'On se sert de couleurs; on peint avec le sentiment.'[52]

OTHER GENRE AND STILL-LIFE PAINTERS: JEAURAT, SAINT-AUBIN, ROLAND DE LA PORTE, LEPRINCE, AND LÉPICIÉ

It would probably have seemed disconcerting to Jeaurat that he should be classed with genre painters, for he was the author of numerous history pictures. However, it is his genre work which entitles him to posterity's attention. Étienne

222. Gabriel de Saint-Aubin: *La Parade du boulevard*, 1760(?). London,
National Gallery

Jeaurat (1699–1789), Chardin's exact contemporary, was born in Paris and became the pupil of Vleughels. When appointed director of the French Academy in Rome in 1724, Vleughels took Jeaurat with him, though no trace of that Italian stay is apparent in Jeaurat's work. He was *agréé* in 1731 and received two years later, with a *Pyramus and Thisbe* (at Roanne). In contradistinction to Chardin, he rose to the highest posts in the Académie, becoming rector and chancellor.

Jeaurat's most interesting genre pictures are a series which illustrate street life in Paris, recording the city's appearance, as well as its inhabitants, with a sub-Hogarthian gusto. Police raids, *filles de joie*, a painter moving house – such are the subjects of these small pictures[53] which he exhibited steadily at the Salon during the 1750s. Although they are not great works of art in themselves, they testify to a steady, vivid interest in daily life, catching at topical, open-air, and urban scenes [221] in a way seldom previously attempted in France. Jeaurat's influence was felt by Gabriel de Saint-Aubin (1724–80), a rarer painter but also the finer artist. Saint-Aubin is most familiar from engravings and drawings, especially his useful sketches in his own Salon *livrets*, but his few surviving paintings have individuality and highly personal charm. *La Parade du boulevard* (London, National Gallery) [222], apparently painted in 1760, is full of surprising colour notes, and even the angle of the composition is faintly unexpected. Saint-Aubin seems to possess an instinctive sense of the decorative which eluded Jeaurat; and he is much less constrained by realistic detail. The tall arching trees which frame the street-show, the energetic player-duellists, and the slender spectators have passed beyond the topical into a realm of enchanted genre. The woman with a parasol who leans from a balcony is brushed in with a felicity which reveals the influence of Boucher. If Saint-Aubin were not established as the picture's author, one would be tempted to suggest it was an early Fragonard.

Saint-Aubin, despite the charm of his work, had a largely unsuccessful career, and at his death his elder brother wrote a severe biographical account, deploring his paintings and the confused existence he led. He painfully failed several times to gain first prize at the Académie and eventually became a member of the Académie de Saint-Luc. He exhibited there in 1774 a variety of paintings, including a 'plafond' of the *Triumph of Love over all the Gods*, and appeared again in 1776 at the Colisée with pictures of all sorts, including some in gouache and pastel. These facts alone make it clear that he did not abandon his ambition to be a painter, while becoming known for his amusing, vivacious engravings which presumably helped him to keep alive. It is an irony that one of the most attractive advocates of the century, making the life of his day seem impregnated with *douceur de vivre*, should have been treated rather shabbily by it.

Much more obscure was the career of Henri-Horace Roland de la Porte (c. 1724–1793), a still-life painter too quickly characterized by Diderot as one of Chardin's victims. It is true that this was for long his posthumous fate, because his best pictures were mistaken for Chardin's. Roland de la Porte was *agréé* in 1761, and it was at the Salon of 1763 that he exhibited a group of pictures which drew down on him Diderot's comment. Some of his work does sail too near the

223. Henri-Horace Roland de la Porte: *The Little Orange Tree*, by 1763. Karlsruhe, Staatliche Kunsthalle

wind of Chardin, but in, for example, *The Little Orange Tree* (Karlsruhe) [223] he attempts something distinctly different, in subject and technique. In some ways he is more naturalistic than Chardin; the glossy-leaved plant – recorded with sensitive precision – springs from a convincingly earthy earthenware pot, across which is bent a stalk which cleverly enhances the three-dimensional effect. Perhaps not too much should be made of a single example, but there are other pictures by Roland de la Porte of growing plants; it is a subject not treated by Chardin and somewhat alien to the pronounced human concern of his still lifes. Yet this picture was bought in Paris within the painter's life-time for the Margravine Karoline Luise of Baden, and at her death, still within his lifetime, was catalogued as by Chardin. Roland de la Porte was thus early his victim, but modern scholarship has convincingly separated his work from Chardin's. Though he can be austere in design, his paint has none of the gritty, viscous character of the greater artist; indeed, in handling, he comes nearer Desportes.

A more prominent figure, and one more typical in the faintly unreal, fancified genre that he produced, is Jean-Baptiste Leprince (1734–81). Born at Metz, he became Boucher's pupil in Paris; that influence remained paramount, and Leprince emulated his master not only in style but in sheer productivity. About 1758 he travelled to Russia, where he was to be extensively employed on decorative pictures for the palaces of the Empress Elizabeth.[54] Experiences of life in Russia provided the basis for his art when he returned to

224. Nicolas-Bernard Lépicié: Le 'Lever de Fanchon', 1773. Saint-Omer,
Musée de L'Hôtel Sandelin

Paris in 1763. He was ambitious to make a name for himself
and launched a virtual campaign for picturesque *russeries*,
with paintings and etchings of Russian customs and costumes,
views of Russian countryside, and the *Russian Baptism*
(Louvre) which was his *morceau de réception*. *Agréé* in 1764,
he became a member of the Académie the following year and
immediately appeared at the Salon with well over a dozen
pictures.

Leprince was able without being particularly interesting,
and his increasing ill health perhaps drove him to a fury of
productivity which has given a deadly monotony to his
pictures. Neither a Boucher nor a Fragonard, he was simply
not sufficiently inventive, despite all his efforts. When illness
required him to leave Paris for the environs he began to paint
landscapes, exhibiting some of these for the first time in 1773.
Though some critics felt that here he challenged Vernet,
Diderot had never showed himself very favourable to
Leprince, and his reserves are fully justified. Even in his
Russian genre pictures Leprince remains weakly fanciful and
unconvincing for one who had visited the country, partly
through an inability to infuse vitality into his figures. Their

wooden faces were unkindly contrasted by several critics with
the lively handling of their costumes. It is no surprise to find
that Leprince owned several Russian costumes and also a
collection of small mannequins which were utilized only too
patently in his pictures.

Much closer to Jeaurat than to Leprince as a painter is
Nicolas-Bernard Lépicié (1735–84), usually associated
nowadays with genre pictures but esteemed at the time
equally for his history pictures.[55] Trained first under his
father, the distinguished engraver and biographer Bernard
Lépicié (1698–1755), and then under Carle van Loo, Lépicié
was *agréé* in 1764 and quickly came into prominence,
exhibiting constantly at the Salon from 1765 onwards. He
became a member of the Académie in 1769. His history
pictures are sometimes of historical interest (e.g. *William the
Conqueror invading England* at the Lycée Malherbes, Caen,
an early example of inspiring national subject-matter, shown
at the 1765 Salon) but of little artistic merit. Nor are his
genre pictures always successful, wavering between Chardin –
several of whose genre pictures had been engraved by the
elder Lépicié – and the sentimental style of Greuze. They

tend to exploit – if the word is not too cruel – the instinctive charm of children, but Lépicié was probably at his best in virtually straightforward child portraits (e.g. *Emilie Vernet*, 1769, Petit Palais, Paris) without anecdotic flavour. Although he began by emulating the texture of Chardin's paint, as in *L'Enfant en pénitence* (Lyon), he already there applied the tearful recipe of Greuze to his subject-matter. In his later genre, the handling grew lighter and more fluttery.

In the struggle for his allegiance Greuze effectively defeated Chardin, but elements of both painters can still be detected in the so-called *Lever de Fanchon* (Saint-Omer) [224], painted in 1773, and shown that year at the Salon. The picture has charm – a natural gift which deserted Lépicié only in high-flown historical subjects – and it is also a perfect document of taste for its particular period. Boucher's improbable girlish nymphs reclining amid velvet cushions have been replaced by an actual nymphet-girl dressing in bed in a carefully realized humble setting. The still life of broom, pots, and plain wooden table forms a homage to Chardin; the tantalizingly disarranged clothes, with all the elusive suggestiveness of the morning toilet, pay their tribute to Greuze. In one way the girl is a descendant of the *baigneuse* (a theme already adumbrated in Santerre's *Susannah* [12] of 1704) but combined now with intense realization of low-life genre – a Rousseau setting of supposedly purer manners and more innocent hearts than would be possible for upper-class people in Paris. The spartan attic is indeed vividly conveyed: the large areas of bare wall and coarse wood even hint towards David's use of such devices in *Marat assassiné*.

Lépicié does not teach an overt moral lesson nor depict any dramatic action, but 'naturalness' and simplicity, attractively located in the environment of a poor but pretty girl, are none the less urged on the spectator. It is thus a picture which could have appealed almost equally to the aged roué Louis XV and to the virtuous domestic dauphin, so soon to become Louis XVI.

GREUZE

Historically, Greuze is the most important painter of mid-eighteenth-century France.[56] If the speedy success of Watteau in the first quarter and David's slower but ultimately greater success in the last decades indicate outstanding *rapport* with their contemporaries, then the huge popular success enjoyed by Greuze reveals how effectively he spoke for the middle years. In that role he is more relevant than Chardin and far more ambitious than other genre painters like Jeaurat and Lépicié.

Yet there is some sense of mismatch in the phenomenon of Greuze. It is as if his undoubted talents did not quite equal his ambition or even his historical importance. Some failure of artistic tact, it may be, mars the very genre compositions for which he became, and remains, rightly famous. There is something soft-centred about them, all the more unexpectedly as Greuze proved himself positively tough and uncompromising as a portraitist, especially of characterful men [225]. At his best he handled paint with great skill and sensitivity, never quite losing some feel for it, as his last self-portrait (Marseille), tense and proud, sent to the Salon of 1804, movingly confirms. And as a draughtsman Greuze was astonishing in his range and accomplishment, in style as

much as in subject-matter; the pen drawing of his wife (Amsterdam) [226] is in itself a miniature masterpiece.

Nevertheless, it was not for such examples of his art that Greuze won his greatest success. It was for genre painting, of a kind which is unprecedented (owing little to Hogarth and not much to Dutch seventeenth-century genre) and which is intended to affect the spectator less by surface realism than by intense psychological truth. Greuze's forerunner is thus Poussin, rather than any genre painter as such. And where Chardin is calming, Greuze is consciously disturbing: he aims at sensations of drama, and in his most elaborate genre scenes he therefore introduces conflicting emotions which should stir the spectator to enter a similar state. In this he positively anticipates David; one of the first critiques of the *Oath of the Horatii* emphasized the most interesting contrast between the sublime heroes and the sorrowing women, and expressed admiration for the 'magic brush' which knew 'how to awake in the mind such opposing and powerful emotions'. Before David, Greuze realized that the unit of the family is the framework within which most emotional havoc can be caused. The inherent conflict between parent and child provided a theme for most of his large-scale figure compositions; and this is still relevant even for those which depict extreme harmony – for example *La Piété filiale*, *La Mère bien-aimée*, *Le Fruit de la bonne éducation* (the *Paralytic*) – since these examples hint at the alternative, which indeed Greuze often depicted in a deliberate pendant. In such pairs lie opportunities for conflicting emotions: 'look here upon this picture, and on this'.

To stir the emotions became an end in itself for Greuze. For that reason he has rightly been detected as at best an

225. Jean-Baptiste Greuze: *J.-G. Wille*, 1763. Paris, Louvre

226. Jean-Baptiste Greuze: *Madame Greuze*. Drawing. Amsterdam,
Rijksmuseum

ambiguous moralist. Perhaps the earliest criticism was made
by the future Madame Roland, who remarked of *La Cruche
cassée* (Louvre) that one doubted if the girl looked sufficiently
disturbed not to be tempted to repeat her mistake. Despite
Greuze's own claims and all Diderot's assertions – 'c'est la
peinture morale' – Greuze was not a truly moral painter but
a sensational painter, in the sense of affecting the spectator.
Madame Roland appreciated the girl in *La Cruche cassée* as
quite piquant and delightful. Another contemporary, also a
woman, found *La Vertu chancelante* (Munich, by 1776) 'very
affecting'; praise enough. Whatever praise may now be given
to the so-called *Accordée de village*, it is doubtful if it would
be felt that 'le sujet est pathétique et l'on se sent gagné d'une
émotion douce en le regardant', though such were Diderot's
words when he saw it. The *Journal de Paris* reviewed in verse
Greuze's work and urged him on:

> Poursuis, Greuze, poursuis, la faible humanité
> Pour le peintre du cœur te réclame et te nomme.

'Peintre du cœur' was Greuze's title to his period's interest.
The heart, so clearly left untouched by Boucher and
significantly not appealed to by Chardin, was to be virtually
assaulted by Greuze. Although he did not create the taste for
emotionalism, he ministered to it. It was an appetite which
did not need to feed on contemporary subject-matter either,
but could find sufficient tearful nourishment in, for example,
the *Sacrifice of Iphigenia*. Of Carle van Loo's composition of
that subject Caylus had said: 'le spectateur n'en est frappé
qu'après avoir versé des pleurs ...'. If this might be said in
praise of Van Loo's work, it is clear that an audience already
existed to enjoy the patent emotionalism of Greuze, so
constantly conjuring us to feel – and only secondarily, if at
all, concerned with what exactly we feel.

A new emphasis was increasingly placed on the value of
feeling, as such. Artistically, this was shown by the century's
concern with expressive physiognomy, typified by Hogarth
and Lavater, as well as by La Tour, and by Caylus' foundation
at the Académie of a prize for 'expression'. A sufficient subject
for a picture existed in a head which conveyed an emotion –
and this did satisfy, to some extent, a new psychological
interest. Yet Greuze betrays his own tendencies by preferring
girls' heads as his theme, perhaps believing, wrongly, that
sensibility is a female prerogative. What is more, Greuze

Detail of plate 228

227. Jean-Baptiste Greuze: *La Paresseuse Italienne*, 1756. Hartford,
Wadsworth Atheneum, Ella Gallup Sumner and Mary Catlin Sumner
Collection

could convey emotion in a way which particularly appealed to the period, by giving it virtually literary expression: 'd'enchaîner des événements d'après lesquels il serait facile de faire un roman' was one of Diderot's most pertinent comments on Greuze, intended as praise. Some of Greuze's pictures are indeed modern novels in themselves, with every detail meant to be read, and he increasingly supported them by descriptive matter, usually published in the *Journal de Paris*. This literary tinge naturally appealed to a literate public – the readers not only of Rousseau and Voltaire but of Richardson (about whom Diderot wrote in the *Journal étranger* (1762) a glowing *Éloge*, praising his novels as different from those of previous writers because they touch the soul and breathe 'l'amour du bien'). To help the less literate or intelligent, Greuze actually composed his more ambitious pictures like theatrical tableaux.

All this confirms the existence of a wide public – very different from the small amateur circle who had appreciated Watteau. Not only did Greuze make the fullest possible use of the Salon exhibitions, but through engravings of his pictures he ensured that they remained familiar even when the original had passed into private ownership. In this use of engraving for dissemination of his important compositions he once again anticipated David.

There is one final important factor in Greuze's success. The parallel between his work and the novel – even more than the stage – is closest in the concern of each not merely to tell a story but to tell one which had never been told before. No other eighteenth-century French figure painter avoided conventional and familiar subject-matter so completely as did Greuze. Chardin often reworks Dutch genre subjects, and the novelty of subject-matter as such is never his aim. Apart from one early religious picture, a commissioned work, Greuze painted hardly any religious pictures – unlike Watteau, Boucher, Fragonard, and David. He rarely painted mythology, and his one history picture is of an obscure incident. His elaborate genre scenes are contemporary stories of his own devising; they require to be read the more carefully just because they do not derive from a known literary source, and they could make their effect without any of those odious comparisons likely to arise when what has been described in literature is illustrated by painting (cf. Diderot on Homer and Vien[57]). There was astuteness in Greuze's method, reversing the process by writing about what he had previously painted. Above all, he provided the public with what it has always enjoyed: pictures which tell stories simple enough to be deciphered, yet topical and fresh. The expressions, the gestures, the 'telling' detail, all help to make one forget one is confronting art; it becomes as actual and arresting as a street accident.

When a taste for different subject-matter – more heroic, closer to the battlefield than the pavement – grew prevalent, Greuze naturally fell from favour. The faults of his actual painting were revealed; age increased them and time confirmed them. He had enjoyed a great measure of popular success, beginning with the burst of fame which came to the previously unknown painter at the Salon of 1755. His last years were like a dreadful lingering revenge taken by the public on its one-time favourite. In 1802 Farington (*Diary*) glimpsed him in Paris; with unconscious cruelty he qualified the name with the words 'formerly an Artist of very great reputation'.[58] Not until 1805 did Greuze die.

Jean-Baptiste Greuze was born at Tournus in 1725. His father was a tiler and dealer in masonry who seems to have hoped at first that Greuze would become an architect. Recognizing however his son's gift for painting, he sent him to study at Lyon under the mediocre Grandon. Ambitious, confident of his talent, always childishly arrogant, Greuze must quickly have realized the need to go to Paris. It is not established exactly when he arrived, but he soon impressed some distinguished confrères, including the royal drawing master, Silvestre, and Pigalle (both of whose portraits he painted; shown at the Salons of 1755 and 1757 respectively). It is possible that he had begun at Lyon the *Père de famille expliquant la Bible* (Salon of 1755) which was bought by the well-known amateur La Live de Jully, who became a considerable collector of Greuze's work and was twice portrayed by him. To these useful acquaintances was soon to be added the Abbé Gougenot, a close friend of Pigalle's.

Greuze's obscurity ceased abruptly in 1755. A month or two after being *agréé*, he showed at the Salon a group of pictures, including the *Père de famille*, which La Live de Jully had already exhibited privately within his own circle. Critics, other artists, the public, all joined in praise of this new talent; it was probably the most brilliant début of the century, and perhaps the century took a first conscious revenge when all the court', Marigny explained, though Greuze showed no haste to execute them.

In 1757 he returned to Paris and never travelled abroad again. Yet despite exhibiting a great deal, he did not capture public attention as successfully as he had done before, until at the 1761 Salon he showed *Un Mariage (l'instant où le père de l'Accordée délivre la dot à son gendre)* (Louvre) [228]. With this he consolidated his fame, both contemporaneously and posthumously, because this picture remains the popular fourteen years later Greuze's *Septime Sévère* was to be somewhat unfairly attacked, beginning with the Académie's snub in receiving him not as a history but merely as a genre painter. Meanwhile, in 1755, with success doubtless inflating his always abnormal vanity, Greuze went off to Italy with Gougenot, arriving in January 1756 in Rome, where he was welcomed by Natoire.

It is not easy to sum up what Italy meant to Greuze in terms of art, though he exhibited at the Salon of 1757 four pictures 'dans le costume italien', including *Indolence* or *La Paresseuse Italienne* (Hartford) [227]. Here one might see the influence not only of Caravaggio but of Subleyras, notably in the beautiful response to tones of cream and white, set off by passages of warm colour, like the girl's scarlet shoes. Greuze's feel for textures is demonstrated in the range of material suggested: from the delicacy of glass to the coarse fabric of the skirt, not overlooking the pale yet sensuously heavy tones of flesh. A typically Greuzian fondness for the pleasures of disorder characterizes the whole composition. Not Italy but his own temperament seems the inspiration behind it. The most useful aspect of Greuze's visit to Italy was perhaps that it led to Marigny writing about him to Natoire. Thus we learn how highly regarded he already was by Marigny, who commissioned two pictures from him for Madame de Pompadour's apartment at Versailles; 'they will be seen by symbol of Greuze. Once again he had achieved success by depicting a family – and though much can and should be said

228. Jean-Baptiste Greuze: *'L'Accordée de village'*, 1761. Paris, Louvre

against Greuze's typical numerous girls, it is noticeable how often in his major subject pictures he emphasizes the role of the father (that figure markedly absent from Chardin's genre scenes): a father explains the Bible, a father hands over his daughter's dowry – both duties with moral and social significance. It is of course a father who is involved in *Septime Sévère*. Indeed, one of the last pictures Greuze ever exhibited was a *Père de famille remettant la charrue à son fils devant toute la famille* (Salon of 1801).

L'Accordée de village, as it is now usually called, is in effect the *Oath of the Horatii* for the middle years of the century. Even its ownership is typical. Bought by Marigny himself, it was to be acquired at his death on behalf of Louis XVI by d'Angiviller, on the enthusiastic recommendation of Cochin and Pierre. It remains the essence of Greuze, compositionally as well as in other ways. His preferred setting is an interior, a shallow stage-like area, normally with one right-angled wall; the figures are assembled in a loosely-knit frieze across the composition, a tendency increasing in his later work. The emotional variations exploited by the subject are much greater than in the *Père expliquant la Bible*. Watteau had made the subject[59] a symbol of almost cosmic peace, with music and

dance gracefully uniting humanity with nature – open-air nature of a tranquil village amid tufted trees. Greuze concentrated on human nature, excluding the natural world and simplifying the setting so as not to distract from the gamut of emotions expressed by the faces. Each figure expresses an individual reaction to the moment. Disunity in the family is prophesied, for the mother tearfully must part with her daughter, whose younger sister is also saddened, while her elder is sullenly envious. The tearful yet ineffective females contrast with the trio of men: the dignified father praising his daughter and exhorting his future son-in-law, a serious young man who receives girl, dowry, and exhortation, and the sly peasant notary who literally documents the occasion and reminds us that it is as much legal as domestic. In the very division between men who act and women who remain passive, it is perhaps not excessive to see some hint of the *Horatii*.

All this makes sense if Greuze, like David, looked back to Poussin for inspiration. Indeed, there can be little doubt that at least instinctively Greuze was painting comparable mixtures of emotion ('choses ... qui ne déplairont pas à ceux qui les sçauront bien lire', as Poussin had written of his own

229. Jean-Baptiste Greuze: *Septime Sévère*, 1769. Paris, Louvre

Gathering of the Manna) before he turned to the frankly Poussin-style *Septime Sévère* (1769, Louvre) [229]. What still needs clarification is Greuze's stylistic sources, an inevitably complicated matter since little is yet established about his earliest years. Although Italy played small part in his development, it is probably right to see an influence of Reni in his expressive heads. When he was in Rome he became aware perhaps of new neo-classical tendencies represented by Gavin Hamilton (whose work Natoire was to praise) and doubtless saw something of Subleyras' work. Back in Paris he seems to have come close temporarily to Chardin's handling of paint – seldom closer than in the fine *Écolier qui étudie sa leçon* (Edinburgh) [230] of 1757, which has the unforced sobriety of his best male portraits. There is considerable variety in Greuze's style, yet with a movement away from Chardinesque vigour towards smoother, even glossy handling of paint – especially when dealing with more upper-class milieux like those of *Le Tendre Ressouvenir* and *Une Jeune Fille qui a cassé son miroir* (London, Wallace Collection), both of 1763. Something of the same oscillation is apparent in Fragonard.

The step which took Greuze from modern family subject-matter to the imperial Roman dissension between Septimus Severus and his son Caracalla was almost inevitable.[60] Jeaurat and Lépicié were both accepted as painters of history as well as of genre, and Greuze must have wished to be recognized as at least their equal. He chose an obscure subject to illustrate, but it may well have seemed ideally chosen: historical and antique, it could also be seen as a variation on *le fils ingrat* or a *malédiction paternelle*. Varied emotions are at work too within it: from Caracalla's angry shame to the surprise of the chamberlain, Castor, at the emperor's recklessly heroic gesture which is at once a challenge and a rebuke. Feebler pictures were painted by Vien, and indeed by a whole generation of later neo-classical painters who escaped the censure given to Greuze by the Académie. The bas-relief composition and the dull colouring could be found in other pictures by Greuze; as he himself fairly remarked, why should he alone be judged by the standard of Poussin? It is difficult not to think that the picture's chief fault was its prematureness; ten years later it might well have sufficed to qualify Greuze as a history painter. Certainly there is some

230. Jean-Baptiste Greuze: *Un Écolier qui étudie sa leçon*, 1757. Edinburgh,
National Gallery of Scotland

irony in the fact that it should have been so violently criticized in a climate which was imperceptibly changing and would soon warmly encourage this sort of stern, antique, semi-patriotic subject for pictures; and there is further irony in the fact that, when a genre painter took the step so often and widely urged – to ennoble his art – he was rebuffed.

The incident led Greuze to a quite different step, yet one in which he once more anticipates David. He broke with the Académie and never exhibited again at the Salon during the *ancien régime*. As David was to do, he made his studio his place of exhibition; there he received the Emperor Joseph II, Marie-Antoinette's brother, and there he exhibited his portrait of Franklin – both events made much of in the press. Greuze soon proved that press publicity was more valuable than the prestige of the Salon. His highest prices and greatest fame came in the years from 1769 onwards, until the arrival of David. But though his popularity declined, he remained active. He seems positively to have welcomed the Revolution, parading republican sentiments which should not be dismissed as just claptrap; rather, they may cast reflective light on the real similarity of his attitude to Rousseau's. He went on to paint portraits of the revolutionary leaders and stirring scenes of contemporary life – among them the *Death of Marat*. Favoured by the Bonaparte family, he was commissioned in 1804 to execute a portrait of the First Consul; in his long, remarkable career perhaps nothing makes a more suitably remarkable closing incident than that virtually his last portrait should be of Napoleon (1804–5, Versailles), and that he should share the single posing session for it with the youthful Ingres.[61]

HISTORY PAINTERS: HALLÉ – DOYEN – LAGRENÉE THE ELDER – DESHAYS – BRENET – DURAMEAU

Not every painter-member of the Académie Royale deserves discussion, even if there were space here to do so. Diderot would pardon the omission of Noël Hallé (1711–81), succinctly characterized by him as 'pauvre homme, artiste médiocre'.[62] But it is useful to remember that, particularly in the middle years of the century, the painters who have tended to be singled out by posterity lived and worked – and exhibited – amid contemporaries who then ranked as at least equally important.

Hallé, son and grandson of painters, was a highly successful artist, eventually, if briefly, *recteur* of the Académie and made chevalier of the order of Saint Michel after settling matters at the Académie de France in Rome following the disorder of Natoire's régime. Like many a painter of the period, Hallé seems at his liveliest on a small scale and in sketches. Nevertheless, he received major commissions for large-scale work, typified by the *St Vincent de Paul preaching* (Versailles Cathedral) [231], exhibited at the Salon of 1761. Although Diderot spent several paragraphs stigmatizing the picture, it is not as banal as he would imply. The church interior is conveyed with a good deal of care, and the congregation vividly characterized, at least in terms of seventeenth-century costume. In fact, the picture could fit well into the 'historical' vein of art to be associated with d'Angiviller's tenure of office at the Bâtiments in the closing years of the *ancien régime*. And it is interesting to find that Grimm added a postscript to Diderot's strictures (which he thought too severe), agreeing

231. Noël Hallé: *St Vincent de Paul preaching*, 1761. Versailles Cathedral

that Hallé was no genius, but stating that he had 'de la vérité'.

In the middle period of the century there was a lack of stylistic coherence but no lack of practitioners – and some remarkable work was produced. Doyen scored a success in 1767 with '*Le Miracle des ardents*' [232], a miracle of St Genevieve, which is one last robust homage to *Rubénisme*. It has often been pointed out that his commission for Saint-Roch was painted and exhibited in the same year as Vien's *St Denis preaching* [192], an effective neo-classical exercise for the same church; it is less often realized that the latter project had originally been given to Deshays. Two years earlier Diderot had praised the elder Lagrenée, admittedly in terms which contain a significant reserve ('... tout, excepté la verve'), and Lagrenée's work now looks half-heartedly neo-

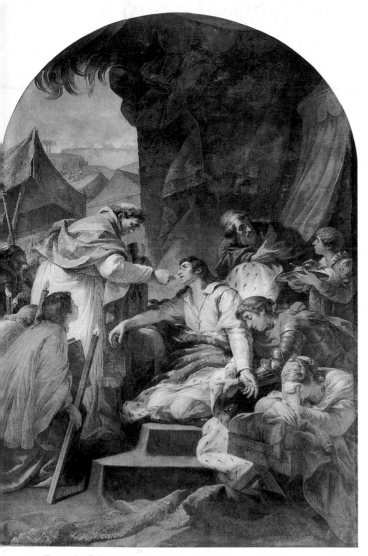

233. François-Gabriel Doyen: *The Last Communion of St Louis*, 1773. Paris, chapel of the École Militaire

There is another aspect of Doyen, represented by *The Last Communion of St Louis* [233], painted in 1773 for the high altar of Gabriel's cool and classical chapel of the École Militaire. Hung high above the high altar, Doyen's composition needed to read clearly, and in fact the familiar air of it is explicable because it goes back to Domenichino's famous *Last Communion of St Jerome*. A particularly French period touch is the figure of the afflicted woman at the right; she seems to appear in one guise or another in so many comparable paintings, like an incarnation of *sensibilité*, though of a kind rather studied and ultimately unaffecting.

It is not quite clear whether Doyen should have proved the highest hope of French painting, a precursor of Romanticism perhaps; on the outbreak of the Revolution he became involved with the national museum project,[64] and in 1791 left France altogether for Russia. Although the effect of the '*Miracle des ardents*' is somewhat confused, it has a sense of real drama otherwise largely lacking in French eighteenth-century religious pictures. The saint herself and the cloudy vision of the Virgin are remarkable enough, but perhaps most admired were the afflicted figures who writhe in the lowest portion of the composition. It is tempting to see in them precursors of the occupants of the *Raft of 'Medusa'*.

Such almost Romantic realism was beyond Doyen's near-contemporary Louis-Jean-François Lagrenée (1725–1805), a more typical pupil of Van Loo, who also travelled to Russia but returned in 1763, after a three-year sojourn. Like Doyen, Lagrenée studied as a prize pupil in Rome, where he was to return in 1781 as Director of the French Academy.[65] Lagrenée's work shows the influence of Domenichino as well as Reni, and also unfortunately a prosaic quality derived directly from Van Loo. Although his subjects were increasingly of high antique virtue (drawn from Quintus Curtius, Valerius Maximus, and Plutarch), the paintings themselves convey little emotion and rarely suggest much emotion. At best they contain competent studies of drapery, elegantly arranged even in situations where elegance is unlikely to have been the first consideration (cf. *La Fidélité d'un satrape de Darius*, Salon of 1787, now at Aurillac). If Doyen once approaches Tiepolo, Lagrenée often comes close – perhaps deliberately – to Batoni.

Lagrenée received several royal commissions in a busy life. Royal in its subject matter, and commissioned by the tutor to the royal children, the Duc de la Vauguyon, was Lagrenée's *Allegory of the Death of the Dauphin* (Fontainebleau) [234], which is something of a painted equivalent to the younger Coustou's tomb [122–4]. Although the figures are not strictly allegorical, apart from the sorrowing France behind the bed, for they represent the dauphine and the couple's sons (including the dead one who appears with a crown of stars for his dying father), the effect is of allegory rather than fact. And the idiom in which the picture is painted is certainly classical, much as interpreted by Batoni, though to critics of the day it suggested Guido Reni.

Markedly different is the idiom of Deshays, and one may wonder how he would have interpreted a similar commission (Greuze had been the artist first commissioned on this occasion by Vauguyon). Jean-Baptiste Deshays (1721–65) was born at Rouen, the birthplace of one of his early masters, Restout.[66] He trained under a variety of painters, being most

classical, stylistically ticking over in a narrow lay-by on the road from Boucher to David. Deshays is something quite different: a painter widely recognized at the time as one of the highest hopes of French art, likely to stir it from its lethargy, but dead before he could establish his leadership. And Brenet was an uncommitted but successful figure of the day – a long day – who encountered hostile criticism only at the end of his career.

François-Gabriel Doyen (1726–1806), a Parisian pupil of Carle van Loo, responded to late Baroque Italian painting when he went to Italy in 1746, having won first prize at the Académie.[63] Unlike Greuze, he ventured to visit Venice as well as Rome; his style was indeed formed by colourists – Giordano among them – and an explicit debt to Rubens is shown by his visiting Antwerp before painting '*Le Miracle des ardents*'. The result marks the high point in Doyen's career, and the mingled influences bring it close, at least compositionally, to Tiepolo's late altarpieces (the *S. Tecla* at Este in particular).

232. François-Gabriel Doyen: '*Le Miracle des ardents*', 1767. Paris, Saint-Roch

234. Louis-Jean-François Lagrenée: *Allegory of the Death of the Dauphin*, 1767. Fontainebleau, Musée National du Château

235. Jean-Baptiste Deshays: *The Martyrdom of St Andrew*, 1759. Rouen, Musée des Beaux-Arts

influenced by Restout and Boucher, whose daughter he married. Although he did not owe his success to Boucher, it is probable that Boucher facilitated his rapid rise to recognition. He won first prize at the Académie in 1751 and went to Italy three years later. His brilliance and vigour had been encouraged; on that foundation he built the elements of Baroque design, studying the Carracci as well as Rubens, and – it may reasonably be assumed – Pietro da Cortona. In or around 1758 he returned to Paris and was *agréé* in 1759, exhibiting at the Salon for the first time that year.

Although Deshays was talented, it is not altogether easy now to understand why his work created the sensation that it did. By 1761 Diderot was calling him 'le premier peintre de la nation'. Other critics were equally appreciative. It is true that Deshays appeared at a moment of artistic lull, when the older men were growing noticeably older and there seemed a marked diminution of talent. More important was the category of picture which he concentrated on, the grand-scale machine, preferably with a dramatic subject: miracles, deaths, martyrdoms, for which he was perhaps better suited than for more conventional *galant* subjects. Doyen's later success with '*Le Miracle des ardents*' shows that traditional religious subject-matter, treated in a dramatic way, was widely acceptable. Deshays' *Martyrdom of St Andrew* (Rouen) [235],

destined for a church of that saint at Rouen, achieved a positively sensational success at the Salon of 1759; two years later he exhibited another scene from the saint's life, an altarpiece which led Diderot to hail him with the words quoted above.

Yet it is hard to feel that stylistically Deshays was basically much of an innovator. His sketches may be superior to those of De Troy and Natoire, but they are otherwise very similar. His subject-matter is usually very different from that preferred by Boucher, yet one may think that in the 1730s Boucher could have produced a dramatically stirring altarpiece that might later have won Diderot's approval – if he had not known the author. Deshays' martyrdoms and deaths do not have the intensity – or the novelty – of Restout's *St Scholastica* [50]. Deshays is perhaps to be classed among the last of Baroque exponents; certainly in handling paint he is nearer to Fragonard than to David. And the supposedly black year of 1765, which saw the death of Carle van Loo followed

236. Nicolas-Guy Brenet: *Homage rendered to Du Guesclin*, 1777. Versailles,
Musée National du Château

shortly by that of Deshays, was also to be the year of
Fragonard's Salon début, when his vast *Corésus et Callirhoé*
proved not only a defiant Baroque gesture but a triumph for
the previously unknown painter.

Before Deshays' death there had appeared the apparently
promising figure of Nicolas-Guy Brenet (1728–92),
immediately praised at his first Salon showing of 1763 for
the 'grande manière' revealed by a large-scale *Adoration of
the Kings* (lost).[67] He worked hard, especially in his early
period, pressed by the need for money ('Annulé par
l'indigence', Diderot was to say crisply, if cruelly, four years
later). Originally a pupil of Coypel and Boucher, Brenet
seems to have been most significantly formed by his years at
the École des élèves protégés under Van Loo. His was a style
of academic realism, competent, often bold in chiaroscuro,
certainly not Baroque but equally not neo-classical. Le Sueur,
and perhaps Vouet, meant much more to him than Poussin.
In some ways subject-matter was more important than style
to Brenet who – though he may reasonably be claimed as
more robust than, for example, Vien – is basically interesting
as a historical phenomenon.

Up to 1775 Brenet was associated particularly with
religious pictures. On the appointment of d'Angiviller to the
Bâtiments, Brenet largely renounced such subject-matter for
classical and modern historical themes. This new emphasis
on the true history picture clearly suited him and was
encouraged by d'Angiviller to an extent which became
publicly clear at the Salon of 1777.[68] That year Brenet
exhibited the earliest of his versions of the *Homage rendered
to Du Guesclin* (Versailles) [236], one of the first medieval
subjects commissioned 'pour le roi' by the new director-
general. This deathbed scene, where the hero is honoured by
his enemies (the English) and mourned by his own
countrymen, combined affecting themes of humanity and
patriotism in a way that aims to be historically accurate.
Bayard and Henri II were other French historical characters
to be painted by Brenet,[69] in a style little different from that
he used for Scipio and Roman heroes, but in each case with
careful attention to costume and location. His pictures at the
Salon of 1789, the last to which he contributed, were tersely
criticized ('manque de noblesse') by the *Journal de Paris*,
which – like nearly every other newspaper – was warm that
year in praise of David. By then David had set an artistic
standard which Brenet could not approach. Yet there is an
element of stark pathos and grandeur in his concept of the
Du Guesclin where the great general lies armoured but
convincingly dead – a stiff figure with upturned feet, prone
on a high bed under the sombre hangings of his vast tent. It
is romantic without being rhetorical, and is the more effective
in the original version through the unexpected upright shape
which enhances the tall lines of the tent and concentrates the
composition on the corpse.

Brenet's *Du Guesclin* was exhibited at the Salon of 1777 in
a specific category, as envisaged by d'Angiviller, representing
an 'Act of Respect for Virtue'. Its pendant as an 'Act
of Respect for Morality' was *The Continence of Bayard*
(Grenoble) [237] by Louis-Jean-Jacques Durameau (1733–
96).

A pupil first of the sculptor Defernex,[70] Durameau trained
at the École royale des élèves protégés and then went to

237. Louis-Jean-Jacques Durameau: *The Continence of Bayard*, 1777.
Grenoble, Musée des Beaux-Arts

Rome in 1761. A souvenir of his years there is his boldly
atmospheric, almost timeless gouache of a saltpetre factory
(Louvre), signed and dated 1766? [238], exhibited with a
Neapolitan view by him at the Salon of 1767. On his return
to France Durameau was to work as a decorative ceiling
painter (e.g. part of the Galerie d'Apollon, Louvre) but
particularly as a painter of sober 'history' pictures. History
and religion conveniently blend in his impressive *St Louis
washing the Feet of the Poor* (1773, chapel of the École
Militaire, Paris), with its Italianate chiaroscuro and richly-
applied pigment, as in the robes-cum-vestments of the royal
saint.

The Continence of Bayard is artistically much less confident
(nor is the subject easily taken seriously). The composition
reads rather awkwardly. We have to understand that Bayard
has not only declined to seduce a pretty girl but is returning
her intact to her mother with a small dowry that Durameau
makes resemble a mislaid dorothy-bag. The would-be
medieval costumes are in an anthology of 'period' dress, worn
by oddly commonplace figures; Durameau succeeds best with
the setting, which is carefully realized as an elaborate Gothic
interior. Yet whatever the picture's artistic failings, its
importance is considerable. It is a forerunner of a complete
style of art, called 'Troubadour' in France, which was to
prove popular throughout northern Europe and which would

238. Louis-Jean-Jacques
Durameau: *A Saltpetre
Factory in Rome*, 1766(?).
Paris, Louvre, Cabinet des
Dessins

survive well into the nineteenth century, embracing such varied phenomena as the Middle Ages, Sir Walter Scott, and Cavaliers and Roundheads. Indeed, it can be said to survive as late as Yeames's 'moral history' picture '*And when did you last see your father?*', painted in 1878.

Durameau and Brenet may seem to form less an epilogue to the middle period of the eighteenth century than prologue to the late years. Yet by 1781 the author of the *Mémoires secrets* could state that it was no longer the Viens, Doyens, Van Loos, and Brenets who were admired, nor the ennobled and high-ranking academicians, but the beginners, the *agréés*[71] – in a word, the new generation.

The Late Years

Sculpture: The Period of Houdon's Ancien Régime Career

INTRODUCTION

Houdon, born in 1741, exhibited for the first time at the Salon of 1769 – showing there earlier, that is, than some of his senior fellow-sculptors. The last Salon to which he contributed was that of 1814. Thus his active career provides a convenient section of broader study, covering historically the most eventful years of post-Renaissance Europe; in his own sculpture can be traced the end of the *ancien régime*, the rise of new men, new policies, and of course the new, republican, world of America. It is easy to think of him as somehow a parallel to David, but he is perhaps better paralleled in Goya; like Goya, Houdon mirrors an international, not merely national, climate. Since he lived to see the Allies in Paris, it is almost surprising that he, who executed a bust of the Czar Alexander I, never sculpted Wellington.

Houdon far outlived all the late-eighteenth-century French sculptors of any importance. His own career subsumes virtually the complete lifetime of Chaudet and the working life of Chinard – the two most robust and interesting sculptors to emerge on the artistic scene towards the end of the century. Well before Houdon's death, Rude (1784–1855) and David d'Angers (1785–1856) were engaged on their reliefs for the Arc de Triomphe; Barye was being employed under Fauconnier, the Duchesse de Berry's goldsmith; and in the year before Houdon died, Carpeaux was born. Indeed, Houdon's lifetime carries French sculpture so deep into the new century, itself born to unprecedented complexity compared with the calm of 1700, that he takes it beyond the scope of this volume.[1] But his own art was formed long before 1800, by which time he had in fact achieved much of his finest work.

The last quarter of the eighteenth century in France is marked by yearly knells of doom for the old political system, dying in public, and only too conscious of needing remedies.[2] Statesmen passed with bewildering speed. Summoned like doctors, they tinkered vainly with the body politic and then disappeared: Turgot, Necker, Calonne, and then Necker again. There was even a shadowy evocation of the great days of cardinal-ministers when the Cardinal de Brienne briefly appeared – with a revolutionary proposal to tax the privileged classes – between Calonne's fall and the return of Necker. The cardinal had to be dismissed by the king, who announced the summoning of the States-General. They met eventually at Versailles in May 1789. Thence onwards the Revolution – which came into existence almost officially with the Oath of the Tennis Court (20 June 1789) – can be charted by monthly,

not yearly events. These succeeded each other with hectic rapidity – as if the century had suddenly to make up for all those years of lethargy and apparent ease. The Republic, so dramatically established before the eyes of Europe, was itself not to survive the century, disappearing with it at the *coup d'état* of November 1799 which made Napoleon the master of France.

All that momentous history had touched sculptors as much as painters. If it did not produce a figure to rival the authority of David, it yet certainly inspired men like Jacques-Edme Dumont (1761–1844), who returned to Paris from Italy in 1793 and was soon active in giving sculptural expression to the new Republican ethos. Some of his work remained merely projected, but his plaster statue of *Liberty* (1795) was executed and set up.[3] Events could divide families in almost Roman fashion; the Deseine brothers were temperamentally split in their allegiance, and while the younger brother Claude-André offered his bust of Marat to the Convention in 1793, Louis-Pierre had proclaimed his sympathies by offering Marie-Antoinette in 1790 a bust done after nature of the dauphin. The steps in the rise of Napoleon are positively charted by the busts executed by Boizot, of him as general, as first consul, and finally as emperor. Napoleon's patronage lies outside this volume's scope, and in sculpture – with his preference for Canova – virtually outside France; but probably no one more effectively and economically depicted him as naturally divine and naturally imperial than Houdon [254]. This arrogantly simple, classic mask of terracotta is of a man – but one who is master of the world. For all its positive execution in the nineteenth century, it marks an end rather than a beginning, both politically and artistically. It may legitimately find its place as the epilogue to a century which had opened with a different monarch and a different artistic style: the Coustou brothers' Baroque, which had been specifically approved by Louis XIV.

The problem years of the century, artistically, lay in the period which immediately preceded the Revolution: that rather fatigued *ancien régime* conducted during the reign of Louis XVI. During that period the greatest new sculptural talent was clearly Houdon's, but official patronage of him was very slight. His visit to America was made in much the same circumstances as Falconet's to Russia; he believed he would get the opportunity to create an equestrian statue – a monument of the type he was not commissioned to produce in France. Even in that he was, unlike Falconet, disappointed. No doubt his career in Paris was checked through the presence of Pajou, who retained under Louis XVI the favour shown him by Madame du Barry. But the lack of interest in Houdon is itself an indication of the somewhat insipid nature of patronage during Louis XVI's reign and of the resulting insipidity and uncertainty of style – so well conveyed by the work of Pajou himself. This is not entirely, and perhaps not

at all, a question of the rise of neo-classicism. Before Chaudet there was no French neo-classical sculptor – unless Bouchardon during the first half of the century.

Apart from Houdon, and leaving aside Clodion, the sculptors emerging in Louis XVI's reign were largely lacking in clear-cut adherence to any particular style. Their strongest trait was itself negative: an avoidance of the Baroque. The masterpiece in this 'styleless style', where repose and grace were the most positive qualities, was created not by Pajou but by Julien, whose seated *Girl tending a Goat* [248] perfectly expresses the aims of a basically aimless period. It was an official royal commission, an immediate popular success, decorative as well as decorous (an important point in a prudish climate which excluded Houdon's naked *Diana* from the Salon),[4] the sculptural equivalent to a picture by Vien.

A sort of lassitude lay over the arts, at least in sculpture and painting. New idioms and new inspirations were needed – and hence, incidentally, the sense almost of relief at the arrival of David. But in sculpture there was to be nothing comparable to the *Oath of the Horatii*, and of course no sculptor to assume the prestige and power of David. Houdon is not in any way David's equivalent: he had nothing of the rebel and little even of the innovator in his nature. Although his career was to confirm that a sculptor – as Clodion's career suggested – need not depend for fame or commissions on the official and established forces of patronage, Houdon himself had no urge to opt out of the *ancien régime* system. It must always be remembered that his ambition was not at all to become a *bustier*; circumstances made him one, and in doing so they uncovered the real nature of his highly competent yet essentially uninventive talent.

An enervating mood originated in the last years of Louis XV's reign; Diderot, reporting on the state of painting at the Salon of 1767, had already prophesied gloomily 'Je crois que l'École a beaucoup déchu, et qu'elle déchéra davantage.'[5] It was to combat such a general feeling, and to stir France out of political as well as artistic decrepitude, that the scheme of the 'grands hommes' was conceived under d'Angiviller, appointed Directeur Général des Bâtiments in 1774, the year of Louis XVI's accession. The basis of d'Angiviller's scheme was historical, rational, and patriotic.[6] The Louvre should become a huge public museum – a notion that had long been aired – and among the objects in it would be a series of lifesize statues of the great men of France: writers, astronomers, philosophers, and artists, as well as the inevitable soldiers and statesmen. It is only one of several ironies surrounding the late years of the century that the Revolution should have precipitated the museum's existence. Under Napoleon and Louis-Philippe the scheme was in fact to continue. Yet the 'grands hommes' have never been assembled together anywhere, and are today divided into three major portions, two of them located somewhat inaccessibly for the public.

The individual statues are naturally very varied in quality, though not always in the way that might be expected. Houdon's wind-blown *Tourville* (1780–1, Versailles) is faintly absurd and undoubtedly his least successful large-scale work,[7] while Clodion's *Montesquieu* (1778–83, also Versailles) is a surprisingly accomplished and impressive monumental achievement. The stylistic shifts in the series are not connected just with individual sculptors' merits but reveal

the same oscillation apparent elsewhere in work produced during Louis XVI's reign and the basic lack of a dominant sculptural idiom. But the overall significance of d'Angiviller's scheme is unmistakable. First it substitutes interior for exterior location – and an interior neither religious nor royal but public and fully national. The sculptors were employed not on decoration, nor on subjects of mythology, but on those of national history, 'propres à ranimer la vertu et les sentiments patriotiques'. This is a tacit admission that such feelings have sunk to a state requiring re-animation. There is a subtle avoidance of too patently monarchical themes: no evocation of the misty past of Clovis and the Frankish kings. And even when a soldier was selected, it was not simply his military achievement which gained him his place. Writing to Pierre in 1779 about the choice of subjects for statues to be ready for the Salon of 1781, d'Angiviller stated that he had the king's approval for four new figures, including the Maréchal de Catinat: 'un général de terre non moins recommendable par ses talents militaires que par son désintéressement, son humanité et son esprit philosophique'.[8] In that phrase there is a Voltairian echo, an optimistic belief in reasonable standards which events were soon ruthlessly to destroy. France was not going to be saved by d'Angiviller's scheme for its 'grands hommes' to be sculpted in marble, and what humane and philosophic sentiments had not achieved was to be gained by violence.

The 'grands hommes' scheme was the last, the most elaborate, and perhaps the most intelligent act of *ancien régime* patronage. It made explicit ideas which may reasonably be said to be detectable, however faintly, in the mid 1730s under Orry. Its fault lay in being too consciously an effort made against an existing climate and standards; and as a result it became somewhat boring, for the sculptors one may guess as well as for the ordinary public. The most percipient comment on it came as its epitaph, provided by d'Angiviller himself, who wrote in 1790 that he had attempted to give purpose and direction to the arts, of both painting and sculpture, at a period when the category of historical work was being replaced by the inferior genres of portraiture and landscape, and when there were few decorative commissions available to artists. To some extent d'Angiviller recognized that he had failed – at least that he had not totally succeeded; and one may sympathize with his position, between a largely apathetic court and artists who were not always as eager as he thought they should be to execute his elevated commissions. Clodion, Pajou, Houdon, Julien, were basically much better employed in other directions; after all, they were artists not moral regenerators. When the Revolution came it would have its own heroes, before it learnt that there was only one hero, a single living 'grand homme' who was enshrined in the public museum when – swollen with his spoils – it became the Musée Napoléon.

Detail of plate 258

CLODION

Artistically the most attractive sculptor of the later years was not the officially approved Pajou, nor Houdon, but the much more elusive Clodion. And although it is necessary not to exaggerate Clodion's role – for he received full academic training in Paris and at Rome, several large-scale commissions, and a great deal of praise – it remains true that he stands for private art and triumphant liberation of the artist in the same way as does Fragonard. They have more than that in common, but historically it is this emancipation – a last grace-note of *douceur de vivre* – that gives them their importance; aesthetically, of course, they have it by sheer stature. The very fact that neither fits into any postulated artistic pattern is an indication of originality. About both their lives remarkably little is known; their personalities remain quite obscure, and gradually the two artists retreat from the official stage of the Salon into private commissions and unexhibited work – which deepens their obscurity. By an irony, it is during the Revolution and the years immediately following that their careers emerge into the open again. But their best work was done; it seems no more relevant that Clodion contributed to the decoration of the Vendôme column than that Fragonard became a sort of republican party official.

Clodion's emancipation is in marked contrast to the Adam milieu from which he came, with its anxiety for respectable, royal commissions and its eagerness to execute large-scale fountains and monuments. Yet it is reasonable to think that he had an innate affinity with the decorative principles of their work, sharing the same emphasis on excitement and movement, and the same preference for not too serious, mythological subject-matter. Even less than the Adam did he concern himself with portrait busts; and, like them, his decorative powers were best expressed in a medium other than marble. Although the life-size *Montesquieu* [242] is by itself sufficient indication of Clodion's ability to handle marble, his name is rightly associated forever with terracotta – the medium whose potentialities for small-scale decorative works had first been fully revealed by Le Lorrain. Nothing helps more to make apparent how different was Clodion's aim from Falconet's than their different media: the chilled white figurines of Falconet inhabit an arctic climate of frozen gesture and northern pudicity compared with the warm-coloured, sun-baked, dancing fauns and delirious nymphs whom Clodion sets in recklessly erotic motion.

Claude Michel, always to be known as Clodion, was born at Nancy in 1738, tenth child of a family that was to produce several other sculptor sons. His father was some sort of humble trader, and it proved of more significance that his mother, Anne Adam, was the sister of the Adam brothers; under Lambert-Sigisbert, Clodion received his first training, leaving Nancy for Paris and entering his uncle's studio about 1755. These were not very fortunate years for the elder Adam, who had ceased to exhibit at the Salon and was anxious only to receive the sums due to him for several works, including the *Abundance* which may well have been completed by Clodion after his death. At Adam's death Clodion entered Pigalle's studio for a brief period in 1759; he won first prize for sculpture at the Académie in the same year and then entered the École des élèves protégés. After three years there he received his *brevet* as a pensioner at the French Academy in Rome (a document which is, perhaps significantly, silent about his training before Pigalle). He reached Rome on Christmas Day 1762 and did not return to France until the spring of 1771.

As for so many other French sculptors, Rome proved the decisive experience for Clodion – not only the Rome of ancient and modern monuments but that of connoisseurs and collectors. It was there that his uncle Lambert-Sigisbert had won the competition for the Trevi fountain. Clodion sought no public work but was himself sought out. His biographer and friend Dingé was to write of these Roman years that 'his products were bought even before they were finished'.⁹ Success brought commissions and offers from beyond Rome; by 1767 Jullienne owned at least two terracotta statuettes by him, and other French collectors – including Boucher – acquired work by him during these years. Catherine the Great tried to draw him to Russia, probably about 1766 and perhaps before Falconet's arrival at St Petersburg. Whether or not Clodion was tempted, he did not yield. Always somewhat apart from his fellows, whether pupils or mature artists, he was ideally placed in Rome: almost like another Poussin, 'en quelque petits coings . . . à son aise', with a supply of patrons and close to the sources of his art. A comparison with Poussin may seem shockingly ludicrous, but only if the gaiety of some of Poussin's paintings, and the severity of some of Clodion's statues, is missed. And whatever Clodion made of his inspiration, there can be no doubt that it sprang from a vision of classical Antiquity.

This was not in general the accepted academic concept of nobility and dignity – though Clodion could achieve both when required – but a sense of countrified, quite literally *pagan* manners: closer to the Campagna than to the city, expressing a golden age of liberty when wine and love were mankind's only concerns. With him this becomes a single theme, symbolized by the rhythm of the dance, sometimes graceful and enchanted, sometimes rude to the point of rape. Throughout there is a mood of escape which deepens to romantic intensity:

> What maidens loth?
> What mad pursuit? What struggle to escape?
> What pipes and timbrels? What wild ecstasy?

Keats's 'Grecian Urn' was probably conflated from more than one work of art, including Claude's paintings, as well as engravings of vases; and Clodion's classical world was probably derived equally from similarly multiple sources, with some glances at the nymphs and satyrs of, for example, Lauri's pictures. His dancing, chasing, usually Bacchic, people are probably directly inspired by antique vases rather than by figurative sculpture. As for the material of terracotta, it is tempting to see more than coincidence in his being in Rome – as was the young Nollekens – at a period when groups of antique terracottas were being discovered there. We know how much these struck Nollekens, who essayed some terracotta models of his own;¹⁰ and the mention of Cipriani admiring the original antique terracottas is a further hint, sentimental though his nymphs and children are in comparison with those of Clodion.

239. Clodion: *Relief of a Nymph and Faun*, 1776. Cambridge, Fitzwilliam Museum

Clodion's golden age is naturally when the world was young; not only do his subjects tend again and again to treat, or include, children, but a childish air is part of the charm of his nymphs, so much fresher and yet more truly abandoned [239] than the girls of the *Parc aux cerfs*. His vision is one more testimony to humanity's belief in the rejuvenating, liberating property of the countryside. A tambourine and a bunch of grapes are all we need, apart from a companion in love. And perhaps the final effectiveness of his work comes from the basic truth of his vision; as much as Watteau he speaks quite seriously, for all his gaiety, of passion.

It is probable that his first essays at Rome were terracotta figures, on the miniature scale he was to make so much his own, but single ones. Some were reductions or pastiches of classical statues: vestals, veiled priestesses at their rites, which were in antique taste, with conscious classical purity of line. His vases were similar in style; that in the Mariette sale of 1775 typically showed children playing, and the commendation given to the sculptor neatly sums up what appealed to the period: 'Il règne dans les ouvrages de ce jeune artiste une correction de dessin supérieure et une touche pleine de feu et d'esprit.'[11] Just so might someone have greeted the early work of the young Bouchardon. But where Bouchardon was to sacrifice fire for correctness, Clodion was to preserve, and even intensify, the energy which was soon animating not merely single figures but complete groups.

Once he had established his style it was to evolve very little in the years of his popularity extending up to the Revolution. Immediately recognizable and immediately appealing, his work managed to remain marvellously inventive. Whatever

240. Clodion: *Satyr carrying a Bacchante playing a Tambour*. Philadelphia Museum of Art

241. Clodion: *Pair of Bacchic Figures with a Child*. Waddesdon Manor (National Trust)

variations of scale and treatment he was capable of, it is in the small terracotta groups that his energy and delicacy and variety are best displayed. Sometimes chasing each other, sometimes embracing, often accompanied – if not positively urged on – by a mischievous child, these groups of men and women, or satyrs and nymphs, seem like graceful opposing forces from whom a spark is always struck. Even when not actually in contact, their bodies seem to betray on their sensuous surfaces awareness of each other's sex. Man is often the satyr, a little grotesque, a little clumsy, but only to set off the piquant contrast of some slim, naked nymph [240], herself by no means repelled by a rustic lover. Clodion can hardly help putting them in action; and it is here that the groups have an advantage over even his most attractive single figures. Sometimes it is violent impetuosity that hurls the bodies along, with flying hair and breathless faces; but at other times the tempo is gentle, even wistful [241]: the figures are an enchanted, eternally youthful, family moving amid the scattered grapes, coming as if from some *vendange*, sated with autumnal fullness.

When the sculptor left Rome in 1771 he returned to Paris already successful and well-known. He had established his own category of sculpture and had no need to fear or envy Caffiéri or Pajou or Houdon (who had been in Rome for part of the same period). Clodion settled down to become almost a factory, his work being duplicated in porcelain and bronze, and his studio busy with the sedulous-ape activities of his brothers.[12] He exhibited at the Salon for the first time only in 1773, having been *agréé* earlier that year. Neither then nor at his rare later appearances did he, however, show any of his most brilliant terracotta groups. It seems that, at least in 1773, he was eager to emphasize the range of his talents; there was a small marble of a child satyr with an owl, vases, and graceful bas-reliefs, but also a *Hercules*, a *Rhine*, and a *Jupiter* in plaster which was presumably the model for Clodion's never-produced *morceau de réception*. These indicate the sculptor's ambition to be serious, even severe, proclaiming that he was not only the master of graceful, miniature groups but capable of tackling a large-scale, elevated commission.

That one of these now came his way was owing partly to changing circumstances. When the Salon of 1773 opened, Marigny (become Marquis de Ménars) had resigned and been replaced as Directeur des Bâtiments by Terray – who commissioned the group of *Music and Poetry* (Washington)

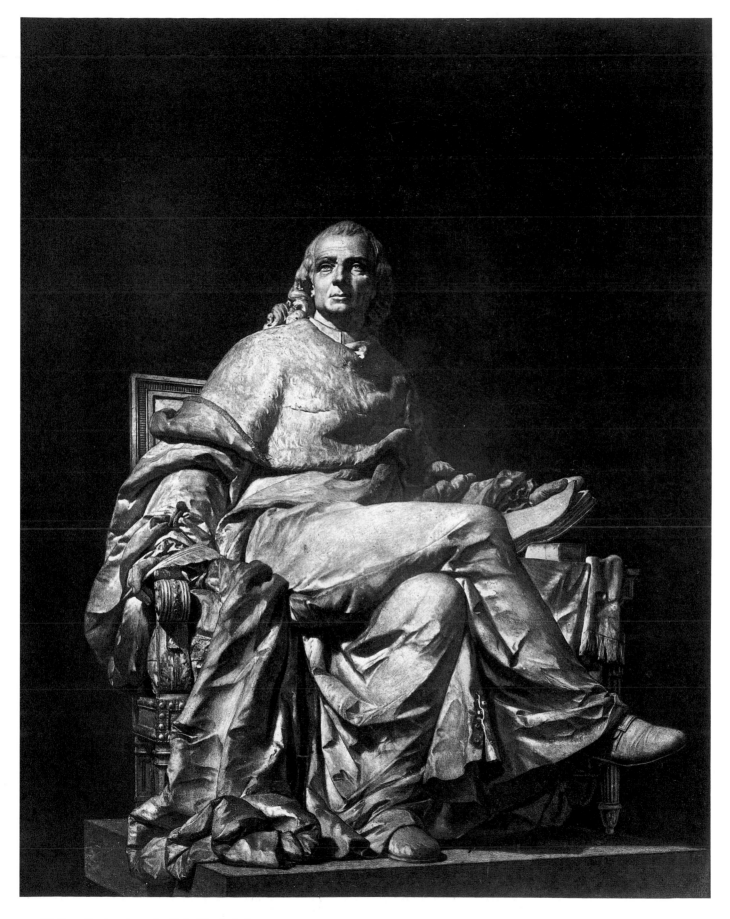

242. Clodion: *Montesquieu*, 1783. Paris, Musée du Louvre

243. Clodion: *Relief of Satyresses and Baby Satyrs, c.* 1781. New York, Metropolitan Museum of Art

from Clodion, along with Caffiéri's *Geometry and Architecture* [152], Lecomte's *Astronomy and Geography* [154], and Tassaert's *Painting and Sculpture* (also Washington). If the group of *Music and Poetry* was close in concept to Clodion's previous work, the commission from the cathedral authorities at Rouen for a *St Cecilia* (1775–7) was more unexpected and the result not particularly remarkable except as showing that Clodion had studied Bernini and Algardi (notably the *St Mary Magdalen* in San Silvestro al Quirinale). In late 1773–1774 Clodion was briefly back in Italy[13] – officially occupied with selecting the marble for this statue at Carrara and also some blocks for the Bâtiments – and it is likely that he looked with care at the achievements of the great Roman Baroque sculptors, already engaged as he was to Rouen to execute his first large-scale religious figure.

When he returned to Paris it was to a new king and a new Directeur des Bâtiments. The immediate result of d'Angiviller's appointment was of course the initiation of the scheme of the great men of France – nearly all chosen from the seventeenth century. It was perhaps Clodion's fortune that when one of these commands was assigned to him in 1778, he received that for the most recent personage in the series, Montesquieu (d. 1755). Modern costume must have seemed wrong for an image of the philosopher, and Clodion seems to have sought a compromise between realism and classicism, perhaps partly suggested by Pigalle's *Voltaire*, with the figure loosely draped but exposing one bare leg. The plaster model appeared at the Salon of 1779, the same year as Houdon showed his bronze of *Voltaire seated* and his bust of Voltaire 'drapé à la manière des Anciens'. It would be easy to say how typical of the late years of the century were the solutions of Clodion and Houdon – but, if so, they were undoubtedly precipitate. Truth was valued, somewhat naively valued, before any homage to classicizing ideals.[14] Both sculptors were at once strongly criticized in almost identical terms. Houdon seems to have been unaffected, but Clodion

was working for the Crown; he took the critics' advice and for the final statue of 1783 produced the *Montesquieu* [242], clad in the dignified, faintly ecclesiastical costume of *président à mortier* in the *parlement* of Bordeaux.

For some reason, the seated statues in the great men series are more successful than the standing figures, but among them all Clodion's is the finest achievement. It is not so much rivalled by Houdon's *Voltaire* [258] as conceived in absolutely opposite terms: as patent as the opposition of Slodtz' *St Bruno* to Houdon's – and *Montesquieu* has indeed some Slodtzian echoes. In the *Voltaire* Houdon concentrates mobility on the face and for the rest gives permanence to the seated figure with its few simple folds of heavy drapery: a literally statuesque pose which expresses pride and senility – for there is a sense of Voltaire impotent to move, physically petrified for all the marvellous mental alertness.

Clodion had to be content with recording Montesquieu's features in a finely carved if rather fixed mask of shrewd thought, abstracted and far-gazing. But for the pose he chose an animated, cross-legged position which, in conjunction with the multifarious folds of drapery, gives a swinging instantaneous effect and a positively Caffiéri-like sparkle to the creased surfaces of the costume. With Houdon, everything is compact. The statue is still haunted by the dimensions of the cube from which it was carved, and it remains very consciously a cube. It is static, timeless, its power held within it as essentially as the will-power which kept its sitter alive. Clodion, with no living sitter to inspire him, gave his own artistic vitality to the challenging figure, seized at a moment, with hands – and even the foot – as if in action. All this is accompanied by tremendous surface animation, which yet manages not to be distracting despite the details of unbuttoned gown, creased and folded-up cape, fringed tablecloth, and so on. The robes cascade over the chair and nothing seems to keep a completely contained shape: the tablecloth is disarranged, the leaves of the book bent. All

the proportions seem emotionally dictated, fluid, elongated, spilling out of one plane into the next; but the final effect is commanding, largely owing to the proud pose of the head. There is nothing intimate in the statue. Julien seems to have directly borrowed its cross-legged pose for his statue of *La Fontaine* in the same series (the plaster model appearing at the Salon of 1783, where Clodion exhibited his finished marble), but he used it to suggest a relaxed mood. The *Montesquieu* is much sharper and more formal; as well as of the philosopher, we are reminded of the patrician.

It was a deserved success, and the only surprising thing is that Clodion did not receive the commission for another great man; he had to wait until in 1810 Denon requested from him a statue of General Lacoste which was never executed. The *Montesquieu* remains the most obvious proof of Clodion's abilities as a sculptor in marble and on a large scale. Further indications of his moving beyond the restrictions of the small terracotta group are the bas-reliefs and other decorations which he contributed to several interiors and exteriors: from the décor for the hôtel of Jacques-Louis Bouret de Vézelay to the complete bathroom scheme for the Baron de Besenval, via the superb stucco decorations for the courtyard of the Hôtel de Bourbon-Condé. Brongniart was the architect involved on each occasion and presumably suggested Clodion's name as a suitable sculptor. If the Besenval reliefs (Paris, Louvre) make a slightly cold effect, the Bourbon-Condé work [243] is wonderfully zestful and redolent of the Renaissance in its unforced, enchanted pagan air, bringing hints of the countryside of antiquity into late eighteenth-century urban Paris.

Clodion thought it worthwhile to submit two models to the competition which d'Angiviller devised, and then lost interest in, for a monument to the famous balloon ascent from the Tuileries Gardens in 1783. One of these (1784–5, Metropolitan Museum) [244] might well have been designed by Fragonard and represents the last, light-hearted extreme of an enchanted world: countless rioting putti toil and play about the balloon itself, tumble around the plinth from which it rises, decorate and distract from it, blinding science by their presence. The Montgolfier brothers are forgotten (though recalled by a medallion on Clodion's other design) and it is love that fires the balloon – as it had fired so much eighteenth-century art.[15]

Perhaps not surprisingly, Clodion was not among the four sculptors d'Angiviller singled out to submit further models. Like Fragonard, and in some ways like the Guardi, Clodion represents the extreme dissolution of a style. Beyond him there was only imitation or reaction. It is not just latent Goncourt-ism to see the *Balloon Monument* as a farewell to the graces of the century, disappearing from the scene in a confused flutter of wings and ribbons and babies' bottoms. After the Salon of 1783 Clodion did not exhibit there again until 1801 – and then with a group in a new manner. Clear warning had been issued by an anonymous critic at the Salon of 1793: 'En effet, les allégories de l'amour, les portraits des courtisans ... nous intéresseront fort peu désormais.'[16] Clodion, amazed everyone by the heroic, grim, and pathetic plaster group of *The Deluge*, which showed a Géricault-like tableau of a dead woman and a struggling father carrying the exhausted body of his son. It was shown at the Salon of 1801

with other exhibits by Clodion, including a subject from the *Arabian Nights*. Thus, unlike Fragonard or Greuze, Clodion was able to adapt to the new climate of ideas;[17] *The Deluge* seems to have been a success and led to several state commissions. He took his place with such sculptors as Chaudet, twenty-five years his junior.

Clodion died on 28 March 1814, less than a month before Napoleon's abdication. He had outlived his brothers, who had continued for so long to pastiche his style; one of them had even borrowed his name. One pupil survived to carry his style further into the nineteenth century: Joseph-Charles Marin (1759–1834), whose terracottas at their best come very close to Clodion: *Head of a Bacchante* (signed and dated 1786) [245]. Marin's career took him to Italy at the end of the century, and again from 1802–10, when his patrons in Rome included Chateaubriand. Some of Marin's later work is in a

244. Clodion: *Montgolfier Balloon Project*, 1784–5. New York, Metropolitan Museum of Art

246. Clodion(?):
Ram and Ewe, 1759(?).
Nancy, Musée Historique
Lorrain

sterner vein but he figures prominently as a beneficiary in Clodion's will and is designated as 'ami'.

The inventory of possessions at Clodion's death reminds one of where his real affinities and achievements lay: with pictures by Boucher, a drawing by Fragonard, plaster models of Pigalle's *Venus* and the famous *Mercury*. It is not that he was a typically boudoir artist, serving fashion and being just decorative. His god was nature, encountered in gardens and fields, figured often as Priapus or Pan. This naturalism shows perhaps most clearly in those terracotta models of animals [246][18] which are closely associated with his style if not necessarily by him. While never lubricious or sly, the sculptor definitely recognised something of the animal in men – seeing there no cause for shame. Clodion is as indifferent to topicality as to costume. His interest in Antiquity is *au fond* liberty of spirit; his religion is the need for love. Though so little is

known of his life and personality, he expresses the artist's freedom in abstention from the Académie (never becoming a full member), in his delight in the imagination, and even in his apparently confused amours. Certainly he belongs in the eighteenth century – if only through his grace and wit – but in many ways he anticipates the following one.

JULIEN

Apart from the obvious exceptions, a cluster of not very dazzling talents represents the new generation of sculptors active largely in Louis XVI's reign and destined to survive the century. Probably the least significant, though he would have been surprised to hear it, was Mouchy, who barely reached the new age, dying in 1801. Several other sculptors are remarkable for some single piece rather than for profoundly important or interesting careers; thus Jean-Baptiste Stouf (1742–1826) lingers in the memory for the *Abel mort* (Louvre), suitably etiolated and collapsed, his *morceau de réception*, dated 1785, which is perhaps the last piece to be presented under the *ancien régime* to the Académie.

245. Joseph Charles Marin: *Head of a Bacchante*, 1786. London, Victoria and Albert Museum

The oldest and most talented of these men was Pierre Julien (1731–1804), for various reasons slow to appear on the official Parisian scene, but the one who best embodies the chaste insipidity of the Louis XVI style. Julien was born in provincial obscurity in the small town of Saint-Paulien in the environs of Le Puy. There he is said to have been employed as a boy watching flocks, and that certainly provides a satisfactory background for the sculptor of the *Girl tending a Goat* [248], though she has long been removed from any rustic reality. One of Julien's uncles, a Jesuit, remarked his ability and had him apprenticed to a sculptor-gilder at Le Puy, in a studio concerned with the production of wooden religious statues for local consumption. From that he moved to Lyon, were he worked under Antoine-Michel Perrache (1726–79). Probably in 1758 Perrache sent him to Paris, with a recommendation to the younger Guillaume Coustou. In 1765 Julien won first prize at the Académie and then spent three years at the École des élèves protégés before setting out for Rome in 1768.

For the formation of Julien, and for his presumed orientation towards classical Antiquity, some claim has been made about the influence of Dandré-Bardon, professor of history at the École. It is true that Dandré-Bardon lectured on classical subject-matter and had views on the uses of mythology and allegory, but, like his paintings, his written works show him quite uncommitted, able to praise Pietro da Cortona or Bernini as fairly as some antique artist. Like Dandré-Bardon, Julien was to be unengaged, affected more by the pressure of fashion than his own instinct. When he executed his first statue for the series of 'grands hommes', the *La Fontaine* [247], he showed the writer in complete seventeenth-century costume; the plaster model for that statue was executed in 1783. By the time he came to execute his second commission for this series, the *Poussin* (Louvre), of which the model was done in 1789, classical-style costume and poses had grown much more fashionable. Julien managed to drape the painter in a sort of nightgown-toga, with folds falling to expose one bare knee: a conscious piece of antique homage which the figure's statuesque pose emphasized. It was Clodion, much more truly in touch with the sources of Antiquity, who had envisaged classical costume when first trying to depict Montesquieu as a Roman philosopher – only to be severely criticized for so doing. No adverse criticism, however, seems to have been made of Moitte's semi-classically costumed, Roman-style, *Cassini*, the model of which was shown at the Salon of 1789; in ten years taste had come to accept what had earlier seemed an affectation – though there was a precedent for it in Pajou's classically draped *Buffon*. The distinctly different climate at the end of the century was best, if most ludicrously, summed up in Stouf's nearly naked *Montaigne*: 'depouillé des habits de son siècle', as the Salon *livret* of 1800 explained, going on to emphasize that nudity was a state that had been consecrated by the Greeks and Romans in their masterpieces.

There is no evidence of Julien being markedly orientated towards neo-classicism of this programmatic kind. However, it is likely that a tendency to simplicity was implanted in him by his work under Coustou – himself already tending to the 'correct' and flavourless. Coustou is the more likely to have given direction to Julien, since Julien returned from Rome in

1773 to work further under him for the next few years. At this date Coustou was engaged in the major task of the monument to the dauphin, on which Julien probably assisted him. It has even been suggested that Julien was the actual sculptor of the figure of Conjugal Love, the most striking portion of the monument. There are similarities between this figure and Julien's *Ganymede* (Louvre), the model for which was presented to the Académie in 1776, the year before the Sens monument was completed. But the position is complicated by the existence of a *Ganymede* by Coustou (Victoria and Albert Museum), a much more truly classical piece than Julien's, though less delicate, now somewhat weathered, and probably always less highly finished. Indeed, it is partly the picturesque elaboration of Julien's statue – with its obtrusively detailed Wedgwood-style jug, its pudgy cloud and huge eagle – that makes it so clearly of its period. Coustou's is closer to antique prototypes, in pose and execution (the treatment of the hair in both statues is worth comparing).

It is conceivable that the existence of Coustou's statue was the explanation of why Julien met with an unexpected rebuff from the Académie. Sculptor and model were both rejected in 1776, for reasons not made explicit.[19] But it is worth noting that Coustou was at that date rector of the Académie. Julien seems to have been utterly disheartened by his rejection: he contemplated retiring in dudgeon to Rochefort, where there was a demand for carvers of ships' prows. This extreme step was avoided. Julien recovered his spirits and was soon successfully set on his career. He became *agréé* on presenting the *Dying Gladiator* in 1779 (Louvre) and also received the commission to execute his *Ganymede* in marble for the Baron de Juis, a Lyonnais who became his staunch patron and supporter. At the Salon of 1779 the *Gladiator*, so much more brusque and tough a subject than the *Ganymede*, was highly praised; exception was taken only to the gladiator's hands, which were shrewdly noticed to be sculpted with perhaps 'trop de délicatesse'.[20] And that quality – of sentiment and handling – remained typical of Julien.

He seems never to have executed any portrait busts or monumental groups. Even in the *La Fontaine* [247] he scarcely attempted to produce accurate portraiture but concentrated on a lively, perhaps suitably anecdotal, effect, with a generalized shrewdness and vivacity in the subject's features. Julien's delicacy of handling is apparent not only in the somewhat over-detailed treatment of the hair but also in the frieze of bas-reliefs, illustrating scenes from the fables, which decorate the pedestal. The fables are yet more patently present in the slightly porcine fox, with one paw on a book, which creeps out from La Fontaine's cloak and peers up at him.

D'Angiviller constantly wrote of wanting the subjects chosen for the 'grands hommes' to suit, as far as possible, the nature of each sculptor's talents. Julien's certainly made him a more suitable sculptor of La Fontaine than of, for example, Turenne. In the Salon of 1783 Julien's model was found the

247. Pierre Julien: *La Fontaine*, designed 1783. Paris, Louvre

best of the four exhibited, the others being Pajou's *Turenne*, Caffiéri's *Molière*, and *Vauban* by Charles-Antoine Bridan (1730–1805), creator of the exuberantly Baroque decoration of the *Assumption*, unexpectedly located in the cathedral choir at Chartres.[21]

Perhaps the subject offered Julien the necessary excuse; altogether his statue is the first, and probably the last, of the whole series that is relaxed and even playful in its effect. A writer's life seldom has many of those significant moments of decisive action that could be grasped in depicting a great general; nor could La Fontaine be given the authoritative pose justified for a writer such as Descartes. Julien's 'moment of action' is not, significantly, a moment at all (despite the Salon *livret*'s mention of his seizing 'ce moment'), for it depicts La Fontaine dreaming in an attitude he had held throughout a day's work and thought. The statue's mood is disarming, charming, and natural. Its mood is carried over, even to the inclusion of a pet animal, in what was probably always the sculptor's most famous work: the *Girl tending a Goat* (1786–7, Louvre) [248], originally the centrepiece of a decorative scheme in Marie-Antoinette's dairy at Rambouillet.

This pavilion was planned by the king as a present for the queen, and designed by the obscure Thévenin, on the ideas of Hubert Robert [249]. The finished building and its interior decoration were seen by the court in July 1787, when it was warmly approved.[22] Although the arrangement is not entirely clear, the scheme was simple enough: the decoration, with two bas-reliefs and four medallions, of a room shaped at one end into a rocky grotto, where Julien's girl or nymph was seated with her goat. The two large bas-reliefs do not apparently survive, but their subjects alone hint at a changed climate since Madame de Pompadour had commissioned statues for her dairy at Crécy. For her Boucher had designed gracefully natural girls, occupied not too seriously with churns and eggs. That particular note, a mingling almost of rouge and rusticity, would have sounded too heartless and even flippant to the ears of d'Angiviller. The Rambouillet dairy was spiced instead with classical learning: to their country themes the bas-reliefs added Antiquity, illustrating the *Nurture of Jupiter* and *Apollo with the Herds of Admetus*. The pedestal of the La Fontaine statue already offered evidence of Julien's ability to handle the bas-relief, but at Rambouillet he was assisted on the one pair by Louis Foucou (1739–1815), whose intervention there was sufficient for him to beg the commission for a 'grand homme'; and in the same year, 1787, he received the command to sculpt a *Du Guesclin* (Versailles), producing a romantic, fully troubadour-style image. Foucou was not Julien's only assistant at Rambouillet, for he seems to have also sought the services of Claude Dejoux (1732–1816), probably on the other bas-relief.

The reason for this assistance lay probably in Julien's uncertain state of health. He had received the Rambouillet commission while resting at Lyon in 1785, recovering from illness, and though he returned to Paris the following year to start work on the task, he may well have been pressed to complete it by a stipulated time. Having placed subsidiary portions of the scheme in the hands of Foucou and Dejoux, Julien would have been free to concentrate on the major centrepiece, the lifesize *Girl*, which is a fully modelled statue.

248. Pierre Julien: *Girl tending a Goat*, 1786–7. Paris, Louvre

Along with Pajou's *Psyche*, she presides over the Louis XVI style in sculpture. More decorous than the *Psyche*, she is altogether a more successful piece of work by her very limpidity and lack of drama; she simply sits on a rock, holding her goat's tether in one hand and clasping drapery to her bosom with the other. The modelling of face and hair, the texture of the goat's coat, and the flat, leather-like reins that hold it, are all delicately observed without too obtrusive effect. The statue is natural by the standards of the new style: it is consciously simple, quite un-Baroque, and quite unerotic (far removed from Clodion's contemporary terracottas). Chastity, stillness, a grace of drapery and purity of profile: such are its qualities, none of them carried to an extreme and all governed by the overall wish to charm. It may be doubted if this can be called true neo-classicism, but it might be accepted as neo-Pompeian. Nor need one be surprised that Julien was unable to stamp his work with any very dominant stylistic traits. Even a much more vital and inspiring figure like Chinard was to oscillate between nature and the antique, never quite settling to practise permanently the neo-classicism expected of him. Julien's artistic world was not one of glory, military necessity, patriotism, and duty; it was the last sigh of the *ancien régime*, and, rather like Marie-Antoinette's plain white dresses, very much a matter of fashionable simplicity.

249. Hubert Robert and Thévenin: *Grotto of the Queen's Dairy*, 1785–7. Château de Rambouillet

MOUCHY, BOIZOT,
THE DESEINE – MOITTE

Oscillation between a training which emphasized nature and an environment increasingly preoccupied by the antique is the typical movement of lesser sculptors towards the end of the century. More than one had been the pupil of Pigalle, but no other was quite such a close follower as Louis-Philippe Mouchy (1734–1801), Pigalle's nephew by marriage.[23] His career was really one long homage to the great man's style. *Agréé* in 1766, he became an academician two years later with his reception piece, *Un Berger qui se repose* (Louvre) – itself noted at the time as being close in style to Pigalle's *Mercury*. Only Pajou received more commands than Mouchy for the 'grands hommes' series, and he seems to have had the special favour of d'Angiviller. Costume of the seventeenth century and a general air of realism suited him better than any pretensions to classical style, and his closest essay in a neoclassical manner was in fact to execute a copy of Bouchardon's *Cupid*.

Mouchy's own antique deity, *Harpocrates* (Luxembourg), was significantly to be criticized as being designed on Pigalle's system 'sans oser rien rectifier à la nature'. This rather feeble seated figure was a commission pressed on d'Angiviller by the sculptor himself, 'maintenant peu occupé', in 1782. He had already shown d'Angiviller his model for the statue, but four years later d'Angiviller was still hesitating over whether to order the marble life-size work. His reserves were expressed in a letter to Pierre, then Premier Peintre, explaining that the statue's head had not seemed noble to him.[24] Finally he allowed the statue to be executed in marble, but the figure remained – in Cochin's word – spindly. Not notably talented, and quite markedly uninventive, Mouchy seems equally to have been lacking in concern for Antiquity – and the capital letter is here justified to symbolize the importance it was again coming to have.

Mouchy had been engaged in collaboration on statues for Saint-Sulpice with Simon-Louis Boizot (1743–1809), a sculptor almost as much as Mouchy untouched by classical currents. Despite the fact that his official career began during Louis XVI's reign, Boizot belonged by temperament to the middle years of the century. He was a good choice as director of the sculpture studio at Sèvres, and his most attractive work was probably always on a small scale. A miniature terracotta group by him was already in Jullienne's collection by 1767, and Boucher too owned some of his work; it was probably hard to distinguish these from Clodion's contemporary terracottas.

The son of the painter Antoine Boizot, he became a pupil of Michel-Ange Slodtz before winning first prize for sculpture at the Académie in 1762.[25] He may also have had some training under Pigalle, who certainly knew his family well enough and sculpted Boizot's mother in a bust shown at the Salon of 1745. After three years at the École des élèves protégés, he went to Rome in 1765, the year of Slodtz' death, and returned to Paris in 1770. The following year he was *agréé*, and the rest of his career followed the pattern of success. In 1774 he was appointed director at the Sèvres factory. In 1777 he was chosen to execute busts of *Louis XVI* and *Joseph II of Austria* for Marie-Antoinette. He became an academician in 1778, on presentation of the *Meleager* (Louvre; signed and dated that

year). In 1783 he solicited and obtained a commission for the *Racine* (Comédie Française) from d'Angiviller, who in giving it him privately mentioned his success at Sèvres.

Hints from Bernini and from Bouchardon combine in Boizot's typical statuette of *Cupid* (Louvre) [250], dated 1772, the commission for which is not known. Certainly it looks backward rather than into the climate of Chaudet's *Cupid* [252], against which it is quite patently Baroque. Perhaps it is not too fanciful to see in it some echo of Slodtz' projected *Cupid* for Madame de Pompadour. The sly baby of Falconet's imagining has become an adolescent, but though Boizot preserves the device of an arrow being withdrawn from Cupid's quiver there is no serious suggestion of menace. This is just a charming figurine, sexless, rather soft, posed in a way that ultimately goes back to Bernini's *David* – though even a passing mention of that is cruel to Boizot's piece of what might almost be table decoration. Nevertheless, it is the pose of the *Cupid* which possesses some sweep and vitality; with pretty eagerness, he still dashes forward into a period which would soon expect more sober deportment from its classical gods.

Some sculptors hardly younger than Boizot were to aim consciously to create that climate. Although Jean-Guillaume Moitte (1746–1810) had been the pupil of Pigalle and Lemoyne, it was as the disciple of Antiquity that he was specifically praised by Quatremère de Quincy in his *Éloge* at Moitte's funeral.[26] And although Louis-Pierre Deseine (1749–1822) was to note daily life in the streets of Rome during his stay at the French Academy, it was his study of the antiquities in the city that proved more significant. The elder Deseine, Claude-André (1740–1823), is a rather shadowy figure: deaf-mute from birth, he never won a prize and appeared first at the Salon de la Correspondance in 1782. He worked chiefly as a *bustier* in plaster or terracotta, executing a tinted plaster bust of *Mirabeau* in 1791 (Rennes). Like other surviving work by him, this shows an almost grotesque sense of character and animation. His strongly republican sympathies contrast with those of his younger brother, who was as patently royalist as he was classically orientated.

Louis-Pierre Deseine trained under several sculptors, including Pajou – of whom he executed a bust (Salon of 1785) – and won first prize at the Académie in 1780. That year he received his *brevet* for Rome, where he studied from 1781 to 1784. An album of his Roman sketches and drawings (now in the Louvre) fortunately survived in his family and testifies to his concern with classical art, interpreted to include the Carracci and Poussin as well as antique sculpture. It was perhaps already a mark of his interests that he left the faces inexpressive in his drawn copies of classical statues and concentrated on study of their drapery. On his return to Paris he became *agréé* in 1785 and an academician in 1791, presenting the rather dull *Mucius Scaevola* (Louvre) as his reception piece. Between those years he received no important Crown commission, though he was employed by the Prince de Condé on statues for the dining room at Chantilly. He was chosen by Vien in the hectic days of 1792, at the time d'Angiviller had emigrated, to contribute a *Puget* to the scheme of the 'grands hommes'; but nothing seems to have come of Vien's proposal.[27]

250. Simon-Louis Boizot: *Cupid*, 1772. Paris, Louvre

251. Jean-Guillaume Moitte: *Cassini*, ordered 1787. Paris, Observatoire

Deseine's royalist principles kept him faithful to the Prince de Condé, and with the restoration of the Bourbons he was to receive several important commissions. He, who had executed busts of Louis XVI and Louis XVII, was indeed the proper sculptor to produce a bust of the new monarch, Louis XVIII (1817, Chantilly, Musée Condé) – though the commission was not in itself very inspiring. Deseine's principles seemed naturally to attract him to religious, legitimist subjects. He was responsible in 1819 for the monument to Cardinal de Belloy in Notre-Dame, and was interested in projecting a monument for Bossuet. His bust of *Pope Pius VII* (Salon of 1806) – another inevitable subject – is impressive, if eclipsed by Canova's of the same sitter. With the return of the Bourbons, Deseine had resumed his old title of 'premier statuaire du Prince de Condé', and to him was given the highly charged, emotional commission of a monument commemorating what the Restoration regarded as the legal murder of the Duc d'Enghien. He produced several drawings and models, the latter exhibited at the Salon of 1819, but the monument itself (at Vincennes; 1816–22) was finished by his nephew after his death. Throughout the development of the concept there existed a rather uneasy mingling of modern dress and allegory, as well as some confusion between classicizing and romantic tendencies in style. Although French taste seems always somewhat suspicious of Canova and his achievements, the Duc d'Enghien monument is the type of work which Canova could have carried out impressively; Deseine, probably not without side glances at the Italian sculptor, achieved what now looks like pedestrian pastiche.

Moitte is yet one more instance of a sculptor receiving his first training under Pigalle. His father, the engraver Pierre-Étienne Moitte, had produced the engraving of Pigalle's Louis XV monument at Reims, and the young Jean-Guillaume entered Pigalle's studio as a boy. Unfortunately his health was already weak, and because of this he rarely embarked on large-scale sculpture. Perhaps his poor health affected his character; his serious, taciturn nature made him very unpopular with his fellow students, and when, in 1768, he won first prize for sculpture there were extraordinary scenes in which Moitte was publicly humiliated. Although he received a *brevet* for Rome in 1771, he was forced back to Paris after illness in 1773. Yet his stay had been long enough to confirm his passion for Antiquity – manifested particularly by his bas-reliefs and his frieze-like drawings in pen and ink. Indeed, it was for these drawings, of which he executed over a thousand, that Moitte became most famous. Their decorative basis is shown by the fact that they were often to

be utilized by Louis XVI's goldsmith, Auguste, and their severity and novelty in disseminating a good knowledge of Antiquity were praised by Quatremère de Quincy. They have a linear delicacy and even filigree refinement which makes the three-dimensional achievement of Moitte's *Cassini* (Paris, Observatoire) [251] the more unexpected. Although the marble full-size statue was completed only posthumously, the plaster model had been shown, and praised, at the Salon of 1789: in style as fully 'engaged' a piece of neo-classicism as David's *Brutus* of the same year. Moitte himself was no less than David politically engaged as well; his wife was an early patriot, one of the women depositing their jewels at the Bar of the National Assembly in 1789.

In Moitte's *Cassini*, the seventeenth-century astronomer, Italian by birth but called to France by Colbert, is treated as a Roman philosopher: his hair deliberately stylized, his feet bare, posed like another Cicero as he ponders a mathematical problem. Whereas Julien, exhibiting his model of Poussin in the same year, still thought it necessary to explain the classical costume as really nightwear in seventeenth-century Rome (as if to check any criticism), Moitte offered no explanation and, indeed, patently intended to evoke Antiquity by every available device. The visitor to the Salon that year could choose his preferred style: from Moitte's tenacious classicizing, via Julien's watered-down compromise, to the troubadour romanticism of Foucou's model of *Du Guesclin*. Perhaps no trio of statues could better convey the uncommitted, wavering nature of official style in what was to be the last Salon under the full *ancien régime*.

CHINARD AND CHAUDET

To couple these two figures in this way, especially given the alliteration of their names, may suggest that they were somehow a team. Though in fact they never worked together, they do have a certain amount in common – including patronage by Napoleon. And though they both lived into the nineteenth century, each is really symptomatic of the closing years of the eighteenth: it is to its standards that they basically conform. By the time the Romantic movement was under way Chaudet's style would look very posed and chilly; and for many years Chinard remained totally ignored.[28]

The career of Louis-Pierre Deseine is sufficient warning against equating neo-classicism with revolutionary political ideas. Although Chaudet and, especially, Chinard were sympathizers with the new republican world which abruptly became Napoleonic, their styles were not formed in that climate. Indeed, the direct effect of the Revolution on French sculpture was not great. Temporarily it may have encouraged some patriotic efforts like Boizot's contribution to the Salon of 1793: 'A Republican maintaining Union and Equality'. Yet it is remarkable how quickly these disappeared when Napoleon became the patron-dictator as well as the subject of most sculpture. The Revolution's chief contribution had been unfortunately to destroy royal monuments in Paris and elsewhere; little was executed to replace them, apart from the inevitable statues of Liberty, often of plaster and thus nearly as ephemeral as the political ideal they represented. The turning of the church of Sainte-Geneviève into the Panthéon gave employment to Moitte, for instance, but he was

afterwards to be employed on the new-style propaganda represented by subjects like his bas-relief for the Louvre: 'La Muse de l'histoire inscrivant le nom de Napoléon sur les tables de mémoire.' And soon Napoleon was taking more drastic steps, even in sculpture, to ensure that the muse of history did not forget him. By an irony, the emergence again of a strong ruler returned conditions of patronage nearly to their old *ancien régime* state under Louis XIV.

Both Chinard and Chaudet were naturally caught up in the Napoleonic machine, Chaudet the more directly. Yet even Chaudet is more remarkable for his essays in a quite unengaged, consciously charming mood, nearer to Regnault or Prud'hon than to David, which is well represented by the *Cupid presenting a Rose to a Butterfly* (Louvre) [252] – of which the very title has a graceful, Alexandrian echo.[29]

Denis-Antoine Chaudet (1763–1810) was born at Paris and entered Stouf's studio. He won the second prize for sculpture in 1781 and first prize three years later with the *Joseph sold by his Brothers* (Louvre). The same year he received his *brevet* for Rome and set off for the city where shortly before Canova had definitely settled. In Rome he was troubled by ill health and returned to Paris in 1789, becoming *agréé* at the Académie but never an academician; that year he exhibited *La Sensibilité* at the Salon.[30] Like other sculptors of the period, Chaudet showed his concern for design by an interest in drawing;[31] unlike most of them, he was also a painter – as was his wife. As well as receiving important Imperial commissions, summed up – quite literally, one might say – by the statue of Napoleon for the top of the Place Vendôme column, he contributed to the illustration of Didot's edition of Racine (published in 1801) and provided designs for bronze decorations on Jacob's furniture. The advent of the new empress, Marie-Louise, unfortunately coincided with Chaudet's death; otherwise he would almost certainly have been commissioned to execute something in connection with the marriage, and it is exactly the type of commission to have inspired him.

Chaudet's classicism is essentially decorative and delicate. It is no accident that the *Cupid* should be one of his best known sculptures, and its base is no less typical of his style, even if its execution is not entirely his, with its playful, graceful frieze showing on one side amoretti who have fired their arrows at a beehive and are alarmed at the result.[32] That the theme goes back eventually to an idyll by Theocritus provides a hint of Chaudet's preferred climate. Some of his drawings take the theme of Love versus Reason, with Love triumphing; Love weighs the heavier when put in the scales against Reason, or Love overturns a statue of Minerva. The *Cupid* resumes all the eighteenth-century concepts of this presiding god, but in style is particularly suited to preside in some pavilion at Malmaison. Unarmed and quite naked, Cupid crouches, occupied with a blameless task; no longer is he mischievous or menacing but a pretty accomplice of nature's. His own gracefulness is just a touch exaggerated; the pose, with one delicate foot barely in contact with the ground,

252. Denis-Antoine Chaudet: *Cupid presenting a Rose to a Butterfly*, c. 1802. Paris, Louvre

is almost too suave, while the extended fingers of the hand which holds the butterfly suggest genteel deportment. Yet, without dullness, Chaudet has achieved stillness, just as he has achieved a delicacy of effect which really is more refined than Julien's or Pajou's. His statue is classical, lyrically so; it holds a balance between art and nature which the eighteenth century would have recognized and approved. Although the marble statue was completed only after Chaudet's death, and not until 1817, the plaster model had been shown at the Salon of 1802. It is typical of that brief Empire period (in 1802 Napoleon was emperor in all but name) which makes perhaps a more fitting epilogue to the eighteenth century than prologue to the century of which it was actually a part.

If that is largely true of Chaudet, it is even more true of the older sculptor, Joseph Chinard (1756–1813). Chinard was born at Lyon, where he was to spend a good part of his working life and where he died. He is easily the most distinguished sculptor working outside the capital, and Lyon provided him with many of his sitters, including Madame Récamier. Although Chinard produced some attractive, Clodion-style terracottas, and also more patently neo-classical, sternly republican sculpture, he remains most remarkable for his portrait busts. At their finest these rival Houdon's in realistic vitality, and in addition have a poetic refinement which is Chinard's own. He could respond to a wide range of character, but he was at his best with female sitters, where, without flattery, he could suggest a certain mystery, even reserve, beneath a charming exterior. His *Madame Récamier* (Lyon) [253] is certainly the masterpiece of those,[33] but his other busts, often of unknown women, have much of the same unforced freshness combined with a faintly pensive air. The costume styles of the Consulat and Empire, with their somewhat contrived simplicity, suited Chinard perfectly; he paid tribute to their delicacy by the delicacy of his handling which could beautifully suggest the curl straying from a high comb or the creasing over shoulder and bosom of a light gauze dress. Such suggestions harden into the virtuosity of the marble *Madame Récamier*, where the piled coiffure is a triumph of artful negligence, and yet more eloquent vitality is given by inclusion of the sitter's hands clasping pleated drapery which falls about her shoulders to expose one perfect breast.

Perhaps Chinard was fortunate not to be born in Paris and not to undergo full Academic training. He certainly retained an individuality and independence which were basically artistic but also personal. Recently it has been questioned whether Chinard was a neo-classical sculptor at all – though it is a fact that he could produce work in a neo-classical vein – and the question raises a larger one of terminology. To some extent there is a stylistic division in Chinard's work outside portraiture; it is symbolized already in his small terracotta *Perseus and Andromeda* which won first prize in 1786 at the Accademia di San Luca (in that collection) at Rome.[34] Into the arms of a Perseus with classical profile and heroic air of Antiquity there slips a pouting, Clodion-style nymph who seems almost to defy her rescuer to remain indifferent to the proximity of her body. Perseus becomes a Pygmalion embarrassed by what he has achieved; and Chinard conveys spontaneously all the effect for which Falconet had vainly striven in his *Galatea* group.

253. Joseph Chinard: *Madame Récamier*, 1802. Lyon, Musée des Beaux-Arts

Chinard arrived in Rome in 1784. Originally he had been destined for a career in the Church, but he early showed promise as a sculptor and, after a period at the École Royale at Lyon, went to work under Barthélemy Blaise (1738–1819). His training must have encouraged a Baroque vigour, intended to be curbed perhaps by his patron, the friend also of Julien, the Baron de Juis. It was at his expense that Chinard travelled to Rome, where he is recorded as working to commission, employed on making many copies of famous antique statues. Back in Lyon in 1787, he was commissioned to execute a marble version of his prize-winning *Perseus and Andromeda* (Lyon) which remains unfinished but betrays a chilling of the verve so apparent in the terracotta group. It has grown more formal, and perhaps for that reason the sculptor himself lost interest in it. Certainly he returned to

the theme, but significantly in terracotta again, and produced a version of the group for himself when in Rome once more during the years 1791–2. This is elaborated from the first model but is yet more deeply *dix-huitième* in sentiment: Andromeda retains her very youthful piquancy, while greater sense of movement in the pose of Perseus makes him more animated. As a treatment of the subject it might have seemed very flippant in the Rome that was soon to see the pseudo-heroic posturing *Perseus* of Canova.

It was, however, for different reasons that Chinard found himself condemned. Two groups of *Apollo treading Superstition underfoot* and *Jupiter treading Aristocracy underfoot* (1791, Paris, Musée Carnavalet) resulted in his being imprisoned in Castel Sant'Angelo, from which he was released on French representation. It is part of the eddying, complex tide of events at the period that Chinard, after returning to Lyon, should have been arrested again, this time accused of being too moderate a republican. He was acquitted and released in 1794, not before he had presented the judges with a highly pertinent group of *Innocence seeking Refuge in the Bosom of Justice*. The style of this was probably resolutely neo-classical – for Chinard seems to have supposed that this style guaranteed political engagement – but Chinard's neo-classicism was never less than delicate and seldom dull. There is strong vitality in his bas-relief model of *Honneur et Patrie* (Lyon) which was intended to decorate the Arc de Triomphe that Bordeaux planned to set up in Napoleon's honour. Individualized faces of the citizens contrast with their Roman and Greek helmets, and the whole bas-relief is alive and boldly tingling – strangely more Renaissance than neo-classical in its romantic use of Antiquity. The bas-relief form suited Chinard very well; the pedestal of his own version of the *Perseus and Andromeda* is decorated with a lively frieze of figures with graceful limbs and flying folds of expressive drapery; and he produced a series of vigorous portrait medallions before concentrating on portrait busts.

The years of the Consulat and Empire brought him several times to Paris. As well as working on the Arc du Carrousel, along with sculptors like Deseine, he executed busts of both Napoleon and Josephine's relations. His bust of Josephine herself (Stockholm, Nationalmuseum) is good but suffers from the sitter's personality being more sympathetically interpreted by paint than by sculpture. With Madame Récamier he succeeded where most paintings – even David's – fail. The ever-smiling, eternally gracious, but seldom yielding sitter was probably a sphinx without a secret. Chinard's bust hints at inner vacuousness but conveys the surface mixture of modesty and voluptuousness which fascinated and tormented so many men – Madame de Staël among them, one inclines to say. Indeed, the action of the hands that play with such teasing effect recalls the description of Juliette Récamier in *Delphine* when the character who is she draped herself in an Indian shawl which outlined her figure. In a moment or two, it seems, the woman of Chinard's bust will untie the bandeau in her hair and let it wave about her in the final climactic moment of her dance. This portrait is the total expression of that frigid personality, lost in smiling self-esteem and wrapped in self-admiration, which led Madame de Staël to ask: 'Why, whether in love or in friendship, is one never necessary to you?'[35] Even to that apparently simple question Chinard's Madame Récamier is too absorbed by her own beauty to give an answer.

HOUDON

Not singled out for special treatment during the *ancien régime*, Houdon did not enjoy any particularly outstanding success under Napoleon. Although his was perhaps the finest bust to be produced of the emperor [254], it is rivalled by the sharply observant bust of General Bonaparte (1799, Lille) by Charles-Louis Corbet (1753–1808),[36] a sculptor whom Boilly painted among the assembled artists in his picture of Houdon's studio. It is posterity that has given Houdon pride of place, not without some concomitant unfairness to other great sculptors and some slight over-estimation of Houdon's own abilities.

The very realism of his portrait busts – which has helped to make him famous and popular – was sometimes disturbing to the eyes of his contemporaries. Quatremère de Quincy, for example, spoke of truth pushed 'à l'outrance' in busts like those of Gluck and Mirabeau (1791, Louvre).[37] This truthfulness is certainly the most positive mark of Houdon's thoroughly scientific observation. He obeys the century's dictum to follow nature until that obedience becomes his style. Although the results have astonishing virtuosity and

254. Jean-Antoine Houdon: *Bust of Napoleon*, 1806. Dijon, Musée des Beaux-Arts

effectiveness, they do not encourage us to investigate the character of their creator; personally Houdon remains an uninteresting figure, somewhat unimaginative, and in one way perhaps too dependent on the canon of realism.

Even the eighteenth century did not mean its dictum about following nature to be taken quite as literally as Houdon took it. But Houdon shows how uncertain other standards had become by the time he was first active – in the late sixties. The Baroque was out of date; neo-classicism was not – was never? – firmly established as the distinctive, fashionable style. The safest convention lay between these two: simply to be realistic. Houdon early showed his preference for that stylistic alternative not only in the scientific *Écorché*, of which he remained so proud, but in the contemporary *St Bruno* in Santa Maria degli Angeli in Rome (1767) [255]. Despite that statue's colossal scale, it is not a heroic or extraordinary figure. What distinguishes it is sober realism: it is the portrayal of any monk rather than of a fervent saint.[38] When Réau described the *St Bruno* as having the head of the *Écorché* planted on a cowl, he presumably meant to praise,[39] yet he also indicated some limitation in the statue and its sculptor. Houdon's whole career reveals him tacking about stylistically, veering between extremes of Rococo and neo-classicism, displaying even romantic *style troubadour* tendencies, as in the *Tourville*, but ultimately making his criterion nature's. Problems of imagination which afflicted him in non-portrait work disappeared when he was face to face with a sitter; here was the standard which he effortlessly understood. Art must be made to seem more natural than nature itself.

Jean-Antoine Houdon (1741–1828) was trained under Michel-Ange Slodtz, but was significantly influenced by Lemoyne and also by Pigalle. Most significant of all was his attachment to his profession. Born the son of the concierge at the École des élèves protégés, where he was later a pupil himself, Houdon might well claim to have been, as he stated in an autobiographical notice, 'Né pour ainsi dire au pied de l'Académie.' He went on to say that he had worked as a sculptor since the age of nine. Even if that is something of an exaggeration, it expressed Houdon's lifetime absorption in his work. Without social or literary ambitions, barely educated, and interested outside sculpture only in his family and the theatre, he is the typical eighteenth-century worker-artist. He has no claims as a great draughtsman. His activity and his attitude were not made to soften the court prejudice which Cochin had recorded as expressed in the comment: 'il y avoit bien des mechanismes dans la sculpture.' The status of the sculptor in France was not altered by Houdon's career. He played no outstanding part in the Revolution, and perhaps was at heart a royalist. Despite some complaints by Pajou, he seems to have been largely unambitious. It is true that he put forward a request in 1803 for the Légion d'Honneur – which was granted – but in his letter of application he stressed his scientific application rather than the nobility of his art. 'Above all,' he wrote, 'the constant occupation of my whole life has been the study of anatomy applied to the fine arts.'[40]

Houdon's *Écorché* (1767, Gotha), which was of course

256. Jean-Antoine Houdon: *Diana*, 1780. Lisbon, Gulbenkian Museum

mentioned in his letter to illustrate that preoccupation, had been conceived and executed while he was still a student at the French Academy in Rome. Already at fifteen he had won a prize at the Academy school in Paris; in 1761 he won first prize, and after the customary three years at the École des élèves protégés, received his *brevet* for Rome in 1764. He returned to France in 1768, was *agréé* in 1769, and immediately took advantage of his new position to exhibit that year at the Salon. The pieces he showed not merely reflected, but were the positive fruits of, his Roman stay. They were much praised and indeed revealed a fresh artistic talent; varied in subject, scale, and style though they were, there was one conspicuous lack in the light of Houdon's later career: no male portrait bust.

Houdon's work in Rome had prepared him for a career quite different from that of *bustier*. But the fundamental realism of his art was already patently declared in the origin of the *Écorché*, intended at first to be just a model for the *St John the Baptist* which had been commissioned along with *St Bruno* for the same church. The model eclipsed the final statue in importance; already Natoire, director of the French Academy at Rome, is found urging Marigny to allow a cast

255. Jean-Antoine Houdon: *St Bruno*, 1767. Rome, Santa Maria degli Angeli

of the *Écorché* to be placed in the Academy. And it is worth noting that when Houdon was pressing for the commission, which never came, to execute an equestrian statue of Washington,[41] he prepared an *écorché* of the horse to convince Congress. To some extent he sought to combine his natural abilities with ambition to produce a monument comparable to those of Bouchardon, Lemoyne, and Falconet. Such projects were to be floated before him, but never to resolve into hard accomplished facts: an elaborate monument to Louis XVI at Brest, a simpler one to Gessner at Zürich – both were carefully planned in model but not finally executed.

Yet it is difficult to regret this. Although some of the reserves felt about Houdon were perhaps no more than intrigue, and the jealous reaction of fellow-sculptors like Caffiéri, there can be little doubt that he was not best suited to the creation of large-scale allegorical monuments. As long as taste required veils of gracious mythologizing to overlay a reality, Houdon was working to some extent in an unsympathetic climate. That this was not more noticeable is owing to his virtuosity and his ability to produce sculpture in almost pastiche style. Even in his portrait busts the stylistic shifts are patent and often quite surprising; this is less a matter of conscious essays *à l'antique* than of changes in mood between sober and Rococo realism which are like nods in the direction now of Pigalle and now of Lemoyne. In non-portrait sculpture there is yet more patent variety. *La Frileuse* (1785, Montpellier, Musée Fabre) is an essay in imitating Falconet; the Comte d'Ennery tomb (1781, Louvre) is sentimentally neo-classical; the *Diana* looks back to the School of Fontainebleau. Yet throughout there is that stamp of realism which becomes most obvious when Houdon's work is compared to Pajou's and Julien's. Julien's seated *Nymph*, or Pajou's *Psyche*, are like whitewashed plaster, cold and inert beside the springing, insolent vitality of the marble *Diana* of 1780, poised so unexpectedly today in the Gulbenkian Museum at Lisbon [256]. She is a woman before she is a goddess, but her superiority consists above all in having existence. Had she been placed in the dairy at Rambouillet it would have been an almost brutal naturalism which would have confronted Marie-Antoinette and the court. Even Catherine the Great, who became its owner without having commissioned the work, seemed to recognize its grasp of realism and positive lack of divinity when she wrote in 1786: 'La *Diane* est depuis ce printemps à Tsarsko-Sélo. Ce Tsarsko-Sélo renferme bien des diableries.'[42]

If mythology and allegory were not best suited to be illustrated by Houdon this was not because he lived in an age of reason, but because his working methods largely dispensed with imagination altogether. Increasingly driven to be a sculptor of portrait busts, he first publicly revealed his abilities with the *Diderot* (New Haven, Conn., Seymour Collection) [257] – shown at the Salon of 1771 – the first of his own personal series of 'grands hommes'. The breathing, almost indeed breathless, quality of this is more exciting and immediate than in many of Houdon's later busts. Regardless of its likeness to Diderot, it remains lifelike. The pupils of the eyes are deeply cut, dark, and extraordinarily impressive, and the mouth is open – an effect Houdon did not often use again for busts of adults but sometimes for children. The inquiring twist of the head emphasizes another of Houdon's

257. Jean-Antoine Houdon: *Bust of Diderot*, 1771. New Haven, Connecticut, Seymour Collection

gifts of observation: that character can be conveyed by the way the head is held on the neck. The neck itself, in the *Diderot* just wrinkled as the head turns, becomes an object of study to the sculptor. Voltaire's bare skeletal throat suggests age more terribly than his still animated face [258]; Benjamin Franklin's thick dewlap sags slightly on to his neckcloth (an example of 1778 is in the Metropolitan Museum, New York). Part of the power of the *Diderot* comes from its simple directness and lack of accessories. Its nobleness has a naked quality, a candour, that perfectly suits the sitter. Perceptive and yet childishly enthusiastic, marked by life and yet still innocent, Diderot seems here the very image of his writings. There is an imaginative sympathy, or so it appears, between the comparatively young sculptor and the ageing writer; but the talents of Houdon are hardly similar to genius as defined by Diderot (*Encyclopédie*, VII, *Génie*): 'Je ne sais quelle rudesse,

258. Jean-Antoine Houdon: *Voltaire seated*, 1781. Paris, Comédie Française

VOLTAIRE.

259. Jean-Antoine Houdon:
Bust of Anne-Ange Houdon,
c. 1791. Houston, Museum
of Fine Arts, The Edith A.
and Percy S. Straus
Collection

les personnes qu'ils représentent que par leur exécution qui, en général, est froide et maigre'.

Yet to leave that as an implied summing-up of Houdon's achievements in busts alone would be absurd. Whatever may be granted to the character of his very varied sitters, his response to them, his capturing of them, must be recognized as astonishing and, in the best sense, artful – for all the apparent directness. His busts of children acknowledge the l'irrégularité, le sublime, le pathétique, voilà dans les arts le caractère du *génie.*'

Just as he had studied in a Roman hospital to produce the *Écorché*, so Houdon brought an almost medical attitude to the heads of his sitters. His use of life and death masks, his

measurements of the subject's head – and, in the case of Washington, all the subject's dimensions – point to an attitude paralleled perhaps only by Stubbs' concern with accurate anatomical depictions of the horse. Houdon is professional in a way that cannot be claimed for Lemoyne. Lemoyne seems to work by instinct; the result is uneven, occasionally dull, but often brilliant. Houdon is not uneven, never less than lifelike, careful of detail (even to the patterning of a coat, as in the bust of Turgot), and 'natural' by a re-definition so sober and exact that Lemoyne's busts by comparison may seem theatrical and over-expressive. Some of Houdon's contemporaries found his work limited, and possibly it always remains too dependent on the physiognomy of a sitter: 'des

260. Jean-Antoine Houdon:
Bust of Alexandre Brongniart,
1777. Washington, National
Gallery of Art, Widener
Collection

portraits', said the *Journal de Paris* (19 September 1789) reviewing the Salon of that year, 'plus recommendables par individuality of each and do not make the mistake of treating every face as just a smiling putto-style mask. There is a touching quality to his plaster of his very young daughter, Anne-Ange (Houston) [259], hardly more than a baby, especially when compared to the keen-eyed, not unmischievous-looking Alexandre Brongniart, son of the architect (Washington) [260], whose very hair suggests liveliness. It seems fitting that the popularity of this bust, existing in terracotta and bronze, should have extended to its manufacture in Sèvres porcelain, since the adult Alexandre was to become director of the Sèvres factory.

The statesman is seen not only in Houdon's familiar busts of Washington but also in the much rarer and certainly no less fine bust of Jefferson (Boston) [261]. The tautness of the features, the slight tilt of the head make of it something challenging, without exaggeration. Time has been at work on the features, too, and subtly does the sculptor hint at the hollowing out of the throat, as more obviously in the sharply chiselled lines down the cheeks. As a contrast in vivacity, as well as sex, Houdon's *Comtesse de Sabran* (Potsdam) [262] could hardly be greater. There are so many charming, animated busts of women in French eighteenth-century art that it comes as a relief to know, on the testimony of Madame Vigée-Le Brun, that the Comtesse really was charming, lively,

262. Jean-Antoine Houdon:
*Bust of the Comtesse de
Sabran, c.* 1785.
Potsdam, Neues Palais

and intelligent – all as Houdon conveys, not least by the device of the sharply-turned head. And these four examples, in marble, plaster and terracotta, range in chronology over nearly a decade and a half: from young Brongniart (1777) to Anne-Ange Houdon (*c.* 1791).

261. Jean-Antoine Houdon: *Bust of Thomas Jefferson,* 1789. Boston, Museum of Fine Arts, George Nixon Black Fund

Houdon never goes to an extreme. In that sense he is a classical artist, moving serenely between those poles represented in his early years by Slodtz and at the end of his career by Canova. It may be that for many people he represents the finest achievement of eighteenth-century sculpture; but it must always be remembered that his achievement did not altogether coincide with the century's aims in sculpture. Houdon is not above his century: he is part of a complex stylistic pattern which contained within it other great sculptors.

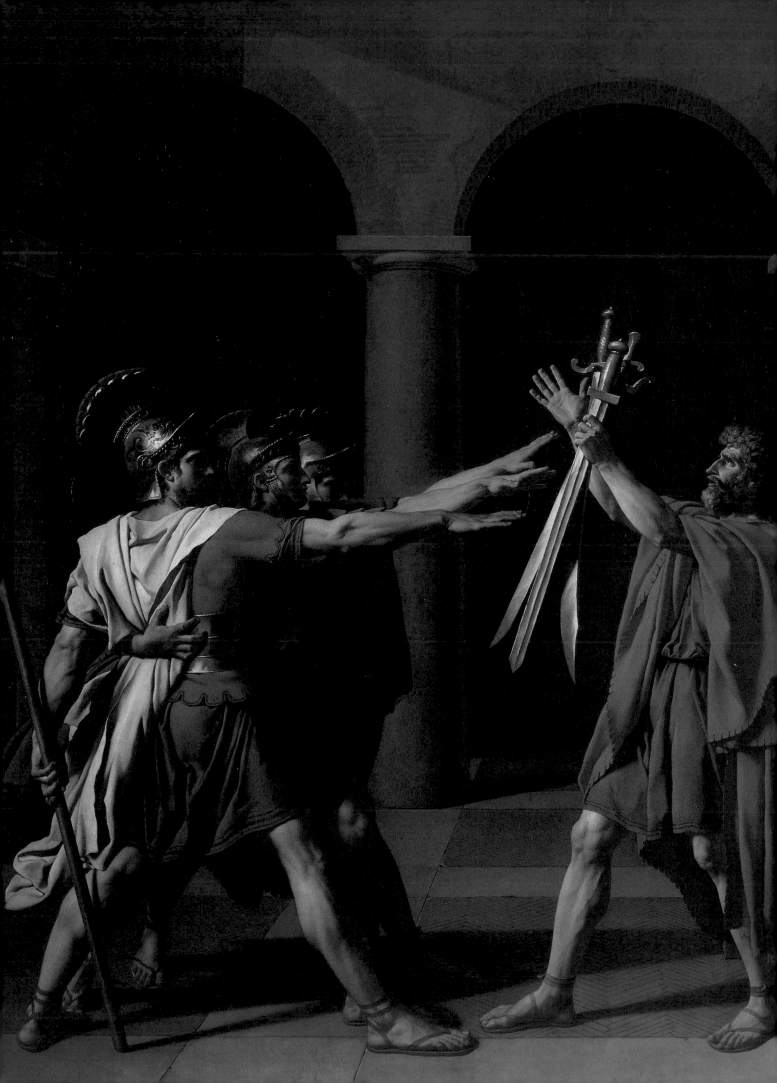

Painting: Up to the Salon of 1789

INTRODUCTION

'I have no great knowledge of painting, but you make me fond of it.'[1] With these typically unassuming words, the highest source of artistic patronage in France – Louis XVI – approved the work of Madame Vigée-Le Brun in 1788, the last year of unchallenged *ancien régime* rule. The artistic taste of Louis XVI would scarcely sustain a thesis; more can be said of Marie-Antoinette's, for hers not only had its individual aspects but was the source of Louis XVI's own slight stirring of interest. Apart, however, from the inevitable royal concern with portraiture, neither of them displayed much specific interest in painting.[2]

This withdrawal, accidental though it may be, conforms with the final shift of patronage from the monarch to the state, and from the palace-eye view of art to the emerging concept of the public museum. In Louis XIV and his demands, all these strands had been united; his palace virtually was his museum, and the king was the state. The regent, Louis XV, and Madame de Pompadour had played up the personal, even private, uses of art for themselves and the décor in which they lived at leisure. But already under Louis XVI, and much more patently under Napoleon, art was being directed towards a public end, to reanimate 'les sentiments patriotiques', in the words of d'Angiviller, the newly-appointed and last Directeur des Bâtiments. It was for the national museum which d'Angiviller planned to make out of a royal palace, the Louvre, that the statues of the 'grands hommes de la France' were destined, as were the large history pictures annually commissioned – including David's *Oath of the Horatii* and *The Lictors bringing Brutus the Bodies of his Sons* [294, 295]. It is wrong to argue that such paintings could not have any concealed revolutionary or republican message *because* they were executed for the king. They may well not have had a message of this nature – the point is to be discussed – but they were already destined for public display, to stir not the monarch but the nation. Nor did the Revolution or Napoleon alter the course of David's art; his subject-matter merely evolved from the historical to the actual, from the heroes of Antiquity to the heroes of the present.

David's is the dominating personality among painters in the late years of the century. Yet he had had to struggle for the mastery, to assert himself at first amid indifference or the preference for other painters. The enormous success of the *Oath of the Horatii* came when he was already thirty-seven – the age at which Watteau had died. It is more than phrase-making to call David the child of the eighteenth century; he was formed in it and by it, and perhaps was basically unable to understand the world which he faced when his heroic god Napoleon fell. Like Goya, he came virtually to prefer exile to attempting a return to his own country. Like Goya too, if

not so movingly or effectively, he evolved a personal late style, scarcely foreseeable from his early work.

It would be convenient if the last years of the eighteenth century in France showed a stylistic homogeneity in painting which could be labelled 'neo-classicism'. However, this is no more true of painting than of sculpture.[3] 'Neo-classicism' is a term that not only fails to do justice to Prud'hon; it is often something of a hindrance to understanding David. A blanket use of it conceals the strong rising interest in nature redefined which manifested itself by marked concern with landscape painting – a European as well as French phenomenon. If some of Madame Vigée-Le Brun's portraits can – just – be called neo-classical, the term is irrelevant to other contemporary portraitists. It is meaningless in relation to Hubert Robert and positively mocked by the sparkling existence of the greatest painter of the period apart from David, the one who escapes labelling of any kind, as he escaped academic trammels and most official commissions: Fragonard.

Nevertheless, there was a significant change in the category of picture being encouraged in these years in France, specifically at Paris. The phenomenon is connected not with Antiquity as such but with history: a turning back to the country's past to gain inspiration for the present, a moral regeneration which art should achieve and which was already in 1777 called a 'revolution'. It was associated rightly with d'Angiviller but answered a general feeling, as well as giving official employment to painters who specialized in large-scale work. Subject-matter was more important therefore than style; and far from the typical, popular productions being neo-Poussinesque essays, some of the most successful include Brenet's *Du Guesclin* [236], Vincent's *President Molé stopped by Insurgents* [286], and Ménageot's *Death of Leonardo da Vinci* [287] – all would-be realistic, boldly handled, positively proto-romantic works in style. In more wildly romantic and troubadour style were Foucou's *Du Guesclin* and Pajou's *Turenne*. Henri IV proved more popular than the Horatii, and in 1783 Vincent was commissioned to produce a series of six compositions dealing with his life, to be woven at the Gobelins.

This vein of historicism was increasingly apparent at the Salon exhibitions. Comparing that of 1787 with the Royal Academy exhibitions, Arthur Young wrote, 'For one history piece in our exhibitions at London here are ten' (*Travels...*). Yet at the same time, it must be remembered that not only were d'Angiviller's efforts being made against general inertia but that those very Salons which contained large-scale history pictures also contained still lifes by Anne Vallayer-Coster (1744–1818) and flower pieces by the Parisian-Dutchman Gerardus van Spaendonck (1746–1822), both artists highly esteemed for their specialized work. Indeed, it is no paradox to presume that a flower piece by Spaendonck, considerably employed for the Crown, would have pleased Louis XVI or

Detail of plate 294

263. Anne Vallayer-Coster: *Portrait of Two Women*. Barnard Castle,
Bowes Museum

264. Anne Vallayer-Coster: *Musical Instruments*, 1770. Paris, Louvre

Marie-Antoinette at least as much as the *Lictors bringing Brutus the Bodies of his Sons.*

Over Madame Vallayer-Coster it is worth pausing, for the quality of her art and also for the variety of genres she practised. Anne Vallayer (she married a lawyer, Jean-Pierre-Silvestre Coster, in 1781) is now most often thought of as a painter of still life and flowers but she also painted portraits. Her first recorded picture, of 1762, is indeed a portrait. Into her double portrait of two women, presumably mother and daughter (Bowes Museum, Barnard Castle), she ingeniously works a certain amount of still life, including a large clock, and puts into the hand of the younger, standing woman a bunch of vividly-painted flowers [263].

She was enormously prolific and extremely popular. Her still lifes tend to be more anecdotal and less austere than Chardin's. How she trained is not established, and she is a quite unforeseen phenomenon at the end of the century, though clearly a welcome one to her contemporaries. The Académie accepted her with none of the problems that Vigée-Le Brun was to encounter through the hostility of Pierre. Admittedly, unlike Vigée-Le Brun, she did not seek to be accepted as a history painter. One can see pride as well as accomplishment in her two reception pieces of 1770, still lifes showing the attributes of the arts and the attributes of music (Louvre) [264]. They inaugurated an official career that may have lost impetus with the fall of the monarchy but which closed only in 1817, in which year she sent a picture to the Salon for the last time.

It would be wrong to make an arbitrary pattern – as is so often done – out of something as spontaneous as artistic genius and as changeable as taste. Yet a broad view of the period, extending beyond France, shows that Fragonard, for instance, is not a figure strayed from the Régence beginning of the century. He has affinities with other European painters of approximately his own date – with Guardi and at times with Goya. In his own country he is reasonably to be paralleled with Clodion. Like Clodion's nymphs and satyrs, Fragonard's cupids stand for more than just erotic decoration; by an easily sensed metaphor, they represent nature and natural forces. They are a reaction against artifice and a protest against languor. Nature is redefined yet once again, and released by Fragonard in a sheer jet of individual energy.

For the more conscious effort of the period, perhaps no better written evidence was published than a passage in *L'Année littéraire* of 1777, in an anonymous review of that year's Salon, addressed by one cultivated amateur to another.[4] This sets the mood of an intentionally altered world: 'For a long time, Monsieur, you along with the true amateurs have sighed to see the category of the history picture forgotten, even annihilated to some extent. Indeed, when one reflected that this category, the highest of all, which requires the greatest genius, demanding constant and profound study of the human heart, of the passions of the soul, of nature and its varying effects, which presumes an exact knowledge of mythology, of historians, of poets, which puts the palette on a level with the lyre – when one reflected, as I say, that this category, like the epic, seemed to exist no longer among us ... one could have wept.... Nevertheless, I think you have noticed that this neglect ought to be ascribed not to the artists but to the frivolity of the century. That distinction, honours, wisely diffused encouragement, with taste and discernment,

would make the flame of genius burn brightly, such is the revolution now achieved by the Count d'Angiviller, in accordance with the king's benevolent intentions.' This passage preludes, significantly, references to a portion of the Louvre being set aside for the newly commissioned history pictures and statues of the 'grands hommes'.

FRAGONARD

Jean-Honoré Fragonard was born at Grasse in 1732, the son of a tradesman who came to Paris when Fragonard was still a child. After a brief, apparently disastrous, apprenticeship to Chardin, he became a pupil of Boucher in 1751; the following year he won first prize at the Académie, defeating Saint-Aubin among others. After three years under Van Loo at the École des élèves protégés, he went in 1756 to the French Academy at Rome, where at first he failed to display the ability with which he had early been credited. The Académie had speedily recognized his great technical facility – but it was disconcerted by some of the work he sent back for inspection from Rome, preferring his drawings to his paintings (with some acuteness, it must be agreed).

Already it was difficult to categorize Fragonard. While it is true that he had learnt much from Boucher, he later showed himself not indifferent to the subject-matter of Chardin and Greuze. Later still he certainly studied seventeenth-century Dutch masters. We may guess, yet cannot say for certain, that he early came under the influence of Watteau. Italy to him artistically meant a highly personal selection of painters, including Pietro da Cortona, Giordano, Solimena, and Tiepolo; but it also provided a landscape to which he responded with an intensity romantic in its fervour, far removed from the sober picturesqueness of Vernet. By 1760 Natoire (so quick to recommend landscape as a suitable category, on being appointed director[5]) was reporting that Fragonard (whom he went on calling 'Flagonard') had spent a month at Tivoli, with the Abbé de Saint-Non, doing admirable studies.[6] Although Fragonard was to produce other wonderful landscape drawings – in both red chalk and bistre – nothing perhaps equals his response to the gardens of the Villa d'Este. The sheer enchantment of such compositions [265] makes it easy to forget their application and their novelty. They are not just casual sketches but highly elaborated, totally serious works of art, concerned with contrasts of foliage as well as effects of light and shade, catching a sense of heavy, almost fragrant heat. Fragonard's response to natural phenomena is at once instinctive and excited. As seen by him, the gardens of the Villa d'Este shimmer impressionistically, reducing the human element to a few ant-like figures, utterly dominated by the giant cypresses which shoot up to fill virtually the whole height of the composition. Again and again he makes his dominant motif that of nature. His trees are seldom content merely to crowd into a shade but are invested with the vitality of perfect phallic symbols, asserting their primeval virility either over mankind or as a suitable setting for an erotic adventure.

After a century of so much slack painting and competent yet dull drawing, Fragonard's great gift of energy – communicated to everything he touched – was certainly revitalizing. How spontaneous it was is best seen perhaps in

265. Jean-Honoré Fragonard: *Cypresses in the Garden Avenue of the Villa
d'Este*. Drawing. Besançon, Musée des Beaux-Arts

266. Jean-Honoré Fragonard: *'The Fête at Saint-Cloud'*, *c.* 1775. Paris,
Banque de France

what is otherwise not a major aspect of his art, though an
interesting one: his copies in red chalk of paintings which he
recorded either for himself or for his constant patrons, Saint-
Non and Bergeret. There is nothing tame or timid about
these copies; not only inspired, they are often inventive,
variations on a theme provided by another painter, positive
capricci which interpret with something of the same freedom
found in the Guardi brothers' treatment of other painters'
compositions. They tell something else about Fragonard,
which time made only the clearer. The basis of his art is
draughtsmanship, more patently even than is Boucher's.
Although capable of a high polish on certain pictures, he was
at his best when positively drawing with the paint, sketching
boldly, and thus obtaining a 'quality of lightness of manner
and effect', in the words Reynolds used to characterize
Gainsborough's handling. It is indeed hard to believe that
Gainsborough and Fragonard did not know each other's
work.

The discovery of Villa d'Este as a theme was in many ways
a discovery by Fragonard of his own talents. He owed much
to the encouragement of the young dilettante Saint-Non (very
much an Abbé in *dix-huitième* style) and something doubtless
to Hubert Robert, also working at Tivoli under the abbé's
patronage. It seems likely that Rome had previously disturbed
rather than confirmed Fragonard's ability. He was an
individual artist who needed individual subject-matter. His
concept of the natural was to extend beyond subject-matter
to style, and indeed to his personal life. He was, and remained,

a private figure. His best patrons became his close friends.
He obviously worked most satisfactorily without too specific
a commission (for all its fame and charm, *The Swing* (1768/9,
Wallace Collection) is not Fragonard at his very finest) and
in an atmosphere of friendly encouragement, vivacity, and
perhaps wit. Another aspect of the natural in his art is its
element of humour; this is apparent not only in the
deliberately amusing erotic subjects but in his treatment of
Boucher-style themes, in which any mood too voluptuous or
highflown is punctured by rapid, amused strokes of the brush,
pen, or chalk. Fragonard's natural and instinctive urge – and
his most significant – was to express his own reactions. He
did not imitate or simulate nature. His nudes have none of
the saturated, pearl-flesh texture of Boucher's; instead of
density they possess a linear vitality which is less sheerly
illusionistic but at least as artistically satisfying. His portraits
share this linear vitality, though sometimes they may not
be of real people, and even as likenesses are intentionally
capricious.

Fragonard's revolution is in brief this: he dethrones
subject-matter and sets up a fresh concept of a work of art
as a piece of the artist's style. Any competent topographer
could have produced an accurate view of the gardens of the
Villa d'Este; that is, in effect, merely the starting point for
Fragonard's vision, where the villa recedes and the trees like
fountains foam higher and higher. Indeed, in most of his
paintings and drawings of gardens, foliage like foam
overgrows the balustrades and statues, arches up into a huge

267. Jean-Honoré Fragonard: *Corésus sacrificing himself for Callirhoé*, 1765.
Paris, Louvre

bower, or is flecked rapidly across the sky. It is no exaggeration to say that the gardens of the Villa d'Este haunt all Fragonard's later landscapes – at least the freedom of interpretation is still there, even in the apparently French setting of the so-called *Fête at Saint-Cloud* (*c*. 1775, Banque de France) [266], one of the masterpieces of eighteenth-century landscape painting, no 'tame delineation of a given spot' but an enchanted as well as intensely vigorous view of nature. It may be paralleled in literature by the excited praise given to Saint-Cloud in Delille's *Les Jardins* (1780): 'Aux eaux qui sur les eaux retombent et bondissent/Les bassins, les bosquets, les grottes applaudissent.' That Fragonard set some store on his Villa d'Este drawings is shown by the fact that he chose two of them for exhibition at his first Salon appearance in 1765. At the time the success of *Corésus and Callirhoé* probably prevented their receiving the attention

they deserved, but their exhibition confirms the seriousness of such work; and suitably enough, the two drawings of that Salon were identified as belonging to Saint-Non.

After travelling widely in Italy with Saint-Non, Fragonard returned in 1761 to Paris. His public career was about to begin. He was *agréé* by the Académie in 1765, and at the Salon that year the large *Corésus* (Louvre) [267], which had been praised at first sight even by the sober Wille ('très grand tableau d'histoire ... très beau': *Mémoires*), was a great, if misleading success. It seemed to be a bid by its author to offer himself as the exponent of grand manner to replace his one-time master, Van Loo, and his fellow pupil in Boucher's studio, Deshays, both of whom had died earlier in the year. That the picture is not a success now seems obvious enough. According to Diderot, the public began to have reserves after the first enthusiastic reception. Still, it was bought by Marigny for the royal collection and was intended to be copied in Gobelin tapestry. Nor should the picture's artistic failure be too much emphasized. Although its subject now seems more than faintly absurd, it marks a change of mood when compared with, for example, Boucher. It is intended

268. Jean-Honoré
Fragonard: *Progress of Love:
The Meeting*, 1771–3.
New York, Frick Collection

to be serious as profane history, with a moral clash of duties. It is a sacrifice-of-Iphigenia-style subject – a girl fainting at the altar amid horrified spectators – to which has been added the additional frisson of suicide as the high priest plunges the sacrificial knife into his own breast. Pietro da Cortona and Solimena are drawn on stylistically, as they were to be in David's early pictures. The swooping, glaring figure rushing down from the clouds is rhetorical – but with something of the rhetoric afterwards to be found in Prud'hon's *La Justice et la Vengeance divine poursuivant le Crime*. For its date the *Corésus* is extremely up-to-the-moment. Its black mood is so exaggerated as to border on the unintentionally comic; that

is rare in Fragonard's work, but only too typical of the grim deluge that was to follow (among the better-known, the work of Guérin (1774–1833), e.g. *Clytemnèstre*, Louvre, provides a good example).

What was unexpected, and remains largely unexplained, is that Fragonard did not go on to establish a public career. After appearing at the Salon of 1767 he never showed there again. Like Clodion, he never bothered to become a full member of the Académie. While he remained highly active, he nearly disappears from art history. As with Clodion, we know little of his private life or his personality. The chronology of his work also becomes difficult to trace. His

269. Jean-Honoré
Fragonard: *Progress of Love:
Love Letters*, 1771–3.
New York, Frick Collection

style does not evolve neatly, despite an enlarging of the northern influences on him and probably a visit to the Netherlands. The most important semi-official commission he received was from Madame du Barry, for the panels to decorate Louveciennes which she then rejected, preferring Vien. This awful error of taste – due conceivably to misunderstood ideas of the neo-classical as likely to be more chic – was bad enough in itself. What she rejected may justly be called Fragonard's masterpieces, the four large *Progress of Love* paintings (1771–3, New York, Frick Collection) [268, 269], decoration which is more than decoration and yet pictures whose first felicity is their decorative effect as an

ensemble in a room. Madame du Barry's reasons for rejecting the series are not known for certain, but Louveciennes was designed by Ledoux, and it must indeed be admitted that the consciously classical ethos of Vien's series was better suited there than Fragonard's garden charades – light-hearted, scarcely allegorical, and certainly not antique lovers' games, at once lively and tender yet unsentimental.[7] More dominant than the actors is their natural setting, where a riot of flowers and foliage engulfs both human figures and statuary. There is indeed contrivance in this ordering of nature, but the study and beautiful use of natural motifs are unmistakable. Suggestions of a wilder, always burgeoning, nature beyond

270. Jean-Honoré Fragonard: *La Résistance inutile*. Stockholm,
Nationalmuseum

the bounds of private park or garden – all massed sparkling leaves and jagged branches of moss-grown trunks or graceful bending saplings – hint at new freedom both for artist and ordinary people. Like Corot, Fragonard might have said, in his own way, 'Je me suis lancé sur la nature.'

His experiences with Madame du Barry perhaps completed his disillusionment with court and official patronage. He made Greuze's discovery that such support was no longer necessary for the successful painter. Fragonard was indeed successful and tremendously active up to 1789. He gained middle-class clients and a few particular patrons and was in demand as designer of amusing, often erotic engravings (himself active also as engraver and etcher) which, far from damaging his reputation, pay tribute to his wonderful inventiveness. Amorous mishaps and girls' nightgowns inevitably on fire alternate with straightforward scenes of country life and unexpectedly sentimental, almost keepsake-style subjects like *Le Chiffre d'amour* (Wallace Collection). In the same way Fragonard varied his manner and subject-matter as a painter. Nature meant also happy mothers and demure school-teachers – indeed, an interesting concern with family life – be-ginning to appear in his pictures. He retained

his fluent brushwork for such sketches, yet also produced carefully executed genre pictures, whose enamel surface is more typical of Boilly. One other development was graceful, proto-Prud'hon allegory, expressing the unity of love not by genre but by faintly classical figures – yet, typically, active not passive – as in *La Fontaine d'amour* (c. 1785, Wallace Collection).

At the patriotic ceremony of 7 September 1789, when leading artists' wives came to offer their jewellery to the National Assembly, Fragonard's wife joined the wives of Vien, Moitte, Suvée, David, and others. Though David remained his friend, Fragonard's life and activity were fatally damaged by the Revolution. He held a few posts in the artistic administration, yet without much success. As a painter, even Greuze contrived to be better employed. Fragonard's death in 1806 was not quite so completely ignored as the Goncourt supposed, but it made little stir. In some ways consideration of Fragonard has remained coloured by his sad late years. It is too easy to make him the final representative of all Rococo eighteenth-century tendencies, the late bright spark of love and frivolity extinguished in a stern Republican climate. The truth is probably more complicated. Though he was a

responsive pupil of Boucher, he appears partly in reaction against Boucher; his very palette – with little use of blue – is distinct. Far from being a painter of the artificial, he was a painter of the instinctive, the impulsive, the natural.

Although it is convenient to speak of him as a painter, it is significant how in his work the categories of drawing, sketch, painting, virtually merge and interchange; there are highly finished drawings and very hasty incomplete sketches in oil. A few of his masterpieces are on a fairly large scale, but as a presumed decorative artist he produced an unusually high number of no less fine small works [270]. Watteau apart, no other painter in France during the century achieved such consistently high quality in all that he executed in all media. It is clear that he wished always to be actively employed but not tied down too specifically by the terms of a commission. Left 'à sa volonté' – free from the Bâtiments, Madame du Barry, or the Gobelins – he was in effect working for himself. If that was not a total revolution, it consolidated Watteau's revolution at the beginning of the century and would have its relevance for artists in the subsequent one. It is pleasantly apt that when Fragonard fled from Paris to Grasse in 1790, he should have installed the series of the *Progress of Love* in the very house where he lived.

ROBERT, MOREAU,
AND OTHER LANDSCAPE PAINTERS

It is beside rather than after Fragonard that Hubert Robert (1733–1808) should ideally be placed, so closely contemporary were they and so closely did they work together in their early Italian years. Some drawings even pose problems of attribution between them. And, like Fragonard, Robert may be claimed as in one way the last exponent of a certain type of decorative art – in his case the caprice ruin picture – and yet also as a forerunner of romantic responses to nature. This indeed was the aspect of his style instinctively seized on by Diderot when Robert first exhibited in Paris in 1767.

What is often rather slickly defined in histories of the century as 'the rediscovery of nature', something credited largely to Rousseau, was a complicated but not abrupt phenomenon. In painting alone it is obvious that Watteau early 'discovered' nature; and in the sense of release in natural surroundings from city ways, he not only expressed his awareness in painting but retreated there to die. Although Rousseau's response to nature and scenery was intensely important, his didactic moral fervour is more typical of the eighteenth century than of purely romantic sensations for their own sake. In such a complex matter, so deeply connected with the whole century's concern with nature, generalization is dangerous.[8] Still, it may be said that Diderot's delighted response to Robert and Vernet (and even to Poussin's landscapes) is more aesthetic than moral. And, in passing, that is intensely true of such proto-Romantic responses as that where (in a letter of 1760 to Sophie Volland) he speaks of listening to the beating rain while 'je m'enfonce dans mon lit'. Diderot's famous passage about the melancholy pleasure of ruins ('Tout s'anéantit, tout périt, tout passe...') was not only specifically evoked by Robert (Salon of 1767) but seems true to the pleasurable, if not particularly melancholy, intentions of Robert's pictures. By the standards of the

landscape painters who followed, Robert may even seem too frankly governed by the desire to please, his 'nature' too contrived and decorative. It must be admitted that he painted too much and often worked to a rather obvious formula; but as well as Fragonard-like gardens and Panini-like ruins, he produced some views of Paris and Versailles which are direct and vividly atmospheric. It is for its wonderfully atmospheric sky of drifting sunset cloud that the *Pont du Gard* (by 1787, Louvre) [271] remains most memorable. Robert was officially commissioned to depict this famous Provençal monument; what he produced combines the grandeur of man's construction with nature's grandeur in a poignant manner to which Diderot – dead three years before it was executed – would have done eloquent justice.

Hubert Robert was born in Paris but his parents came from Lorraine. His father was valet-de-chambre to the Marquis de Stainville, whose son – the future Duc de Choiseul – carried the young Robert to Rome as his protégé when appointed ambassador there in 1754. Although not officially a pensioner of the French Academy, Robert gained a place there, with Marigny's approval, due to his distinguished patron. Natoire reported that he had 'du goût pour peindre l'architecture', and the example of Panini – for long associated with the French colony in Rome – influenced Robert to the end of his career. If to some extent he was never to be as sheerly competent as Panini, he was also never to be so prosaic. His own lively temperament, itself no doubt part of the reason why he became friendly with Fragonard and Saint-Non, led him to airier, lighter-coloured, and more light-hearted effects than those of the much older Italian. Steeply-rising, silvery trees, sunny skies, sweeps of staircase and balustrade suggest rather than positively depict identifiable settings in Robert's most delightful pictures [272]. Something sketch-like and spontaneous is preserved in them. Like Francesco Guardi, he could paint with topographical accuracy but clearly enjoyed indulging his inventive gifts in caprice views. As Guardi's are more spontaneous than Canaletto's, so Robert's are more spontaneous than Vernet's.

Not until 1765 did Robert return to Paris. He was *agréé* and received in a single session at the Académie the following year and became highly fashionable – even over-employed. That he was also a social success is testified to by Madame Vigée-Le Brun, whose *Memoirs* give a good idea of his vitality and popularity. He was involved with several schemes for re-designing gardens, was involved in the Laiterie at Rambouillet, was d'Angiviller's choice as curator for the new national museum, and – probably inspired by the Parisian views of Pierre-Antoine de Machy (1723–1807) – turned to record the late *ancien régime* construction and destruction of Paris in a fascinating series (Paris, Carnavalet) which could easily be mistaken for nineteenth-century work. Although imprisoned at the Revolution, Robert was eventually released and was as fortunate in death, Madame Vigée-Le Brun remarked, as he had been in life.

Directly a pupil of de Machy was the more obscure Louis-Gabriel Moreau (1740–1806), a member of the Académie de Saint-Luc and painter to Louis XVI's brother, the Comte d'Artois. His glowing, simple landscapes, often of the environs of Paris, form a bridge between Desportes and Corot. While his slightly younger brother, Jean-Michel Moreau (1741–1814), produced vividly detailed, brilliantly

271. Hubert Robert: *The Pont du Gard*, by 1787. Paris, Louvre

composed plates of urban upper-class life in the *Monument du Costume* (1783) [273], Louis-Gabriel responded with no less sensitivity – in etchings as well as paintings and gouaches – to the countryside, scarcely peopled at all. Some of his pictures, like the *View of Vincennes from Montreuil* (Louvre) [274], are virtual cloudscapes. They suggest study of Ruisdael, combined with fresh observation of the shifting atmosphere of light and shade; such a basis is close to Constable's, and the *View of Vincennes* is indeed not unworthy of him.

Directness of vision also lies behind the more classically

composed, and classically peopled, landscapes of Pierre-Henri Valenciennes (1750–1829), a pupil of Doyen and a recognized precursor of Corot, who should perhaps yield in precedence and talent to Moreau. Yet Valenciennes, for all the classical theme of, for instance, *Mercury and Argus* (1793(?), Barnard Castle, Bowes Museum), is interested in the landscape elements for their own sake; without the foreground group his transformed Io would seem no more than the study of a cow close to some shady trees. Valenciennes' Italian sketches (Louvre) confirm this spontaneous reaction to natural scenery which became

272. Hubert Robert: *Garden Scene with Fountain*, 1775. Belgium, Fernand Houget Collection

273. Jean-Michel Moreau, engraved by de Launay: *Les Adieux*, from the *Monument du Costume* (1783). Paris, Bibliothèque Nationale

274. Louis-Gabriel Moreau: *View of Vincennes from Montreuil*. Paris, Louvre

275. Jean-Laurent Houël: *Vue de Paradis*, 1769. Tours, Musée des Beaux-Arts

deliberately formalized, with homage to Poussin, only in his worked-up pictures.

More than one other landscape painter could probably be cited to show the century's late tendency to enjoy and encourage straightforward depictions of nature – and nature interpreted in the simplest terms of French skies and fields without cataclysms or precipices. Jean-Laurent Houël (1735–1813), born at Rouen but active in and around Paris, seems an apt example. Another protégé of Choiseul, he painted – among other landscapes – enchanting views around Chanteloup, the property to which Choiseul was banished in 1770. Rustic château life seems idyllic in these *plein-air* scenes, where a few people may stroll in the sun, gardeners garden, and cultivated nature merges into meadows extending gently towards the low horizon. Such is the *Vue de Paradis* (dated 1769, Musée de Tours) [275]. Nothing disturbs the wide expanse of clear sky except a swarm of homing-pigeons, flying and clustering round a pointed tower of the old country house. As an image of security and contentment it has now become hackneyed. In Houël's picture – itself so freshly painted – it is seen as if for the first time. The whole view speaks of nature in terms which make Watteau's countryside remote and Boucher's artificial. Houël must not be pushed out of his century – any more than his patron should be – but his vision is certainly very close to 'nature' as Europe would interpret it in the subsequent period.

PORTRAITURE: DUPLESSIS – DUCREUX – VESTIER – LABILLE-GUIARD – VIGÉE-LE BRUN

Inevitably, the demand for portraiture did not slacken in the last few years of the *ancien régime*. The prime requirement was for a good competent likeness, of the kind that Roslin continued to provide. There were no innovations of style or even composition – before the vogue associated with Madame Vigée-Le Brun, itself partly a matter of costume more than of artistic style. Few or none of the portraits produced attempted profound study of the sitter's character. Attention continued however to be paid – and was perhaps paid more keenly than ever before – to details of costume and setting. It does not have the obsessive quality of Ingres' observation, but there are hints which lead towards the extraordinary intensity of his response to his sitters' clothes and jewellery. It is typical that Duplessis, charged to execute the official full-length of Louis XVI in the costume of the Sacre, should ask to borrow the actual robes, chains, and sword, so as to paint them accurately. Such determined truth to nature anticipates David's borrowing of Napoleon's clothes, and even his saddle, when painting *Bonaparte crossing the Alps* [297].

The most forthright portraitist of these years was probably Madame Labille-Guiard, who had a boldness of handling and a tendency towards unidealized portraiture both in contradistinction to her rival, Vigée-Le Brun, who has triumphed with posterity. Labille-Guiard was, perhaps significantly, never employed by Marie-Antoinette. But most of the portrait painters discussed here sought and received royal and court patronage; although that did not compel them to any uniformity of style, it was an important aspect of their careers. And in judging their work, the often crippling and confusing amount of replicas they had to produce must not be forgotten.

Joseph-Siffred Duplessis (1725–1802) after a slow start was to become Louis XVI's official painter. Born at Carpentras, in Provence, he studied for about four years at Rome under Subleyras until the latter's death in 1749. Little of this training could be guessed from his highly accomplished but often painfully hard portraits, where a show of shiny materials often competes for attention with the sitter's face. After some

276. Joseph-Siffred Duplessis: *Gluck composing*, 1775. Vienna, Kunsthistorisches Museum

277. Antoine Vestier: *Jean Theurel*, 1788. Tours, Musée des Beaux-Arts

years working at Carpentras, he came to Paris in 1752, but was not *agréé* until 1769. In 1774, the year of Louis XVI's accession, he was finally received at the Académie. The following year he exhibited the *Gluck composing* (Vienna) [276], where an almost Romantic sense of inspiration combines with sober portraiture in what remains probably his best known work.[9] Allegrain and Vien were among the colleagues he painted. D'Angiviller sat to him for a benevolent official portrait (John Sheffield Collection), shown at the Salon of 1779; this may be compared with Tocqué's portrait of the young Marigny (Versailles), also seen as Directeur des Bâtiments, painted almost a quarter of a century before.[10] There is something stultifying in Duplessis' blandly academic approach, despite his ability. A cruel epigram which greeted the full-length *Louis XVI* (now at Versailles) at the Salon of 1777 – 'very like except for the head' – sums up one's nagging feeling of lifelessness amid surface veracity in the majority of his portraits.

Against those pictures, the work of Joseph Ducreux (1735–1824) is less competent but more personal. The pupil of La Tour, and influenced also by Greuze, Ducreux worked in both pastel and oil. He was fortunate enough to succeed in 1769 with a portrait, executed at Vienna, of the young Archduchess Maria Antonietta. When she became queen of France, Ducreux was appointed painter to her, and he remained faithful to the royal family. Although he escaped to London in 1791 (exhibiting once, not very successfully, at the Royal Academy), he returned to France in time to draw the last portrait of Louis XVI (Musée Carnavalet), either in

prison or during his trial. This has particular documentary interest, yet Ducreux's most vivid work is probably in expressive self-portraits – a welcome echo of La Tour – of which he produced a great many.

Antoine Vestier (1740–1824) was an artist of provincial origin, born at Avallon (Yonne), trained under Pierre in Paris and travelling in both Holland and England. He entered the Académie only late, in 1786, his *morceau de réception* being a portrait of Doyen (Louvre), which he had painted several years before. That composition continues a tradition of painters shown seated beside their easels, but the sitter is given a markedly thoughtful air, and a bust in the background of Homer suggests interest in and use of antiquity. Vestier is an attractive but variable portraitist, sometimes rather dry in his handling of paint. Yet he produced one or two memorable images, among them the three-quarter-length of the tall, elderly, but upstanding Jean Theurel (Tours) [277], of 1788. Here it may not be chauvinistic to see something 'British', in artistic terms, about the direct, forceful confrontation of painter and sitter.

At the Salon of 1787 the rival women portraitists, Adélaïde Labille-Guiard (1749–1803) and Élizabeth-Louise Vigée-Le Brun (1755–1842), had their work hung so close together that it was virtually intermingled. Each appeared that year with – among other pictures – one full-length royal portrait which well represented not so much their styles as their individual sources of patronage. It was inevitable that the two painters should be compared. Both were received by the Académie on the same day in 1783. Even in their private lives there was

278. Adélaïde Labille-Guiard: *Madame Adélaïde*, 1787. Versailles, Musée National du Château

279. Élizabeth-Louise Vigée-Le Brun: *Marie-Antoinette and her Children*, 1787. Versailles, Musée National du Château

some similarity, for despite their hyphenated married names neither was very happy with her husband. The Revolution divided their loyalties. Madame Labille-Guiard sided with it; Madame Vigée-Le Brun fled from France, began a fresh European career, and, towards the end of a long life, was able to write her *Memoirs* without naming the one-time rival whom she had signally eclipsed and outlived. More than eighty years ago Madame Labille-Guiard's biographer claimed it was time to do her justice, but her reputation has been slow in re-establishing itself.[11] For Madame Vigée-Le Brun posterity has had a weakness rather than any real appreciation.[12] It is tempting to redress the balance drastically, yet it must be admitted that in the very real success Madame Vigée-Le Brun enjoyed there is significance. She was to employ – if not positively exploit – her own femininity, throwing it over her female sitters with almost exaggerated effect. It was for painting with masculine vigour that Madame Labille-Guiard was praised; and pre-1789 she was probably the more widely and highly estimated artist.

Pajou was a friend of her father's, and it was with an excellent portrait of him (Louvre, Salon of 1783) there she was received at the Académie, on the distinguished recommendation of Roslin. She had trained under François-Élie Vincent (1708–90), father of the better-known François-André whom she eventually married as her second husband. She worked in pastel and oil, doggedly anxious to be more than a charming pastellist or miniaturist. Clearly well thought of by many professional colleagues, she was patronized by the Duc d'Orléans and especially by Mesdames, Louis XV's daughters, to whom she was officially appointed Premier

Peintre. Her full-length of *Madame Adélaïde* (Versailles) [278] was, it has been suggested, something of a moral and political 'answer' at the 1787 Salon to Vigée-Le Brun's *Marie-Antoinette and her Children* (Versailles).[13] The plain spinster princess – many years earlier gracefully transformed into the element of Air by Nattier – is soberly depicted, standing before an easel on which are profile heads supposedly painted by her, of Louis XV, Marie Leczinska, and their son the dauphin. This impressively dignified portrait, rich, solidly painted, faintly sad, is one aspect of Madame Labille-Guiard's talent. No less rich, but gay and brilliant as well, is her full-length of *Madame Infante with her Daughter* (1788, Versailles), where strong sunlight and Rubensian costume bring back to life the dead duchess who had never posed to the painter. Madame Guiard (she dropped the Labille) kept up some royal connections even in the changed, strange climate between the king's acceptance of a constitution and his execution. In March 1792 the *Petites Affiches de Paris* announced that Louis XVI had given her the commission for a portrait of himself, but events overtook the sitter and the picture.

Madame Vigée-Le Brun's *Marie-Antoinette and her Children* [279] was the artist's most official, dynastic image of the queen. Even while depicting the mother, it emphasized the continuity of the French Crown, showing the healthy present rather than the moribund past evoked by Madame Adélaïde. 'More of a historical document than a portrait' was

280. Élizabeth-Louise Vigée-Le Brun: *Self-portrait with her Daughter, Julie*, c. 1789. Paris, Louvre

281. Antoine Raspal: *Atelier des couturières*, 1760(?). Arles, Musée Réattu

282. Étienne Aubry: *L'Amour paternel*, 1775. Birmingham, Barber Institute of Fine Arts

in fact d'Angiviller's description of the picture.[14] It is an effective, and probably quite conscious, attempt by the painter to rival the work of Madame Labille-Guiard. The gamut of textures, the elaborately realized setting, the combination of dignity with intimacy – all seem to mark its ambitious nature. There is also perhaps a deliberate retreat from Madame Vigée-Le Brun's too intimate portrait of Marie-Antoinette 'en Gaulle' – in light dress, simple hat, and holding a rose – which had been considerably criticized for lack of decorum at the Salon of 1783.

It is inevitable to connect Madame Vigée-Le Brun with the queen, yet in many ways this, as such, is the least interesting aspect of her career. Her own *Memoirs* give some account of her early years and artistic training, at first under her father, Louis Vigée. Vernet, she records, advised her to study the Italian and Flemish masters but above all to follow nature. This she did, with many a glance back not only at Rubens and Van Dyck, as well as Greuze, but at Domenichino and perhaps also Reni. Although she proved capable of surprisingly competent male portraits (e.g. *Calonne*, dated 1784, Royal Collection), it was portraits of women which brought her greatest fame. She may not have initiated the new fashion for simplicity in dress, but she followed it for herself and other female sitters. She encouraged a concept of nature which dispensed with wigs and formal clothes, and which emphasized feeling rather than thought. There is an increasing tendency towards sentimentality, but also an effort to achieve something spontaneous-seeming in pose, now liable to strike the spectator as merely arch yet meant to be natural. Her women are usually idle or maternal – but certainly never intellectual (no wonder her *Madame de Staël* (1808, Geneva) is so ludicrous). For D'Angiviller she painted herself about 1789 in a Greuzian transport of maternity with her own daughter, Julie (Louvre), and with a more marked neo-classical flavour than had appeared before in French portraiture [280]. It is a mood quite foreign even to David's portraits before the Revolution. It is also much less well drawn than any David (Julie's head is awkwardly foreshortened and

made oddly insubstantial to tuck in under her mother's chin, while her right eye glares impossibly). Yet the picture is skilfully composed. The result is a memorable icon, less of maternal love, on scrutiny, than of the painter's narcissism.

Vigée-Le Brun is probably to be credited with having mixed a wide variety of sources – including possibly English mezzotints – to produce a new style of portrait in France. In her handling of paint there are indications also of novelty – at least, a breakaway from the Roslin–Duplessis facture – with touches of sketch-like spontaneity, which do perhaps derive from David. In one way it is a pity that she left France at the Revolution; the Empress Joséphine would have been an admirable subject for her brush, and the result might have been something of a masterpiece.

GENRE: AUBRY AND BOILLY

Too dogmatic a generalization about a pervasive neo-classical or even 'historic' artistic climate in the later years of the century remains unjustified – from the point of view both of the period and of individual patrons. Even d'Angiviller's undoubted eagerness to encourage noble history pictures was partly *against* the general climate, as he came to recognize. In 1787 Pierre reported to him about the prospects of that year's Salon, 'les portraits et les genres étoufferont un peu l'histoire'. And he added, 'cela est la marche de toutes les écoles; l'on prétend qu'il y a plus de cent Français à Rome, tous paysagistes'. When the following year d'Angiviller explained to Pierre his distribution of commissions, he tacitly recognized the situation; he wished to give history painters the specific opportunity to produce work – otherwise, 'il est à craindre que, vû nos mœurs actuelles, les expositions prochaines ne nous présentent plus que des tableaux de chevalet'.[15]

D'Angiviller, it could be argued, had not only a hopeless task but one at times even harmful. His protégé, Aubry, a gifted genre painter (whose work of that kind was in d'Angiviller's own collection), was encouraged by him to

attempt history pictures, and failed dismally. Outside Paris, genre and portraiture remained the chief categories of picture in demand. Even if masterpieces were seldom produced, the results were often more agreeable than any except the finest history pictures (Vernet had once told d'Angiviller, 'avec la supériorité et la franchise d'un grand homme', that his pictures were better than most history pictures; the source for this is a letter of d'Angiviller's to Vien, in 1790). Unexpected minor works of delightful art could be painted, like the *Atelier des Couturières* (1760?, Arles) [281] by the arlésien Antoine Raspal (1738–1811), which has quite Sunday-painter originality and charm.

Perhaps down in Arles Étienne Aubry (1745–81) would have lived longer and more happily.[16] He was trained in Paris under Vien, and d'Angiviller early showed a special interest in his career. Although Greuze is usually claimed as the prototype for his studies of single heads and small genre scenes (he also executed some portraits), Aubry had more in common with Lépicié. His delicate talent was at its best in unexaggerated, unaffected, family scenes such as *L'Amour paternel* (Barber Institute) [282], lent by d'Angiviller himself to the Salon of 1775. If there is sentimentality in that picture, it is so slight as not to matter. The tone is unforced. There is no weight of anecdote, but instead a delicacy which extends from deft observation to the actual handling of the paint. Two years after it was painted, Aubry was sent to the French Academy at Rome, but he seems to have been unhappy there, and d'Angiviller's ambitions for him were doomed to disappointment. His wife had died; his health was not good; his talent was forced towards subjects for which it was not suited. In place of a simple modern family scene he now attempted the antique one of *Coriolanus taking leave of his Wife* (lost?). This apparently unsatisfactory effort appeared at the Salon in 1781, the year of Aubry's premature death.

As mere postscript, to carry genre successfully into the following century, Louis-Léopold Boilly (1761–1845) should be mentioned if not seen. His countless over-polished little pictures – whose handling suggests study of Terborch and Metsu – can be appreciated in much the same way as Baudelaire appreciated the fashion plates of the Revolution and the Consulat. Boilly was indeed better attuned probably to costume and décor than to people. Born near Lille, he arrived in Paris in 1785 but did not exhibit at the Salon until 1791. Under suspicion during the Revolution, he hastily painted a *Triumph of Marat* (Lille). Iconographically more interesting pictures are his views of two artists' ateliers: *Houdon modelling the Bust of Laplace* (1804, Musée des Arts Décoratifs) and the *Studio of Isabey* (Louvre, Salon of 1798). His most typical genre scenes sometimes catch an echo of Greuze but are more trivial and insipid than the eighteenth century ever encouraged. He seems ready – even before it came – for the world of Louis-Philippe.

CALLET, SUVÉE, PEYRON, VINCENT, MÉNAGEOT, REGNAULT, JEAN-GERMAIN DROUAIS

'Enfin David vint', one is tempted to write, varying Boileau's famous words, in an attempt to clarify the pattern of painting, especially history painting, in the final years of the *ancien régime*. That David arrived is certainly the dominant fact as posterity tends to see it, outshining most of his contemporaries in terms of permanent fame.

But in pre-1789 Paris the issue was nothing like so clear-cut. Apart from the older generation of painters, represented at its oldest and most distinguished by David's master, Vien, there were several close contemporaries of David who also received official 'national' commissions and who competed openly with him for public interest in their appearances at the biennial Salon exhibitions.

It would be dangerous to generalize too sweepingly about the tone and tendency of the subject pictures that were exhibited at the Salon in these last years, but it seems broadly true that there was now a preference for ancient history over ancient mythology.[17] *The Judgment of Paris* was less likely to be depicted than some more elevated and 'male' subject concerning, say, Socrates or Oedipus. If Cleopatra appeared it was more often as dying than as feasting. It cannot be chance that the *Iliad* proved far more popular a source than the *Odyssey* (though fitful use was still made of Fénelon's *Télémaque*). In style and subject, Callet's *Achilles dragging the Body of Hector* (Saint-Omer), exhibited in 1785, is a typical example of these tendencies, although Antoine-François Callet (1741–1823) could be more patently decorative and less severely gloomy. He painted cartoons for the Gobelins of the *Four Seasons* (Louvre and Amiens) and is probably best remembered for his full-length portrait of Louis XVI (Grenoble). The *Iliad* still haunted him in the *Venus wounded by Diomedes* (Louvre) [283], exhibited at the Salon of 1795, a strange *mélange* of the Baroque and the classical, and oddly affecting in its strangeness. Yet, like many painters of the period, Callet survived to find himself dealing with very unexpected, modern subjects associated with the 'modern' hero, Napoleon. Not Troy, but Marengo and Ulm and Austerlitz ultimately inspired in his case allegorical interpretations in paint (Versailles). No single adjective could possibly sum up the stylistic character at a time of fluctuation, artistic as well as political. Subject-matter may often have dictated treatment, and even into classical themes

283. Antoine-François Callet: *Venus wounded by Diomedes*, 1795. Paris, Louvre

284. Joseph-Benoît Suvée: *Admiral Coligny confronting his Assassins*, 1787. Dijon, Musée des Beaux-Arts

intruded the influence as much perhaps of Caravaggio as of antique art. Callet may not have offered real rivalry to David, but other figures, of distinct ability, some only recently revived by scholarship and made visually accessible again, were jostling intensely for position. At the Salon of 1789 (a Salon taking on retrospective significance), the visitor would have seen not only David's large-scale contributions but those of Suvée, Peyron, Vincent, and Regnault.[18]

Joseph-Benoît Suvée (1743–1807) was born at Bruges and trained first at the Academy there.[19] He arrived in Paris at the age of twenty and became a pupil of Bachelier (1724–1806). In 1771 he defeated David in competing for the *premier prix* (which led the successful competitor to Rome) on a subject from the *Iliad*, *The Combat of Minerva and Mars*. David's picture had to take second place to Suvée's (Lille), which is hardly less 'rococo' in style. In Rome Suvée developed a more personal style, converted to 'antique grace' by his environment and encouraged by entry into the circle around Mengs. His subsequent, slightly 'posed' and consciously elegant manner is exemplified by the *Birth of the Virgin* (1779, church of the Assumption, Paris). However, a less insipid aspect of his art emerges in the *Admiral Coligny confronting his Assassins* (Dijon) [284], exhibited at the Salon in 1787 and part of the French history series to which belong Brenet's *Duguesclin* [236] and Durameau's *Continence of Bayard* [237] as well as Vincent's *Président Molé* [286]. Antique grace was not required by the subject of Coligny, and for the nocturnal drama of his composition (inclusive of the flaring torch) Suvée had perhaps glanced, usefully, at

Pope Nicholas V having the Vault of St Francis of Assisi opened, by La Hyre (Louvre). During the Terror Suvée was imprisoned but eventually returned to Rome as Director of the French Academy there.

In 1773 David suffered a further defeat, one that perhaps rankled more, when to his version of the given subject, *The Death of Seneca* (Petit Palais, Paris), was preferred that by Jean-François-Pierre Peyron (1744–1814).[20] Peyron promised to be a more exciting and arguably greater artist than Suvée, one more profoundly absorbed by Antiquity and severe antique subject-matter, approached very much through the eyes of Poussin. He certainly handled paint with much more feel for the *matière* than did Suvée.

When Vien was appointed Director of the French Academy in Rome in 1775 he took Peyron with him, along with David. Like Vien, d'Angiviller thought highly of Peyron and privately perhaps hoped he would eclipse David. David himself confessed a debt to Peyron's pioneering interest in both Antiquity and Poussin. At the Salon of 1785 Peyron's *Alceste mourante* (Louvre) [285] was much admired, three years after the painter had returned from Rome. Peyron had already impressed by *The Funeral of Miltiades*, painted at Rome in 1782 (Louvre), but a subject of heroic female virtue in itself makes something of a welcome change amid much male heroics in the decade, and though echoes of Poussin are loud in the *Alceste*, there is also a tender, if sombre, moving quality, as well as fine painting. In a letter to Cochin, written after the Salon closed in 1785, d'Angiviller communicated his pleasure, 'je l'avoue, à voir en lui [Peyron] un homme réellement fait pour être distingué'.[21] This was a good deal warmer than his attitude to David, about whom he hoped merely that he would not be harmed by either small-minded criticisms or (more pointedly) 'les éloges peutêtre exagérés' which he had received. In fact, Peyron's chance of making an impact with the picture was diminished by the sensation of David's. And in 1789 David virtually revenged himself for the student defeat of 1773 by his privately commissioned *Death of Socrates* (Metropolitan Museum, New York), a composition skilfully organized both artistically and emotionally, in contrast to Peyron's version of the same subject, which was proclaimed as 'pour le roi' but failed as art. Although Peyron lived on, the end of the *ancien régime* marked the effective end of what had been expected to be a great career.[22]

Something rather similar happened to François-André Vincent (1746–1816). Only two years older than David, he enjoyed much earlier success. In 1768 he was acclaimed as winner of the *premier prix* at the Académie. Little is known of his student years in Rome, but in 1777 his first appearance at the Salon, with no less than fifteen pictures, led to critics speaking of him as an artist 'qui vise aux grands effets...'. The *Mercure* prophesied, 'Il ira loin.' At the next Salon, of 1779, his *Président Molé stopped by Insurgents during the Fronde* (Chambre des Députés, Paris) [286] rightly caused a stir. It is a history picture of unexpected veracity and vigour, showing marked ability by the painter to project himself back into the French past. Just as much as any famous antique subject, it celebrates bravery in an aged, unarmed hero, fearless and morally confident before the spectacle of mob rule.[23] Delacroix would not have been ashamed of responsibility for the impetuous figure of the threatening foreground man, the

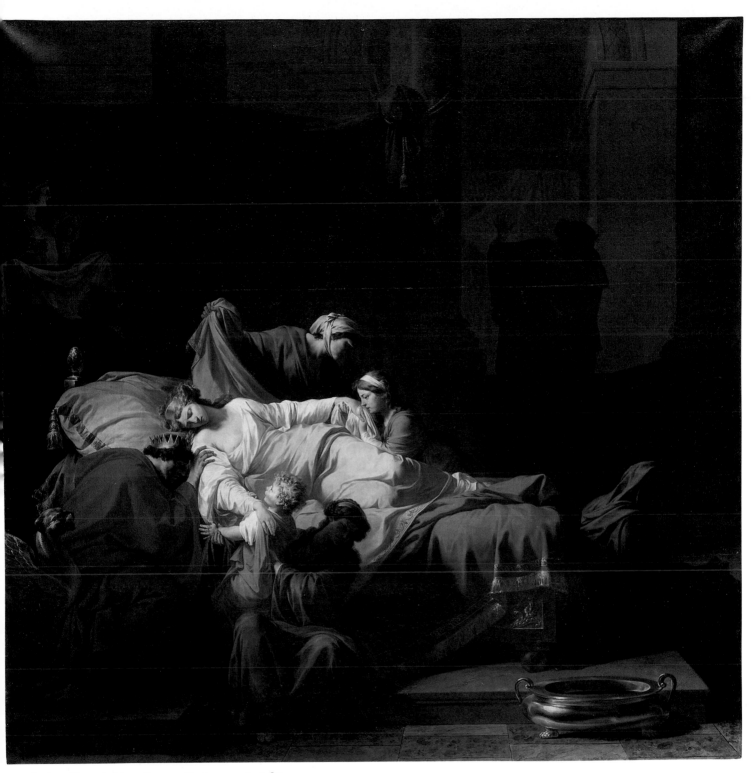

285. Jean-François-Pierre Peyron: *Alceste mourante*, 1785.

strong diagonal of whose body really seems to bar Molé's progress. A no less effective diagonal is achieved by the diminishing line of Parisian house-fronts, helping to enclose the scene. The picture is one of the best products of d'Angiviller's national programme, and rather more thrilling than Vincent's neo-classic vein as expressed in *Zeuxis choosing Models from the most beautiful Girls of Crotona* (Louvre), similarly an official commission, exhibited at the Salon of 1789. This return to the world of his master, Vien, is almost a confession of vacillation. Vincent's vigour and energy had dwindled in the very year that David showed the *Brutus* [295]. Accidentally or not, it was the latter picture which seemed to suit the mood of the day. And Vincent faded as any sort of rival to David. His few later subject pictures are tame, though as a portrait painter he retained his flair.[24]

One final possible rival did not exhibit at the Salon of 1789 partly because he was away in Rome, having been appointed two years previously director of the French Academy there: François-Guillaume Ménageot (1744–1816).[25] The pupil of Deshays and Boucher, Ménageot is rightly remembered for

286. François-André
Vincent: *Président Molé
stopped by Insurgents*, 1779.
Paris, Chambre des Députés

The Death of Leonardo da Vinci (Amboise) [287], which was
such a success at the Salon of 1781. As a subject from French
history (the painter dying in the arms of François I), and
indeed as a prominent deathbed, it had been preceded by
Brenet's *Du Guesclin* [236], but it is an early example of that
category of artists' lives and last moments which became so
popular for pictures in the following century. It is more
intimate and perhaps more touching than Brenet's vaguely
medieval scene. The dying painter and the gracious monarch
were Renaissance figures more easily evoked. The picture
formed part of d'Angiviller's scheme, and to the general
patriotic-historical basis it adds the attractive ingredient of
royal recognition of artistic genius. In its style as in its subject,
Ménageot's picture is very different from the 'hard-edge'
classicism that David was to develop. If he was eclipsed at
the Salon of 1785 by David, he yet continued his professional
career. He continued to receive official commissions from
d'Angiviller, in spite of the fact that the last hectic years of
the century he spent prudently in Rome (though even there
revolutionary agitation seized the students under him), not
returning to France until 1801, to an artistic world ruled by
David.

Although rather younger than any of the painters discussed
above, Jean-Baptiste Regnault (1754–1829) made his mark at
the Salon of 1789 with the stark *Descent from the Cross*
(Louvre) [288], commissioned for the high altar of the Chapel
of the Trinity at Fontainebleau. Subsequent political events
prevented it being placed in position.[26] Regnault's is a
remarkable career, and not only in its length. He apparently
worked as a cabin boy in extreme youth, and in the last year
of his life he was ennobled as a baron under Charles X, the
grandson of Louis XV, in the middle of whose reign painter
and future king had been born.

Regnault shows an almost Vicar-of-Bray-like susceptibility
to varied circumstances, with concomitant variety of subject-
matter and styles. He can figure – and has – as a neo-classic
artist, even being described, somewhat unfairly, as among
'the minor followers of David'.[27] Perhaps he suffers still in
having a career that straddles two centuries interrupted by a
Revolution. As a boy he accompanied his teacher Jean Baudin
(1732–1809) to Rome and was there much influenced by the
antique. His *morceau de réception* in 1783 was the elegantly
classical *Education of Achilles by Chiron* (Louvre), painted in
Rome in the previous year. *The Descent from the Cross* shows
him in very different mood, adopting a style that leads back
to Jouvenet. In the full tide of the Revolution he produced
topical allegorical pictures vaguely 'classical' in manner, like
Liberty or Death (Hamburg). And at the turning-point of the

287. François-Guillaume Ménageot: *The Death of Leonardo da Vinci*, 1781. Amboise, Hôtel de Ville

288. Jean-Baptiste Regnault: *Descent from the Cross*, 1789. Paris, Louvre

century he exhibited, in his own studio, *The Three Graces* (Louvre) [289], in which Paris and Pompeii meet to chic and piquant effect.

Regnault can be little more than a footnote in an account of the last years of the *ancien régime*. A footnote of a very different kind is provided by Jean-Germain Drouais (1765–88), actual son of the painter François-Hubert Drouais but in artistic and emotional terms son of David (the son he never had). Had Drouais lived longer, he might, however unwillingly, have become the true challenger of his beloved master, David. Temperamental as well as gifted, Drouais was far quicker to forge a style like a weapon, hard, spare and sharp (and made possible, of course, by David's own forging). What Drouais could achieve is summed up in *Marius at Minturnae* (Louvre) [290], painted in Rome in 1786.[28] The Académie refused to accept this as Drouais' posthumous *agrégation* piece, ostensibly because it had been painted abroad – despite pleas by his fellow-students. Thus it never appeared at a Salon and entered the Louvre only in the reign of Louis XVIII.

In itself, the rare subject offers a perhaps accidental foretaste – in classical dress – of future events. Marius, tribune of the Roman people, and violently opposed to the aristocracy, might serve as prototype for one or more Revolutionary leaders. Confronted at Minturnae by a would-be assassin, the defenceless, captive Consul by sheer charisma compels his attacker to retreat (as Marat failed to do with Charlotte Corday). Drouais makes of the confrontation of the two men on a dark stage a drama tauter and even more concentrated than in David's *Horatii*. Colouristically, too, the picture is bolder. Borrowing, as it were, the red cloak of the father in the *Horatii*, Drouais recreates it as the voluminous, more stridently scarlet garment wrapped around Marius's body like a vast flag of defiance. It remains unclear if Drouais could have kept his art at this fierce pitch. He was dead at twenty-three, leaving David at the age of forty to continue the battle, artistic, personal, and possibly also political.

DAVID

Jacques-Louis David had been born in Paris in 1748. He did not die until 1825, by which time he could have seen Géricault's *Radeau de la 'Méduse'*, Delacroix's *Massacre de Scio*, and Constable's *Haywain*, had he not been living in Brussels in virtually self-imposed exile since 1816. David's career is a complicated story in several chapters – *ancien régime* painter, republican official, court artist to Napoleon – with an epilogue of being left working 'à sa volonté'. Of this fluctuating narrative only the *ancien régime* chapter can be touched on here. Unfortunately these are the very years about which least is clear, notably about David the man. In many ways he remains an elusive personality; yet in that very elusiveness there is perhaps something significant: something

289. Jean-Baptiste Regnault: *The Three Graces*, by 1799. Paris, Louvre

290. Jean-Germain Drouais: *Marius at Minturnae*, 1786. Paris, Louvre

waxlike and highly susceptible to widely different impressions until stamped with the seal of Napoleon. Although later to be hailed constantly as the reformer of the French school, the restorer of correct principles, David was to grasp this role only slowly. He never achieved total artistic consistency – and in that perhaps lay his best proof of talent, as painter and as teacher. Lack of coherence of a similar kind probably accounts for the slow and uncertain steps of David's early career. He is not always an easy artist to understand, and it may be doubted if he ever quite understood himself.

As a boy he was passionately interested in drawing and in little else. His widowed mother took him to Boucher, a relation of hers, who recommended Vien as a good teacher. This was perceptive advice. Vien became David's master and, it is not too slick to say, a second father to him. Ambitious but hot- rather than clear-headed, David needed someone to control what Vien called his 'trop grande sensibilité'. From 1769 to 1774 he was competing for prizes at the Académie. His *Combat of Mars and Minerva* (Louvre) lost to Suvée's version in 1771; his *Death of Seneca* (Petit Palais) to Peyron's in 1773, though in that year he received the Caylus prize for an expressive head (*La Douleur*; École des Beaux-Arts).

Not until 1774 did he at last gain the *premier prix*, for

Antiochus and Stratonice (Ecole des Beaux-Arts). It is fortunate that these three early paintings have survived, because they reveal affinities that might not be expected. All are much more forceful than anything by Vien. They show no interest in developing the bas-relief composition and neo-Poussinesque air of Greuze's *Septime Sévère*. Among contemporary French painters, Doyen and Deshays seem much more potent influences and, rather than Vien, it is Boucher – the vigorous Boucher of work like *Neptune and Amyone* (Versailles) – who is recalled by passages in all three pictures. Compositionally, that actual picture seems to lie behind the *Combat of Mars and Minerva*. The *Death of Seneca* [291], the best picture of the three, suggests even closer Baroque connections, especially with Solimena, a painter whom Doyen is recorded as having particularly admired, and Doyen early took a personal interest in the young David. The *Death of Seneca* – for all its Baroque properties of braziers and looped curtains – belongs to the ethos of David's mature work. Its grimly noble masculine subject suits him, to begin with. A thundery sense of drama smoulders behind it – and even the device of concealing the hero's torso in shadow anticipates the figure of Brutus in the Salon composition of 1789. Indeed, the whole picture is much bolder than the

291. Jacques-Louis David: *The Death of Seneca*, 1773. Paris, Petit Palais

possibly more 'correct' *Antiochus and Stratonice*, where as an influence Solimena seems receding, to be exchanged for Le Sueur. This does not mean that David had become converted to neo-classicism, but it establishes his growing awareness of another pole – which may be called *Poussinisme*, idealism, rationalism, neo-classicism – between which and contrary elements of *Rubénisme*, naturalism, emotionalism, Baroque verve, he would never quite cease oscillating.

By temperament, we may guess, he was instinctively attracted to the latter qualities. Too much ardour in the man, too much red tonality in the work: such were typical early official criticisms recorded in the exchanges between Rome and Paris during Vien's directorship of the French Academy in Italy.[29] In his work, at least, David soon recognized the need for control. We cannot call it an explicit programme, for there is no direct evidence, yet he may have felt it was his destiny to unite *Rubénisme* and *Poussinisme*, to produce an art which would bring together conflicting tendencies of the century: to be at once intensely natural and supremely elevated, passionate in content, yet meticulous in form, a lesson in morality but also great purely as painting.

The year after David had won first prize for the *Antiochus*, Vien was appointed director of the French Academy at Rome. David travelled there with him, and in the subsequent five years spent at Rome 'discovered' classical Antiquity. Although this is true on the surface, there was more to David's discoveries. Appeased partly by his eventual student success, he was now eager to undergo discipline by constant drawing and by studying anatomy. It was not only Trajan's Column that he drew but compositions by Ribera, Caravaggio, and Veronese. He was still seeking, in effect, a style. Later he was to pay tribute to the antiquarian theorist, Quatremère de Quincy, for revealing Antiquity to him, but Peyron's neo-Poussinist tendencies seem more apparent in the first classical pictures which resulted from these Rome years. In fact, other painters probably meant more to him than Antiquity as such. Certainly the influence of Gavin

292. Jacques-Louis David: *Count Potocki*, 1781. Warsaw, National Gallery

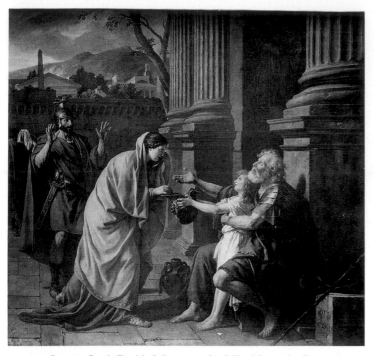

293. Jacques-Louis David: *Belisarius*, 1781. Lille, Musée des Beaux-Arts

Hamilton (whose work had earlier been specifically reported about in France)[30] was very real, in composition as well as subject-matter. Batoni's handling of paint – smooth and quite free of any tendencies towards 'trop de rouge' – also affected his technique. These were still apprentice years for David, when he was forging not so much a single style as a dogged competence, in itself greater than any his rivals would achieve.

When he exhibited at the Salon in 1781, having been *agréé* earlier that year, it was in a variety of styles, with varied subject-matter. This was the last exhibition to be reviewed by Diderot, and the occasion is one when history fully lives up to romantic expectations. Unfair to Boucher, too optimistic about Greuze, somewhat reserved over Vien, Diderot deserved to see the last high hope of the French school make his début – and to greet with perceptive enthusiasm *Belisarius receiving Alms, St Roch interceding with the Virgin* (Marseille), *The Obsequies of Patroclus, A Woman suckling her child*, and *Count Potocki* (Warsaw) [292]. 'Superbe ... beau ... bien dessiné ... nobles et naturelles' (important conjunction): with such adjectives Diderot praised each picture, whether sketch, large-scale history, or portrait.[31] He did not, it is true, go on to prophesy David's future greatness, but it was already inherent in this group of paintings – of which *Potocki* alone is a masterpiece. That shows David's rapid response to a glamorous sitter, and his ability to respond with Rubensian *fougue* to the implicit *fougue* of the subject. Richly coloured and richly painted, it contrives to suggest sparkling eye-witness spontaneity, in piquant contrast to the measured gravity of the *Belisarius*, itself so much more deeply serious – and better painted – than most previous French history pictures in the century.

In its very restraint *Belisarius* (Lille) [293] may be claimed to be more effective than some of David's own later pictures, being considerably closer to Poussin than the oddly fussy *Andromache mourning Hector* (his *morceau de réception*) of 1783

(École des Beaux-Arts). The emotional repercussion of the incident across the composition, the scale of figures to the architecture – and the use of this too to gravely weight the picture emotionally – all look forward to the achievement of the *Serment des Horaces*. This is David the creator of an ideal world of stern but poignant Antiquity, intensely realized (as in the almost hallucinatory clarity of the steep pavement in *Belisarius*) and conveyed as intensely important. Some moral lesson seems intended by *Belisarius* – perhaps several. What is undoubtedly mingled is the sense of state and individual: here personal charity, however kindly, will not remove the shocking wrong done to the great soldier, what Lemprière (1788) was to call 'the trial of royal ingratitude', which had already been popularized by Marmontel. ('Ah, mon ami, le beau sujet manqué,' sighed Diderot in a letter to Falconet, when Marmontel's *Bélisaire* first appeared.) David persuades us that he is taking the story seriously, probably in more than artistic terms. Certainly he establishes a reality artistically no less 'real' than the actual living fact of Count Potocki. Thus he is equipped to serve both as the history painter long desired by the century and as one of its greatest portraitists. From *Potocki* descend the *Leroy* (1782–3, Montpellier) and *Lavoisier* portraits (New York, Metropolitan Museum) [296] and eventually *Napoleon in his Study* (1810, Washington); from *Belisarius*, not only the *Horaces* and *Brutus* but the peculiar state and personal concerns which mingle at the very centre of that reconstructed history, the *Crowning of Josephine* (the so-called *Sacre*; 1805–7, Louvre) and give it memorable intensity.

Although the period between *Belisarius* and the *Horatii* (exhibited at the Salon of 1785 and now in the Louvre) was quiet compared with the agonies and ambitions which had made David literally ill in Rome, it was marked by almost yearly increases of confidence. He married, became a full member of the Académie, started to acquire the first of his vast number of pupils, and received from d'Angiviller an official commission for a picture, 'pour le roi'. After some uncertainty about which incident in the story of the Horatii to select, David chose that where the three brothers unite to swear to die if necessary in defence of their country.[32] He returned to Rome to finish the picture, on which the young Drouais collaborated to a slight degree, and it was finished and enjoying celebrity there in the summer of 1785. Much goes on being written about this famous picture, which consolidates David's artistic revolution and which is perhaps touched also with hints, however slight, of the Revolution [294].

The programme into which it fitted was a national patriotic one, focused neither on ancient nor on modern royalty but on the concept of the fatherland. To speak of a republican air about the picture is not to be anachronistic or to suggest that David was in 1785 secretly plotting the overthrow of the monarchy. It may be pedantically inaccurate, because the Horatii had lived in the time of kings at Rome, but French contemporary opinion thought in terms of the Republic: 'l'on se voit transporté aux premiers tems de la République Romaine', was the comment of the *Journal de Paris* (17 September 1785). Since the government of Louis XVI was in warm alliance with the American Republic (and in 1785 Mouchy exhibited at the Salon his project for a Statue of Liberty, flanked by Franklin and Washington with drawn

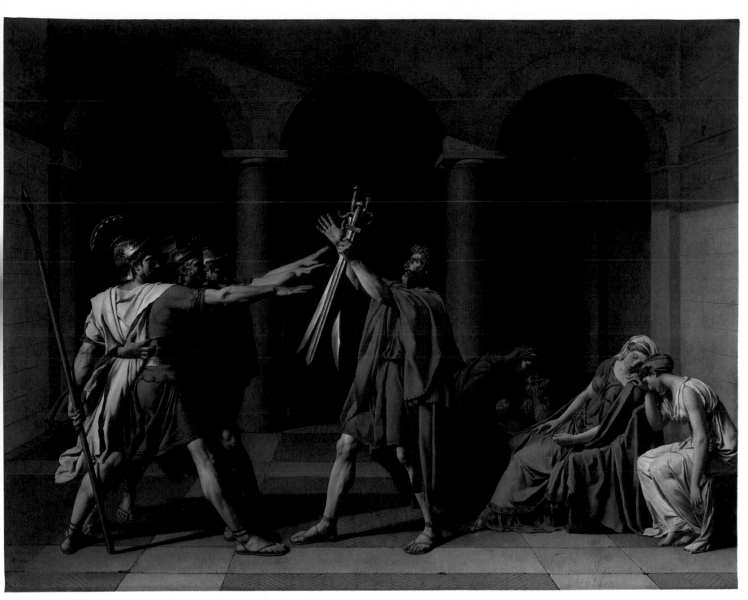

294. Jacques-Louis David: *The Oath of the Horatii*, 1785. Paris, Louvre

sword), David would be sustaining no very dangerous analogy if he intended the *res publica* of France to be understood by his Roman subject-matter. He merely urges unity, brotherhood, and inequality for women (reduced to swooning grief). It may be said that nothing has been discovered to prove David was a revolutionary *avant la Bastille*. However, nothing suggests that he was ever pro-royal, and it would be astonishing if, at the age of forty-one, he became the committed revolutionary which he undoubtedly did without having ever previously reflected on events in the uneasy years which preceded the Revolution itself.[33] Indeed, we have Madame Vigée-Le Brun's testimony that David much disliked court people,[34] and Drouais' scoffing references in letters to him about the conservative element they called 'les perruques'. Though David himself was writing particularly about his own decision to paint the *Horatii* on a scale larger than customary for official royal commissions, there is a ring of independence in his declaration (in 1785): 'j'ai abandonné de faire un tableau pour le Roi, et je l'ai fait pour moi'.[35]

What cannot be doubted are David's revolutionary views about the Académie royale – perhaps more pertinent in the long run than his purely political opinions. Fragonard and Clodion had quietly removed themselves from the academic structure, just as had Greuze for a different reason. David actively challenged it; and only to the obstinately naïve will it appear an accident that his rebellion was supported by Pajou and Madame Labille-Guiard, themselves proving warm supporters also of the Revolution. Like the régime, the Académie hesitated, proving neither truly firm nor truly flexible. David's subsequent success, after being ejected by it, confirmed its loss of value. Academic attitudes to teaching, restrictive concepts of nature, the regulations governing admittance to the Salon: these are just tokens of David's active dissatisfaction with the idea of art being codified and regulated. The evidence of Delécluze provides a convincing view of David as a teacher with the widest possible artistic sympathies – not at all a figure forcing neo-classical doctrines on his extremely heterogeneous assortment of pupils.[36] It should not be forgotten that Gros was among them, as well as Ingres.

It is worth emphasizing the violent and revolutionary – if not doctrinaire Revolutionary – aspect of David not only

295. Jacques-Louis David: *The Lictors bringing Brutus the Bodies of his Sons*, 1789. Paris, Louvre

because this aspect links him to the artistic rebels of the subsequent century but because his increasing intransigence before the whole *ancien régime* system proclaimed its unsuit-ability for dealing with artistic genius. Not since Puget had an artist confronted the system so aggressively.[37] The eighteenth century had regularly called for artistic reforms, but before David no one had welded personal, artistic – and possibly social – reformatory zeal into a positive weapon. Something intransigent and agate-hard burnishes the steely tableau of the *Oath of the Horatii* and gives it that edge of 'difference' which so excited the earliest spectators of it. The neo-classicism in which this difference is clothed is probably largely an accident: it happens to symbolize the extreme to which David was driven at that moment of historical taste. At another period, when neo-classicism was the established current style, he might well have expressed *his* revolution by an equal insistence on the natural and actual – by painting, one might say, his own *Radeau de la 'Méduse'*. The 'realism' of the *Horatii* is indeed more marked than its classicism: it is forcefully primitive and almost brutally clear in composition and application of paint – and less mannered

than the later *Brutus*. David never had an artistic programme which went further than that quoted at the beginning of this book and formulated at the beginning of the century by Antoine Coypel: 'il faut joindre aux solides et sublimes beautez de l'Antique, les recherches, la variété, la naivété et l'âme de la nature'. But he had the ability to redefine this in moral terms, and to paint with an intensity beside which the pictures of Coypel must shrivel.

David's proposed showing at the Salon of 1789 – itself a vexed point of scholarly discussion – reveals the continuing twin current of his mind: 'l'âme de la nature' in the Lavoisier double portrait [296] and 'sublimes beautez de l'Antique' in *The Lictors bringing Brutus the Bodies of his Sons* (Louvre) [295]. As it happened, the Salon opened without either of these pictures, and at first David was represented only by the somewhat insipid *Paris and Helen* (Louvre), specifically

296. Jacques-Louis David: *Monsieur and Madame Lavoisier*, 1788. New York, Metropolitan Museum of Art

commissioned by the determinedly libertine, royal Comte d'Artois. Despite at least one attempt to prove the opposite, it is a fact that the pictures for the Salon which opened after the fall of the Bastille were censored so as to avoid exhibiting anything likely to disturb the public.[38] The name of the Comte d'Artois was thought best suppressed. Lavoisier, in his role as Fermier-Général not as chemist, was also thought a provocative subject and his portrait did not appear. Since it had been finished and paid for in 1788, it is obviously not the picture under discussion in August 1789, when an underling of d'Angiviller's expressed to Vien his relief that the 'tableau de M. David' was 'loin d'être achevé'. This latter was the *Brutus*. Its grim subject was patently thought disturbing,[39] though it did eventually enter the Salon and achieved a success.

The Lavoisier portrait [296] was probably commissioned through Madame Lavoisier, herself a painter and an ex-pupil of David. She is of at least equal importance with her husband in the composition, which celebrates the marriage of their minds – not in some sentimental pose *à la* Vigée-Le Brun, but through careful natural gestures and the recording of the chemical apparatus in which both were deeply interested. A drawing by Madame Lavoisier shows her taking notes during one of Lavoisier's experiments;[40] in David's picture, it is Lavoisier who seems almost taking dictation from her. The picture is imbued with unaffected rationality, optimistic about human nature, affection, and scientific knowledge. Its detailed depiction of a shared life – being at once genre and portraiture – makes it a quintessential product of its century. From its contented, intelligent domesticity to the domestic tragedy of the *Brutus* is an abrupt shift of mood, yet the *Brutus* too is quintessential to the century's demand for pictures to affect people.[41] It is indeed among the very subjects La Font de Saint-Yenne had recommended to painters in 1754 (*Sentimens...*): Brutus condemning his sons 'à périr pour avoir appuyé la tirannie de leurs Rois, et les immole à la liberté de sa patrie'. It offers no optimistic solutions. It suggests that reasons of state can destroy a family, that mercy is weakness, and it asks us, by implication, to admire the stoic patriot who had his sons killed for siding with the expelled tyrant, Tarquinius. Extreme to the point of irrationality, it is the century's own revenge on itself for having once been civilized with Watteau and titillated by Boucher. The small private virtues tacitly praised by Chardin are replaced by a grand public piece of heroic fortitude. It was David who once again selected the theme, having rejected Coriolanus and Regulus, subjects elevated yet insufficiently bloody, for Coriolanus' resolve weakened at the pleading of his family and Regulus sent no one but himself to death.

The ethos adumbrated by the *Brutus* is connected less with the Revolution than with Napoleon. *Marat assassiné* (1793, Brussels) is a masterpiece, a shock which is the century's shock at humanity betrayed, but the hero is dead. Not until he painted Napoleon in 1800, 'calme sur un cheval fougueux' (Versailles) [297], did David synthesize actuality and dream, rational portraiture and an idealized all-conquering aura – in an icy climate and on a peak raised far above any even Louis XIV had scaled. This portrait has figured in at least one romantic exhibition; in its idealism, its conscious rearrangement of the natural, it might be admitted to a neo-

classical exhibition, despite its hero's contemporary costume. And its message is 'into battle'. Patriotism is defined as aggression. As stoic as Brutus, Napoleon orders death for those who oppose him. The fatherland demands blood, as the *Horatii* and the *Brutus* prophesied it would.

With David, painting is passing out of any recognizable eighteenth-century world. His later career belongs in other books on other periods of art history. Just as his early years were spent amid talents once thought as promising as his, so in maturity he was increasingly not alone. Although not perhaps estimated as much of a challenge for most of the period, the existence of Pierre-Paul Prud'hon (1758–1823) certainly causes posterity to reflect. He is more than a decorative alternative to David: wayward, poetic, capable of memorably sensitive portraits (e.g. *Georges Anthony*, *c.* 1796, Dijon), he refuses to be neatly categorized. Among the many shrewd acts of Napoleon, not least was his selection of Prud'hon to serve his two empresses – and well were they both served by his portraits and decorative schemes.

David's most gifted pupils too were beginning to show their own individual abilities. In 1789 Anne-Louis Girodet-Trioson (1767–1824) was the winner of the first prize at the Académie and reached Rome that year. Soon he was to be joined there by the precocious François Gérard (1770–1837), of whom Brenet reported already in Paris 'né pour faire quelque chose, mais donnant dans la mode de David et n'écoutant pas son maître'.[42] Jean-Antoine Gros (1771–1835) too would soon be there, a great if flawed painter, whose genius was instinctively understood by Géricault and Delacroix. That none of these three leading pupils of David can properly be described as 'neo-classical' is a last reminder that that word is no torch to guide us through the darkening complex wood of late-eighteenth-century France. Yet that is a wrongly emotive description of what at first sight seemed the final reform, and the final revolution, in a century which had made such constant efforts to relate art and life.

In the Salon *livret* of 1791 the Assemblée Nationale had replaced the Comte d'Angiviller on the title page. It was hardly the occasion for printing a Cochin-style preface about the 'puissante protection d'un monarque'. Here was one more reform of the century, drastic and unforeseen. What, one cannot help asking, absurd though the question is, would Louis XIV have said? No longer did the strict regulations of the Académie prescribe which artists might be allowed to exhibit; the Salon was open to all. A strange summing-up it may well seem, too optimistic about the future and too biased in its rejection of the past, when we read the words which introduced that year's vast Salon, an epilogue on the old and would-be prophecy for a bright new world: 'Les Arts reçoivent un grand bienfait; l'empire de la Liberté s'étend enfin sur eux; elle brise leurs chaines; le génie n'est plus condamné à l'obscurité.' What was ushered in proved not quite so straightforward. But with this new 'liberty', the arts under *ancien régime* conditions had certainly come to an end.

297. Jacques-Louis David: *Napoleon crossing the Alps*, 1800. Versailles, Musée National du Château

List of the Principal Abbreviations

A.A.F.	*Archives de l'Art Français*
B.S.H.A.F.	*Bulletin de la Société de l'Histoire de l'Art Français*
Burl. Mag.	*Burlington Magazine*
Correspondance des Directeurs	A. de Montaiglon and J. Guiffrey, *Correspondance des Directeurs de l'Académie de France à Rome* (Paris, 1887–1908)
Dezallier d'Argenville	A. N. Dezallier d'Argenville, *Vies des fameux sculpteurs depuis la Renaissance des arts* (Paris, 1787)
Diderot Salons	J. Seznec and J. Adhémar, *Diderot Salons* (Oxford, 1957–67)
G.B.A.	*Gazette des Beaux-Arts*
J.W.C.I.	*Journal of the Warburg and Courtauld Institutes*
Locquin	J. Locquin, *La Peinture d'histoire en France de 1747 à 1785* (Paris, 1912)
Lugt	F. Lugt, *Répertoire des catalogues de ventes publiques intéressant l'art ou la curiosité*, I (The Hague, 1938)
Mémoires inédits	L. Dussieux a. o., *Mémoires inédits sur la vie et les ouvrages des membres de l'Académie Royale de Peinture et de Sculpture* (Paris, 1854).
N.A.A.F.	*Nouvelles Archives de l'Art Français*
Souchal	F. Souchal, with F. de la Moureyre and H. Dumuis, *French Sculptors of the Seventeenth and Eighteenth Centuries. The Reign of Louis XIV* (Oxford), I (1977), II (1981), III (1987)
Vies d'artistes	Comte de Caylus, *Vies d'artistes du XVIIIᵉ siècle* (Paris, 1910)

Notes

CHAPTER I

1. A. de Montaiglon, *Procès-verbaux de l'Académie Royale de Peinture* (Paris, 1875–92), III, 272; attention is drawn to this particular passage by M. Stuffmann in *G.B.A.* (July–August 1964), 26; see further Note 13 below. It should also be noticed that de Piles, while placing so much emphasis on nature – as is widely known – stated elsewhere that the painter must also have a knowledge of history. For discussion of de Piles' views see A. Fontaine, *Les Doctrines d'art en France de Poussin à Diderot* (Paris, 1909), 120 ff. It cannot be made clear too soon that judgements such as W. Friedlaender's in *David to Delacroix* (New York, 1968 ed., 3) that the whole artistic movement of the early part of the century 'became still more strongly opposed to the Academy' are totally misleading and over-schematic. Further for de Piles, see B. Teyssèdre, *Roger de Piles et les débats sur le coloris au siècle de Louis XIV* (Paris, 1964).

2. Watteau's decorations for the Château de La Muette were almost certainly executed before 1716, when the regent bought the château for the Duchesse de Berry.

3. See H. Jouin, *Conférences de l'Académie Royale de Peinture et de Sculpture* (Paris, 1882), 313.

4. *Ibid.*, 277–8.

5. Cited in connection with aesthetic attitudes and arguments by R. G. Saisselin, *Taste in Eighteenth Century France* (Syracuse, N.Y., 1965), 10.

6. The complex effects of this form the theme of T. E. Crow, *Painters and Public Life in Eighteenth-Century Paris* (New Haven and London, 1985); especially relevant are chapters III and IV, 79 ff.: 'The Salon and the Street' and 'Whose Salon?'.

7. For the Salon literature pre-Diderot, see H. Zmijewska in *G.B.A.* (July–August 1970), 1–144.

8. See 'Le Concours de peinture en 1727' by P. Rosenberg in *Revue de l'Art*, no. 37 (1977), 29–42.

9. The relevant painters not otherwise mentioned in the text here were: Louis-Michel van Loo; Carle van Loo; Deshays; Le Bel; Vernet; Roland de la Porte; and François Casanova.

10. The letter quoted in J. Locquin, *La Peinture d'histoire en France de 1747 à 1785* (Paris, 1912), 114. Among other memorable phrases, Lagrenée wrote: 'en vain, ajouta-t-il des règlements, on exigera pour l'avancement de la peinture, que l'on se lève à telle heure . . .'.

11. A. Blunt, *Art and Architecture in France: 1500–1700* (Pelican History of Art), 4th ed. (London, 1980), 380–404, discusses La Fosse, Jouvenet, Antoine Coypel, the Boullongne, François de Troy, Largillierre, Rigaud, and Desportes.

12. Rigaud's inventory, at the time of his marriage in 1703, printed in *N.A.A.F.*, 3rd series, VII (1891), 61.

13. A fundamental article in his reassessment by M. Stuffmann in *G.B.A.* (July–August 1964), 6–120, with *catalogue raisonné*.

14. Letter of 22 December 1716: B. Sani, *Rosalba Carriera, Lettere, Diari, Frammenti* (Florence, 1985), I, 314–15; for the further reference in the text, Sani, *op. cit.*, 348–9.

15. See pp. 54–6.

16. For this incident, and further references, see S. Béguin, 'Rosso in France', *Burl. Mag.*, CXXXI (1989), 830–1 and figure 20.

17. Further for Courtin, see M. Faré in *G.B.A.* (May–June 1966), 293–320.

18. *Le Peinture au musée du Louvre: École française*; L. Gillet, *XVIIIᵉ siècle* (Paris, 1927), 26: 'On reconnaît la Parisienne'.

19. See the catalogue by W. McAllister Johnson of the travelling exhibition, *French Royal Academy of Painting and Sculpture, Engraved Reception Pieces: 1672–1789*, Kingston, Montreal, London, etc., 1982–3, no. 83.

20. See pp. 50–4.

21. The range of his work is well conveyed by the numerous engravings after it; see D. Wildenstein, ed., 'L'Œuvre gravé des Coypel, II', *G.B.A.* (September 1964), 141–52.

22. For the whole scheme, see A. Schnapper in *Revue de l'Art* (1969), 33–42.

23. *Mémoires inédits*, II, 300; cited by Lady Dilke, *French Painters of the XVIIIth Century* (London, 1899), 33.

24. See pp. 21–5.

25. Quoted by C. White in the catalogue of the exhibition *Rembrandt in Eighteenth Century England*, ed. C. White, D. Alexander, E. D'Oench, New Haven, 1983, 16.

26. *Le Siècle de Louis XIV: Œuvres de Voltaire* (Paris, 1819 ed.), XVII, 181. For the topic generally, see J. Cailleux, 'Les Artistes français du dix-huitième siècle et Rembrandt', in *Études d'art français offertes à Charles Sterling*, ed. A. Châtelet and N. Reynaud (Paris, 1975), 287–305.

27. See p. 40.

28. See pp. 79, 80, 86.

29. The 'legend' of Grimou discussed by G. Levitine in *Eighteenth Century Studies*, I (University of California, 1968), 58 ff. For Bouys, referred to in the text above, see M. Faré in *Revue des Arts* (1960), 201 ff.

30. *Mémoires inédits*, II, 255 ff for contributions to the biography of De Troy. A posthumous sale of his collection (containing pictures attributed to Tiepolo, among much else of interest) at Paris, 9 ff. April 1764 (Lugt 1372).

31. This picture (lent to the exhibition *France in the Eighteenth Century*, R.A., 1968, no. 670), with its companion, in the Wrightsman Collection, New York.

32. The painter was not identified by Goethe but his reactions, recorded in *Dichtung und Wahrheit*, are quoted by G. H. Lewes, *The Life of Goethe* (London, 1864 ed.), 67–8.

33. The impact of the Salon of 1737 was recreated by the exhibition *Les Artistes du Salon de 1737*, Paris, 1930, where much of the sculpture, as well as paintings, was assembled.

34. Mariette shrewdly put his finger on the success and failure of De Troy, noting that he pleased at Paris 'par ses petits tableaux de modes qui sont en effet plus soignés que ses grands tableaux d'histoire': *Abécédario*, ed. Ph. de Chennevières and A. de Montaiglon (Paris, 1853–4), II, 101. The Wrightsman pair (cf. Note 31) exemplify De Troy's 'soigné' achievement.

35. His reputation emerges clearly from the fact that his views on the models Slodtz was preparing for the Montmorin monument *c.* 1740 were much sought for by the commissioner; see further Note 69, Chapter 2.

36. See p. 125.

37. For these and comparable criticisms, made particularly by Cochin and Blondel, see the valuable discussion in M. Roland Michel, *Lajoüe et l'art rocaille* (Neuilly, 1984), 154 ff.

38. An old and not very satisfactory work is G. Duplessis, *Les Audran* (Paris, 1892); see also the exhibition catalogue *Claude Audran*, Paris, Bibliothèque Nationale, 1950, to which several of the Cronstedt Collection drawings were lent (see text further).

39. Sale, Paris, 27 March 1737, lot 71: 'Guilloz [sic] ou Vateaux, Deux tableaux.' Cited by M. P. Eidelberg, 'Watteau in the Atelier of Gillot', *Antoine Watteau (1684–1721): The Painter, His Age and His Legend*, ed. F. Moureau and M. Morgan Grasselli (Paris–Geneva, 1987), 53.

40. Engravings after the two lost portraits conveniently in the catalogue of the exhibition *Watteau 1684–1721*, ed. M. Morgan Grasselli and P. Rosenberg, Washington–Paris–Berlin, 1984–5, 22 (Watteau) and 40 (Gillot).

41. In his *Vie de Watteau* (1748); see Notes 45 and 46 below.

42. Gillot's inventory was published by G. Wildenstein in *B.S.H.A.F.* (1923), 114 ff.

43. See p. 72.

44. Montaiglon, *op. cit.* (Note 1), LIV, 150; Gillot's reception was not formally recorded.

45. Gersaint's is certainly the most moving and personal of the early 'lives' of Watteau, and its publication (in the sale catalogue of 'feu M. Quentin de Lorangere', Paris, 1744) marks it as very different from the best other life, that by Caylus, not published until the nineteenth century and which should be seen as governed partly by the circumstances of being read at the Académie. Nevertheless, both writers are dealing with events of many years before and in neither case is everything they say to be taken literally.

46. The early 'lives' now conveniently collected, with useful supplementary material, in P. Rosenberg, *Vies anciennes de Watteau* (Paris, 1984).

47. The words are from the obituary notice by Antoine de La Roque in the *Mercure [de France]* (August, 1721): Rosenberg, *op. cit.*, 5.

48. In Rosenberg, *op. cit.*, 13.

49. For this picture, see E. Camesasca and P. Rosenberg, *Tout l'œuvre peint de Watteau* (Paris, 1983 ed.), no. 186.

50. A perceptive article by H. Opperman, 'The Theme of Peace in Watteau', in *Antoine Watteau (1684–1721) . . .* ed. F. Moureau and M. Morgan Grasselli (Paris–Geneva, 1987), 23–8.

51. It should be said that a few of Van der Meulen's drawings, vivid in themselves, show a more direct and 'human' observation; see the catalogue of the exhibition *Van der Meulen, peintre des conquêtes de Louis XIV*, Musée de Douai, 1967.

52. Caylus, *Vie . . .* (Rosenberg, *op. cit.* (Note 46), 80).

53. *Abrégé de la vie . . .*, *ibid.*, 39. Questions arise as to what extent these definite, undeniable traits of character in Watteau can be sensed in his art – if at all. For a robust view of the matter see the provocatively titled 'Watteau mélancolique: la formation d'un mythe', by D. Posner, *B.S.H.A.F.* (1974), 345–61.

54. The picture had usually, perhaps always, been accepted as a pilgrimage setting out towards Cythera (an 'Embarquement...') until the present writer proposed that the pilgrimage had already reached the island (hence the statue of Venus, etc.): *Burl. Mag.*, CII (1961), 180 ff. This has been rejected by several writers, e.g. H. Bauer, 'Wo liegt Kythera? Ein Deutungsver-such an Watteaus "Embarquement"', *Probleme der Kunstwissenschaft*, II (Berlin, 1966), 251–78. For a balanced, if inconclusive, account of the differing interpretations, see the catalogue of the Watteau exhibition, Washington–Paris–Berlin, 1984–5, 396–411 (under nos. 61 and 62, the Paris and Berlin versions, which in Paris at least could be seen adjoining each other).

55. That the left-hand figure there is Vleughels has long been recognized. That the central woman might conceivably be the actress Charlotte Desmares has also been mooted. I believe the seated bagpiper to be a self-portrait and that there is some personal significance to be detected, though not easily unravelled, in the composition; for some further comment see M. Levey, *Rococo to Revolution* (London, 1st ed., 1966), 74–8.

56. Of the 'Pèlerinage à l'île de Cythere' he wrote: '... tout y est traité avec une plénitude d'idées qui lui donne la profondeur et la philosophie d'une des compositions de Poussin'. For the full text, see Rosenberg, *op. cit.* (Note 46), 125–7. Until recently, at least, this was not a common view taken of the picture by scholars.

57. The point stressed by F. Haskell, *The Painful Birth of the Art Book* (Walter Neurath Memorial Lecture) (London, 1987), 54. For the Abbé Haranger (referred to in the preceding paragraph of text), including his inventory, see J. Baticle in *Revue de l'Art*, LXIX (1985), 55–68.

58. Today Charlottenburg well reflects the environment and attitude of Frederick the Great, with Pater and Pesne as his preferred artists, in addition to Watteau; see further the catalogue of the exhibition *La Peinture française du XVIIIe siècle à la cour de Frédéric II*, Paris, Louvre, 1963.

59. Although there are now individual studies of some of these figures, the best general account is probably still R. Rey, *Quelques satellites de Watteau* (Paris, 1931).

60. For Quillard in detail, see M. P. Eidelberg in *The Art Quarterly* (1970), I, 39–70.

61. Montaiglon, *op. cit.* (Note 1), V, 47.

62. The Comtesse de Verrue and her collection were brought into focus first in L. Clément de Ris, *Les Amateurs d'autrefois* (Paris, 1877), 153 ff.; and see B. Scott in *Apollo* (January 1973), 20–4.

63. For some comment on Mercier within the context of Watteau and as active in England, see B. Allen, 'Watteau and his Imitators in Mid-Eighteenth-Century England', in *Antoine Watteau...*, *op. cit.* (Note 39), 259 ff.

64. Portail had a successful career and held several official posts, being Dessinateur du Roi and also Garde des Tableaux in the royal collection. There is a sense in which he is truly an heir of Watteau; and in some landscape drawings he stands between Watteau and Boucher: compare his *Aqueduct at Arcueil*, included in the exhibition *French Landscape Drawings and Sketches of the Eighteenth Century*, British Museum, 1977, no. 31. An old monograph by A. de Lorme, *J.-A. Portail* (Brest, 1900).

65. See below.

66. Cited by Rey, *op. cit.*, 19.

67. *Watteau et sa génération*, exhibition catalogue, Cailleux, Paris, 1968, no. 73. For another aspect of Oudry, see the discussion of him as illustrator of Scarron's *Roman comique* by H. N. Opperman in *G.B.A.* (December 1967), 329 ff. There are now Opperman's dissertation and his catalogue of the Oudry exhibition, 1983 (*see* the Bibliography).

68. Jouin, *op. cit.* (Note 3), 378 ff. It was, as Oudry explains, Largillierre who taught him to achieve tonal subtlety by a direct example involving the use of white rather than obviously contrasting colours. How closely Oudry's own words anticipate the *White Duck* may be seen from his mention of silver as well as white: 'Ces différents blancs vous feront évaluer le ton précis du blanc...'.

69. Further see J. Seznec in *G.B.A.* (1948), II, 173 ff.: for wider implications of the subject see C. de Schoutheete de Tervarent, 'Les Tapisseries de Don Quichotte et les raisons de leur faveur au XVIIIe siècle', in *La Tapisserie flamande aux XVIIe et XVIIIe siècles* (Brussels, 1959). Several of the other paintings mentioned here are known through contemporary engravings; cf. the collaborative articles prepared under D. Wildenstein, 'L'Œuvre gravé des Coypel', in *G.B.A.* (May–June 1964), 261–74, and *ibid.* (September 1964), 141–52.

70. Further for Coypel's proposal, see M. Furcy-Raynaud, *Inventaire des sculptures exécutées au XVIIIe siècle pour la Direction des Bâtiments du Roi*, *A.A.F.*, new period, XIV (Paris, 1927), 38–83. In the light of this, it seems as if contemporaries like Diderot were a little unfair in complaining that it was 'le petit Coypel' who disliked Slodtz and left him unemployed; Slodtz was the only name specifically put forward when Coypel referred to 'cinq de nos habiles sculpteurs'.

71. For Bridan's letter of 1776 to d'Angiviller about this statue (throwing some unfavourable light on Pierre, incidentally), see Furcy-Raynaud, *op. cit.*, 62–3.

72. An exception should be made for such an attractive-seeming portrait as that of his sister-in-law, Madame Philippe Coypel (apparently dated 1732), which is charmingly 'bourgeois' in concept, closer to Aved than to Nattier: *French Masters of the Eighteenth Century*, exhibition catalogue, New York, Finch College Museum, 1963, no. 12; there exists a pendant of Philippe Coypel, exhibited *Watteau et sa génération* (*op. cit.*, Note 67), no. 107, now in the Louvre; cf. I. Compin in *Revue du Louvre* (1969), 2, 93–7. For Noël-Nicolas Coypel (further below) see D. Lomax in *Revue de l'Art*, LVII (1982), 29–48.

73. Very full discussion of the life and work of Restout by J. Messelet in *A.A.F.*, N.P. XIX (1938), 99 ff. See now the exhibition catalogue by P. Rosenberg and A. Schnapper, *Jean Restout*, Rouen, 1970.

74. For Deshays, cf. p. 227–30. Jean Barbault (1718–62) was active as painter and engraver; his is a minor talent, but with its own attractive individuality, including a welcome freedom in handling of paint: see further J. Picault in *B.S.H.A.F. 1951* (1952), 27–31. See now the exhibition catalogue by P. Rosenberg and N. Volle, *Jean Barbault (1718–1762)*, Beauvais, etc., 1974–5. For C.-N. Cochin (1715–90) as an artist, see S. Rocheblave, *Charles-Nicolas Cochin* (Paris, 1927); some survey of Cochin's career is in Lady Dilke, *French Engravers and Draughtsmen of the XVIIIth century* (London, 1902), 37 ff.

75. La Tour's comments to Diderot about Restout in *Diderot Salons*, IV, 85.

76. See particularly Fontaine, *op. cit.* (Note 1), 237–9. On Galloche, there is a chapter by C. Saunier in *Les Peintres français du XVIIIème siècle*, ed. L. Dimier (Paris–Brussels, 1928–9), I, 217–26. A master's thesis exists by M. C. Sahut (Paris, 1972).

77. The history of this, seen in connection specifically with Pellegrini, is given by C. Garas, *Bull. Mus. Hongrois des Beaux-Arts* (1962), 75 ff. For the Salon d'Hercule ceiling in detail, see J.-L. Bordeaux in *G.B.A.* (May–June 1974), 301–18.

78. An interesting reference to Berger travelling in Italy with 'un fort habile Peintre François' (obviously Lemoyne) is made in a letter of 28 July 1724 from Vleughels to the Abbé Grassetti at Modena; see G. Campori, *Lettere artistiche inedite* (Modena, 1866), 159.

CHAPTER 2

1. The story is told vividly and at length in C. Henry, *Mémoires inédits de Charles-Nicolas Cochin* (Paris, 1880), 115–24, 126.

2. Discussed in Furcy-Raynaud, *op. cit.* (Chapter 1, Note 70), 386 ff.

3. See C. Dreyfus in *B.S.H.A.F.* (1908), 108–9, and, better, the same author in *A.A.F.* (1908), 260 ff.

4. The anecdote is reported in, for example, Dezallier d'Argenville, 281.

5. A marble version of the terracotta at the Walker Art Gallery, Liverpool, is catalogued by F. Souchal, *French Sculptors of the 17th and 18th centuries, The Reign of Louis XIV*, I, *A–F* (Oxford, 1977), 151, as perhaps studio work.

6. Henry, *op. cit.* 93.

7. Nevertheless, these tombs represent a style going out of date, despite which the *Mercure de France* in November 1738 was full of praise for the Forbin Janson tomb; see F. Ingersoll-Smouse, *La Sculpture funéraire en France au XVIIIe siècle* (Paris, 1912), 124–5.

8. See for example the engraving reproduced by J. and A. Marie, *Marly* (Paris, 1947), 128. To the previously suggested sources for the *Chevaux de Marly* another one (Primaticcio-designed, destroyed frescoes in the Hôtel de Guise) is proposed by F. Hamilton Hazlehurst, *G.B.A.* (1965), 219–22.

9. *Vies...*, 309.

10. Further on him see Dezallier d'Argenville, 246 ff. For his inventory at death, cf. L.-H. Collard in *B.S.H.A.F.* (1967), 193–210. A very full account now in Souchal, *op. cit.*, III, *M–Z* (Oxford, 1987), 367–402, including a reprint of his inventory.

11. The point made by Souchal, *op. cit.*, III (1987), 368.

12. The term is used by Caylus in his 'life': *Mémoires inédits*, II, 74.

13. The phraseology of this minute is variously quoted, though the sense remains the same. The form given here is from F. J. B. Watson, *Wallace Collection Catalogues: Furniture* (London, 1956), xxxvi, where it is cited in a valuable discussion of new decorative tendencies in French art of all kinds.

14. There is a brief mention of him in Dezallier d'Argenville, 252, but he has remained a little-discussed figure and his *œuvre* is very restricted. The latter remains true; his *œuvre* is catalogued in Souchal, *op. cit.*, I (1977), 82–6.

15. For some interest in the theme of Dido, see P. Marcel, *Le Peinture française au début du XVIIIe siècle 1690–1721* (Paris, n.d. but 1906), 202. For the subject of the *Aeneid* in French art, see H. Bardon in *G.B.A.* (July–September 1950), 77 ff.

16. Studied very thoroughly by J. Colton, *The Parnasse Française, Titon du Tillet and the Origins of the Monument to Genius* (New Haven–London, 1979).

17. See pp. 154–7.

18. Cf. p. 64.

19. Souchal, *op. cit.*, II (1981), 377–8.

20. For his activity in Spain see Y. Bottineau, *L'Art de cour dans l'Espagne de Philippe V, 1700–46* (Bordeaux, n.d. but 1961), and now Souchal, *op. cit.*, II

(1981), 310–53.

21. See R. Wittkower, *Art and Architecture in Italy 1600–1700* (The Pelican History of Art), 3rd (paperback) ed. (Harmondsworth, 1973), 433, 436, and also, at greater length, L. Réau, *Les Sculpteurs français à Rome* (Paris, 1945), 45 ff. Fully for Legros and his work in Rome see R. Enggass, *Early Eighteenth Century Sculpture in Rome* (University Park, Penn. and London, 1976), 124–48.

22. François Dumont was usefully discussed by F. Souchal in *G.B.A.* (April 1970), 225–50; for the catalogue of his work, cf. Souchal, *op. cit.*, II, 269–77.

23. Louis-François Le Lorrain, cited by Souchal, *op. cit.*, II, 345. Chief sources on Le Lorrain are the Abbé Gougenot in *Mémoires inédits*, II, 210 ff. (whence comes the quotation in the subsequent paragraph of the text here) and Dezallier d'Argenville, 289 ff. Fresh information and focus on him are provided by M. Beaulieu in *Jardin des Arts* (1956), 20, 486–92; see now her monograph, *Robert Le Lorrain (1666–1743)* (Neuilly, 1982).

24. *Abécédario*, III, 126.

25. It is a tradition that the *Horses* are late work. That the date of execution might be one of two different periods was suggested by M. Beaulieu in *A.A.F.* (1950–7), 142–9. However, information from J.-P. Babelon about building work showed the earlier date to be impossible; Beaulieu, *op. cit.* (1982), 71–5, accepts a date of 1736–7.

26. Quoted by L. Réau, *Les Lemoyne* (Paris, 1927), 44; the letter is printed in *Mémoires inédits*, II, 228–30.

27. One may also compare the undated *Fall of Phaeton* (Victoria and Albert Museum), by Dominique Lefebvre, Flemish by birth (died after 1719): Souchal, *op. cit.*, II, 227–8 (no. 11), who points out the derivation from a Roman sarcophagus relief of the subject, example in the Louvre.

28. Bouchardon's comment is recorded by Cochin; cf. Henry, *op. cit.* (Note 1), 92.

29. The king stood godfather to one of his children, at Lemoyne's wish, and a vivacious anecdote in this connection is told by Dezallier d'Argenville, 357. It is very doubtful if Louis XV honoured any other sculptor in this way.

30. Réau, *op. cit.* (Note 26), figure 43 for a bronze reduction; the full-scale monument was never executed. For the project in detail, cf. L. Courajod in *G.B.A.* (1875), 44 ff.

31. I am grateful to Mr Peter Marlow for informing me that a few mutilated fragments survive even today in the director's garden at the École des Beaux-Arts, Paris. For what is said further in the text concerning the tinting of the marble by Lemoyne, see Dandré-Bardon's *Mercure de France* article (March 1768), quoted by Réau, *op. cit.*, 66.

32. The incident is recorded by Dezallier d'Argenville, 359.

33. Cited by Réau, *op. cit.*, 117. In 1787 Dezallier d'Argenville commented darkly, 'le brillant de l'imagination, comme un piège dangereux, a trop souvent couvert le vice de ce qu'on appelle manière' (*Vies . . .*, 364). French sculpture might have benefited from falling into this 'trap' more often. Lemoyne was still thought worth stigmatizing – 'maître dont le faux gout . . .' – in Chaussard's *Le Pausanias français* (Paris, 1806), 462, in contrast to Pajou.

34. Henry, *op. cit.* (Note 1), 85.

35. His drawn copies are in the Louvre: J. Guiffrey and P. Marcel, *Inventaire général des dessins de l'école française*, I (Paris, 1933), 96–100. Further light on his artistic interests is cast by the posthumous sale of December 1762 (Lugt, 1254), with brief but notable biography: he owned a Velázquez of Philip IV, Domenico Tiepolo's *Flight into Egypt* etchings, and one or more drawings of Piazzetta, in addition to a large quantity of miscellaneous engravings.

36. Cf. Dezallier d'Argenville: 'On souhaiteroit en général plus de feu dans ses sculptures' (*Vies . . .*, 327).

37. A whole series of works in the Nationalmuseum, Stockholm, including allegorical sculpture, a good bust of the architect Cronstedt, and the polychromed, charming – if considerably restored – full-length boy, the future Gustave III. The daughter Jacquette Bouchardon (1694–1756) remained a dutiful assistant and housekeeper to her father.

38. See the letter (item 12) quoted in the Bouchardon exhibition, Chaumont, 1962. To the older literature cited here should be added two important articles on Bouchardon by G. Weber, in *Revue de l'Art* (1969), 39 ff., discussing drawings and maquettes, and in *Wiener Jahrbuch für Kunstgeschichte*, XXII (1969), 120 ff., on the statues at Saint-Sulpice.

39. D'Antin's letter is cited by A. Roserot, *Bouchardon* (Paris, 1910), 45.

40. Further on it see P. Metz and P. O. Rave in *Berliner Museen*, VII (1957), 19 ff. That such a bust is, rather than an anticipation, a survival (to be compared with a bust of the fifth Earl of Exeter dated 1701, published in *The Connoisseur* (May 1958), 220), is claimed by H. Honour, *Neo-Classicism* (Harmondsworth, 1968), 193.

41. For the Polignac bust (Musée de Meaux) see *Huit siècles de sculpture française, Chefs d'œuvre des musées de France*, exhibition catalogue (Paris, Louvre, 1964), no. 82.

42. *Vies d'artistes*, 90.

43. A letter of 4 September 1732 from Vleughels to the Abbé Grassetti at Modena praises Bouchardon, who carried the letter with him on his way there,

returning to France: 'le plus habile homme sans contredire qui soit au monde . . .'; G. Campori, *Lettere artistiche inedite* (Modena, 1866), 175. For Bouchardon in Rome, see L. Réau in *A.A.F.* (1950–7), 142–9, and E. M. Vetter, 'Edme Bouchardon in Rom . . .', *Heidelberger Jahrbücher*, VI (1962), 51 ff.

44. Bouchardon probably prepared two models for this commission, hoping not to share it with Adam (about whose work at Grosbois he wrote as scathingly as usual); his two terracotta models are in the Hermitage and the commission is usefully discussed by N. K. Kosareva in *Trudy gos. Ermitaža*, VI (Leningrad, 1961), 292–300.

45. *Lettre de M . . . à un ami de province au sujet de la nouvelle fontaine de la rue de Grenelle* (Paris, n.d.); letter on the *Amour* in *Mercure de France* (May 1750).

46. *Vies d'artistes*, 96.

47. Letter of 30 November 1752, to Gabriel; M. Furcy-Raynaud, *Inventaire des sculptures exécutées au XVIIIᵉ siècle pour la Direction des Bâtiments du Roi* (Paris, 1927), 52–3. That the statue had had 'peu de succès' was to be recalled by Dezallier d'Argenville, 324.

48. Perhaps a more powerful reason was the fall of Orry and the rise of Madame de Pompadour; Orry had been associated with Fleury and was dismissed from the Bâtiments in December 1745. The final payment to Bouchardon for what he had executed (models, etc., see further in the text) was effected only in 1760.

49. More than three hundred of these drawings are in the Louvre; Guiffrey and Marcel, *op. cit.* (Note 35), II. See also the catalogue of the exhibition *La Statue équestre de Louis XV, Dessins de Bouchardon, sculpteur du Roi* Paris, Louvre, 1973.

50. But the final effect, as far as it can be judged, should be compared with such a study as the strikingly direct one of man and horse seen frontally (Guiffrey and Marcel, *op. cit.*, II, 924); cf. *Dessins français du XVIIIᵉ siècle* (Paris, 1967), no. 39 and plate XXI, with full bibliography.

51. In this connection Mr Allan Braham kindly drew my attention to the engravings in J. D. Le Roy, *Les Ruines des plus beaux monuments de la Grèce* (Paris, 1758), where plate XVII of the second part gives an elevation of the Erechtheum and plate XXI gives the caryatid porch in some detail; it is mentioned as 'le seul exemple antique' and as 'ignoré jusqu'ici', 19.

52. Roserot, *op. cit.* (Note 39), 120–1.

53. H. Thirion, *Les Adam et Clodion* (Paris, 1885), 62.

54. For the history of the Fontana di Trevi, see H. Lester Cooke in *The Art Bulletin*, XXXVIII (1956), 149 ff. Adam's design is most fully discussed in the important article on him by Don Calmet in *Bibliothèque Lorraine* (Nancy, 1751), 8 ff.

55. See p. 82.

56. Diderot's exclamation about Nicolas-Sébastien in *Diderot Salons*, II, 221.

57. Salon of 1741, where he showed two small plaster models, one probably of Juno placing the eyes of Argus in her peacock's tail, its pendant 'Cléopâtre . . . dans le moment qu'elle remporta le prix de la gageure qu'elle avoit faite avec . . . Marc-Antoine . . .'. On the other hand, his *morceau de réception* was a *Prometheus*; for it and a previously unknown terracotta maquette, see P. Pradel in *Le Pays lorrain* (1958), 129–32.

58. Some old photographs show the figure of the queen wearing a coronet, a mistake in overzealous restoration which has now been removed.

59. Cited by Thirion, *op. cit.*, 165, derived from Dezallier d'Argenville, 384.

60. Ingersoll-Smouse, *op. cit.* (Note 7), plate VI. It is now generally accepted that this tomb is the work of Guidi.

61. In turn it is probable that Adam's maquette suggested the Slodtz' concept for the *pompe funèbre* of Catharina Opalinska; F. Souchal, *Les Slodtz, sculpteurs et décorateurs du roi* (Paris, 1967), plate 53a.

62. That he had seen it, doubtless when travelling to or from Italy, is established by Cochin; Henry, *op. cit.* (Note 1), 116.

63. A curt entry for 'Michelangelo Slode' in the *Dizionario delle belle arti* (Bassano, 1797), II, 243.

64. Even Milizia, *op. cit.* (previous Note), II, 242, had to admit of the Icarus 'è stimato', and that Paul-Ambroise's work at Saint-Sulpice was 'di qualche pregio'.

65. Souchal, *op. cit.*, (Note 61), plate 36a and b.

66. *Correspondance des Directeurs*, VII, 482.

67. These busts were published and discussed by Souchal in *B.S.H.A.F.* (1961), 85–96.

68. Perhaps it is more than accidental that hints towards the concept can be found in the work of Legros; cf. his St Philip Neri in San Girolamo della Carità (Réau, *op. cit.* (Note 21), plate 10), with its swinging draperies and fluid, expressive gestures.

69. The documents were first published by G. George in *Réunion des Sociétés des Beaux-Arts*, XX (1896), 325 ff.; they show incidentally how closely involved De Troy was in approval of the scheme.

70. Bouchardon's cruel comment is recorded by Cochin; Henry, *op. cit.* (Note 1), 91.

71. See for example figure 18 in H. Rousseau, *La Sculpture aux XVII^e et XVIII^e siècles* (*Collections des grands artistes des Pays-Bas*) (Brussels–Paris, 1911).

72. To the assembly of Slodtz' work in Souchal, *op. cit.* (Note 61), a previously unrecognized marble bust of De Troy (Victoria and Albert Museum) is added by T. Hodgkinson in reviewing that monograph, *Burl. Mag.*, CXI (1969), 159–60.

CHAPTER 3

1. Apart from what is cited elsewhere in this book, see also J. Seznac, *Essais sur Diderot et l'antiquité* (Oxford, 1957). It should also be remembered that Diderot's Salon reviews were intended to be read out of France; they were not available in print until the very end of the century (1795) and are likely to have been less influential, or at least less discussed, than brochures printed at the time and articles published in periodicals in Paris. It should also be noted that Grimm sometimes intervened with his own gloss on what Diderot had said, sometimes very effectively, e.g. 'Les Carraches, les Tintorets, les Dominiquins gâtent bien des tableaux français quand on se les rappelle' (Salon of 1763).

2. *Diderot Salons*, II, 224.

3. The circumstances are vividly recalled by Rousseau himself in the *Confessions*, II, 8.

4. See for example E. Bourgeois, *Histoire du biscuit de Sèvres au XVIII^e siècle* (Paris, 1909).

5. La Live de Jully's remarks cited by L. Réau, *Étienne-Maurice Falconet*, I (Paris, 1922), 75.

6. On Allegrain, see S. Lami, *Dictionnaire des sculpteurs de l'école française au XVIII^e siècle* (Paris, 1910–11), I, 22–5.

7. In an undated letter of *c.*1755: Furcy-Raynaud, *op. cit.* (Chapter 1, Note 70), 31.

8. The circumstances of the monument's state at the time are revealed by d'Angiviller's letter of 12 August 1777 to Pierre, *N.A.A.F.* (1906), 132.

9. The archbishop of Sens had been his tutor.

10. *Projets de tombeau*: cited by E. F. S. Dilke, 'Les Coustou', *G.B.A.* (1901), I, 210, note 3. For Guillaume Coustou II, see now the contribution by F. Souchal to *Thèmes et figures du Siècle des lumières, Mélanges offerts à Roland Mortier* (Geneva, 1980).

11. Nevertheless, there seem some clear hints towards it to be found in the urn and mourning figures which form part of the Slodtz' design for the *pompe funèbre* at the death of another dauphine, Marie-Thérèse d'Espagne, in 1746 (engraved by Cochin and here illustration 113).

12. *Diderot Salons*, I, 137.

13. Vassé is discussed by L. Réau in *G.B.A.* (1930), 31 ff. The elder Vassé was essentially a decorator, employed on a wide variety of tasks; see further Souchal, *op. cit.* (Chapter 2, Note 10), III (1987), 402–42, inclusive of the inventory of sculpture in his studio at his death.

14. See for example V. Sloman, 'Nogle Medailler og Plaketter efter Saly', in *Kunstmuseets Aarsskrift*, XVI–XVIII (1931), 199 ff.; a portrait of Saly by Juel is reproduced by J. Rubow in *Kunstmuseets Aarsskrift*, XXXIX–XLII (1956), 100. For the Frederick V statue, see H. Friis in *Artes* (Copenhagen), I (1932), 191 ff.

15. The identity of the sitter is discussed by M. Levey in *Burl. Mag.*, CVII (1965), 91.

16. Further cf. L. Réau, 'Le Faune au chevreau de Saly', in *B.S.H.A.F.* (1924), 6 ff.

17. It should perhaps be recalled that the Amalienborg was intended to be not a royal palace but houses for noblemen; it is a piece of urban planning comparable to the Praça do Comercio in Lisbon or the Place de la Concorde in Paris. For this edition the ground at Copenhagen has been trodden again, and what was said previously of Saly's equestrian statue somewhat modified favourably as a result.

18. Letter of 17 March 1766: Y. Benot, *Diderot et Falconet, le Pour et le Contre* (Paris, 1958), 156.

19. Marie-Anne Collot, though edged out here, was a talented portrait sculptor; in addition to her *Falconet*, she worked on the *Peter the Great* head for the equestrian statue. Her work and career are discussed by L. Réau in *B.S.H.A.F.* (1924), 219 ff. See also H. N. Opperman, 'Marie-Anne Collot in Russia: Two Portraits', in *Burl. Mag.*, CVII (1965), 408 ff.

20. The fact is mentioned by Réau in publishing part of Falconet's inventory at death in *B.S.H.A.F.* (1918/19), 164.

21. Cited by Réau, *op. cit.* (Note 5), I, 211,

22. The myth is interestingly discussed by J. L. Carr, 'Pygmalion and the *Philosophes*', in *J.W.C.I.*, XXIII (1960), 239 ff.

23. *Diderot Salons*, I, 245.

24. Given Falconet's distinct admiration for Rubens (for some of his favourable comments on whom see A. B. Weinshenker, *Falconet: His Writings and his Friend Diderot* (Geneva, 1966), 15–16, 85, 108), it is possible that he may have drawn some general inspiration from Rubens–Van Dyck compositions of the subject (e.g. Vienna and London); Falconet showed a good deal of awareness of works of art he had not actually seen – not hestitating to criticize them.

25. Weinshenker, *op. cit.*, 6, seems wrong in claiming that 'many artists tried to obtain the commission'. Several set estimates so high as to amount to refusals: Pajou, 600,000 Livres; Coustou, 450,000; etc. Catherine was offering only 300,000: see F. Vallon, *Falconet: Falconet et Diderot, Falconet et Cathérine II* (Senlis, 1927), 88. For comparison it may be worth noting that Pigalle was finally paid 98,184 Livres for the Saxe monument.

26. Letter from Falconet to Marigny, quoted by Réau, *op. cit.* (Note 5), I, 79.

27. Benot, *op. cit.* (Note 18), 157.

28. Quoted by Réau, *op. cit.*, II, 360.

29. In this connection it is perhaps worth referring to an evocative photograph of the monument in winter, reproduced in G. Levitine, *The Sculpture of Falconet* (Greenwich, Conn., 1972), figure 103.

30. *Œuvres d'Étienne Falconet, Statuaire: contenant plusieurs Écrits relatifs aux Beaux Arts, dont quelques-uns ont déjà paru, mais fautifs: d'autres sont nouveaux* (Lausanne, 1781).

31. It is discussed and more favourably judged by M. Charageat in *La Revue des Arts* (1953), 217 ff.

32. L. Réau, *J. B. Pigalle* (Paris, 1950), plate 15.

33. *Ibid.*, plate 23.

34. See M. Levey in *Burl. Mag.* CVI (1964), 462–3.

35. For an interesting discussion of Pigalle's work for Madame de Pompadour, see K. K. Gordon in *The Art Bulletin*, L. (1968), 249 ff.

36. The point already published by Patte, *Monumens érigés en France* (Paris, 1765): there are no slaves at the feet of this monarch, 'dont l'humanité est l'âme de tous les actions'; 174–5.

37. 'Correspondance de M. de Marigny', *N.A.A.F.*, XIX (1904), 34; the fullest documentation of the protracted arrangements from 1751 to 1777 in Furcy-Raynaud, *op. cit.* (Chapter 1, Note 70), 272 ff.

38. In fact, immortality is symbolized by the pyramid against which the drama takes place, but that is as much a profane as Christian symbol; and even so, the visual effect is such that one concentrates on the action, taking little notice of the background pyramid. What is noticeably lacking is any religious imagery as such.

39. *Op. cit.* (Note 36), 16.

40. On whom see for instance L. Réau, *Les Sculpteurs français en Italie* (Paris, 1945), 88–9, with further references.

41. On the family, see J. Guiffrey, *Les Caffiéri* (Paris, 1887).

42. The portrait (signed and dated 1785) is now at Boston.

43. Terray succeeded Marigny (Ménars) in July 1773 and was replaced by d'Angiviller in August 1774. For the whole series cf. the exemplary discussion in T. Hodgkinson, *The James A. de Rothschild Collection at Waddesdon Manor: Sculpture* (Fribourg, 1970), 16–19.

44. Further for Tassaert, cf. L. Réau in *Revue Belge d'Archéologie et d'Histoire de l'Art*, IV (1934), 289 ff.

45. Letter of 14 March 1776: *Correspondance de M. d'Angiviller*, cited by Furcy-Raynaud, *op. cit.*, 400.

46. Some discussion of him by L. Réau in *G.B.A.* (1931), I, 349 ff.

47. Further for this bust see the catalogue of the exhibition *Huit siècles de sculpture française, Chefs d'œuvre des musées de France*, Paris, Louvre, 1964, no. 81.

48. Reproduced by H. Stein, *Augustin Pajou* (Paris, 1912), 389.

49. An interesting biography, 'Notice inédite et historique sur la vie et les ouvrages de M. Augustin Pajou', in *Le Pausanias français* (Paris, 1806), 462 ff.

50. His drawings, particularly those at Princeton, are studied by M. Benisovich in *The Art Bulletin*, XXXV (1953), 295 ff., and *Record of the Art Museum, Princeton University*, XIV (1955), 9 ff.

51. The relief appears prominently in Roslin's portrait of *General Ivan Betskoi* (signed and dated 1758), which was in the Count Thure Bonde sale, Sotheby, 25 November 1970 (lot 83).

52. The bronze is in the Louvre; a terracotta in the Musée de Nantes.

53. Pajou's remarks to d'Angiviller on the Psyche (letter of February 1783) in Stein, *op. cit.*, 350.

CHAPTER 4

1. Apart from Marigny's official correspondence, which sometimes includes orders for Madame de Pompadour, a good deal can still be learnt about brother and sister from E. Campardon, *Madame de Pompadour et la cour de Louis XV* (Paris, 1867); see also J. Nicolle, *Madame de Pompadour et la société de son temps* (Paris, 1980), and for Marigny E. Plantet, *La Collection de statues du Marquis de Marigny* (Paris, 1885), which provides a biography. The mood of these years is well set by the note at the front of the Salon *livret* for 1755 (by Cochin?), saying how happy the arts are when honoured by the 'puissante protection d'un monarque ... dirigés avec lumière et que les graces (sources de l'émulation) sont dispensées avec un choix judicieux'.

2. The painting in the Musée Arbaud, Aix-en-Provence; the drawing in the Louvre, cf. *Dessins français du XVIII^e siècle* (Paris, 1967), no. 45, with full discussion.

3. L. Courajod, *L'École royale des élèves protégés* (Paris, 1874), 32, for the appointment of Van Loo. Courajod prints the statutes of the École, 18 ff.

4. For the theme, see T. E. Crow, *Painters and Public Life in Eighteenth-Century Paris* (New Haven–London, 1985) in general but especially chapters III–IV, 'The Salon and the Street' and 'Whose Salon?', 79–133; for La Font de Saint-Yenne (text further below), *passim* and particularly 123–7.

5. Other pictures for the chapel, exhibited in the same year, included 'St Louis carrying the Crown of Thorns' by Hallé; 'The Interview between St Louis and Pope Innocent IV' by Lagrenée; 'The Last Communion of St Louis' by Doyen, for the high altar; and 'St Louis administering Justice under an Oak Tree' by Lépicié.

6. *Abécédario*, I, 165–6.

7. Some pioneering discussion of his early work, and influences on it, by H. Voss in *Burl. Mag.*, XCV (1953), 81 ff., XCVI (1954), 206 ff. Some fresh light on Boucher's early years was provided by the Boucher exhibition, New York–Detroit–Paris, 1986–7, including a 'Moses and the Burning Bush' (no. 14) presumably done in Paris soon after his return from Italy. For discussion of his early activity see P. Rosenberg in the catalogue (French ed.), 47–61.

8. A fine Berchem (1005) owned by Boucher is now in the National Gallery, London.

9. The subject is not totally relevant here, but see particularly, for emphasis on the French connections, A. Griseri in *Paragone*, XII (1961), 42 ff.: 'Il Rococó a Torino e Giovan Battista Crosato'.

10. See J.-P. Babelon, *Les Archives nationales, Notice sur les bâtiments* (Paris, 1958), *passim*.

11. Boucher's work for the Crown (that is, Louis XV, Marie Leczinska, and Marigny in his official capacity) is documented in F. Engerand, *Inventaire des tableaux commandés et achetés par la Direction des Bâtiments du Roi (1709–1792)* (Paris, 1900), 39 ff.

12. A previous supposition that these pictures showed traces of under-painting in grisaille, mentioned in the earlier edition of this volume and originating in a Wallace Collection catalogue, is disposed of by J. Ingamells, *The Wallace Collection; Catalogue of Pictures*, III, *French Seventeenth and Eighteenth Century* (1989), 68.

13. G. Duplessis, *Mémoires et journal de J.-G. Wille* (Paris, 1857), I, 470; Boucher's treasure house of possessions may best be appreciated from this posthumous sale catalogue, Paris, 18 February ff. 1771: 'Catalogue raisonné des Tableaux, Dessins, Estampes, Bronzes, Terres cuites, Laques, Porcelaines de différentes sortes ... Meubles curieux, Bijoux, Minéraux, Cristallisations, Madrepores, Coquilles et Autres Curiosités ...'.

14. The reference, comparing Boucher's work to 'cette fade poésie galante de Dorat', quoted by P. de Nolhac, *Boucher* (Paris, 1925), 197.

15. Pierre-Antoine Baudoin (1723–69) painted only gouaches. He is not remembered for his *Life of the Virgin* illustrations, or those for the Epistles and Gospels, but for much-engraved compositions like *L'Épouse indiscrète* and *Le Carquois épuisé*, treated as if by Saint-Aubin sharing the obsessions of Fragonard. 'Petit genre lascif ...' was the priggish verdict on his work in Grimm's *Correspondance littéraire* (15 June 1770), remarking of the dead artist, 'épuisé par le travail et les plaisirs': cited by Lady Dilke, *French Painters of the XVIIIth Century* (London, 1899), 131, note 4.

16. Nougaret, *Anecdotes des Beaux-Arts* (Paris, 1776), II, 227.

17. This is not merely a modern judgement. Although Marmontel is sometimes instanced as an example of superior literary attitudes to practitioners of the visual arts, his comments on Van Loo are pointedly apt: 'l'inspiration lui manquait, et pour y suppléer il avait peu fait de ces études qui élèvent l'âme, et qui remplissent l'imagination de grands objets et de grandes pensées': *Mémoires de Marmontel* (Paris, 1878), 235.

18. The family background, but chiefly Carle himself, dealt with by L. Réau in *A.A.F.* (1938), 9 ff. See now also the exhibition catalogue by M.-C. Sahut, *Carle Vanloo*, Nice–Clermont-Ferrand–Nancy, 1977.

19. The picture, along with preparatory drawings, is studied by F. H. Dowley in *Master Drawings*, V (1967), 42–7.

20. P. Rosenberg in catalogue of the exhibition *The Age of Louis XV, French Painting 1715–1774*, Toledo–Chicago–Ottawa, 1975–6, 1977.

21. At the Salon of 1750 Van Loo exhibited what may be presumed to be a sub-Boucher style 'Tableau de Paysage orné de Figures et d'Animaux; il a 8 pieds de large sur 3 et demi de haut'.

22. The engraving by Mechel of this composition is reproduced in *Diderot Salons*, I, plate 25.

23. Further for Natoire, see the catalogue raisonné by F. Boyer in *B.S.H.A.F.*, XXI (1949), 31 ff., and M. Sérullaz, 'Recherches sur quelques dessins de Charles Natoire', in *Revue des Arts* (1959), 65 ff. Further see I. Julia *et al.*, catalogue of the exhibition *Charles-Joseph Natoire*, Nîmes–Rome, 1977.

250. 24. For virtually a monograph on Trémolières, see the catalogue of the exhibition of P. Rosenberg, J. F. Méjanès, and J. Vilain, *J.P.C. Trémolières (Cholet, 1703–Paris, 1739)*, Cholet, 1973. For Subleyras, P. Rosenberg and O. Michel, catalogue of the exhibition *Subleyras 1699–1749*, Paris–Rome, 1987.

25. Cf. pp. 278–9.

26. For Pierre see further J. Locquin, *La Peinture d'histoire en France de 1747 à 1785* (Paris, 1912), *passim*, and 184–7 especially.

27. Salon of 1748; attention first focused on this picture in the catalogue by J. Dupont and J. Litzelmann of the exhibition *Peintures méconnues des églises de Paris*, Paris, 1946.

28. See Note 10 to Chapter 1.

29. Vien's extraordinary *Mémoire* (of 22 nivôse, An III) is published by G. Vautier in *B.S.H.A.F.* (1915–17), 124 ff. The highest tributes to Vien come, significantly, from the end of his career – e.g. P. Chaussard's *Le Pausanias français* (1806), 39 ff.

30. Locquin, *op. cit.*, 191–3. The arrival of Vien on the artistic scene was warmly welcomed, cf., for example, *Jugement d'un amateur sur l'exposition des tableaux* (Paris, 1753), 53: 'il y a un M. Vien très jeune encore qui donne les plus belles espérances ...'. La Font, *Sentimens ...* (Paris, 1754), 46 ff., was no less complimentary.

31. *Diderot Salons*, I, 119.

32. The evidence is on one of Blarenberghe's miniatures showing the interior of the Hôtel Crozat de Châtel, absorbingly discussed by F. J. B. Watson, *The Choiseul Box* (Charlton Lecture on Art) (London, 1963).

33. *Mémoires inédits*, II, 351.

34. P. de Nolhac, *Nattier* (Paris, 1925), 145.

35. *Ibid.*, 219.

36. Madame Roslin, née Marie-Suzanne Giroust (1734–72), also deserves a mention. She married Roslin in 1759, was active as a portraitist in pastel, and was received at the Académie in 1770, presenting her highly accomplished portrait of Pigalle (Louvre), which was shown at the Salon the following year and praised by Diderot.

37. Cited by G. Wildenstein, *Le Peintre Aved* (Paris, 1922), I, 86–7.

38. Further for this portrait and some others by Nonnotte, see the catalogue of the exhibition *Paris et les ateliers provinciaux au XVIIIᵉ siècle*, Bordeaux, 1958. For what follows in the text here about Colson, see the catalogue by P. Quarré *et al.* of the exhibition *Trois peintres bourguignons du XVIIIème siècle. Colson, Vestier, Trinquesse*, Dijon, 1969; *Le repos* is included in the exhibition organized by Rosenberg (cited above, Note 20), no. 17.

39. Further for her see J. Billiou in *G.B.A.*, XX (1938), 173–84; for the *Seated Woman*, Rosenberg, *op. cit.*, no. 32.

40. The family is discussed in C. Gabillot, *Les trois Drouais* (Paris, 1906). For some portraits by F.-H. Drouais of children dressed as Savoyards, see E. Munhall, 'Savoyards in French Eighteenth-Century Art', *Apollo* (February 1968), 86 ff.

41. 'Le plus beau paysage fût il du Titien et du Carrache ne nous émeut pas plus que le ferait la vue d'un canton de pays affreux ou riant: il n'est rien dans un pareil tableau qui nous entretienne, pour ainsi dire': *Réflexions sur la poésie et sur la peinture* (Paris, 1733 ed.), I, 52. Such opinions are the very opposite of Diderot's – in the middle of a once presumed prosaic age – but not perhaps so very far from Baudelaire's, whose reserves on the category of landscape are made plain in his review of the Salon of 1859.

42. Marigny's letter of 9 October 1756 is printed by L. Lagrange and A. de Montaiglon in *A.A.F.*, VII (1855–6), 123; see now the catalogue by P. Conisbee of the exhibition *Claude-Joseph Vernet 1714–1789*, Kenwood, 1976, unpaginated but under no. 75, and *Joseph Vernet*, Paris, 1976–7, 78–9 (no. 43).

43. For the picture and critical reaction in detail, see Conisbee, *op. cit.*, Kenwood (no. 37); Paris, 86–8 (no. 49).

44. Further for Volaire, see J. Foucart in the catalogue of the exhibition *De David à Delacroix*, Paris–Detroit–New York, 1974–5 (French ed.), 666–9; illustration 211 is no. 118 of Rosenberg, *op. cit.* (Note 20).

45. See the catalogue by P. Quarré of the exhibition *Un Paysagiste dijonnais du XVIIIème siècle, J.-B. Lallemand, 1716–1803*, Dijon, 1954.

46. See the catalogue by R. Joppien, *Philippe-Jacques de Loutherbourg*, Kenwood, 1973. As a footnote to a footnote, Simon-Mathurin Lantara (1729–78) deserves mention as more than just a follower of Vernet. Little is known of his early life. Two of his drawings were owned by Boucher (1771 sale, lot 1858); for his 'legend' as a bohemian artist, see G. Levitine, *G.B.A.* (September 1975), 49 ff.

47. Attention drawn to this in G. Wildenstein, *Chardin* (Paris, 1933), 138–9; in fact, d'Angiviller considerably softened the hard tone of Pierre's draft at this point. See the exchange of letters set out in full in the biography contributed by S. Savina to the catalogue by P. Rosenberg of the exhibition *Chardin*, Paris–Cleveland–Boston, 1979 (French ed.), 404–5. On the painter and his period, see especially E. Snoep-Reitsma, 'Chardin and the Bourgeois Ideals of his Time', in *Nederlands Kunsthistorisch Jaarboek*, XXIV (1973), 147–243.

48. Cf. p. 52.

49. Cf. p. 49.

50. The artistic affinity between Rembrandt's *Flayed Ox* and Chardin's work is touched on by C. Sterling, *Still-Life Painting* (Paris, 1959), 88.

51. Notably in sales by Andrew Hay and Geminiani, London, where between

1738 and 1743 are to be found such subjects as *A Girl with Cherries, A Boy at his Drawing, A Girl at Needlework, A Woman with a Frying Pan, Savoyards Dancing, A Boy playing with a Totum*, and *Dead Game*. See also D. Carritt, 'Mr Fauquier's Chardins', *Burl. Mag.*, CXVI (1974), 502–9.

52. Reported by Haillet de Couronne, whose *Éloge*, based on recollections by Cochin, was read to the Académie in 1780: *Mémoires inédits*, II, 441.

53. Several of these, in the collection of Earl Beauchamp, were lent to the R.A. exhibition, *France in the Eighteenth Century* (1968), nos. 345–9.

54. For Leprince in this context, see the catalogue of the exhibition *La France et la Russie au Siècle des Lumières*, Paris, 1986–7.

55. Catalogue raisonné in the posthumous article of P.-G. Dreyfus, *B.S.H.A.F.* (1922), 139 ff.

56. The previous lack of a monograph has been supplied by that of A. Brookner (1972), see Bibliography, and the catalogue by E. Munhall of the exhibition *Jean-Baptiste Greuze, 1725–1805*, Hartford, 1976–7 (subsequently San Francisco and Dijon). Earlier articles by both writers are relevant: A. Brookner in *Burl. Mag.*, XCVIII (1956), 157 ff., 192 ff.; E. Munhall, 'Greuze and the Protestant Spirit', *Art Quarterly* (1964), 3 ff., and *idem*, 'Quelques Découvertes sur l'œuvre de Greuze', *Revue du Louvre* (1966), 85 ff.; see also W. Sauerländer, 'Pathosfiguren im Œuvre des Jean-Baptiste Greuze', *Festschrift W. Friedlaender* (Berlin, 1965), 146–50, and Crow, *op. cit.* (Note 4), Chapter V, 'Greuze and Official Art', 134–74.

57. See pp. 185–6.

58. See *The Diary of Joseph Farington*, V (New Haven and London, 1979), ed. K. Garlick and A. Macintyre, 1878; Farington does, however, add that Greuze looked healthy.

59. Cf. pp. 33–4.

60. See further particularly E. Munhall, 'Les Dessins de Greuze pour Septime Sévère', *L'Œil* (April 1965), 23 ff., and J. Seznec, 'Diderot et l'affaire Greuze', *G.B.A.* (1966), I, 339 ff.

61. See R. Rosenblum, *Ingres* (New York, n.d.), 60, where the Greuze portrait is reproduced. In fact, the head in that portrait seems based on a bust length by Greuze of Napoleon as captain in an artillery regiment, of presumably autumn 1792; see further Munhall, *op. cit.* (Note 56, 1976–7), 215 (no. 109).

62. For Noël and earlier generations of the family, see O. Estournet, *La Famille des Hallé* (Paris, 1905).

63. Locquin, *op. cit.* (Note 26), *passim*. Doyen's pre-Russian work studied by M. Sandoz in *B.S.H.A.F., 1959* (1960), 75 ff., but see now his monograph on the painter (1975) in the Bibliography.

64. For his activities then see H. Stein, 'Le Peintre Doyen et l'origine du Musée des Monuments français', in *Réunion des Sociétés des Beaux-Arts* (1888), 238 ff.

65. Aspects of Lagrenée studied by M. Sandoz, 'Paintings by Lagrenée the Elder at Stourhead', *Burl. Mag.*, CIII (1961), 392–5, and *B.S.H.A.F. 1962* (1963), 115–36; for him as draughtsman, M. Sandoz in *The Art Quarterly* (1963), 47 ff.

66. Deshays as history painter studied by M. Sandoz in *B.S.H.A.F. 1958* (1959), 7 ff.; see now the same author's monograph (1978) in the Bibliography.

67. Brenet is studied by M. Sandoz in *B.S.H.A.F. 1960* (1961), 115–36; for the same author's monograph (1979), see Bibliography.

68. See further on this point p. 265.

69. Bayard was also the subject of a statue for the 'grands hommes' series, commissioned from Bridan in 1785, finished only post 1789 and signed by the sculptor as 'Citoyen Français'; Furcy-Raynaud, *op. cit.* (Chapter 1, Note 70), 66–73. Du Guesclin was similarly commissioned from Foucou in 1788.

70. See p. 153.

71. Cited by Crow, *op. cit.* (Note 4), 191.

CHAPTER 5

1. He has also been dealt with by F. Novotny in the Pelican History of Art volume *Painting and Sculpture in Europe: 1780–1880*, 2nd (paperback) ed. (Harmondsworth, 1971), 377–9.

2. This point must be borne in mind by those who wish to deny, for example, any political awareness in David before 1789. In the summer of 1787 Arthur Young (*Travels in France and Italy . . .* (London, 1927 ed.), 80) found at a Parisian dinner-party that 'One opinion pervaded the whole company, that they are on the eve of some great revolution in the government . . . a strong ferment amongst all ranks of men, who are eager for some change: and a strong leaven of liberty, increasing every hour since the American revolution.'

3. For Dumont's *Liberty*, see S. Lami, *Dictionnaire des sculpteurs de l'école française au XVIII^e siècle* (Paris, 1910–11), I, 303.

4. On which see L. Roger-Milès, *Les Dianes de Houdon et les caprices de la pudeur esthétique à la fin du XVIII^e siècle* (Paris, 1913).

5. *Diderot Salons*, III, 318.

6. It is discussed at length by F. H. Dowley in *The Art Bulletin*, XXXIX (1957), 259 ff.

7. It and a terracotta maquette reproduced by L. Réau, *Houdon, sa vie et son œuvre* (Paris, 1964), II, plates 34A and B.

8. D'Angiviller's letter to Pierre (of 5 October 1779) in *N.A.A.F.*, XXI (1906), 265.

9. H. Thirion, *Les Adam et Clodion* (Paris, 1885), 241, 243, 387, for what follows about early collectors of Clodion's work (the date of Boucher's posthumous sale is given wrongly). But Thirion's comments are now superceded by the mass of facts set out by A. L. Poulet and G. Sherf in the fundamental exhibition catalogue, *Clodion* (Paris, 1992).

10. Roman terracottas were purchased for Charles Townley by Nollekens, and brought back to England in 1770: M. Whinney, *Sculpture in Britain: 1530–1830 (Pelican History of Art)*, 2nd ed., rev. John Physick (London, 1988), 288.

11. Thirion, *op. cit.*, 388.

12. The brothers were Sigisbert-François (1728–1811), Sigisbert-Martial (1727–after 1785), Nicolas (b. 1733), and Pierre-Joseph (b. 1737). The considerable problems of connoisseurship connected with work signed 'Clodion' long awaited investigation. They are admirably dealt with by G. Sherf in *Revue de l'art* (91), 1991, 47–59.

13. A relief, signed and dated 'CLODION in Carare 1773', is published in an article, with new letters, by A. Griseri in *The Connoisseur* (April 1961), 164 ff.; a relief related in style and subject (signed and dated 1776) is now in the Fitzwilliam Museum, Cambridge.

14. 'On l'a félicité de ne s'être point asservi au costume, et je crois, au contraire, un reproche qu'on peut lui faire, parcequ'il n'est pas question de draper la statue d'un Français du XVIII^e à la grecque, à la romaine, ou de lui donner un costume idéal, mais de la représenter avec le costume de la nation et du temps où il a vécu'; *L'Année littéraire* (1779), cited by Thirion, *op. cit.*, 311.

15. Further for these two modelli see P. Remington in *Metropolitan Museum of Art Bulletin*, N.S. II (1943–4), 241 ff.; for the proposed scheme and competition Furcy-Raynaud, *op. cit.* (Chapter 1, Note 70), 417 ff.

16. *Tableaux de la Révolution* (1793), cited by Thirion, *op. cit.*, 346.

17. Cf. the attitude of *Le Pausanias français* (1806), 488, speaking of Clodion's contribution to the Salon of that year: 'dans un âge où l'on ne change guère de manière, a cherché à s'élever jusqu'au style sévère qui s'est introduit dans l'École.'

18. Published by M. Beaulieu, 'Terres cuites de Clodion', in *Revue du Louvre* (1961), 95–6.

19. If one recalls that Falconet's *Milo* was criticized at the Académie for supposedly being plagiarized from Puget's very different group, it is by no means unlikely that an implication of plagiarism was made against Julien – and, on the face of it, more reasonably – in connection with Coustou's *Ganymede*.

20. The comment on Julien's *Gladiator* by the Continuateur de Bachaumont is recorded by A. Pascal in *G.B.A.* (1903), I, 333.

21. Considerably more effective, and somewhat less disconcerting in its environment, than photographs usually suggest, Bridan began the *Assumption of the Virgin* group in Italy in 1768 (L. Réau, *Les Sculpteurs français à Rome* (Paris, 1945), 86, gives, by a printing error, 1708) and in a memorandum of *c.* 1797 (printed by Furcy-Raynaud, *op. cit.*, 68–9) claims that he was commissioned by the Chapter of Chartres that year. The cathedral at Chartres provides a link between Bridan and his near-contemporary Pierre-François Berruer (1733–97), by whom are two signed reliefs there. Berruer executed *D'Aguesseau* (Salon of 1779) in the 'grands hommes' series; he was also the sculptor of the model (Salon of 1785) of an interesting-sounding cenotaph in honour of those who fell in the American war: 'Patriotism uncovers the monument of their glory . . . and shows that these brave officers died for the freedom of America who, filled with gratitude, holding the emblem of liberty, gives them crowns and the order of Cincinnatus.' Not the least interesting aspect of this is the date at which it was shown, for it is most probable that the American Revolution played its part, even artistically, in stimulating a new sense of French patriotism. In 1784 the Toulouse painter Suau gained first prize at the Academy there with a glorification of *American Independence*: J. Locquin, *La Peinture d'histoire en France de 1747 à 1785* (Paris, 1912), 282.

22. The whole scheme is discusssed by J. Langner in *Art de France* (1963), 171 ff.

23. Some discussion of Mouchy in L. Réau, *J. B. Pigalle* (Paris, 1950), 133–4.

24. Further for the statue and the correspondence concerning it, cf. Furcy-Raynaud, *op. cit.*, 232–4. Cochin's comment on it cited by Réau, *op. cit.* (Note 23), 134.

25. For Boizot see Lami, *op. cit.* (Chapter 3, Note 6), I, 85 ff.

26. See the quotation from this *Éloge* in *Dessins de sculpteurs de Pajou à Rodin*, exhibition catalogue, Paris, Louvre, 1964, 13; further for Moitte's activity, see H. Thirion, *Le Palais de la Légion d'Honneur* (Versailles, 1883), 83 ff.

27. Furcy-Raynaud, *op. cit.*, 409.

28. Chaudet remains an under-studied figure (the days being gone when there was a Salle de Chaudet at the Louvre); Chinard has been the subject of several articles by M. Rocher-Jauneau, including a convenient general introduction to

his work in *Apollo* (September 1964), 220 ff.

29. For it see the entry by G. H(ubert) in the catalogue of the exhibition *The Age of Neo-Classicism*, Royal Academy and Victoria and Albert Museum, London, 1972, 221–2 (no. 341).

30. Noticed and praised, along with the model of Moitte's *Cassini*, and Julien's of *Poussin* (i.e. work by established men), in the *Journal de Paris* (supplement for 16 November 1789).

31. P. Vitry, 'Un Album des dessins du sculpteur Chaudet', *B.S.H.A.F.* (1924), 27, though this is hardly more than a mention of the album's existence; see further *Dessins de sculpteurs . . .* (1964), no. 4.

32. According to P. Vitry, *La Sculpture française classique* (Paris, 1934), 110, this is the work of P. Cartellier (1757–1831).

33. Numerous replicas exist; this finished marble version was given by the sitter to her father. For literature and the version in the Museum of Art, Rhode Island School of Design, see G. Hubert, *op. cit.* (Note 29), 225 (no. 346).

34. Reproduced by Rocher-Jauneau, *op. cit.*, figure 1.

35. Quoted by J. C. Herold, *Mistress to an Age* (London, 1959), 284.

36. For that bust see the catalogue of the exhibition *Huit siècles de sculpture française, Chefs d'œuvre des musées de France*, Paris, 1964, no. 87.

37. L. Réau, *Houdon, sa vie et son œuvre* (Paris, 1964), I, 230.

38. Reappraisal of this statue on the spot inclines me to modify this judgement somewhat. Although what is said in the text seems true to the frontal view of the figure, when seen from the side – as first approached – there is a vivid 'disturbed' quality about the draperies which would probably be still more apparent if the statue did not stand in a niche.

39. L. Réau, *Houdon* (Paris, 1930), 23.

40. Réau, *op. cit.* (Note 37), I, 180.

41. There is a passing, previously unremarked English reference to him as 'Heudone' in Desenfans' preface to his sale, London, 8 April ff. 1786, viii: 'A famous sculptor sent by the King of *France* last year to America to make the statue of General *Washington*.'

42. Her letter to Grimm, quoted by Réau, *op. cit.* (Note 37), I, 230.

CHAPTER 6

1. *Souvenirs de Madame Vigée Le Brun* (Paris, n.d. [1891]), I, 50.

2. See further M. Jallut, *Marie-Antoinette and her Painters* (Paris, n.d. but c. 1960?).

3. It may be pertinent to quote a scholar who has very closely studied the period in France: 'In terms of quantity alone, in fact, there is enough Rubensian and Rococo survival, or revival, in classical history painting of the late eighteenth century to warrant considerable modification of prevailing ideas about the hegemony of Neoclassic style at the time': R. Rosenblum, *Transformations in Late Eighteenth Century Art* (Princeton, 1967), 54, note 13.

4. *L'Année littéraire* (Paris, 1777), VI, 313–14.

5. Cf. pp. 178–81.

6. *Correspondance des Directeurs* (letter of 27 August), XI, 354.

355. 7. For the change from Fragonard to Vien, suggesting that new classicizing tastes lay behind Madame du Barry's change, cf. F. M. Biebel in *G.B.A.* (July–December 1960), 207 ff.; also the discussion in *The Frick Collection, Illustrated Catalogue: The Paintings* (New York, 1968), II, 94 ff.; for the iconography cf. W. Sauerländer in Munich *Jahrbuch* (1968), 127 ff., and D. Posner in *Burl. Mag.*, CXIV (1972), 526–34.

8. It has therefore been avoided here; but those who still suspect that the eighteenth century was indifferent to the charms of 'nature' should begin with Linnaeus; a remarkable passage of his, dating from 1732, is accessibly quoted by P. Hazard, *European Thought in the Eighteenth Century* (Harmondsworth, 1965), 378. The topic is obviously a wide one, only partly relevant here, but it is worth citing D. G. Charlton, *New Images of the Natural in France* (Cambridge, 1984), which is concerned largely with the later eighteenth century.

9. It may be compared, as a likeness, with Houdon's busts of Gluck which originate with a plaster bust (destroyed), shown at the same Salon of 1775. Gluck's interest in the painting is documented by his letters; cf. H. and E. H. Müller von Asow (eds.), *Collected Correspondence and Papers of Christoph Willibald Gluck* (London, 1962), 61, 71, 195, 202.

10. For Duplessis' portrait of d'Angiviller see *France in the Eighteenth Century*, exhibition catalogue, London, Royal Academy, 1968, no. 212. For a full biography of the sitter, see J. Silvestre de Sacy, *Le Comte d'Angiviller, dernier directeur des bâtiments du roi* (Paris, 1953); *ibid.*, 49 ff., for his directorship.

11. See R. Portalis in *G.B.A.*, XXVI (1901), 354. There is now a modern monograph (1973) by A.-M. Passez; see Bibliography.

12. But Vigée-Le Brun has been championed in a scholarly way by the work of J. Baillio; see his catalogue of the exhibition *Elizabeth Louise Vigée Le Brun*, Fort Worth, 1982.

13. See J. Cailleux in *L'Art du dix-huitième siècle*, supplement to *Burl. Mag.*, CXI (March 1969).

14. Cited by Jallut, *op. cit.* (Note 2), 54.

15. For these exchanges of letters, see *N.A.A.F.*, XXII (1907), 205–6, 225–6.

16. Further see F. Ingersoll-Smouse, 'Quelques tableaux de genre inédits par Étienne Aubry', in *G.B.A.* (1925), I, 77 ff., and C. Duncan, 'Happy Mothers and Other New Ideas in French Art', *The Art Bulletin* (1973), iv, 270–83.

17. See H. Bardon, 'Les Peintures à sujets antiques au XVIIIᵉ siècle d'après les livrets de Salons', *G.B.A.* (April 1963), 217–50.

18. In a letter of 1787 from Cochin to d'Angiviller, Suvée, Peyron, and Vincent are claimed as the best after David: J. J. Guiffrey, *Notes et documents inédits sur les expositions du XVIIIᵉ siècle* (Paris, 1873), 97.

19. Further for Suvée see the catalogue by D. Coeckelberghs of the exhibition *Les Peintres belges à Rome de 1700 à 1830*, Brussels–Rome, 1976, 214–24.

20. See P. Rosenberg in the catalogue (French edition) of the exhibition *De David à Delacroix*, Paris–Detroit–New York, 1974–5, pp. 555–60 (Peyron's *Death of Seneca* is lost), and now the monograph (1983) by P. Rosenberg and U. van de Sandt (Bibliography).

21. Guiffrey, *op. cit.* (Note 18), 85; the letter can be seen as something of a snub, as Cochin had said how obvious it was that David's picture was the better one.

22. The text here is indebted to the discussion in T. E. Crow, *Painters and Public Life in Eighteenth-Century Paris* (New Haven–London, 1985), especially 241–5.

23. Molé was to reappear in the series of 'grands hommes' statues, though shown seated and undramatic; the commission went to Étienne Gois (1731–1823), a Parisian pupil of Slodtz (plaster model at the Salon of 1785). Gois received several other official commissions, including a bust of Louis XVI. Gois had earlier (1776–7) executed a standing figure in the 'grands hommes' series of the Chancelier de l'Hôpital, conceived as 'exilé dans son château, apprenant par ses domestiques que ses ennemis venaient pour l'assassiner' and having the doors opened to receive them. In writing to the widow of a descendant of the Chancelier, d'Angiviller described Gois as 'un de nos artistes les plus distingués': Furcy-Raynaud, *op. cit.* (Chapter 1, Note 70), 153 ff.

24. For Vincent, see particularly J. P. Cuzin in the catalogue of the exhibition *De David à Delacroix*, Paris–Detroit–New York, 1974–5 (French ed.), 661–6.

25. For Ménageot see the monograph (1978) by N. Willk-Brocard (Bibliography).

26. For Regnault's *Descent from the Cross* further see J. P. Cuzin, *op. cit.* (Note 24), no. 148.

27. Thus F. Novotny, *Painting and Sculpture in Europe 1780–1880* (*Pelican History of Art*) (Harmondsworth, 1971 ed.), 28.

28. For Drouais' *Marius* further see Jacques Vilain in *op. cit.* (Note 24), no. 52.

29. The reports of the Académie on inspecting David's work sent back from Italy are published in *A.A.F.*, I (1852), 339 ff.

30. In August 1763 the French chargé d'affaires at Rome sent back to Paris fairly detailed reports, for publication in the *Gazette littéraire*, of two pictures just finished by Hamilton, *Achilles dragging Hector's Body round the Walls of Troy* and *The Death of Lucretia*. Of the former he reported 'Ce tableau excite également des mouvemens d'horreur et de compassion'. See *Correspondance des Directeurs*, XI (1901), 475.

31. *Diderot Salons*, IV, 377–8.

32. See F. Hamilton Hazlehurst, 'The Artistic Evolution of David's Oath', in *The Art Bulletin*, XLII (1960), 59 ff., and A. Calvet, 'Unpublished Studies for "The Oath of the Horatii" by Jacques-Louis David', in *Master Drawings*, VI (1968), 37 ff., where a drawing (Albertina) is published which bears the date *1781* and shows Horatius returning in triumph to Rome, with the spoils of the Curiatii and with Camilla's dead body in the foreground. This is a clumsy mingling of public and private concerns – artistically speaking – but interesting evidence for the date at which David began considering the Horatius story.

33. On this point, attitudes to human nature as well as to art history are involved. A strong case for seeing nothing proto-revolutionary in David's work up to 1789 was made by L. D. Ettlinger, 'Jacques Louis David and Roman Virtue', in *Journal of the Royal Society of Arts* (January 1967), 105 ff. Unfortunately, this is marred by several factual mistakes (e.g. David in the company of Caylus (died 1765) while in Italy) and by some generalizations which are no more acceptable, e.g. that in 1785 no one had yet in France 'seriously considered the abolition of the monarchy'. Perhaps Rousseau is not sufficiently serious when he writes (*Émile*, 1762) 'Nous approchons de l'état de crise et du siècle des révolutions', adding as a note, 'Je tiens pour impossible que les grandes monarchies de l'Europe aient encore longtemps à durer.' See also T. E. Crow, *The Oath of the Horatii* in 1785: Painting and Pre-Revolutionary Politics', in *Art History*, I (1978), 424–71, and the same author, *op. cit.* (Note 22), 211–54. Further for *The Oath of the Horatii* and related studies, see the catalogue by A. Schnapper and A. Sérullaz of the exhibition *Jacques-Louis David 1748–1825*, Paris–Versailles, 1989–90, 162–71.

34. *Souvenirs* (*op. cit.*, Note 1), II, 266.

35. The text of the letter to d'Angiviller is given by J. L. Jules David, *Le Peintre Louis David* (Paris, 1880), 28.

36. See *Louis David, son école et son temps* (Paris, 1855), 53 ff. for vivid characterization of David with his pupils.

37. Falconet, it might be said, had been defeated by the system; at least, he retired before it. I have no space here to make the point fully, but David's aggression – if one may call it that – seems based on artistic determination. It is reasonable to see a wide context to his remark recorded via Haydon (*Autobiography* (London, 1926 ed.) II, 578), who concurred: 'When you cease to struggle, you are done for.'

38. Clearest evidence in J.-G. Wille, *Mémoires*, II, 214 (12 August 1789): 'Comme j'avois été nommé par l'Académie, dans notre dernière assemblée, un des juges pour la révision de tous les ouvrages que les divers membres se proposent d'exposer au Salon prochain ...'. The actual committee of scrutiny was long-established, but under d'Angiviller had already been keen in detecting indecencies (*sic*), and he guided them on politically sensitive points. That grim subjects continued to seem provocative may be gauged from a passage in a letter of 17 May 1790 from d'Angiviller to Vien (*N.A.A.F.*, XXII (1907), 289–90): 'J'ai reçu, M', la lettre pas laquelle, d'après quelques observations faites par le Roi sur les tableaux de *Maillard* et *l'amiral Coligny*, relativement au sang qui y est répandu, vous avés pensé devoir surseoir à les remettre sur le métier ...'.

39. The letter of d'Angiviller's assistant, Cuvillier, is of 10 August 1789, printed in *N.A.A.F.*, XXII (1906), 263–5.

40. It is reproduced in E. Grimaux, *Lavoisier* (Paris, 1888), facing 128; David's receipt (of 16 December 1788) for the double portrait is given *op. cit.*, 365. The portrait is virtually evoked by Arthur Young's description (*Travels in France and Italy ...* (London, 1927 ed.), 78) of his visit to the two Lavoisier in 1787.

41. For it see particularly the excellent discussion in Rosenblum, *op. cit.* (Note 3), 76 ff. For a complete monograph on the picture: R. L. Herbert, *David: Brutus* (Art in Context) (London, 1972).

42. L. Courajod, *L'École royale des élèves protégés*, (Paris, 1874), 165 (report of 1786 on Gérard).

Select Bibliography

The bibliography below does not include periodical literature, to which some references are made in the Notes. No attempt has been made to list every exhibition of French eighteenth-century art, but some major ones are cited. The bibliographies accompanying the volumes of *The Pelican History of Art* between which this one comes should also be consulted.

I. PAINTING AND SCULPTURE

A. *Sources*

CAYLUS, COMTE DE. *Vies d'artistes du XVIII^e siècle*. Paris, 1910.

DUPLESSIS, G. *Mémoires et journal de J.-G. Wille*. Paris, 1857.

DUSSIEUX, L., a.o. *Mémoires inédits sur la vie et les ouvrages des membres de l'Académie Royale de Peinture et de Sculpture*. Paris, 1854.

FURCY-RAYNAUD, M. *Correspondance de M. de Marigny (N.A.A.F.)*. Paris, 1904–5.

FURCY-RAYNAUD, M. *Correspondance de M. d'Angiviller (N.A.A.F.)*. Paris, 1906–7.

GUIFFREY, J. *Livrets des Salons* (reprinted). Paris, 1869–70.

GUIFFREY, J. *Notes et documents inédits sur les expositions du XVIII^e siècle*. Paris, 1873.

HENRY, C. *Mémoires inédits de Charles-Nicolas Cochin*. Paris, 1880.

JOUIN, H. *Conférences de l'Académie Royale de Peinture et de Sculpture*. Paris, 1883.

MONTAIGLON, A. DE. *Procès-verbaux de l'Académie Royale de Peinture*. Paris, 1875–92.

MONTAIGLON, A. DE, and GUIFFREY, J. *Correspondance des Directeurs de l'Académie de France à Rome*. Paris, 1887–1908.

RAMBAUD, M. *Documents du Minutier Central concernant l'histoire de l'art (1700–1750)*. Paris, vol. I, 1965; vol. II, 1971.

SEZNEC, J., and ADHÉMAR, J. *Diderot Salons*. Oxford, 1957–67.

WILDENSTEIN, G. *Le Salon de 1725*. (*Compte-rendu par le Mercure de France*). Paris, 1924.

B. *General Works*

1. EXHIBITION CATALOGUES

Les Artistes du Salon de 1737. Paris, Grand Palais, 1930.

Exposition esquisses/maquettes … de l'école française du XVIII^e siècle. Paris, Cailleux, 1934.

Exposition de l'art français au XVIII^e siècle. Copenhagen, 1935.

French Painting and Sculpture of the XVIII Century. New York, Metropolitan Museum of Art, 1935–6.

Louis XV et Rocaille. Paris, Orangerie, 1950.

Kunst und Geist Frankreichs im 18. Jahrhundert. Vienna, 1966.

Dessins français du XVIII^e siècle. Paris, Louvre, Cabinet des Dessins, 1967.

The Age of Rococo. Munich, 1958.

France in the Eighteenth Century. London, Royal Academy, 1968.

The World of Voltaire. Ann Arbor, Michigan University Museum, 1969.

The Age of Neo-Classicism. London, Royal Academy and Victoria and Albert Museum, 1972.

Louis XV: un moment de perfection de l'art français. Paris, Hôtel de la Monnaie, 1974.

1700-tal Tanke och form i rokokon. Stockholm Nationalmuseum, 1979–80.

2. BOOKS

BENOÎT, F. *L'Art français sous la Révolution et l'Empire*. Paris, 1897.

BOUCHER, F., and JACOTTET, P. *Le Dessin français au XVIII^e siècle*. Lausanne, 1952.

CASTAN, A. *L'Ancienne École de Peinture et de Sculpture de Besançon 1756–1791*. Besançon, 1888.

COURAJOD, L. *L'École Royale des Elèves Protégés*. Paris, 1874.

DACIER, E. *L'Art au XVIII^e siècle (Époques Régence–Louis XV)*. Paris, 1951.

FONTAINE, A. *Les Doctrines de l'art en France de Poussin à Diderot*. Paris, 1909.

HILDEBRANDT, E. *Die Malerei und Plastik des 18. Jahrhunderts in Frankreich*. Wildpark-Potsdam, 1924.

RÉAU, L. *L'Art au XVIII^e siècle (Style Louis XVI)*. Paris, 1952.

ROSENBLUM, R. *Transformations in Late Eighteenth Century Art*. Princeton, 1967.

SCHNEIDER, R. *L'Art français au XVIII^e siècle*. Paris, 1926.

II. SCULPTURE

A. *Sources*

DEZALLIER D'ARGENVILLE, A.N. *Vies des fameux sculpteurs depuis la Renaissance des arts*. Paris, 1787.

FURCY-RAYNAUD, M. *Deux Musées de sculpture française à l'époque de la Révolution*. Paris, 1907.

FURCY-RAYNAUD, M. *Inventaire des sculptures exécutées au XVIII^e siècle pour la Direction des Bâtiments du Roi*. Paris, 1927.

PATTE, P. *Monumens érigés en France à la gloire de Louis XV*. Paris, 1765.

B. *General Works*

Dessins de sculpteurs de Pajou à Rodin (exhibition catalogue). Paris, Louvre, Cabinet des Dessins, 1964.

DILKE, LADY. *French Architects and Sculptors of the XVIIIth Century*. London, 1900.

GONSE, L. *La Sculpture française depuis le XIV^e siècle*. Paris, 1895.

INGERSOLL-SMOUSE, F. *La Sculpture funéraire en France au XVIII^e siècle*. Paris, 1912.

LAMI, S. *Dictionnaire des sculpteurs de l'école française au XVIII^e siècle*. Paris, 1910–11.

RÉAU, L. *Les Sculpteurs français en Italie*. Paris, 1945.

ROSTRUP, H. *Franske portraetbuster fra det XVIII aarhunde*. Copenhagen, 1932.

SOUCHAL, F., with MOUREYRE, F. DE LA, and DUMUIS, H. *French Sculptors of the 17th and 18th centuries. The Reign of Louis XIV*. Oxford, 1977–87.

VITRY, P. *La Sculpture française classique de Jean Goujon à Rodin*. Paris, 1934.

ZARETSKAYA, Z., and KOSAREVA, N. *La Sculpture française des XVII–XX^e siècles au Musée de l'Ermitage*. Leningrad, 1963.

C. *Individual Sculptors*

ADAM
Thirion, H. *Les Adam et Clodion*. Paris, 1885.

BOUCHARDON
La Statue équestre de Louis XV. Dessins de Bouchardon, sculpteur du Roi (exhibition catalogue). Paris, Louvre, Cabinet des Dessins, 1973.

Colin, O. *Edme Bouchardon* (exhibition catalogue). Chaumont, 1962.

Roserot, A. *Edme Bouchardon*. Paris, 1910.

BOUDARD
Barocelli, F. *Jean-Baptiste Boudard 1710–1768* (exhibition catalogue, Parma). Milan, 1990.

CAFFIÉRI
Guiffrey, J. *Les Caffiéri*. Paris, 1877.

CLODION
Poulet, A.L. *Clodion Terracottas in North American Collections* (exhibition catalogue). New York, Frick Collection, 1984.

Poulet, A.L. and Scherf, G. *Clodion* (exhibition catalogue) Paris, Louvre, 1992.
See also ADAM

COUSTOU
Souchal, F. *Les Frères Coustou*. Paris, 1980.

COUSTOU I, Guillaume
Gougenot, L. *Vie de Coustou le jeune* (Societé des Bibliophiles François, Mélanges, no. 4). Paris, 1903.

COUSTOU II, Guillaume
Anon. *Éloge de Monsieur Coustou*. Paris, 1778.

Réau, L. *J.-B. Pigalle*. Paris, 1950.
Rocheblave, S. *Jean-Baptiste Pigalle*. Paris, 1919.

SALY
Jouin, H. *Jacques Saly*. Mâcon, 1896.

SLODTZ
Souchal, F. *Les Slodtz, sculpteurs et décorateurs du Roi (1685–1764)*. Paris, 1968.

III. PAINTING

A. *Sources*

ARGENS, MARQUIS BOYER D'. *Réflexions critiques sur les différentes écoles de peinture*. Paris, 1752.
COCHIN, C.-N. *Recueil de quelques pièces concernant les arts*. Paris, 1757.
DEZALLIER D'ARGENVILLE, A.-J. *Abrégé de la vie des plus fameux peintres*, Paris, 1745–52.
ENGERAND, F. *Inventaire des tableaux commandés et achetés par la Direction des Bâtiments du Roi (1709–1792)*. Paris, 1900.
LA FONT DE SAINT YENNE. *Réflexions sur quelques causes de l'état présent de la peinture en France*. The Hague, 1747.
LÉPICIÉ, N.-B. *Vies des Premier-Peintres du Roi depuis M. le Brun jusqu'à présent*. Paris, 1752.
MARIETTE, P. J. *Abécédario de P. J. Mariette*, ed. Chennevières, P. de and Montaiglon, A. de. Paris, 1851–60.
ORLANDI, A. *L'Abcedario pittorico*. Bologna, 1719 ed.
TELLIAB (MYLORD) (BAILLET DE SAINT-JULIEN). *Caractères des peintres actuellement vivants*. Paris, 1755.
WILDENSTEIN, D. *Documents inédits sur les artistes français du XVIII^e siècle*. Paris, 1966.
WILDENSTEIN, D. *Inventaires après décès d'artistes et de collectionneurs français du XVIII^e siècle*. Paris, 1967.

B. *General Works*

1. EXHIBITION CATALOGUES

Paris et les ateliers provinciaux au XVIII^e siècle. Bordeaux, 1958.
De David à Delacroix, Paris (Detroit–New York: *The Age of Revolution*). 1974–5.
De Watteau à David. Peintures et dessins des musées de province français. Brussels, 1975.
Rosenberg, P. *The Age of Louis XV: French Painting 1715–1774*. Toledo–Chicago–Ottawa, 1975–6.
French Landscape Drawings and Sketches of the Eighteenth Century. London, British Museum, 1977.
Diderot et l'art de Boucher à David. Les Salons: 1759–1781. Paris, Hôtel de la Monnaie, 1984.
The First Painters to the King: French Royal Taste from Louis XIV to the Revolution. New York, Stair Sainty-Matthiesen, 1985.
Rosenthal, D. A. *La Grande Manière: Historical and Religious Painting in France 1700–1800*. Rochester, New Brunswick and Atlanta, 1987–8.
Bailey, C. B. *Les Amours des dieux*. Paris, Grand Palais, 1991–2; *The Loves of the Gods*. Philadelphia and Fort Worth, 1992.

2. BOOKS

BLANC, C. *Les Peintres des fêtes-galantes*. Paris, 1854.
BRYSON, N. *Word and Image: French Painting of the Ancien Régime*. Cambridge, 1981.
BUKDAHL, E. M. *Diderot, Critique d'Art* (Trans. Pilosz, J.) Copenhagen, 1981–2.
CONISBEE, P. *Painting in Eighteenth-Century France*. London, 1981.
CROW, T. E. *Painters and Public Life in Eighteenth-Century Paris*. New Haven–London, 1985.
DILKE, LADY. *French Painters of the XVIII Century*. London, 1899.
DIMIER, L. (ed.). *Les Peintres français du XVIII^e siècle*. Paris–Brussels, 1928–30.
DUMONT-WILDEN, L. *Le Portrait en France*. Brussels, 1909.
FARÉ, M. and F. *La Vie silencieuse en France: la nature morte au XVIII^e siècle*. Fribourg, 1976.
FLORISOONE, M. *La Peinture française: le dix-huitième siècle*. Paris, 1948.
FRIED, M. *Absorption and Theatricality: Painting and Beholder in the Age of Diderot*. Berkeley, 1980.
FRIEDLAENDER, W. *David to Delacroix*. Cambridge, Mass., 1952.
GONCOURT, E. and J. DE. *L'Art du XVIII^e siècle*. Paris, 1880–4.
LOCQUIN, J. *La Peinture d'histoire en France de 1747 à 1785*. Paris, 1912 (reprinted 1978).

MARCEL, P. *La Peinture française au début du dix-huitième siècle, 1690–1721*. Paris, n.d. (1906).
RÉAU, L. *Histoire de la peinture française au XVIII^e siècle*. Paris–Brussels, 1925–6.
THUILLIER, J., and CHÂTELET, A. *French Painting: From Le Nain to Fragonard*. Geneva, 1964.
WAKEFIELD, D. *French Eighteenth Century Painting*. London, 1984.
WILSON, M. *Eighteenth-Century French Painting*. Oxford, 1979.

C. *Individual Painters*

AUDRAN, Claude
Duplessis, G. *Les Audran*. Paris, 1892.

AVED
Wildenstein, G. *Le Peintre Aved*. Paris, 1922.

BOILLY
Harisse, H. *Louis-Léopold Boilly*. Paris, 1898.

BOUCHER
Ananoff, A. *L'Œuvre dessiné de Boucher*, I. Paris, 1966.
Ananoff, A., and Wildenstein, D. *François Boucher*. Paris, 1976.
François Boucher Premier Peintre du Roi (exhibition catalogue). Paris, Cailleux, 1964.
François Boucher: Gravures et dessins... (exhibition catalogue). Paris, Louvre, 1971.
François Boucher (exhibition catalogue). New York–Detroit–Paris, 1986–7.
François Boucher: His Circle and Influence (exhibition catalogue). New York, Stair Sainty Matthiesen, 1987.
Brunel, G. *Boucher*. Paris, 1986.
Jean-Richard, P. *Musée du Louvre: Cabinet des Dessins ... École Française*, I. *L'Œuvre gravé de François Boucher dans la Collection Edmond de Rothschild*. Paris, 1978.
Macfall, H. *Boucher*. London, 1908.
Mantz, P. *Boucher, Lemoyne et Nattier*. Paris, n.d.
Michel, A. *Boucher*. Paris, n.d.
Nolhac, P. de. *Boucher, premier peintre du roi*. Paris, 1925.

BOULLONGNE
Caix de Saint-Aymour. *Les Boullogne*. Paris, 1919.

BRENET
Sandoz, M. *Nicolas-Guy Brenet 1728–1792*. Paris, 1979.

CHARDIN
Conisbee, P. *Chardin*. Oxford, 1986.
Pascal, A., Rothschild, H. de, and Gaucheron, R. *Documents sur la vie et l'œuvre de Chardin*. Paris, 1931.
Rosenberg, P. *Chardin*. Geneva, 1963.
Rosenberg, P. *Chardin* (exhibition catalogue). Paris–Cleveland–Detroit, 1979.
Rosenberg, P. *Tout l'œuvre peint de Chardin*. Paris, 1983.
Wildenstein, G. *Chardin*. Paris, 1933.

COLSON, Jean-François Gilles, called
Quarré, P., a.o. *Trois Peintres bourguignons du XVIII^e siècle: Colson, Vestier et Trinquesse* (exhibition catalogue). Dijon, 1969.

COYPEL, Antoine
Garnier, N. *Antoine Coypel*. Paris, 1989.

COYPEL, Charles-Antoine
Jamieson, I. *Charles-Antoine Coypel*. Paris, 1930.

DANDRÉ-BARDON
Chol, D. *Michel-François Dandré-Bardon ou l'apogée de la peinture en Provence au XVIII^e siècle*. Aix-en-Provence, 1987.

DAVID
Brookner, A. *David*. London, 1980.
Cantinelli, R. *Jacques-Louis David*. Paris–Brussels, 1930.
David e Roma (exhibition catalogue). Rome, 1981–2.
David, J. L. Jules. *Le Peintre Louis David*. Paris, 1880.
Delécluze, M. E. J. *Louis David, son école et son temps*. Paris, 1855.
Hautecœur, L. *Louis David*. Paris, 1954.
Schnapper, A. *David, témoin de son temps*. Paris, 1980.

Schnapper, A., and Sérullaz, A. *Jacques-Louis David 1748–1825* (exhibition catalogue). Paris–Versailles, 1989–90.
Wildenstein, D. and G. *Louis David. Recueil de Documents...* Paris, 1973.

DESHAYS
Sandoz, M. *Jean-Baptiste Deshays 1729–1765*. Paris, 1977.

DESPORTES
L'Atelier de Desportes à la manufacture de Sèvres (exhibition catalogue). Paris, Louvre, 1982–3.

DOYEN
Sandoz, M. *Gabriel-François Doyen (1748–1772)*. Paris, 1975.

DROUAIS, Jean-Germain
Ramade, P., ed. *Jean-Germain Drouais 1763–1788* (exhibition catalogue). Rennes, 1985.

DUCREUX
Lyon, G. *Joseph Ducreux*. Paris, 1958.

DUPLESSIS
Belleudy, J. *J.-S. Duplessis*. Chartres, 1913.

DURAMEAU
Sandoz, M. *Louis-Jacques Durameau 1733–1796*. Paris, 1980.

FRAGONARD
Ananoff, A. *L'Œuvre dessiné de Jean-Honoré Fragonard*. Paris, 1961.
Ashton, D. *Fragonard in the Universe of Painting*. Washington–London, 1988.
Cuzin, J.-P. *Fragonard: Life and Work*. New York, 1988.
Cuzin, J.-P., a.o. *J.-H. Fragonard e H. Robert a Roma* (exhibition catalogue). Rome, 1990.
Mandel, G. *L'Opera completa di Fragonard*. Milan, 1972.
Nolhac, P. de. *J.-H. Fragonard*. Paris, 1906.
Portalis, Baron H. *Honoré Fragonard, sa vie et son œuvre*. Paris, 1889.
Rosenberg, P. *Fragonard* (exhibition catalogue). Paris–New York, 1987–8.
Sheriff, M. D. *Fragonard. Art and Eroticism*. Chicago, 1990.
Sutton, D. *Fragonard* (exhibition catalogue). Tokyo–Kyoto, 1980.
Wakefield, D. *Fragonard*. London, 1976.
Wildenstein, G. *Exposition Fragonard*. Paris, 1921.
Wildenstein, G. *Fragonard*. London, 1976.

GILLOT
Poley, J. *Claude Gillot. Leben und Werk*. Würzburg, 1938.
Populus, B. *Claude Gillot (1673–1722), Catalogue de l'œuvre gravé*. Paris, 1930.

GREUZE
Brookner, A. *Greuze: The Rise and Fall of an Eighteenth-Century Phenomenon*. London, 1972.
Hautecœur, L. *Greuze*. Paris, 1913.
Martin, J., and Masson, C. *Œuvre de J.-B. Greuze*. Paris, 1908.
Mauclair, C. *Greuze et son temps*. Paris, 1926.
Munhall, E. *Jean-Baptiste Greuze 1725–1805* (exhibition catalogue). Hartford–San Francisco–Dijon, 1976–7.

GRIMOU
Gabillot, C. *Alexis Grimou*. Paris, 1911.

HOUËL
Vloberg, M. *Jean Houël*. Paris, 1930.

JOUVENET
Schnapper, A. *Jean Jouvenet 1646–1717 et la peinture d'histoire à Paris*. Paris, 1974.

LABILLE-GUIARD
Passez, M.-A. *Adélaïde Labille-Guiard*. Paris, 1973.

LALLEMAND
J.-B. Lallemand, paysagiste dijonnais du XVIIIᵉ siècle (exhibition catalogue), Dijon, 1954.

LANCRET
Wildenstein, G. *Lancret*. Paris, 1924.

LARGILLIERRE
Rosenfeld, M. N. *Largillierre and the Eighteenth-Century Portrait* (exhibition catalogue). Montreal, 1982.

LA TOUR
Besnard, A., and Wildenstein, G. *La Tour*. Paris, 1928.
Bury, A. *Maurice-Quentin de la Tour*. London, 1971.

LEMOYNE, François
Bordeaux, J.-L. *François Le Moyne 1688–1737 and his Generation*. Paris, 1984.
Mantz, P. *Boucher, Lemoyne et Nattier*. Paris, n.d.

LÉPICIÉ
Dreyfus, P. G. *Lépicié*. Paris, 1923.

LE PRINCE
Hédou, J. *Jean Le Prince et son œuvre*. Paris, 1879.

LIOTARD
Fosca, F. *Liotard*. Paris, 1928.
Humbert, E., Revilliod, A., and Tilanus, J. W. R. *La Vie et les œuvres de Jean-Étienne Liotard*. Amsterdam, 1897.

LOO, Carle van
Dandré-Bardon, M.-F. *Vie de Carle Vanloo*. Paris, 1765.
Sahut, M.-C. *Carle Vanloo* (exhibition catalogue). Nice–Clermont-Ferrand–Nancy, 1977.

LOUTHERBOURG
Joppien, R. *Philippe-Jacques de Loutherbourg*, (exhibition catalogue). London, Kenwood, 1973.

MÉNAGEOT
Willk-Brocard, N. *François-Guillaume Ménageot*. Paris, n.d. but 1978(?).

MOREAU, Louis-Gabriel
Wildenstein, G. *Un Peintre de paysage au XVIIIᵉ siècle: Louis Moreau*. Paris, 1923.

NATOIRE
Julia, I., a.o. *Charles-Joseph Natoire* (exhibition catalogue). Nîmes–Rome, 1977.
Mantz, P. *Boucher, Lemoyne et Nattier*. Paris, n.d.

NATTIER
Nolhac, P. de. *Nattier, Peintre de la cour de Louis XV*. Paris, 1905.
Nolhac, P. de. *Nattier*. Paris, 1925.

OUDRY
Cordey, J. *Esquisses de portraits peints par J.-B. Oudry*. Paris, 1929.
Lauts, J. *Jean-Baptiste Oudry*. Hamburg–Berlin, 1967.
Locquin, J. *Catalogue raisonné de l'œuvre de Jean-Baptiste Oudry (A.A.F.)*. Paris, 1912; reprinted 1968.
Opperman, H. N. *Jean-Baptiste Oudry* (dissertation). New York–London, 1977.
Opperman, H. N. *J.-B. Oudry* (exhibition catalogue). Fort Worth–Kansas–Paris, 1983.

PARROCEL
Parrocel, E. *Monographie des Parrocel*. Marseilles, 1861.
Roeingh, R. *Vom Schritt zur Capriole*. Berlin–Paris, 1943.

PATER
Ingersoll-Smouse, F. *Pater*. Paris, 1928.

PERRONNEAU
Vaillat, L., and Ratouis de Limay, P. *J. B. Perronneau, sa vie et son œuvre*. Paris, 1923.

PESNE
Berckenhagen, E., a.o. *Antoine Pesne*. Berlin, 1958.
Börsch-Supan, H. *Der Maler Antoine Pesne*. Berlin, 1986.

PEYRON
Rosenberg, P., and Sandt, U. van de. *Pierre Peyron 1744–1814*. Paris, 1983.

PILLEMENT
Pillement, J. *Jean Pillement*. Paris, 1945.

RAOUX
Bataille, G., in Dimier, L., ed. *Les Peintres français du XVIIIᵉ siècle*, II. Paris–Brussels, 1928–30.

RESTOUT
Rosenberg, P., and Schnapper, A. *Jean Restout* (exhibition catalogue). Rouen, 1970.

RIGAUD

Colomer, C. *Hyacinthe Rigaud, 1659–1743*. Perpignan, 1973.
Roman, J. *Le Livre de raison du peintre Hyacinthe Rigaud*. Paris, 1919.

ROBERT

Beau, M. *La Collection des dessins d'Hubert Robert au musée de Valence*. Lyon, 1968.
Burda, H. *Die Ruine in den Bildern Hubert Roberts*. Munich, 1967.
Carlson, V. *Hubert Robert, Drawings and Watercolors* (exhibition catalogue). Washington, National Gallery of Art, 1978–9.
Cuzin, J.-P., a.o. *J.-H. Fragonard e H. Robert a Roma* (exhibition catalogue). Rome, 1990.
Exposition Hubert Robert. Paris, Orangerie, 1933.
Gabillot, C. *Hubert Robert et son temps*. Paris, 1895.
Hubert Robert, The Pleasure of Ruins (exhibition catalogue). New York, Wildenstein, 1988.
Leclerc, T. *Hubert Robert et les paysagistes français du XVIII^e siècle*. Paris, 1913.
Nolhac, P. de. *Hubert Robert*. Paris, 1910.

ROSLIN

Lundberg, G. W. *Roslin, Liv och Verk*. Malmö, 1957.

SAINT-AUBIN

Dacier, E. *Gabriel de Saint-Aubin, peintre, dessinateur et graveur*. Paris, 1929–31.
Moureau, A. *Les Saint-Aubin*. Paris, n.d.

SANTERRE

Potiquet, A. *Jean-Baptiste Santerre*. Paris, 1876.

SUBLEYRAS

Rosenberg. P., Michel, O., and Morel, P. *Subleyras 1699–1749* (exhibition catalogue). Paris–Rome, 1987.

TOCQUÉ

Doria, A. *Louis Tocqué*. Paris, 1929.

TRÉMOLIÈRES

Pierre-Charles Trémolières (Cholet, 1703–Paris, 1739) (exhibition catalogue). Cholet, 1973.

TROY, Jean-François de

Brière, G., in Dimier, L. *Les Peintres français du XVIII^e siècle*, II. Paris–Brussels, 1928–30.

VALLAYER-COSTER

Roland Michel, M. *Anne Vallayer-Coster*. Paris, 1970.

VERNET

Conisbee, P. *Claude-Joseph Vernet 1714–1789* (exhibition catalogue). London, Kenwood, 1976.

Conisbee, P. *Joseph Vernet* (exhibition catalogue, slightly varied from above). Paris, Musée de la Marine, 1976–7.
Ingersoll-Smouse, F. *Joseph Vernet*. Paris, 1926.
Lagrange, L. *Joseph Vernet et la peinture au XVIII^e siècle*. Paris, 1864.

VESTIER

Passez, A.-M. *Antoine Vestier*. Paris, 1989.
see also under COLSON

VIEN

Gaehtgens, T., and Lugand, J. *Joseph-Marie Vien*. Paris, 1988.

VIGÉE-LE BRUN

Baillio, J. *Élizabeth Louise Vigée Le Brun 1755–1842* (exhibition catalogue). Fort Worth, 1982.
Hautecœur, L. *Madame Vigée-Lebrun; étude critique*. Paris, n.d. (1917).
Nolhac, P. de. *Élizabeth Vigée-Lebrun*. Paris, 1908 (revised ed., 1912).
Vigée-Le Brun, E. L. *Souvenirs de Madame Louise-Elizabeth Vigée le Brun ...* Paris, 1835–7.

WATTEAU

Adhémar, H., and Huyghe, R. *Watteau, sa vie – son œuvre*. Paris, 1950.
Banks, O. T. *Watteau and the North: Studies in the Dutch and Flemish Baroque Influence on French Rococo Painting* (dissertation). New York–London, 1977.
Brookner, A. *Watteau*. London, 1967.
Camesasca, E., and Rosenberg, P. *Tout l'œuvre peint de Watteau*. Paris, 1970 (new ed. 1983).
Champion, P. *Notes critiques sur les vies anciennes d'Antoine Watteau*. Paris, 1921.
Cormack, M. *The Drawings of Watteau*. London–New York, 1970.
Dacier, E., Herold, J., and Vuaflart, A. *Jean de Jullienne et les graveurs de Watteau au XVIII^e siècle*. Paris, 1921–2 and 1929.
Ferré, J., a.o. *Watteau*. Madrid, 1972.
Matthey, J. *Antoine Watteau, peintures réapparues*. Paris, 1959.
Moureau, F., and Morgan Grasselli, M., eds. *Antoine Watteau (1684–1721), The Painter, His Age and His Legend* (international conference, 1984). Paris–Geneva, 1987.
Nemilova, I. S. *Watteau et ses œuvres à l'Ermitage*. Leningrad, 1964.
Parker, K. T., and Matthey, J. *Antoine Watteau, Cata-logue complet de son œuvre dessiné*. Paris, 1957–8.
Pilon, E. *Watteau et son école*. Paris, 1912.
Posner, D. *Antoine Watteau*. London, 1984.
Rey, R. *Quelques satellites de Watteau*. Paris, 1931.
Roland Michel, M. *Watteau, An Artist of the Eighteenth Century*. London, 1984 (French ed., Paris, 1984).
Rosenberg, P. *Vies anciennes de Watteau*. Paris, 1984.
Watteau et sa génération (exhibition catalogue). Paris, Cailleux, 1968.
Watteau 1684–1721 (exhibition catalogue). Washington–Paris–Berlin, 1984–5.
Zolotov, Y. *Antoine Watteau. Gemälde und Zeichnungen in sowjetschen Museen*. Leningrad, 1986.

Index